Chicago: Growth of a Metropolis

Harold M. Mayer and Richard C. Wade

With the Assistance of Glen E. Holt Cartography by Gerald F. Pyle

Chicago: Growth of a Metropolis

The University of Chicago Press, Chicago and London

The University of Chicago Press, Chicago 60637
The University of Chicago Press, Ltd., London

© 1969 by The University of Chicago

All rights reserved. Published 1969
Printed in the United States of America

82 81 80 79 78 9 8 7 6 5

International Standard Book Number: 0-226-51273-8 (clothbound)

Library of Congress Catalog Card Number: 68-54054

13Apr81

Contents

Introduction

This is the story of Chicago and how it grew. In a little over a century it rose from a mere frontier outpost to become one of the great cities of the world. In 1820 the site contained a fort, a few dwellings, and no special prospects. Eighty years later Chicago, comprising almost two million people, was the vital center of a whole continent, and the home of many of the nation's largest business enterprises. In the 1960's its metropolitan population exceeded seven million, its hinterland covered nearly a million square miles, and its commercial interests stretched around the globe.

No single book can possibly encompass the immense scope of this development or convey the endless diversity of the life of Chicago's people. But with the help of the camera it is possible to capture some dimensions of this extraordinary story—for most of Chicago's past lies within the history of photography. As early as the 1850's, amateur and professional photographers became fascinated with the changing city, catching its many faces and recording its constantly shifting profile. These pictures, supplemented by a few drawings and sketches, constitute a priceless archive and make it feasible to reconstruct much of the physical shape of Chicago at different stages of its growth.

This volume, however, tries to do more than show physical development—it attempts to suggest *how* the city expanded and *why* it looks the way it does. This broad purpose explains the dual authorship, for the task seemed to require the tools of both the historian and the geographer—the former with his emphasis on the texture of life and the latter with his concern for spatial relationships. It is the joining of the land and the people that makes the city, and the partnership of two disciplines appeared to be an appropriate strategy in approaching this process.

Because it asks different questions, this book differs markedly from other "pictorial histories" of American cities. Instead of emphasizing society and customs, this volume deals with the physical conditions of life. In place of the conventional interest in "founding fathers" and leading families, it is more concerned with street scenes and ordinary people. Without neglecting the downtown, it also reaches into the residential areas and neighborhood shopping centers. Moreover, this volume is concerned with suburbs and "satellite" towns as well as the historic city. It encompasses the area from Waukegan on the north, to Elgin on the west, to Gary on the east. In short, it tries to reconstruct metropolitan Chicago and to see it as it appeared to successive generations of residents and visitors.

This book also differs from other "pictorial histories" because it attempts to use photography as evidence instead of as mere illustration. Generally, historians have employed pictures to illustrate a text or to make an event or personality more vivid and compelling. In some

instances, a powerful photograph is thought to convey an emotion in a way which words cannot; "one picture is worth a thousand words" is the popular shorthand for this practice. "Illustrated histories" have been the result, and many are beautifully and effectively executed.

This volume, however, uses photographs as documents. Thus, Hesler's panorama of Chicago in 1857 is not simply a quaint view of a young town; it is a visual census of the city which tells us things that we cannot get easily or at all in other ways. For instance, the mixture of land uses—with residential, commercial, and industrial buildings abutting each other—is clearly displayed: it reveals the scale and spatial relationships of the urban environment; it fixes the relationship of the city to the lake and to the surrounding countryside; and, it locates the traffic in the river. Although contemporary drawings and sketches often faithfully reproduce the size and shape of buildings, the photograph provides fuller fidelity and much wider coverage.

Photographic documentation is especially useful in describing the physical growth and internal spatial patterns of cities. In no other way can we see the successive stages of development; no other source shows so clearly the trans-formation of open land to urban purposes or so well traces the intensification of urban use over a period of time. In a unique way, too, the camera records the changing skyline, from the first court houses and churches to the dominant commercial skyscrapers of the present. An aerial view can convey the pattern of the metropolis; a snapshot can catch the tangled texture of the neighborhood or street. And a photograph handles the problem of scale—the size of things in the environment—in a way that cold statistics never can.

Yet, like all documents, the photograph has its limitations. The photographer, no less than any other observer, selects his material. Out of an almost infinite range of possibilities he chooses the subjects which interest him most. Thus any one photographer will capture but a small part of a city's life; even taken together as a group, photographers have missed many aspects of Chicago's past. While pictures of famous buildings are plentiful; shots of residential neighborhoods are not. Disasters are usually witnessed by many cameras; routine events pass by unrecorded. Moreover, whole groups of people or sections of town are missed because no photographer found them significant. Immigrant areas, for example, are badly under-represented in photographic remains; Negroes, until recently, have been almost invisible.

In addition to omissions, photographic documentation also contains the problem of bias. For the professional photographer, no less than the writer, tries to say something through his art. He might be outraged by bad housing, exhilarated by the skyline, awed by a new building, or appalled by the despoilment of the landscape. A picture, at least a good one, conveys more than it records. Perhaps the "camera never lies," but the photographer does select. The finger that snaps the shutter may also write a message or grind an axe.

Moreover, the limitations are technological as well as personal. The camera works best in strong light. Thus photographers have preferred to avoid nights and overcast and inclement days. The reader will therefore be struck by the brightness of the Chicago that appears in this volume and will miss the city after sundown or in climatic duress. In addition, until recently, the long time exposure of early cameras made it difficult to handle movement. Thus the photographer went about his work when the traffic was lightest and when few people were around. The result is many shots of downtown streets with only an

occasional vehicle or pedestrian. When people do appear they are obviously on stage, holding a pose. Even modern photographers interested in recording the physical shape of the city often time their work to minimize moving objects.

Another limitation in the use of photography as documentation stems less from the technology of the camera or the personal views of the photographer than from the fecklessness of historical preservation. Since photographs have been used only marginally by historians, few libraries or societies collected them systematically. Pictures surviving this neglect have only recently made their way into archives, and they are often the last items to be catalogued. Interest has increased recently, but the new concern largely has concentrated on the photographer rather than on the subject, on the quality of performance, not the coverage of important themes.

Despite these handicaps the sources for pictorial documentation are extensive and rich. Chicago is particularly fortunate, though nearly every city has more visual material than scholars realize. The Chicago Historical Society is the largest single repository in the city. Indeed its collection of *Daily News* pictures, containing nearly 100,000 items and covering the years from about 1900 to the mid 1950's, is one of the largest in the world. But local public libraries, community historical societies, photographic companies, and many ordinary citizens have thousands of pictures which have somehow survived and are available for scholarly use. For many topics the problem is abundance, not scarcity—selection, not discovery.

The choice of pictures in this volume was dictated by this concept of documentation. That meant choosing those which best conveyed our analysis of the growth of the metropolis. Thus many good, even great, photographs do not appear. Others bear the obvious mark of the amateur. Occasionally, it was even necessary to include pictures which do not reproduce well. Early panoramas are so rare and important that we have used them wherever possible, even where a panel was missing or the quality was uncertain. We also tried to avoid reproducing pictures that have appeared elsewhere; indeed, most of the photographs in the book have never been used before.

To aid the reader in the reconstruction of the growth of Chicago, we have prepared a group of maps. They cover a variety of topics, but three series are especially important. One set depicts the growth of the city at each period of development. The built-up area is never the same as the formal municipal limits. In the nineteenth century the developed part of the city was generally much smaller; in the twentieth century the population has spilled outside that boundary and reached into seven nearby counties. Another series—of the harbor, canals and rivers, of the railroads, horse-cars, trolleys, and of the streets and expressways—emphasizes the role of transportation in the development of the city. Still another plots the concentration and dispersal of ethnic groups, as well as the growth of the Negro ghetto.

A final note on the use of the word "Chicago." We mean by Chicago the entire metropolitan area, not simply the legal municipal unit. The modern metropolis, with its central city, suburbs, and "satellite cities," is a single historic and geographic entity. Today it is politically fragmented, but in every other way it constitutes a functional unit. All of its parts grew out of the same historical roots; its present problems and prospects are interwoven; and all of its people will share a common future. At a time when so many see only a city divided between suburb and central core, or between black and white, the historian and geographer feel it is important to emphasize the shared heritage of all who live in "Chicago."

Chicago:

Growth of a Metropolis

1 | Prairie Seaport, 1830-51

The site was unpromising. The river ran sluggishly across a flat plain to the lake. A low ridge eight miles inland cut the connection between Lake Michigan and the water route that ran westward to the Mississippi. No promontory, no hill caught the eye. The lake alone was arresting. By turns blue and tranquil, then green-gray and angry, it provided a stunning gateway to an indifferent landscape. "The appearance of the country near Chicago," wrote a traveler wearily in 1823, "offers but few features upon which the eye . . . can dwell with pleasure." The "uniformity in the scenery," he complained, evoked a "fatiguing monotony."

Yet the location of the future metropolis was as significant as its site was inconsequential. Indeed, nature had richly, if subtly, endowed Chicago. Situated astride the great water highways of the mid-continent, it served a vast region stretching eastward through the Great Lakes to the Saint Lawrence River and thence to the ocean, northward into Canada, westward through the Mississippi River system to the Rocky Mountains, and southward to the Gulf of Mexico. The lines of travel converged at the southern tip of Lake Michigan; whether persons and goods moved overland or on the water, they converged on Chicago. Henry R. Schoolcraft, an early visitor, saw the splendid prospects as early as 1820 when he predicted that the place would become "a depot for the inland commerce, between the northern and southern sections of the union, and a great thoroughfare for strangers, merchants, and travellers." Within a few decades after the first settlement, the spot where the river joined the lake would be the focus of a commercial empire that dominated mid-America and an industrial center whose products found markets throughout the world.

The configuration of the Chicago area as Indians and whites first saw it was the result of ancient geologic forces. More than four hundred million years before, the site lay beneath a tropical sea that occupied the heart of the North American continent. Before the waters receded there was deposited on the sea bottom the material that constitutes the bedrock of Chicago. Known as the Niagara formation, this limestone would ultimately prove useful to city dwellers, both as a building material and as the raw material of cement. Above the limestone, glaciers left layers of impermeable clay that prevented the draining off of surface waters and created a high water table. (As a result, early Chicago was a sea of mud a good part of the year, obstructing transportation and inconveniencing pedestrians.)

The surface of the site was more obviously determined by later glaciation. Millions of years after the tropical sea receded, a succession of great ice sheets moved down over the northern part of the continent, extending to the Ohio Valley and covering most of Illinois.

1. Site of Chicago, Westward View, 1779

So predominant was the flat grassy plain around Chicago that nineteenth-century travelers found it a tourist attraction. Charles R. Weld, an English traveler who came to Chicago in 1854, advised readers of the account of his "tour" that it was "worth while going" to Illinois "for the purpose of seeing the prairies near Chicago." Two years later a reporter for *Putnam's Magazine* put the matter succinctly when he wrote that "Chicago stands . . . on a prairie, *a country having a face but no features.*" A likeness of Jean Baptiste Point du Sable and a view of his cabin are seen in the insets. "Du Sable 'drove his stakes' in the neighborhood of Dearborn and Water Streets" and from there " 'laid claim' to the surrounding country." (Aquatint engraving, Raoul Varin, 1930, after frontispiece in A. T. Andreas, *History of Chicago*. Courtesy Chicago Historical Society.)

2. View of Chicago, 1820

Chicagoans have always been conscious of their history, and when early pictorial

These glaciers, advancing and retreating, left behind a series of concentric rings of debris called moraines. Rough, boulder-strewn ridges and mounds, they interrupt the flat intensity of the prairies. Poorly drained, irregular and rocky, these modest hills are unsuited to extensive farming, but their wild woods and little lakes make them popular resort spots. Lake Geneva and the Fox Lake chain are water-filled depressions among moraines, and many of the forest preserve areas have the same origins.

As the last ice sheet receded, meltwaters occupied a large basin that the advancing glaciers had scoured out. Blocked to the northeast by the glacier itself, the accumulating waters of what geologists would later call Lake Chicago found their way through the drainage divide at two places. These valleys, or sags, carried the overflow westward into the Mississippi system. Created by ancient necessity, the two exits played an important role in the development of Chicago and are still visible today. The Calumet Sag Channel, a vital link in the nation's inland waterway system, runs through one old glacial streambed, and the Chicago Sanitary and Ship Canal follows the second fissure through the moraines. The latter, sometimes called the Chicago portage, was the route of the Illinois and Michigan Canal in the nineteenth century.

The retreating glaciers also bequeathed the region a series of formations that became routes of Indian trails and, still

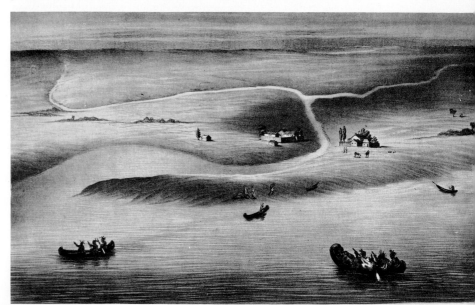

1

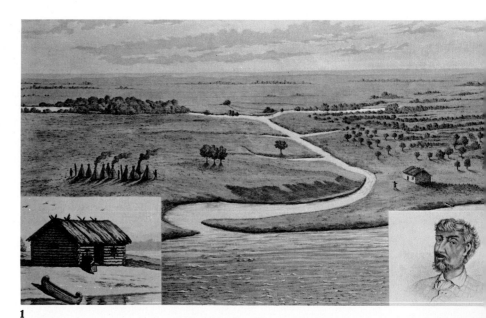

2

sources have not existed, they sometimes have set out to create them. This lithograph was published about 1857. It represents an artistic conception of how the city looked a generation before.
(Lithograph, J. Gemmel, published by D. F. Fabronius. Courtesy Chicago Historical Society.)

3. Section of La Hontan's Map of the Chicago Region, 1703

During the exploration period of Chicago's history it was common practice for map makers to plagiarize previous maps, filling in the details by the use of sheer imagination. The problem was complicated by occasional shifts in the portages because of floods and erosion. A late nineteenth-century map authority notes La Hontan's maps as generally "mendacious." This "small section of his map . . . though not altogether free from distortion" is, however, not a completely inaccurate picture of the region in 1703.
(From A. T. Andreas, *History of Chicago*.)

4. Chicago Bedrock

The limestone bedrock underlying the site of Chicago is revealed in Stern's Quarry at Twenty-seventh and Halsted streets.
(Courtesy Material Service, division of General Dynamics Corporation, Chicago.)

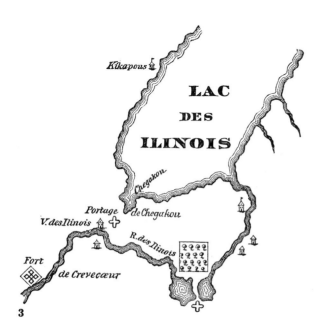

3

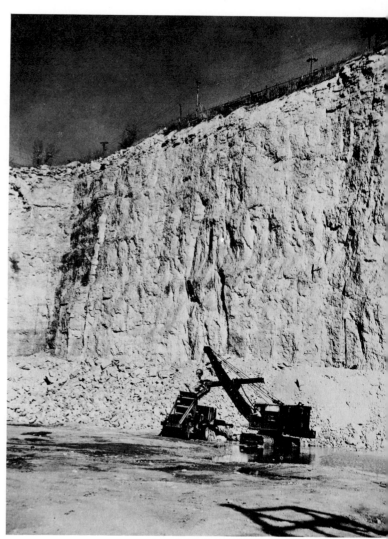

4

1. The Original Fort Dearborn, 1803-12
Embodying the best military thinking of the time, the fort, surrounded by a log palisade, took advantage of a natural defensive site—the neck of land formed by the southward bend at the river mouth. Green stripes in the sidewalk at the intersection of Michigan Avenue and Wacker Drive now mark the outlines of old Fort Dearborn.
(From A. T. Andreas, *History of Chicago.* Courtesy Chicago Historical Society.)

2. Jacques Marquette (1637-75)
After passing through the Chicago portage on his route between the Mississippi and Lake Michigan with the explorer, Jolliet, in 1673, Marquette returned to Green Bay. On his next exploring trip during 1674-75 he wintered at Chicago. His account of the region includes trading with the Indians, the difficulties of the winter, and even notice of the lake tides "which made the water good or bad, because that which flows from above comes from prairies and small streams." Marquette also mentioned

later, highways. As the ice sheet retreated irregularly, it occasionally paused long enough to permit shore currents in the lakes formed by the meltwater to create spits, bars, and beaches. In later times these sandy strips were the only well-drained ground in the spring, and the Indians used them for overland travel when the surrounding area was waterlogged. U.S. Routes 30, 6, and 20 at the southern end of Lake Michigan are constructed on old beaches. In Chicago, some of the major streets that deviate from the general rectangular pattern, such as North Clark Street, Ridge Avenue, and Vincennes Avenue, were old glacial formations and well-traveled Indian trails.

The Indians had early appreciated Chicago's strategic location in the lake, prairie, and river complex of the Middle West. The French, too, soon discovered it. In the autumn of 1673 Père Marquette and Louis Jolliet paused briefly at the mouth of the river after a long trip through the Mississippi Valley which had taken them as far south and west as Arkansas. A little more than a year later, Marquette wintered at the same place, becoming the first semipermanent resident of Chicago. His visit signaled the growing interest of European nations in the area. Before long, the portage route became a major link in the chain of waters that carried men and goods from the Mississippi Valley along the Saint Lawrence to French Canada.

Despite French activity, the area

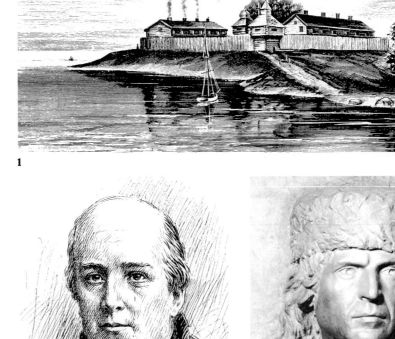

1

2

3

crossing the Chicago portage, "of only half a league into the Lake of the Illinois [Lake Michigan]."
(Ink sketch, Jules M. Gaspard, probably 1903. Courtesy Chicago Historical Society.)

3. Louis Jolliet (1645-1700)

Jolliet was a Canadian fur trader, who headed an exploratory expedition down the Mississippi in 1673. Sailing down the Wisconsin, he did not see the Chicago portage until his return with Marquette late in that year. Later he wrote his Canadian sponsors, "that an all water transit between Lake Erie and the

Mississippi was possible." He advised that there would be but one canal to make, by cutting half a league of prairie to pass from the Lake of the Illinois into St. Louis River [the Illinois, including the DesPlaines], which empties into the Mississippi." Another great explorer, LaSalle, who traveled through the Chicago area in 1682, was extremely disdainful of Jolliet's "proposed ditch." Jolliet, he said, "proposed it without regard to its difficulties."
(Bronze plaque by Edward Kemeys, 1894. Courtesy Chicago Historical Society.)

4. Surface Configuration and Drainage Pattern of the Chicago Area before Original European Settlement

Traveling through the region in 1817, an Easterner noted that "the country suffers, at the same time, from water, and from the want of it. The deficiency of circulation, not of water itself, produces this contradiction. It is not sufficiently uneven to form brooks to lead off its redundant rains, and form a deposit for mid-summer. The snows of winter dissolve and remain on the ground, until exhaled by the sun, at a late period of spring."

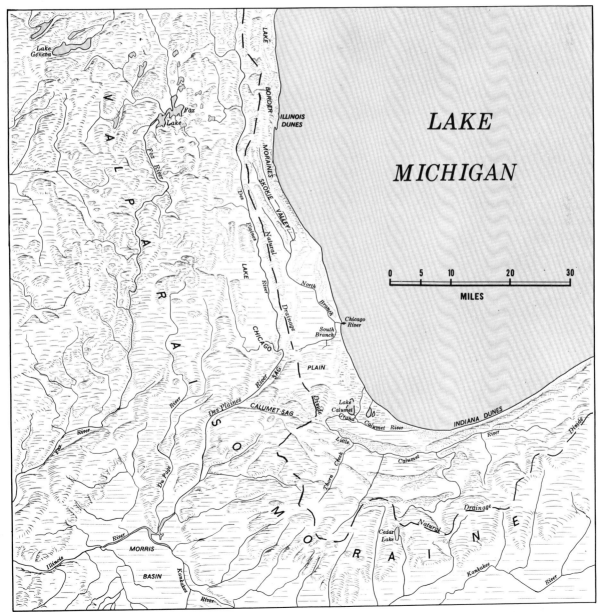

1. Schoolcraft's View of Chicago, 1820

Henry Schoolcraft made this sketch "from a standpoint on the flat of sand which stretched in front of the place." From his account we are afforded evidence of the completeness of the sketch: "This view embraces every house in the village, with the fort, and if the reproduction of the artist . . . may be subjected to any criticism, it is perhaps that the stockade bears too great a proportion to the scene, while the precipice observed in the shore line of sand is wholly wanting in the original." After commenting on the fertility and beauty of the surrounding region, Schoolcraft, more in the role of soothsayer than descriptive geographer, proclaimed Chicago's advantages: "To the ordinary advantages of a market town, it must add that of being a depot for the commerce between the northern and southern sections of the Union, and a great thoroughfare for strangers, merchants, and travelers." Through this simple Schoolcraft sketch many Americans got their first glimpse of the rising frontier town.
(Engraving, *Chicago Magazine*, 1857, after a drawing by Henry Rowe Schoolcraft.)

passed to England in 1763 as part of the settlement ending the Seven Years' War. Twenty years later it became part of the United States by the treaty that secured the independence of the young republic. The British, however, lingered illegally. They needed time to reorganize the communication lines of their fur trade over the Great Lakes, and some expected that the American experiment in self-rule would be short-lived anyway. Jay's Treaty of 1794 brought a pledge of British evacuation, but Indian strength in the West remained formidable, making permanent settlement precarious.

"Mad Anthony" Wayne's defeat of the Indians at Fallen Timbers reduced the pressure somewhat. More important, by the Treaty of Greenville, which followed in 1795, the Indians ceded "one piece of land six miles square at the mouth of the Chicago River emptying into the Southwest end of Lake Michigan." This transaction cleared the title to Chicago. Less than a decade later, in 1803, Fort Dearborn was built to secure the site.

The erection of the fort represented a new permanence in the Chicago area. It was not, however, the beginning of settlement. Even before 1803, traders had used the spot, and Jean Baptiste Point du Sable, whose father was from a Quebec mercantile family and whose mother was a Negro slave, established a trading post at the mouth of the river in the 1770's. Hurried off to Fort Mackinac by the British during the Revolutionary

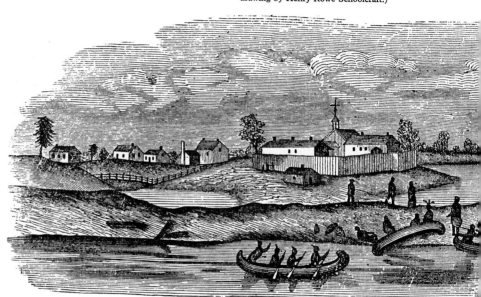

1

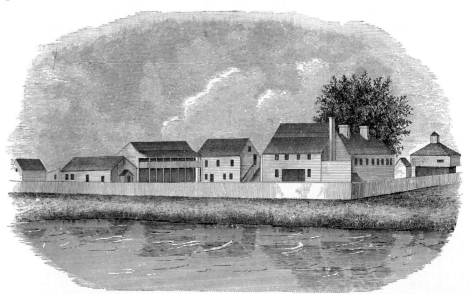

2

2. The Second Fort Dearborn

Constructed in 1816 on a site overlapping that of the original fort, the new fort maintained the two-story barracks and pillared porches of its predecessor, but differed in that it had only one blockhouse and a single palisade.

(From A. T. Andreas, *History of Chicago*. Courtesy Chicago Historical Society.)

3. Interior of Fort Dearborn

Fort Dearborn had outlived its military usefulness by 1841, when James Silk Buckingham came to the city. He saw it as "forming a venerable relic of the comparatively olden time, in this otherwise entirely new town of Chicago." Alexander Hesler's photo taken in 1856 adds credence to Buckingham's words; the shabby fort appears as an ancient anachronism against the background of the imposing Lake House across the Chicago River. The four-story hotel, a symbol of Chicago's enthusiastic surge to urbanity, overshadows the fort, which was demolished in 1857.

(Courtesy Chicago Historical Society.)

4. Land Use in the Vicinity of Fort Dearborn, 1830

The Federal government sent a civil engineer to draw this map of the mouth of the Chicago River to plan improvements in the city's harbor. In this map, the engineer indicated many of the important features of the fort community on the eve of its first decade of important growth.

(Redrawn from A. T. Andreas, *History of Chicago*.)

CHILDS & C?

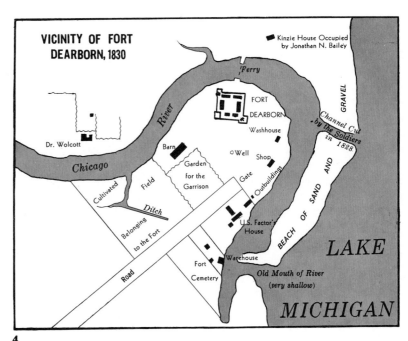

VICINITY OF FORT DEARBORN, 1830

Kinzie House Occupied by Jonathan N. Bailey

Ferry

FORT DEARBORN

Dr. Wolcott

Chicago River

Barn

Washhouse

Well

Shop

GRAVEL

Channel Cut by the Soldiers in 1828

Garden for the Garrison

Cultivated Field

Gate

Outbuilding

Ditch

Belonging to the Fort

U.S. Factor's House

BEACH OF SAND AND

Road

Fort Cemetery

Warehouse

LAKE

Old Mouth of River (very shallow)

MICHIGAN

4

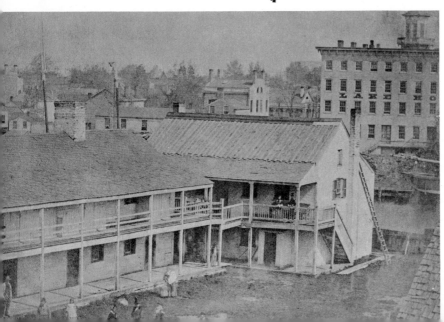

3

10

1. Old Kinzie Mansion As It Appeared in 1832

John Kinzie came to Chicago in 1804. There he traded with the Indians and was sutler for the fort. After the disruptions of the War of 1812, Kinzie returned in 1816 to take up residence in this small cottage in the area of the present Equitable Life Building at 401 North Michigan. From there he continued to trade with the Indians. Later Mrs. John H. Kinzie described the old Kinzie House as a "long, low building with a piazza extending along its front, a range of four or five rooms. A broad green space was enclosed between it and the river, and shaded by a row of Lombardy poplars. Two immense cottonwood trees stood in the rear of the building. A fine well-cultivated garden extended to the north of the dwelling, and surrounding it were various buildings appertaining to the establishment—dairy, bake-house, lodging-house for the Frenchmen, and stables."
(Sketch done originally from a description by John H. Kinzie, redrawn for A. T. Andreas, *History of Chicago*. Courtesy Chicago Historical Society.)

War, he returned to his old stand at the end of the conflict. Du Sable's twenty-two by forty-foot cabin probably marks the first permanent residence on the Chicago site. When he left in 1800, the locale was sprinkled with settlers.

Fort Dearborn was something more than a local garrison. When Captain John Whistler arrived at the muddy site near the mouth of "Chicago creek," it was to guard the portage route, an important link in the line of national communication, connecting as it did the Great Lakes and the Mississippi Valley. For nine years it was an uneventful outpost. But when war with Britain came, the fort was ordered abandoned as part of the general policy of contracting the western military perimeter of the United States. Led by William Wells, the soldiers and settlers started the retreat to Ft. Wayne. About a mile and a half outside Fort Dearborn they were ambushed by Indians. The casualties were frightful—thirty-nine men, two women, and twelve children dead and a score wounded. For four years the mangled bodies of these early Chicagoans lay unburied in the drifting sand. The fort, charred and plundered, stood as a gaunt reminder to returning residents of the precariousness of the city's first days.

Peace came in 1815, but the terror of 1812 remained fixed in the minds of the survivors of the isolated outpost. Indeed, throughout the West a general demand grew for better protection on the frontier. The federal government responded

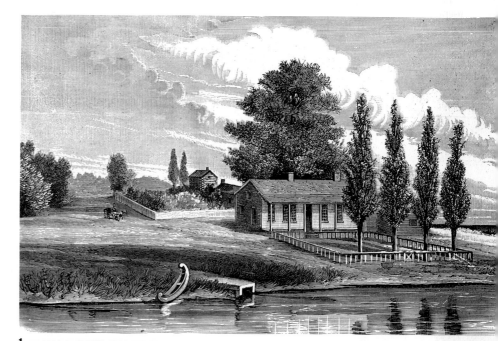

1

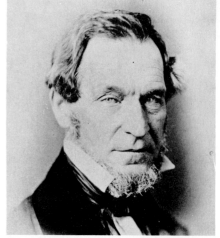

2

2. John H. Kinzie (1803-65)

Bringing his family to Chicago in 1834, John H. Kinzie established himself rapidly among Chicago's leading citizens. He was appointed first president of the village, and at the completion of the Illinois and Michigan Canal was appointed collector of tolls. His real-estate speculations extended far outside the city; and as early as 1835, he was engaged in securing a charter for a Chicago railroad. He was also president of the Chicago branch of the second Illinois State Bank. (Courtesy Chicago Historical Society.)

3. Principal Indian Trails and the Indian Cession of 1816 Related to the Physiographic Features of the Chicago Region

The cultural features on this map are from data by James Scharf, who was a careful and devoted student of Indian lore. His extensive research covered many areas of the United States, among them Chicago, where he made a series of maps covering the trails, camps, and burial places of Indian tribes of the Chicago Region. A soldier passing through this area in 1827 noted that Chicago "was composed at this time of six or seven American families, a number of half breeds and a lot of idle, vagabond Indians loitering about."

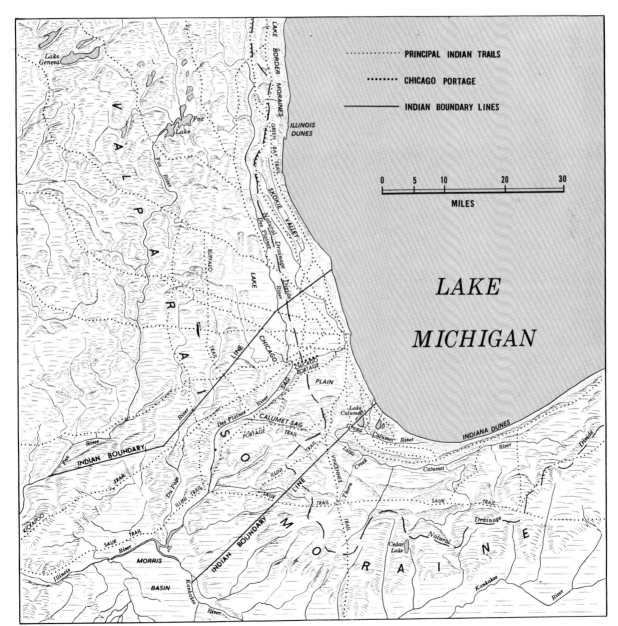

1. Plat of the Original Town, 1830

This little map did much to determine the shape of the future metropolis. It was drawn by James Thompson, who was hired by the Canal Commissioners of the new community. The original site was a few blocks from Lake Michigan; it was not until April 25, 1832, that a fifty-foot wide street was surveyed from "the east end of Water street . . . to Lake Michigan," the purpose being to form a road "of public utility and a convenient passage from the town to the lake." Additions to the city over the past century have extended the grid pattern established in the original design. It is not until the suburbs are reached that we see major interruptions of the rectangular grid, a pattern which is so predominant that it led one nineteenth-century traveler to call Chicago "the most right-angle city in the United States." Apparently, this reproduction is of a copy of the original Thompson plat, since the original map was in the Recorder's Office, which was burned in the Fire of 1871. (Courtesy Chicago Historical Society.)

with a chain of forts. A new Fort Dearborn became the Chicago anchor in the system. Built on nearly the same site as its ill-fated predecessor, it stood until 1857. The fort became a landmark in the young city, but its military importance quickly dwindled. In 1836 the federal government shut down its operations there, a gesture that symbolized the growing security of the town and the passing of an important phase in Chicago's history.

The city's safety stemmed in part from the further removal of the Indians from the area. In 1816 the Sacs and Foxes ceded the United States a strip of land extending southwestward from the Chicago river almost to Ottawa, Illinois. The gift included the crucial portage route and thus secured Chicago's connection with the western hinterland. The boundaries of the ceded Indiana territory, however, are still visible on the present metropolitan landscape. Running parallel to the old route and about ten miles north and south of it, they form diagonal streets and roads. Rogers Avenue and Forest Preserve Boulevard represent the northern edge of the cession; part of the old George Brennan highway (now Interstate 57) ran along its southern boundary.

Events in the East were also favorable to the rapid growth of the city. The opening of the Erie Canal in 1825 created a new avenue for migration and trade between Chicago and the more settled parts of the union. The old pattern of

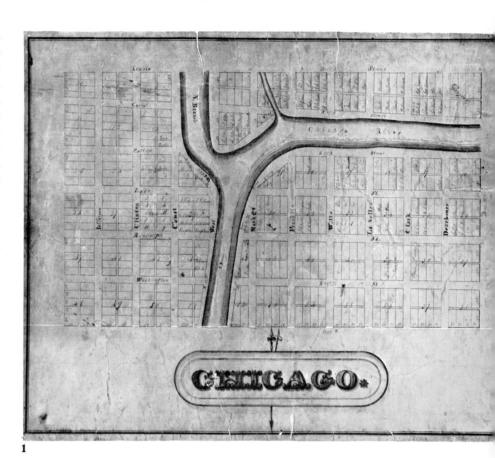

1

2. Early Landholdings in Chicago

This map, published in 1884, shows the canal sections and abundant woods that were part of the original site of the city. (From A. T. Andreas, *History of Chicago*. Courtesy Chicago Historical Society.)

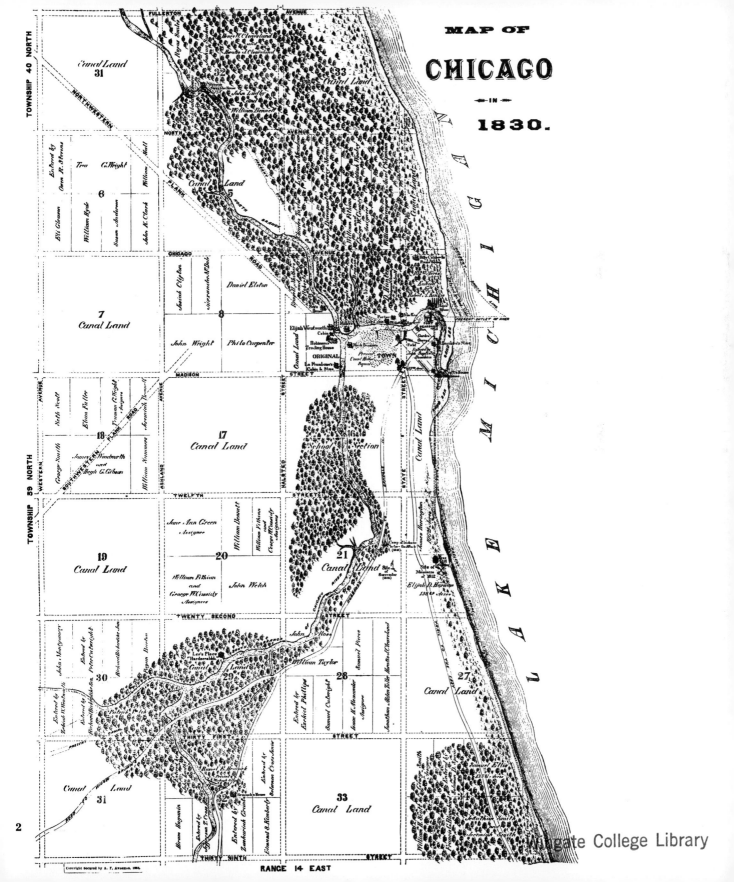

MAP OF
CHICAGO
—IN—
1830.

14

Early contemporary accounts of Chicago are usually quite at odds with the serene, almost bucolic, quality portrayed by Justin Herriott in his watercolor done about 1902. In 1833, the year depicted by Herriott, Charles Joseph Latrobe, an English traveler, was astounded at the dirt and disorder: "The interior of the village was one chaos of mud, rubbish and confusion. Frame and clapboard houses were springing up daily under the active axes and hammers of the speculators, and piles of lumber announced the preparation for yet other edifices of an equally light character." The same year a prominent Scotch farmer, Patrick Shirreff, saw the business potential of the frontier village. "This is already a place of considerable trade," he wrote, "and when connected with the navigable point of the river Illinois, by a canal or railway, cannot fail of rising to importance. Almost every person I met regarded Chicago as the germ of an immense city, and speculators have already bought up, at high prices, all the building-ground in the neighborhood." (Courtesy Chicago Historical Society.)

movement had been across the Appalachians and into the Ohio Valley, a pattern that had built Pittsburgh, Cincinnati, Louisville, and St. Louis, as well as a score of lesser communities along the Ohio River. Now another route became available—up the Hudson, across the Erie Canal, and into the Lakes. Buffalo, Cleveland, Detroit, and Chicago would be the major beneficiaries.

Plans for a canal in Illinois further brightened the city's prospects. The object was to connect Lake Michigan and the Mississippi and to facilitate the movement of persons and goods throughout the new country. The idea was an old one; Jolliet had suggested it in the seventeenth century. In 1829 the Illinois legislature took the first steps in converting the dream to reality by appointing a canal commission to plot the course of the waterway and dispose of the public lands along the route. The next year the commissioners laid out the towns at either end of the projected canal—Ottawa at the southwest and Chicago at the northeast.

The original plat of Chicago was simple and conventional. Like most towns of the time, it followed the grid system. Only three-eighths of a mile square, it straddled the banks of the river. Kinzie and Madison Streets formed the northern and southern boundaries, State Street and Des Plaines Avenue the eastern and western edges. The popular sixty-six-foot width was adopted for the streets. Alleys sixteen feet wide sliced through

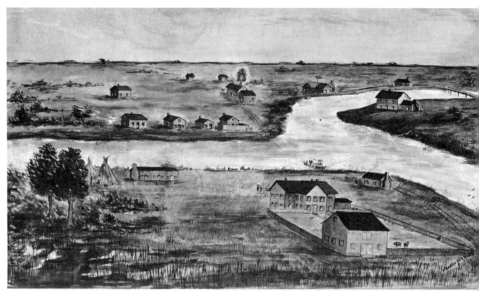

1

2

2. William B. Ogden (1805-77)

The first mayor of Chicago, he was also connected with almost all of its important early developments; typical of these were the canal, the Galena and Chicago Union Railroad, and the McCormick reaper. As one contemporary put it, he was one of the city's "solid men" who amassed a fortune of "several millions . . . with none of the *fera natura*, or wild cat genus about it, but the whole represented by real estate in Chicago and Cook County."
(Photograph, Matthew B. Brady, New York Studio, November, 1861. Courtesy Chicago Historical Society.)

3. South Water Street, 1834

John Watkins, the first school teacher in Chicago, came in 1832. As an old man, he recalled the condition on his arrival of the city's first commercial street. "There was but one frame building there," he reminisced, "and that was a store owned by Robert A. Kinzie. The rest of the houses were made of logs. There were *no bridges*. The river was crossed by *canoes!*" The "slough" at the left entered the river near what is now State Street.
(Tinted print, prepared for Ivy Green Series about 1902. Courtesy Chicago Historical Society.)

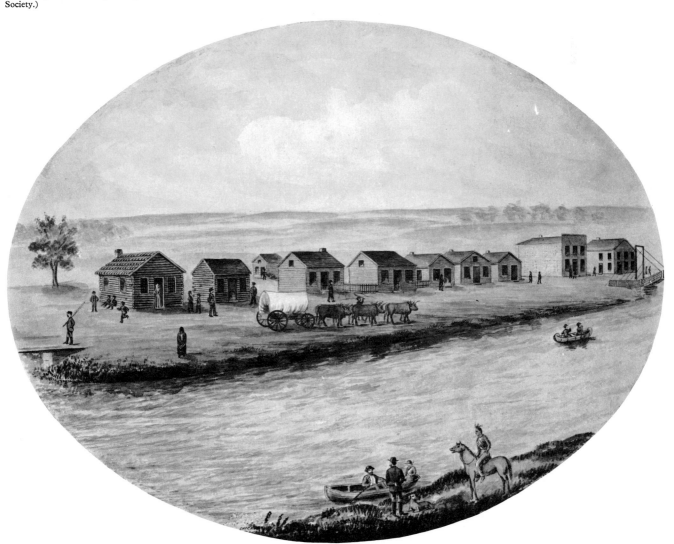

3

1. Captain Allen's Chart

One reason why LaSalle had been so pessimistic about the possibility for future commercial use of Chicago River was "that the lake of the Islinois [sic] always forms a sandbar at the mouth of the Channel which leads to it; and I greatly doubt, notwithstanding what is said, that it could be cleared or swept away by the force of the current of the Checagou [sic], since a much greater, in the same lake, has not removed it." The future would prove LaSalle wrong, but only through changes like those registered in this 1837 chart that shows two piers built out into the lake to protect the entrance to the river, which had been cut open in 1834. The city's early leaders were well aware of the importance of this brackish stream. "In this narrow, muddy river lies the heart and strength of Chicago," a magazine writer observed in the 1850's. "Dry this up, and Chicago would dry up with it, mean and dirty as it looks. From the mouth of the St. Joseph River, in Michigan, round to Milwaukie [sic], in the state of Wisconsin, . . . Chicago is the only place where twenty vessels can be loaded or unloaded, or find

the center of each block. The original design also provided for streets along the banks of the river. The rectangular grid system was reinforced by the federal Ordinance of 1785, which had called for dividing the new country into mile-square sections. Beyond the boundaries of the first plat the edges of these units furnished convenient locations for streets. Roosevelt Road, North Avenue, Western Avenue, and Pulaski Road, among others, had their origins in these early surveys. Although Chicago owed its location to the lake, and later called herself the Queen of the Lakes, the first plat, ironically, provided no frontage along the shore. This was hardly a plan for the nation's "Second City," but it was more than adequate for the fifty settlers occupying the area in 1830.

Work on the canal did not actually begin until 1836, and no boat moved through it until a decade after that. Yet the anticipation was enough. The first parcels of land went at auction for a modest price, the highest being $100 for an 80 by 100-foot lot. Within four years, however, the speculative rage set in. An 80 by 100-foot parcel at the corner of South Water and Clark Streets soared in value from $100 to $3,000 in the two years between 1832 and 1834. The following year it sold for $15,000. The *Chicago American*, joining the general exuberance, claimed that one piece of property had "risen in value at the rate of one hundred per cent per DAY, on the original cost ever since [1830], em-

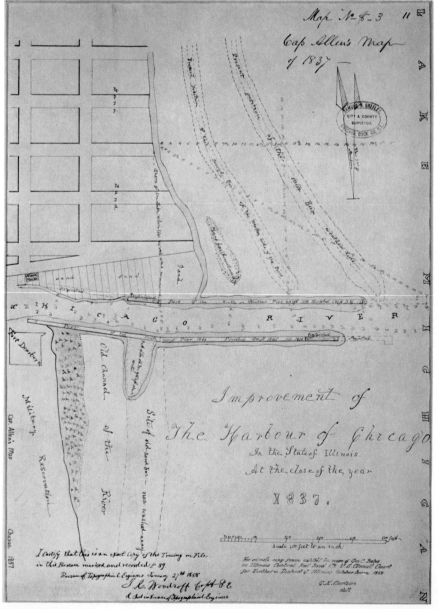

1

shelter in a storm. A glance at the map . . . will show that it is the only accessible port —and hence the commercial centre of a vast territory, measuring thousands of square miles of the richest agricultural country in the world."
(Courtesy Chicago Historical Society.)

2. The Remains of the Abandoned Fort Dearborn

The deterioration of the fort, the new lighthouse erected in 1832, and the heavy river traffic, indicate that the needs of trade had already replaced defense considerations. Confirming this new interest in trade, "a rather venturesome trader" sent seventy-eight bushels of wheat past the fort into the Great Lakes in the year this picture was drawn. By 1848, over two-million bushels were shipped past the same point; by 1870, the figure was sixteen-million bushels.
(Courtesy Chicago Historical Society.)

3. Eliza Chappel's School

Miss Chappel opened this school in September, 1833, in John S. Wright's store located at what is now Wacker Drive between State and Dearborn Streets. This is justifiably called Chicago's first public school, since the classes were partially financed by revenue from the sale of canal lands. The next year Miss Chappel moved her classes to more adequate quarters in the First Presbyterian Church building.

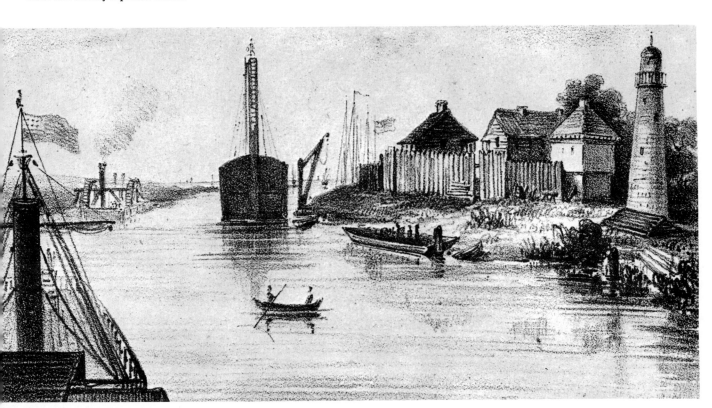

2

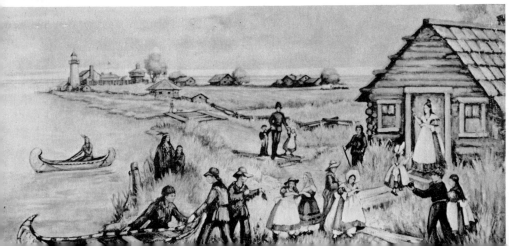

3

18

The soaring value of land in "downtown" Chicago was associated with intensive use. By 1838 contiguous building had become common; two-and three-story structures were replacing single-story construction, and a common building line marked store fronts along the streets. The Tremont House, one of the city's fashionable hotels, occupied a key location.
(Watercolor by N. Roswell Gifford, done about 1900, reconstructs the scene from contemporary sources. Courtesy Chicago Historical Society.)

Although this was Chicago's second market, it was the first to be constructed with public funds. Located in the middle of State Street, fronting on Randolph Street and running 180 feet north toward Lake Street, it contained thirty-two stalls on the first floor and a library and official city facilities on the second. The architect was John M. Van Osdel, Chicago's most prominent and productive building designer of the time.
(Detail from lithograph, "Chicago in 1857," Christian Inger, after the drawing by James T.

bracing a period of *five years and a half*." "Everyman who owned a garden patch," another later recalled, "stood on his land and imagined himself a millionaire."

Substantial citizens as well as sharp operators were infected by the mania. William B. Ogden came to Chicago at the height of the speculative craze to look after a relative's $100,000 real estate investment. After standing ankle deep in mud while surveying the property he wrote back sadly: "You have been guilty of the grossest folly." Yet he succeeded in selling off one-third of the land for the entire original purchase price. His first reaction was to dismiss the whole thing as lunacy. "There is no such value in the land," he asserted, "and won't be for a generation." Soon, however, he opened a real estate office and built a mansion on an entire "square" of city land. In 1837 he became Chicago's first mayor.

In these early days Chicago seemed less a community than a real estate lottery. Inevitably, late in 1837, the speculation bubble burst. Yet there were many substantial reasons for the optimism of the early settlers. The basic ingredient, population, was there in ever-increasing volume. The number of residents jumped from fifty to 4,170 in the seven years after 1830. As a result, construction boomed. But supply never kept up with demand. Shelters of all kinds appeared overnight; contracts for houses sometimes called for completion within the week.

The extraordinary demand for quick

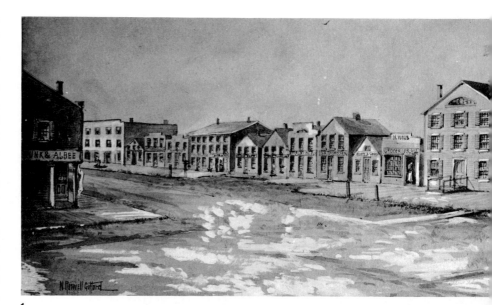

1

2

Palmatary, lithographed by Herline & Hinsel, Philadelphia, and published by Braunhold and Sonne, Chicago, 1857. Courtesy Chicago Historical Society.)

4. The Dearborn Street Drawbridge

Erected in 1834, this bridge connected the little settlements on either side of the river. Southsiders felt it helped the North Side too much, and when the city council ordered its demolition in 1839, they arose before the next dawn and brought it down with axes. Actually, the narrow horizontal clearance had impeded vessel traffic; and the bridge was afflicted by continual mechanical difficulties.
(From A. T. Andreas, *History of Chicago*. Courtesy Chicago Historical Society.)

5. Remains of the Fire of 1839

The rapid growth of the city plus the wide use of wood in construction made Chicago always vulnerable to fire. Even before the great holocaust of 1871, fires were frequent and damage extensive. On October 27, 1839, a conflagration swept away buildings on both Dearborn and Lake Streets and was stopped only by D. W. Raymond and Co.'s fireproof building, the first of its kind in the city.
(Drawing made at the scene by George Davis, 1839. Courtesy Chicago Historical Society.)

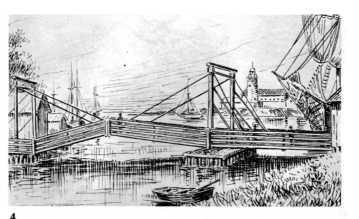

4

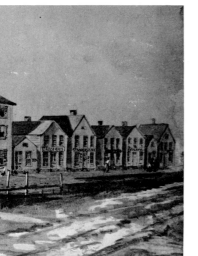

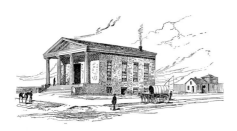

3. First Court House and Jail

In the fall of 1835 a brick one-story court house was erected by Chicagoans, at the northeast corner of Clark and Randolph Streets. City offices were in the basement, and the first floor consisted of one large room used for court sessions. The structure behind the court house is the log jail. It is perhaps a tribute to the rugged character of the Chicago citizenry that some form of public jail had been in existence since 1832.
(From A. T. Andreas, *History of Chicago*. Courtesy Chicago Historical Society.)

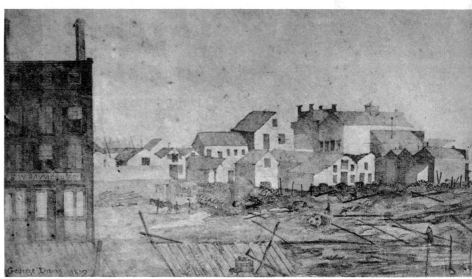

5

1. Chicago Streets and Subdivisions, 1834

As soon as the city had been laid out (in 1830), subdividers began their work. This map shows Chicago's first real estate developments: the Thompson plat of 1830, the Kinzie Addition north of the river and east of State Street, and the Wolcott Addition along the North Branch. The only public land reserved downtown was the federal reservation surrounding Fort Dearborn. The channel at the Chicago River mouth shown on this plat, was replaced by the artificial entrance across the sand bar in 1834.
(Courtesy Chicago Historical Society.)

shelter led to Chicago's first reputation for architectural innovation. In 1833 St. Mary's Church was built on a new principle of construction—"the substitution," as Siegfried Giedion describes it, "of thin plates and studs—running the entire height of the building and held together only by nails—for the ancient and expensive method of construction with mortised and tenoned joints." The mass production of nails and the abundance of lumber made the new system perfectly adapted to the needs of the booming town. A house now could be erected in a week, and larger buildings with commensurate swiftness.

For many years it was thought that George Washington Snow, a New Hampshire surveyor who came to Chicago in 1832, first devised the balloon frame construction; it now appears that this honor belongs to Augustine Taylor, who built St. Mary's Church. At any rate, the innovation quickly conquered Chicago and was soon adopted across the country. "If it had not been for the knowledge of the balloon frame," the New York *Tribune* asserted in 1855, "Chicago and San Francisco could never have arisen, as they did, from little villages to great cities in a single year." And, as would be the case later in the century, the new method was called, simply, "Chicago construction."

Builders of residences took advantage of the newer balloon frame and the older methods. Soon they spread their opera-tions away from the stem of the river. Moreover, the newcomers required stores, warehouses, taverns, and—soon, churches and schools. The people and the installations would survive even the prolonged depression after 1837.

So too would the city's incomparable commercial situation. In fact, the 1830's had seen a promising beginning in the exploitation of its trade advantages. Chicago's superiority rested in its location at the foot of the lake and at the head of the portage routes to the interior. Its rivals, Michigan City and Milwaukee, had better natural harbors. The Chicago River was too sluggish to keep sand from clogging its mouth; hence vessels had to anchor offshore while passengers and cargo were brought to land in lighters. The city moved quickly to improve its facilities. A lighthouse was erected in 1832. Two years later, $25,000 from the federal government permitted a start on cutting a channel through the sandbar. At the same time, nature assisted with a flood that scoured a path through the obstruction. In July, 1834, the 100-ton schooner *Illinois* slipped into the river to the ringing cheers of residents lining the banks and began a new epoch for the Port of Chicago. For 72 years, the river remained the principal water entrance to the entire area.

Overland trade also flourished. Foodstuffs came in from the Wabash Valley to supplement the inadequate production of the sparsely settled farmlands around the city. In turn, Chicago merchants sold all kinds of supplies to the surrounding region. Already a meat-packing plant, a tannery, a soap factory, and a brickyard turned out manufactured items for exchange in the hinterland. But the principal business was forwarding, and such firms as Newberry and Dole, Kinzie, Hunter and Company, and Hubbard and Company built prosperous enterprises on this regional trade. Although other cities forced Chicago to share the increasing market of the lake country, Chicago was from its earliest days the Middle West's leading entrepôt.

The speculative balloon of the 1830's was punctured by the Panic of 1837. Beginning as a financial crisis, it soon became a full-fledged national depression. Initially Chicago seemed less affected than other places, but within a few months bad times settled down on the young community. For nearly five years dark clouds cast a pall over economic activity. Real estate values plummeted, prices fell, debtors defaulted. Land bought for $11,000 an acre in 1836 could not be sold for $100 just four years later. The State of Illinois defaulted on its obligations; work on the canal stopped. Few people escaped. By 1842 nearly every leading member of the business community had been ruined or severely compromised. For years residents would recall the "blight and mildew" of these times.

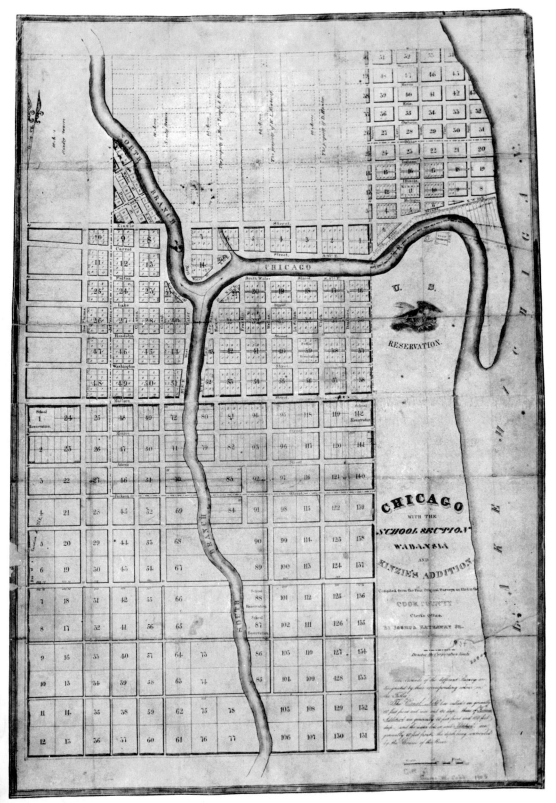

CHICAGO
WITH THE
SCHOOL SECTION
WABANSIA
AND
KINZIE'S ADDITION

Compiled from the Four Original Surveys as filed in the

COOK COUNTY
Clerk's Office.
By JOSHUA HATHAWAY Jr.

U. S.

RESERVATION.

22

A water vendor peddles his product for a few cents a barrel in front of the line of retail stores on Lake Street. The plank sidewalk and unpaved street were typical of the sprawling young community. While Lake was one of the earliest streets to be blessed with wooden planks, these were never very satisfactory. In 1854, a traveler noted that "there is . . . vast room for improvement in the construction . . . even in the principal streets, . . . formed of planks, from between which, as they were pressed by passing vehicles, the mud beneath oozed and spurted over the unwary pedestrian." This drawing by W. E. Trowbridge in 1902 depicts the tenants of the building in 1843.
(Courtesy Chicago Historical Society.)

2. St. Mary's Catholic Church

Originally costing $500 and built with the new "balloon frame" construction, this building reflected the constantly changing character of the city. In 1833 Catholics erected this small church on a canal lot near the southwest corner of Lake

Economic difficulties obscured the fact that with each passing year Chicago looked more and more like a city and less and less like a frontier settlement. Symbolizing the change, its first city charter was granted in 1837. The municipality was divided into six wards, a city council was elected, and William B. Ogden became mayor. Although forced to operate on meager budgets, the new government was able in a few years to set up a central market, throw a bridge across the South Branch of the river, build schools, and provide primitive systems of police and fire protection.

The pattern of settlement was already distinctively urban. Although one resident in 1840 could describe the corner of Clark and Lake Streets as "a lonely spot almost inaccessible on account of the surrounding sloughs and bogs," and Harriet Martineau three years later thought Chicago "looked raw and bare, standing on its high prairie above the lake shore," the city in fact was taking shape. The first residents clustered around Wolf Point and Fort Dearborn. By the late 1830's, the original plat had been enlarged by the Kinzie and Wolcott "additions," and by 1840 James Silk Buckingham could assert that "the main-street of business presents as bustling an aspect as any street in Cincinnati or St. Louis." Most of the stores were "capacious and substantial," and many were built of brick.

Residential building moved away from the stem of the river. To the north Buck-

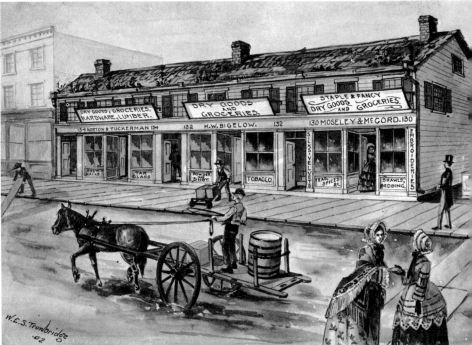

1

2

and State Streets. The building, twenty-five by thirty feet, was later moved to the southwest corner of Wabash and Madison. When the new brick St. Mary's was erected, the old church was moved again, this time farther west in the same block. (Carte-de-visite photograph. Courtesy Chicago Historical Society.)

3. Henry B. Clarke House
This retouched photograph of a daguerreotype shows the graceful original appearance of Chicago's first "suburban" dwelling, built in 1836. Some thirty-five

years later, the new owner, John Chrimes, moved it nearly four miles farther south, where it still stands. The building, now at 4526 S. Wabash Avenue, is used as a rectory and community house by St. Paul's Church of God and Christ. (Courtesy Chicago Historical Society.)

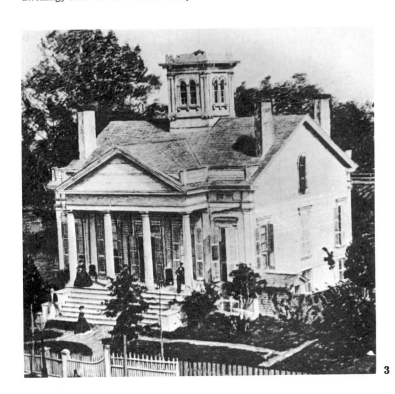

3

1. Transportation Routes of the Chicago Area, 1850

Commenting in 1868, the writer of a city guidebook described the city's geographic advantages but added an important qualification. "The growth of Chicago, since 1833, strikes every mind with wonder and astonishment. The mystery, however, may in a measure be solved in considering the location of the city. Standing as it does at the southern end of Lake Michigan, gives it necessarily a leading share of the commerce of all the lakes, and easy access by land, round the southern shore of Lake Michigan, to all the East and Southeast. Chicago might have continued as it was previous to 1833, if the region behind it had remained unpeopled. The city has grown with the development of the region round about, and has become its grand depot, exchange, counting-house, and metropolis." He might have added that Chicago's entrepreneurial drive had built transportation tentacles into this vast western hinterland, tying it to the destiny of the city.

ingham found "mostly pretty villas, some of them large and elegant, built with great taste, and surrounded with well planted gardens." This area was "the fashionable quarter," since the "business streets and business transactions are chiefly on the other side." South of the commercial activity were three blocks of small frame houses, set close together but with gardens attached. Not only was this part of the present Loop a pleasant, unpretentious neighborhood, but the intersection of State and Madison, later called "the busiest corner of the world," was still open country.

If some downtown buildings were impressive, the streets were not. To be sure, in good weather they had a certain charm. Buckingham found them "of ample width, being mostly lined with rows of trees separating the side walks from the main centre." He even found some with a "green turf of prairie grass" down the middle. To residents, however, the streets were dust traps in summer and a quagmire the rest of the year. "They were begot in mud, born in mud, and bred in mud," an early Chicagoan remembered. Residents placed signs reading "NO BOTTOM," "TEAM UNDERNEATH," and "STAGE DROPPED THROUGH" to warn the unsuspecting of particularly treacherous spots. At one place a hat was dropped on the mud with the marking "MAN LOST." Paving was too expensive, and planking proved ineffective. Wooden sidewalks, however, bordered the streets, and footbridges over the gutters made crossing possible if not pleasant. Hitching posts along the curbs provided parking facilities.

The early city had plenty of room for all its residents. Yet at the outset, a suburban movement appeared. Henry B. Clarke, who came to Chicago in 1833 and became a partner in the South Water Street hardware firm of King, Jones and Company, was among Chicago's early successful businessmen. In 1836 he left his log cabin in town and built a large house on a twenty-acre lot at what is now Michigan Avenue and Sixteenth Street. Early visitors noted its "unusually splendid appearance as a country residence, standing isolated upon the prairie, surrounded by fine poplars, and other young ornamental and fruit trees and shrubbery." After the fire of 1871, the house was moved to 4526 S. Wabash Avenue where, minus its imposing portico, it is now used as a church rectory, the oldest building in the city.

Clarke was among Chicago's first suburbanites, but there would be more at each stage of the town's growth. It is often assumed that suburbanization is a relatively recent urban development. Yet it is important to note that the centrifugal movement in Chicago began with the first generation of urban dwellers. Even the word "suburb" soon appeared to describe the process. As early as 1857, the *Chicago Magazine* used it to describe " 'outside settlers' who had linked their fortunes with Chicago" though they lived beyond the municipal boundaries. For three-quarters of a century "suburb" would indicate the *connection* of the surrounding population to the city; only in more recent times has the word come to connote the *difference* between those who live in the city and those who reside in adjacent areas.

If Chicago's metropolitan future was visible as early as the 1830's, so too was its industrial destiny. The North Branch of the Chicago River quickly became the focus of manufacturing activity. In 1829 Archibald Clybourne built the first meatpacking plant a short distance above Wolf Point. Though established to serve a local market, it was prosperous enough to permit its proprietor to erect a large and elegant brick residence nearby. A lumber mill in the same area went into operation in 1833 and its finished products soon replaced logs as the city's characteristic building material. Thus the North Branch's industrial complex had its beginnings before Chicago got its first municipal charter, and meat packing and lumber quickly emerged as key items in the city's economy.

The great stimulus to Chicago's growth, however, came from the extension of eastern transportation facilities to the city. As the depression of 1837 lifted and the West resumed its prodigious growth, overland routes multiplied, water connections with the East were improved, a new canal brought the trade of the Mississippi to the back door of the city, and, of even greater portent, the first railroad edged across the prairie to-

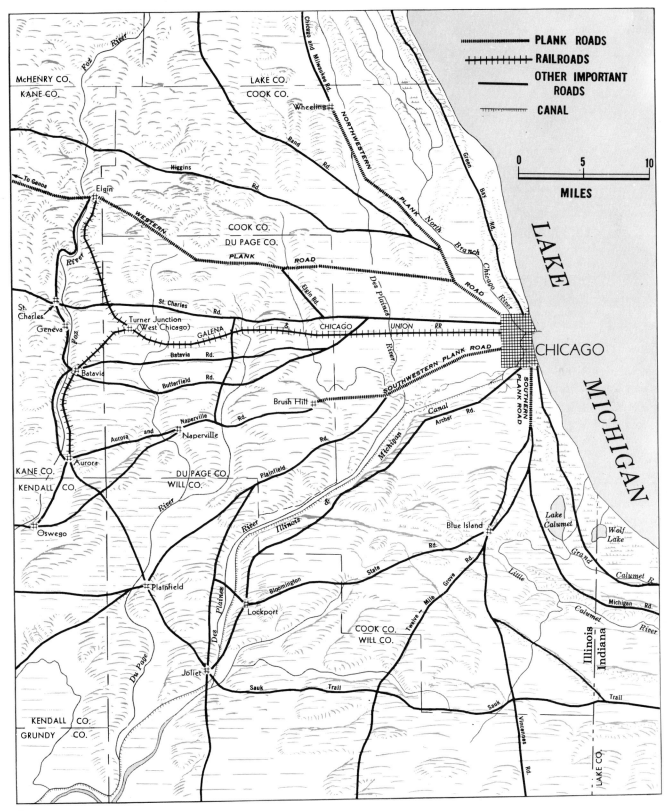

McHENRY CO.
KANE CO.

LAKE CO.
COOK CO.

Wheeling

Fox River

Chicago and Milwaukee Rd.

To Genoa

Elgin

Higgins Rd.

Rand Rd.

NORTHWESTERN PLANK ROAD

North Branch Chicago River

Green Bay Rd.

LAKE MICHIGAN

PLANK ROADS
RAILROADS
OTHER IMPORTANT ROADS
CANAL

0 5 10
MILES

WESTERN

River

COOK CO.
DU PAGE CO.

PLANK ROAD

Elgin Rd.

Des Plaines

St. Charles

Geneva

Fox River

Turner Junction
(West Chicago)

St. Charles Rd.

GALENA

Batavia Rd.

Butterfield Rd.

& CHICAGO UNION RR

River

CHICAGO

SOUTHWESTERN PLANK ROAD

SOUTHERN PLANK ROAD

Batavia

Naperville Rd.

Naperville

Brush Hill

Aurora and

Aurora

KANE CO.
KENDALL CO.

DU PAGE CO.
WILL CO.

Plainfield

River

Rd.

Michigan

Canal

Archer Rd.

Lake Calumet

Wolf Lake

Grand

Little

Calumet R.

Oswego

River

Illinois

River

&

State

Blue Island

Rd.

Twelve - Mile Grove Rd.

Michigan Rd.

Calumet River

Plainfield

Des Plaines River

Bloomington

Lockport

COOK CO.
WILL CO.

Illinois
Indiana

Du Page

Joliet

Sauk Trail

Sauk Trail

Vincennes Rd.

LAKE CO.

Trail

KENDALL CO.
GRUNDY CO.

1

1. The *Empire*

Built in 1844 in Cleveland, the *Empire* was one of the largest ships in the world at the time. Eastern delegates to the Rivers and Harbors Convention of 1847 described it as a floating palace.
(From John Brandt Mansfield, *History of the Great Lakes*.)

2. Opening of the Illinois and Michigan Canal, April, 1848

The idea of a canal through the Chicago portage had been around for a long time before it was finally to become a reality.

First mentioned on the floor of Congress in 1810, it was lauded in the *Niles Register* four years later: "By the Illinois River it is probable that *Buffalo*, in New York, may be united with *New-Orleans* by inland navigation, through Lakes Erie, Huron, and Michigan, and down the river to the Mississippi. What a route! How stupendous the idea! How dwindles the importance of the artificial canals of Europe compared to *this* water communication. If it should ever take place—and it is said the opening may be easily made—the Territory

ward Galena. A new and quicker means of communication, the telegraph, put the lake port in close touch not only with the Atlantic seaboard, but with New Orleans and the cities of the Ohio Valley as well. By 1850 Chicago had become the center of nearly all the lines of transportation that entered the West.

The earliest connections with the immediately surrounding region were by coach. Often following old Indian trails, the roads came in from all directions. But overland travel was at best uncertain and always uncomfortable; indeed, in spring and fall most roads were impassable. And early turnpikes did not help much since they were generally only prairie soil graded up. One solution brought some relief in the 1840's. "Plank roads," which had enjoyed a modest success in New York, were adopted on some of the major routes. Called the "poor man's railroad," they were simply boards nailed to long timbers. In 1848, 200 wagons a day rumbled into town, most choosing to pay tolls for the privilege of using these "improved roads." Planking might seem primitive later, but many merchants at the time thought this system almost revolutionary and certainly less risky than railroads.

With better roads came regular stagecoach service. The first came in from Detroit. Carrying mail as well as passengers, the coaches made scheduled runs to the growing communities throughout the region. Soon express service operated daily between Chicago

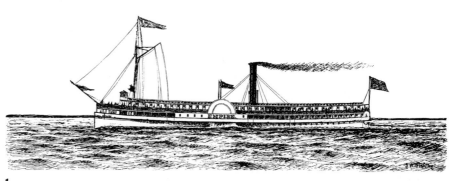

1

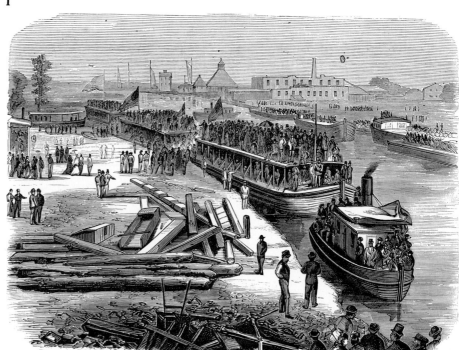

2

[of Illinois] will become the seat of an immense commerce, and a market for commodities of all regions."
(Engraving from *Leslie's Illustrated Newspaper*, August 26, 1871. Courtesy Chicago Historical Society.)

3. Pumping Station on the Illinois and Michigan Canal, Bridgeport (undated)

Canal boats like those moored in the right background brought more than enough commodities into Chicago to justify its promoters' faith. Not only were corn, sugar, salt, lumber, and pork brought into the city by way of the canal, but one of the largest categories was for "merchandise," or general freight. Railroads were, however, soon in active competition for the carrying of goods to and from Chicago's hinterland.
(Courtesy Chicago Historical Society.)

4. The Canal in Later Years

A scene along the Illinois and Michigan Canal about 1900-1910. Note how the dimensions of the lock limited the size of craft that could move through the canal.
(Courtesy Chicago Historical Society.)

5. A Typical Canal Lock

This photograph of a lock on the Illinois and Michigan Canal is undated but was probably taken between 1900 and 1910, when the canal was handling only a fraction of its earlier traffic.
(Courtesy Chicago Historical Society.)

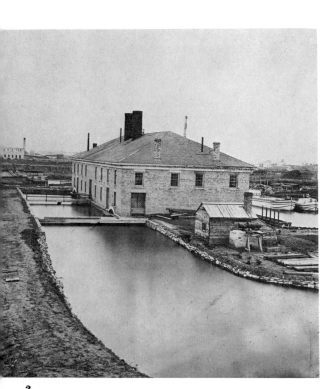

3

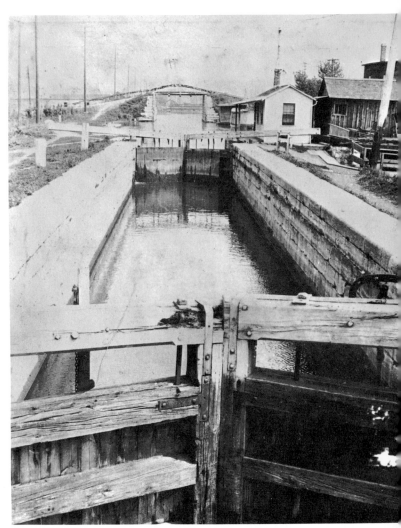

5

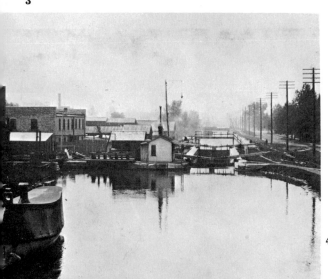

4

and New York. The success of stage-coach operations lured many companies into the business, but the largest by far was Frink and Walker, which controlled more than 2,000 miles of mail routes in the Middle West and whose central office was at Lake and Dearborn Streets in the heart of Chicago's business district.

Yet the demand for transportation to the opening West could not be handled by turnpikes and stages alone. The water routes also teemed with passengers and freight. Steamboats and schooners swarmed over the Lakes bringing new residents and every type of merchandise. Chicago's harbor, never very capacious, had to be dredged and improved constantly to handle the mounting traffic. Not only did steamers cut travel time from the East, but they greatly enhanced the comfort of travel as well. Some, like the *Empire*, the pride of the Lakes, which ran between Buffalo and Chicago, were almost literally floating palaces. An elegantly furnished 1,200-ton vessel, she had luxurious staterooms, a spacious dining room, a paneled bar, and strolling musicians. "Going west" became less and less of a chore each year.

Increasing traffic on the lakes and improved contact with the East made the completion of the canal to the Mississippi even more urgent. As early as 1836, when the State of Illinois decided to go ahead with the project, a large subdivision had been laid out three miles up the South Branch of the river to

accommodate the influx of workers. Early known as "Hardscrabble," it was later called Bridgeport. It lay unoccupied for almost a decade as the depression halted construction. But with recovery came new activity. The area filled up quickly, mostly with Irish. The canal was completed in 1848, and Bridgeport became the northeastern terminus of the new waterway. For a generation the Illinois and Michigan Canal played a key role in the development of Chicago; for more than a century Bridgeport would remain Irish, providing muscle for the city's yards, mills, and factories, and more than its share of political leadership.

In an age of great canals, the Illinois and Michigan was not a major enterprise. Narrow and shallow, it could not handle steamboats; and a complicated lock system slowed the passage of barges through its ninety-seven–mile course. Yet, despite these limitations, the canal was a major factor in the extraordinary growth of Chicago in the next two decades. Creating a water opening to the Southwest, it drew more and more of the surrounding country into the city's commercial orbit. As an added dividend, it badly hurt Chicago's rival for leadership in mid-America, Saint Louis—for trade could now move north to the Lakes as well as south to the Gulf. Canal traffic reached a peak in 1882, and decline after that was precipitous.

The cheers that met the opening of the canal had hardly died away before

a new means of transportation offered an even larger future to the city. Railroads, starting in the East, thrust across the new country toward the young metropolis, carrying with them the promise of more rapid travel and a closer connection with the Atlantic. Initially, there was no certainty that Chicago would become the central focus of an extensive national network. Other cities also had claims, and competing companies made their own plans. Yet Chicago, without a single mile of track early in 1848, was the railroad center of the West within six years.

Surprisingly enough, however, the first rail enterprises in the city laid their tracks to the west. A railroad across the prairies to the lead-mining town of Galena had been a gleam in the eye of William Ogden as early as 1836. But the depression was no less the enemy of the railroads than of the canal. Ten years later Ogden revived the project, and with the help of Illinois farmers, eastern capitalists, and Chicago investors work began. On October 25, 1848, a secondhand locomotive, the *Pioneer*, puffed uncertainly to Oak Park and back with the directors aboard; on November 20, it brought in a load of wheat from the Des Plaines River. "Chicago had become Chicago."

If by 1850 Chicago's transportation primacy was foreshadowed, so too was its role as the nation's convention center. Eastern and western spokesmen, complaining about federal neglect of internal

1. John Wentworth (1815-88)

Few young cities have had such an energetic and eloquent advocate as Chicago's "Long John" Wentworth. Two times mayor and three times a congressman, he was instrumental in improving city services, promoting railroads, and stimulating the civic life of the city. (Courtesy Chicago Historical Society.)

2. Depot of the Galena and Chicago Union

This is Chicago's first railroad terminal. Located at Canal and Kinzie Streets, it was used as a depot from 1848 until 1853, when it was converted into an employees' reading room. The cupola was used to sight trains approaching from the west. (Courtesy Chicago Historical Society.)

3. The *Pioneer*

This old wood burner was first used on the Utica and Schenectady Railroad. Named the *Alert*, the engine came to Chicago when it was purchased by the Michigan Central. The eleven-year-old, ten-ton locomotive was then purchased by the Galena and Chicago Union and renamed the *Pioneer*. (Courtesy Chicago Historical Society.)

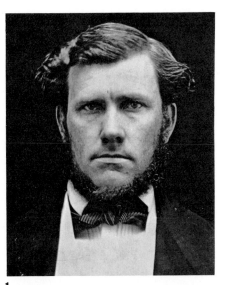

1

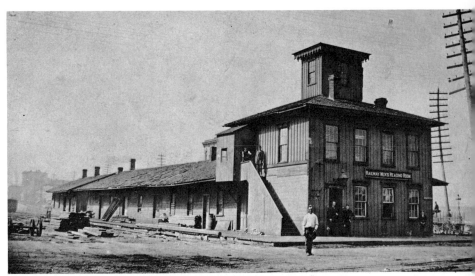

2

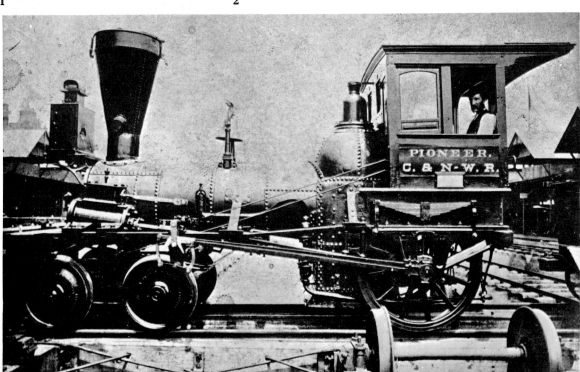

3

improvements in their regions, chose Chicago for a massive protest meeting. In 1847 a city of 16,000 thus played host to 20,000. In fact one delegate claimed it to be "undoubtedly the largest deliberative body ever assembled." Some of the country's major figures attended. Horace Greeley, editor of the *New York Tribune*, Erastus Corning, later president of the New York Central Railroad, and Senator Tom Corwin of Ohio were all present. So too was an obscure Whig congressman from downstate Illinois named Abraham Lincoln. All agreed that Chicago was a promising town. One New Yorker even went so far as to predict that within fifty years it might boast 125,000 inhabitants. That he missed by a million was not so important as the fact that the city on the lake had already established its credentials as a convention setting.

In 1850 Chicago was only thirteen years old; its residents numbered fewer than thirty thousand. Yet as the twig was bent, so the tree would grow. Nearly all the elements that characterize the city today were already present. Chicago had become the hub of the major transportation routes, presaging its destiny as the nation's busiest rail and air center.

Clybourne's meat-packing plant foreshadowed the day when the town would be called the "hog butcher of the world." McCormick's reaper had been on the market for just a few years, but farmers already looked for a Chicago trademark on industrial goods. And grain elevators and bulging warehouses signaled a unique connection between the urban merchant and the rich farmlands of the Middle West.

Internally, too, many characteristics that mark the modern metropolis were developed in Chicago's first decade and a half. The River and Harbor Convention had tested the city's hospitality, and a flood of permanent newcomers gave a cosmopolitan cast to the population. Of the 29,963 inhabitants, more than half had been born abroad. The largest number were Irish and German, but the English, Scots, Swedes, Norwegians, Danes, and French were also represented in significant numbers. And if some congestion appeared in the business district, a few Chicagoans with wealth had already opted for suburban living beyond municipal boundaries. In short, if one looked carefully at the youthful city of 1850, the features of its adulthood were already discernible.

1. Cyrus Hall McCormick (1809-84)

Robert McCormick, the father of Cyrus H. McCormick, had been one of the pioneers who tried to design a reaper and failed. His son, at the age of twenty-two, took up his father's work and successfully demonstrated his reaper at Steel's Tavern, Virginia, in 1831. After improving his model, he manufactured the machine in Cincinnati, Ohio, in 1845. He moved the

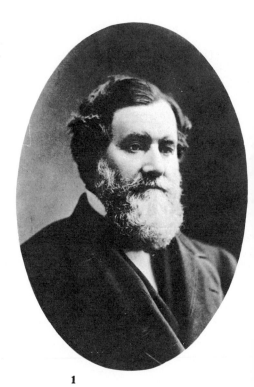

1

enterprise to Chicago in 1847; and by 1884 he had made enough improvements that one Chicagoan boasted that "the machine, as now perfected, is capable of cutting and binding in sheaves at the rate of two acres an hour, under the sole management of any boy or girl having skill enough to drive the span of horses attached to it."
(Gravure. Courtesy Chicago Historical Society.)

2. McCormick Reaper Factory, 1847

The factory was located between North Water Street and the Chicago River, just east of the present Michigan Avenue bridge. In 1848, 700 machines were manufactured here; by 1850 the output had more than doubled.
(Engraving. Courtesy International Harvester Company.)

3. Dearborn School, North Side of Madison Street between State and Dearborn Streets, 1856

Chicago's first permanent school building was erected in 1845, mainly due to the efforts of Ira Miltimore, a prominent citizen. The cost of "Miltimore's Folly," $7,500, was considered outrageous by many. Mayor August Garrett thought the school much too large and even suggested it be made into an insane asylum.
(Watercolor sketch, John J. Flanders. Courtesy Chicago Historical Society.)

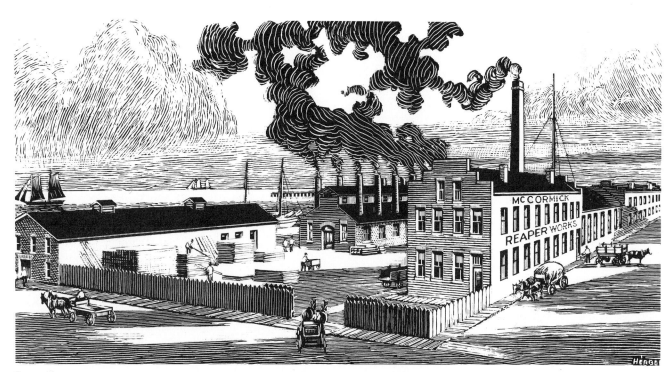

2

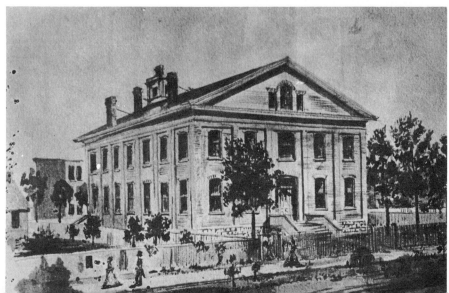

3

PEYTON'S DESCRIPTION OF CHICAGO, 1848

The city is situated on both sides of the Chicago river, a sluggish, slimy stream, too lazy to clean itself, and on both sides of its north and south branches, upon a level piece of ground, half dry and half wet, resembling a salt marsh, and contained a population of 20,000. There was no pavement, no macadamized streets, no drainage, and the three thousand houses in which the people lived were almost entirely small timber buildings, painted white, and this white much defaced by mud. . . . To render the streets and sidewalks passable, they were covered with deal boards from house to house, the boards resting upon cross sills of heavy timber. This kind of track is called "the plank road." Under these planks the water was standing on the surface over three-fourths of the city, and as the sewers from the houses were emptied under them, a frightful odour was emitted in summer, causing fevers and other diseases, foreign to the climate. . . .

On the outskirts of the town where this kind of road terminated, the highways were impassable, except in winter when frozen, or in summer when dry and pulverized into the most penetrating of dust. At all other seasons they were little less than quagmires. . . . Of architectural display there was none. The houses were built hurriedly to accommodate a considerable trade centering here, and were devoid of both comforts and conveniences. . . . a kind of restless activity prevailed which I had seen no where else in the west except in Cincinnati. . . .

Chicago was already becoming a place of considerable importance for manufactures. Steam mills were busy in every part of the city preparing lumber for buildings which were contracted to be erected by the thousand the next season. Large establishments were engaged in manufacturing agricultural implements of every description for the farmers who flocked to the country ever spring. A single establishment, that of McCormick, employed several hundred hands, and during each season completed from fifteen hundred to two thousand grain-reapers and grass-mowers. Blacksmith, wagon and coachmaker's shops were busy preparing for a spring demand, which, with all their energy, they could not supply. Brickmakers had discovered on the lake shore . . . excellent beds of clay, and were manufacturing, even at this time, millions of brick by a patent process, which the frost did not hinder or delay. Hundreds of workmen were also engaged in quarrying stone and marble on the banks of the projected canal; and the Illinois Central Railway employed large bodies of men in driving piles, and constructing a track and depôt on the beech [sic]. Real estate agents were mapping out the surrounding territory for ten and fifteen miles in the interior, giving fancy names to the future avenues, streets, squares and parks.

John Lewis Peyton, *Over the Alleghenies and across the Prairies* (1869), pp. 325–29.

1. Newspaper Row, 1851

The corner of Clark and Randolph Streets was Chicago's early newspaper and job-printing center. William Stuart, editor of the *Daily American*, the city's first daily newspaper founded in 1839, enhanced its importance when he became postmaster and moved the post office there in 1841. This sketch includes one of the familiar horse-drawn omnibuses, which carried passengers from the railroad depots and wharves to hotels.
(Courtesy Chicago Historical Society.)

2. City of Chicago, Looking Northeastward, 1845

This engraving is from the Norris City Directory of 1845.
(Courtesy Chicago Historical Society.)

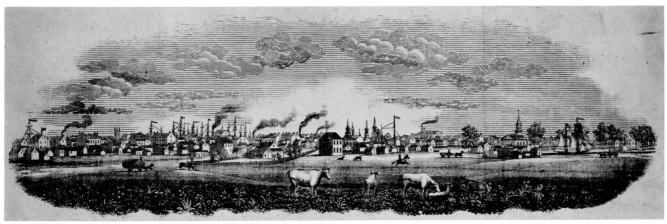

1

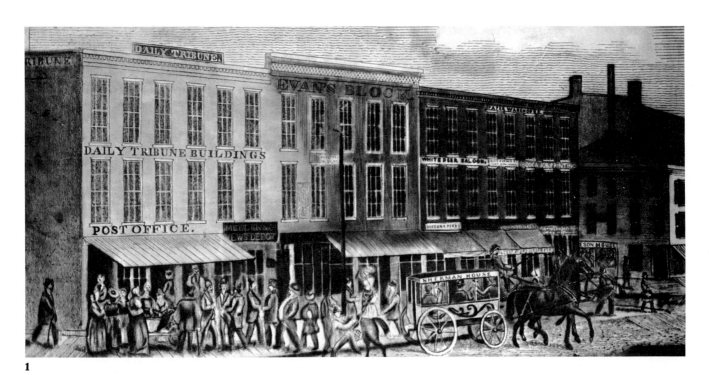

2

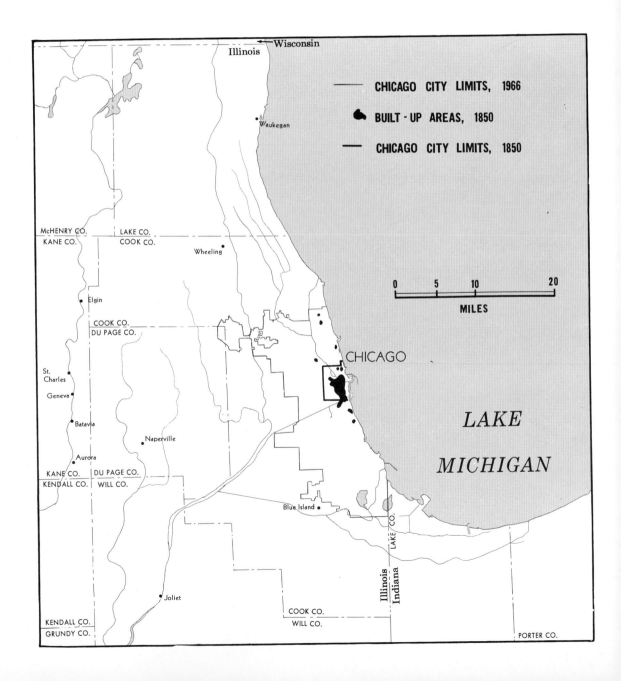

Wisconsin
Illinois

Waukegan

CHICAGO CITY LIMITS, 1966

BUILT - UP AREAS, 1850

CHICAGO CITY LIMITS, 1850

McHENRY CO.
KANE CO.
LAKE CO.
COOK CO.

Wheeling

0 5 10 20

MILES

Elgin

COOK CO.
DU PAGE CO.

St.
Charles
Geneva

CHICAGO

Batavia

Naperville

LAKE

Aurora

MICHIGAN

KANE CO. DU PAGE CO.
KENDALL CO. WILL CO.

Blue Island

LAKE CO.

Joliet

Illinois
Indiana

COOK CO.
WILL CO.

KENDALL CO.
GRUNDY CO.

PORTER CO.

2 | Railroad Capital, 1851-71

A British visitor, Sara Jane Lippincott, summed up the Chicago story best in 1870 when she wrote that, "The growth of this city is one of the most amazing things in the history of modern civilization." Within a single lifetime, a place that had been the haunt of Indians and the bivouac of traders became a modern metropolis. To convey the speed of the transformation Mrs. Lippincott called Chicago "the lightning city." "It now has 300,000 of a population—has streets seven or eight miles long—has street railways traversing the city in all directions, carrying annually 7,000,000 passengers," she noted incredulously. "The log huts have made way for magnificent ware houses and palaces of marble; the little traders have become great merchants, some of them worth millions of dollars, and doing business on a scale of extraordinary magnitude."

Nor was there any hint that this development would soon end. Chicago "grows on Independence days and Sabbath days and all days. It grows o'night." In fact, it seemed that "a great part of the west side of the city" had been "heaved up out of the mud by a benevolent earthquake." And everywhere the city expanded. "Foot by foot, inch by inch," she recorded, it is "formed on swampy flats, on oozing claybanks, on treacherous sand-heaps." The old boundaries moved steadily outwards; yet Chicago still reached out for more land. "Wooden pavements, splendid macadamized roads, and the new boule-

vards are fast bringing the beautiful suburban settlements of Lake View, Kenwood, and Hyde Park into the municipal fold. The city is bearing down on them at a tremendous rate." Soon, Mrs. Lippincott predicted, "the roar of traffic will . . . drown for them . . . the deep sweet monotone of the lake."

The instruments of this development were the railroads. Connecting Chicago first with the Atlantic and then with the Pacific, they made it the focus of a growing transcontinental network; fanning out into the productive prairies of the Middle West, they drew the wheat, corn, and livestock of the whole region to the town's wharves, elevators, and packing-houses. Over the tracks, too, came the flood of passengers from the East and from abroad to populate both Chicago and the new country. And the railroads were crucial not only in increasing the size of the city but also in determining its shape. Tracks, terminals, and other facilities altered the appearance of the city, while suburban stations became the centers of population beyond the municipal borders.

In 1850 only one railroad, the Galena and Chicago Union, entered the city. Two years later four more lines were in operation, two connecting with the East, one with the South, and another with the West. During the next four years, still others joined. By 1856 Chicago was the focus of ten trunk lines with nearly 3,000 miles of track; fifty-eight passenger and thirty-eight freight trains arrived

1. Lake Street East from Clark Street before the Fire

Heavy traffic, numerous pedestrians, and cluttered and littered streets indicate why the Lake and Clark corner was the business center of town before the rise of State Street. A magazine reporter looking at the city's street life in 1856 wrote that "in the principal streets, the motion of team, carriages, and foot-passengers, is equal to that of the great avenues of New York, Broadway excepted Over a space of from one to two miles in each direction, every avenue is alive with the stir and bustle of an active, enterprising population."
(From a stereograph.
Courtesy Chicago Historical Society.)

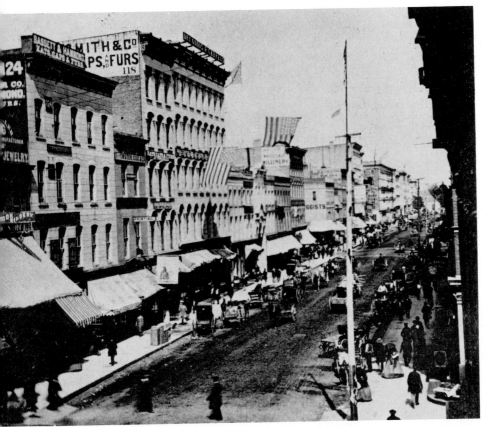

1

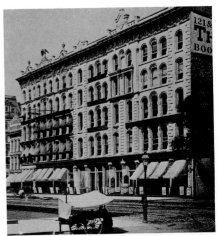

3

2. Chamber of Commerce Building, Southeast Corner of LaSalle and Washington Streets, 1871

Completed in 1865 and replacing the the First Baptist Church, this building on the Court House Square was the first of three Chambers of Commerce which stood at this site. After the Chicago fire, this building was erected to the same height, although by different architects.
(From a stereograph.
Courtesy Chicago Historical Society.)

3. "Booksellers' Row," about 1868

Looking northwest across the corner of State and Madison, this photo shows the five-story construction characteristic of the finest commercial structures before the development of the elevator. The opulent Field-Leiter store in the left background and the marble-fronted "Booksellers' Row" were only two of the impressive facades along State Street in the late 1860's.
(Courtesy Chicago Historical Society.)

4. Cook County Court House and City Hall, Looking Southeast, 1858

The Court House occupied the site of the present City Hall and County Building, the block bounded by Randolph, Clark, Washington, and LaSalle Streets. Chicago's first important architect, John M. Van Osdel, designed the original two-story structure erected in 1853. A third story was added in 1858. Its domed tower provided viewers with uninterrupted view of the surrounding city.
(Courtesy Chicago Historical Society.)

5. Chicago in 1857

The city's rectangular street grid is the most prominent feature of this "bird's eye" view. The industries along the river, the few diagonal streets, and the Illinois Central Railroad on its lakefront trestle also can be identified easily. Although marred by small errors especially at the city's outer edges, the rendering provides a discerning picture of the whole urban area in the mid 1850's.
(Lithograph, Charles Inger, after a drawing by J. T. Palmatary, published by Braunhold and Sonne, Chicago. Courtesy Chicago Historical Society.)

6. John M. Van Osdel (1811–92)

A self-taught architect who prepared by reading for two years in "The Apprentice Library" in New York City, Van Osdel first came to Chicago in late 1836 at the invitation of William B. Ogden. At first he occupied the position of a master builder, but Ogden commissioned him not only to build but to design his house on Ontario Street. Van Osdel's name is associated with much Chicago building: the finishing work on the first ships built in Chicago, the *James Allen* and the *George W. Dole;* the erection of grain elevators; the Tremont House; all the five-story iron front buildings erected before the mid-1860's; and homes for several Chicago leaders.
(Photograph, J. Carbutt, from *Biographical Sketches of the Leading Men of Chicago, 1868.*)

4

6

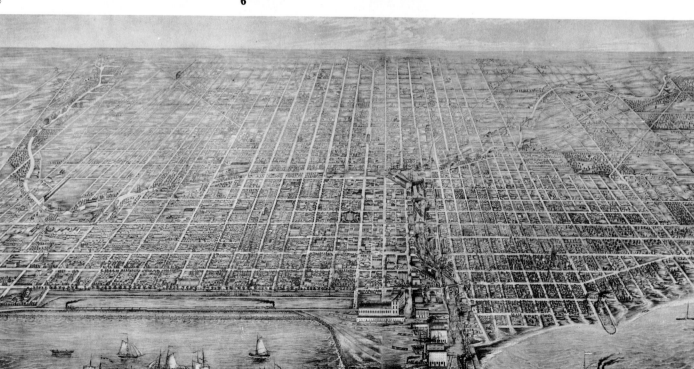

38

1. **Chicago's Wholesale District on South Water Street, 1867–69**

Looking east from State Street toward the river, photographer J. Carbutt's early morning stereographic view reveals the healthy business character of this section. Crates and barrels spill out of the trading houses to fill the plank sidewalks and loading ramps of the street, which became a congested madhouse of sweating men and impossible street traffic during business hours.
(From a stereograph, J. Carbutt. Courtesy Chicago Historical Society.)

2. **Marine Bank Building, Northeast Corner of LaSalle and Lake Streets, 1856**

Alexander Hesler's photograph catches the rapidly changing character of the young city. The new Marine Bank building sits among jerry-built balloon frames, board sidewalks, and plank streets, and the unfinished building and piles of construction materials near the river. A new skyline replaced the old in the ageless process of urban renewal.
(Courtesy Chicago Historical Society.)

and departed daily. In a half-dozen years, the young metropolis had become the world's largest railroad center.

The Illinois Central was a characteristic enterprise. Although it was originally planned by speculators promoting Cairo, Illinois, it received crucial political support from Chicagoans Stephen A. Douglas in the Senate and former mayor "Long John" Wentworth in the House. Chicago advocates hoped that it would ultimately connect the city with Mobile and New Orleans on the Gulf of Mexico. The immediate problem, however, was the location of the route inside the city. After a bitter controversy, an arrangement between the railroad and the city council permitted the Illinois Central to enter by way of a 300-foot-wide strip of submerged land along the lake front. For this privilege, the corporation promised to maintain a breakwater from the municipal limits to the Chicago River. The bargain was never satisfactory to either party. The railroad had to give up its hope of entering the city near the industrial section farther west, and the city would later try to recover the valuable lake-front property ceded to it.

For a northern terminus, the Illinois Central purchased part of the Old Fort Dearborn reservation as well as land along the river. The tracks approached these installations across a trestle erected in the water from Twenty-second Street to the Randolph Street depot. From Senator Douglas the company purchased

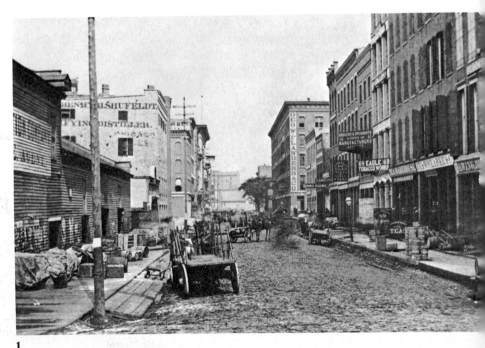

1

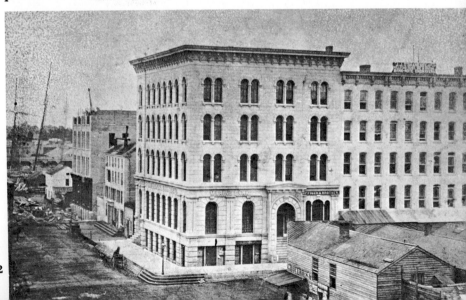

2

3. Timetable of the New York and Erie Railroad

This line, completed between Piermont Pier, on the Hudson River above New York City, and Dunkirk, New York, on Lake Erie, in 1851, was the longest railroad in America and competed with the Hudson River and the New York Central as a link in the rail-steamboat route to Chicago.
(*American Railway Guide and Pocket Companion*, 1851.)

4. Timetable of the Michigan Central Railroad, 1851

This line, the first to be completed to Lake Michigan from the East, connected with Lake Erie steamboats at Detroit, and with steamboats to Chicago across Lake Michigan at New Buffalo. In the following year it was completed around Lake Michigan.
(*American Railway Guide and Pocket Companion*, 1851.)

5. Timetables of Chicago's Westerly Carriers in 1851: Illinois and Michigan Canal Packets and the Galena and Chicago Union, Aurora Branch and St. Charles Branch Railroads

(*American Railway Guide and Pocket Companion*, 1851.)

UPPER LAKE STEAMERS.

NEW YORK AND ERIE RAILROAD.
WINTER ARRANGEMENT.

For Dunkirk, Cleveland, Cincinnati, Detroit, Chicago, Milwaukie, &c.

Trains leave New York as follows, from the Pier foot of Duane street, daily (Sundays excepted)

1. MAIL TRAIN—At 8 A.M., stopping at all the Stations.
2. DAY EXPRESS TRAIN—At 2 30 P.M. for Canandaigua, Rochester and Buffalo. Passengers by this train proceed immediately to Canandaigua, in time for the Express Train West, arriving in Buffalo at 9.30 o'clock next morning.
3. WAY TRAIN—At 2 15 P.M., via Piermont, for Sufferns and intermediate Stations.
4. EVENING EXPRESS TRAIN—At 4 P.M., for Dunkirk, Geneva, Canandaigua, Rochester and Buffalo. This Train connects at Dunkirk with first class Steamers running direct to Cleveland, and also to Detroit, leaving immediately on the arrival of the train, and connecting at Cleveland with the Cleveland, Columbus & Cincinnati R.R. and at Detroit with the Michigan Central R.R. Boats also leave daily, on the arrival of this train, for Erie, Sandusky, Toledo and Monroe. Passengers by this train can remain at Elmira till 8 45 A.M., and proceed to Geneva, or to Canandaigua, Rochester and Buffalo.
4. EMIGRANT TRAIN—At 5 P.M. for Dunkirk, taking Emigrants for all the principal cities and towns in the West.

TRAINS TO NEW YORK.

1. MAIL TRAIN—Leaves Dunkirk at 7 45 A.M., stopping at all Stations West of Elmira, and connecting there with the Express Train from Canandaigua to New York.
2. WAY TRAIN—Leaves Sufferns at 6 12 A.M., via Piermont.
3. MAIL TRAIN—Leaves Elmira at 8 A.M., stopping at all Stations, and arriving in New York same evening.
4. ACCOMMODATION TRAIN—Leaves Dunkirk at 7 45 A.M.
5. DAY EXPRESS TRAIN—Leaves Canandaigua at 2 P.M., Elmira at 7 45 P.M., and Geneva at —
6. NIGHT EXPRESS TRAIN—Leaves Dunkirk at 4 30 P.M. and Canandaigua at 9 30 P.M., taking passengers from the Night Express Train from Buffalo and Rochester.

FARES—FROM NEW YORK,

To Dunkirk	$8 00	To Cleveland	$10 50
" Detroit	12 00	" Buffalo	7 50
" Chicago and Milwaukee	18 50	" Rochester	6 30
" Southport and Racine	18 50	" Geneva	5 00
" Cincinnati	16 50		

CHARLES MINOT, Superintendent.

3

MICHIGAN CENTRAL RAILROAD.
JOHN M. FORBES, Pres., Boston, Mass. J. W. BROOKS, Eng. & Supt., Detroit

Miles	Fares	DETROIT to N. BUFFALO. TRAINS LEAVE	1st Tr'n A.M.	2d Tr'n P.M.	Miles	Fares	N. BUFFALO To DETROIT. TRAINS LEAVE	1st Tr'n A.M.	3d Tr'n P.M.
		Detroit*	7 45	5 00			Michigan City	5 00	9 30
10	35	Dearborn	8 10	5 30	10		New Buffalo	5 45	10 15
17	60	Wayne	8 30	5 53	2?	55	Terre Coupee	6 30	11 08
		Denton's			31	75	Buchanan	6 45	11 25
29	95	Ypsilanti	9 00	6 30	37	90	Niles	7 05	11 45
37	1 10	Ann Arbor	9 25	6 55			Pokagon		
47	1 35	Dexter	9 55	7 25	48	1 15	Dowagiac	7 40	12 20
56	1 65	Chelsea	10 22	7 52	60	1 50	Decatur	8 08	12 50
65	1 95	Grass Lake	10 55	8 22	68	1 75	Paw Paw	8 30	1 13
76	2 25	Jackson	11 25	8 55	85	2 25	Kalamazoo	9 15	2 00
85	2 55	Gidley's	12 05	9 30	95	2 50	Galesburg	9 45	2 30
96	2 85	Albion	12 52	10 15	107	2 90	Battle Creek	10 40	3 23
108	3 20	Marshall	2 10	11 40	120	3 30	Marshall	12 00	4 45
121	3 60	Battle Creek	3 05	12 28	132	3 65	Albion	12 52	5 38
135	4 00	Galesburg	4 00	1 23	143	3 95	Gidley's	1 35	6 20
143	4 30	Kalamazoo	4 30	2 00	152	4 20	Jackson	2 10	6 50
160	4 75	Paw Paw	5 20	2 46	163	4 55	Grass Lake	2 42	7 22
168	5 00	Decatur	5 40	3 07	172	4 85	Chelsea	3 13	7 48
179	5 35	Dowagiac	6 10	3 38	181	5 10	Dexter	3 40	8 12
		Pokagon			191	5 40	Ann Arbor	4 07	8 38
191	5 70	Niles	6 45	4 15	91	5 65	Ypsilanti	4 32	9 00
197	5 85	Buchanan	7 05	4 33			Denton's		
203	6 00	Terre Coupee	7 17	4 52	211	6 00	Wayne	5 07	9 30
218	6 50	New Buffalo	8 00	5 45	218	6 20	Dearborn	5 30	9 50
228		Michigan City	8 40	6 30	228	6 50	Arr Detroit*	6 00	10 15

* Connects with Pontiac R.R. at this point; see below.

On SUNDAYS a train leaves Detroit at 5 A.M.

Stages run from Battle Creek to Grand Rapids; Ypsilanti to Adrian; Dexter to Mason; Jackson to Jonesville and Lansing; Marshall to Coldwater, Centreville, Jonesville and Hillsdale; Kalamazoo to Grand Rapids, Allegan, Three Rivers and Mottville, Niles to Logansport.

Steamers leave New Buffalo, on arrival of each train, for Chicago, Waukegan, Kenosha, Racine, Sheboygan and Manitoowoc.

4

GALENA & CHICAGO UNION RAILROAD.
JOHN B. TURNER, Pres and Supt., Chicago, Ill.

Miles	Fares	CHICAGO To ELGIN. TRAINS LEAVE	1st Tr'n A.M.	2d Tr'n A.M.	3d Tr'n P.M.	Miles	Fares	From ELGIN To CHICAGO TRAINS LEAVE	1st Tr'n A.M.	2d Tr'n P.M.	3d Tr'n P.M.
		Chicago	6 00	8 00	3 00			Elgin	8 00	3 00	
10	75	Desplaines	6 35	8 38	3 35	10		Clinton	8 16	3 16	
16	50	Cottage Hill	6 56	9 04	4 03	25		Wayne	8 33	3 33	
20	60	Babcock's Gro	7 10	9 26	4 30			St. Charles	8 00	3 00	
25	75	Wheatons	7 28	9 45	4 45	25		Ar Junct'n	8 54	3 45	
30	90	Junction	7 45	10 20	5 06						
		Le Aurora	7 45		5 00	15		Aurora	7 30		5 00
6	1 15	Batavia	8 06		5 30	7		Batavia	8 06		6 25
8	1 25	Arr. Aurora	8 30		6 00	37		Ar. Junct'n	8 54		6 45
		Le Junct'n				13		Junction	8 54	3 54	6 40
		St. Charles		10 06	6 00	55		Wheatons	9 15	4 15	7 00
7	1 15			11 00	6 00	65		Babcock's Gro	9 30	4 30	7 20
35	1 00	Wayne		10 27	5 27	70		Cottage Hill	9 57	4 57	7 34
38	1 15	Clinton		10 44	5 44	80		Desplaines	10 23	5 23	7 55
43	1 25	Arr at Elgin		11 00	6 00	43	1 25	Arr Chicago	11 00	6 00	8 30

* Aurora Branch Railroad. Passengers leaving Chicago at 6 A.M. will have daylight on the route via Oswego, Newark and Ottowa, and arrive at La Salle and Peru in time for evening boats on Illinois River. Those leaving Peru and La Salle by A.M. stage will get 6 P.M. train from Aurora, and arrive in Chicago at 8 30 same evening.

† St. Charles Branch Railroad.

Steamers leave Chicago daily, for all points on the Lakes, and to connect with Michigan Central R.R. for Detroit, etc.

Stages leave Aurora and St. Charles for Dixon, Albany and Rock Island. Leave Elgin for Galena and other points West and North.

ILLINOIS & MICHIGAN CANAL PACKET BOATS.

Three daily lines between Chicago and Lasalle, Ill. River Two daily lines expressly for passengers leave Chicago at 8 A.M. and 5 P.M., and Lasalle at 8 A.M. and 5 P.M.—through in about 22 hours.

	Miles.	Fares.		Miles.	Fares.
Chicago to Bridgeport	4	$	Chicago to Dresden	54	$2 25
" Summit	12	0 50	" Auxsable	56	2 25
" Athens	25	1 00	" Morris	61	2 50
" Lockport	33	1 40	" Marseilles	78	3 25
" Joliet	37	1 50	" Atlane	85	3 50
" Chanahon	48	2 00	" Lasalle	100	4 00
" Rankokee	51	2 00			

The 3d or Express Freight Packet line leaves Chicago at 2 P.M. and Lasalle at 9 P.M. daily, for the conveyance of emigrants and movers with their furniture, &c. and other light freights. Fare, including board, $3 00, and in proportion for less distances.

These lines connect at Lasalle with one or more daily lines of Steam Packets for St. Louis and intermediate places on Illinois River.

Distance from Chicago to St. Louis, 400 miles; fare through, $9 00 cabin passage; time from 60 to 72 hours. J. BLINN, Sup't.

5

40

1. Downtown Lakefront, 1858

Alexander Hesler's camera captured the reality of the downtown shoreline. Temporary wharves, piles of boards and rock, board sidewalk, and a dirt beach testify to the unsightly character of the city's front porch on the lake. In the background is the entrance to the Illinois Central and Michigan Central depot and the Illinois Central yards.

(Photograph, Alexander Hesler. Courtesy Chicago Historical society.)

2. Northward on Michigan Avenue from Congress Street, 1868–69

The elegant town houses at the left of this photograph were considered by one mid-60's traveler as "the best" of the city's early suburbs. "These are built of a cream-coloured stone, and many of them give one a favorable idea of the architectural taste, as well as of the wealth of their inhabitants." In the lake the Illinois Central's expensive lake front trestle, providing a privately-financed breakwater for the city's beaches, extended to Monroe street, north of which the tracks fanned into the I.C.'s yards. The huge

additional water rights south of the city limits. Farther south, Paul Cornell, owner of 300 acres in what is now Hyde Park, agreed to deed sixty acres to the railroad for a right of way in return for daily service to his property. Thus within a decade the Illinois Central altered the face of the lake front and stimulated suburban development along its tracks.

The story of the Illinois Central is in many ways the story of other railroads coming into Chicago. Although no one yet spoke of a single consolidated terminal, companies often shared the use of tracks and terminals. Like animals in Noah's ark they came in twos: the Galena and Chicago Union with the Aurora Branch Railroad; the Michigan Southern and Northern Indiana with the Rock Island; the Pittsburgh, Fort Wayne and Chicago with the Chicago, Alton and St. Louis; and the Illinois Central with the Michigan Central. These arrangements, of course, were not always amicable. At one point, the Michigan Southern refused to permit the Illinois Central to cross at grade. Under the cover of darkness, however, tracklayers from the aggrieved line overpowered the guard, and the crossing (now known as Grand Crossing) was installed by daybreak.

Each new railroad that came to the city helped fashion its future. Wherever the tracks ran, the use of the land was affected. The yards and depots dominated surrounding neighborhoods, and

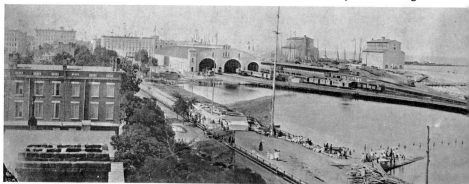

1

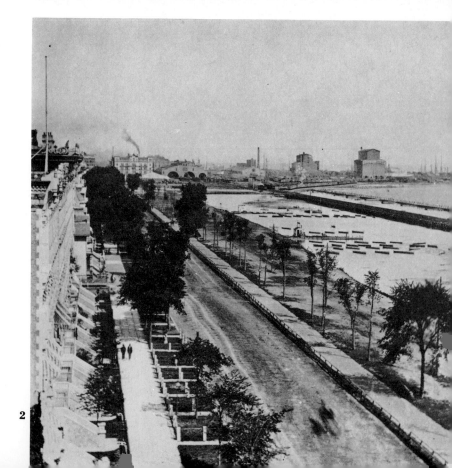

2

train shed with the half-moon doors in the upper center stood on what is now the site of the Illinois Central suburban terminal and the Prudential building.
(From a stereograph, J. Carbutt. Courtesy Chicago Historical Society.)

3. The Illinois Central Terminal Complex, Northeast from Randolph Street, East of Michigan Avenue

By the mid-1860's the Illinois Central–Michigan Central terminal facility was handling nearly capacity traffic.
(From a stereograph. Courtesy Chicago Historical Society.)

4. Second Depot of the Galena and Chicago Union Railroad, at Kinzie and Wells Streets, 1864–71

After the erection of the first two stories in 1852-53, this building served until 1864 as the joint terminal for the Galena and Chicago Union and the Aurora Branch railroads. The third story was added in 1863. This station and a later one built in 1880 and in operation until 1911, stood on the site of the present Merchandise Mart.
(From a stereograph. Courtesy Chicago Historical Society.)

5. Stephen A. Douglas, 1813–61

Douglas played a key role in Chicago's history. He speculated in Chicago land, both on the lakefront and in the Lake Calumet region, was one of the promoters of an early public transportation scheme in 1853, and was instrumental in obtaining the federal land grant which made the Illinois Central possible. His tomb is located at 35th Street, within sight of the railroad he helped to launch.
(Photograph, Case and Getchell, Boston, about 1861. Courtesy Chicago Historical Society.)

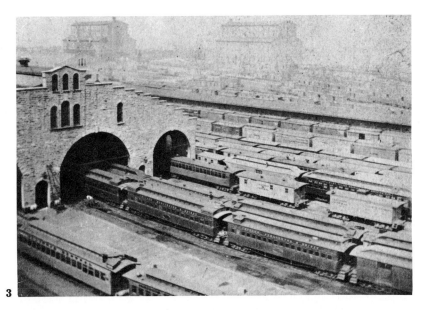

3

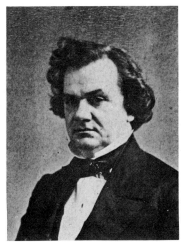

5

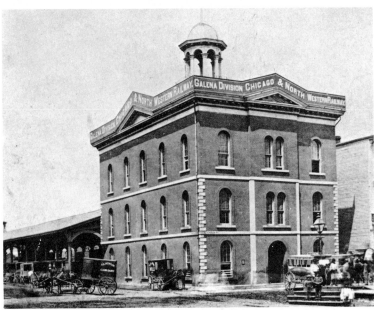

4

42

1. First LaSalle Street Station, Southwest Corner, LaSalle and Van Buren Streets, 1867–71
W. W. Boyington designed this joint terminal of the Rock Island, and the Michigan Southern, and Northern Indiana railroads. It was completed in 1867 at a cost of $225,000.
(From a stereograph.
Courtesy Chicago Historical Society.)

rail facilities became the nuclei of industrial and commercial growth. This crucial development was unplanned and only remotely governed by public policy. The council granted or refused rights of way, demanded or waived taxes, and favored or denied petitions; but the needs of the companies rather than the plans of the city determined the pattern of railroad development. Once established, these installations could not easily be altered. Future planners might talk of terminal consolidation or the recovery of the lake front, but these early railroad decisions were written on the map in lines of iron and for more than a century have constituted fixed features of the Chicago scene.

Almost as spectacular as Chicago's railroad expansion was the growth of lake traffic during the same years. Lumber from northern Wisconsin and Michigan, iron from the northern Great Lakes area, men and goods from the East, all moved across the water to the crowded wharves of the river while other vessels carried the grain of the new country to mills in New York and New England. Tonnage entering the harbor jumped from 440,000 in 1844 to over 3 million in 1869. As many as 300 vessels arrived in a single twelve-hour period, passing through the drawbridges at a rate of two a minute at peak hours.

Lumber comprised one of the central commodities in this maritime commerce. Cut on the upper Great Lakes and fun-

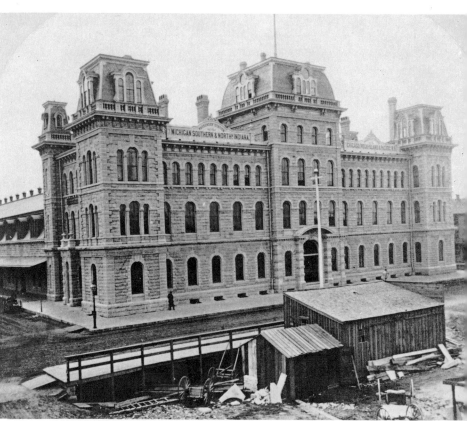

1

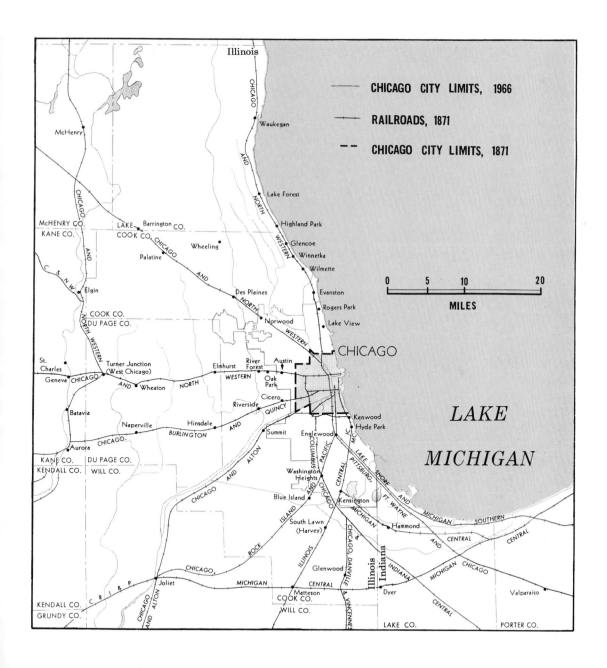

1. *Lady Elgin*

Built at Buffalo in 1851 at a cost of $96,000, this sidewheel passenger vessel ran first between Buffalo and Chicago, then between Chicago and Collingwood, and finally made regular trips into Lake Superior. The large paddle-boxes, arched wooden "hog-frames," and diamond-shaped walking beam were characteristic of side-wheeler lake steamers for nearly a century. In 1860, she collided with another vessel ten miles off the shore of Winnetka. The "Lady" went to the bottom taking 287 people to their death.
(Courtesy Chicago Historical Society.)

2. *Planet*

A ship of the Goodrich lines passenger fleet, it is here tied up at the wharf on the south bank of the River east of the Rush Street bridge. The wharf was used by Goodrich vessels until the 1930's. The *Planet* was 993 tons, built in Newport, Michigan, in 1855 and served until her dismantling in June, 1866.
(Courtesy Chicago Historical Society.)

neled through Chicago, the timber provided fencing and homes for the farmers of the prairie and also the basic building material for the booming construction business in the city. "Miles of timber yards extend along one of the forks of the river," wrote the visiting historian James Parton in 1867. "The harbor is choked with arriving timber vessels; timber trains snort over the prairie in every direction." Among the unusual items of the trade were ready-made houses, leading Parton to observe wryly that "there is a firm [Lyman Bridges] in Chicago, which is happy to furnish cottages, villas, school houses, stores, taverns, churches, court-houses, or towns, wholesale and retail, and to forward them securely packed, to any part of the country."

Soon the area along the river became the largest center for lumber distribution in the world. Fifty million pine boards measuring 614 million feet were sold in 1867 alone; the total of all wood sales reached almost a billion and a half feet. To handle this trade, the "lumber district" grew up along the South Branch of the river between Halsted and Western avenues. Allied industries appeared too. Not only Bridges' famous prefabricated houses, but planing mills, furniture manufacturing, and wagon and ship building prospered. Although the city is no longer preeminent as a lumber distributor, Chicago's present key role in the furniture world dates from this lumber trade a century ago.

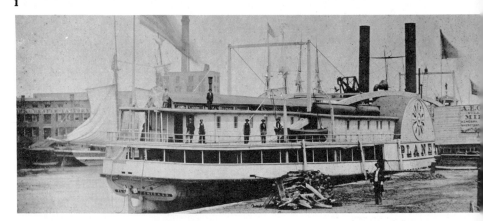

1

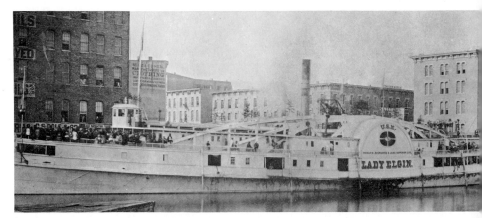

2

3

3. Northwest

This vessel was built in Manitowoc, Wisconsin, in 1867, and was powered by the engine formerly installed in the *Planet*. She operated for one year along the west shore of the lake, then was placed on the run between Cleveland and Detroit until 1876. Immediately behind the *Northwest* on the south bank east of Rush Street is a large stone Illinois Central freight shed which was erected in the 1850's and still stands in 1969.
(Amkrotype. Courtesy Chicago Historical Society.)

4. South Branch of the Chicago River in the Mid-1860's

This photograph shows the Lake, Randolph, and Madison Street bridges in early morning. Through the haze the camera picks up the lake and canal traffic with its waiting vessels and the river lined with commercial buildings and wharves.
(Carte-de-visite photograph.
Courtesy Chicago Historical Society.)

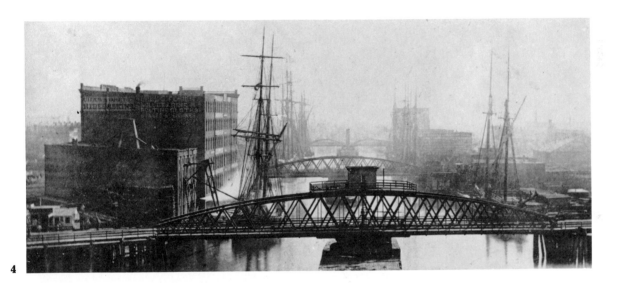

4

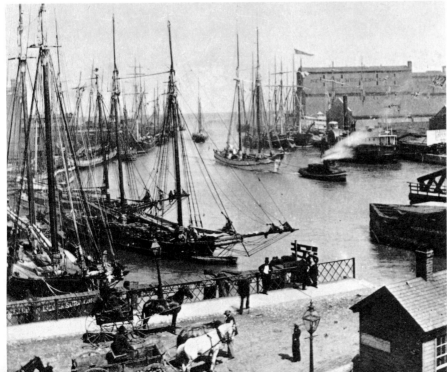

5

5. Chicago River, East from the Rush Street Bridge, about 1869

Land travel was often delayed while lake vessels passed through open bridges. Here a steam tug tows a sailing vessel into the river. A writer in *Putnam's Monthly Magazine* in 1856 found the bridge openings so numerous that he could only compare them with talkative women. "These bridges, as is scandalously asserted of certain ladies' tongues, are hung in the middle, and play at both ends." As the bridges were turned, "people jump on and jump off as long as the policemen will let them; those that are on (the bridge), horse and foot, quietly stand still and are ground round to the other side While the process is going on, a row of vehicles and impatience frequently accumulates that is quite terrific. I have seen a closely-packed column a quarter of a mile in length, every individual driver looking as if he thought he could have turned the bridge sixteen times, while he had been waiting"
(Courtesy Chicago Historical Society.)

The city's leadership in the grain trade was no less commanding. With this commodity as with lumber, Chicago owed its supremacy to both its location and its ingenuity. Ideally placed to handle the produce of the prairie, Chicago transacted a business that astonished and bewildered observers. It was not only the quantity involved—almost 60 million bushels in 1870—but also the new techniques for handling the grain that created the interest. "Whether it arrives by canal, railroad, or lake," Parton noted, "it comes 'in bulk' The train or vessel stops at the side of one of these seventeen elevators, by which the grain is pumped into immense bins, and poured out into other cars or vessels on the other side of the building—the double operation being performed in a few minutes by steam." A few blocks away from the elevators, in a long, narrow, dingy room on the second floor of a South Water Street building, the Board of Trade, the "altar of Ceres," organized the buying and selling of the mountains of grain that paused momentarily in the city.

The elevators quickly became landmarks on the Chicago skyline and symbols of the city's connection with the grain trade. Standing at the junction of railroads and the river and along the North and South Branches, they hovered over tracks and trains and sailing ships. Some, like one Sturges, Buckingham & Company building, lasted nearly a hundred years. And with grain Chicago first

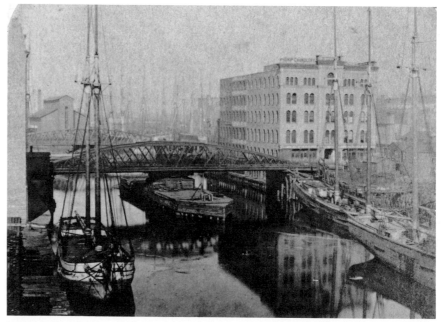

1

2

3. The LaSalle Street Tunnel

Opened in July, 1871, this was "the larger and more interesting of the two tunnels" under the river, a Chicago resident wrote in 1880. "It is a marvelous underground highway, containing two passage-ways for vehicles, besides a footway for pedestrians, passing not only under the river but also under several squares either side, making it an easy grade, and, with its long row of gas-lights, a very 'cheerful tunnel.' "
(From *Seven Days in Chicago,* 1877.)

4. The Forks of the Chicago River, North from Randolph Street

In 1871, lumber yards, occupying nearly ten miles of river frontage, received over a billion feet of lumber (not including 600 million shingles). By 1879, over one and one-half billion feet of lumber comprising nearly a third of the entire manufacture of the Northwest, came into the city. In the photograph, the open bridge is at Lake Street, and immediately beyond is the river fork and Wolf Point, the center of the Chicago settlement in the 1830's. The Illinois and Michigan canal barges on the right are tied up in the main stem of the river.
(Courtesy Chicago Historical Society.)

3

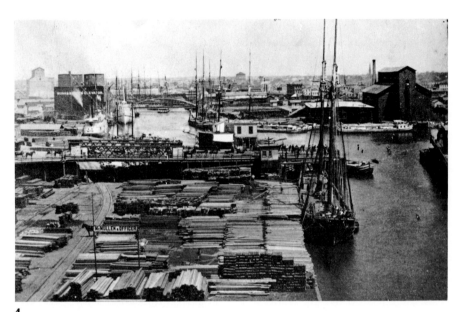

4

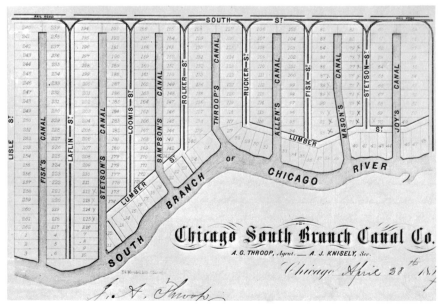

5

5. Plat of an Industrial Subdivision by the Chicago South Branch Canal Company, 1857

Located on the north bank with Halsted Street to the east and Ashland Avenue to the west, this area and its mile-long extension to the west were rapidly filled with lumber yards and associated industries. The many "canals" or slips made the lumber yards accessible to sailing vessels from the northern Great Lakes region and to barges of the Illinois and Michigan Canal.
(Courtesy Chicago Historical Society.)

1. Looking North towards the Sturges and Buckingham Elevators in the Illinois Central Terminal Complex

Pre-fire visitors were always impressed with the immense size of the S. & B. elevators. Even two decades after this photo was taken an excited visitor wrote: "the elevator swallows the grain like a hungry dog devours a mouthful of meat, and is ready for more before any more is ready for him."
(From a stereograph.
Courtesy Chicago Historical Society.)

2. The Chicago River, Looking East across the Rush Street Bridge, about 1860

Each winter found Chicago's elevators crammed with grain, often with vessels along the adjoining docks filled with the overflow. In 1871, Chicago's total elevator storage was 11,375,000 bushels. Sturges and Buckingham alone stored 2,850,000 bushels in that year.
(From a stereograph.
Courtesy Chicago Historical Society.)

entered the international market. In 1856 the schooner *Dean Richmond* threaded its way through the canals around the Saint Lawrence rapids and carried a cargo of wheat to Liverpool; the following year the *Madeira Pet* tied up in the river after an eighty-day voyage from England. These two trips inaugurated direct trade with overseas countries and established Chicago as an international port a century before the opening of the enlarged Saint Lawrence Seaway.

Cattle and hogs were just as fitting symbols of the young metropolis as wheat and corn. In fact, looked at in one way, they were pretty much the same thing. As a contemporary put it, "The corn crop is condensed and reduced in bulk by feeding it into an animal form, more portable. The hog eats the corn, and Europe eats the hog. Corn thus becomes incarnate; for what is a hog, but fifteen or twenty bushels of corn on four legs?" And like grain, the meat-packing trade was on a prodigious scale. One-third of all the slaughtering of the West took place in Chicago. Indeed, in 1863 alone the hogs processed in the city, if arranged in single file, would have reached all the way to New York. And enough cattle were "lodged, entertained, and despatched" to make Chicago, as one guide book suggested "THE GREAT BOVINE CITY OF THE WORLD."

With the growth of the industry, more factory space had to be found. In the 1860's, meat-packing gravitated to an area four miles southwest of the city

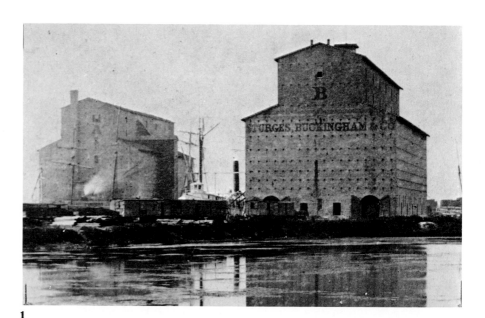

1

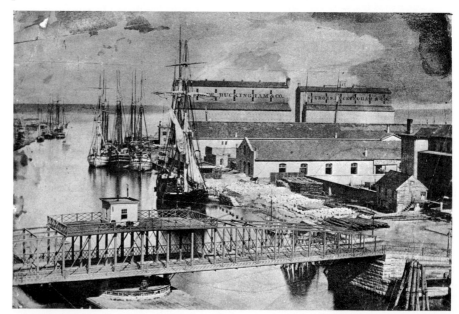

2

3. *Dean Richmond*

Built in Cleveland in 1855, the *Dean Richmond* was a 375 ton schooner. After loading 5,000 bushels of wheat at Chicago and an additional 9,000 bushels at Milwaukee, the schooner set out for Europe by way of the Canadian canals circumventing the St. Lawrence rapids.
(An oil painting by an unknown artist done in the late nineteenth century. Courtesy Chicago Historical Society.)

4. *Madeira Pet*

A British brigantine of 123 tons, this vessel reached Chicago on July 14, 1857, the first vessel to arrive from a European port.
(From the *Chicago Magazine,* August, 1857. Courtesy Chicago Historical Society.)

4

3

5

5. View of the Union Stock Yards, 1866

"Out on the prairie, four miles south of the city, and two feet below the level of the river, may be seen the famous Stock Yards," a Chicago guide book of 1868 observed. "Two millions of dollars have been expended there in the construction of a cattle-market. The company owning it have nearly a square mile of land, 355 acres of which are enclosed with cattle pens— 150 of these acres being floored with plank. There is at the present time pen-room for 25,000 cattle, 80,000 hogs, and 25,000 sheep, the sheep and hogs being provided with sheds. . . . One hundred tons of hay are frequently used in the yards in one day. If these yards were in any of the Eastern States, the sale of the manure would be an important part of the business; but the fertile prairies not needing anything of the kind, they are glad to sell it at ten cents a wagon-load, which is less than the cost of shovelling it up."
(From a lithograph by Jevne and Almini, after a drawing by Louis Kurz. Courtesy Chicago Historical Society.)

1. Stock Yards Consolidation Map
Nine railroads which had great interest in the city stock trade put up nearly all the money for the consolidation project. Beginning work on June 1, 1865, "an almost valueless marsh" was drained, and by Christmas the Stock Yards company began operation. In 1871 over 500,000 cattle and nearly 2,400,000 hogs were received at the Yards.

2. Main Portal of the Union Stockyards
Erected in 1865 and built of Lemont limestone, this same entrance welcomed visitors to the Stockyards at its centennial in 1965. Housed in the gate in 1889, when this gravure was made, was an office of the Illinois Humane Society.
(Courtesy Chicago Historical Society.)

center near the South Branch of the river. Here the elaborate Union Stock Yards were built. On nearly a square mile, with pens which would house 20,000 cattle, 75,000 hogs, and 20,000 sheep, and with hotels, restaurants, and an exchange, the business opened on Christmas Day, 1865. Almost a city in itself, the yards were laid out on a grid pattern, with streets and alleys for its unusual population; and puckishly, the principal street was named Broadway. Nine railroads constructed branches to the yards and a small canal connected it with the river. The whole operation was so cut off from downtown that the historian Parton claimed that residents could live many years in Chicago and never "suspect any business was done in cattle, never see a drove, never hear the bellow of an ox." Yet when the wind was right, the secret was quickly revealed, and complaints about smell and refuse began to pour into City Hall.

In 1869 the introduction of refrigerator cars widened even further the opportunities for Chicago's packers. In the following decades, Gustavus Swift revolutionized the livestock and meat industry by exploiting this new possibility. Meanwhile such famous brands as Libby and Armour had already become household names. Moreover, enterprises using by-products of the meat industry soon sprang up with substantial markets of their own. "Mr Dooley" later epitomized the ramifying effect of the meatpacking business when he observed with

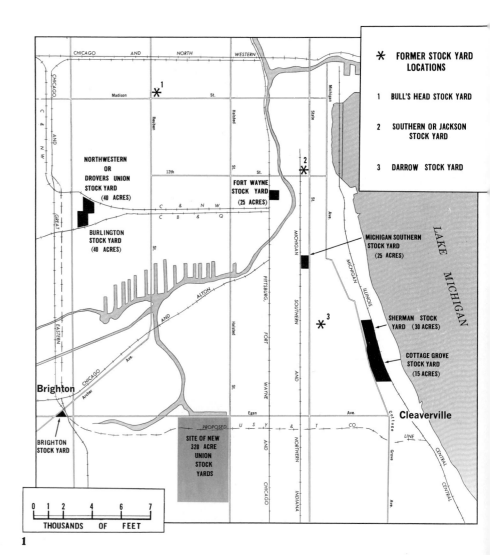

FORMER STOCK YARD LOCATIONS

1 BULL'S HEAD STOCK YARD

2 SOUTHERN OR JACKSON STOCK YARD

3 DARROW STOCK YARD

1

3. First Armour and Company Packing Plant

When it opened in 1867, Armour's had a capacity to butcher 30,000 hogs annually, with operations taking place only in the winter months. By 1871–72, as the fifth largest of the 26 packers who processed at least 5,000 hogs annually, the firm butchered over 68,000 hogs. Until the development of the refrigerator car, pork was usually packed in barrels like those on the loading dock.
(Courtesy Armour and Company.)

4. Philip Danforth Armour, 1832–1901

Armour, after having "accumulated some money" in the California gold fields, made his first fortune by selling pork short just before the close of the Civil War. He moved the headquarters of Armour and Company to Chicago from Milwaukee in 1875. A decade later his firms employed 10,000 men and the products they manufactured were valued at $50,000,000 annually.
(Courtesy Chicago Historical Society.)

2

4

3

1. McCormick Reaper and Mower Works, Looking Southeast in the 1860's

The Works were on the north bank of the River between Pine and Sands Streets, directly opposite the Illinois Central grain elevators. By 1868 the McCormick firm was selling 10,000 Chicago-made reapers annually. Many of these went to foreign countries, the reaper having been introduced abroad as early as 1851 when it won Grand Prize at the London Exposition.
(Courtesy International Harvester Company.)

2. North Bank of the Chicago River, between Rush Street and Lake Michigan

Sharp contrasts in land use appear in this A. J. W. Copelin photo taken about 1860. The four-story cupolaed Lake House appears as the physical antithesis of "Marsh's Caloric Grain Dryer," "B. Carpenter, Packer and Provision Dealer," the McCormick Works, and various mercantile establishments and two-story frame houses.
(Courtesy Chicago Historical Society.)

only slight exaggeration that "a cow goes lowin' softly into Armours and comes out glue, gelatine, fertylizer, celoolid, joolry, sofy cushions, hair restorer, washin sody, soap, lithrachoor, and bed springs, so quick that while aft she's still cow, for'ard she may be anything fr'm buttons to pannyma hats."

If Chicago took the grain and livestock of the farms, it also returned some things of its own. Most important were agricultural implements to break the soil and harvest the crops; for as one contemporary noted, "the prairie world is mowed and reaped by machines made in Chicago." By 1870 McCormick's reapers not only dominated the American market but won international prizes at Paris and Hamburg. His massive plant on the north bank of the river was among the city's major employers, and his agents, scattered across the countryside, were among Chicago's most persuasive boosters.

The iron industry too had its birth in this period. Organized on an almost imperial scale, it went into the Lake Superior region for ore, into Pennsylvania, Ohio, and southern Illinois for coal, and into Michigan for limestone. The three basic ingredients had their rendezvous along the forks of the Chicago River. The North Chicago Rolling Mills produced the nation's first steel rails in 1865; a decade later more steel rails were rolled in Chicago than in any other American city. The foundation of the city's primacy in the manufacture of

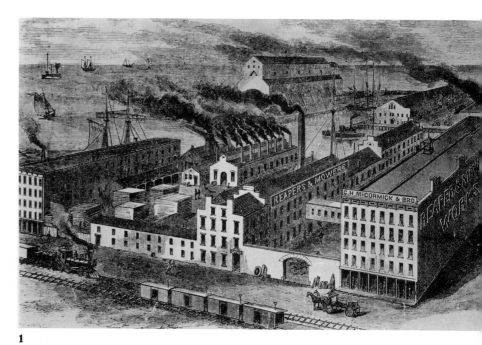

1

3. North Chicago Rolling Mill, about 1900

Chicagoans of the nineteenth century were unblushing advocates of industrial development. Not even the increasing smoke and pollution reduced this enthusiasm. Indeed, they gloried in it and viewed black smoke as a sign of progress, not contamination. This letterhead substantiates this attitude, and it also illustrates the excellent rail and water connections that brought manufacturers to Chicago. In 1857, this plant, Chicago's first steel rolling mill, was established on the west bank of the North Branch of the Chicago River. At first it re-rolled imported rails, but in 1865 it produced America's first steel rails. Blast furnances were added in 1870 and a Bessemer converter in 1872.
(Courtesy United States Steel Corporation.)

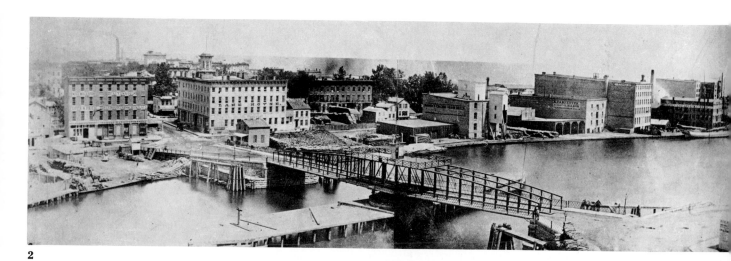

2

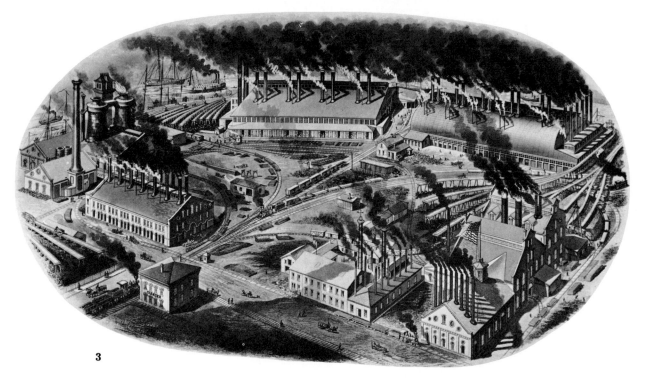

3

Potter Palmer's Chicago

Writing in 1867, a contemporary looking over the leading men of the city could observe that Potter Palmer was "the first merchant prince of Chicago." By 1865 he had enough money to retire from "mercantile pursuits." He then turned to real estate, and by 1867 it was estimated that "the buildings that he has now in

the central product of modern society had already been laid.

By almost any measurement Chicago was a success. And people flocked to the city to share it. The population jumped from about 30,000 in 1850 to almost ten times that (298,977) two decades later. More than half came from abroad, sustaining Chicago's reputation as one of the nation's most cosmopolitan places. Irish and Germans continued to predominate among the newcomers, but the sprinkling of other European nationalities constantly increased. Although most American-born Chicagoans came from the Old Northwest, there were contingents from the East, a few from the South, and fewer still from the Far West.

The old boundaries could no longer contain the burgeoning commerce and industry and the increasing population. Lumber yards, factories, elevators, warehouses, docks, and depots lined the river and pushed north and south along the banks of both branches; commercial facilities steadily expanded at the city's center, forcing residential construction to move out to the edge of town and even into the suburbs beyond. Shops and stores replaced pleasant dwellings; old neighborhoods gave way before the spread of new building. The familiar process of urban displacement, so often thought to be a modern phenomenon, had begun; everywhere the real estate developer and speculator was busy.

The rise of State Street as "that great street" was at once characteristic and spectacular. In the mid-sixties, it was narrow, shoddy, and unpromising. Small shops and shanties edged wooden sidewalks and unpaved streets. Most retail activity took place along Lake Street and wholesaling along South Water Street. If Chicago had a focus, it was at Clark and Lake, where land values reached $2,000 a front foot in 1865 compared with $150 at Washington and State, just three years earlier.

Into this scene, just after the Civil War, stepped Potter Palmer. A successful retail and wholesale merchant in the 1850's, he had made a fortune in cotton speculation during the war. In 1867 he bought three-quarters of a mile along State Street and within two years transformed the whole area. He persuaded the other owners and the city council to agree to widening the street, replaced the shacks at State and Monroe Streets with an elegant hotel that bore his name, and induced Field, Leiter and Company to move from Lake Street by building for them a new and opulent store. The effects of these decisions were felt throughout the business community, and the shift to State Street was sudden and dramatic. One contemporary thought the change so important and far-reaching that he called Palmer's work the "Haussmannizing of State Street," likening it to the rebuilding of Paris by Baron Georges Eugène Haussmann under Napoleon III. By 1869 thirty or forty stone-

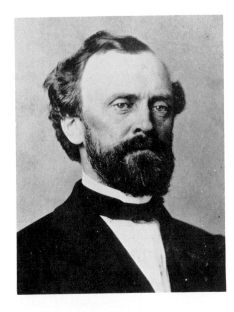

1. Potter Palmer 1826–1902
(From a stereograph.
Courtesy Chicago Historical Society.)

process of construction, together with those completed the present year, will cost over six hundred thousand dollars." While the Palmer name is generally associated with more opulent buildings, his real estate holdings contained every kind of property —from workers' cottages to middle class duplexes, from meat markets to stables. Fortunately, Palmer left behind a personal pictorial record of his holdings in the city for a single year. During 1868–69, his real estate agent put together an album which contained photographs of nearly all his holdings. When matched with the pages from his rent accounts, the beginnings of the immense Palmer fortune become clear. Palmer was not only "the first merchant prince of Chicago," he was also one of the city's real estate kings.

(Uncredited figures in this section are from Potter Palmer's Real Estate Album, 1868–69. Courtesy Chicago Historical Society.)

2. State Street, South from Lake Street, between 1869–71

The new State Street had begun to emerge in this pre-fire photo. In the middle distance, on the east side of the street, is the new Field, Leiter and Company building. Wooden sidewalks still border the west side of State Street, but at the new grade level. More permanent sidewalks have already been installed on the east side of the street.

(From a stereograph, J. Carbutt. Courtesy Chicago Historical Society.)

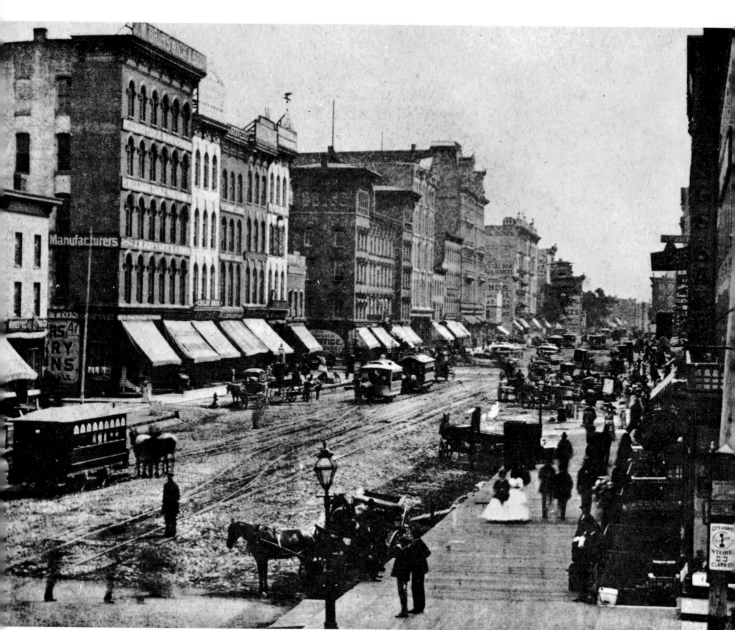

Potter Palmer's Chicago

faced buildings had sprung up along the renewed street. Land values soared, and the commercial axis of the city, which had previously extended east and west along the river, assumed its present north-south orientation.

The expansion of the city altered residential as well as commercial patterns. As business facilities took over more and more of the downtown area, homesites had to be found elsewhere. The first to move were the wealthy, who could afford to buy wherever they wanted: increasingly they headed for spacious grounds well removed from the built-up areas. To be sure, Wabash and Michigan Avenues remained favorite streets, but in the 1860's the focus of fashionable living moved toward Twenty-second Street along the avenues"—Indiana, Prairie, Calumet, and South Park. A decade later, the mansions of Marshall Field and Philip Armour placed the social seal of approval on the green and gracious neighborhoods of the South Side.

The West Side had its fashionable areas too. Along Washington Boulevard and in the vicinity of Union Park wealthy merchants, lumber dealers, and manufacturers built elegant houses away from the congestion of the city. In 1864 Samuel J. Walker developed Ashland Boulevard between Monroe and Harrison Streets by widening the street, planting trees, installing sewers and pavement, and constructing six expensive houses at different corners. Marked by all the delights of suburban living,

Account Pages from Potter Palmer's Real Estate Album

169 State Street (Now 105 S. State Street)

282 State Street (Now 400 S. State Street)

325 State Street (Now between 505–509 S. State)

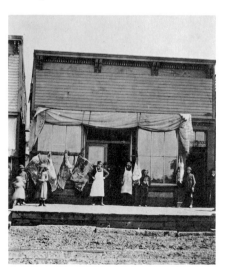

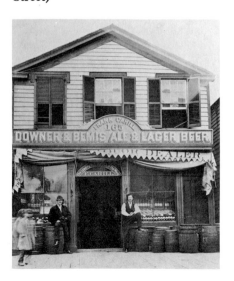

913 State Street (Now 1901–7 South State, between Archer and State)

165 State Street (Now 101 S. State, Location of the Palmer House)

474 State Street (Now Railroad Property between 800 and 900 South State Street)

Potter Palmer's Chicago

889 State Street, 1868–69 (between Eighteenth and Nineteenth Streets)

Many of these two-story workers' houses crowded along State Street before the fire. This building rented for $480 per year. At the foot of the plank sidewalk is an early "billboard" placed there by the enterprising salesman of "Azurene."

282 State Street (400 State Street), Known as 70 Van Buren Street (9 Van Buren Street), 1868–69.

This building was originally at the rear of a lot fronting on State Street. By 1868–69 it fronted on Van Buren, though its backside character still dominated.

640 State Street (New Railroad and Warehouse Property near Twelfth Street)

177 State Street (113 South State Street—Palmer House)

87, 89, 91 State Street (Now 103 S. State in the Marshall Field Block)

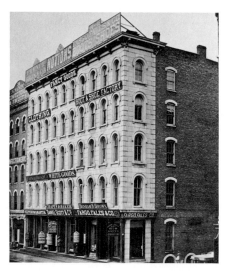

40–46 Randolph Street (Now 29 W. Randolph in the Marshall Field Block)

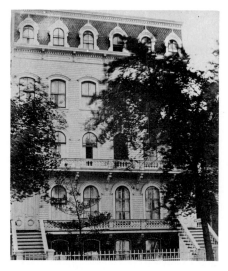

281–282 Michigan Avenue (Now 816 S. Michigan)

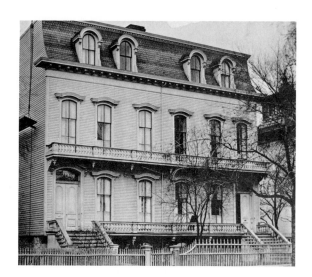

310–311 Michigan Avenue (Now 1014 S. Michigan)

772–774 State Street (Now between Springer Street and Burlington Crossing)

Potter Palmer's
Chicago

The First Palmer House
Opened September 26, 1870, this building cost $200,000 and had furnishings valued at $100,000. John M. Van Osdel was the architect of the elegant 225-room hotel, staffed almost entirely by Negroes.
(From a stereograph.
Courtesy Chicago Historical Society.)

**Field, Leiter and Company,
Northwest Corner of State and
Washington Streets, 1868–71**
Field's was not only a wholesale dry goods business, but it pioneered in the techniques of the modern department store. The annual rent paid to Potter Palmer was $50,000.
(From a stereograph.
Courtesy Marshall Field and Company.)

**1. Residence of H. H. Honoré,
Northwest Corner of Michigan Avenue
and Adams Street**
(From a stereograph.
Courtesy Chicago Historical Society.)

**2. Marshall Field Residence, 1905
Prairie Avenue**
 In 1874 Marshall Field estimated that he
had spent $175,000 to build and furnish
this mansion. The architect was Richard
M. Hunt from New York.
(Courtesy Chicago Historical Society.)

**3. Residence of George Sedgwick,
Southwest Corner of Michigan
Avenue and Adams Street**
(From a stereograph.
Courtesy Chicago Historical Society.)

**4. Philip Armour Residence,
2115 Prairie Avenue**
 The "Prairie Avenue Set" of high society
included the Armours, Fields, the George
M. Pullmans and the William G. Hibbards.
Their activity furnished the inspiration for
Arthur Meeker's *Prairie Avenue*.
(Courtesy Chicago Historical Society.)

1

2

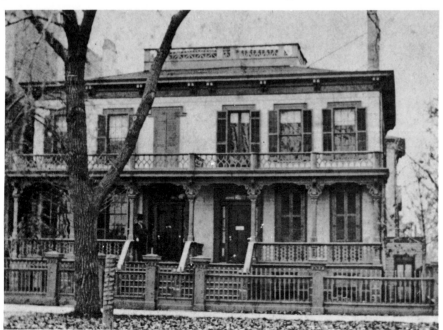

3

4

1. Home of Leonidas Virgil Badger, 1870

The Badger home stood on Reuben Street (Ashland Avenue) between Harrison and Congress. Among almost everything else, the mansion had a gallery and a cupola where a telescope was set in place. Nearby is Union Park with its artesian well. The unknown photographer's wagon darkroom stands at the left of the photograph. (Courtesy Chicago Historical Society.)

2. Looking Northeast from the Badger Home in 1870 across Congress and Reubens (Ashland Avenue)

Row houses had already become fashionable among the well-to-do and were quite in keeping with the neighborhood's suburban character. New plantings along the streets indicate the newness of the development.
(Courtesy West Side Historical Society, Legler Branch Library.)

it beckoned to the rich and successful.

The North Side alone found it difficult to attract the city's emerging business families. Streets like Dearborn and LaSalle kept their aristocratic tone, but communications to the rest of the city were too uncertain to encourage additional residential investment. Steady river traffic kept the drawbridges open producing intolerable delays and interrupting intercourse with the commercial area, while the unimproved lake front drew squatters and irregulars rather than the stylish. Yet the plans for Lincoln Park and the appearance of the Ogden, McCozy, and Arnold mansions indicated that the fuller development of the North Side was not far away.

Workers were less fortunate. Unable to get away from the noise and odor of packing houses, tanneries, and distilleries, the bulk of them huddled in modest pine cottages on small lots without the benefit of paved streets or sewers. More than 200,000 Chicagoans were jammed into these frame jungles. City fathers and visitors alike might take pride in the fact that few tenements were built and that "thrifty workmen own the houses they live in" or can "rent a whole house," but filth, disease, vice, and privation were the constant companions of those living in the poor neighborhoods.

These sections could be easily identified. On the North Side, the worker's district ran west of Wells Street; on the West Side, it lay west of Ashland Boulevard and stretched from north of Kinzie

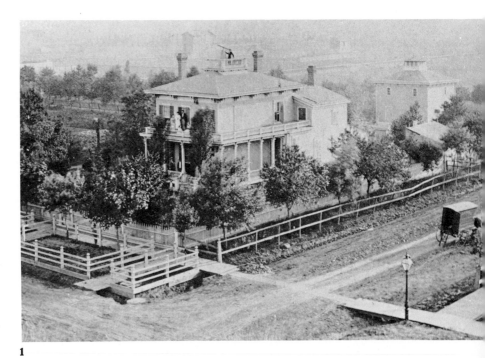

1

2

3. Union Park, East of Ashland, between Lake and Madison, 1864–70

"This is a little gem park in the West Division," J. B. McClurg wrote in 1880. "It abounds with rustic bridges, miniature lakes, etc., and is a popular resort." To this "little gem park" Samuel J. Walker tied part of his real estate development on Ashland Avenue. Taking advantage of the movement of the upper and middle class to settle around this sylvan setting, he carried the park theme to Ashland by planting trees along the sidewalks at a cost of $30,000.
(From a stereograph.
Courtesy Chicago Historical Society.)

4. Frederick Wallis Residence, 85 Huron (Huron and Sedgewick), 1863

The wooden frame construction of most Near North Side buildings is readily apparent in this photograph of a two story duplex. Frederick Wallis and his mother were professional photographers, a fact which perhaps accounts for this photograph of an otherwise unimportant home.
(Courtesy Chicago Historical Society.)

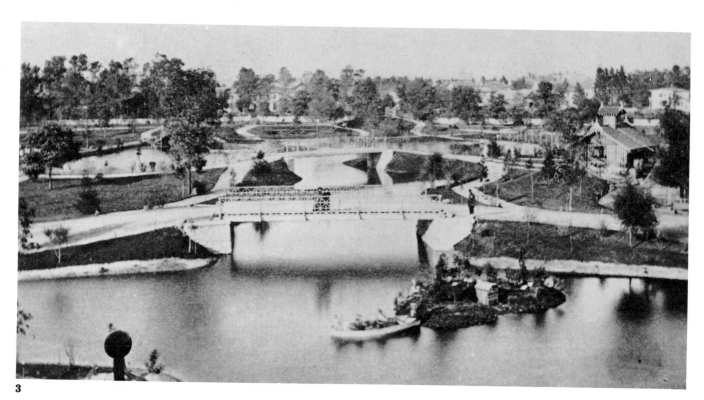

3

4

64

1. Ashland Avenue at Madison Street in 1872

This engraving from a real estate promotional brochure captures the appealing features of 19th century suburban living: the West Madison horse car lines, the omnibus, and carriages emphasize the ease of access to the central city; fine homes, ample lots, and shady streets suggest the comfortable circumstances of its residents.
(Courtesy West Side Historical Society, Legler Branch Library.)

to south of Harrison; on the South Side it lay west of State Street. Crowded from the beginning, these neighborhoods absorbed still greater numbers as the city grew and the economy expanded. Indeed, the population of the West Side quadrupled during the decade after 1863, growing from 57,000 to 214,000. On the North and South sides the number of residents doubled during the same period, and both areas became increasingly congested.

The quality of these areas contrasted sharply with those of "the avenues." Buildings and people were crowded into very limited space. Lots often had two buildings—one facing the street and the other the alley. Jerry-building was widespread, and frame construction made whole blocks kindling wood for the first ambitious fire. Streets remained unpaved; alleys were littered; even life itself, as measured by mortality rates, was cheap.

Strong ethnic concentrations joined with low incomes and crowding to give these neighborhoods their peculiar character. The Swedes and Norwegians congregated around Chicago Avenue west of Wells; the Germans held the area just to the north of them; the Irish stronghold remained Bridgeport. A small Negro population could be found just south of Harrison. Among the important structures in the European neighborhoods were the churches, which offered newcomers the chance to worship in a familiar tongue.

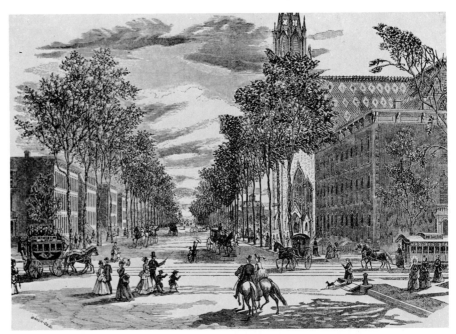

1

2. Real Estate Broadside Addressed to Workingmen, 1868

Real estate men knew that working class families were often eager to escape the congested city. The Butters company offered the "'old time term' of one quarter down, balance in one, two and three years, with interest at six per cent." Located between 26th and 29th, between Stewart and Wallace, this neighborhood was serviced by two horsecar lines. Auctioning was popular with realtors, for many felt a better price was gained in this way than by establishing a fixed price.

(Courtesy Chicago Historical Society.)

3. Detail of a Plan for a Block of Thirty-Two Frame Houses Built on North LaSalle Street, 1869

Balloon frame construction, whether it had elaborate ornamentation or not, was the most common way builders found to meet the demand for new housing. This rendering shows the facade detail of one of thirty-two houses erected at one time. The builders boasted that "the partition between the houses are all double, with a four inch space between the studs that will enable the proprietors to remove them. . . . in case of fire." A stream of water could then be directed into the space.

(Courtesy Chicago Historical Society.)

1. Early Commercial Development in Rogers Park, 1875

The two-story shop very early dotted the Chicago commercial landscape. The first floor contained the business establishment, the upper story was occupied by the proprietor or renters. These structures, on the east side of Clark Street, south of Greenleaf Avenue, in 1875 were only one block west of the suburban Rogers Park station of the Chicago and North Western Railway. The steep slope east of Clark Street at the rear of the buildings indicates that they stood at the edge of one of the old post-glacial beaches.
(Lillian M. Campbell Memorial Collection, Courtesy West Side Historical Society, Legler Branch Library.)

Between the fashionable neighborhoods and the congested quarters of the laboring class lay areas of modest but comfortable housing. Occupied by white collar workers or skilled laborers, these dwellings were usually single-family houses built on small lots near better neighborhoods. Others were tucked in among commercial buildings, and some shopkeepers lived over their stores on secondary business streets. These enclaves were often too scattered to achieve much sense of neighborliness or to develop strong local institutions. Yet this group grew larger each year.

The emerging residential pattern was shaped in large part by the development of local mass transportation. So long as the city was small and compact, people could walk to work or to where they wished to shop or visit. Those with means could appropriate high ground, a better view, or a large plot, but they would never be far from neighbors with lesser resources or from commercial and industrial installations. Archibald Clybourne built his house within the shadows of his meat-packing plant; shanties stood within easy sight of William B. Ogden's mansion.

The introduction of the horse-drawn omnibus drastically altered this arrangement. Although its adoption would have far-reaching consequences, the omnibus could hardly have looked less like a revolutionary agent. Carrying only a few passengers in each car, slow by modern

1

2

2. Subdividing a Swamp

"Land is the grand topic of conversation in the streets, hotels, and liquor saloons of Chicago," wrote an observer who was in the city in 1854, "and the acquisition of wealth by its sale and purchase is the ruling passion among the citizens of the prairie city. The columns of the newspapers are crowded with advertisements of 'eligible lots,' and the land agents suspend huge maps in their windows to attract the speculator. Auction-rooms are crowded with bidders, and the cry of every one is that of the distressed mariner, though in a different sense, land! land! land!" Not all this speculation was honest and the unwary were warned in a pamphlet expose of the *Tricks and Traps of Chicago* published in 1859.
(Courtesy Chicago Historical Society.)

3. Urbanized Area in Chicago, 1850–71

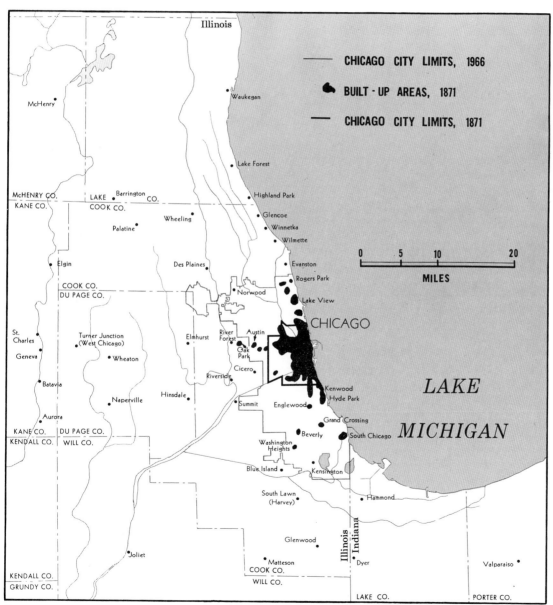

CHICAGO CITY LIMITS, 1966

BUILT · UP AREAS, 1871

CHICAGO CITY LIMITS, 1871

1. An Omnibus from the Citizen's Line
Chicago's first omnibus line ran from downtown to what is now Lincoln Park in 1850. By 1852 a scheduled route extended down Lake Street to Bull's Head Inn on the South Side. In 1855 Franklin Parmalee, previously a driver for the Warren and Parker Omnibus Company, purchased several of these twenty passenger "intracity stages" from hotels and began the "Citizen's Line." His first regular runs were to the Brighton Race Track and the unincorporated village (now neighborhood) of Brighton Park. (Courtesy Chicago Historical Society.)

2. Horse Car Lines
By the mid-1860's the horse car had replaced the omnibus as the city's chief public carrier. While the initial horse railroads were enfranchised in 1856, it was not until two years later that Henry Fuller, Franklin Parmalee, and Liberty Bigelow, under a different ordinance, began building the first line in the city. This summer car, with its advertisement for a Luxemburger picnic, was one of the first placed on Chicago streets, where it ran until 1900. (Courtesy George Krambles Collection.)

standards, and generally uncomfortable, it gained its utility from the simple fact that many of them together could move large numbers of people, at low cost, over an extensive area. By 1856 eighteen lines were making more than 400 trips daily. Soon tracks were laid to handle the traffic on the most heavily used routes. Although they traveled at only six miles an hour, horse-drawn street railway cars were twice as fast as walking and hence doubled the radius of settlement. Later, cable cars, electric lines, elevated and subway trains, and automobiles would immensely enhance the capacity of the metropolis to absorb people. But the process of expansion through innovations in mass transit, a process that has done much to shape the Chicago area, began when a horse pulled an awkward coach across the planked streets more than a century ago.

Now it was possible for people to live well removed from the downtown area and commute to work. Those with money, of course, had the widest residential choice. Very rapidly they moved away from the business center and created fashionable neighborhoods along the lake shore and at the edges of the city.

The railroads also played a crucial role in the distribution of settlement outside the city. Almost from the beginning, suburbs appeared like beads on a string along the lines leaving Chicago. Occupied in large part by the well-to-do, they depended for their existence on

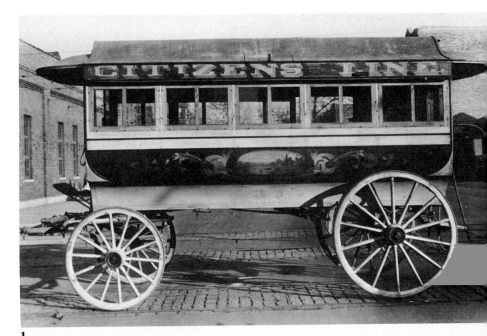

1

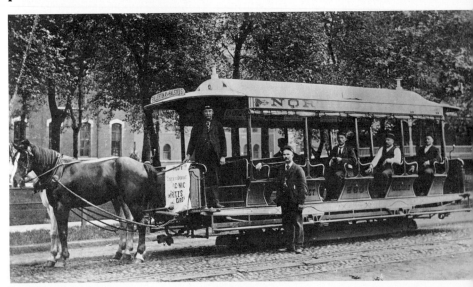

2

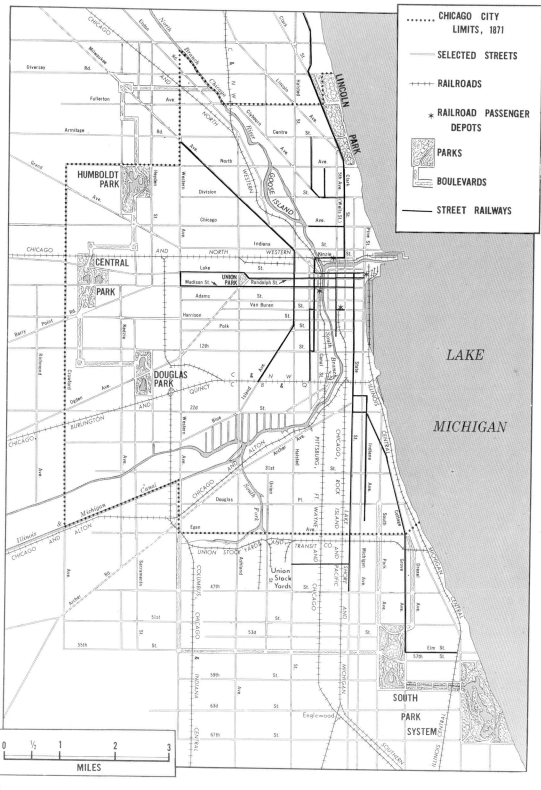

CHICAGO CITY LIMITS, 1871

SELECTED STREETS

RAILROADS

* RAILROAD PASSENGER DEPOTS

PARKS

BOULEVARDS

STREET RAILWAYS

LINCOLN PARK

HUMBOLDT PARK

CENTRAL PARK

DOUGLAS PARK

GOOSE ISLAND

UNION PARK

LAKE MICHIGAN

Union Stock Yards

SOUTH PARK SYSTEM

Diversey Rd.

Milwaukee Rd.

Fullerton Ave.

Armitage

Grand

North Ave.

Division

Chicago

Indiana

Lake St.

Madison St.

Randolph St.

Adams St.

Van Buren St.

Harrison

Polk

12th St.

Quincy

22d

31st

47th

51st

53d

55th

57th Elm St.

59th

63d

67th

Englewood

CHICAGO AND NORTH WESTERN

CHICAGO AND ALTON

CHICAGO, ROCK ISLAND AND PACIFIC

PITTSBURG, FT. WAYNE AND CHICAGO

ILLINOIS CENTRAL

MICHIGAN CENTRAL

MICHIGAN SOUTHERN

CHICAGO AND BURLINGTON

Illinois & Michigan Canal

UNION STOCK YARDS AND TRANSIT CO. AND

Michigan Ave.

State St.

0 ½ 1 2 3

MILES

1. Steam-Dummy Railroad in the 1860's

This steam-dummy locomotive and trailer car was typical of those serving as suburban extensions to the horse-powered street railway lines of the city. Throughout the sixties and seventies, this locomotive and car operated on Evanston Avenue, now Broadway, from the city limits to Graceland Cemetery. The steam-dummy got its name because of the "dummy" sides covering the boiler, used to avoid frightening the horses.
(Lillian M. Campbell Memorial Collection. Courtesy West Side Historical Society, Legler Branch Library.)

daily commuting service to the city. The railroad station was, symbolically, the center of life of the suburban community, and many were large and even elegant. Spaced miles apart and often quite distant from the municipal boundary, the suburbs were nevertheless a part of the metropolis.

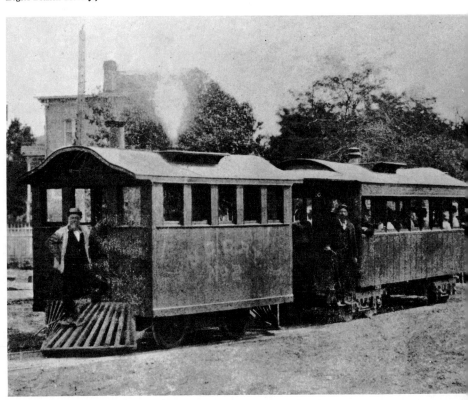

1

2. Chicago Suburban Centers, 1873

Two years after this map was made a Chicago resident wrote in a national magazine that "there is a large portion of the people who do business in Chicago who reside in the suburban towns and villages. These people reach the city and return by railway. . . . An idea of the rapid change going on in the character of the property in the district outside of the city, especially since the fire, may be gathered from the fact that, in 1869, 1873, and 1874, the comparative number of building lots, averaging 25 × 125 feet each, in the city and county was:

YEAR	NUMBER OF LOTS
1869	126,000
1873	177,000
1874	226,000

For 1875, the official figures are not in hand, but the increase is even greater. These lots are the result of converting farms into town lots, there being now about thirty villages and towns in the county outside the city, all rapidly filling up as residences."
(From a real estate promotion map. Courtesy Chicago Historical Society.)

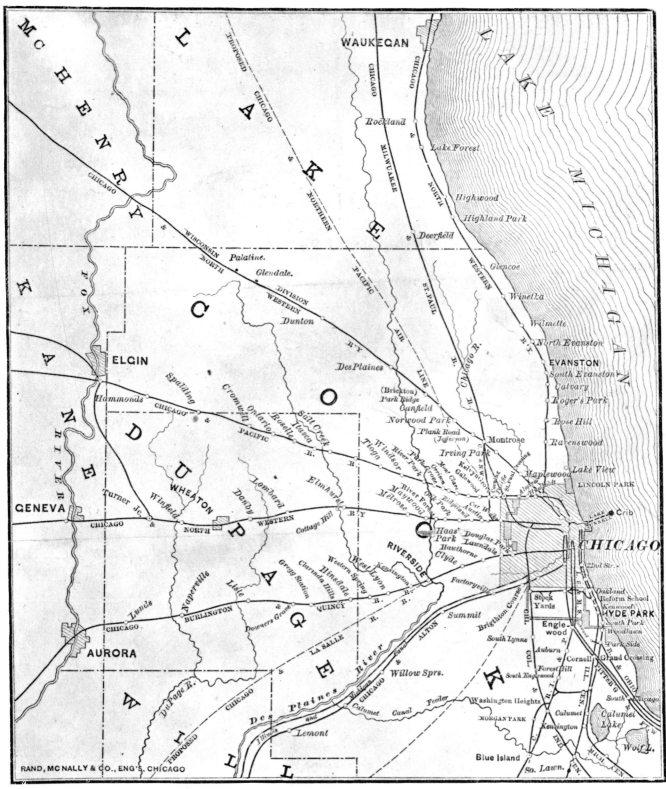

RAND, McNALLY & CO., ENG'S. CHICAGO

2

1. Kenwood Station of the Illinois Central Railroad, Established in 1859

General George B. McClellan established this station when he was vice-president of the Illinois Central. Never exactly defined, the Kenwood area was that which surrounded the home of John A. Kennicott, who had settled there in 1856, naming it for an ancestral home near Edinburgh, Scotland. When this photo was taken in 1882, the city limits were one mile north of the station.
(Courtesy Chicago Historical Society.)

1

2. Chicago and North Western Railway Station, Looking East at Norwood Park, about 1890

Norwood Park was developed by a group of Chicagoans which called itself the Norwood Park Land and Building Association. Purchasing 840 acres in 1869, they proceeded to lay out a town, naming it after *Norwood*, a novel by Henry Ward Beecher. A Chicago and North Western Railway station was erected there the same year. For the first two months, only one passenger rode regularly to and from the city. By 1884, nine trains stopped there daily serving sixty to seventy passengers. Even when this photo was taken, wood planking and oil lamps prevailed, and fences were still present to keep livestock off the tracks.
(Courtesy Chicago Historical Society.)

3. Park Ridge Station

In 1856 the Chicago, St. Paul, and Fond du Lac Railroad (later the Chicago and North Western) reached Park Ridge. Then called Brickton, the little settlement 18 miles northwest of the city was named for a large brick plant established there in 1854. The photo was taken at the arrival of the first suburban train of the Chicago and North Western Railway in Park Ridge in 1874.
(Courtesy Chicago and North Western Railway.)

2

3

74

Evanston

1. Original Plan of Evanston
This is a copy of the original plat of the city of Evanston, which was laid out in the winter of 1853–54. The three "proprietors" of the town included one acting as an individual, one representing Northwestern University, and one acting both as an individual and for the University. The first assessment valued this property at $6,000. (From a copy made in 1897. Courtesy Evanston Historical Society.)

Evanston was the largest and one of the oldest suburbs. Located twelve miles north of Chicago along the Chicago and Milwaukee (later the Chicago and North Western Railway), it owed part of its attractiveness to the lake front; but, as a local real estate agent observed, "its proximity to Chicago gives it life and activity." Twenty-two passenger trains daily brought commuters to the city for about fifteen cents a ride. Moreover, Evanston was close enough to Chicago to profit by road connections, and by the mid-seventies the Lake Shore Drive, called by contemporaries "one of the handsomest carriage ways to be found in the world" was carrying a growing traffic. Unlike many suburban plats, however, the town was laid out rectangularly with "no suspicion of a curve to the right or left."

Though oriented toward the city, Evanston owed much of its early development to Northwestern University. Founded in 1851 as a Methodist college and situated on the lake, it not only attracted faculty and students but also set the tone of the town. "The air of intense respectability which clothes the average Evanstonian," a local booster claimed, "is relieved by his devotion to music, to literary evenings, to the work of the gospel." This "respectability" was encouraged by the prohibition on the sale of liquor, making the residents, as one observed soberly, "compulsory teetotalers." The landscape was dotted with the imposing residences of Chicago merchants who, in the words of an early historian, showed "an enlightened taste and a ready purse—two most excellent things."

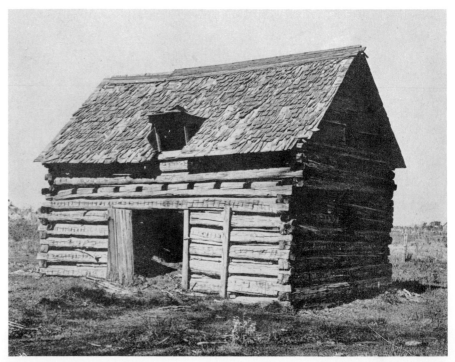

2. Early Log Cabin Built in the Evanston Area
A manuscript label identified this cabin as having been built in 1846, and it is representative of the type which other early residents are known to have erected. The little cabin stood on Church Street in November, 1901, when this photograph was taken. (Courtesy Evanston Historical Society.)

2

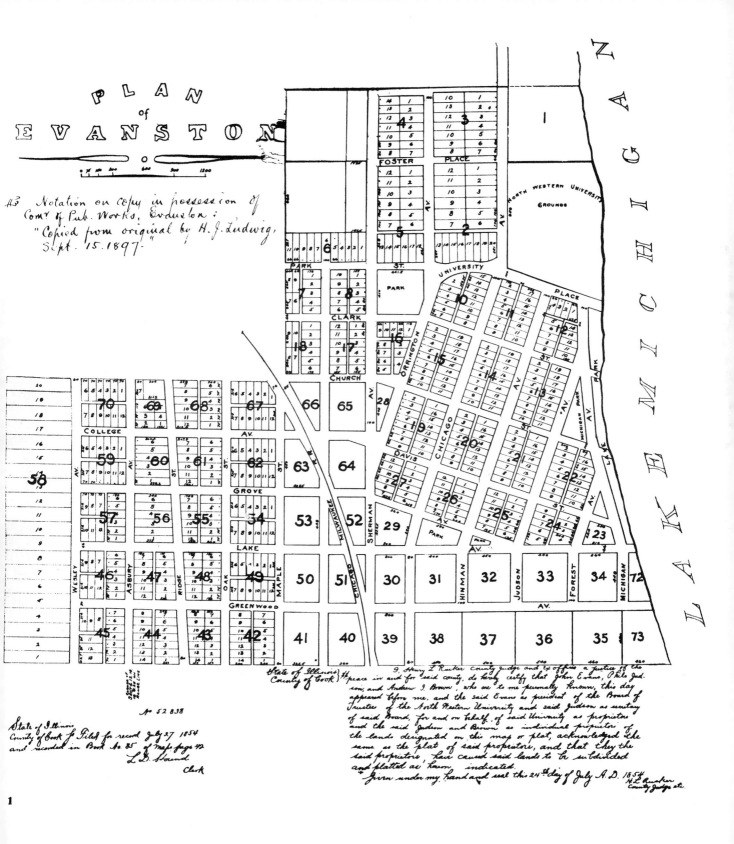

PLAN of EVANSTON

#3 Notation on copy in possession of Comr. of Pub. Works, Evanston:
"Copied from original by H. J. Ludwig, Sept. 15. 1897."

State of Illinois
County of Cook } Filed for record July 27 1854
and recorded in Book No. 85 of maps page 42
L. D. Hound
Clerk

No 52.838

State of Illinois
County of Cook } ss peace in and for said county, do hereby certify that John Evans, Philo Judson, and Andrew J. Brown, who are to me personally known, this day appeared before me, and the said Evans as president of the Board of Trustees of the North Western University and said Judson as secretary of said Board, for and on behalf of said University as proprietor and the said Judson and Brown as individual proprietors of the lands designated on this map or plat, acknowledged the same as the plat of said proprietors, and that they the said proprietors, have caused said lands to be subdivided and platted as herein indicated.
Given under my hand and seal this 24th day of July A.D. 1854.
H. L. Rucker
County Judge etc.

Evanston

Evanston had been organized as a town for nearly two decades when its citizens celebrated their country's one hundredth birthday with the erection of a fountain in the city square. Willard Hall, the Northwestern University building in the background, overshadows the small frame businesses and dwellings, unpaved streets, and open drains in the central business district of the town.
(Courtesy Evanston Historical Society.)

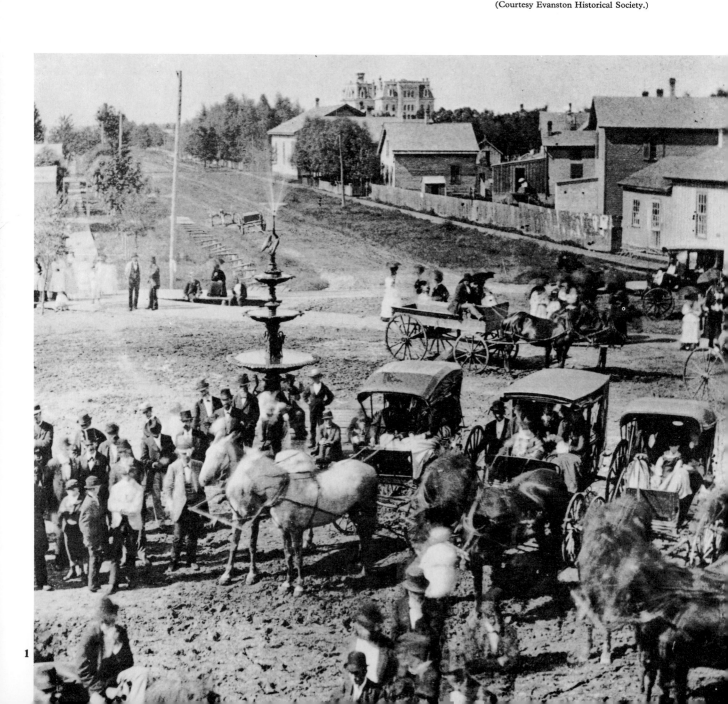

1

2. Evanston's Two Railroad Stations, about 1897

Looking northwest across Davis Street, a contemporary photographer saw the Chicago and North Western station (at the left) and the Chicago, Milwaukee and St. Paul station, the two steel links connecting Evanston with Chicago at the turn of the century. Evanston had a railroad station as early as 1854, when the Chicago and Milwaukee, later the Chicago and North Western, built a depot there. The Chicago, Milwaukee and St. Paul station occupies the site of the present Chicago Transit Authority elevated station.
(Courtesy Evanston Historical Society.)

3. Fountain Square, 1894

In 1880 Evanston had a population of only 4,400; by 1900, it would have over 19,000, with many "of the most prominent business men of Chicago having their homes in this beautiful suburban village." Generally, a contemporary wrote in the mid-80's, these citizens were "of a progressive disposition. They have a fine system of water works, a village of wide and cleanly avenues and streets, lighted with gas, a free public library . . . and prosperous looking business houses established in substantial brick buildings."
(Courtesy Evanston Historical Society.)

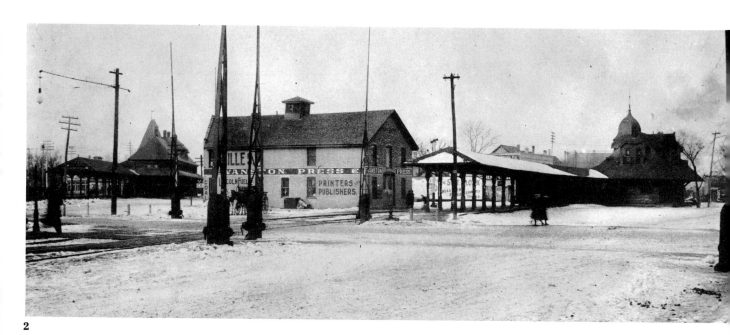

2

3

Evanston

1. Thomas Bates Residence, Southwest Corner of Maple Avenue and Lake Street, about 1890

Frances Willard, writing in 1891, provided readers with an impressionistic, if somewhat romanticized, description of Evanston. According to the long-time resident, it was "a quiet city that still prefers to call itself a village; kissed on one cheek by Michigan's waves, fanned from behind by prairie breezes, jeweled with happy homesteads set in waving green, and wreathed about with prairie wild flowers, a town comely as a bride, even to strangers' eyes."
(Courtesy Evanston Historical Society.)

2. Thomas Cosgrove Residence, Southwest Corner of Chicago Avenue and Davis Street

At another point in her account of Evanston, Willard summarized the city's

1

2

3

charms. Exaggerating the population by only a few thousand she wrote: "Count half a dozen blocks of stores, half a score of smaller churches, four spacious public school buildings and a fine high school, and fill in the rest with comfortable and often palatial homes for about twelve thousand people, and you have a faint outline of the picture which Evanstonians love."
(Courtesy Evanston Historical Society.)

3. Fountain Square in Evanston, about 1929

A local newspaper man called Fountain Square "the Heart of Evanston," with the streets radiating from it like "arteries of the heart." The towered building at the left is City Hall and beyond is Marshall Field's suburban department store.
(Courtesy Chicago Historical Society.)

4. Sheridan Road across Greenwood Street, in the 1920's

"The peculiar glory of the village is its streets," wrote Frances Willard in 1891"—

its long avenues bordered with wide-spreading elms and maples and grand old oaks, that stood proud sentinels over Indian wigwams in ages past." While it was true that Evanston still proclaimed itself "The City of Homes" in the 1920's, the rapid growth of population, and the coming of new apartment houses and manufacturing establishments meant that increasingly the city's life had a wider focus. Still, Evanston's marvelous tree-shaded streets were among the community's chief assets.
(Courtesy Chicago Historical Society.)

4

5

6

5. Orrington Hotel, North on Orrington Avenue in the 1920's

"Evanston is really a continuation of the city," Robert Shackleton wrote in 1920, "and at first impresses one as not being noticeably different from the city (of Chicago), but after a while one comes to realize that it has an individuality all its own, and a general aspect as of churchliness."
(Courtesy Chicago Historical Society.)

6. North Shore Hotel, North on Chicago Avenue, in the 1920's

Evanston experienced a greater growth in the 1920's than in any decade of its history. Its combination of a "close-in location, its railroad and elevated connections with Chicago, its lake shore location, and its outstanding educational facilities, attracted 26,000 new residents in that decade." By 1930, Evanston had over 63,000 people.
(Courtesy Chicago Historical Society.)

Evanston

The history of the North Shore Line goes back to 1895, when a company known as the Bluff City Electric Interurban Street Railway completed a track between Waukegan and Tenth Street in North Chicago. In 1899 Evanston was joined to Highland Park with a ten mile line. However, it was not until 1919 that the

1

2

Chicago, North Shore & Milwaukee was allowed to enter the Loop, by way of the Milwaukee Road tracks and the Chicago elevated railway system. The late twenties was the "Shore Line's" most prosperous period; bankruptcy came with the depression, and while the railroad continued to operate for another three decades it never recovered the good times of the earlier period.
(Courtesy Evanston Photo Service.)

2. Fountain Square in Evanston, about 1940

More and more the old square gave way to the needs of the automobile and public transportation. Traffic lights, an elaborate street marking system, and an Evanston Bus Company vehicle all demonstrated the changing functions of the sixty-year-old square.
(Courtesy Evanston Photo Service.)

3. Fountain Square, 1946

The old Rood Building, standing since the turn of the century, had been gutted by fire when this aerial photograph was made. While the city maintained its close contacts with Chicago, the height of the buildings of its own business district revealed the importance of the independent community.
Courtesy Evanston Historical Society.)

Evanston

No waste space was left in this first college building; it held a chapel, museum, six classrooms, two meeting halls, belfry, and a three-room attic, which housed several students who did part time work for the university.

(Courtesy Northwestern University Archives.)

1

2

2. University Hall, Northwestern University, Built 1870

The building is faced with Lemont Limestone. Except for the late addition of a clock on the tower, the external appearance of the building is unchanged today.
(Courtesy Evanston Historical Society.)

3. Northwestern University Campus, Northeastward, 1907
(Courtesy Northwestern University Archives.)

4. Northwestern University Campus, 1965

This air photograph looking northward shows the 70-acre land fill expansion of the Northwestern campus. The new area will accommodate a library complex as well as additional classroom space and an astronomical observatory.
(Courtesy Northwestern University Archives.)

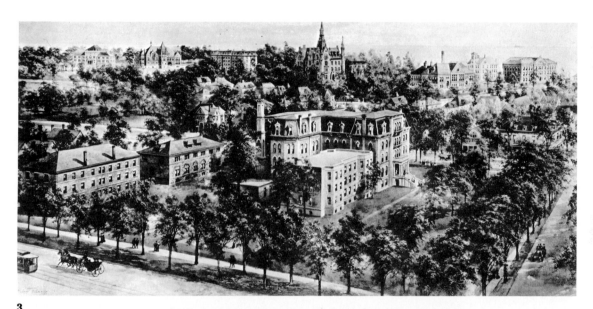

3

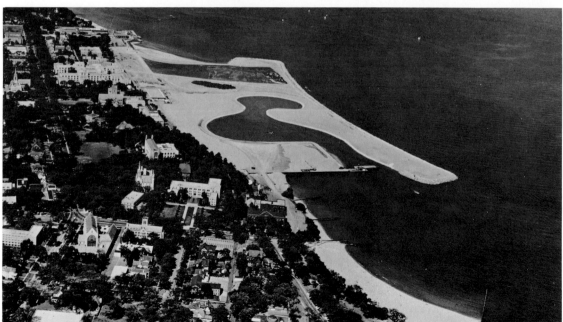

4

Lake Forest

Among the first permanent structures was this school built in 1860. A year later the school board hired Miss Frances Willard, later a national leader in the temperance movement, to be a teacher. Even as the school was being built, a writer of a Chicago guide book presaged the history of Lake Forest. "This pleasant woodland town is situated on . . . the Chicago and Milwaukee Railroad, twenty-five miles from Chicago," he wrote. "There are several . . . pleasant homesteads

Twenty miles farther north, Lake Forest developed as Chicago's most exclusive suburb. Although it was also connected in its origin with a prospective college, it very early became "the favorite resort of the better class of Chicago's inhabitants." Laid out in 1856, its curved drives and capacious lots were soon occupied by elaborate homes. For example, John V. Farwell, a dry goods merchant, built a turreted baronial castle with an exterior of concrete and an interior of black walnut and cherry, and Charles Bradley's "large English cottage" was on a scale that reminded visitors of the aristocratic affluence of the Old World. While the men commuted to the city, the women of Lake Forest created a rich tradition of social participation in metropolitan affairs.

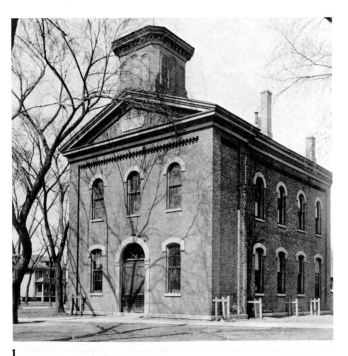

1

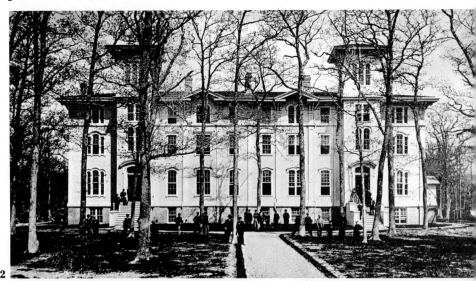

2. Lake Forest Academy, 1865
Built in 1858, the Academy opened its doors the following January at the western edge of what is now the Durand Institute campus. By 1860, the forty-nine registered students entered a building, later described as "an imposing one for its epoch." It was "very large, high and white, with green blinds, and having two cupolas, one on each side." The Academy's present campus was not laid out until 1893.
(Courtesy Lake Forest College Library.)

2

which add an attraction to the surrounding fine landscape and form the nucleus of a future pretty residence town. . . . The location is splendid, being close on the lake shore, and the land has an elevation above the lake higher than any other part of the shore. The atmosphere is bracing and the region fertile. Lake Forest will undoubtedly become one of the finest suburban resorts for the merchants of the city, who are remarkable for their fondness of the rural districts during the warm summer months."
(Courtesy Chicago Historical Society.)

3. Plat of Lake Forest, 1873

In 1856 several wealthy Chicagoans formed the Lake Forest Association to build a suburban community on 1,300 acres of wonderfully wooded and irregular land twenty-five miles north of the city. Part of this plan intended sixty-two acres "as a campus for a future university." A generation later the Association sold 650 acres to themselves and "their friends whom they desired as neighbors." With part of the money from these sales and on the recommendation of Olmsted, Vaux and

Company of New York, they hired Jed Hotchkiss, a St. Louis landscape architect, to lay "the prospective town with winding streets that have ever since been a source of pride to the inhabitants, and a bewildering maze to the newly arrived." In 1861, the State Legislature approved the incorporation of the City of Lake Forest. The city was platted in a scenic area, where the moraines are truncated by the lake shore, forming scenic bluffs, with narrow, steep ravines dissecting the uplands.
(Courtesy Chicago Historical Society.)

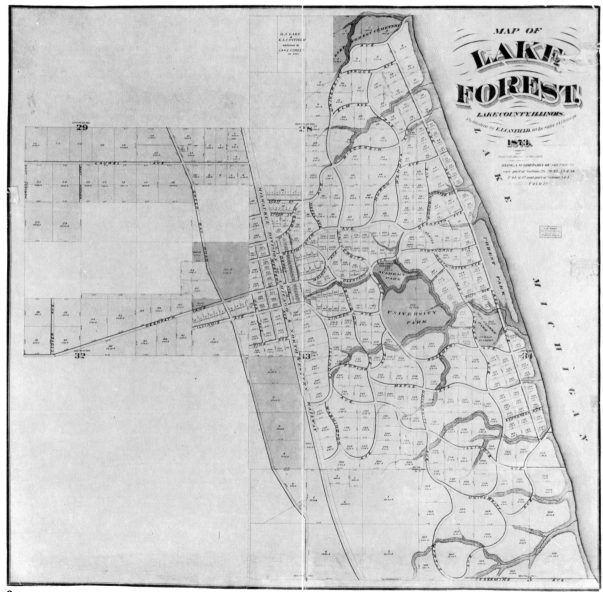

Lake Forest

1. Eastward from College Hall on Lake Forest College Campus, about 1905

" 'Beautiful for situation on the sides of the North,' was the comprehensive language of the prophet in describing the position of his beloved and holy city," the *Lake Forest Reporter* editorialized on August 1, 1872. "Our readers must pardon us if we find ourselves uttering these words, 'beautiful for situation,' as we walk around about our city of Lake Forest." The Lake Forest College (Old North) gymnasium, erected in 1890, is in the foreground. In the center background is the John V. Farwell residence, and to the right on the Lake is Ferry Hall.
(Courtesy Lake Forest College Library.)

1

2. Lois Durand Hall, Lake Forest College, 1899

"This building was constructed in 1898 in honor of the mother of Mr. Henry Clay Durand. With Gothic features and Renaissance architectural details it has been described as 'a quaint irregularity.' "
(Courtesy Lake Forest College Library.)

3. Chicago and North Western Railway Station, Lake Forest, about 1905
(Courtesy Lake Forest College Library.)

4. Lake Forest Market Square, Southwest, about 1930

About the time this photograph was taken, Arthur Meeker wrote: "Lake Forest has become so amazingly 'the thing' that it is almost impossible nowadays to find standing room for your household gods. Nine-tenths of the population are composed of two classes—(1) young marrieds living in 'made over' village houses (this class is so numerous that one wonders where the villagers themselves have vanished), and (2) slightly older married living in whitewash-and-timber Norman villas boldly set on a bit of quaint Illinois prairie." Actually what Meeker was observing was Lake Forest's greatest decade of growth: the suburban town's population nearly doubled between 1920 and 1930.
(Courtesy Chicago Historical Society.)

5. Lake Forest Market Square, Looking Northwesterly, about 1930

A Lake Forest resident, Howard Van Doren Shaw, was the architect of this pioneer shopping and business center. Planned and executed with an eye to beauty and usefulness, it was the first "integrated and artfully designed shopping center" in this country. It comprised twenty-five stores, twelve offices, and twenty-eight apartments, occupying a lot with a depth of 400 feet by 260 and a 260-foot frontage on Western Avenue.
(Courtesy Lake Forest College Library.)

4

5

Lake Forest

The excitement of a summer tennis tournament is captured in this photo taken on July 5, 1897, a year after it had been organized by the author Hobart Chatfield-Taylor, who was a Lake Forest resident. "Many communities have their country clubs," a 1916 publication noted, "but

1

2

3

none fit more fully and delightfully into the spirit of the community it graces, than does Onwentsia Club into the daily life of the city of Lake Forest." One of the members of this tennis foursome is the young Joseph Ryerson, a well-known Chicago philanthropist and business man. (Courtesy Chicago Historical Society.)

2. The Lawrence Armour Residence, Lake Forest

The tradition of large suburban homes still remains strong in Lake Forest, just as the connection between well-known Chicago business names and Lake Forest residents continues unabated.
(Photograph, James D. McMahon. Courtesy Chicago Historical Society.)

3. Lasker Estate, Lake Forest, 1932
(Courtesy Chicago Historical Society.)

4. Lake Forest Horse Show, 1935
(Courtesy Chicago Historical Society.)

4

Along the Illinois Central south of the municipal line, Hyde Park grew up as another suburb, although later it would be annexed to Chicago. Containing more than 3,000 residents, served by a dozen trains daily, and at the head of fashionable boulevards, it was, with Evanston, the best known of Chicago's offspring. In 1874 a contemporary reporter described it as having "a first class hotel, beautiful residences, fine drives, delightful lake privileges, and first class society." Yet from the very start Hyde Park prided itself on its mixed population. While the same observer admitted that many houses cost $20,000 to $50,000, he also noted a "large number of pretty, modest residences" which established the "important fact that the society of this charming suburb is not exclusive." Just north of Hyde Park lay Kenwood, often called the "Lake Forest of the south," a village of mansions, rolling lawns, and quiet elegance.

Washington Heights on the southwest was also destined for incorporation into the city, but in the 1860's it was the scene of one of the most energetic and elaborate suburban developments in the metropolitan area. The Blue Island Land and Building Company had selected the site because it occupied a ridge from forty to 100 feet above the surrounding area. It also lay along the route of the Chicago, Rock Island and Pacific Railroad. The proprietors cut up the land into lots, put in six-foot sewers, planted shade trees and even built a branch line of the railroad to bring the tracks closer to the residences. Moreover, to attract "people of modest means" they built houses and sold them on time payments. The hucksters at auction sales of lots described the limitless possibilities of the area in such terms that it led an early commuter to "suppose that P. T. Barnum had spread his canvas on the prairie." In short, the company anticipated nearly every technique of the modern suburban developer. By 1873 the area around the depot was "thickly settled," and subdividers were busy laying out the surrounding areas that would later be known as Morgan Park and Beverly.

Just south of Washington Heights lay Blue Island. Laid out as an independent village in the 1830's, in its early years it was only marginally connected with Chicago. The coming of the Rock Island railroad, however, soon brought it into the orbit of the booming city sixteen miles to the northeast. By 1869, *Out of Town*, a suburban directory, listed it among the other residential satellites beyond the municipal limits and noted that many of its leading citizens had "special interests" in the city. Unlike its northern neighbors, Blue Island was never annexed and remains one of Chicago's oldest incorporated suburbs.

The dazzling transformation of open land into suburban subdivisions also characterized the area west of the city. Thirty minutes away on the Chicago, Burlington & Quincy was Hinsdale, with some of its hills rising "as high as seventy feet above Lake Michigan" and already earmarked for the well-to-do. Similarly Oak Park and River Forest, lying on the Galena division of the Chicago and North Western, had modest beginnings before the Chicago Fire. Closer to Chicago, places like Austin and Maywood grew rapidly. Thus by 1871 the suburban process, and especially the movement of wealthy and successful Chicagoans to the pleasant, spacious towns beyond the city limits, was well under way.

Blue Island

Plat of Blue Island

Peter Barton arrived in the Blue Island area in 1837. Calling it Portland, he "indulged in hopes of building up a city, . . . but like many other enterprises, his was destined to failure." Barton built a frame store, chartered a ship to supply him; and with another early resident, he laid out what is now known as Vincennes Avenue to Chicago. Barton waited in vain for the city to prosper as a trading center. His vision was thwarted by the improvements in land transportation in the 50's, especially the railroads; thereafter farmers found it easier and more profitable to go the few extra miles to Chicago than to trade in Blue Island.
(From a map published in 1861. Courtesy Chicago Historical Society.)

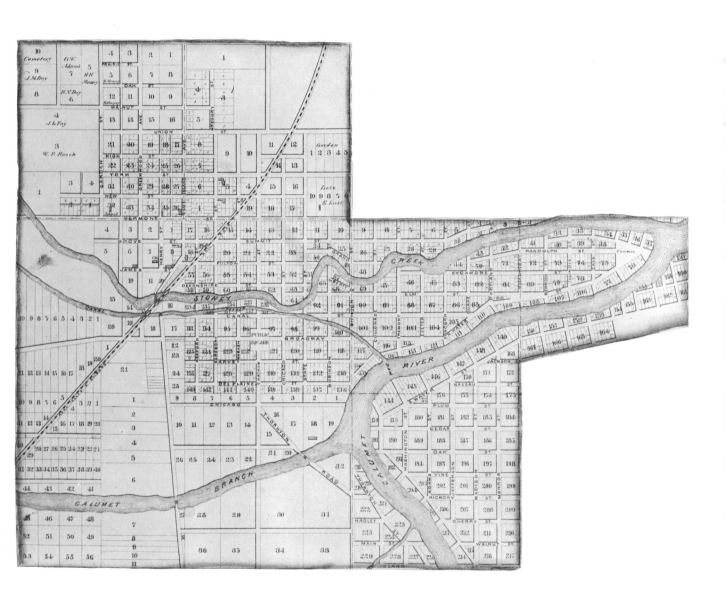

Blue Island

1. Blue Island, in the 1860's

While Blue Island got its own post office (called Worth) in 1838, it remained the City of Portland until it organized as a village in 1872. Looking southeast from the southern end of Blue Island Ridge, at Western Avenue south from Vermont Street, the scene, except for the distinctive ridge, might be in any frontier town of the 1860's. A shoe shop, saloon, and grocery, harness shop, restaurant, wagon shop, and paint store were some of the early market functions provided by Blue Island. (Courtesy John H. Volp Collection.)

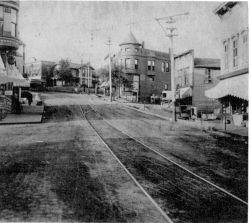

1

2

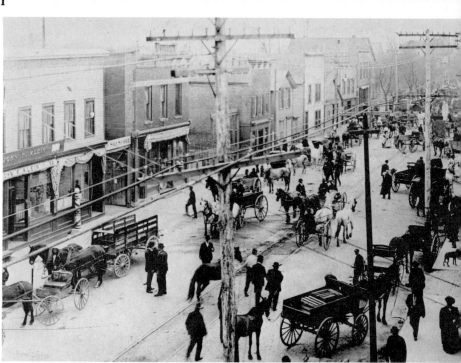

3

2. Blue Island Hill, about 1905

The camera looks north on what is now Western Avenue. The slope of the hill was so steep that early streetcars had to loop around it. The streetcar, of course, was the visible symbol of the pull of Chicago; but Blue Island remained in 1905 much the same as a contemporary described it in 1884, "a quiet, though one among the prettiest little suburban towns in the West." (Courtesy John H. Volp Collection.)

3. Market Day in Blue Island, Western Avenue, North of Broadway, 1908–9

The first Thursday in every month was Market Day until 1924 when the City Council finally closed it as a nuisance. By that time what had begun as a featured attraction for local farmers had become infested with peddlers, shills, and other undesirables. (Courtesy John H. Volp Collection.)

4. Vermont Street East of State Street

While difficulties of travel still hindered suburban growth after the turn of the century, urban services—such as regular milk delivery, fire protection, and the telephone—were increasingly available farther from the central city. Builders responded and developed subdivisions filled with small frame cottages on narrow lots to meet the demands of the suburban exodus. (Courtesy John H. Volp Collection.)

4

5

5. Little Calumet River, Blue Island

Although it was low and swampy, the Little Calumet provided an early recreational facility. (Courtesy Chicago Historical Society.)

6. Division Street in Blue Island, in the 1920's

In some outlying sections city services came slowly. Difficult travel conditions, spotty land use, and poor drainage were part of the price of living in this portion of Blue Island around 1920. (Courtesy Chicago Historical Society.)

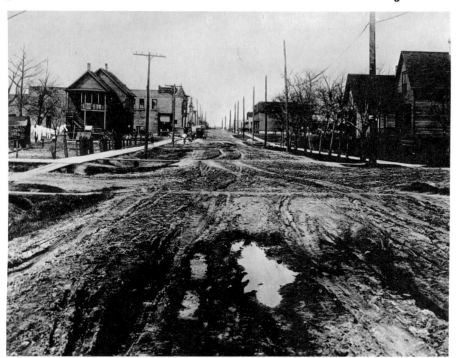

1. Raising the Grade, North Side of Lake Street between Clark and LaSalle, 1857

"The sidewalks of Chicago are . . . remarkable," a traveler wrote in 1856. "With almost every block of buildings there is a change of grade, sometimes of one foot, sometimes of three feet, sometimes of five. These assents [sic] or descents are made by steps, or by short, steep, inclined planes of boards, with or without cleats or cross-pieces, to prevent slipping, according to the fancy of the adjoining proprietor who erects them. The profile of a Chicago sidewalk would resemble the profile of the Erie Canal where the locks are most plenty. It is one continual succession of ups and downs."
(Lithograph, Edward Mendel, about 1860. Courtesy Chicago Historical Society.)

While developers were busy at the edges of the metropolitan area, city officials launched a series of improvements that literally transformed the downtown area. At the same time they made provision for fresh water supplies and new parks that would meet the needs of the next generation. Previously Chicago had grown so rapidly that public policy could never keep up with the census taker. Even while the city council considered a particular issue, the situation might change so quickly that yesterday's discussion would be out of date the next day. Three questions, however, persisted and demanded radical action: improving the streets, supplying the city with water, and reserving land for park and recreational use. It was a measure of the statesmanship of early Chicagoans that these problems were met with bold, imaginative programs.

The streets created the most obvious and pressing civic question. Built only slightly above water level and usually unpaved, they became quagmires most of the year. Drainage systems failed and plumbing proved inadequate. The alternatives seemed grim: either put up perpetually with the inconveniences or pull down the city, raise its grade level, and rebuild. Yet another possibility remained—contrive a way to hoist up the city itself. As outlandish as it seemed to some, Chicago chose the most difficult policy. In 1855 and 1856 the council simply declared that the grade be elevated. For two decades Chicago under-

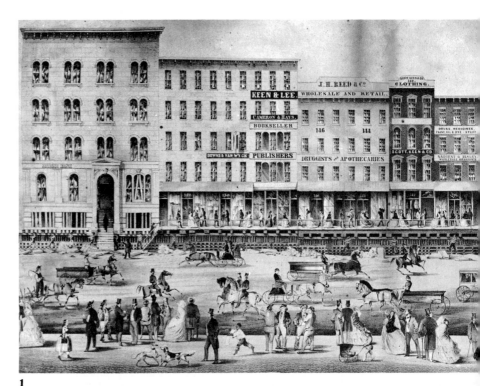

1

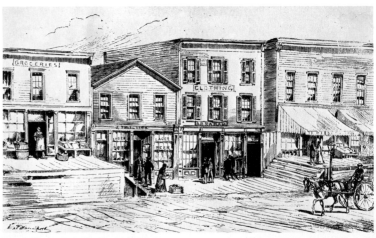

2

2. Clark Street 1857

Often some merchants were reticent about raising their buildings to the new grade; the results made walking something of a steeplechase.
(From A. T. Andreas' *History of Chicago*, 1884. Courtesy Chicago Historical Society.)

3. Raising the Briggs House, Northeast Corner of Randolph and Wells Streets, 1857
(Courtesy Chicago Historical Society.)

4. The Wigwam, Corner of Lake and Market Streets

To attract the Republican Convention of 1860, the city's business leaders underwrote the cost of this frame structure. Built in only five weeks, it provided the setting for the nomination to the presidency of Illinois' most famous son.
(Photograph, probably Alexander Hesler. Courtesy Chicago Historical Society.)

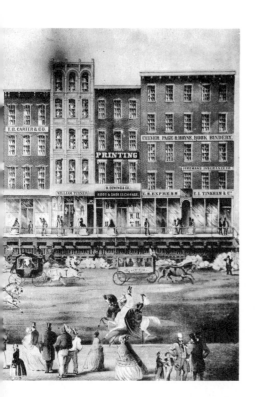

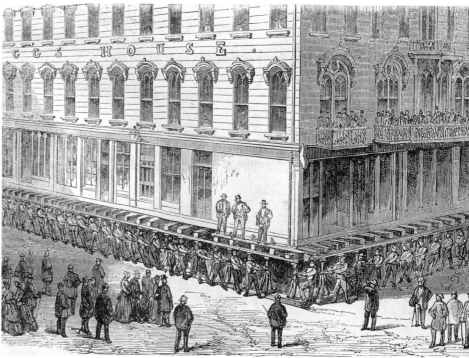

3

4

1. Moving a Building in Chicago

"From the rapid growth of the city some of the edifices are rendered unsuitable for what they were originally intended; this is what has given rise to the extraordinary practice of house moving, for which this city is so famous," wrote two Scottish brothers after visiting Chicago in 1869. "No sooner is a better house wanted in any given location than the old erection is put upon wheels or rollers and drawn off to a more suburban site."
(From L. Simonin, *Le Monde Americain,* Paris, 1877.)

2. Installing Nicholson Pavement, 1859

The first Nicholson pavement was laid in Chicago in 1857. Boulder stone, cobblestones, block limestone, macadam, and cinders were also tried, in a persistent attempt to overcome Chicago's muddy streets.
(From *Ballou's Pictorial Drawing Room Companion,* October 15, 1859. Courtesy Chicago Historical Society.)

went an extraordinary transformation; streets were raised, buildings were jacked up, and new drainage and paving were installed.

The raising of Chicago soon became one of the great wonders of the nation. David McCrae, a British traveler, was astonished: "Great blocks of masonry . . . have been lifted from four to fourteen feet," he wrote in 1867. "The Briggs House, a gigantic hotel, five storeys high, solid masonry, weighing 22,000 tons, was raised four and a half feet, and new foundations built below. The people were in it all the time, coming and going, eating and sleeping—the whole business of the hotel proceeding without interruption." A friend stayed at the Tremont House during its lifting and only realized something was happening because front stairs got progressively steeper each day. Sometimes whole blocks were not only elevated but moved back to permit the widening of the street.

Most bizarre of all, many houses were simply moved to a new location and replaced by new stone-faced buildings. "Never a day passed," McCrae recalled, "that I did not meet one or more houses shifting their quarters. One day I met nine. Going out Great Madison Street in the horse-cars we had to stop twice to let houses get across." Usually the people sat casually at the window as their dwelling migrated to a new neighborhood. McCrae was especially amused by seeing a shop amble by and "as it moved along the shopkeeper stood leaning

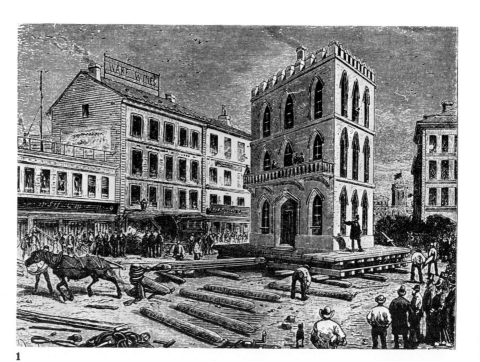

1

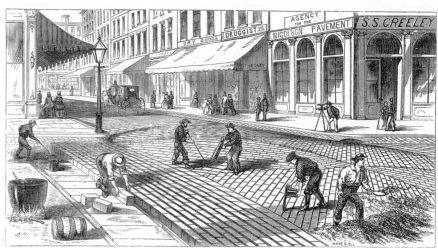

2

3. Chicago's First Publicly Owned Water Works, Lake Michigan at the Foot of Chicago Avenue, 1857

Built of brick in what was called the "modern Italian Style," this plant provided water for the North Side. Erected in 1853–54, the pumping station was beset by nearly constant difficulties, but still managed to supply over 7,000 buildings with water by 1857.
(From *Chicago Magazine*, March, 1857.)

4. Workmen Constructing the Upper Arch of the Water Tunnel, 1866.

The tunnel was large enough for two mules to work abreast in it. Sixty feet below the lake surface and lined with two courses of brick, it stretched two miles into the lake to a "crib," or water intake. By 1880 a second tunnel was installed, leading to the West Side Pumping Works at Blue Island and Ashland Avenues. Six miles in length, this second tunnel passed "under and across the entire city in a Southwesterly direction," and was believed by contemporaries to be "one of the grandest triumphs of modern engineering."
(From *Frank Leslie's Illustrated Newspaper*, November 3, 1866. Courtesy Chicago Historical Society.)

3

4

5. The Original Two-Mile Crib, off Chicago Avenue, Completed in 1867

"The 'Crib', an immense octagonal box of about fifty feet diameter and seventy feet long, . . . having been built on shore, and made water tight, was . . . floated out two miles off into the lake, and sunk in a depth of water of about forty feet. Stone masonry was then built inside so as to sink it some nineteen feet deeper into the mud at the bottom of the lake. An iron tube of ten feet in diameter was fitted inside the masonry with proper openings to admit the water. This tube was joined to the shore by a brick tunnel six feet under the bed of the lake, and is a work of no ordinary engineering difficulty." In fact, the tunnel was, in Mayor J. B. Rice's words, "the wonder of America and the world."
(From *Frank Leslie's Illustrated Newspaper*, November 3, 1866. Courtesy Chicago Historical Society.)

5

1. Dedication of the Water Tower and Laying of the Cornerstone, March 25, 1867

This new tower was about one half block west of the old tower and eventually was completed to a height of 130 feet. Workers' houses in the background suggest the early character of the North Side.
(From a stereograph.
Courtesy Chicago Historical Socity.)

2. Ellis S. Chesbrough (1813–86)

Forced to go to work to help support his family as a small boy, Chesbrough received only fragmentary and brief education until 1828, when he began working with his engineer father on the construction of the Baltimore and Ohio Railroad. There he received training from the Army Engineers. Before coming to Chicago, he supervised engineering, location construction of the buildings and aqueducts of the Cochituate aqueduct in Boston. In 1855 Chesbrough received appointment as Chief Engineer of

against the door-post smoking a cigar." Not all owners cooperated, and for some time the wooden sidewalks bobbed up and down to accommodate the uneven heights of various buildings.

The Chicago solution to its paving problem was unique without being so daring. In place of plank or stone, city engineers developed a system employing pine blocks dipped in tar and laid like bricks. Pitch was then poured over the surface and gravel topping added. Called by a visitor "the *ne plus ultra* of comfort for horse and rider, for passer-by and ladies living near," this Nicholson pavement soon became standard on the principal thoroughfares and was widely adopted by other cities.

The water question posed no less of a problem. Although Chicago had a limitless supply of fresh water at its front door, the early system of distribution not only was inadequate in volume, but as one resident put it delicately, the water often came to the glass with "piscatorial offerings of a very diminutive character." Moreover, when the wind came from the west, it drove the "fetid accumulations from slaughter houses, tanneries, distilleries and glue factories" into the intakes. The city's response was to reach out two miles into the lake with a five-foot tunnel and tap the water just above the bottom. When completed in 1867 the water system was the pride of the townspeople, and the new water tower became a special symbol of Chicago's civic energy and ingenuity.

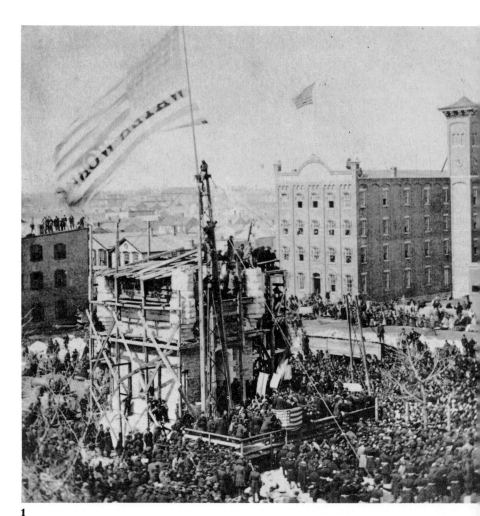

1

the Board of Sewerage Commissioners of Chicago.
(Photograph, J. Carbutt, *Leading Men of Chicago*, 1869.)

3. William W. Boyington (1818–98)

Boyington began his career as a carpenter, but by studious work rose to the position of contractor and architect. He came to Chicago in 1853, and between then and the Fire of 1871 was credited with erecting buildings valued at nearly twenty millions of dollars. In addition to the building and tower of the water works, Boyington built six of the city's most influential churches, the Sherman House, the first University of Chicago, the depot of the Chicago, Rock Island and Pacific and the Michigan Southern and Northern Indiana railroad companies, and Crosby's Opera House, as well as many business buildings, warehouses, and several of the more palatial homes of the city.
(Photograph, J. Carbutt, *Leading Men of Chicago*, 1869.)

4. The Nearly Completed Water Works, Late in 1869

When City Engineer Ellis F. Chesbrough conceived the new water tower and tunnel with their complex mechanisms, conservatives ridiculed it as a "visionary scheme," an "expensive experiment," and an "unprecedented bore." But by 1869, the project was nearly completed. W. W. Boyington was the architect of the building which one historian has called "castellated Gothic" in its design.
(From a stereograph. Courtesy Chicago Historical Society.)

2

3

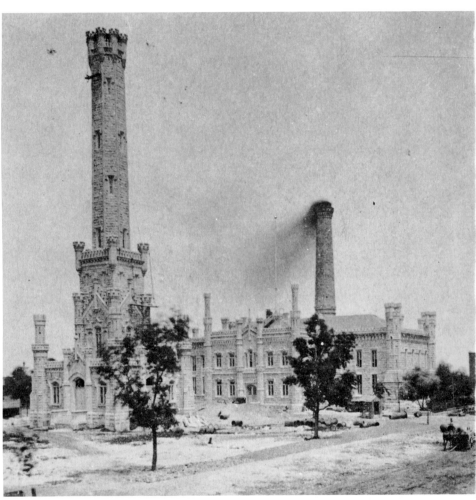

4

1. Lincoln Park Lagoon, Known as Swan Lake, 1870–71

"Lincoln Park, on the north side, is perhaps the most striking and apparently magical of all the enterprises and improvements of the city," wrote Sara Jane Lippincott. "It is already very beautiful, with a variety of surface and ornamentation most wonderful, when we remember that scarcely five years ago the spot was a dreary waste of drifting sand and unsightly weeds. . . . The present entrance to Lincoln Park is a little depressing, being through a cemetery, for those old settlers are fast being unsettled and re-established elsewhere. Even the dead must 'move on' in Chicago."
(From a stereograph, Copelin and Melander. Courtesy Chicago Historical Society.)

Building a park system for Chicago required persuasion rather than pioneering. The spread of the city was so rapid and so extensive that all open space within miles seemed destined for development. No provision had been made for any substantial amount of park land and less still was reserved for other recreational purposes. In the late 1860's a movement arose to create a ring of parks around the city. Anchored at the north by Lincoln Park and at the south by the South Parks (Jackson and Washington), a green belt of boulevards and parks was to encircle the built-up area. Despite opposition and set backs, the land was acquired and improvement begun before the Fire.

Like so much else in the growth of Chicago, transportation governed the location and use of the parks. It would have made little sense to have large preserves without any means for the public to get to them. With the exception of Lincoln Park, which depended on horse cars, all the other parks were laid out near routes used by commuter trains of the major railroads. The commissioners observed, for example, that "an important reason" for the location of the

1

2

2. South Park, 1870–71

The thousand acres of the South Park system later became Jackson and Washington parks. Taken soon after completion, this photo shows how Olmsted's plans called for grading and leveling, with shrubbery being placed in a planned landscape.
(From a stereograph. Courtesy Chicago Historical Society.)

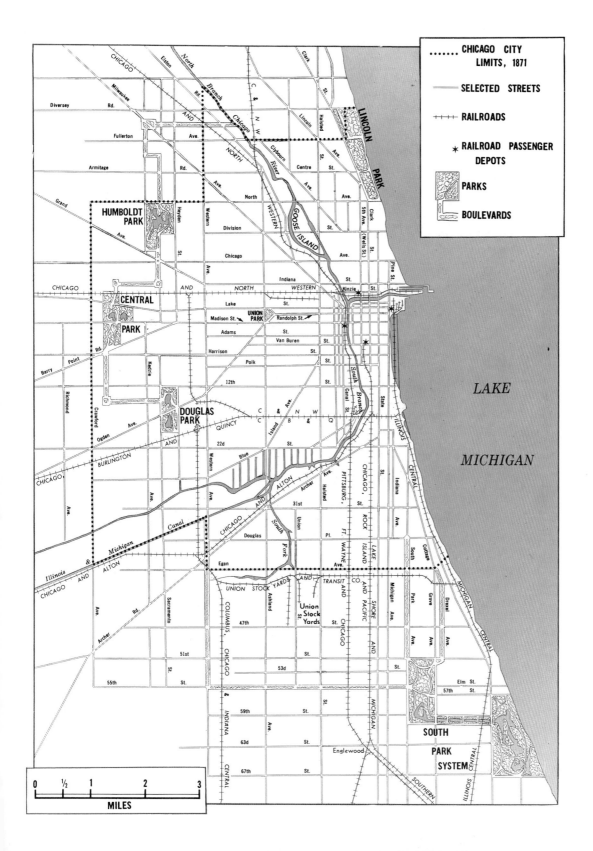

Parks and Railroads in 1871

CHICAGO CITY LIMITS, 1871

SELECTED STREETS

RAILROADS

★ RAILROAD PASSENGER DEPOTS

PARKS

BOULEVARDS

LAKE MICHIGAN

LINCOLN PARK

HUMBOLDT PARK

CENTRAL PARK

DOUGLAS PARK

UNION PARK

GOOSE ISLAND

UNION STOCK YARDS

Union Stock Yards

SOUTH PARK SYSTEM

Englewood

Diversey Rd.

Milwaukee Rd.

Fullerton Ave.

Armitage Rd.

Grand

Chicago

Elston

North Branch

Clark St.

C & N W

Lincoln Ave.

Halsted St.

5th Ave. (Wells St.)

Pine St.

Clark St.

Kinzie St.

Lake St.

Madison St.

Randolph St.

Adams St.

Van Buren St.

Harrison

Polk St.

12th St.

Fullerton

North Ave.

Division

Chicago Ave.

Indiana St.

NORTH WESTERN

Hayden

Western

Kedzie

Crawford

Point Rd.

Barry

Richmond

Ogden Ave.

CHICAGO AND NORTH WESTERN

NORTH

Chicago River

Clybourn Ave.

Centre Ave.

Western Ave.

Clark St.

Illinois

State St.

South Branch

Canal St.

South Branch

QUINCY

22d St.

Blue Island Ave.

Archer Ave.

Halsted St.

31st

Douglas

Egan Ave.

C B & Q

C & N W

CHICAGO BURLINGTON

CHICAGO AND ALTON

Illinois & Michigan Canal

CHICAGO AND ALTON

Michigan Canal

South Fork

Union Pl.

PITTSBURG,

FT. WAYNE AND CHICAGO

CHICAGO, ROCK ISLAND

LAKE SHORE AND

TRANSIT CO. AND

MICHIGAN CENTRAL

Illinois

Indiana Ave.

South

Cottage

Park Ave.

Grove Ave.

Drexel Ave.

Michigan Ave.

ILLINOIS CENTRAL

MICHIGAN CENTRAL

Archer Ave.

Sacramento

Columbus, Chicago

Ashland

Union Stock Yards St.

Michigan Ave.

47th St.

51st St.

53d St.

55th St.

57th St.

59th St.

63d St.

67th St.

Elm St.

Indiana Ave.

INDIANA

MICHIGAN CENTRAL

ILLINOIS CENTRAL

SOUTHERN

0 ½ 1 2 3

MILES

102

The First University of Chicago
Standing on land donated by Stephen A. Douglas, near what is now the Douglas Tomb at 35th Street and the Illinois Central Railroad, the University opened in 1859. In June, 1886, wracked by internal dissention, financial difficulties, and partial destruction of the building by fire, it closed.
(From a stereograph, Copelin and Melander, 1870–71. Courtesy Chicago Historical Society.)

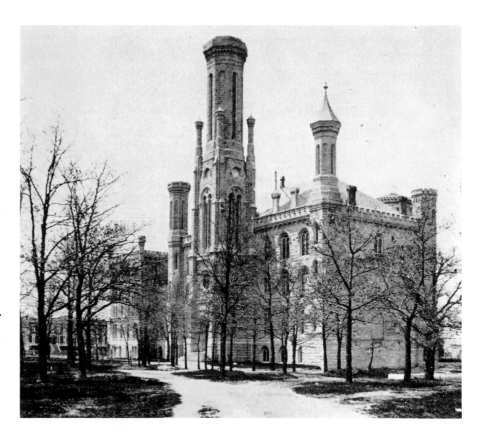

South Park complex was "found in the fact that there are five independent lines of railroad that pass within a very short distance of its limits, or through it, and that on any of these roads the park can be reached within from twenty to thirty minutes." In short, the parks were designed from the very beginning for all the people of Chicago.

Civic leaders with the largest view believed that parks were cultural as well as recreational spots. As one of them observed, "The Parks first, and museums and libraries will follow." By 1871 many of the important cultural landmarks had already appeared. The Chicago Historical Society was fifteen years old and boasted a library of more than 15,000 volumes; the old University of Chicago, located at the outskirts of town near the Douglas properties, enjoyed a growing reputation; and the Chicago Library Association had laid the foundations for a public library. Moreover, the city had established a public school system which the historian Parton pronounced in 1867 "among the very best in the United States." The buildings, he added, were "large, handsome, and convenient"; furthermore, "colored children attend . . . and no one objects, or sees anything extraordinary in the fact."

"See two things in the United States, if nothing else," Richard Cobden advised a friend making his first trip to America, "—Niagara and Chicago." The

Prefire Panorama

A decade after Alexander Hesler had made his "visual census" of Chicago, the top of the City Hall and Court House was still the best place from which to examine central Chicago. An excited contemporary observed that "in the central parts of the city, where all the buildings are good and massive, and the smoke—for here they burn bituminous coal—has put a complexion upon them something like that of London, you could never guess that you were standing in a city so young, that many of its inhabitants, still young themselves, remember the erection of the first brick house in the place; you would be more likely to suppose that you were surrounded by the evidences and appliances of the commercial prosperity of many generations."

1

2

Prefire Panorama

3. East-Northeast from the Dome of the City Hall, about 1868–69.
(From a stereograph, J. Carbutt.
Courtesy Chicago Historical Society.)

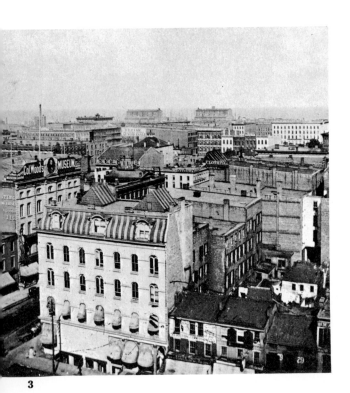

3

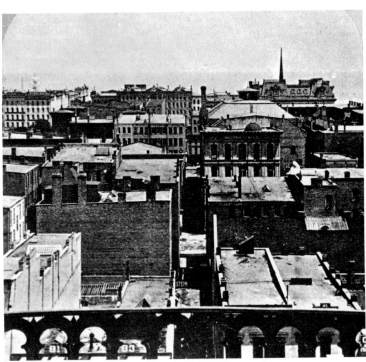

4

4. East from the Dome of the City Hall, about 1870–71
(From a stereograph, Copelin and Hine. Courtesy Chicago Historical Society.)

5. Southeast from the Dome of the City Hall, Late 1860's
(From a stereograph, J. Carbutt. Courtesy Chicago Historical Society.)

6. West from the Dome of the City Hall, Probably 1870–71
(From a stereograph, Copelin and Melander. Courtesy Chicago Historical Society.)

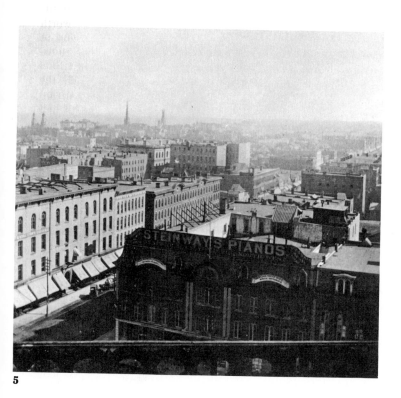

5

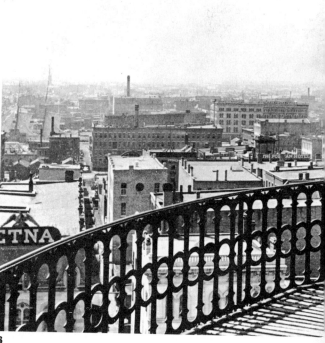

6

two had come to symbolize wonders of the New World—one the lavish hand of nature upon the continent, the other man's capacity to create. But it had taken many centuries to fashion Niagara; Chicago was built in a man's lifetime. In less than four decades the concentrated energies of the West had placed a metropolis of over 300,000 on what had been soggy marshland. By 1871, it had become the rail, livestock, grain, and lumber center of the world, and a burst of civic energy had greatly improved the physical conditions and quality of city life. Yet, far from resting on their accomplishments, Chicagoans looked forward to new triumphs. Would not the center of national life itself shift to the mid-continent and would not Chicago be its logical seat? Yet these days of grand dreams suddenly turned to ashes. In 1871 a fire swept across the heart of the city, destroying its whole commercial district, gutting most of its fine neighborhoods, and leaving a third of its people homeless.

The fire broke out just a few minutes past nine on Sunday evening, October 8, in a little barn behind Patrick O'Leary's shingled cottage on De Koven Street. How it started is still not certain. Popular legend has it that Mrs. O'Leary's cow kicked a lantern into the hay. But one thing is clear—once under way the fire spread quickly. The summer had been unusually dry; a southwest wind skipped off the prairie to the lake; and the O'Leary neighborhood was covered with wooden buildings and frame dwellings. Into this kindling box, as one contemporary described it, Lucifer had thrown his match. The fire department, exhausted from a large and costly fire that had wiped out four square blocks the day before, could not get equipment to the scene fast enough. Within minutes the blaze was out of control.

The flames ate their way across the West Side, consuming a thousand shanties, houses, and planing mills. At Van Buren Street the fire vaulted the South Branch of the river. The gasworks at Adams Street went; then three blocks of pine rookeries called Conley's Patch; the "fireproof" mercantile buildings along LaSalle Street followed. The city now lay at the mercy of the fire's caprice. By one o'clock in the morning the Chamber of Commerce had fallen. Two hours later the Court House went down, its great bell pealing until the end. Soon the whole commercial center was wreathed in red and orange. The *Tribune* building, thought to be uniquely fire-resistant, was abandoned in the morning; two and a half million dollars' worth of stock and the marble magnifience of the Field, Leiter store lay in ruins.

Having sacked the Near West Side and leveled the business district, the fire headed north across the main stream of the river. As if by instinct it hit first at the engine house of the waterworks, knocking out the water supply, and then proceeded to devour the frame buildings along the river. Almost nothing was overlooked. Wooden houses, commercial and industrial buildings, private mansions, and even markers in the cemetery were consumed before the lake confined the blaze. "As a spectacle," an eyewitness recalled, "it was beyond doubt the grandest as well as most appalling ever offered to mortal eyes. From any elevated standpoint, the appearance was that of a vast ocean of flames, sweeping in mile long billows and breakers over the doomed city. A square of substantial buildings would be submerged by it like a child's tiny heap of sand on the beach of a lake, and when the flood receded, there was no more left of the stately block than of the tiny sandheap." After almost three days, the fire slowly died, leaving behind rubble and ashes where there had once been life and expectation.

Fire Panorama

The Chicago Fire of 1871 was one of the most spectacular events of the nineteenth century. In loss of life and property it became a convenient yardstick by which to measure other disasters. Chicagoans subsequently dated much of their own history with the simple phrases "after the Fire" or "before the Fire." Curiously, however, no photographs of the conflagration have survived; indeed we do not know if any were ever taken. The early photographer's equipment was difficult to manage in the extreme heat and brightness of the fire. More grisly still, it is possible that many pictures were taken only to be themselves consumed in the spreading flames. At any rate, in the days following the holocaust the camera caught the magnitude of the catastrophe in ways which no words can match.

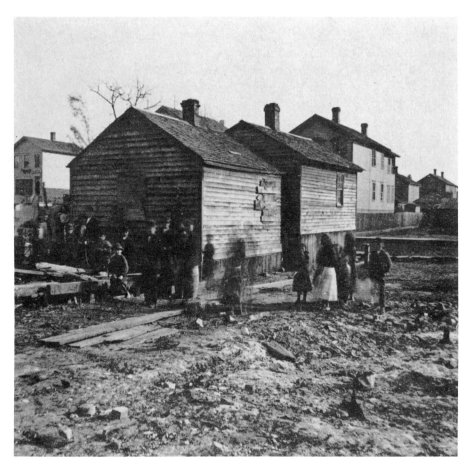

2. Mrs. O'Leary's Cow Kicks Over the Lamp to Start the Chicago Fire

O. W. Mull's cartoon conveys the demonic overtones many contemporaries saw in the origin of the Chicago fire. Another observer, investigating Conley's Patch, captured the tragic irony of the O'Leary Cottage's survival. He found it "a warped and weather-beaten shanty of two rooms, perched on thin piles, with tin plates nailed half way down them like dirty pantalets. There was no shabbier hut in Chicago nor in Tipperary. But it stood there safe, while a city had perished before it and around it. It was preserved by its own destructive significance. It was made sacred by a curse that rested on it—a curse more deadly than that which darkened the lintels of the house of Thyestes. For out of that house, last Sunday night, came a woman with a lamp to the barn behind the house, to milk the cow with the crumpled temper, that kicked the lamp, that spilled the kerosene, that fired the straw, that burned Chicago. And there to this hour stands that craven little house, holding on tightly to its miserable existence."
(From a stereoptican slide. Courtesy Chicago Historical Society.)

1. Rear View of the O'Leary Cottage, Following the Fire of 1871

"I found De Koven street at last," a newspaper reporter observed, a few days after the fire, "a mean little street of shabby wooden houses, with dirty door-yards and unpainted fences falling to decay. It had no look of Chicago about it. Take it up bodily and drop it out on the prairie, and its name might be Lickskillet Station as well as anything else. The street was unpaved and littered with old boxes and mildewed papers, and a dozen absurd geese wandered about with rustic familiarity. . . . On the south side of the street not a house was touched. On the north only one remained. All the rest were simply ashes. There were no piles of ruin here. The wooden hovels left no landmarks except here and there a stunted chimney too squat to fall."
(From a stereograph, Shaw Photographers. Courtesy Chicago Historical Society.)

Fire Panorama

1. The Area Destroyed by the Great Fire, October 9, 1871

The sober, almost prosaic, words of the 11th Annual Report of the Board of Public Works recorded simply the unprecedented damage of the conflagration: "The most notable event which occurred in the past year, or which has occurred in any year in the history of Chicago was the destruction of a large portion of the city by fire. . . . The loss of property was greater than has ever occurred before, from the same cause, in the history of the world, amounting . . .

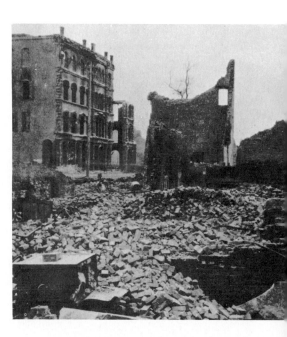

2. Corner of State and Madison Streets

Advertising was certainly not killed by the fire. At the left, "Hall's Safe and Locks" notifies all passers-by that the contents of their safes are "O.K." no matter how great the holocaust.
(Lillian M. Campbell Memorial Collection. Courtesy West Side Historical Society, Legler Branch Library.)

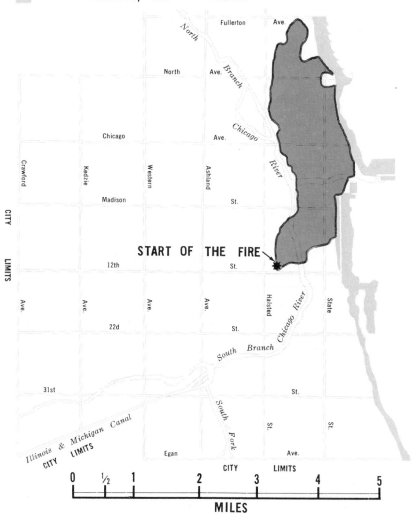

⬤ AREA DESTROYED BY THE GREAT FIRE OF 1871

▨ LAND ACCRETIONS, 1871 TO PRESENT

START OF THE FIRE

MILES

0 ½ 1 2 3 4 5

1

to two hundred millions of dollars. . . .
The fire was speedily under full headway,
and, aided by a furious south-west wind . . .
spread in a northerly and easterly direction
with wonderful rapidity, over a territory
about four miles in length by an average of
two-thirds of a mile in breadth, and
comprising about 1,688 acres. . . . It burnt
over on the average, sixty-five acres per
hour, and the average destruction of
property for the same time was about
seven and a half million of dollars, or
about $125,000 per minute."

**3. View from the Southwest Corner
of Dearborn and Monroe Street:
In the Foreground is the Honoré
Block, and the Grand Pacific Hotel
is in the Distance**

A contemporary observer, after viewing
the devastation wrote that "toward the
west (from State Street) arose the white
marble walls of the Postoffice; only its
blind, glassless windows and its roofless
upper story showing that it was a mere
empty shell. A fine tall arch of pointed
gothic was remarkable as it stood like a

gateway; vacancy behind it, It was the
remains of the entrance to the Honoré
Building on Dearborn Street."
(From a stereograph, Jex Bardwell of Detroit.
Courtesy Chicago Historical Society.)

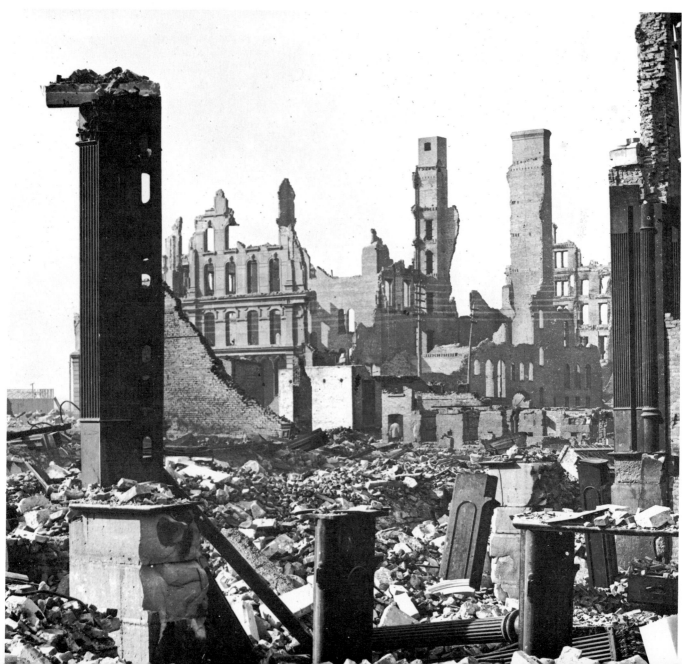

3

Fire Panorama

"The walls of the Customs House are still standing; the Court House wings refuse to fall. The fire-proof *Tribune* disdains surrender, though only a phantom house. A few heavily buttressed church towers wait also for the hammer of demolition. But with these exceptions the central region of Chicago has ceased to exist."
(From a stereoptican slide. Courtesy Chicago Historical Society.)

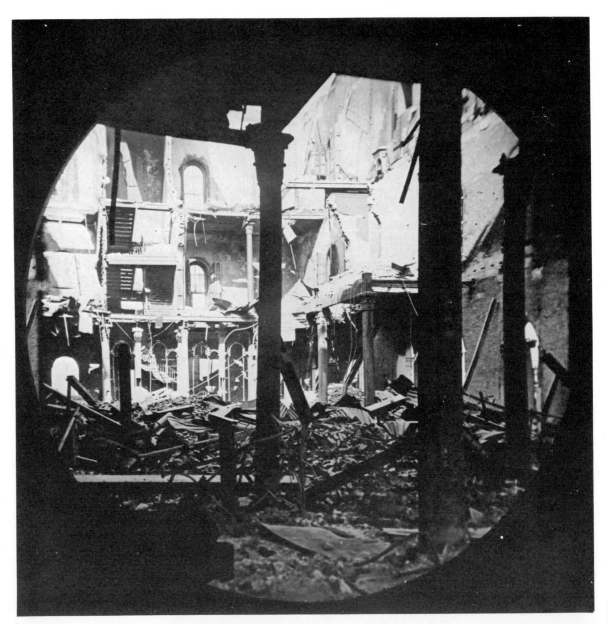

1

2. Remains of the Tremont House

A New Yorker, Alexander Frear, caught in Chicago when the city was in flames later reported one incident of the fire. "I ran on down toward the Tremont. . . . The elevator had got jammed, and the screams of the women on the upper floors were heart rending. I forced my way upstairs, seeing no fire, and looked into all the open rooms, calling aloud the names of Mrs. Frear's daughters. Women were swarming in the parlors; invalids, brought there for safety, were lying upon the floor. Others were running distracted about, calling upon their husbands. Men, pale and awe-struck and silent, looked on without any means of averting the mischief. All this time the upper part of the house was on fire. The street was choked with people, yelling and moaning with excitement and fright. I looked down upon them from an upper window a moment, and saw far up Dearborn street the huge flames pouring in from the sidestreets I had traversed but an hour ago, and it appeared to me that they were impelled with the force of a tremendous blow-pipe. Everything that they touched melted."

(From a stereoptican slide. Courtesy Chicago Historical Society.)

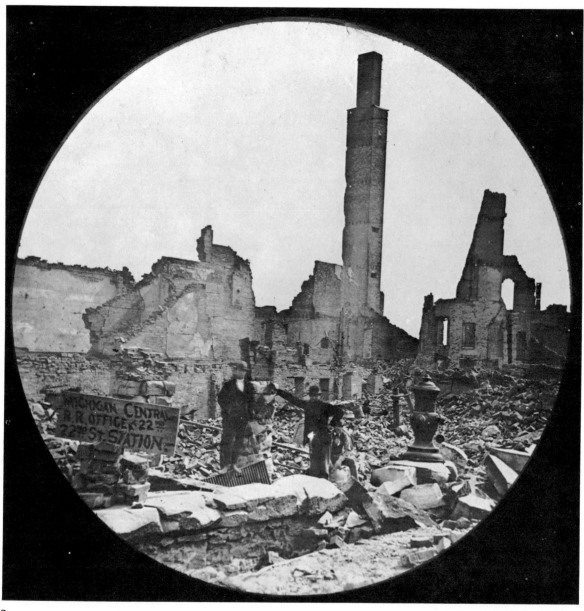

Fire Panorama

1. Looking East from the Courthouse

"It is estimated that the total loss of city property amounted to $2,680,856," stated a city report. "It actually *melted* fifteen thousand water service pipes, and destroyed three hundred and seventy water meters. It got down into the sewerage works, doing damage there to the amount of $42,000; and it burnt bridges and destroyed viaducts which will require an expenditure of $203,310 to replace. 2,162 public lamps

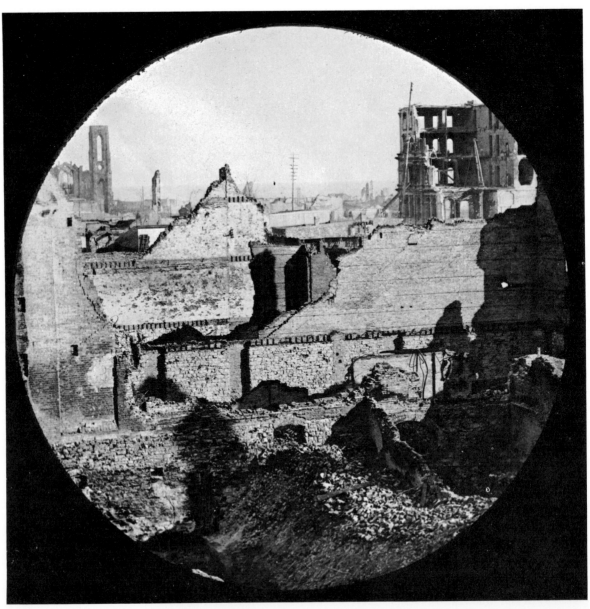

1

and lamp-posts were more or less injured by the fire, and the cost of repairing and replacing them is estimated at $33,000. The fire raged over the wooden block pavement for a distance of twenty-eight and a half miles, doing damage to the extent of $211,350; and it burned up and destroyed the wooden sidewalks along the streets and roads . . . for a total length of one hundred and twenty-one miles and three quarters!"
(From a stereoptican slide. Courtesy Chicago Historical Society.)

2. Field, Leiter Fire Ruins

"State Street was obstructed with street car rails bent, contorted, displaced by the heat, and with tangled skeins of telegraph wire mixed with the brands of burned poles. Perhaps a quarter of a mile away might be seen a building or two which seemed to have escaped the destruction; but on approaching, each one turned out to be only an empty shell, desolate and blackened."
(From a stereoptican slide. Courtesy Chicago Historical Society.)

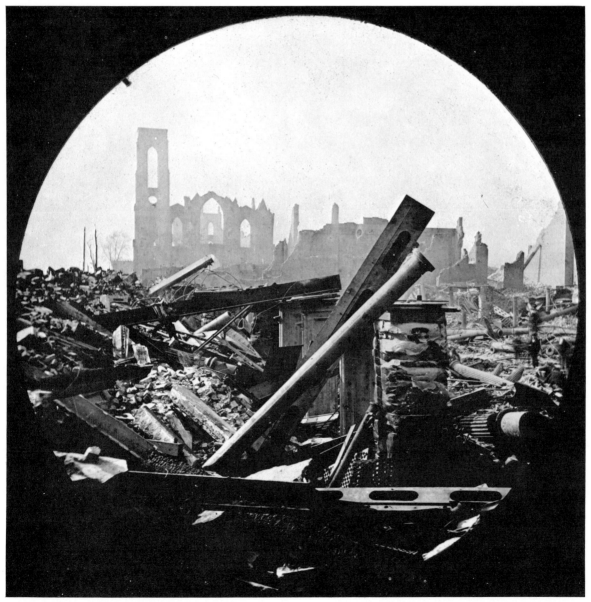

Fire Panorama

1. Destruction North from the Court House, after the Chicago Fire

A New York *Tribune* reporter wrote that "I have here before me six miles, more or less, of the finest conflagration ever seen. I have smoking ruins and ruins which have broken themselves of smoking; churches as romantic in their dilapidation as Melrose by moonlight; mountains of brick and mortar, and forests of springing chimneys. . . . It is the greatest and most brilliant apparition of the nineteenth century. . . ." The Chicago Avenue Water Tower, at the upper right, offers a surviving landmark for this photo.
(From a stereoptican slide. Courtesy Chicago Historical Society.)

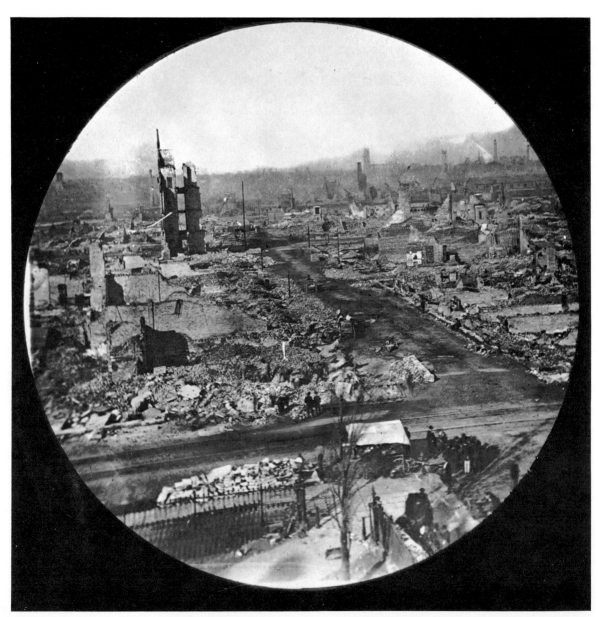

1

2. Smouldering Coal Yard on the Chicago River, a Few Days after the Fire of 1871

"Thursday, the third day after the fire . . . there was no smoke or sign of remaining fire save in the great burning coal heaps along the river, or where the mountains of smouldering grain were all that remained of the destroyed elevators."

"As the sun goes down in the prairie, and the night wind comes in from the Lake, this sleeping fire rouses and stirs in its slumber like a woman who shakes off the day's decorum, and flushes at the coming of her lover. The vast ignited coal beds on the shore of the river throw red greetings to each other through the gathering shadows."
(Carte-de-visite photograph, William Shaw. Courtesy Chicago Historical Society.)

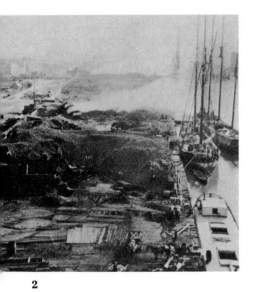

2

1871: "WHAT HAD BEEN THE TOWN"

For half a mile along the North Branch, there was little visible but the flames and smoke of objects still burning. The way in which the devouring element was left to revel at will in factories, warehouses, and stores of fuel, even along the river's bank, told but too plainly how complete had been its victory over every capability of resistance. There had been copious showers during the night, and the gale had died away; yet the fire seemed superior to all these, as well as all human obstacles, and continued its work unconcerned. But it burned languidly, and tossed off racks and sprays of flame in a wanton way, as if the monster had glutted himself on human blood and human handiwork, and was now dawdling with the relics of his feast, like a sated and stupified glutton. And the ribs of the burning buildings showed against the red flame like the naked bones of the monster's victims. . . .

The turbid river was encumbered with masses of charred wood, with black hulks of vessels, and skeletons of fallen bridges. One or two propellers were hugging the hither shore, like white doves frightened from their nests, and shrinking toward what semblance of cover offered itself, if, perchance, it might shelter them from the fell pursuer. . . .

Coming upon Adams Street, where the ruins of an iron viaduct were still standing, I resolved to look the situation in the face. The structure, though tottering, bore my weight, and I pushed on to its further end. The ruins of the river bridge lay in the stream beneath me. The town, or what had been the town, lay prostrate beyond. It was with the greatest difficulty that I could trace any semblance by which the various landmarks of Chicago could be identified. But for the still erect walls of the Court-House, Post-office, and Tribune building, this would have been utterly impossible. The Chamber of Commerce, the Sherman House, the elegant stores of State Street, the Palmer House, the Opera-house, the new palaces of marble to the south of the Post-office—all were leveled in the dust, or shattered into unrecognizable fragments. The Grand Pacific Hotel, which I had been accustomed to gaze on with pride each morning from this precise point of view, was a jagged and crumbling ruin—beautiful still, but a hopeless ruin—nothing more. . . .

I was aroused by the approach of a young man, who, though of rather fine mien in most respects, bore that unkempt, unshaven, unwashed appearance which I afterward found to characterize the whole population of the city for the week following the fire. He came with a small flask to procure water from the river. He was a stranger to me, but somehow he seemed like a brother, so close did the great ordeal bring men together. We talked considerably of the details of the conflagration. I remarked upon the fearful danger to the remainder of the city, resulting from a total failure of the water supply.

"Oh," he said cheerfully, "we'll be all right again soon."

"Yes," I echoed, though mechanically, "we'll be all right again soon."

And the sun shone out at that moment from a rift in the clouds, at the point where the cloudy arch dipped into Lake Michigan, diffusing a rosy light and warmth, as if in confirmation of our cheerful prophesyings. His brightness seemed to foreshadow the future glory of Chicago quite as plainly as the paling lamps behind us had suggested the faded luster of her past.

"A citizen of Chicago" who had returned to the city the day after the fire, quoted by Elias Colbert and Everett Chamberlain in *Chicago, the Great Conflagration* (1871), pp. 280–84.

CHICAGO
(THE GREAT CONFLAGRATION OF OCTOBER 8–10, 1871)

Blackened and bleeding, helpless, panting, prone
On the charred fragments of her shattered throne
Lies she who stood but yesterday alone.

Queen of the West! by some enchanter taught
To lift the glory of Aladdin's court,
Then lose the spell that all that wonder wrought.

Like her own prairies by some chance seed sown,
Like her own prairies in one brief day grown,
Like her own prairies in one fierce night mown.

Bret Harte in Charles Meeker Kozlay, ed., *The Writings of Bret Harte*, vol. 20 (1914), p. 383.

3 | The Second City, 1871-93

The day after the fire John Stephen Wright wandered down Wabash Avenue. The charred ruins still smoldered; here and there thin lines of smoke curled upward; ashes from the burned-out Nicholson pavement covered his shoes. Since 1832, Wright had been Chicago's greatest booster, constantly predicting the ultimate supremacy of the city. In three days the dream of forty years seemed destroyed. Yet when taunted with the question of "what do you think *now* of the future of Chicago," he replied matter-of-factly, "Chicago will have more men, more money, more business, within five years than she would have had without the fire."

Nothing seemed less likely, for the extent of the damage was staggering. Nearly $200 million of property destroyed, almost 100,000 people made homeless, four square miles gutted, nearly the entire business section wiped out. No one really knows how many people perished in the flames. Two hundred and fifty bodies were counted, but how many vagrants and visitors died in hotels and rookeries could not be determined. Of $88 million insurance, not even half was ever collected. While Chicago grieved, its rivals gloated. "Chicago will never be like the Carthage of old," wrote a New Orleans paper, "its glory will be of the past, not of the present; while its hopes, once so bright and cloudless, will be to the end marred and blackened by the smoke of its fiery fate." And in Saint Louis the famed circle of Hegelian philosophers could conceal their satisfaction only with difficulty. One of them later recalled that "we with some public display sent money for the homeless and provisions for the hungry, and even resolutions of sympathy for the unfortunate city—all of which was of right appearance; but privately everywhere could be heard without unhappy tears the pious spiritual ejaculation: 'Again the fire of heaven has fallen on Sodom and Gomorrah.' "

But Chicago refused to die. Within a day John McKnight had a fruit and cider stand ready for business amidst the rubble of Clark Street. Two days later W. D. Kerfoot, a realtor, announced he was reopening with "all gone but wife, children and energy." Within the week 5,497 temporary structures had been erected and 200 permanent buildings were under way. Joseph Medill caught the sense of the city in a *Tribune* editorial on October 11:

> *CHEER UP*
> In the midst of a calamity without parallel in the world's history, looking upon the ashes of thirty years' accumulations, the people of this once beautiful city have resolved that CHICAGO SHALL RISE AGAIN.

Even the booster spirit returned, and soon Chicagoans prided themselves on the magnitude of the disaster. "It has been the greatest fire of the age!" a McCormick salesman wrote proudly to an English customer, "far exceeding the great Fire of London in 1666!"

Despite the destruction, the fire did

118

1. Business As Usual after the Fire

A contemporary manuscript identifies this stand of Schock, Bigford & Co. as the "First Store Opened in the Burnt District." (Courtesy Chicago Historical Society.)

2. W. C. Kerfoot's Block, "First in the Burnt District"

Realtors like Kerfoot realized that the fire would eventually be a stimulus to their business. Their problem was to establish land titles and lot lines which would stand up in court. While all title records were destroyed when the City Hall and Court House burned, controversy was muted somewhat when the state legislature authorized "the purchase of the books of three abstract companies, unharmed by the fire, to aid in the establishment of titles." (Carte-de-visite photo, William Shaw. Courtesy Chicago Historical Society.)

not basically alter the shape of the city. Indeed, it intensified the forces that had characterized Chicago's formative years. The residential movement away from the commercial center accelerated. Business establishments replaced housing downtown, as new dwellings sprang up at the outer edges of the city. State Street continued to be the main retail focus, and industrial activity still clung to the river and the railroads. The most striking change was in the size and height of buildings downtown; Chicago was building bigger and better than before.

But the fire had taught one lesson, and the next year the City Council passed an ordinance outlawing wooden buildings in the downtown area. Fireproofing was still in a primitive stage, and enforcement was never very effective; but this legislation requiring future construction to be of brick and iron did offer some protection against a grisly encore. The new standards were reinforced by insurance underwriters who had learned the hard way that frame structures in congested sections were poor risks. The new regulations not only resulted in more substantial building, but also proved to be a bonanza for architects. They streamed in from everywhere, sensing an almost unlimited market for their talent. Looking back over the rebuilding, the authors of *Industrial Chicago* in 1891 went so far as to suggest that early fires had been "fortunate events for the Garden City as a whole," because "the flames swept away forever

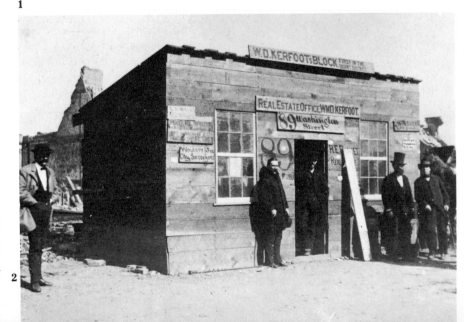

1

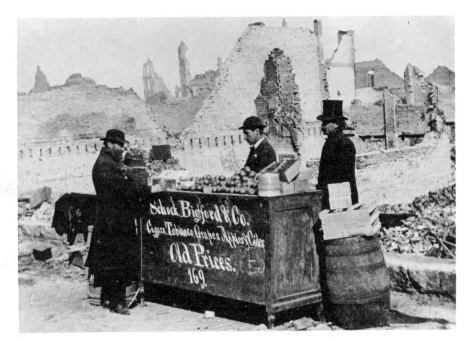

2

3. Bringing Order to the Downtown District, View Northeast from about Clark or LaSalle South of Lake Street, Late 1871 or Early 1872

Rebuilding after the fire was rapid. In this photo taken soon after the fire, a lake vessel had entered the river, streets were graded clean, and temporary buildings took shape.
(Courtesy Chicago Historical Society.)

4. Rebuilding the Near North Side, Northwest from the Water Tower

By the mid-1870's churches and multiple-storied frame structures predominated on the North Side skyline. But on the whole, within the fire limits in the downtown area, the trend towards brick construction was furthered. "Possibly the building law of Chicago is permitted to be evaded as commonly as is that of New York," Walter Marshall wrote after seeing the city in 1880, "but there is this to be said of the Queen City—that of the houses which have been erected since the great fires of 1871 and 1874, there are none that look as if they were about to topple over. There are no 'skin' buildings in modern Chicago."
(From a stereograph. Courtesy Chicago Historical Society.)

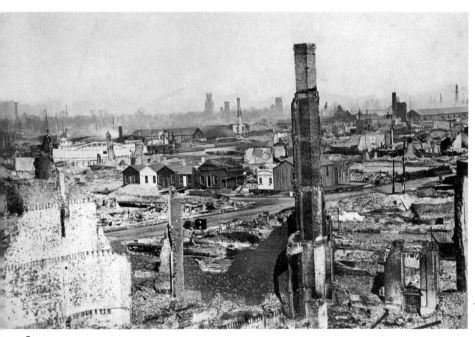

3

5. Rebuilding the Near North Side, Southeast from the Water Tower

"Looking at it now," one observer noted, "you find you are walking through the handsome stone-built streets of a large city, with every evidence of active trade and an intelligent and enterprising people, and of ever-extending commerce, created and promoted by natural and local advantages of the highest order. . . . Speaking generally, the former city has not only been re-built upon a grander plan . . . [but] upon a more extended surface."
(From a stereograph. Courtesy Chicago Historical Society.)

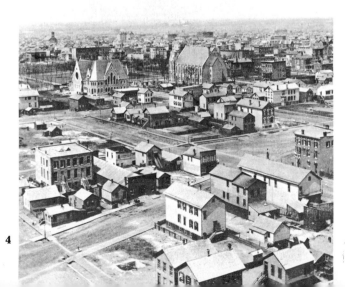

4

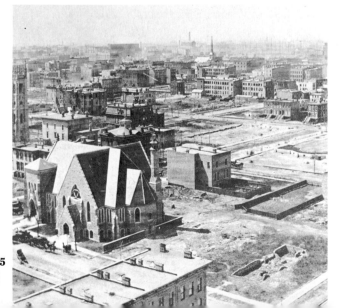

5

1. Rebuilding the Central Business District, View Northeast from LaSalle and Madison Streets, 1872

The symbol of the new Chicago was the derrick hoist which lifted materials for constructing the city's higher skyline. Later, its principle would be refined in the improved elevator. The large building under construction across LaSalle Street is the second Chamber of Commerce building, on the site of the present American National Bank Building. (From a stereoptican slide. Courtesy Chicago Historical Society.)

2. Rebuilding the Central Business District, Looking Northeast

The Marine Building, which stood until 1928 at the northeast corner of LaSalle and Lake Streets, is an excellent example of the higher skyline of post-fire Chicago. The Marine Bank destroyed in the fire was four stories; the new building was six stories, and another story was added about 1890. By the time this building was completed after the fire, a common note was being struck in travelers' observations of the city. "One's first impression on seeing Chicago of to-day," one comment ran, "is that it is scarcely possible the

the greater number of monstrous libels on artistic house-building" and provided an unparalleled opportunity for new construction.

The new business center was more elaborate and ornamental and, foreshadowing Chicago's skyscraping future, substantially higher. Most new construction was four or five stories high, and a half-dozen buildings rose to eight floors. Moreover, the rebuilding was speedy as well as impressive. The introduction of elevators made possible greater height, the use of electric lights a few years later permitted construction to go on at night, and mixing salt with the mortar allowed bricklaying in winter months. "There was built and completed in the burnt district of Chicago a brick, stone, or iron warehouse every hour of every working day" during most of 1872, a British visitor noted with astonishment. "It is difficult to realize the fact," wrote another two years later, "that the busy thoroughfare through which we were passing, with its beautiful buildings constructed of immense blocks of marble, exquisitely chiselled, was but three years before a heap of charred ruins."

The reconstruction of the industrial areas was almost as rapid. Indeed, much of the city's manufacturing capacity lay outside the destroyed area. The Union Stock Yards, which contained most of the packing houses, came through intact. More than 600 factories and workshops on the West Side continued production,

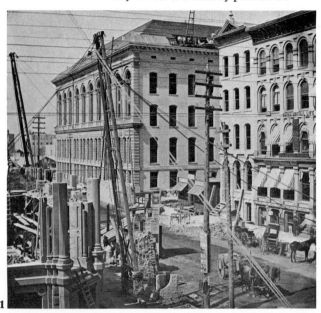

1

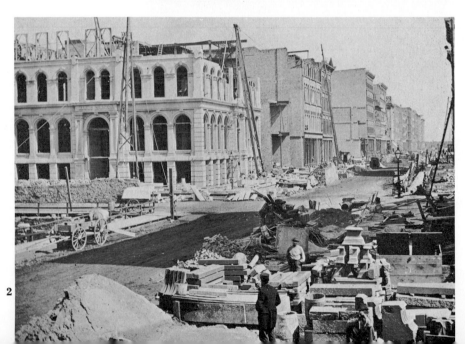

2

magnificent business streets we see extending over a vast area could all have been rebuilt in so short a time." (Courtesy Chicago Historical Society.)

3. LaSalle Street, South from Washington Street, 1874–75

Seen through a maze of telegraph wires is LaSalle Street's rising commercial skyline. The flag-topped white building in the background is the Grand Pacific Hotel. The pre-fire Grand Pacific was almost completed when it was destroyed; W. W. Boyington's architectural plans were again utilized for the new hotel erected

in 1873. The city's rapid recovery surprised visitors. Walter Marshall, who came in 1880, thought that with its "appearance of massiveness and stability pervading the whole place, Chicago more resembles a European than an American city, indeed I do not believe there is a city in America that can be compared with it. . . . When we . . . call to mind the magnificence and solidity with which the new city has risen out of the ashes of the old wooden one, we cannot but admire the marvellous activity, the enterprising spirit of determination displayed by the

inhabitants in restoring their city so thoroughly and in so masterly a manner as they have done." (Courtesy Chicago Historical Society.)

4. Clark Street, South from Randolph, 1874

At the extreme right, the City Hall and Court House faces a group of Chicago's rebuilt business palaces. The forest of telegraph poles festooned with wires added a new element to downtown Chicago's cityscape. On the front post is an advertisement for the transatlantic service of the Cunard Line. (Courtesy Chicago Historical Society.)

5. The Third Palmer House— Southeast Corner of State and Monroe Streets, Built in 1875

John M. Van Osdel designed this seven story building, which the traveler and lecturer Captain Willard Glazier found "more beautiful and remarkable than any building on which the like sum of thirteen million dollars and been spent." "This building," he continued, "is said to contain more bricks than any two hotels on the Continent, and more iron than most of them put together. The flooring contains ninety thousand square feet of marble tiling laid in massive beds of cement The magnificent office is . . . wainscoted with Italian marble, studded with many natural mosaics of rare and curious beauty. The wainscoting of the counter is made of the same exquisite material. The grand staircase is made of the same." Rudyard Kipling was less flattering, and called it simply "a gilded and mirrored rabbit warren" with "a huge hall of tessellated marble, crammed with people talking about money and spitting about everything." The structure stood until 1925, when it was replaced by the present Palmer House. (Courtesy Chicago Historical Society.)

6. Field, Leiter and Company Store Building, Northeast Corner of State and Washington, 1889

A new Field and Leiter Store was erected in 1873, but like the first one, it was later destroyed by fire. The photograph shows the third one, erected in 1878, which was replaced by the present Marshall Field store building in 1907. (Courtesy Chicago Historical Society.)

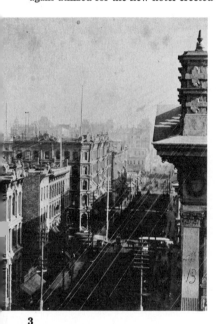

3

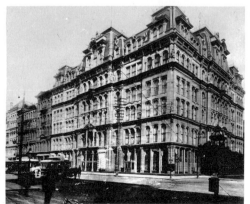

4

5

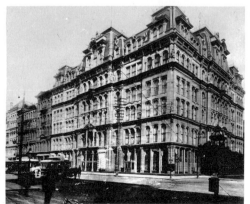

6

1. Inter-State Industrial Exposition Building

Rebuilding and confidence had grown so much by the spring of 1872 that Chicagoans began planning an exposition to call attention to their acheivement. To house the exposition, city fathers called on W. W. Boyington, who designed a glass and iron building, extending from Adams to Jackson. Opening in September, 1873, and running only 18 days, the exposition attracted 60,000 people to view the "material and cultural progress of Chicago and the Northwest." The building, which housed an annual exposition, stood until 1892, when it was razed to make way for the Art Institute. This photograph was taken in 1888–89 from the tower of the newly constructed Auditorium.
(Courtesy Chicago Historical Society.)

2. Union Stock Yards, 1889

Chicago's Stock Yards was an impressive sight to visitor and resident alike. William Hardman, for example, found even the statistics nearly incomprehensible in 1884: "360 acres of land and forty miles of railway track . . . in connection with all the

and the rolling mills also survived. The McCormick reaper plant was destroyed, but its owners had decided even before the fire to relocate at Western and Twenty-second, along the South Branch, where land was cheap and more abundant. Most of the other manufacturers rebuilt as soon as the wreckage could be removed and financing obtained.

The railroads, too, moved to restore their facilities and renew regular service. Most of the freight terminals on the edge of town escaped damage, but nearly all the passenger depots were destroyed. The new stations expressed not only a faith in the revival of Chicago but also the central role of railroads in the life of the city. Companies lavished money and care in making them attractive gateways to the midland metropolis and symbols of its industrial power. Monumentally large and spacious, they were to the modern city what public buildings had been to Rome and the cathedral to the medieval town.

The fire dislocated the working population more than it did the business and industrial facilities. Most of the 100,000 homeless came from this group, and few had the resources to recover quickly. In addition, the new ordinance forced them to find housing outside the "brick area" downtown. As a result, they crowded into wooden cottages that ringed the inner city a short distance from the business center. In a broad semicircle about a mile wide, from Fullerton Avenue and Lincoln Avenue on the north to State

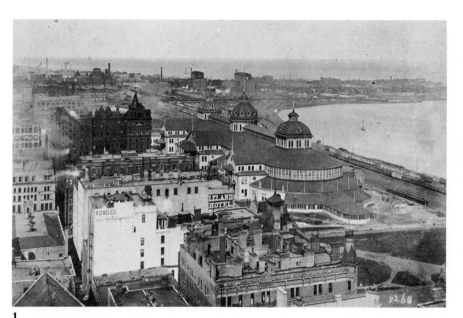

1

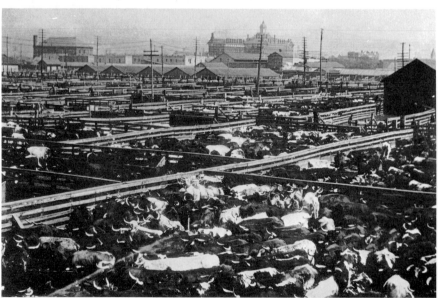

2

railroads entering Chicago . . . 175 acres are . . . 'enclosed.' A hundred acres are devoted to cattle yards, and seventy-five to covered hog and sheep pens Fifteen miles of macadamized streets run through the yards, and forty miles of water and drainage pipes underneath, while more than 500 men are constantly employed If, for ten hours of every working day in the year, a constant stream of cattle at the rate of ten per minute, of hogs at the rate of thirty per minute, with the small addition of four sheep every minute, passed through these yards, it would fall short of the actual numbers brought to this market for sale, slaughter, or distribution!" (From *Select Chicago,* 1889. Courtesy Chicago Historical Society.)

4. The Chicago River, East from Wolf Point, 1875

Elevators, lumber yards, and the continual opening and closing of the center-pier swing bridges combined to create serious congestion on the river. By the mid 1880's the river had thirty-five movable bridges across it and two tunnels under it, but the problem still increased each year.

The preponderance of sailing vessels in the Great Lakes trades is clearly evident. In the foreground are barges used on the Illinois and Michigan Canal, which had its peak traffic, slightly over one million tons, in 1882. The "Air Line Elevator" at the left is on the site of the present Merchandise Mart. (Courtesy Chicago Historical Society.)

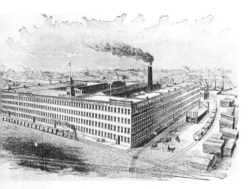

3. McCormick Harvesting Machine Company Plant

By 1869, the McCormick works had already outgrown their location and the owners purchased a new site before the fire. The plant was moved to this twenty-four–acre site at Blue Island and Western Avenue on the South Branch of the River and officially opened in February, 1873. (Courtesy International Harvester Company.)

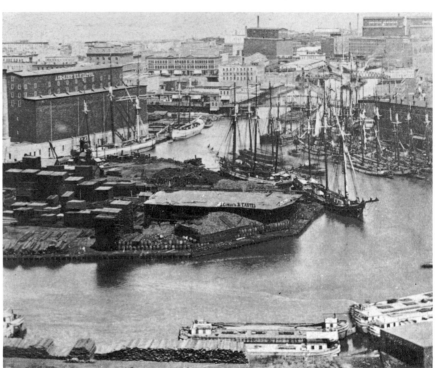

4

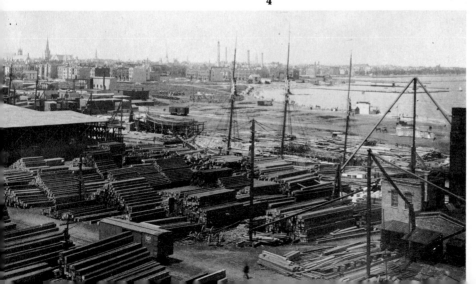

5. View Northwest from the Lighthouse on the North Pier at the Entrance of the Chicago River

When this photo was taken in the late 1880's a shipyard with a half-finished vessel occupied what would become the site of the North Pier Terminal Company's loft building. The sailing vessel in Ogden Slip is a lumber carrier typical of those engaged in the Great Lakes trade until the early twentieth century. (Courtesy Chicago Historical Society.)

1. South Water Street, East from Market Street, 1892

South Water was the city's principal center for wholesale produce marketing from the earliest days until 1925, when the market was relocated to make way for Wacker Drive. "This street is about half a mile in length, and is at all hours a most interesting and picturesque pandemonium," wrote Franklin H. Head in 1892. "The sidewalks are packed with boxes and barrels, along which thousands of people elbow their several ways, and the street is so filled with teams that one wonders how any can ever be extricated." It was, he concluded, a scene of "interminable confusion and endless hurly-burly." (From *Chicago*, 1892. Courtesy Chicago Historical Society.)

2. Haymarket Square, 1892

This widened stretch of Randolph Street, shown here looking west towards Halsted Street, is still a center of wholesale

and Fifty-first on the south, they occupied one- and two-story frame dwellings.

A nationwide depression that began in 1873 slowed down the burst of post-fire activity in Chicago. Unlike the panic of 1837, however, hard times did not come suddenly. "There was no wild scare, no rushing, no jostling," wrote a real estate editor. Rather the market "yielded inch by inch." But if the decline came slowly, it disappeared only reluctantly. Not until the last years of the decade did a new vitality appear. Meanwhile fortunes lay strewn amid the economic wreckage. Samuel J. Walker, for example, who was reputedly worth $15 million in 1873, had lost all his property by 1877. No one else suffered that much, but attrition was visible everywhere—construction lagged, land values dropped, profits disappeared, wages were sheared in half. "Fickle Fortune," one victim wrote whimsically, "in contrast to her previous smiling visage, threw aside her mask and showed an ugly countenance."

But fire and depression could not stop but only slow the growth of the city. By 1880 a new cycle of expansion and development was under way. The prosperity of this period not only made up the lost ground, but ushered in one of the most important epochs in Chicago's history. In these years, Chicago created a distinctive urban form in the skyscraper, adopted radical innovations in mass transit, became the nation's "sec-

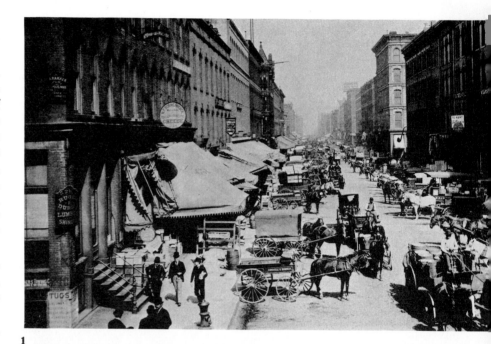

1

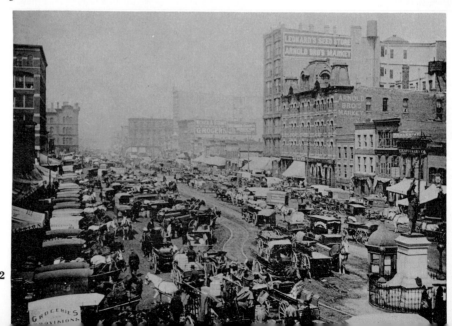

2

produce distribution. Many of the workers
employed here lived in the immediate
neighborhood, both in apartments and
small one- and two-story houses. The
statue at the right commemorates the labor
riot of May 4, 1886.
(From *Chicago,* 1892. Courtesy Chicago
Historical Society.)

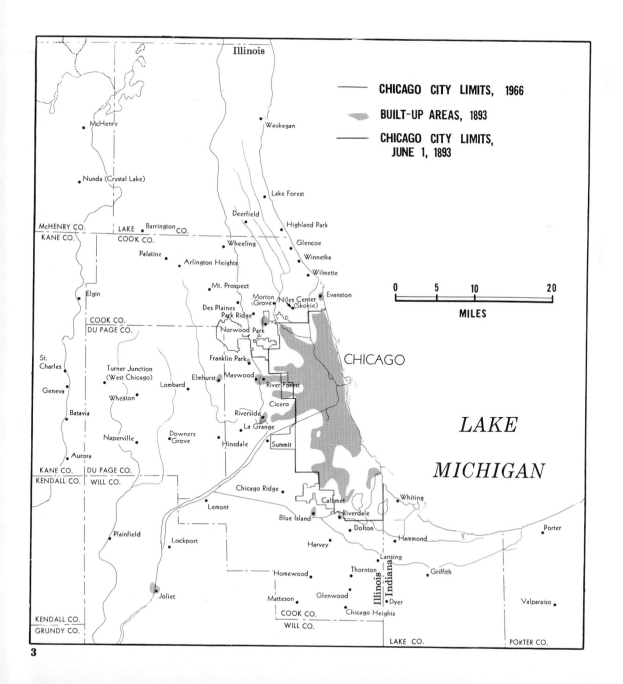

Illinois

CHICAGO CITY LIMITS, 1966

BUILT-UP AREAS, 1893

CHICAGO CITY LIMITS,
JUNE 1, 1893

McHenry

Waukegan

Nunda (Crystal Lake)

Lake Forest

Deerfield

McHENRY CO. LAKE Barrington
KANE CO. COOK CO. CO.

Highland Park

Wheeling

Glencoe

Palatine

Winnetka

Arlington Heights

Wilmette

Elgin

Mt. Prospect

Morton Niles Center Evanston
Grove (Skokie)

Des Plaines
Park Ridge

COOK CO.
DU PAGE CO.

Norwood Park

St.
Charles

Franklin Park

CHICAGO

Turner Junction
(West Chicago)

Elmhurst Maywood

Geneva

Lombard

River Forest

Wheaton

Cicero

Batavia

Riverside

Naperville

Downers
Grove

La Grange

Aurora

Hinsdale

Summit

KANE CO. DU PAGE CO.
KENDALL CO. WILL CO.

Chicago Ridge

Calumet Whiting

Lemont

Riverdale

Blue Island

Dolton

Plainfield

Lockport

Hammond Porter

Harvey

Lansing

Homewood

Thornton

Griffith

Joliet

Matteson

Glenwood

Dyer

Valparaiso

KENDALL CO.
GRUNDY CO.

COOK CO.
WILL CO.

Chicago Heights

LAKE CO. PORTER CO.

0 5 10 20

MILES

LAKE

MICHIGAN

1. Chicago and North Western Depot, Wells and Kinzie Streets, about 1885

In 1881 this massive structure, designed by W. W. Boyington, replaced temporary facilities erected after the fire of 1871. Later a commuter annex was added to accommodate increased suburban traffic. The depot was used until 1911, when it was replaced by the present terminal on West Madison.

(Courtesy Chicago and North Western Railway.)

2. Passenger Terminal and Yard of the Chicago and North Western Railway, Eastward from Orleans Street

This area is now the site of the Merchandise Mart.

(Courtesy Chicago and North Western Railway.)

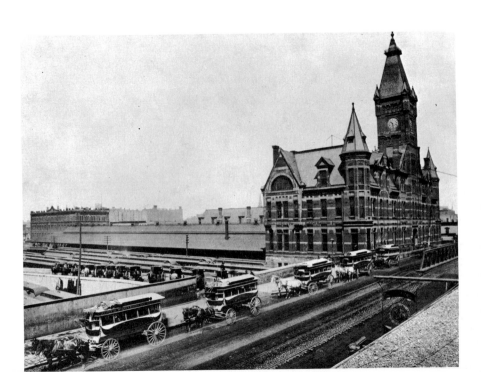

1

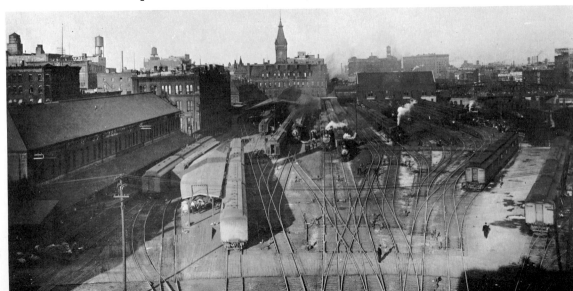

2

3. Dearborn Station at Polk and Dearborn, Shortly after Completion in 1885

This structure is the oldest of the six downtown passenger stations. Its ornate cupola was removed following a fire in 1922; otherwise its exterior has been little changed.
(Courtesy Chicago Historical Society.)

4. Central Station of the Illinois Central Railroad at Park Row (East 11th Place), 1894

Completed in 1892, this depot was built by the Illinois Central to serve as its major Chicago terminal and to house its tenants, including the Michigan Central and the "Big Four" of the New York Central. Although the lake has now been filled east of the depot, the station, which was to have been replaced in accordance with the Lake Front Ordinance of 1919, still stands as one of the city's "monumental" terminals.

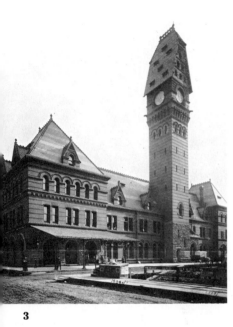

3

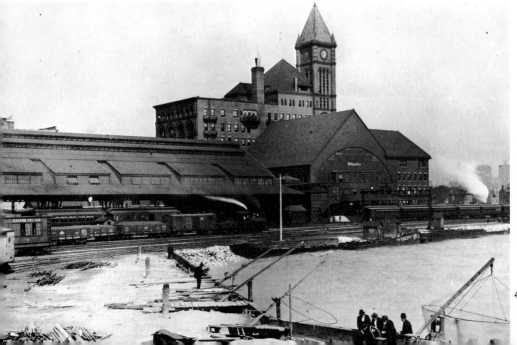

4

128

2. Monadnock Block, 53 West Jackson Boulevard

Burnham and Root's sixteen-story Monadnock building includes only the north half of what is now the block-long Monadnock, the other half having been built in 1893 under the architectural direction of Holabird and Roche. A contemporary described his skepticism with the original scope of the project: "When . . . Owen P. Aldis put up the Monadnock on Jackson boulevard there was nothing on the south side of the street between State street and the river but cheap one story shacks, mere hovels. Everyone thought Mr. Aldis was insane to build way out there on the ragged edge of the city. Later when he carried the building on through to Van Buren street they were sure he was." (Courtesy Chicago Historical Society.)

ond city" with the addition of 120 square miles and 200,000 people, solidified its industrial and commercial leadership of the midcontinent, and dazzled millions with its Columbian Exposition in 1893.

The city grew upward as well as outward. "Tall buildings will pay well in Chicago hereafter," wrote Peter Brooks, a Boston real estate investor in 1880, "and sooner or later a way will be made to erect them." The next year Brooks's company and its Chicago agents, Aldis and Company, commissioned Daniel H. Burnham and John Wellborn Root to act on this prediction. The result was the Montauk Block, one of the important buildings in the new skyline. Despite its ten-story height, however, its real significance lay below the surface. For its "floating raft" foundation solved one of the most persistent problems in Chicago construction—how to erect massive structures on the soft sand and clay of the area.

The prospects that the new system had opened up to conventional techniques were most brilliantly illustrated a decade later in the Monadnock Building. Commissioned by the same company, designed by the same architects, and completed in 1891, it was among the finest expressions of the "Chicago School" and remains in 1969 one of the country's great triumphs of commercial architecture. A leading contemporary critic in 1893 called the Monadnock "an achievement unsurpassed in architectural history," and years later, Louis

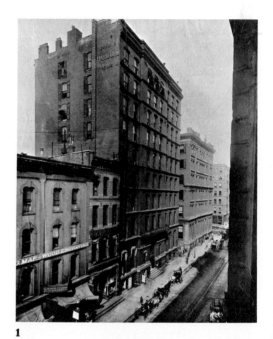

1

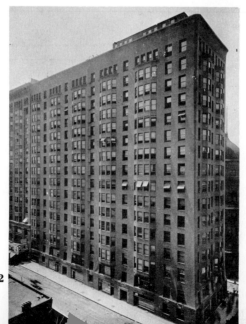

2

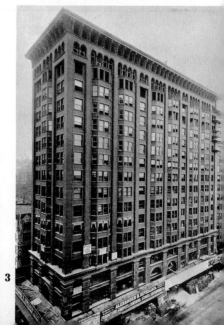

3

3. Second Half of the Monadnock Block, Built 1893

The Katahdin Building, unlike the wall-bearing design of the Monadnock, was constructed with steel framing, but in keeping with the design of the original. (Courtesy Chicago Historical Society.)

4. Construction of the Fair Store, 1891

The Fair Store was originally established in 1875, but after outgrowing its accommodations it was replaced by a new Fair Store occupying the entire side of Adams Street, between Dearborn and State. The steel-frame structure of "the Chicago method" is exposed clearly. Buildings built in this manner, one contemporary wrote, were "like enclosed bird-cages, . . . The exterior walls are mere envelopes. They are so treated that the buildings look like heaps of masonry, but that is homage paid to custom more than it is a material element of strength." The Fair Store was remodeled as the downtown store of Montgomery Ward and Company in 1965. (Courtesy Chicago Historical Society.)

129

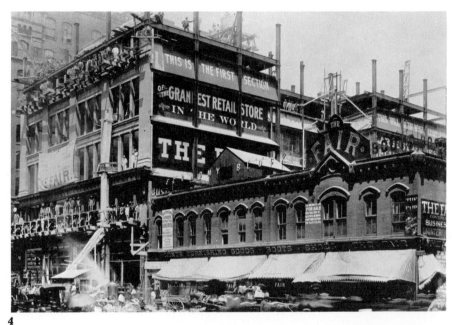

4

5. Home Insurance Building, Northeast Corner of LaSalle and Adams Streets

Several iron-framed buildings were built before Jenney planned the Home Insurance Building, but "the decisive step," "the reduction of the exterior wall to a mere curtain or envelope," still had not been done. Architectural historian Carl Condit writes that it was the Home Insurance Building that was "the major step in the conversion of a building from a crustacean with its armor of stone to a vertebrate clothed only in a light skin." A colleague of Jenney's later summarized the architect's motive: "While he felt he was contributing to the making of new architectural forms, that was not his motive His main purpose was to create structural features which increased the effective floor areas and made it possible to secure more daylight within the building." The building was demolished in 1931, to make way for the present Field Building. (Courtesy Chicago Historical Society.)

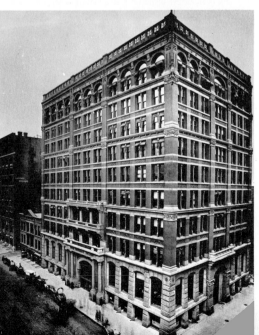

1. The Auditorium Building, Northwest Corner of Michigan Avenue and Congress Street, 1889

The weight of the Auditorium's ten stories and its large tower created difficult foundation problems which were complicated by its proximity to the lake. The architects, Adler and Sullivan, solved them by a massive five-foot-thick raft made of layers of timber, concrete, and iron beams. Taken shortly before the building was completed, this photograph shows residential structures still occupying the site upon which the Congress Hotel was built in 1892.
(Courtesy Chicago Historical Society.)

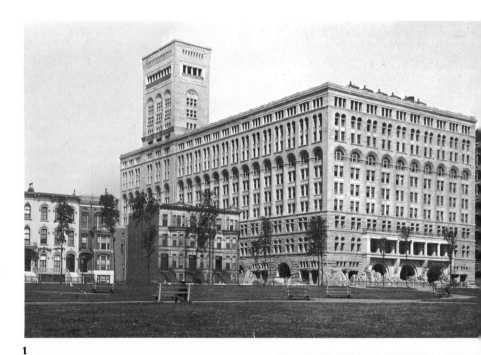

1

Sullivan could describe it enthusiastically as "an amazing cliff of brickwork, rising sheer and stark, with a subtlety of line and surface, a direct singleness of purpose, that gives one the thrill of romance. It was the first and last word of its kind; a great word in its day."

In fact, the new day was already at hand. Indeed six years before, William Le Baron Jenney had created in the Home Insurance Building what historian Carl Condit has called "the major progenitor of the true skyscraper." Though originally only nine stories above the basement, it embodied the technological elements that make possible the towering construction of modern times. Jenney adopted a new structural system that eliminated the need for heavy masonry walls in large structures. By using wrought iron and steel beams, he developed a skeletal construction that could carry great weight without the use of a clumsy masonry shell. The Monadnock needed a seventy-two inch wall at the base to hold its sixteen stories; in the Home Insurance Building, the exterior was merely a skin on an iron and steel cage.

Jenney sought efficiency and economy in his buildings; hence most tended to be a simple expression of the underlying metal skeleton. Louis Sullivan, on the other hand, used the new construction in a richer, more ornamental way. In the Auditorium, the Old Stock Exchange, and especially in the Carson Pirie Scott Store, the giant of this "heroic age"

**2. Chicago Stock Exchange Building
(30 North LaSalle Street Building),
Southwest Corner of West Washington
and LaSalle Streets**

Designed by Adler and Sullivan, this
thirteen-story building was erected in
1894 and housed the Exchange until 1930
when the present Board of Trade was
completed. The caisson foundations under
the building's west wall are among the first
such ever used. This innovation, originally
developed for the City Hall in Kansas City,
Missouri, in 1888–90, was utilized in the
Stock Exchange to avoid damaging the
newspaper presses of the neighboring
Chicago Herald Building.
(Courtesy Chicago Historical Society.)

3. Louis Sullivan (1856–1924)

Boston-born, Sullivan, who came to
Chicago in 1873, was one of the many
architects and builders attracted to the city
during the post-fire reconstruction. He
became a student of William Le Baron Jenney
for a year and then went to Paris to continue
his studies. Five years later he returned,
and in 1880 formed the partnership with
Dankmar Adler, which would do much to
help revolutionize the building arts.
(Oil painting, Frank A. Werner, 1919.
Courtesy Chicago Historical Society.)

3

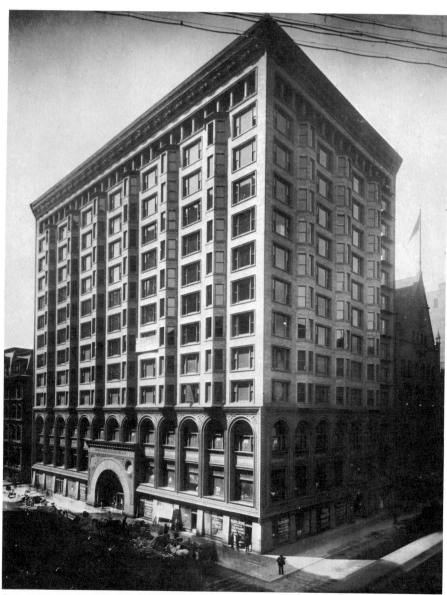

2

1. **Southward View from the Rookery on LaSalle Street toward the Board of Trade Building, LaSalle and Jackson, about 1886**
"For her grain and provision trades, of which Chicago is very proud, she has recently erected a grand monument and abiding place at a cost of more than £200,000," the London *Times* reported in October, 1887. "At the head of LaSalle street, and making a fitting close to the view along that highway of imposing business structures stands the tall building with its surmounting clock and spire of the Chicago 'Board of Trade.' " On the west side of LaSalle are the Counselman, Gaff, Mailers, and Insurance Exchange buildings, all of which have been replaced.
(Courtesy Chicago Historical Society.)

created some of the most enduring monuments of the Chicago School. In these decades, then, the essential forms of modern architecture were born in the city between the lake and the prairies. And for more than eighty years Chicago has remained, as critic Allan Temko put it in 1965, the "chief stronghold of modern architecture."

The new architecture was significant not only because it solved the technical problems of architects, but because it also answered the needs of a booming commercial city. Now it was possible to build more intensively at the center simply by going higher. Hence, the new skyline became a kind of physical reflection of the soaring land values of the business district. And it is not surprising that the new architecture was at its best when handling commercial structures—retail stores, office buildings, and hotels. Even warehousing, as the Hiram Sibley Warehouse and the Walker Warehouse suggest, seemed appropriate for the new breed of architects.

If the skyscraper made possible the vertical growth of Chicago, improvements in mass transit accelerated its horizontal expansion. In the decades after the Fire, large areas around the city were opened up for settlement. The horse-drawn omnibus and horse railway had already permitted new development well beyond the old boundaries, but the introduction of cable cars, elevated steam railroads, and electric surface lines intensified this

1

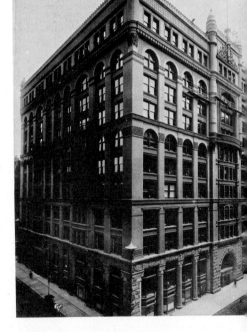

2. **Rookery Building, Southeast Corner of Adams and LaSalle**
Burnham and Root's eleven-story Rookery Building contained more than 600 offices. Built between 1884 and 1886, it stands as one of "the final monuments of the art of masonry architecture." Architectural historian Carl Condit writes: "The architectural excellence of The Rookery's outer elevations grows chiefly out of the extraordinary openness of the walls, the airy yet vigorous articulation of the elevations, precise scale and pleasing proportions, and the first integration of many diverse elements of decorative detail At the time he designed the building Root wondered whether the profusion of ornament would stand the test of time. It has, through his sure sense of organization and his subordination of detail to mass and structure."
(Courtesy Chicago Historical Society.)

3. Westward on Madison from State Street, 1888

For many years this corner had the highest land values in downtown Chicago, and claimed to be the "World's Busiest Corner." (Lillian M. Campbell Memorial Collection. Courtesy West Side Historical Society, Legler Branch Library.)

4. Randolph Street, East from LaSalle, 1892

The omnibus, horsecar, and cable car were all used on Randolph Street in 1892. On the right side of the busy thoroughfare is John Van Osdel's City Hall and County Building, completed in 1885. On the left, at the northwest corner of Clark Street, is the 300–room Sherman House, built in 1872. On the northeast corner is the Ashland Block, completed in 1892, which stood until 1949 when it was razed to make way for the Greyhound Bus Terminal. The tall building still farther down Randolph Street is the Schiller (later the Garrick) Building, and in the distance is the Masonic Temple. (From *Chicago*, 1892. Courtesy Chicago Historical Society.)

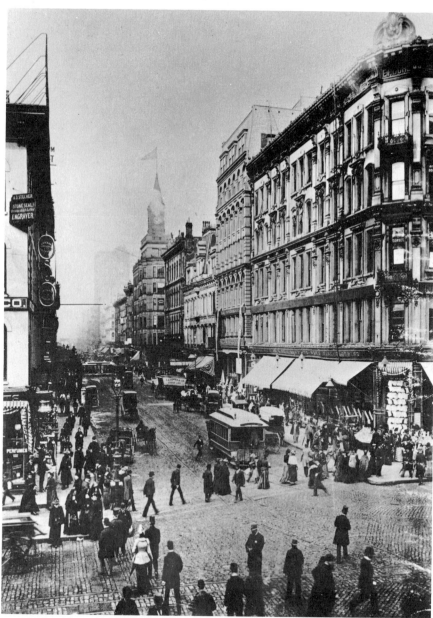

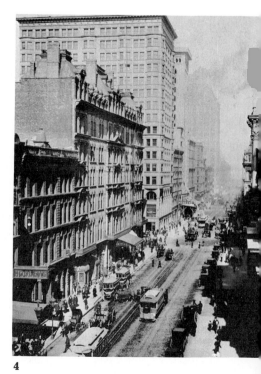

4

3

1. Dearborn Street, North across Madison Street, 1892

Capturing the vitality of Chicago's business district, this photograph shows the sidewalks crowded with pedestrians and streets filled with buggies, cable cars and horse cars. It was scenes such as this that led foreign visitors in the decades after the fire to comment on the haste of doing things in the booming metropolis. An Englishman, C. B. Berry, returning after his stay in Chicago in 1879 wrote: "*The* feature of Chicago is its marvellous energy. America is energetic, but Chicago is in a fever. It does not rest one moment, but goes on, on—ever ceaselessly ahead— to buying, and selling, and getting gain. Everything is rapid, everything is keen. There are hardly any idlers on the streets. Everyone has an object in immediate view, —and is walking fast to reach it." (From *Chicago*, 1892. Courtesy Chicago Historical Society.)

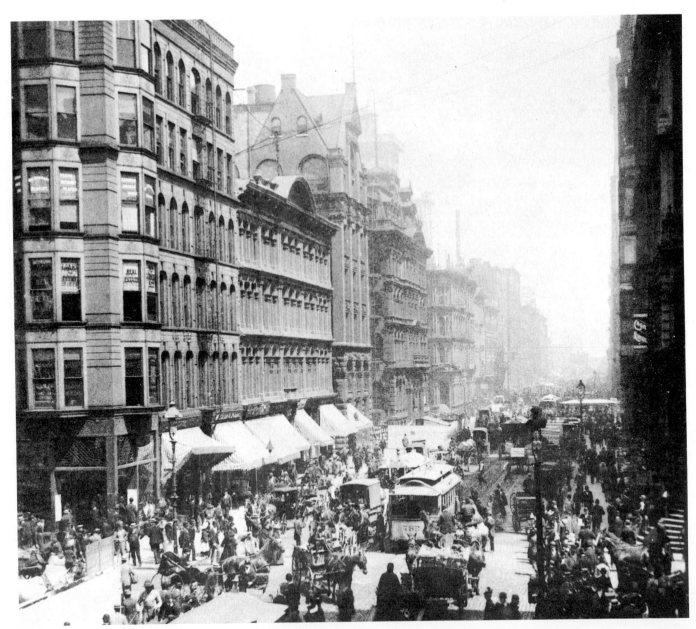

1

2. Michigan Avenue South from Jackson, 1887

A good portion of Chicago's early Michigan Avenue facade appears in this 1887 photograph. At the right is the Leland Hotel, a 272-room structure removed in 1922 to make way for the Straus (Continental Companies) Building, a modern skyscraper. On the south side of the two-story dwelling is the Hotel Richelieu, built in 1885, and the Victoria Hotel, a fashionable apartment building that contained some of Chicago's first "French flats."
(Courtesy Chicago Historical Society.)

3. Michigan Avenue between Congress and Van Buren Streets, 1889

Adler and Sullivan's Auditorium and Hotel (now housing Roosevelt University) is on the left. The Studebaker building in the center was built in 1886; it is now the Fine Arts Building. The Chicago Club building, erected in 1885, was demolished to make way for the present Chicago Club building in 1929.
(Courtesy Chicago Historical Society.)

4. Clark Street North from Jackson, 1892

Parked carriages are lined up at the curb while their drivers conduct business in the Post Office and Custom House at the far right of the picture. Built in 1879, it was demolished in 1896 to make way for another which was itself replaced in 1965 by the modern skyscraper Federal Building.
(From *Chicago*, 1892. Courtesy Chicago Historical Society.)

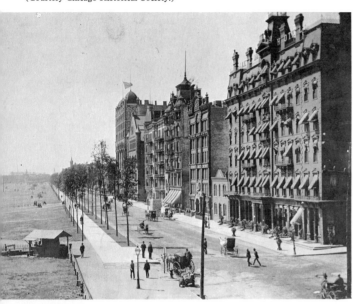

2

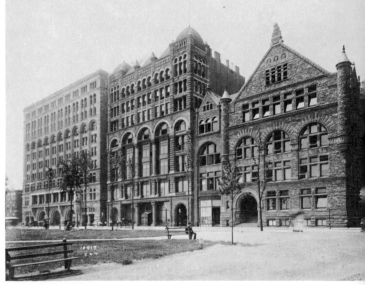

3

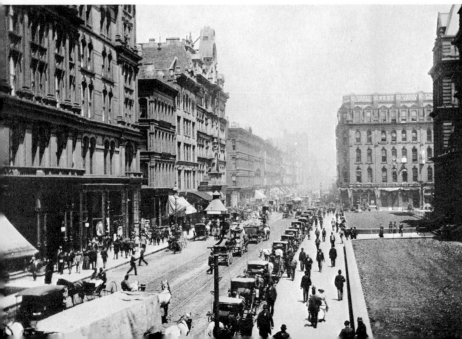

4

136

1. Hiram Sibley and Company Warehouse

Designed by George H. Edbrooke and built in 1883, the building had three sections. The river frontage of what is now the Central Cold Storage Warehouse is supported by thirty-foot oak piles, which a modern critic contends is "the first known use of wood or other piles under a building wall, other than in grain elevators along the Chicago River."
(Courtesy Chicago Historical Society.)

2. Ryerson Building, 200–214 South Market Street

Now the Warehouse of James H. Walker and Company, it was built in 1888 and stands six stories high. Here workers are shown placing the last of Sullivan's decorative lintels.
(Courtesy Chicago Historical Society.)

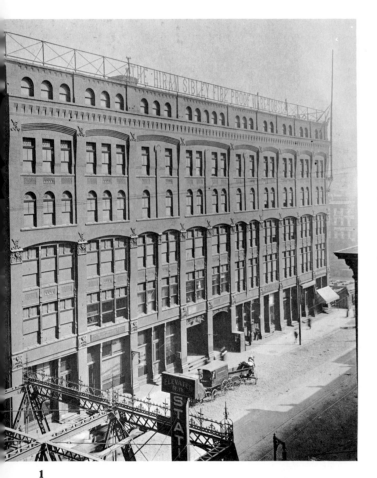

1

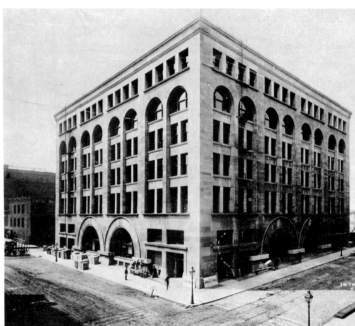

2

3. Marshall Field and Company Wholesale Warehouse

Henry Hobson Richardson designed this monolithic, red granite building with iron interior partitions. Built in 1887, it occupied the entire block bounded by Wells, Quincy, Franklin and Adams streets until it was razed in 1930.
(Courtesy Marshall Field and Company, from files of Chicago Historical Society.)

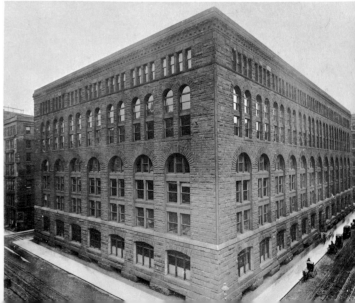

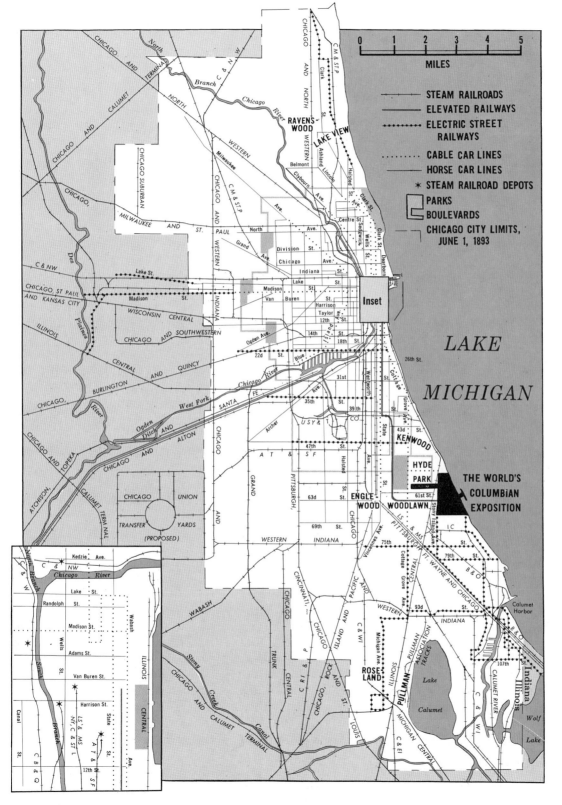

Internal Transit
System of the
City, 1893

MILES

0 1 2 3 4 5

STEAM RAILROADS
ELEVATED RAILWAYS
ELECTRIC STREET
 RAILWAYS
CABLE CAR LINES
HORSE CAR LINES
* STEAM RAILROAD DEPOTS
PARKS
BOULEVARDS
CHICAGO CITY LIMITS,
 JUNE 1, 1893

LAKE

MICHIGAN

RAVENS-
WOOD

LAKE VIEW

Inset

KENWOOD

HYDE
PARK

THE WORLD'S
COLUMBIAN
EXPOSITION

ENGLE
WOOD WOODLAWN

ROSE
LAND

PULLMAN

Lake
Calumet

Calumet
Harbor

Indiana
Illinois

Wolf
Lake

Inset (lower left):

Kedzie Ave.

Chicago River

Lake St.

Randolph St.

Madison St.

Adams St.

Van Buren St.

Harrison St.

12th St.

centrifugal tendency. Thus land previously too remote for residential use was brought into the city's orbit.

The "omnibus on rails," as the horse-drawn streetcar was often called, had been a familiar sight on Chicago's streets since 1859. The constant extension of its lines had served the outlying neighborhoods and the increasing downtown traffic. But in the 1870's another possibility appeared. San Francisco had devised a new transit system that used cables instead of horses. Although more expensive to install than the older system and afflicted with all kinds of mechanical trouble, it was faster and cleaner than horse-drawn vehicles.

San Francisco might have invented the cable car, but Chicago quickly became one of its most avid supporters. The first line was located along State Street from Madison Street to Twenty-first Street and cost $100,000 a mile to construct. To build these four miles of double track took four months and 1,500 men and required ten million pounds of iron and steel, 44,000 barrels of cement, 50,000 wagonloads of stone, sand, and gravel, and 300,000 feet of timber. Initially, there were bitter protests against the innovation. State Street property owners claimed their business would be ruined; others said that many men would be thrown out of work by the automated system; still others feared that the high speeds would kill people and frighten horses.

Despite criticism and high cost, the first section was completed early in 1882. On a bright, crisp January afternoon, a train of ten trailer cars, bedecked with flags and city officials, moved down State Street before a cheering throng of 300,000 spectators. The new system was an instant success. By March, 1894, Chicago could boast eighty-six miles of cable tracks utilized by more than 450 grip cars and operated by eleven power plants scattered around the city. Nearly everyone was satisfied. "The value of removing from a street the voidings of two or three thousand horses," wrote H. H. Windsor, the secretary of the Chicago City Railway, "is a matter not to be lightly estimated in point of health." And the noise reduction was welcomed too since "the constant clatter of hoofs on the pavement is supplanted by the quiet gliding of a train, scarcely audible from the sidewalk."

The South Side was the primary beneficiary of the cable car. All the initial routes were built there, with the State Street and Cottage Grove lines reaching Sixty-third and Sixty-seventh Streets by 1887. A year later, the North Side got its first cable service on Clark and Wells Streets. Running from the edge of the city to its center, these tracks entered downtown through the LaSalle Street tunnel. Shorter lines were constructed on Lincoln and Clybourn Avenues. Yet the North Side system could hardly match the spectacular growth south of the river.

Facilities on the West Side were less satisfactory. The horsecar lines were notoriously slow, seldom making four miles an hour. No cable service was available until 1890. The next few years, however, saw substantial improvements. Four lines brought traffic through the Washington Street tunnel into the business district, and by 1893 construction was well advanced on electric and elevated systems.

Everywhere the cable car went land values were sure to rise and new building begin. "Within six months after the conversion of this company's lines from horse to cable power," wrote H. H. Windsor, "property along these lines rose in value from thirty to one hundred per cent, and on adjoining and contiguous streets in amounts proportionate to the distance from the cable lines." "Only let me know six weeks in advance where the City Railway intends building a cable line," a successful financier observed, "and I will make an independent fortune every time." With this stimulus the new mode of transit facilitated the outward movement of population. It also created an early version of the Loop, for the cable lines all converged to make a loop around the business section before making return runs into the residential areas on the edge of the city.

This centrifugal tendency was greatly accelerated by the introduction of the electric trolley car. Even as the cables were being installed under Chicago's streets, Montgomery, Alabama, was experimenting with running "mule cars by

1. Cutaway View Showing Operation of a Cable Car

A stationary steam engine operated an endless wire rope on rollers in a conduit below the street. A clamp reached down from the car and gripped the moving wire to pull the car along. To stop, the "gripman" released the clamp and applied the brakes.
(Courtesy Chicago Historical Society.)

2. Street Railway Cable Train, 1890

This equipment, operated by the North Chicago Street Railway Company, served the Wells Street line, connecting at its northern terminus with electric cars for Evanston. The open-sided units were summer cars which were replaced in winter with enclosed models.
(Courtesy George Krambles Collection.)

3. Madison Street Cable Train

A Britisher, after examining the "ready-made shoes" worn by Americans and viewing the heavy loads carried by the street cars concluded that the American "does but little walking, always taking a car when he can; and may not therefore feel the same need for a well-fitting boot as the pedestrian Briton. The American uses his boot for sitting in; and for purposes of contemplation. . . . In New York and Boston, the Englishman may get a proper boot as at home; but not, I regret to say, in the West."
(Lillian M. Campbell Memorial Collection. Courtesy West Side Historical Society, Legler Branch Library.)

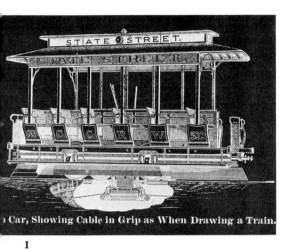

Car, Showing Cable in Grip as When Drawing a Train.

1

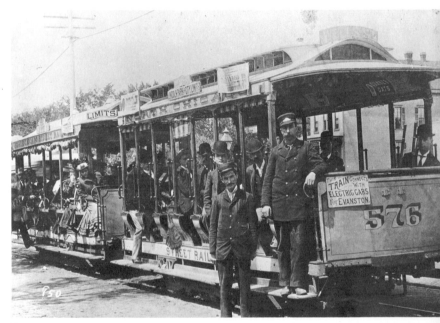

2

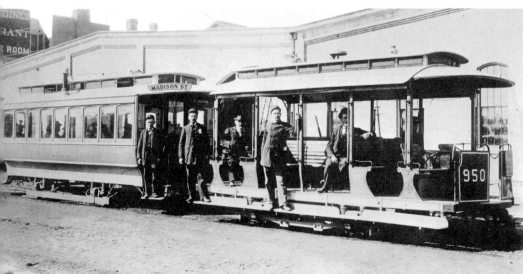

3

1. An Electric Street Railway Car, 1890's

The Chicago City Railway Company operated this type of equipment south and southwest of the central business district. (Courtesy West Side Historical Society, Legler Branch Library.)

2. Charles Tyson Yerkes (1839–1905)

"Charles Tyson Yerkes," wrote historians Paul Gilbert and Charles Lee Bryson in 1929, "lost a fortune in Philadelphia, made a new one in Chicago, gave the city transportation when it needed it, awoke the enmity of a combination of the city's most powerful men of finance, bludgeoned his way to success through legislative lobbies, 'back room' threats, and all in all, led one of the most colorful lives ever led in Chicago." (Engraving, J. K. Campbell, New York. Courtesy Chicago Historical Society.)

lightning." By the late 1880's the electric trolley had proved itself, and city after city retired the horses and the cable cars for the new invention. "The utility of electricity as a motive-power for the propulsion of street-cars is no longer a matter of question," pronounced the authoritative *Street Railway Journal*. Despite heavy investments in the cable car, Chicago jumped on the trolley very quickly.

Electricity soon replaced horses on established street railways, and nearly all new construction after 1892 used the latest innovation. The horsecar was soon relegated to the role of a short-line feeder for cable cars and trolleys, although the Dearborn Street line lasted until 1906. Chicago's need for mass transit induced rapid installation all over the city and into the sparsely settled areas beyond the municipal limits. Profits from these enterprises were usually good; hence stiff competition developed for franchises and customers. By 1893 more than 500 miles of track crisscrossed the city, sustained by more than 200 million fares a year.

In 1886 Charles Tyson Yerkes, an inconspicuous banker from Philadelphia, moved into the somewhat chaotic and highly competitive transit situation. Hoping to organize the system and scoop up the profits, he began to accumulate traction companies. The first was the North Chicago City Railway; next he obtained control of the Chicago West Division Railway. Then he built other lines. Under charters of eight separate companies

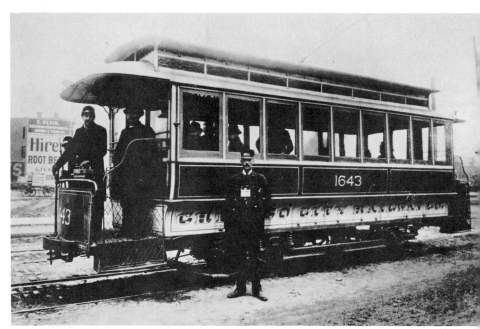

1

2

3. View West on Madison Street from Oak Park Avenue

Electric streetcars began to operate on West Madison Street in 1890. Even in 1903, when this photo was taken, houses were extremely sparse in many parts of the western suburb of Oak Park. But the electric streetcar's greater speed made it possible for more people to move farther out and still work downtown.
(Courtesy Oak Park Public Library.)

4. South Side Elevated Railway

Early passengers often complained about the conditions on the first elevated. The Forney engines had extremely short range and had to make frequent stops for refueling. The wooden open-ended coaches were badly heated in winter and seemed to collect heat in summer. Still, the elevated trains could move faster than surface cars, since grade crossing dangers could be disregarded.
(From *Chicago*, 1893. Courtesy Chicago Historical Society.)

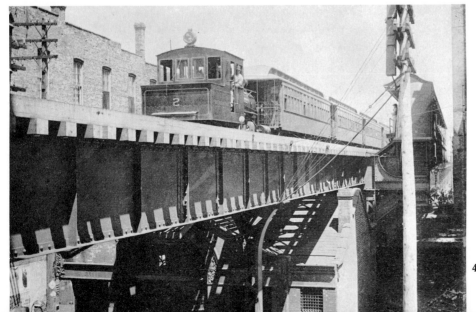

3

4

1. "Flat" Apartment Building on Erie Street, between State and Dearborn

Built in 1878, this structure was perhaps the first modern apartment building in the city. The construction of special structures containing many small suites for families had started in the late 1860's. In the next decade land values rose, making apartment buildings even more practicable. The first flat buildings were three to five stories, but the elevator was soon utilized to allow higher apartment buildings to be erected. In 1883 a newspaper report noted that flat apartments had risen "almost as if by magic on every main and cross street of the city."

(Courtesy Chicago Historical Society.)

he laid 250 miles of track and later merged them into the Chicago Consolidated Traction Company. Soon he was one of the biggest streetcar magnates in the United States—and one of the wealthiest. Yerkes' business tactics were not above question, and controversy constantly swirled around him. Later he sold his interests and moved to New York, taking his money with him but leaving behind one of the best street railway systems in the world.

The new cars carried people at speeds of from nine to twelve miles per hour, nearly doubling that of the horse railway. Not satisfied with this improvement, the South Side Rapid Transit Company started to build an elevated line using steam locomotives that would move passengers at fifteen miles an hour. Beginning at Twelfth Street in 1890, it reached Jackson Park on May 1, 1893, just in time to serve the Columbian Exposition. As with the cable car, the South Side led the way; but the West Side was not far behind. Planning for an elevated line there had begun in 1888, although it was not until late in 1893 that the first section from Market and Madison Streets to Lake Street and California Avenue was completed. And it was not until 1897 that the "Loop" system became a reality.

The broad influence of these innovations in mass transit can hardly be overestimated. The increased speed and efficiency permitted the vast expansion of the city beyond its earlier confines. Un-

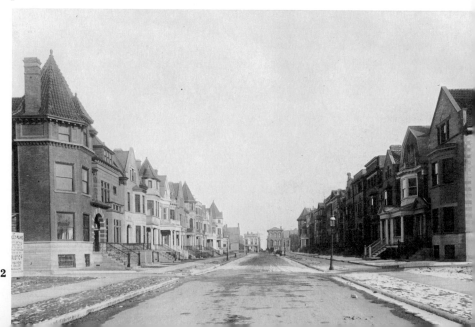

1

2

2. Two- and Three-Story "Town Houses," Thirty-Fifth Street and Cottage Grove Avenue

This Near South Side area was favored by excellent local transportation on the Illinois Central's lake front line and by the street railway on Cottage Grove Avenue. The narrow Chicago lots are quite apparent in this newly built area, even though these houses represented the living standards of all but the "best people."

3. Railroads Entering Chicago, 1893

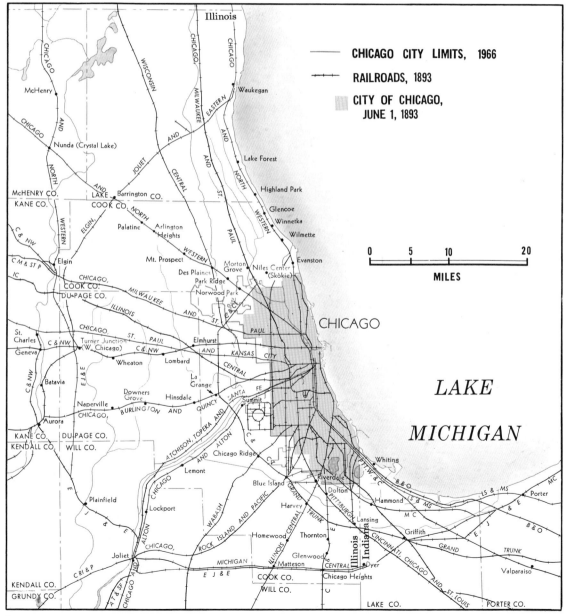

CHICAGO CITY LIMITS, 1966

RAILROADS, 1893

CITY OF CHICAGO, JUNE 1, 1893

144

1. J. J. Glessner Residence, 1800 Prairie Avenue

Built in 1886 by Henry Hobson Richardson, it has heavy granite walls which give it the appearance "almost like a medieval fortress." The design intentionally turned inward from the bustle of the city and toward an interior courtyard. Chicago historian John Drury has summarized the aims and effect of Richardson's work: "He wanted buildings that were simple, direct, solid and tastefully designed. He believed that beauty was to be found in strength. He achieved his aim and, in so doing, created a new architectural fashion. Romanesque buildings sprang up in all parts of America." (From the *Inland Architect* Press. Courtesy Chicago Historical Society.)

used land quickly fell to the developer; new and often expensive residences replaced shanties and irregular building on the outskirts of town. Mid-twentieth-century commentators would use the phrase "exploding metropolis" to convey the magnitude of the burst of urban expansion after World War II; but Chicago first exploded nearly a century before, with the introduction of new means of rapid transit.

On this enlarged urban canvas, the new patterns of land use became more sharply drawn. In the residential areas of the central city, population densities increased. The most frequent illustration of this tendency was the appearance of apartment buildings. Before the Fire these were rare; indeed visitors often thought nothing distinguished Chicago from New York so much as the absence of multifamily dwellings. By the 1880's, however, "flat fever" had set in, and apartments sprang up in many parts of the inner city. The first were built along car line streets like Cottage Grove, but they also appeared in once fashionable but now declining neighborhoods. In a single year, 1883, 1,142 flat buildings went up, signaling a more intensive use of land and the acceptance of a new kind of urban living.

More ominous was the appearance of tenement buildings. The acute housing shortage after the fire put a premium on any kind of shelter, and soon the West Side was peppered with ugly, frame bar-

1

2. Louis H. Sullivan Residence, 4575 Lake Park Avenue

Commissioned by his brother, Albert W. Sullivan, this house was the residence of Louis Sullivan between 1892 and 1897. The two major Sullivan architectural features—"form follows function," and the distinctive ornamentation—are both apparent in this building. This photo was taken in 1952. (Photograph, J. Sherwin Murphy. Courtesy Chicago Historical Society.)

3. George M. Pullman Residence, 1729 Prairie Avenue, about 1910

Prairie Avenue "was little more than a cow path running through sand dunes" when Marshall Field built his home there in 1873. In that same year, Pullman commissioned Chicago architect, John M. Dunphy, to design a mansion for him. After additions were made in 1879, newspapers placed its value between $350,000 and $500,000. Describing the home, historian Stanley Buder writes, "A three-story greystone with mansard roof, it was set in a private garden adorned by lighted fountains and a large conservatory. Its interior was ornamented with teak paneling, marble, and expensive furnishings, and . . . several hundred people could easily be entertained."
(Courtesy Chicago Historical Society.)

4. James Charnley Residence, 1365 Astor Avenue

Charnley was a wealthy lumberman who commissioned Adler and Sullivan to design a house for him, but it was probably Frank Lloyd Wright, an employee of the firm between 1887 and 1893, who conceived the general form. Writing about this house, Louis Sullivan's biographer, Hugh Morrison says: "Although Wright had completely mastered Sullivan's ornament, he tended when left free, to organize it in a tighter geometric fashion, eliminating much of the free-flowing efflorescence of Sullivan's leaf ornament and reducing it to a flatter plane; the difference between the detail of this balcony and Sullivan's own work is striking. . . . The Charnley residence may be considered as essentially a very early work of Frank Lloyd Wright."
(From the *Northwestern Architect*. Courtesy Chicago Historical Society.)

3

4

1. Southeast on Drexel Boulevard from Fortieth Street

An 1887 guide book lauded the attractive features of this boulevard which extended to Washington Park. "This grand drive, the equal of any in the country, is two hundred feet wide, and is ornamented with trees, shrubbery, grass plots, plants of many kinds, beds and borders of flowers, and such other attractive features as make it the favorite equestrain resort." Two- and three-story houses and apartments, each on its narrow lot, filled both sides of Drexel.
(From *Chicago*, 1892. Courtesy Chicago Historical Society.)

racks containing several families. Chicago had had no experience with "the tenement problem" before the Fire, but in 1872 the health commissioners urged the city council to pass legislation controlling the new menace. Yet the constant flood of newcomers, mostly immigrants, with their need for cheap rents, made this use of land profitable, and even mild attempts to control conditions in and around tenement buildings were frustrated.

On the other end of the social scale, the period was marked by the continued drift southward of the city's elite. The special rush was to Michigan Boulevard between Jackson Street and Thirty-fifth. Stockyard magnates, mercantile leaders, and the successful of all kinds built palatial houses along the favored thoroughfare, and the scramble for homesites pushed land prices skyward. But the undisputed hegemony still rested with Prairie Avenue around Eighteenth Street where Marshall Field, George Pullman, and Philip Armour built mansions costing over $200,000. The other avenues sustained their early prominence as the city parks and Washington Park Race Track attracted the established and aspiring elite. One of the colorful social rituals of the time was the Sunday promenade down Grand Boulevard (Martin Luther King, Jr. Drive) in the summer, where thousands of expensive carriages majestically bore the wealthy to the race track south of Washington Park.

On the West Side the conversion of

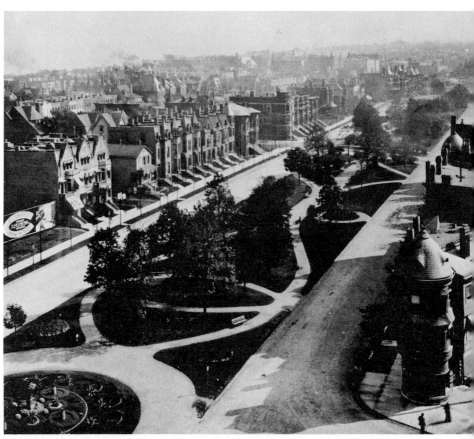

1

2. Grand Boulevard (Martin Luther King, Jr. Drive)

Grand Boulevard paralleled Drexel Boulevard. Each ran from Oakwood Boulevard (35th Street) to the northern edge of Washington Park (51st Street).
(From *Chicago*, 1892. Courtesy Chicago Historical Society.)

3. Michigan Avenue from Twenty-Fifth Street

"The drive along Michigan Avenue was very interesting," wrote William Morris in 1875. "The buildings here had all been built since the fire. They were principally villa residences of marvelous designs, and costing fortunes in their erection. Generally, they are detached, and standing in their own pleasure grounds and gardens, surrounded by beautiful shrubs and flowers."
(From *Chicago*, 1892. Courtesy Chicago Historical Society.)

4. Prairie Avenue, North of Twenty-Third Street
(From *Chicago*, 1892. Courtesy Chicago Historical Society.)

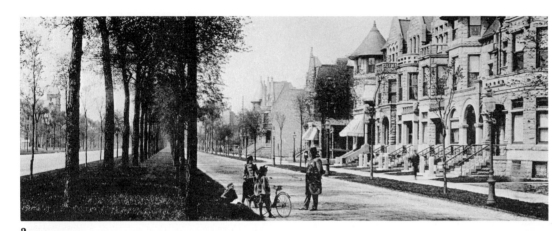

2

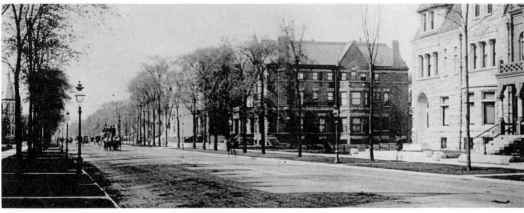

3

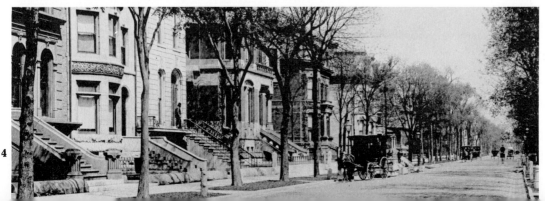

4

1. Meadow in Washington Park, about 1889

The sheep were allowed to graze in the park to help keep the grass down.
(Courtesy University of Chicago Library, Department of Special Collections.)

2. Picnicking in South Park (Jackson Park), about 1889

"I should doubt if any city is better provided with parks and boulevards than Chicago," the Englishman William Hardman wrote in 1884. "The area of the parks amounts . . . to about 1,500 acres, and the boulevards, many miles in length, vary from 200 to 400 ft. in width, the Avenue de l'Imperatrice at Paris having been the model which has been followed." Hardman added one qualification, however, "everything is not yet so completely 'fixed up' as the Old World, but both parks and boulevards are fine examples of landscape gardening."
(Courtesy University of Chicago Library, Department of Special Collections.)

1

2

3

3. Tennis in South Park (Jackson Park), about 1889
(Courtesy Englewood Historical Society, Kelly Branch Library.)

4. "Derby Day" at Washington Park Race Track

Washington Park, located on an eighty-acre plot south of South Park between 61st and 63d streets, Cottage Grove Avenue and Grand Boulevard (Martin Luther King, Jr. Drive), was "the aristocratic racing association of Chicago." The clubhouse cost $50,000; and S. S. Beman, the architect of Pullman, and N. F. Barrett, a landscape gardener, laid out the grounds. The grandstand alone cost $40,000, and the initiation fee for new members was $150.
(From *Select Chicago*, 1889. Courtesy Chicago Historical Society.)

4

1. Ashland Avenue from West Adams Street

Although Samuel Walker himself had gone bankrupt, his Ashland Avenue development continued to prosper, gradually filling up with two- and three-story buildings, and at the extreme right, by an office building.
(From *Chicago*, 1892. Courtesy Chicago Historical Society.)

2. First Skyscraper Office Building on the Near West Side

Located at the intersection of Ashland Avenue, Ogden Avenue, and Madison Street, this building, designed by Alfred Smith, stood until the early 1960's. The picture was taken in 1905.
(Courtesy West Side Historical Society, Legler Branch Library.)

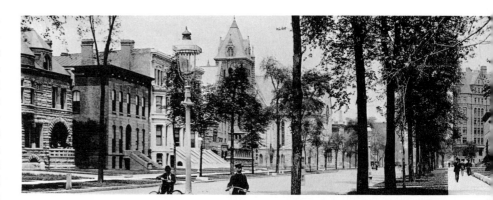

1

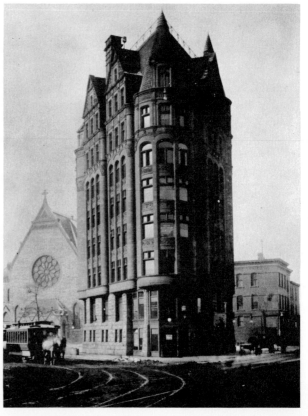

2

Washington Street into a boulevard beyond Ashland Avenue stimulated the development of a new group of fashionable neighborhoods. But since the access to downtown was through congested and unattractive working-class sections, this part of the city found it hard to compete with the South Side. Nor could the North Side compete either, although in 1884 Potter Palmer filled in a frog pond with a quarter-million dollar house and gave an impetus to what would later be known as Lake Shore Drive. In the 1860's his real estate policy had changed the orientation of retail activity; his move north of the river two decades later foreshadowed a similar residential shift.

As the well-to-do moved farther and farther away from the city's center, those of modest means took over the vacated areas. Many of these were second-generation Germans, Scandinavians, and Irish. They, too, were leaving the more congested regions that fringed downtown. Having succeeded modestly and anxious to express their improvement, the sons of immigrants found space in the older, fashionable areas. The cost of housing had declined with these neighborhoods and, though not cheap, prices and rents were manageable for people of limited means. Moreover, conversions to multifamily dwellings became increasingly frequent, increasing the density and threatening to depress land values even further. Nevertheless, these districts still represented a substantial improvement for the new residents who

3. Washington Boulevard and Ogden Avenue, Near West Side

This boulevard extended east and west between Halsted Street and Garfield Park, passing Union Park. An 1887 guide book noted that it was "the great drive of the West side, and is bordered by fine residences its entire length."
(From *Chicago*, 1892. Courtesy Chicago Historical Society.)

4. Garfield Park, 1892

Serving the West Side, Garfield Park was laid out by Frederick Law Olmsted in 1869 as part of the city's circumferential system of parks and boulevards.
(From *Chicago*, 1892. Courtesy West Side Historical Society, Legler Branch Library.)

5. Potter Palmer Residence, 1350 Lake Shore Drive, Late 1880's

"By far the most famous, probably the largest, and by all odds the most imposing house in our city is the Potter Palmer mansion, a mansion to end all mansions," was the way architectural historian Thomas Tallmadge described Palmer's North Side "castle." It was built in 1882 under the architectural direction of Henry Ives Cobb and Charles Sumner Frost. With Palmer's house on the Lake Shore Drive, land values nearby rose from $160 a front foot in 1882 to $800 in 1892. The structure was demolished in 1950 to make way for a high-rise apartment building.
(Courtesy Chicago Historical Society.)

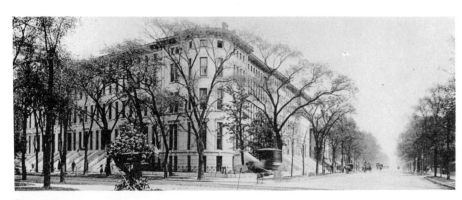

3

4

5

6

6. Pine Street (Now Michigan Avenue), North from Huron Street, about 1886

This high class residential area grew up just north of the downtown business district. The Chicago Avenue water tower is visible in the distance, and wood block paving covers the streets.
(Courtesy Chicago Historical Society.)

Typical of the small cottages built especially for workers, this was located within easy walking distance of the Milwaukee Avenue street car line. (Courtesy Chicago Historical Society.)

The owners of this cottage, located on the city's North Side, were forced to make adjustments for the change in grade. (Courtesy Chicago Historical Society.)

left behind some of Chicago's most deprived areas.

As the city grew and older residents moved outward, the central areas were quickly filled with newcomers. Indeed, they more than took up the vacated space, and soon crowding and congestion became more intense. By 1890 nearly seventy-eight per cent of Chicago's population was foreign-born or children of the foreign-born. Most arrived in this country poor and untrained for life in a great metropolis. Thus they sought companionship and consolation with others like themselves. Of course, certain portions of the city had already developed strong ethnic colorations, but the volume of the new immigration accelerated this tendency.

A substantial number of the newcomers were Poles. Although some lived in scattered enclaves, most settled in the northwestern sector of the city in an area bounded by Chicago Avenue, Clybourn Avenue, and Carpenter Street. Some occupied older downtown buildings, but many bought modest dwellings in new subdivisions farther out. By the mid-eighties, the *Tribune* asserted, more than half of the 30,000 residents of the "Polish section" owned their own homes. Nearby, Saint Stanislaus Kostka Church, at Noble and Bradley (Potomac) Streets, created a tie to the old country in the unfamiliar urban setting.

The Czechs were also relatively new to Chicago. A few had arrived earlier, but the significant numbers came in the

1

2

3. An Early Ecclesiastical Goods Shop Serving the Polish District on the Near Northwest Side

This small shop stood at what is now 1025 North Milwaukee in 1872, when this picture was taken.
(Courtesy Chicago Historical Society.)

4. Commercial Establishment that Served the Polish Community of Chicago

At the southeast corner of Noble and Division streets in 1890, this store was the headquarters of the Kosciusko Guards, named for the Polish patriot.
(Courtesy Chicago Historical Society.)

5. St. Stanislaus Kostka, after 1892

St. Stanislaus Kostka is one of America's first Polish churches. Begun in 1868, it quickly became the "Cradle of Chicago's Polish settlements." The church itself is located on the northeast corner of Noble and Bradley streets, but the rectory, an auditorium and school buildings cover the entire block northward to Ingraham.
(Courtesy Chicago Historical Society.)

3

5

4

seventies and eighties. Soon a congested colony called Pilsen sprang up between Halsted Street and Ashland Avenue south of Sixteenth Street. The Italians crowded into the area along Grand Avenue west of the river, where they found "hand-me-down" housing from the Germans, Irish, and Scandinavians who had left for roomier and more pleasant quarters. Many of the earlier Italian immigrants had come from mercantile and professional families in northern Italy and had dispersed throughout the city; the more recent arrivals, however, were poor, unskilled, and insecure. Hence, they created a Little Sicily on the edge of downtown where they could reconstitute something of the social landscape they had known at home.

The recent east European Jewish arrivals congregated on the West Side in an area bounded by Polk Street on the north, Blue Island Avenue on the west, Fifteenth Street on the south, and Stewart Avenue on the east. German Jews had been in Chicago almost from its inception, but the new migrants came from eastern Europe, and especially Russia. Many left all they had behind in a frantic escape from the pogroms. Thus when they settled in Chicago they had to take what housing they could find—dilapidated cottages, shanties, and three- and four-story brick tenements that lined the narrow streets and alleys of the Poor Jews' Quarter, as it was called.

While these newer groups were arriving in ever greater numbers, the sources of the older immigration did not decrease. The Germans still provided the largest part, and they continued to congregate on the Near North Side. But as the increasing population forced an expansion farther north and northwest, many of the second- and third-generation Germans, now successful and some well-to-do, left the old neighborhoods altogether and built handsome houses in the sparsely settled areas at the edge of the city.

The Irish also went through the same experience. Their increasing numbers could no longer be contained in the old areas, and they moved farther to the southwest. Although the Irish settlements grew, however, many dispersed into more mixed neighborhoods throughout the city. Indeed, some could be found in every ward, and the more prosperous chose the nearby suburbs.

The Scandinavians, among the earliest immigrants in Chicago, increased their numbers more rapidly than either the Germans or Irish. Constituting less than ten per cent of the foreign born in 1870, they took second place from the Irish by 1890 when they made up fifteen per cent. Settling originally on the North Side, they moved farther away from the center of the city, mostly north but also west, as successive generations acquired greater resources.

Thus, the pattern of Chicago's residential areas was shaped significantly by the continuous stream of immigrants who staked their future in the city. The process of incorporating all these newcomers into the city had a cold, grim logic, even though a generally satisfactory result. When they first arrived, migrants took what shelter they could find, usually in discarded houses, rear tenements and congested flats in the old areas near downtown. Conditions were barely tolerable: the areas were overcrowded, streets and alleys always were littered and often unpaved, buildings bulged with families, and jobs for the breadwinner were irregular and poorly paid. Yet in time the second and third generations climbed out of the slums, first into the better areas nearby, and then later into the pleasant neighborhoods of detached houses and comfortable two- and three-story flats around the edge of the city. Increasingly, the descendants of the first immigrants moved into the green suburbs beyond the municipal limits. This system of residential mobility permitted the gradual incorporation of all kinds of people into American life, and the central city became the staging ground for the upward movement of successive groups of newcomers.

The pressure of new population at the center combined with expanding transit facilities to encourage a rapid extension of Chicago's built-up area. But this expansion was not uniform. Rather, it took place most intensively along transportation lines that radiated away from the central business district. In the process,

1. Galvin Residence, 3303 Racine Avenue, Bridgeport

This house was purchased in the 1850's by Michael Galvin, who was employed in a lime plant nearby. The cottage is typical of the dwellings built by pioneer Irish and Germans who were employed in Chicago's infant industries in the heyday of the Illinois and Michigan Canal, when Bridgeport was the heart of one of the city's shipping and industrial areas. The low eaves of the building come from the raising of the grade.

(Courtesy Chicago Historical Society.)

2. Interior of the Illinois Staats-Zeitung office, Washington and Wells Streets, about 1896

The *Staats-Zeitung* was established as a weekly in 1848 and became a daily three years later. It was one of more than thirty German periodicals published in Chicago at one time or another during the nineteenth century.

(Courtesy Chicago Historical Society.)

3. Advertisement for Brick Cottages near Division and Western, 1883

S. E. Gross made a special appeal to Germans in this bilingual advertisement.

(Courtesy Chicago Historical Society.)

1

3

This subdivision by one of Chicago's leading realtors anticipated the area's major population growth by two years. Nearby industrial development to the south and good transportation to the city aided the area's growth for the next two decades. All the ingredients of a modest-income subdivision are here—the street railway, frame construction, schools, churches, and low taxes.
(Courtesy Chicago Historical Society.)

During 1853–54, James H. Rees and E. E. Hundley built this large hotel to draw attention to the potential of the surrounding property for high grade residential structures. Walter L. Newberry, looking east from the porch of the structure in 1854, suggested the name. By 1860 the Lake View House had the reputation of

small residential clusters around the edges, originally localized around suburban railroad stations, were swallowed up, new commercial centers appeared, and the inner suburbs were annexed. The result was an irregular star-shaped configuration, with the points of the star lying along the lines of rapid transit.

Lake View comprised the northern point of the star during this period. The area of continuous settlement had moved out about four miles from the Loop to Belmont Avenue; beyond lay an undeveloped frontier of sparsely occupied land toward Evanston. Railroad connections with the city and the extension of the streetcar lines created a corridor of residential and commercial building along the tracks, and around the old town of Lake View. Comprised largely of single-family dwellings on good-sized lots and new two- and three-story apartment buildings, this area became a series of pleasant suburban neighborhoods for the emerging Swedish, German, and Irish middle class.

The Ravenswood area was also part of this northern extension. Earlier, its truck farmers had sent produce to Chicago's markets, but by the late 1860's new residents began to cluster around the Chicago and North Western Railway station at Wilson Avenue. Its most significant growth, however, came in the 1880's and 1890's. Streetcar lines along Evanston Avenue (Broadway), Clark Street, and Lincoln Avenue, as well as new service on the Chicago, Milwaukee

being "a large and well-kept hotel," a guide book noted. "During summer it is quite a watering place, and seems destined to become the Saratoga of Illinois. Many of our prominent citizens reside there from April to September." As anticipated by its promoters, the hotel soon became a center around which was built a group of fine homesteads. It stood until 1890.
(Courtesy Chicago Historical Society.)

3. Lake View High School

Completed in 1874 after the state legislature passed a law allowing township high schools, the school building was constructed at the corner of Graceland (Irving Park Road) and Ashland Avenue. This location was nearly a mile from the nearest built-up area and four blocks from the terminus of the steam-dummy line on Clark Street, but the free land provided by the Graceland Cemetery Association proved a compelling incentive for township residents. The school was destroyed by fire in 1885, but was replaced in the

following year. By then a substantial population had moved into the vicinity.
(Courtesy Ravenswood–Lake View Historical Association, Hild Branch Library.)

4. Robert Rodman Clark Home, Southwest Corner of North Clark Street and Barry Avenue

Built originally about 1860, this house had several additions over the next decades. This picture was taken in 1911.
(Courtesy Ravenswood–Lake View Historical Association, Hild Branch Library.)

2

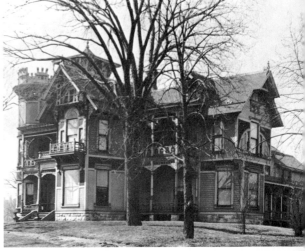

4

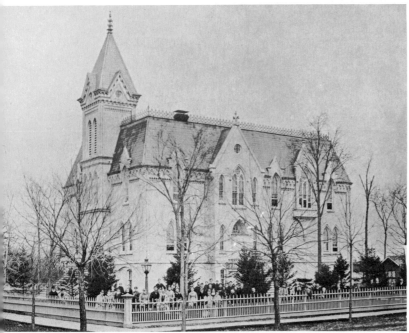

3

1. Southeast Corner of Ravenswood and Sunnyside Avenues

This small business center grew up around the Ravenswood station of the Chicago and North Western Railway. Local merchants here had to compete with the merchants of both Lake View and downtown.
(Courtesy Ravenswood–Lake View Historical Association, Hild Branch Library.)

2. Arlington Avenue (Magnolia Street) North of Leland Avenue, 1891

The half-mile stretch of land immediately north of Graceland Cemetery was subdivided and laid out in the spring of 1891. This photograph was made as sidewalks, pavements, and utilities were being installed. The "bulldozer school" of building was already apparent, with developers leveling everything before putting in planned landscaping.
(Courtesy Ravenswood–Lake View Historical Association, Hild Branch Library.)

& St. Paul, brought population out to what is now Uptown. As in Lake View, detached houses and new flats attested to the area's middle-class character.

The northwestern extension of this urban configuration was formed by Milwaukee Avenue, originally a plank road and later a busy streetcar thoroughfare, and the Chicago and North Western Railway, which early established local passenger service into this section. By 1871 the built-up area reached to Western Avenue and Fullerton Avenue, the northwestern corner of the municipal limits. Beyond this, however, the inner suburbs grew. West Town (East Humboldt), Maplewood (now part of Logan Square), Avondale, Portage Park, Jefferson Park, and Norwood (Norwood Park) all developed along this transportation corridor. Many of these settlements had their origins in the 1840's and 1850's, but the residential rush did not materialize until much later. Yet by 1893 all were annexed to the city. And the familiar thrust of immigrant groups outward was well under way as the Poles began to displace Germans and Scandinavians in the neighborhoods nearest downtown.

The West Side was less fluid in this period than the other two municipal divisions; consequently the point of western extension remained closer to the central city. Indeed, Chicago's present silhouette with its pinched-in waist developed in this period. The key to the slower expansion is to be found in conditions on the Near West Side. Already

1

2

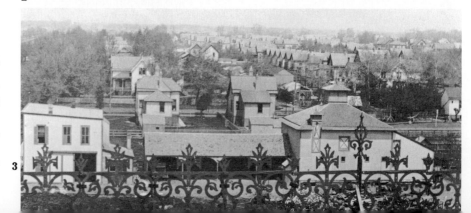

3

3. North from Atop the Bennett Building, Northeast Corner of East Ravenswood Avenue and Wilson Avenue, about 1889

The Bennett building, for many years the community social center, was adjacent to the Ravenswood station of the Chicago and North Western Railway, the tracks of which are visible on the extreme left. Immediately in the foreground was a livery stable. Mass produced dwellings were common. The deep ditches along the unpaved streets on the left were part of the original drainage system established by the Ravenswood Land Company in 1869. The desire for a more efficient sewage system forced Ravenswood to be annexed to Lake View in 1887 and to the city of Chicago in 1889.
(Courtesy Ravenswood–Lake View Historical Association, Hild Branch Library.)

4. Paulina Street between Wilson and Leland Avenues

These large single-family frame houses were within two blocks of the Ravenswood station of the Chicago and North Western Railway.
(Courtesy Ravenswood–Lake View Historical Association, Hild Branch Library.)

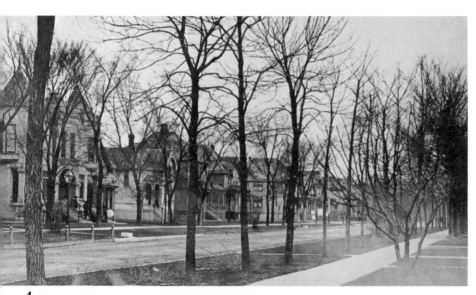

4

5

5. North Branch of the Chicago River, North from Sulzer Road (Montrose Avenue), Late 1880's

This stretch of river formed the general boundary of the Lake View–Ravenswood area. The nearby Diamond Race Track attracted residents from the city.
(Courtesy Ravenswood–Lake View Historical Association, Hild Branch Library.)

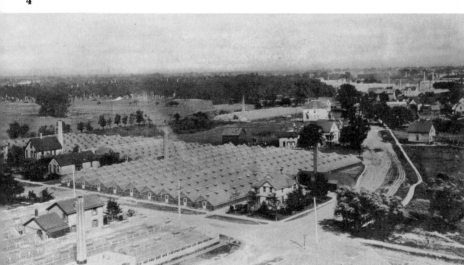

6

6. Budlong Greenhouses in Bowmanville in the Late 1890's

A characteristic use of urban fringe land was the development of intensive horticulture, with most of the produce being sold in the city. The Budlong farms, while serving the city of Chicago, developed a regional market well before 1900. In the distance is Budlong's Woods, which was not developed until legal impediments were removed in the 1940's.
(Courtesy Ravenswood–Lake View Historical Association, Hild Branch Library.)

1. Houses of Working People, Southwest Area of the City, 1880–90
The exact location of this photograph is not known, but it is typical of the houses of those who were making the first step out of the ghetto. One-family cottages, two-family houses, and triple-deckers show the increasing density in the city's inner-city neighborhoods.
(Courtesy Chicago Historical Society.)

the "port of entry" for thousands of immigrants who came to the city each year, it became increasingly congested. Moreover, Madison Street, the section's major east-west axis, contained many of the least attractive commercial enterprises. In addition, public transportation here was slower and less efficient than elsewhere. All these factors combined to retard the kind of rapid residential movement that characterized the rest of the city.

The Near West Side had always been a working-class area. Many of the original residents had worked on the canal or early railroads; others had found jobs in the factories along the south branch of the river. Housing had never been satisfactory; two-story wooden dwellings, rear tenements, and jerry-built flats had put too many people in a confined spot. And as the Irish and Germans moved out, newcomers from eastern Europe, with even fewer resources, jammed in. What remained of older and pleasanter places was soon overrun by the spreading blight.

Hull House stood amid the changing scene—at once a witness to the process and a symbol of help to distressed newcomers. When Charles Hull built it in 1856 at 800 S. Halsted Street, the area was at the edge of the city, a pleasant resort of the well-to-do. As the neighborhood changed, the house became successively a secondhand furniture store, a factory, and then a home for the aged. In 1889 a young woman from Rockford,

Jane Addams, rented a few rooms so that she could live near the city's poor and discover their problems and tend to their needs. Within a few years she and her co-workers had founded her settlement, taken over the entire building, and named their enterprise Hull House. Soon it was among the most famous buildings in Chicago.

From Hull House Jane Addams could see the new ethnic composition of the district. "Between Halsted Street and the river live about ten thousand Italians," she wrote. "In the south on Twelfth Street are many Germans, and side streets are given over to Polish and Russian Jews. Still farther south, thin Jewish colonies merge into a huge Bohemian colony, so vast that Chicago ranks as the third Bohemian city in the world." Northwest she found French Canadians, still clannish, and to the north were "Irish and first-generation Americans." Beyond them were a few "well-to-do English speaking families" as well as "one man . . . still living in his own farmhouse."

The history of the changing area could also be read along Madison Street. Near downtown it harbored skid row—block upon block of buildings converted into "hotels," rows of secondhand stores, and a generous sprinkling of cheap saloons. Half a mile west, at Halsted Street, a major commercial center grew up at the junction of busy streetcar lines. Beyond lay a fashionable residential district of large and stately town houses around

Ashland Avenue. And outside the municipal limits stretched the scattered suburban settlements of Austin and Oak Park. Thus Madison Street was a plumb line that touched the bottom of urban life at one end and stretched to the emerging upper society at the other.

The intensively built-up area of the West Side reached only to Crawford Avenue (Pulaski) by 1893, and the extended corridor did not go beyond Austin Boulevard, although there were suburban clusters farther west. To the southwest, however, the urbanized area spread much more rapidly, extending all the way to Sixty-seventh Street in Englewood. The junction of three railroad routes at Sixty-third Street formed the original inducement for settlement, for each provided quick and easy access to downtown. No single avenue developed as the main street axis, but a series of surface car lines served the section and permitted the rapid filling up. Irish, Germans, and older residents, all moving from the inner city, gave a cosmopolitan and middle-class flavor to the new area.

Farther out, new settlements sprang up. Places like Beverly and Morgan Park would soon become part of Chicago, but they began their history as suburban outposts. Indeed, the developers sought to create communities that would attract the prosperous and successful by combining the advantages of both city and country. Although the village plats used curved streets to emphasize the distinction between the new

2. Madison Street, West from Union Avenue with Halsted Street Intersection in the Middle Distance, 1892

This early commercial center gradually developed into one of Chicago's skid rows. Many of the buildings in this picture were subsequently converted into substandard "hotels" for transients and derelicts. In the 1950's the buildings in the immediate foreground were demolished to make way for the Kennedy Expressway.
(From *Chicago*, 1892. Courtesy Chicago Historical Society.)

3. Austin, Northwest from Town Hall, about 1888

Much of the Austin community on the far West Side was subdivided in the 1850's, but it was not until hourly suburban train service came in the 1880's that much growth occurred. By 1890 Austin had over 4,000 people. In the following decade further transportation development—the Lake Street Elevated, Garfield Park branch elevated to Cicero, and the Madison Street and Chicago Avenue line—stimulated further growth. By 1920, 74,000 lived there; a decade later the population reached 131,000.
(Courtesy West Side Historical Society, Legler Branch Library.)

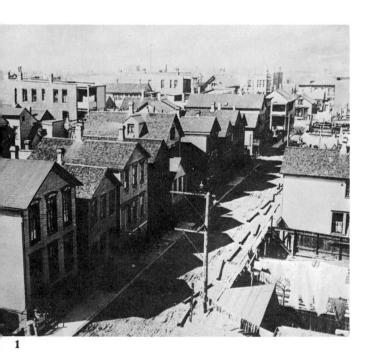

1

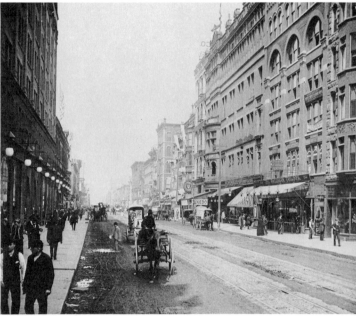

2

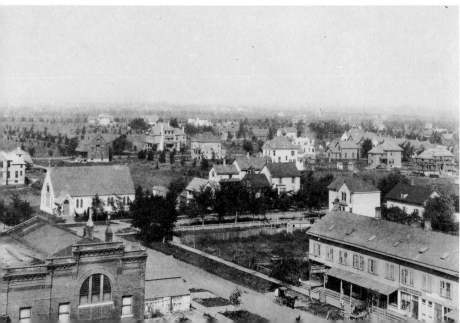

3

1. View Southwest from the Top of the Town Hall, about 1890
Austin's city hall and shopping area erected near the railway station reflected the significance of commuter service in the community's early development.
(Courtesy Albert C. Hulit Collection.)

2. Looking Northwest to Corner of Lake and Park (Parkside), 1888
A three-story building, with commercial establishments on the first floor and residences above, stands on a corner lot of a development largely occupied by large, single family units.
(Courtesy Albert C. Hulit Collection.)

3. Looking Northwest to the Corner of Lake and Parkside, 1963
(Courtesy Albert C. Hulit Collection.)

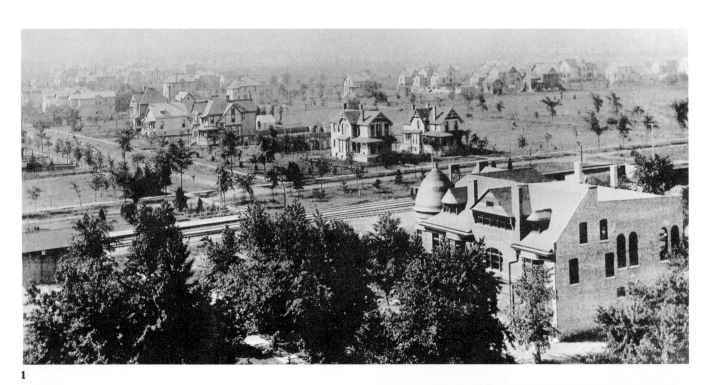

1

2

3

5, 6, 7. Sixty-Third Street and Wentworth Avenue, Southeastward, 1889

Sixty-third Street is in the foreground crossing the railroad tracks of the Pittsburgh, Fort Wayne and Chicago (Pennsylvania, now Penn Central) Railroad (from the bottom left) and the Rock Island railroad. The Lake Shore and Michigan Southern (New York Central, now Penn Central) tracks curve past the Englewood station in the distance. Until 1867 this railroad crossing was called Junction Grove; after 1884, eight railroads with several routes connected Englewood with the city of Chicago.
(Courtesy Englewood Historical Society, Kelly Branch Library.)

5

6

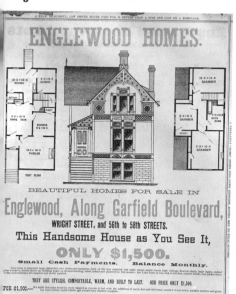

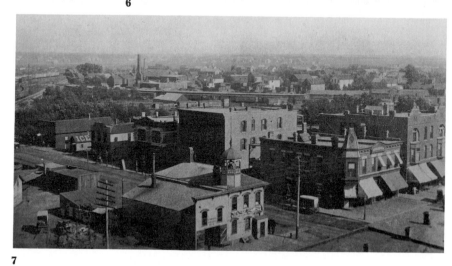

7

4. Advertisement for Homes in Englewood, Published between 1882 and 1885
(Courtesy Chicago Historical Society.)

1. View Northeastward with the Sixty-First Street Viaduct in the Middle Distance, 1889
(Courtesy Englewood Historical Society, Kelly Branch Library.)

2. Looking Southwesterly across the Intersection of Sixty-Third Street and Yale Avenue, 1889

This photo was taken from what is now approximately the location of the 63d Street viaduct across the Dan Ryan Expressway. The church at the upper left is the First Presbyterian at 64th and Yale; that on the upper right is the First Methodist Episcopal, at 64th and Stewart.
(Courtesy Englewood Historical Society, Kelly Branch Library.)

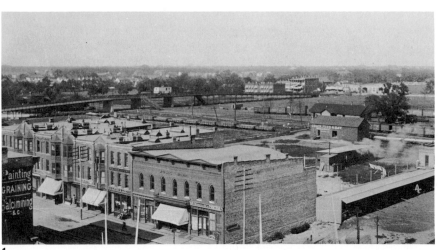

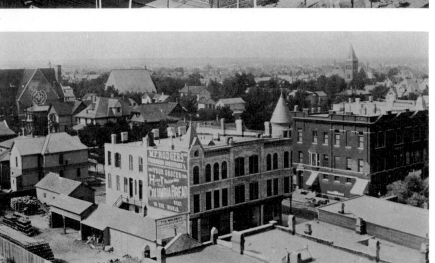

1

2

3. Buildings on the Normal School Campus in Normalville (Normal Park), between 1888 and 1891

Englewood residents competed with residents of Blue Island and Norwood Park to get this early Cook County teacher training institution, finally putting up $25,000 and twenty-five acres of land to obtain it permanently in 1869. On the left is Lewis School, built in 1864; on the right is Champlain School built in 1859 as Englewood's first school, and in the rear is the Englewood High School, first occupied in 1888.
(Courtesy Englewood Historical Society, Kelly Branch Library.)

4. Plat of Morgan Park, about 1905

Morgan Park's streets are bisected by the two lines of the Chicago, Rock Island and Pacific Railroad, the main line on the east and the suburban line on the west. The curved streets are on the slope of the Blue Island ridge, contrasting sharply with the rectangular grid of the level plain to the east.

(From *Homes for the People*, published by Blue Island Land and Building Company. Courtesy Chicago Historical Society.)

5. Transportation Facilities—"The Way We Get to Morgan Park"

Appearing in a Morgan Park Real Estate brochure, these two cuts with their original captions emphasized the attraction of the suburb. The monthly fare was low, $5.25 per month, and "when the change of season requires it" riders would find "a warm car and a roomy seat."

(From *Homes for the People*, published by Blue Island Land and Building Company. Courtesy Chicago Historical Society.)

6. Depot at Morgan Park

(From *Homes for the People*, published by Blue Island Land and Building Company, Courtesy Chicago Historical Society.)

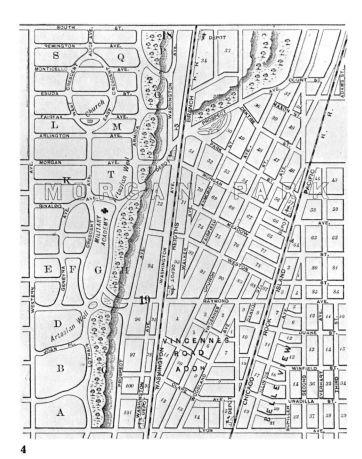

4

The way we get to Morgan Park.

5

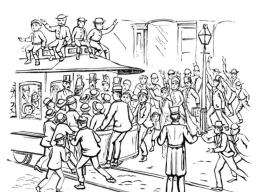

The way the city people get to their homes.

6

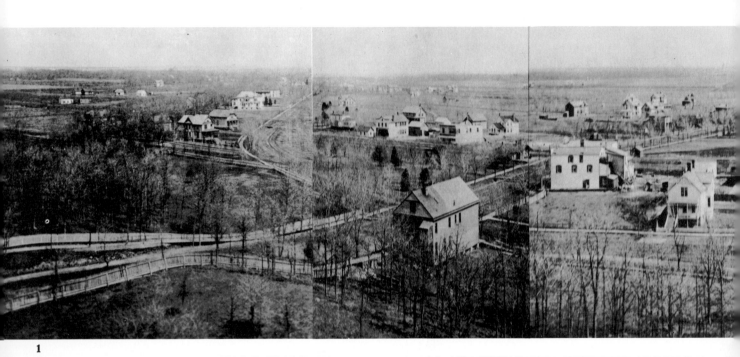

1

1. Panorama View East from the Top of Blue Island Ridge, between 111th and 112th Streets, 1889

The intersection at the left foreground is 111th Street (Prospect Avenue) and Longwood Drive, the latter winding along the base of the ridge. In the middle distance is the branch line of the Rock Island railroad; the main line is barely visible across the plain.
(From *Views of Morgan Park*. Courtesy Morgan Park Historical Society, Walker Branch Library.)

2. Panorama View Northwest from the Observatory, 1889

The large building on the right is the Baptist Theological Seminary, which came to Morgan Park after the Blue Island Land and Development Company offered the Seminary five acres free, contingent on their permanent residence in Morgan Park. Here one aspect of theological education was the training of ministers in Scandinavian languages, so that they might be able "to preach the Gospel to this race of people."
(From *Views of Morgan Park*.
Courtesy Morgan Park Historical Society, Walker Branch Library.)

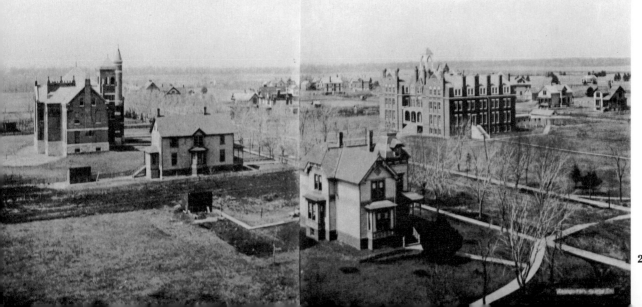

Morgan Park, Neighborhood Shots

Most of these pictures were taken by itinerant photographers who earned a living out of making postcards from snapshots of recently finished houses. Moving down the street, they covered every residence. After developing the film, they returned and sold copies to prideful homeowners, who sent them to distant friends. The practice ended with the appearance of cheap cameras. The few remaining collections, however, constitute a rare inventory of early neighborhood housing.

1. D. C. McKinnon Residence, Southwest Corner of 111th Street and Armida Avenue (Hoyne), 1889
(From *Views of Morgan Park,* Courtesy Morgan Park Historical Society, Walker Branch Library.)

2. A. McPhee Residence, 11313 Fairfield Avenue, 1905
(Courtesy Chicago Historical Society.)

3. 11007 Esmond Avenue, 1905
(Courtesy Chicago Historical Society.)

1

2

3

7

8

9

12

4. 11331 Avon, 1905
(Courtesy Chicago Historical Society.)

5. 11024 Crescent, 1905
(Courtesy Chicago Historical Society.)

6. 10710 Longwood Boulevard, 1905
(Courtesy Chicago Historical Society.)

7. 11322 Prospect Avenue, 1905
(Courtesy Chicago Historical Society.)

8. Gilbert S. Wright Residence, Northwest Corner of 111th Street and Bell Avenue, 1889
(From *Views of Morgan Park*. Courtesy Morgan Park Historical Society. Walker Branch Library.)

9. 11318–20 Walker Avenue, 1905
(Courtesy Chicago Historical Society.)

10. 11320 Lothair Avenue, 1905
(Courtesy Chicago Historical Society.)

11. 10772 Prospect Avenue, 1905
(Courtesy Chicago Historical Society.)

12. 10924 Prospect Avenue, 1905
(Courtesy Chicago Historical Society.)

13. 2304 Morgan Avenue, 1905
(Courtesy Chicago Historical Society.)

14. 10705 Church Street, 1905
(Courtesy Chicago Historical Society.)

4

5

6

10

11

13

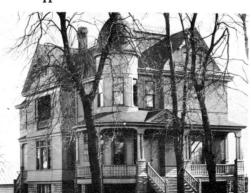

14

1. The Core of the University of Chicago Campus in the 1890's
The large building in the foreground is the Ryerson Physical Laboratory. The omnibus, which carried passengers for five cents each, connected the campus with the 57th Street station of the Illinois Central Railroad, one-half mile to the east.
(Courtesy University of Chicago Library, Department of Special Collections.)

2. Science Buildings on University of Chicago Campus, 1902–5
(Courtesy University of Chicago Library, Department of Special Collections.)

villages and the relentless grid of the metropolis, their location along the Rock Island railroad and at the termini of streetcar lines testified to their connection with Chicago.

The whole process was perhaps best illustrated by a publication of Morgan Park boosters in 1889. The village, they argued, was "much superior to other localities" because it was "near enough to Chicago and sufficiently far removed to afford all the blessings of a Suburban Home with all the conveniences and advantages of the city, far from all its objectionable features." Not only did the Rock Island run forty-six trains daily to Morgan Park, but "electric cars" left every twenty minutes for Seventy-ninth Street. Not the least attraction was the site and the scenery. Set on a ridge one hundred feet above Lake Michigan, it claimed to be located in "semi-mountainous" country, on "the oak-shaded heights of the Blue Island plateau." Of course, the boosters concluded that "the LOVELIEST PEAK OF THE CHAIN IS MORGAN PARK." Within a few years this sylvan sanctuary had become part of Chicago.

The South Side was the area of greatest expansion, its built-up area stretching to Seventy-ninth Street, with irregular development reaching almost to the municipal boundaries in 1893. Its excellent transportation—the Illinois Central Railroad and the extensive cable and electric street service on Cottage Grove Avenue —permitted extraordinary growth. In

1

2

3. An Early View of Marshall Field (later Stagg Field), University of Chicago, Probably in the 1890's

The field was originally named Marshall Field by custom, but student demand in 1914 led the university to rename the ground Stagg Field for Amos Alonzo Stagg, first athletic director to be appointed a regular professor in any American university.
(Courtesy University of Chicago Library, Department of Special Collections.)

4. Girl's Intramural Basketball Game, University of Chicago, about 1903

The three-story, bay-windowed apartment buildings behind the field were erected as part of the building boom in preparation for the World's Columbian Exposition.
(Courtesy University of Chicago Library, Department of Special Collections.)

3

4

1. Timetable of Illinois Central Suburban Service, November, 1871
(Courtesy Illinois Central Railroad.)

2. R. Strahorn Residence in Kenwood
 Kenwood was originally named by Dr. John A. Kennicott, who built a residence near the Illinois Central tracks south of 43d in 1856.
(From *Kenwood*, 1892. Courtesy University of Chicago Library, Department of Special Collections.)

3. Kimbark Avenue South from Forty-Seventh Street, Kenwood
 In the decade after 1885 quiet residential streets, planned landscaping, and urban services combined with excellent transportation to make Kenwood the elite suburb of the South Side.
(From *Kenwood*, 1892. Courtesy University of Chicago Library, Department of Special Collections.)

addition, the establishment of the University of Chicago in 1892 and the Columbian Exposition the next year, together with the city's first elevated railway, substantially accelerated this development. The period between the Fire and the Fair was the South Side's golden age.

The areas of greatest growth lay outside the municipal boundaries of the city, in Kenwood and Hyde Park. Both were located along the Illinois Central and prospered by quick and efficient commuting service, and both attracted relatively wealthy residents. Kenwood, especially, developed the customary suburban signatures—large homes, ample lots, and careful landscaping. The density of Hyde Park was, however, higher. Commercial enterprises grew up around the railroad stations, and the Fair and the University stimulated apartment and hotel construction. Single-family houses still predominated, but the mixture of uses so characteristic of Hyde Park appeared early and by 1893 had become established. The parks which girdled these communities not only made them pleasant neighborhoods for the early settler but, in the long run, gave them a greater resistance to residential change than many other urban neighborhoods.

Woodlawn, across the Midway Plaisance from Hyde Park, also received a great impetus by the location of the Columbian Exposition and the new university. In a few years it was transformed from a sparsely occupied, largely un-

TIME TABLE--GOING NORTH.
To Take Effect Nov. 12th, 1871

Daily, except Sunday. *Lv.*	A. M.	A. M.	P. M.	P. M.	P. M.
Park Side	7.00	8.48	12.46	3.36	6.46
Oak Woods	7.05		1.05	4.30	6.55
Wood Lawn	7.11	8.50	1.11	4.36	7.01
South Park	7.13	8.51	1.13	4.38	7.03
Hyde Park	7.16	8.52	1.16	4.44	7.06
Kenwood	7.19	8.54	1.19	4.46	7.09
Reform School	7.21	8.56	1.21	4.48	7.11
Oakland	7.23	8.58	1.23	4.50	7.13
Fairview	7.26	9.01	1.26	4.52	7.16
31st Street	7.29	9.03	1.28	4.54	7.18
27th Street	7.32	9.05	1.30	4.55	7.20
22d Street	7.35	9.07	1.33	4.58	7.23
Weldon	7.37	9.10	1.35	5.05	7.25
Park Row	7.39	9.12	1.37	5.07	7.27
Central Depot *Ar.*	7.47	9.20	1.45	5.15	7.35
	A. M.	A. M.	P. M.	P. M.	P. M.

1

2

4. Fifty-First Street (East Hyde Park Boulevard), Eastward from Lake Avenue (Lake Park Avenue), 1894

The Illinois Central track elevation was completed in 1893, adding to the safety and speed of suburban transit. This was the first of an extensive series of track elevation projects involving most Chicago railroads between 1892 and 1910. The large white building is the first Chicago Beach Hotel, later replaced by a larger structure which in turn was converted into an army hospital during World War II and later utilized as Fifth Army Headquarters.
(Courtesy Illinois Central Railroad.)

5. Northeast Corner of Lake Avenue (Lake Park Avenue) and Fifty-Sixth Street, 1892

Trainor's was one of the best known taverns of Hyde Park. The area in the picture is now occupied by the newly-constructed town houses of Harper Terrace, a portion of the Hyde Park urban renewal project.
(Courtesy Woodlawn Historical Society, Woodlawn Branch Library.)

6. Del Prado Hotel, on Fifty-Ninth Street between Blackstone and Dorchester Avenues, Hyde Park

Erected in anticipation of the visitors to the Columbian Exposition held in nearby Jackson Park and on the Midway, the Del Prado stood until 1930, when it was replaced by the International House on the University of Chicago campus.
(Courtesy Woodlawn Historical Society, Woodlawn Branch Library.)

3

4

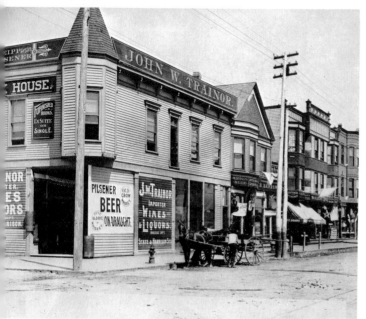

5

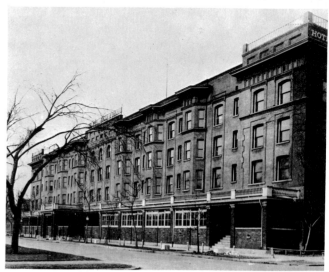

6

174

1. Sixty-Third Street and South Park Way (Martin Luther King, Jr. Drive), 1892

So sparse was the early settlement of Woodlawn that residents in the 1890's recounted that they were able to shoot duck and snipe in the neighborhood. To bring business and settlers to Woodlawn, John R. Towle led the property owners along 63d street to get the South Side Elevated Railroad company to extend their service along that street to Jackson Park.
(Courtesy Chicago Historical Society.)

2. Sixty-Fourth Street Eastward from the Illinois Central Tracks, Immediately before Elevation of the Railroad, 1892

The buildings of the Columbian Exposition are under construction in the distance.
(Courtesy Illinois Central Railroad.)

developed area into a community of more than twenty thousand people. One of the important agents of this transformation was the provision of elevated service to Sixty-third Street for the Fair. It not only connected the new area with the city, but it also created a commercial axis in the neighborhood and provided Woodlawn with its familiar landmark.

The explosive expansion of the city was, of course, accompanied by all kinds of real estate development and speculation. At the height of the land boom in 1890 the veteran real estate firm of S. E. Gross sold as many as five hundred lots a week. It and other large subdividers, such as E. A. Cummings, operated free excursion trains to the new sites, providing free lunches, band concerts, fireworks displays, and bicycle races to entertain prospective buyers. In one day alone, Gross took 3,000 people in twenty-seven railroad cars out to see his West Side property. Much of this activity was pure speculation, and the *Tribune* warned that "values are so full of wind that if any more is pumped in, the blue arch of heaven will have to be lifted to make room for their expansion." Hard times in the 1890's put an end to this kind of activity, but Chicago's actual growth furnished a firm basis for increasing land values over the long run, and some of the city's largest fortunes were built on real estate development.

1

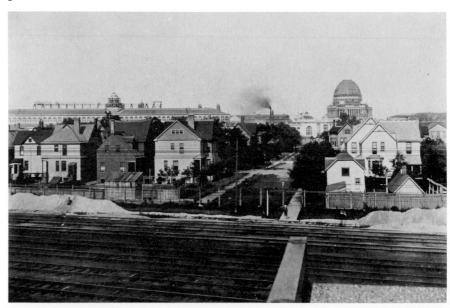

2

3. Sixty-Third Street, East from the Illinois Central Railroad Crossing, 1892

While the buildings of the Columbian Exposition were still being constructed, hotels, both temporary and permanent, sprang up in anticipation of the crowds coming to see the Fair, and for workmen. By the time the Fair opened, the grade crossing had been eliminated by track elevation.
(Courtesy Illinois Central Railroad.)

4. Sixty-Sixth Street (Marquette Road), East from the Illinois Central Railroad

Chicago's suburban real estate development story is told well in this single picture. Here, streets are graded, though unpaved, drainage is poor, with water standing in the curbed street gutters, saplings have been planted to alleviate the bleakness of the landscape, board sidewalks have been added, and street lights erected.
(Courtesy Illinois Central Railroad.)

3

4

1. Jefferson Township Jail, Northeast Corner of Milwaukee Avenue and Graceland (Irving Park Road), about 1870

Police forces in the suburbs were small and usually ill-trained. Indeed a Ravenswood newspaper in 1889 complained editorially that "a policeman had not been seen in weeks." Following annexation, this building became the 36th Precinct Police Station. It was demolished in 1924.
(Lillian M. Campbell Memorial Collection. Courtesy West Side Historical Society, Legler Branch Library.)

2. Water Tower and Pumping Station, 1891

Looking northeast, this Chicago landmark was surrounded mainly by large residential buildings a quarter century after it was built. Land fill had placed the Water Tower far inland in the 1960's; in the 1890's it was close to the lake.
(Courtesy Chicago Historical Society.)

June 29, 1889, is one of the most important dates in Chicago's history. On that day, voters in a surrounding 120 square miles elected to join the city. This action came only after a long and bitter campaign in which almost all the arguments now raised against metropolitan government were used to prevent the merger. But the rapidly growing suburbs found the opportunities opened up by cooperation more attractive than continued independence. Especially appealing to suburbanites were the police and fire protection offered by the city and the chance to be served by growing and efficient water and sewage system. By 1893 Norwood Park, Rogers Park, and additional parts of Calumet were also annexed, bringing the total area of the city to 185 square miles. These annexations brought the fastest growing residential areas into the city. The population of the "old" Chicago increased from 503,000 to 792,000, or fifty-seven per cent, between 1880 and 1890. In the same decade the annexed townships jumped from 40,000 to 308,000, a gain of 650 per cent. Chicago's population now comfortably passed the million

1

2

3

3. Fisk Street Generating Plant

Chicago had to expand its utility services quickly in the 1890's to meet the needs of its newly annexed suburban areas. Fisk Street Plant is the oldest generating plant of the Commonwealth Edison Company. It still stands, in a much expanded form, in 1969.
(Courtesy Commonwealth Edison Company.)

Chicago Annexations

CITY OF CHICAGO, 1871

0 1 2 3 4 5

MILES

178

1. View of Oak Park-Harlem (Now Forest Park and River Forest), 1873

Cutting diagonally through this rendering is the Chicago and North Western Railway. On it a train is approaching the Oak Park Station at Marion Street (Oak Park Avenue). At the intersection of North Boulevard and Euclid is a small pond, which first served as a swimming hole for local boys and later as an open-air reservoir as part of Oak Park's first water works. This depiction is by an itinerant German artist.
(Courtesy Oak Park Public Library.)

2. Chicago and North Western Station, Oak Park, Looking West on Marion Street (Oak Park Avenue), 1882

While the first railroad came through Oak Park in 1848, the little village did not have its own station until 1872, when the Chicago and North Western moved its station from Harlem (now River Forest). Five years later the railroad was running thirty-nine trains daily, except Sunday, between Oak Park and the Wells Street depot. In 1872, the village had a population of about 500.
(Courtesy Oak Park Public Library.)

mark; New York alone among the American cities had more people.

Even these extensive additions did not contain all the land or people of the metropolitan area. Beyond the municipal limits, suburban growth continued unabated. To the north, Evanston quickly developed into a small city. In fact, its expansion presented Chicago with an effective barrier to future annexations on that border. The rapid rise of Oak Park ultimately had the same effect on the west. Though settled as early as the 1850's, it did not flourish until the establishment of good commuting service thirty years later. But by 1884, the historian A. T. Andreas could describe it as a "pleasant suburban town" with "beautifully shaded" streets and "an unusually large proportion of tasteful and elegant residences."

1

2

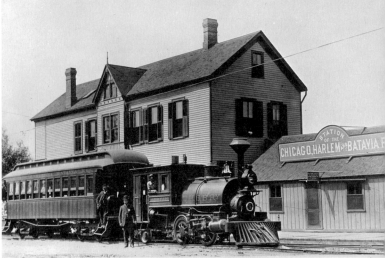

3

3. Eastern Terminal of the Chicago, Harlem and Batavia Railway, about 1885

This steam railway line connected here, at 40th Avenue (later Crawford Avenue, and finally Pulaski Road) and Randolph Street, with the western end of Chicago's West Side street railways. By 1888 the Oak Park *Reporter* could declare that "facilities for reaching the city from western suburbs could not be surpassed. . . . The accommodation to the traveling public is incalculable."
(Courtesy Al Johnson.)

4. Scoville Place, 1900

Located at 515 Lake Street, this large, rambling house was the home of James W. Scoville, who, among other achievements, laid the village's first water pipes in 1885. The Scoville house was built in 1860 and was razed in 1913. At the time this photograph was taken, it was the oldest house in Oak Park.
(Courtesy Oak Park Public Library.)

5. First School, Meeting Hall, and Church in Oak Park

Oak Park got its first school in 1857; it was built by Cicero Township, of which Oak Park was then a part. Another school was built two years later, and an addition was made to that in 1873. Oak Park High School followed in 1890, and the old school building in the photograph was torn down soon afterwards.
(Courtesy Oak Park Public Library.)

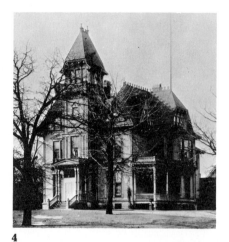

4

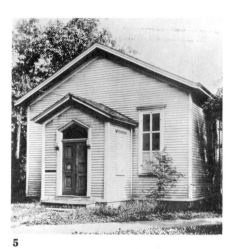

5

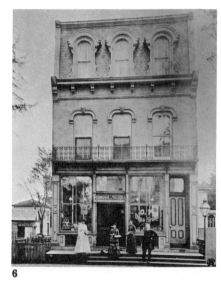

6

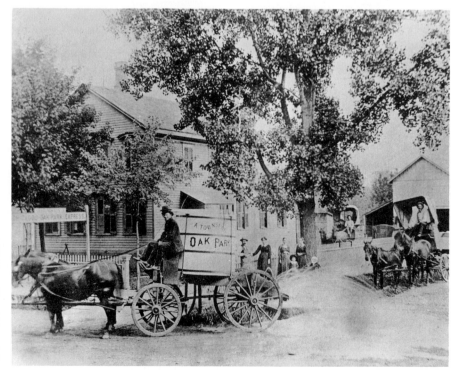

6. First Brick Building in Oak Park, Early 1880's

Built in 1873 by Dr. Orin Peak, Oak Park's first doctor, the building combined his office and a drugstore. At the time it was erected, it joined twelve houses on its Lake Street location.
(Courtesy Oak Park Public Library.)

7. Northwest Corner, Lake and Marion Streets, 1884

Now in the heart of Oak Park's main business district, in 1884 this corner was occupied by the residence of Albert Townsend, who provided Oak Park residents with the services of a freight transfer business and the village's first sprinkling cart. Oak Park did not get its first paved street until 1889.
(Courtesy Oak Park Public Library.)

180

2. Berlin Hotel, Previously Hotel Leonard, Oak Park, 1892

Suburban shopping centers served a variety of residents' needs in the same way that modern suburban centers strive for complete retail and service coverage. These two buildings contained a newspaper office, tin shop, grocery, hotel, and a chapter of the Women's Christian Temperance Union.
(Courtesy Oak Park Public Library.)

3. Northward View on Oak Park Avenue from Madison Street, 1903

Scattered houses, unpaved streets, wooden sidewalks, and overhead utility lines characterized this section of Oak Park at the turn of the century. A realty firm is offering the large tract of land at the left, capitalizing on the urban amenities close at hand. By the end of the next decade the village would be solidly built up, with apartment building already becoming prevalent within Oak Park's strictly restricted boundaries.
(Courtesy Oak Park Public Library.)

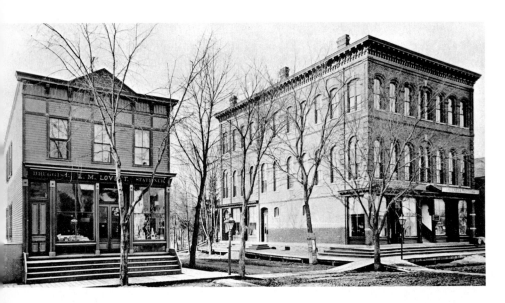

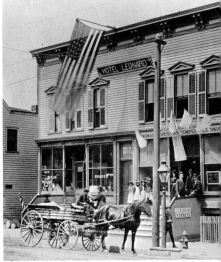

2

1. South from Lake Street on Marion, 1885

At the left is L. M. Lovett's drugstore; at the right is Hoard's Hall, which served as a public meeting place for many years. It occupied the second floor over two stores. A local newspaper provided a succinct description of the village's business district in the same year this photograph was taken: "Lake Street is the commercial thoroughfare, the business of which is contained within the space bounded on the east by Marion Street, and extending west four or five blocks to the line that divides Oak Park and Harlem. Within the radius of the few blocks mentioned are represented the numerous classes of tradesmen who cater to the wants of the denizens of Oak Park, and who tempt their palates and their fancy with all of the 'delicacies of the season' the 'latest importations direct.' "
(Courtesy Oak Park Public Library.)

3

4. North on Oak Park Avenue from North Boulevard, 1899

Within two years after this photograph was taken, Oak Park voted to incorporate as a separate municipality.
(Courtesy Oak Park Public Library.)

5. North on Oak Park Avenue from North Boulevard, 1912

Oak Park nearly doubled its population between 1900 and 1910. Street lights, brick pavements, and a new line of business facades reflected the center's increasingly important status.
(Courtesy Oak Park Public Library.)

6. North on Oak Park Avenue from North Boulevard, about 1960

Increased density of business facilities, extension of business blocks, and new buildings show the changes made in this street over four decades. When this photograph was taken, Oak Park had reached maturity and had begun to lose population, dropping from 66,000 in 1940 to 61,000 in 1960.
(Courtesy Department of Planning and Development, Village of Oak Park.)

7. West on Lake across Marion, 1915

New ornamental signposts had just been installed along the bricked pavements of Oak Park's business center. Most of the buildings are of wood, and a few motor vehicles have begun to utilize the streets.
(Courtesy Oak Park Public Library.)

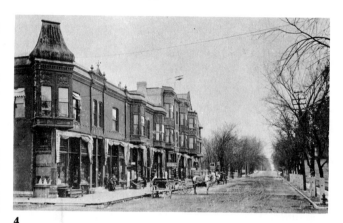
4

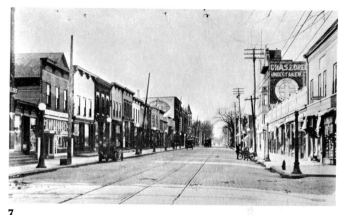
7

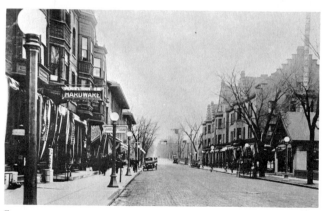
5

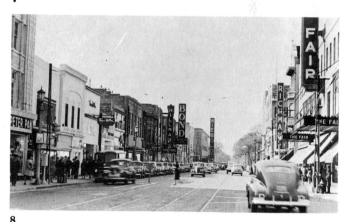
8

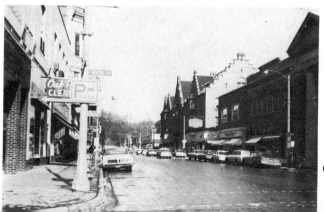
6

8. West on Lake across Oak Park Avenue, 1951

Overhanging signboards are now attached to brick and stone facades in this photograph made thirty-six years later. Streetcar rails are still apparent, but the biggest changes have come as concessions to the automobile—stoplights, safety zones, marked parking spaces.
(Courtesy Oak Park Public Library.)

182

1

1. Kenilworth Avenue Northward, near Chicago Avenue, Oak Park, 1925

In words that real estate men still find useful, the *Oak Leaves* staked Oak Park's claim: "This little village is ideally located . . . first being far enough away from the city to enjoy a thoroughly restful suburban atmosphere, and yet close enough to be reached quickly and conveniently." An observer put it differently in 1927. A man becomes an Oak Parker, he wrote, "because within those walls survives that which is kindred in impending extinction to the buffalo and the newspaper with reading matter—homes."
(Courtesy Chicago Historical Society.)

2

2. Eastward on Lake Street, Mid-1920's

While Oak Park had "few really knockout electric signs to enlighten its marts," in the 1920's it did have a sizable array of business establishments, including an elegant Marshall Field suburban store, pictured at the left.
(Courtesy Chicago Historical Society.)

3. Plan of Riverside, Olmsted, Vaux
and Company, 1869
(Courtesy J. Walsh.)

3

184

1. Riverside Hotel

In the early 1870's the promoters of Riverside erected this hotel with the hope that it would become a summer resort mainly catering to the upper classes of Chicago. Built in the shape of an "E," with two large courts opening on the south, this three story edifice had rooms provided with running water and gas lights. In 1879, the hotel, which had proved financially unprofitable, was turned into a tenement house," that is, a hotel for permanent guests. William Le Baron Jenney was the architect who decided on the Swiss chalet design to take advantage of the large over-hanging verandas for the river vista.
(Courtesy Chicago Historical Society.)

Just a little to the south of Oak Park was Chicago's most famous suburb, Riverside. Laid out by the nation's leading landscapist, Frederick Law Olmsted, on David A. Gage's farm at the crossing of the Des Plaines River by the Chicago, Burlington and Quincy Railroad, it was the most ambitious and successful planned suburb of its time. Although its natural advantages would seem obvious to later generations, an early directory in 1869 noted that the site presented "a plentiful lack of improvements, and an overwhelming generosity of raw prairie wind and waste prairie land which were anything but inviting." Yet, when completed, Riverside gave western Chicago, in the words of the same observer, what it always lacked—"at once an elegant drive, a handsome park, and a delightful suburban city."

Olmsted's town differed markedly from most other Chicago suburbs. Instead of being simply subdivided by developers with few or no controls, it was carefully planned in great detail. Lots were generous, 100 feet by 225 feet, and houses had to be set back thirty feet from the street. Olmsted rejected the conventional grid pattern as "too stiff and formal for such adornment and rusticity as should be combined in a model suburb." Instead, the roadways were "formed to curved lines which make a graceful and harmonious whole." Park land straddled the meandering Des Plaines River, providing a natural focus

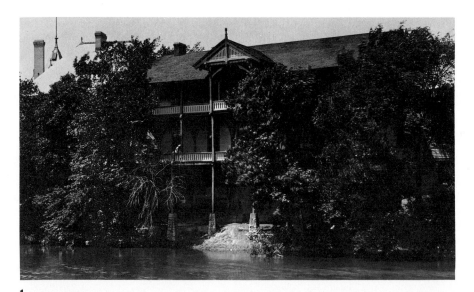

1

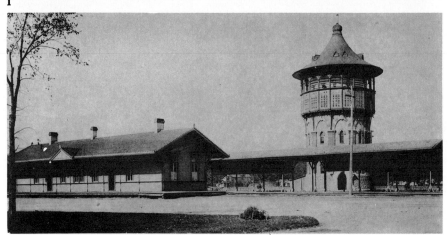

2. Chicago Burlington and Quincy Railroad Station and Riverside Water Tower, Northwestward, about, 1897

Riverside's developers sunk an artesian well to a depth of 735 feet, then built this 108-foot tower with its over-hanging balcony seventy feet in the air. Water was forced upwards by a large steam pump, and the entire Riverside development was then served by this single system.
(Courtesy Chicago Historical Society.)

3. Riverside's Early Business Block, across the Street from the Railroad Station, 1889
(Courtesy Department of City Planning, Village of Riverside.)

4. Residence of George Hunt
(From *Riverside*, 1889. Courtesy Department of City Planning, Village of Riverside.)

5. Residence of C. L. Cross
(From *Picturesque Riverside*, 1889. Courtesy Chicago Historical Society.)

6. Chicago, Burlington and Quincy Railroad Station, about 1930
Except for a few superficial alterations, the Riverside Station has remained unchanged from its initial building.
(Courtesy Chicago Historical Society.)

7. One of the Curved Streets, in the 1960's
Although Riverside was a planned suburb with many advantages, its early development was plagued by financial difficulties, and it was not until after 1885 that steady growth came to the suburb. Many of the streets in Riverside were paved soon after the turn of the century.
(Courtesy Robert Fine.)

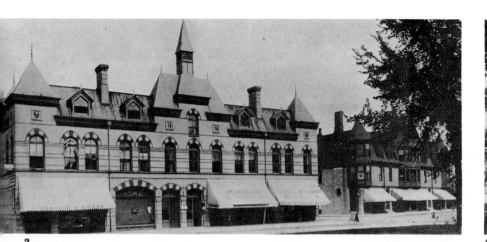

3

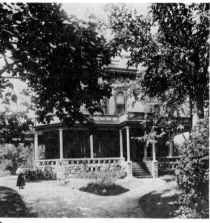

4

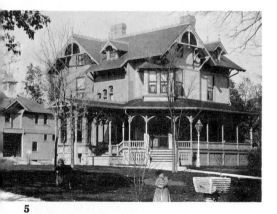

5

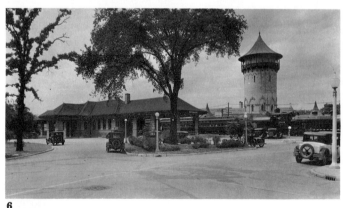

6

7

for the design and a public pleasure ground in the center of town. And the original development included every kind of essential service—water, drainage, lighting, schools, and recreational facilities. In short, it met the expectations of its creator: to "combine the conveniences peculiar to the finest modern towns with the domestic advantages of a most charming country."

The outward expansion of the metropolis was not confined to residential development. The central city was too small and congested to accommodate the growth of manufacturing, an essential ingredient for the continued health of the young giant. Hence investors looked about for undeveloped land close enough to the city to draw on its labor force and market, yet far enough away from downtown to be uncluttered and cheap. Moreover, the new enterprises needed railroad facilities for handling raw material coming in from the outside and for quick access to customers both in the immediate area and across the country. The building of the Chicago Outer Belt Line (Elgin, Joliet and Eastern Railroad) provided one answer. Built in a broad arc about thirty-five miles from the Loop, it tied together the railroads coming into Chicago and also offered almost limitless sites for industrial expansion. Soon a whole set of "satellite cities" grew up along and near its path—Waukegan, Elgin, Aurora, Joliet, Chicago Heights, and (later) Gary. No less

a part of the metropolitan area than the suburbs, these factory towns enhanced Chicago's manufacturing potential.

Typical of these was Chicago Heights. After the completion of the Outer Belt Line in 1887, a land association headed by Charles H. Wacker bought 4,000 acres twenty miles south of the city limits. The company's development plan segregated factory areas on the east side of town from business and residential settlements on the west side. Some housing was permitted in the industrial quadrant, but it soon became blighted. The other areas flourished as manufacturers found the location attractive and workers filled up nearby neighborhoods. Among the first enterprises in Chicago Heights was the Inland Steel Company. In fact, its original plant still operates, although its Indiana Harbor Works is much larger. By 1895 the new satellite city had 1,500 residents; at the end of the next decade it had ten times that number.

One of the primary beneficiaries of the outward movement of industry was the Calumet region. Indeed it was strange that the area had not developed sooner, for it had many of the attributes that initially attracted people to the Chicago site. Lying twelve miles south and a little east of the Loop, it had a natural harbor where the Calumet River entered Lake Michigan. In addition, there was Lake Calumet, a shallow body of water covering three square miles. Moreover, the Calumet Sag depression provided a possible route across the drainage divide

into the Mississippi basin. Yet if the Calumet location never became the center of a great city, it did become the nucleus of the most important harbor complex in the Great Lakes and the industrial heart of the Chicago metropolitan area.

The beginnings of growth came in 1869 when the federal government appropriated money for the improvement of Calumet Harbor. Two years later, the first cargo vessels tied up along its wharves. An immediate real estate boom indicated the future prospects of the area. Soon industries located near the mouth of the river and workers' houses sprang up nearby. The most important newcomer was the North Chicago Rolling Mills, now the South Works of the United States Steel Corporation, which ultimately became the largest steel plant in the city. Around this industrial complex, residential building mushroomed, a business center developed at Commercial Avenue and Ninety-second Street, and the Illinois Central Railroad brought the region more closely into the metropolitan orbit by constructing a branch into South Chicago in 1883.

The growth of the Calumet Harbor area was quick and unplanned, the result of the decisions of many different people and corporations. Across Lake Calumet, however, was Pullman City, an experiment in community development based on a totally different principle. In 1880, as Henry Demarest Lloyd has written, the town site "was a wilder-

3. Michigan Avenue, Looking North across 112th Place

With the turn of the century, Roseland was quietly drawn into Chicago, hence losing its status as an independent settlement and becoming a city neighborhood. Dutch and Swedish names still are to be found on the businesses along this section of 112th Street.
(Courtesy Calumet Historical Society, Pullman Branch Library.)

4. Frame Houses at 108th and Perry Streets, 1905

The monotony of young subdivisions is not a new phenomena. This string of houses put up by the same builder was far more alike than many of those in modern suburbia. Roseland's growth was continual and steady after about 1870, not stabilizing until 1950. Beginning in the 1880's, many workers settled here because they worked in nearby industries or because they found easy access to the Loop by railroads and street cars.
(Courtesy Calumet Historical Society, Pullman Branch Library.)

5. The Original Chicago Heights Steel Mill of the Inland Steel Company
(Courtesy Inland Steel Company.)

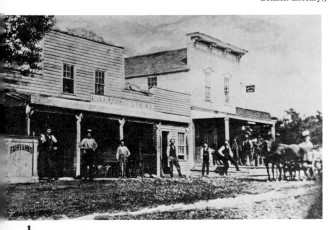

1

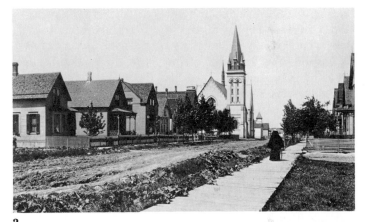

2

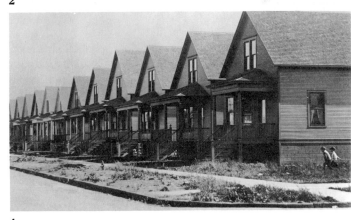

3

4

5

1. Plat of the Town of Pullman
(From Richard T. Ely, "Pullman, A Social Study,"
Harpers New Monthly Magazine, February, 1885.)

2. The Pullman Water Tower
Sixty-eight square feet at its base, 195 feet high, with foundations forty feet below the surface, this huge tower held over half-a-million gallons of water. In the 1880's it boasted being "the largest tank in the world." The water was drawn up by an engine which had powered the machinery at the Centennial Exposition in Philadelphia in 1876. The third and fourth stories contained the glass-making department of the plant.

ness of grass. . . . Its solitary inhabitant was the transient duck alighting for a moment in its flight from the marshes of Kankakee." The only sign of life came from "the smoke rolling from the steel mills of South Chicago several miles to the east, [and] some straggling houses to the south, at an insignificant station on the Illinois Central." A year and a half later, George Pullman's famous company was producing railroad cars in a modern plant; by 1884 the city had more than 8,000 residents.

Overnight Pullman became one of Chicago's showpieces as people flocked to see it or to settle there. "In former times when a man moved away it was said of him G. T. T., gone to Texas," the *Union Stock Yards and South Chicago Weekly* asserted in 1881. "Now it is G. T. P., gone to live at Pullman." Nor was its importance limited to Chicago or the manufacture of sleeping cars.

"The town of Pullman possesses an interest above and beyond that of railcars and wheels," a Chicago minister noted. "It stands related to the question of how cities should be built and in general how man should live." Or, as a French visitor put it, the purpose was "to mould not only a body of employees, but a whole population of workmen and their families to ways of living which would raise their moral, intellectual and social level."

George Pullman engaged an architect, Solon Spenser Beman, and a landscapist, Nathan F. Barrett, to design his ideal manufacturing town. Public buildings were grouped around the park across from the railroad station; residential blocks ran south; factory buildings were placed to the north and east. An attractive arcade provided convenient shopping facilities, and a theater, school, and church comprised a cultural compound

at the city's center. Workers' dwellings were substantially built, if a bit snug; streets and alleys were paved, and trees and shrubs were planted before the houses were occupied. In addition, Pullman bought up much of the surrounding land to protect his planned community from the ravages of speculative development in the region.

For all its apparent utopianism, Pullman City was designed to be good business, not philanthropy. The owner expected every part of the enterprise—the market, the hotel, the housing—to earn a modest profit on his investment. Moreover, the central consideration of the scheme was to make labor more efficient and more productive by providing an environment conducive to work and improvement. A Boston journalist understood the spirit of the undertaking when he wrote that "with such surroundings and such humane regard for the needs

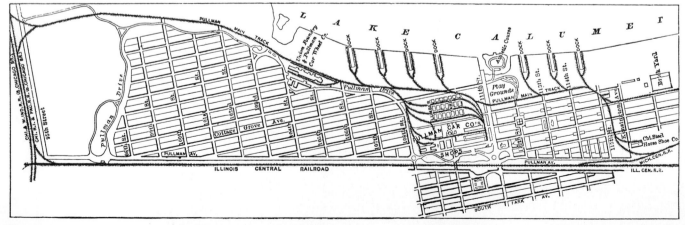

3. Pullman Station, Illinois Central Railroad, 1883–93

4. Market Square, East on 112th Street

All workers' housing was within easy walking distance of this square, the retail center of Pullman. The "large Market-house, 100 by 110 feet in size" had a wide passage extending through it from east to west.
(Calumet Historical Society. Courtesy Pullman Branch Library.)

5. Interior of Pullman Arcade

"The finest building in Pullman is the Arcade," wrote Richard T. Ely in the 1880's, "a structure 256 feet in length, 146 feet in width, and 90 feet in height. It is built of red pressed brick, with stone foundations, and light stone trimmings, and a wide glass roof extends over the entire wide central passage. In the Arcade one finds offices, shops, the bank, theatre, library, etc."

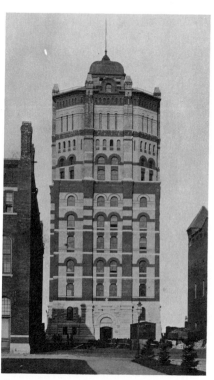

2

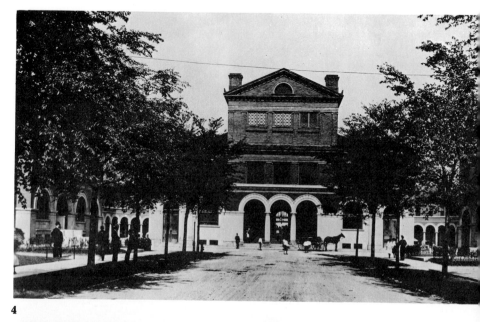

4

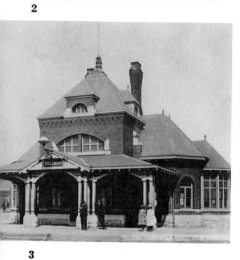

3

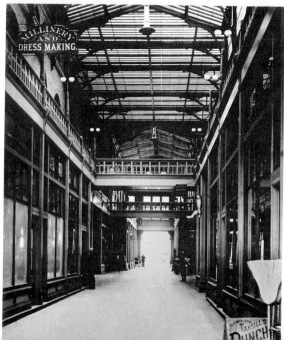

5

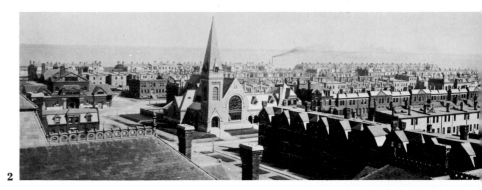

2

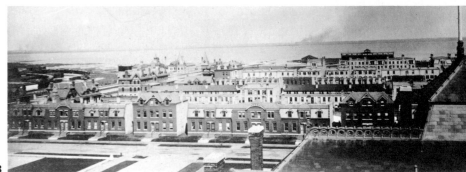

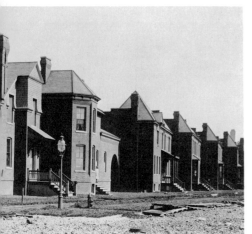

3

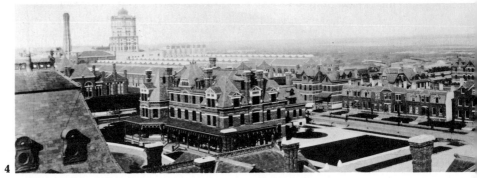

4

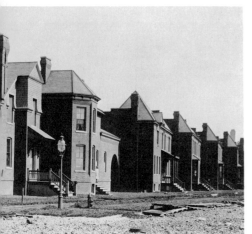

5

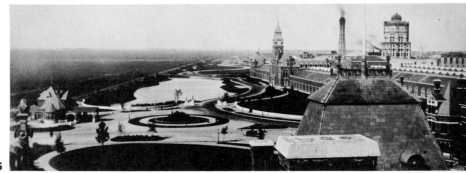

1. Brick Two-Family Workers' Housing in the Early 1880's

An Englishman, William Hardman, traveling through Chicago at almost the same time this photo was taken summarized what he saw as George M. Pullman's housing goals: "The workmen to the number of 2,500, with their families, are accommodated in houses, adapted to their various grades, but all neat, pretty, and comfortable. The total population is about 8,000, and every provision is made for the well-being and amusement of the inhabitants, but especially for their sobriety, the rules as to the sale of intoxicating drinks being very strict."

6. Workers' Housing
The Greenstone Church, at the left, was so named because of its crystalline exterior which contained traces of iron and magnesium.

7. South from the Market Building
George Pullman built his houses well. Many of these row houses are now being rehabilitated by their owners.
(Calumet Historical Society. Courtesy Pullman Branch Library.)

2. Pullman Town Looking Southeast from the Top of the Arcade
At the left is Market Square; Greenstone Church is in the center. Many of Pullman Town's 1,800 model "tenements" are seen in this broad view toward Lake Calumet. Such a perspective always gave visitors a good impression. Charles Beadle, who traveled through Chicago in 1886–87 wrote, "The town is nicely laid out; in the best part there is a very fine hotel, built in the same style as the works—red and black bricks . . . The houses for the managers are prettily designed, and have avenues of trees before them; behind are the houses of the workmen. Ten years ago the place was a swamp."

3. Pullman Town Looking East from the Top of the Arcade
Workers' row housing fills the scene, with the barracks housing for unmarried males at the far back.

4. Pullman Town Looking Northeast from the Top of the Arcade
In the center foreground is the Florence Hotel, described by observer Richard T. Ely as "a large structure, surrounded on three sides by beautiful public squares covered with flowers and shrubbery. It is luxuriously furnished, admirably kept, and contains the only barroom allowed in Pullman." Part of the car works is in the area between the hotel and the water tower.

5. Pullman Town Looking North from the Top of the Arcade
At the left is the Illinois Central station with its iron rails heading across the open ground toward Hyde Park and downtown Chicago. Visitors often commented on the beauty of artificial Lake Vista and the formal park in front of the "Erecting Shops."

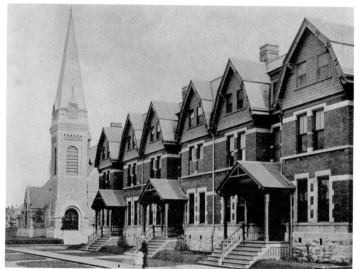

6

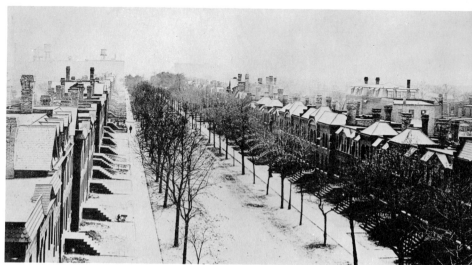

7

of the body as well as the soul . . . the disturbing condition of strikes and other troubles that periodically convulse the world of labor would not need to be feared here." Twelve years later, in 1894, this model town would be wracked by violence and bitterness; yet a London newspaper in 1883 probably summed up the prevailing opinion of the time when it called Pullman "the most perfect city in the world."

The appearance of the model town on the edge of Chicago, itself something of a new city, increased the world's fascination with the rising metropolis of the West. If Rudyard Kipling was revolted by Chicago ("Having seen it, I urgently desire never to see it again. It is inhabited by savages."), others like Julian Ralph, a New York journalist, came away "compelled to acknowledge its possession of certain forceful qualities which I never saw exhibited in the same degree anywhere else." At any rate, few were neutral.

And in 1893, millions were to find out for themselves what this phenomenon was really like. For Chicago was chosen to be the site of an exposition designed to commemorate Columbus's discovery of the New World, four centuries earlier. Competition for this honor among America's cities had been brisk, and New York, Washington, D.C., and Saint Louis had lobbied feverishly in Congress for the prize. But Chicago won, and for nearly five years its leaders pre-pared for the big show—the World's Columbian Exposition. Yet, as one visitor pointed out, the real centerpiece would be the city itself. "Those who come here will wonder how, in less than fifty years, that is, in less than a man's lifetime, it has been possible to transform a swamp, producing only a sort of wild onion, into a powerful and flourishing city."

HAMLIN GARLAND DISCOVERS CHICAGO

With all my pay in my pocket and my trunk checked I took the train for Chicago. I shall never forget the feeling of dismay with which, an hour later, I perceived from the car window a huge smoke-cloud which embraced the whole eastern horizon, for this, I was told was the soaring banner of the great and gloomy inland metropolis, whose dens of vice and houses of greed had been so often reported to me by wandering hired men. It was in truth only a huge flimsy country town in those days, but to me it was august as well as terrible.

Up to this moment Rockford was the largest town I had ever seen, and the mere thought of a million people stunned my imagination. "How can so many people find a living in one place?" Naturally I believed most of them to be robbers. "If the city is miles across, how am I to get from the railway station to my hotel without being assaulted?" Had it not been for the fear of ridicule, I think I should have turned back at the next stop. The shining lands beyond seemed hardly worth a struggle against the dragon's brood with which the dreadful city was a-swarm. Nevertheless I kept my seat and was carried swiftly on.

Soon the straggling farm-houses thickened into groups, the villages merged into suburban towns, and the train began to clatter through sooty freight yards filled with box cars and switching engines; at last, after crawling through tangled, thickening webs of steel, it plunged into a huge, dark and noisy shed and came to a halt and a few moments later I faced the hackmen of Chicago, as verdant a youth as these experienced pirates had ever made common cause against.

All the afternoon and evening we wandered about the streets (being very careful not to go too far from our hotel), counting the stories of the tall buildings, absorbing the drama of the pavement. . . .

Everything interested us. The business section so sordid to others was grandly terrifying to us. The self-absorption of the men, the calm glances of the women humbled our simple souls. Nothing was commonplace, nothing was ugly to us.

Hamilton Garland, *A Son of the Middle Border* (New York, 1918), pp. 268-71.

4 | The White City and the Gray, 1893-1917

The year 1893 was one of ambivalence in Chicago. It began with excitement—the opening of the World's Columbian Exposition in Jackson Park; it ended in despair—a deep depression gripped both city and nation. Even the language of the times reflected the contrast, the Fair being called the "White City," while Chicago was quickly dubbed the "Gray City." Inside the Exposition grounds all was glitter, gaiety, and the celebration of progress; outside sullen men shuffled the streets, slept in parks, and bitterly faced a bleak future. Chicago had sought the Fair to demonstrate the limitless possibilities of metropolitan man; when it closed the future seemed as uncertain as before.

Indeed, contradictions surrounded the enterprise from the beginning. The exposition was held at the birthplace of modern architecture, yet it reached back to antiquity for its basic building design. Augustus Saint-Gaudens might call the Palace of Fine Arts the greatest achievement since the Parthenon, and a visiting English journalist could pronounce it "as divinely proportioned an edifice as ever filled and satisfied the eye of man," but Louis Sullivan, the master of the new techniques, himself the creator of the Transportation Building, thought the Fair an "appalling calamity" architecturally. Instead of drawing on the inventive genius of the new generation, it had settled for classical modes and established idioms. Sullivan was perhaps too harsh in saying that "the damage

wrought by the World's Fair will last for a half a century;" yet he was clearly right in lamenting the loss of a unique opportunity.

The contrasts, however, were revealing. The men who conceived and executed the design of the Columbian Exposition were among the nation's leading planners, architects, landscapers, and sculptors. Daniel H. Burnham presided over the enterprise; Frederick Law Olmsted laid out the lagoons, wooded islands, lawns and plantings; Augustus Saint-Gaudens, Daniel Chester French, and Lorado Taft contributed statuary; and a dozen architects from around the country were commissioned to do the major buildings. So much of the country's talent was assembled for the task that Saint-Gaudens could exclaim after one planning session that "this is the greatest meeting of artists since the fifteenth century." Together they were given a free hand to create the kind of world they had always dreamed of. The result was an artificial city that conflicted with the actual city in almost every important element. Where the American metropolis was chaotic and disorganized, the Exposition was planned and orderly; while the real city was private and commercial, the ideal was public and monumental; where Chicago was sooty and gray, the White City was clean and sparkling.

In short, the architecture of the Fair turned out to be a rejection rather than a celebration of the four centuries of

World's Columbian Exposition

Ground Plan for the World's Columbian Exposition, 1893

Extending from Cottage Grove Avenue to Lake Michigan, and from 56th Street to 67th Street, the exposition grounds were the site of a massive building effort. An English author and lecturer, James Dredge, after examining the effort at first hand, reported to the London Polytechnic Institute a concise description of the Exposition grounds: "The Columbian Exposition is situated seven miles from the center of the city, a distance that will be provided for by trains, tramways, and especially by large steamboats. The site comprises Jackson Park, the Midway-Plaisance, and Washington Park. Of these only the two former will be used for buildings, the Midway-Plaisance—a long strip of land about 600 feet wide and a mile long, being reserved for a Bazaar of Nations. . . . The Exhibition grounds have a long frontage . . . on Lake Michigan, an advantage that gives a special charm to the site; . . . towards the lower end of the grounds, a pier stretches far out into the lake, and is so arranged that it will serve as landing stage, promenade, and breakwater, to enclose a large, smooth-water harbor for the smaller marine exhibits.

"From the shore end of this pier extends westward a long and very wide road—the grand avenue of the Exhibition. In the center of this road is a great basin that forms a part of the extensive water-ways, to be made both for decoration and for the circulation of fleets of omnibus boats, which will be driven by electricity, and constitute one of the important means of transporting visitors. On each side of the Grand Avenue are the facades of the main buildings. . . . At the extreme end of the avenue is the Administration Building, and in front of it the basin is split into a canal to the right and left. . . . To the south of the Grand Avenue are the Agricultural Buildings, with their stockyards and annexes. . . . On the north of the Grand Avenue are the buildings for the Industrial and Liberal Arts, and those for Electricity and Mines and Mining.

"Behind this range of short-lived palaces come many more buildings—the Transportation Hall, the Great Conservatory, the Women's Building, the Pavillion of the State of Illinois, the Art Galleries. North of these latter is a large reserve set aside for the various states of the Union. . . . Returning southward by the lake shore we come to a second large reserve to be allotted to the use of the foreign nations exhibiting. . . ." Dredge closed by noting that "the roofed-in portion will cover 150 acres, . . . and that these buildings will not be sheds, but . . . magnificent—though temporary—structures, both as regards their engineering and their architectural features. . . ."
(Courtesy Chicago Historical Society.)

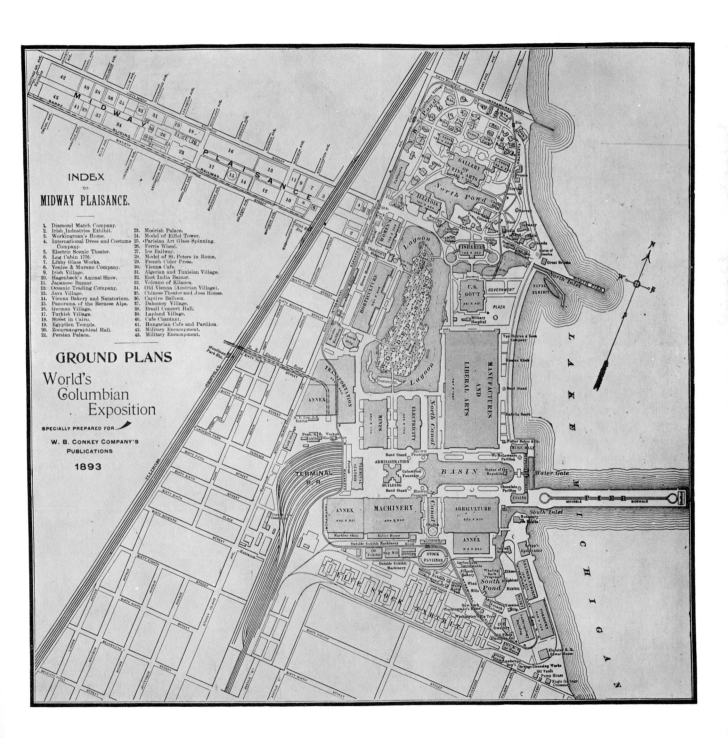

INDEX
TO
MIDWAY PLAISANCE.

1. Diamond Match Company.
2. Irish Industries Exhibit.
3. Workingman's Home.
4. International Dress and Costume Company.
5. Electric Scenic Theater.
6. Log Cabin 1776.
7. Libby Glass Works.
8. Venice & Murano Company.
9. Irish Village.
10. Hagenbeck's Animal Show.
11. Japanese Bazaar.
12. Oceanic Trading Company.
13. Java Village.
14. Vienna Bakery and Natatorium.
15. Panorama of the Bernese Alps.
16. German Village.
17. Turkish Village.
18. Street in Cairo.
19. Egyptian Temple.
20. Zoopraxographical Hall.
21. Persian Palace.

22. Moorish Palace.
23. Model of Eiffel Tower.
24. Model of Eiffel Tower.
25. Parisian Art Glass Spinning.
26. Ferris Wheel.
27. Ice Railway.
28. Model of St. Peters in Rome.
29. French Cider Press.
30. Vienna Cafe.
31. Algerian and Tunisian Village.
32. East India Bazaar.
33. Volcano of Kilaua.
34. Old Vienna (Austrian Village).
35. Chinese Theater and Joss House.
36. Captive Balloon.
37. Dahomey Village.
38. Brazil Concert Hall.
39. Lapland Village.
40. Cafe Chantant.
41. Hungarian Cafe and Pavilion.
42. Military Encampment.
43. Military Encampment.

GROUND PLANS

World's
Columbian
Exposition

SPECIALLY PREPARED FOR

W. B. CONKEY COMPANY'S
PUBLICATIONS

1893

World's Columbian Exposition

1. Daniel H. Burnham, 1846–1912

When Daniel H. Burnham produced the famous Plan of Chicago in 1909, he was already a towering figure in city affairs. While contemporaries around the country associated him largely with the World's Fair of 1893, Chicagoans knew Burnham also as an architect associated for a quarter of a century with some of the most important buildings in the city. The firm Burnham and Root had constructed some of the nation's first "skyscrapers"—the Montauk Building and the Masonic Temple in Chicago and the Flatiron

1

"progress" since Columbus first discovered the new world. The *Tribune's* farewell to the Exposition late in 1893 carried a kind of unconscious irony when it called the Fair "a little ideal world, a realization of Utopia, in which every night was beautiful and every day a festival, in which for the time all thoughts of the great world of toil, of injustice, of cruelty, and of oppression outside its gates disappeared, and in which this splendid fantasy of the artist and architect seemed to foreshadow some faraway time when all the earth should be as pure, as beautiful, and as joyous as the White City itself."

Yet for most of the twenty-one million people who poured through the turnstiles in that memorable summer, the deeper significance of the event was less important than the immediate excitement. "Like everyone else who saw it," the novelist Hamlin Garland later wrote "I was amazed at the grandeur of 'The White City' and impatiently anxious to have all my friends and relatives share my enjoyment of it." During his first visit he wrote hurriedly to his father back on the Dakota farm, "sell the cook stove if necessary and come. You *must* see this fair." Even Henry Adams, who, as usual, tried to find some cosmic meaning in it all, noted enviously that the ordinary American at the Exposition "had the air of enjoying it as though it were his very own; he felt it was good; he was proud of it." Detractors had to admit that it passed the acid test: it made

2. Grading the Midway in Preparation for the World's Columbian Exhibition, 1892

Hundreds, then thousands, of men were employed in preparing the Exposition. Although it was postponed for a year, much was still undone when the Exposition opened in May, 1893. Over $19 million were spent in preparation for the Exposition, with over $16 million going for construction. Of this amount Chicago residents subscribed $5.6 million, and the city government sold bonds for another $6.5 million.
(Courtesy University of Chicago Library, Department of Special Collections.)

Building in New York. Indeed across the nation between 1871 and 1893 the firm's construction income exceeded any others. And Burnham had also already placed his mark on the nascent profession of city planning. In 1902 he and associates drew up the fundamental plan for the nation's capital and later they proposed new schemes for New York, Boston, Pittsburgh, and San Francisco. Hence when he went to work on Chicago in 1906, he brought to the task the most experienced and accomplished background in the country. (Courtesy Chicago Historical Society.)

3. World's Columbian Exposition, View Southeastward from the Intramural Railroad

"The majestic *White City* where poverty has no place to live, exercises over the mind such a charm, that its defects, like the dark spots of the sun, are invisible to the naked eye, owing to the great halo of lustre that pervades throughout," a visitor wrote. "Look from the lake, from the tower, or from the flying trains, its attractiveness is the same. Poets evolve creations from their imagination, which can be enjoyed by the imagination alone. But here, the great poets of science and art created things which can be perceived by the senses and then dwelt upon by the imagination." The intramural railroad from which the photo was taken was a demonstration device to introduce people to the electrified third rail method of power supply. The Fisheries building is on the right.
(Courtesy Chicago Historical Society.)

4. Van Buren Street Station of the Illinois Central Railroad

The Illinois Central enlarged this station to handle the World's Fair traffic and also purchased forty-one locomotives and 300 new side-door coaches for the event. The greatest traffic day in the I.C.'s history occurred in 1893 on Chicago day at the Exposition. On that day 541,312 passengers rode the I.C. trains to the grounds in Jackson Park. In the background is the newly completed Central Station at 12th Street; behind it is South Michigan Avenue.
(Courtesy Illinois Central Railroad.)

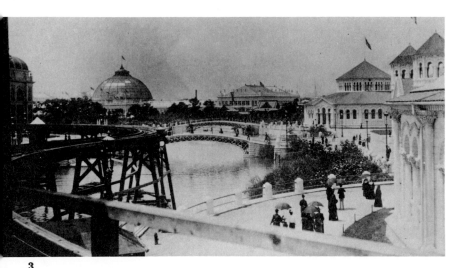

3

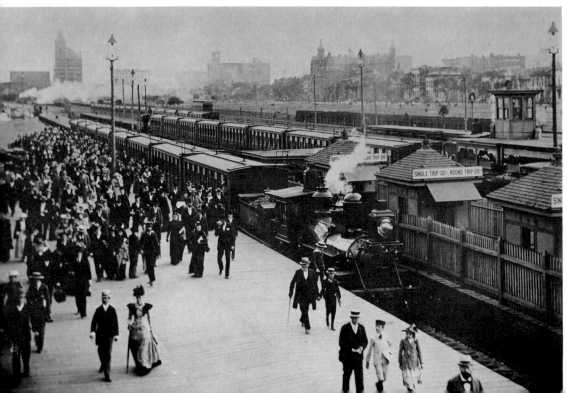

4

World's Columbian Exposition

1. View North from the Roof of the Manufacturers and Liberal Arts Building

In the foreground is the dome of the U.S. Government Building; in the left background is the Illinois Building; between them, in the background, is the Fine Arts Building, which survives today in a remodeled state as the Museum of Science and Industry.
(Courtesy Chicago Historical Society.)

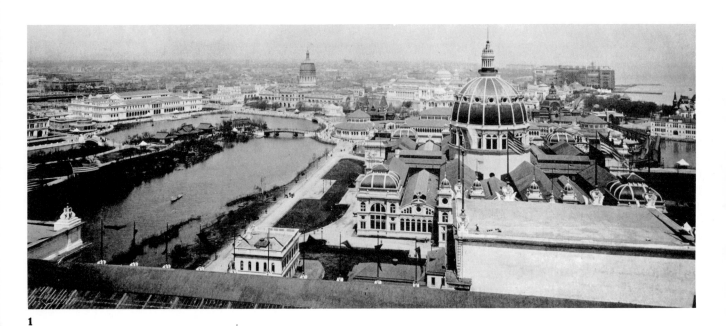

1

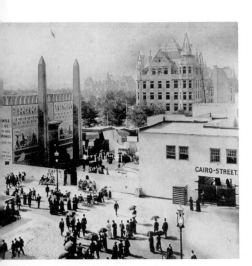

3

3. View North-Northeastward from the Midway at Lexington (University) Avenue

Many Exposition visitors would remember most the "Streets of Cairo" and the daring dancing of "Little Egypt" on the Midway. It took only a few months to create the world of this ancient Egyptian tomb; within a few more months it would be dismantled. Across the street, the stolid neo-Gothic Foster Hall of the University of Chicago neared completion.
(Courtesy Chicago Historical Society.)

4. Eastward on the Midway from the Ferris Wheel at Woodlawn Avenue

A Frenchman described "the principal attractions of the Midway Plaisance. . . . M. Barre's hydraulic train, the same one that ran at the Esplanade des Invalides (in the Paris Exposition of 1889); the Tunisian and Algerian cafe, . . . the Dahomey village . . . ; the restaurant of Mora, a Marseillais who fears nothing when it is a question of making money with simple ideas; and the captive balloon sent over from Paris. There are also a street in Cairo, a Persian harem, a German village, and an Irish market town. China has its corner and its teahouse, and Morocco its mosque. There are many Indians and Eskimos; there are two panoramas: the Hawaiian volcano and the Alps around Berne."
(Courtesy Chicago Historical Society.)

2. North-Northeast from the Roof of the Manufacturers and Liberal Arts Building

Except for the French, most contemporary architects the world over were impressed by the architecture of the Exposition. A typical response appeared in the *American Architect and Building News* on October 28, 1893. "Neither the days of antiquity, nor modern times, have witnessed a work of such architectural grandeur. The mighty rulers of Assyria or Egypt, the emperors of Byzantium or Rome, Charlemagne or Emperor Napoleon have in vain endeavored to enhance their fame by architectural monuments of such beauty, boldness and dimensions, grouped in the most wonderful combinations, as those that are here to-day liberally offered to the American people and its hosts of guests." The domed structure at the left is the U.S. Government building.
(Courtesy Chicago Historical Society.)

5. Northwest Corner State and Madison Streets Showing Street Decorations for the Dedication of the Columbian Exposition, 1892

City residents worked hard and spent much money to bring the exposition to Chicago. When the official dedication occurred, the traditional red, white, and blue draping was added to the already impressive downtown facades, showing that residents realized the whole city was on display. As Julian Ralph, a New Yorker, writing in the February, 1892, *Harper's Monthly* put it: "Chicago will be the main exhibit of the Columbian Exposition of 1893. No matter what the aggregation of wonders there, the city itself will make the most surprising presentation. Those who go to study the world's progress will find no other result of human force so wonderful, extravagant, or peculiar."
(Courtesy Chicago Historical Society.)

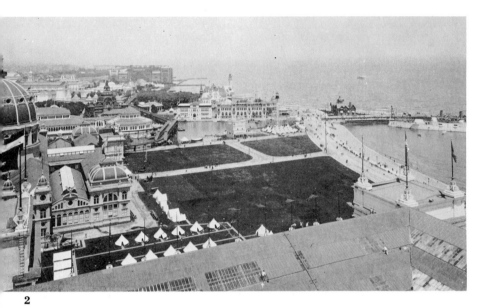

2

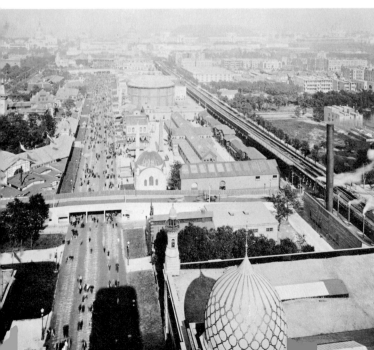

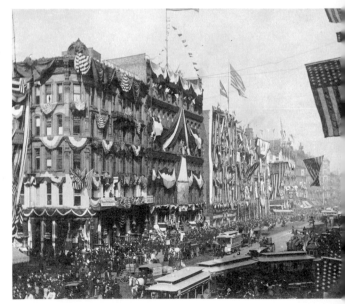

4 5

Situated at the north end of Jackson Park, the Fine Arts Building housed the Field natural history collection for many years. After the completion of the new lakefront Field Museum of Natural History, the old building was allowed to deteriorate. Planning for the restoration of the Fine Arts Building began in 1929; work was

money. The influence of the Fair, however, lingered on after the gates were closed. Only two of the buildings remained—LaRabida, which had housed the Columbus Memorial Building in the Exposition, later became a hospital for cardiac children, and the Fine Arts Building became the Field Museum of Natural History until it moved to Grant Park in 1920. After the Century of Progress Exposition of 1933-34, the former structure became the nucleus for the present Museum of Science and Industry. But, more important, Jackson Park, the principal setting of the Fair, was refashioned out of the Olmsted-landscaped design. The lagoons became small-craft harbors; the wooded island was developed for strolling and picnicking; the Midway was transformed into a tree-lined boulevard, a handsome doorway to the University of Chicago campus; and the beaches, served by excursion boats from downtown, proved to be a favorite resort for thousands of Chicagoans on summer days.

The Fair also bequeathed some problems to the surrounding communities. Anticipation of the demand for housing and hotels had led to overbuilding. "Vacancy" and "for sale" signs dotted nearby Woodlawn and Hyde Park as soon as the Exposition closed. To be sure, the expansion of the University of Chicago took up some of the slack. So, too, did the development of "White City,"

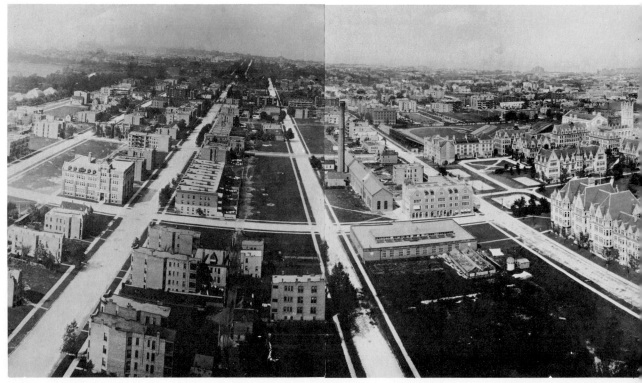

completed during 1933–34, just in time to house many of the science exhibits from the Century of Progress Exposition. The massive white building in the middle center is the Windemere East Hotel. With a few exceptions, the luxury hotels and apartments behind it were built in the 1920's.
(Courtesy Chicago Historical Society.)

2. George Lawrence Panorama, South Side, 1907

In 1907, George Lawrence's camera crew went aloft in a captive balloon to take this aerial photograph of the University of Chicago and its adjacent neighborhoods. Scanning the area from Washington Park on the northwest to 60th Street on the south, Lawrence's camera captured the expanded shape of Hyde Park and distant Kenwood. Newly constructed dumbbell tenements (so named because of the shape of thin walls), and three-storied apartment buildings with their exposed wooden porches, stand along Drexel and Ingleside. Several University buildings were already complete, and many new ones soon filled the empty spaces on the Quadrangles.
(Photograph, George Lawrence. Courtesy Library of Congress.)

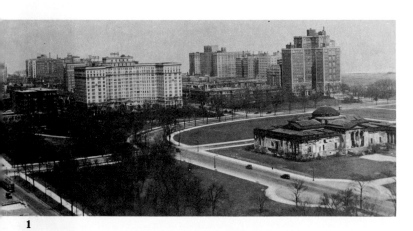

1

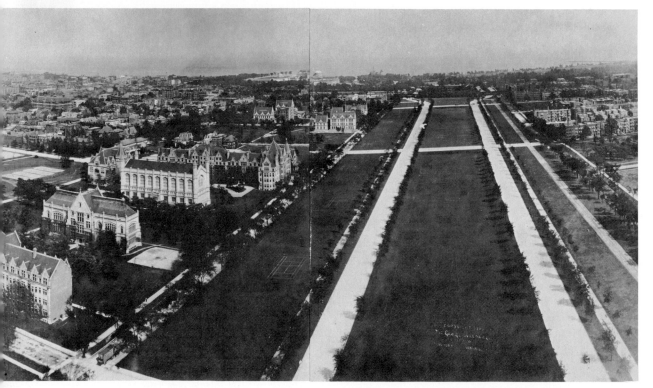

1. Jackson Park at the Turn of the Century

When the Exposition was removed, much of Jackson Park was left in chaos. New plantings of trees and shrubbery and the covering of the rubble with the top soil from a farm south of the city brought the park back into usable condition. Baseball diamonds were just one of the facilities provided; others included a nine- and eighteen-hole golf course, football field, and tennis courts.

(Courtesy Chicago Historical Society.)

2. Lakefront at Jackson Park, about 1900

Jackson Park Beach exerted a strong attraction for Chicago residents at the turn of the century. Its pleasant paved walk extended for nearly a mile and a half along the lake and was readily accessible by Cottage Grove and Jackson Park surface cars, the South Side elevated, and the Illinois Central commuter trains. In the background is the German Building, built

1

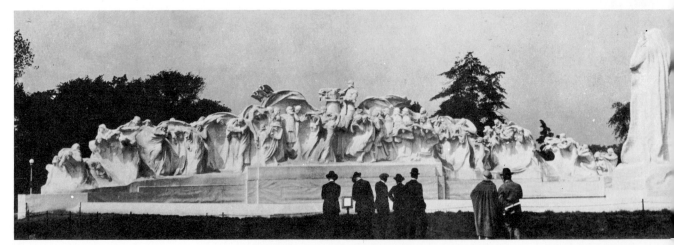

2

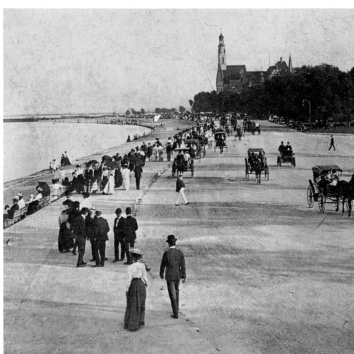

3

for the Columbian Exposition, which at this time contained a refectory and a museum.
(Courtesy Chicago Historical Society.)

3. Lorado Taft's Fountain of Time, Where the Midway Joins Washington Park, 1920's

Born in Elmwood, Illinois, in 1869, Taft was a graduate of the Ecole des Beaux Arts in Paris. He returned to reside in Chicago in 1886 where he aided in the Columbian Exposition, was affiliated with the Art Institute and lectured in art at the University of Chicago. Besides this great stonework in which the Ages of Man pass in review, he also was responsible for the Great Lakes Fountain on the west side of the Art Institute's Morton Wing.
(Courtesy Woodlawn Historical Society., Woodlawn Branch Library.)

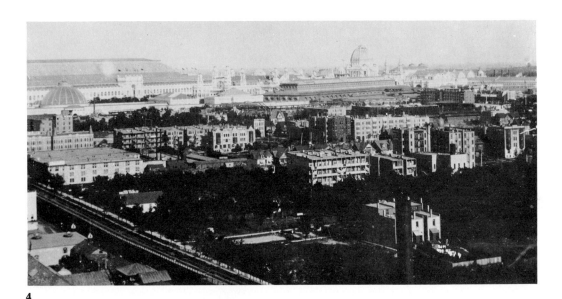

4

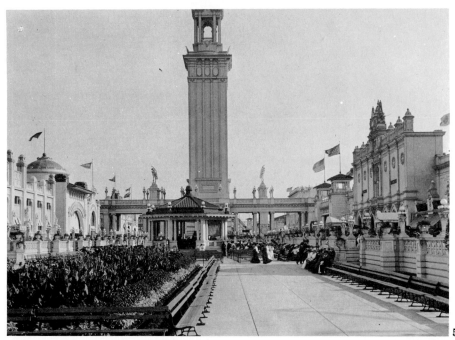

4. Three- and Four-Story Apartments Looking Southeast from the Ferris Wheel at the Midway and Woodlawn Avenue

This photograph is an enlargement of a portion of a more extensive view. Along both sides of the Illinois Central Railroad are the large apartment houses and smaller flat buildings erected in connection with the Exposition.
(Courtesy Chicago Historical Society.)

5. Interior of White City Park, 1905

White City offered its patrons year-round accommodations including two dance floors and a roller skating rink.
(Courtesy Chicago Historical Society.)

5

1. Start of a Balloon Race at White City Amusement Park, 1908

The park not only provided conventional recreation but occasionally a bizarre event as well. This was a balloon race which carried the winner 895 miles in twenty-three hours and finished in Shefford, Quebec.

(Photograph, Fred M. Tuckerman. Courtesy Chicago Historical Society.)

2. Midway (Later Edelweiss) Gardens, at Cottage Grove and the Midway, Probably 1914

Erected on the site of the old Sans Souci Gardens, Midway Gardens was designed by Frank Lloyd Wright and built during 1913–14.

(Courtesy University of Chicago Library, Department of Special Collections.)

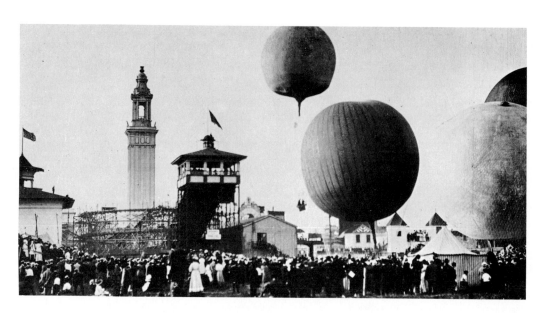

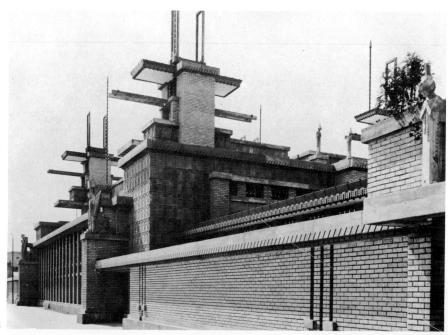

2

3. Interior of the Midway Gardens, 1914

"Built at the zenith of the cabaret vogue, . . . this was one of Chicago's famous pleasure resorts, where, before prohibition, Chicagoans came to dine, dance and while away summer evenings." Even after prohibition it remained "a popular rendezvous for autoists" until it was torn down in 1929 "giving way to an unromantic but modern automobile filling and service station."
(Courtesy University of Chicago Library, Department of Special Collections.)

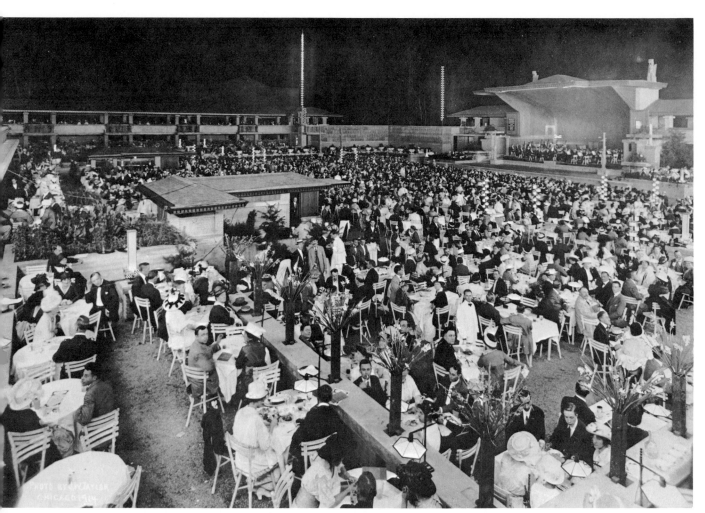

3

1. End of an Era: The Last Day of Cable Car Operation on North Clark Street, 1906

This cable car is running alongside Lincoln Park, just north of North Avenue, on what was the main route to the North Side. The cable railway enjoyed a relatively brief hegemony as Chicago's major local transport facility; the first one was installed on the North Side in 1888. As the photo documents, if the cable car was the end of an era, the automobile had already begun another.
(Courtesy Ravenswood-Lake View Historical Association, Hild Branch Library.)

2. Mass Transportation Lines, 1915

a large commercial amusement park at Sixty-third Street and South Park Way (Martin Luther King, Jr. Drive). And Washington Park race track was always a great attraction for the neighborhood until it moved to its present suburban location in 1908. Yet the area did not require much new residential building until the 1920's.

In fact, the preeminence of the South Side began to diminish after the Fair. The supremacy of that area had stemmed largely from the excellence of its transit facilities. But the completion of elevated transit lines into other sections of the city, coupled with the electrification and expansion of street railways, substantially reduced this advantage in the decades after 1893. The North and West sides now enjoyed the stimulus of good connections with downtown, and both witnessed spectacular growth. If the depression of the mid-nineties inhibited investment, the general prosperity of the following years encouraged new development.

Mass transit still was the crucial catalyst for expansion. The cable car, which had been so important in the eighties and nineties, quietly gave way to the electric street railway and the elevated. Some of the old cable lines hung on, and it was not until 1906 that the final epitaph was written. "State Street bade an unregretful farewell to the last cable train of the Chicago City Railway," the *Tribune* noted wistfully. "Groaning and decrepit it rattled and bumped around

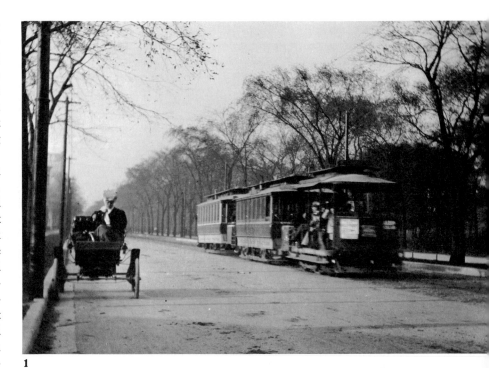

1

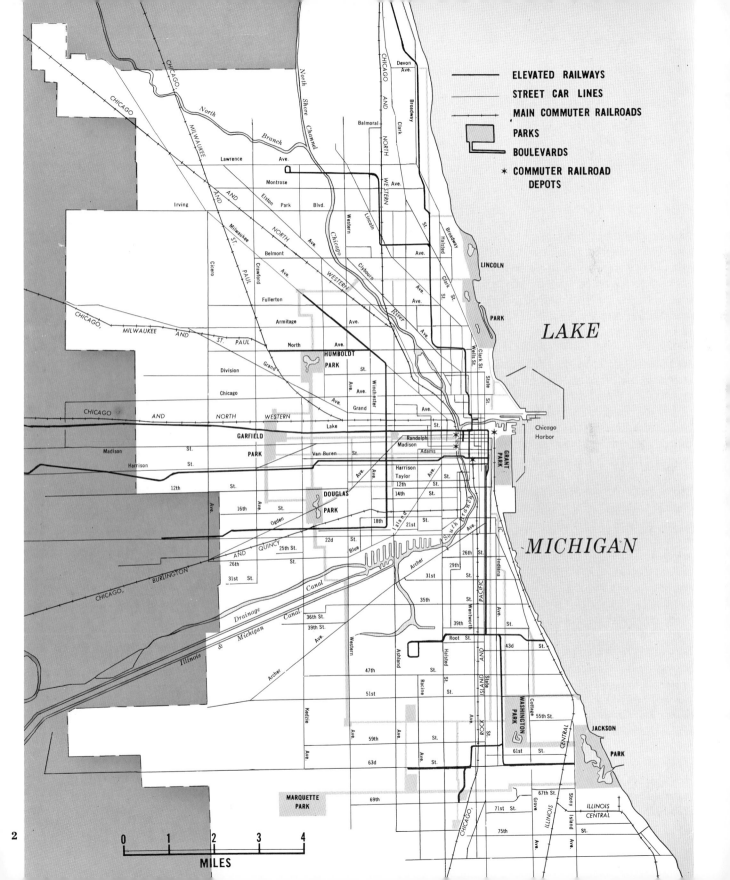

ELEVATED RAILWAYS
STREET CAR LINES
MAIN COMMUTER RAILROADS
PARKS
BOULEVARDS
* COMMUTER RAILROAD DEPOTS

LAKE

MICHIGAN

LINCOLN PARK

HUMBOLDT PARK

GARFIELD PARK

DOUGLAS PARK

GRANT PARK

Chicago Harbor

WASHINGTON PARK

JACKSON PARK

MARQUETTE PARK

CHICAGO AND NORTH WESTERN

CHICAGO, MILWAUKEE AND ST. PAUL

CHICAGO, BURLINGTON AND QUINCY

ILLINOIS CENTRAL

North Branch

North Shore Channel

Chicago River

South Branch

Illinois & Michigan Canal

Drainage Canal

Devon Ave.
Balmoral
Lawrence Ave.
Montrose Ave.
Irving Park Blvd.
Belmont Ave.
Fullerton Ave.
Armitage Ave.
North Ave.
Division St.
Chicago Ave.
Grand Ave.
Lake St.
Randolph
Madison
Van Buren St.
Harrison
Taylor
12th St.
14th St.
16th
18th
21st St.
22d
25th St.
26th
31st St.
35th
36th St.
39th St.
43d
47th St.
51st St.
55th St.
59th
61st St.
63d St.
67th St.
69th
71st St.
75th St.

Madison St.
Harrison St.
12th St.
Ogden Ave.
Archer Ave.
Blue Island
Root St.

Broadway
Clark St.
Halsted
Wells St.
State St.
Clark St.
Western St.
Lincoln Ave.
Clybourn Ave.
Winchester Ave.
Grand Ave.
Cicero
Crawford
Kedzie Ave.
Western Ave.
Ashland St.
Racine St.
Halsted St.
Wentworth Ave.
State St.
Indiana Ave.
Cottage Grove
Stony Island Ave.

Elston
Milwaukee Ave.

MILES
0 1 2 3 4

2

1. Electric Trolley Cars on Madison Street, Westward from Clinton Street, near West Side, 1906

The West Madison Street Surface line was one of the more heavily traveled routes in the city. In 1915 over forty-eight million passengers rode the cars that ran between Austin and Canal Streets. Behind the street cars at the northwest corner of Madison and Clinton is the Grand Central Hotel, a transient hotel just two blocks west of the river.
(Courtesy Chicago Historical Society.)

2. Electric Trolley Car and Trailer, Franklin and Madison Streets, 1906

Unlike some other cities that at first experimented with electric lines in slots between the tracks, Chicago used the overhead power line from the very beginning. The trolley car, with its single four-wheel truck is just turning on to Madison Street bound for Garfield Park.
(Courtesy Chicago Historical Society.)

the Loop for its last performance at 1:35 A.M. The train consisted of a battered grip-car and a twenty year-old trailer."

New electric street railway systems soon laced the city, and nearly everyone was within easy walking distance of some line. The route pattern was rectangular, with service along nearly every section-line street, some half-section streets, and most of the major diagonal arteries. The bitter competition for franchises so characteristic of the earlier period diminished; in 1907 the city council granted franchises to only five companies. Six years later, it put the entire system—nearly 1,000 miles of track—under the management of the Chicago Surface Lines, thus creating what Chicagoans claimed to be the largest unified street railway system in the world. Its volume of traffic reached 634 million fares in 1913; by 1929 that figure soared to nearly 890 million.

The street railways comprised only a portion of Chicago's public transportation, however. Before the electric street railway had completely replaced the horse railway and the cable cars, the elevated railroad added still another dimension to the city's transportation system. First built in 1892 and 1893 to the South Side and West Side, and using small steam locomotives until 1897, the Els were rapidly extended into most parts of the city. Downtown they swung around "the Loop" connecting the various lines and providing Chicago with

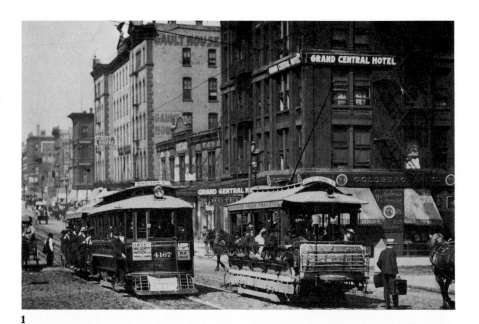

1

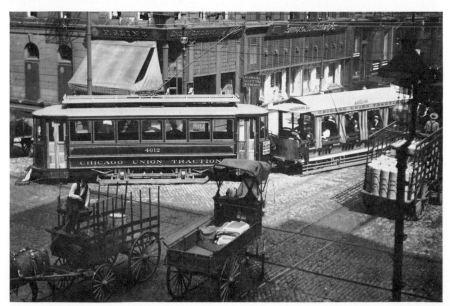

2

3. Streetcar Terminal on Clark Street, South of Howard Street, 1910

Beginning in late 1910, trolley lines outside the city limits were separate from the interior city's street railway system. This view, on the occasion of the "cutting of the line," shows the problem created as passengers now had to walk between an Evanston and a Chicago car. In a graphic way the photo demonstrates the problems created by the artificial boundaries of political units in a metropolitan area; for traction riders it meant inconvenient transfers and the double costs for riding duplicate equipment.
(Courtesy Chicago Historical Society.)

4. Streetcar Excursion

Streetcars were frequently chartered by private groups for special events and excursions. This one was especially decorated for an outing of the Farley-Sweeney Political Club, sometime after 1906.
(Courtesy George Krambles Collection.)

5. Street Railway Post Office Car on West Madison Street, about 1908

Some trolley cars operated as mobile post offices, carrying mail from neighborhood pickup points to the central post office. Sorting took place while the ride was in progress.
(Courtesy West Side Historical Society, Hild Branch Library.)

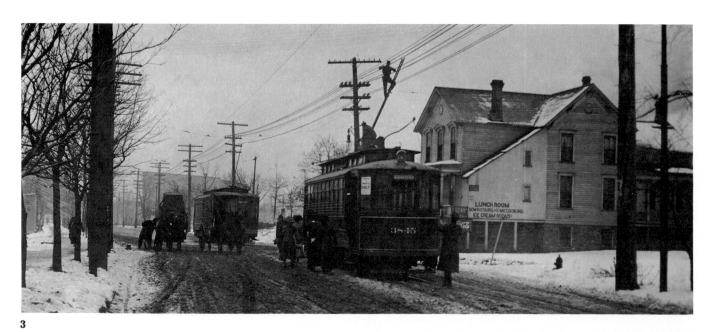

3

4

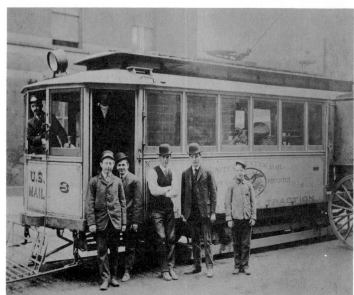

5

one of its most distinctive trademarks. And wherever the elevated lines were constructed, they brought important changes to the areas which they served.

Portions of the elevated railways were built above street level, others cut like a surgeon's knife through the heart of blocks along the alleys. Still others, especially in sparsely settled areas, ran on man-made embankments. If some of the lines depressed commercial values along the street, as in the case of Wabash Avenue downtown, many stimulated extraordinary economic growth. The southwest corner of Sixty-third and Cottage Grove Avenue, for example, carried a price of $8,000 in 1893; by 1920 it was valued at $320,000. Some lines served already dense areas of population; others reached into the newly subdivided parts of the city and nearby suburbs. In nearly every instance, the coming of the elevated meant increased density of population near the routes.

The South Side El had immediately proved itself by carrying immense crowds to the Fair in 1893; yet, even before this, construction had begun on the Lake Street elevated through the West Side. Ultimately the new installations extended through Austin across the city line into Oak Park and River Forest. The Metropolitan Elevated built four more lines into the West Side—the Garfield Park Branch to Cicero Avenue, the Logan Square branch northwesterly, the Humbolt branch to Lawndale Avenue, and the Douglas Park branch to Eighteenth

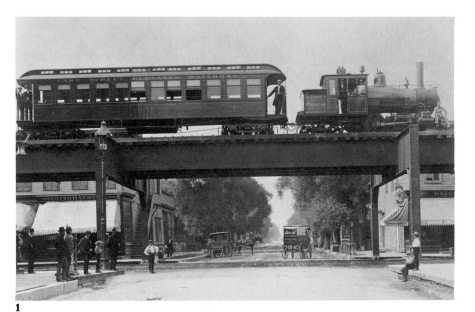

1

2

3. Construction of the Northwestern Elevated Railroad, North from Wilson Street, near Sheffield, 1897

Like the city's modern expressway system, the elevated cut through old established neighborhoods, usually those with the densest population. In this photo the El's concrete foundations are in place, and steel columns and beams are lying alongside. (Courtesy Chicago Historical Society.)

4. Construction of the Northwestern Elevated Railroad, Dayton Street near North Avenue, April, 1897

The rear halves of these residental lots have completely disappeared as they are covered by the sprawling steel structure of elevated supports. The new railroad often painfully revealed the number of back lot buildings which helped house Chicago's booming population. (Courtesy George Krambles Collection.)

3

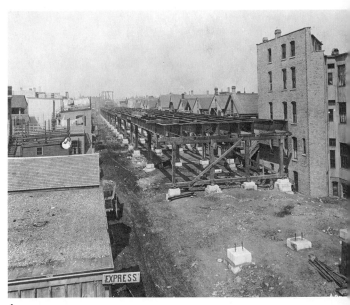

4

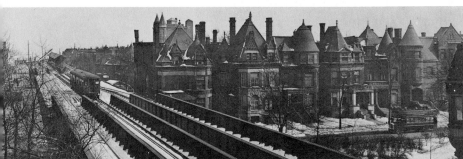

5. Kenwood Branch of the South Side Elevated Railroad, Drexel Boulevard and Fortieth Street, about 1920

In 1910 a branch of the elevated line was built into Kenwood, finally ending at 42d Place and the Lake. Developers responded by building new apartments along Drexel Boulevard and by converting large single-family dwellings into rooming houses north of 47th Street. At first it was white collar workers, including many German Jews, Irish, and English, who traveled the "old elevated trail." Increasingly, however, transients and single persons moved there, especially in the 1930's; in the 1940's they were followed by large numbers of Negroes. (Courtesy George Krambles Collection.)

1. Elevated Station at Sixty-Third Street and Harvard Avenue in Englewood, 1924

The elevated was extended into Englewood in 1907; the construction of apartment houses occurred in the years following, adding to the double and triple deckers already there. In 1920, over 86,000 people lived in Englewood, with about one-fifth being foreign born and another two per cent black. Many of the foreign stock, especially the Irish, moved there from the "Back of the Yards" after the turn of the century.

(Courtesy George Krambles Collection.)

2. Northeastern Corner of the Stockyards Elevated Soon after Completion, 1910

Cutting through the maze of pens and barns, the Stockyards branch of the South Side Elevated carries a train load of commuters. Although a great portion of yards workers lived within walking distance of the plants others lived northeast and southeast of the district where they could use the elevated to commute to work. The view is northeast across Exchange and Racine Avenues.

(Courtesy George Krambles Collection.)

Street. For the most part this network served built-up areas, encouraging the construction of three-story apartment buildings along the routes. Austin, Lawndale, Oak Park, and Cicero filled up rapidly after rapid transit became available.

Nowhere, however, was the impact of the new transportation more quickly felt than on the North Side. Because of poor facilities, its connections with downtown had never been as good as those of other parts of the city. With the opening of the Northwestern Elevated Railroad in 1900 this handicap disappeared. The original terminus was at Wilson Avenue where the Uptown shopping center and hotel complex grew up. In 1907 a new branch, the Ravenswood line, made possible the development of Albany Park and another important commercial concentration. In the same year the Northwestern elevated extended its line on a right-of-way formerly used by commuter trains of a steam railroad to Central Street in Evanston; by 1908 it was in operation to Wilmette.

The South Side El also sprouted branches, but the new routes were designed to tap established neighborhoods rather than to stimulate new growth. The Englewood line served what soon became Chicago's largest outlying shopping center at Sixty-third and Halsted. Another line circled the Union Stockyards with stations at each of the major plants. Other branches served northern Kenwood and Normal Park.

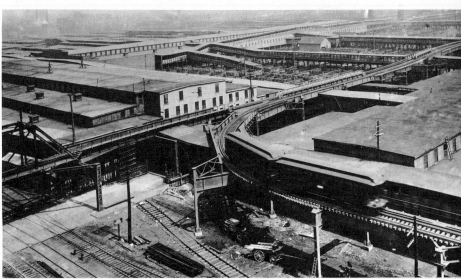

1

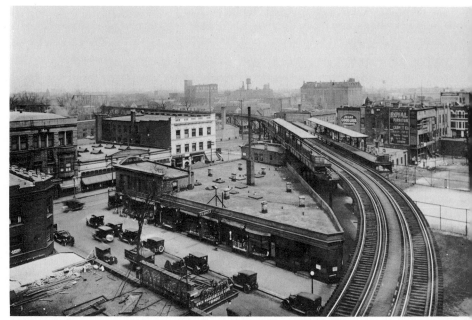

2

3. Loop of the Stockyards Branch of the South Side Elevated Railroad in "Packingtown," 1910

Two giants of Chicago's meat packing trade, Swift and Company and Libby, McNeill & Libby, dominated a large area of the land in "Packingtown." The elevated lines made its turn at the corner of Packers and Exchange avenues.
(Courtesy George Krambles Collection.)

4. View Southwest across Stock Yards at Exchange Avenue, about 1910

Crowded pens signify the importance of the stock yards operation in the first decade of the twentieth century. Over three million cattle and six million hogs were received at the Yards in 1910.
(Courtesy George Krambles Collection.)

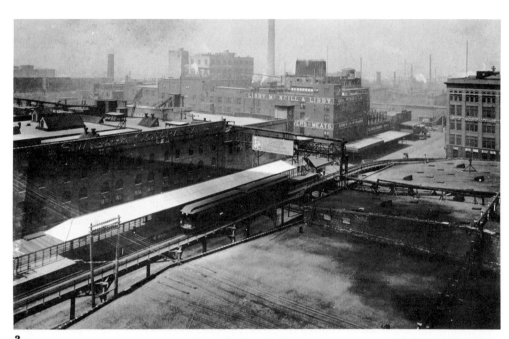

3

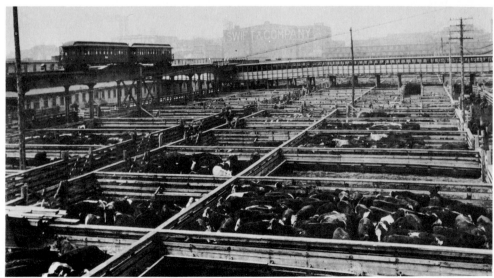

4

1. Lake and Wells Street Intersection, Northwest Corner of the Elevated Loop, Looking Northward, 1912-13

To carry the thousands of passengers to and from work, elevated trains ran on close headways, especially during the morning and evening rush hours. In 1916, 100,000 passengers rode the elevateds daily during the peak hour between five and six in the evening; rush hour pile-ups of traffic often occurred at Loop intersections. (Courtesy George Krambles Collection.)

2. Looking North at State and Madison Streets, about 1911

Over "twenty-odd thousand street-cars and more than 130,000 vehicles," both horse-drawn and motor-driven, entered the loop on each working day in 1919. Combining this street traffic with the walking movements of the one-and-a-half million people who were usually there created immense congestion, especially at State and Madison. Adding to the problem were rough brick pavements and loose traffic control. (Courtesy Chicago Historical Society.)

The most striking and visible legacy of the new transit system was the downtown Loop. A steel girdle around the business section, it unmistakably defined the core of Chicago's central business district and identified the desirable and prestigious locations. Some complained that the elevated created a kind of Chinese Wall that damaged property outside; others thought the massive steel structures awkward and ugly, obstructing ground traffic and shutting out the sun and daylight; and nearly everyone objected to the rumbling of coaches overhead, the squealing wheels, and the incessant noise of trains starting and stopping. "The sky is of iron, and perpetually growls a rolling thunder," a French artist wrote after standing under the El at Wabash. "Electric lights are emitting burning sparks; below are wagons of every size and kind, whose approach cannot be heard in the midst of the noise; and the cars, with jangling voice which never ceases, cross and re-cross." "If the most noisy place is hell—surely Chicago must be hell," a bewildered Japanese visitor wrote in 1900.

By 1910 the transit systems, elevated and surface, poured over three-fourths of a million people a day into the Loop area, with most of them arriving by surface streetcar. The result was bedlam. "I saw here for the first time in my life such a dangerous procession of street cars—cars above my head, cars under my feet, cars everywhere," wrote a trav-

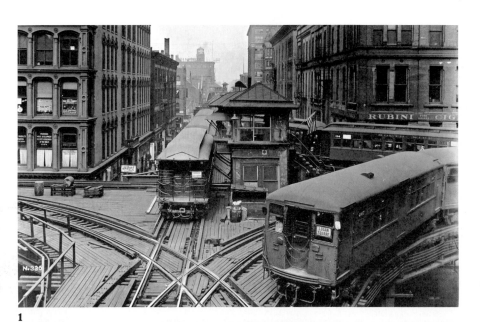

1

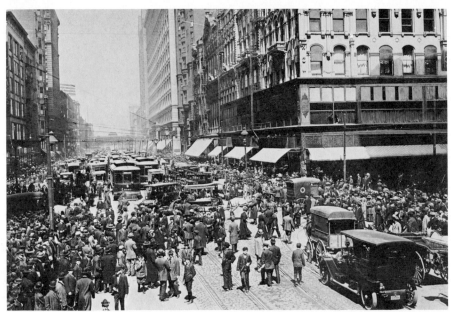

2

3. State and Madison Streets, "The Busiest Corner in the World," Looking Northeast, about 1905

Cable cars, horsedrawn carriages, and early horseless carriages share the street as they pass the iron-facaded front of the Carson, Pirie Scott store on the southeast corner. On the northeast corner is Mandel Brothers.
(Courtesy Chicago Historical Society.)

4. South on Dearborn Street from Randolph Street, about 1905

"The city is fearfully busy at all of its downtown corners," Edgar Hungerford wrote in 1913. "New Yorkers shudder at Thirty-fourth street and Broadway. Inside the Chicago loop are several dozen Thirty-fourth streets and Broadways. . . . It is no laughing matter to folks who have to thread it. Trolley cars, automobiles, taxicabs, the long lumbering 'buses that remind one of the photographs of Broadway, New York, a quarter of a century ago or more, entangle themselves with one another and with unfortunate pedestrians and still no one comes forward with practical relief."
(Courtesy Chicago Historical Society.)

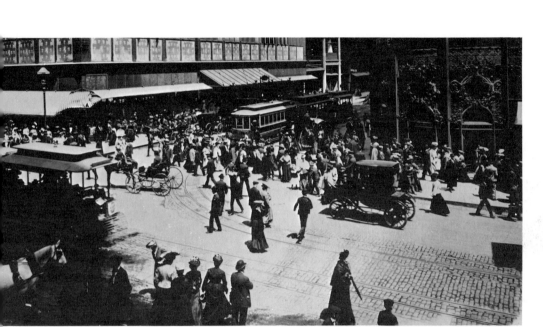

3

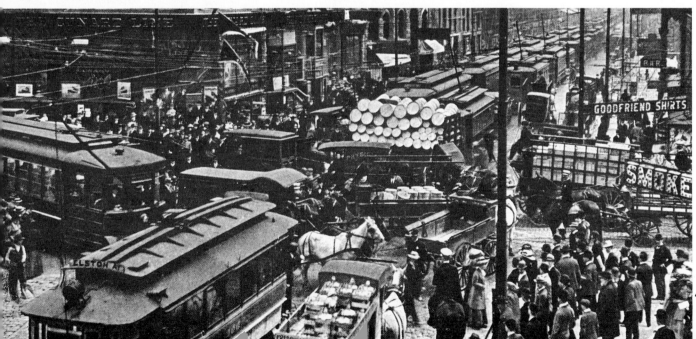

4

1. Map of the Tunnel System of the Chicago Tunnel Company, 1912

The tunnels were an average of forty-two feet below the ground. They connected with every major railway terminal and had four public receiving depots outside the Loop. The little freight cars delivered about 650,000 tons of package freight to these terminals in 1920. The Tunnel Company estimated that their operation saved about 5,000 truck movements per day. "Without the tunnels," one of their boosters wrote, "there would be added to the traffic in the loop and immediate vicinity a line of motor trucks that would extend from Madison Street to Waukegan. Tunnel service is the one reason why that additional traffic is not in the loop streets."
(From the *Electric Railway Journal*, 1912.)

eler who had threaded his way nimbly through downtown streets. State and Madison, already the world's busiest corner, became an impossible mixture of street cars, wagons, pedestrians, and a sprinkling of automobiles. "You take your life in your hands when you attempt crossing State Street with its endless stream of rattling wagons and clanging trolley cars," another visitor observed warily. "New York does not for a moment compare with Chicago in the roar and bustle and bewilderment of its street life."

Congestion would have been even more intolerable had it not been for the construction of an elaborate freight subway system to move goods underground in and near the Loop, thus reducing truck and dray traffic on the surface. Originally, the subterranean network was created by a telephone company for its cables, but the excavations were large enough to accommodate two-foot-gauge electric railway lines. "This is the latest Chicago idea," a visiting journalist noted in 1907. "It is so new that few of the hurrying things in the downtown district have seen the wonderful railway system that is operating forty feet below the sidewalk. Yet it has already displaced seventy postal-wagons and hundreds of drays. When it is in full swing it may go far toward clearing the streets of forty thousand turbulent teamsters, and toward making Chicago the handiest city in the world." By 1914 there were sixty-two miles of tunnels under the major

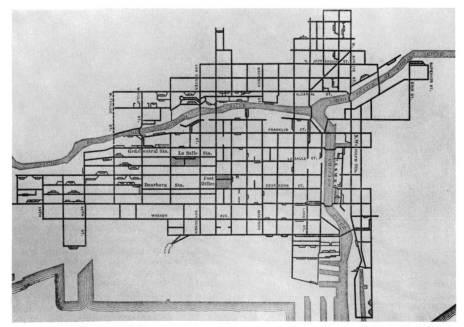

1

2

2. A Portion of the Freight Tunnel System, Showing Locomotive and Cars, 1924

The Tunnel Company hauled not only package freight but ashes, coal and excavated material from newly dug downtown foundations. All loading of coal was done outside the Loop, as was the dumping of ashes and garbage; the latter was "loaded on barges and towed thirteen miles out in the lake for dumping."
(Courtesy Chicago Historical Society.)

3. Main Entrance to Marshall Field Store on the East Side of State Street, about 1905

Grecian columns at Marshall Field's main entrance have been a feature of the store since 1902. At the curb an early automobile, a horse-drawn cab, and the Field omnibus mark the city's major transportation developments. The next year trolley lines would be added to State Street and the old store on the extreme right would be replaced by the imposing and uniform block-long facade of Marshall Field's.
(Courtesy Chicago Historical Society.)

4. State Street South from Lake Street Elevated Station, 1906

Cable cars such as the one running on the street railway tracks of the far left would disappear shortly after this photo was taken, to be replaced by electric cars like those already occupying the two other tracks. The large building with the theater is the Masonic Temple, tallest building in the world when constructed in 1892. At the left are several small restaurants and service stores which huddled around the larger State Street establishments to serve both their patrons and their employees.
(Courtesy Chicago Historical Society.)

3

4

5

5. Construction of the Boston Store, September 16, 1915

Holabird and Roche made little attempt to conceal the steel-frame construction of the Boston Store. Built between 1905 and 1917 and later converted to an office building, the seventeen story building fronts on State, Madison, and Dearborn streets. In this photograph the last section is about one-half completed.
(Courtesy Chicago Historical Society.)

1. Michigan Avenue between Jackson and Adams, about 1912

Daniel Burnham and Company were responsible for three of the newer buildings in this photo. At the left is the seventeen-story Railway Exchange Building, built in 1904; next to it is Orchestra Hall erected a year later, and the twenty-story People's Gas Company, completed in 1911. The older Pullman Building at the southwest corner of Michigan and Adams was built in 1884; a pioneer of its time, it contained both offices and apartments.
(Courtesy Library of Congress Collection.)

2. Northwest from Eighth Street on Michigan Avenue

Houses fill the block that in 1927 would become the site of Holabird and Roche's Stevens (Hilton) hotel. The Blackstone (Sheraton-Blackstone) Hotel had been completed in 1909 at the northwest corner of East Balbo Avenue. Its twenty-two stories were placed atop rock caissons. Marshall and Fox were the architects.
(Courtesy Chicago Historical Society.)

downtown streets, with 117 locomotives and 3,000 cars carrying goods, fuel, and workers throughout the business district. The motor truck ultimately replaced this unique underground system, but only after more than thirty years of sturdy service.

The daily influx of commuters reflected the commanding importance of the Loop in metropolitan Chicago. Its most glittering attractions were the department stores along State Street. Marshall Field's was easily the most famous enterprise, with a floor area of nearly forty acres in its new buildings, forty-five display windows, and fifty elevators. It was, as a national magazine observed in 1907, "more than a store. It was an exposition, a school of courtesy, a museum of modern commerce."

And it had its rivals. Down the street was Carson, Pirie Scott Company's store. Louis Sullivan had designed the building and made it one of the landmarks of the "Chicago School" of architecture; energetic entrepreneurs had made it a serious competitor of Marshall Field's. Mandel Brothers was on the same side of State Street, and the Boston Store was across the street just a little farther south. The Fair, Rothschilds, Siegel, Cooper and Company, and Stevens stores were others among State Street's retail giants. "These huge establishments are from twelve to fifteen stories high," wrote two astonished visitors, "and contain every possible article

1

2

3. Northwest Corner, Michigan Avenue and Harrison Street, about 1900

Fashionable townhouses still crowded the edges of the downtown at the turn of the century, although North Lake Shore Drive was beginning to drain away residents from both this area and places farther south like Prairie Avenue. Between 1902–7, these houses were replaced by the fourteen-story Congress Hotel Annex, designed by Holabird and Roche. (Courtesy Chicago Historical Society.)

4. Michigan Avenue North from Lake Street, 1914

Loft manufacturers, distribution establishments, warehouses, sign companies, locksmiths, taverns, and numerous other businesses lined North Michigan Avenue in 1914. Even then, the avenue was a major traffic artery. (Courtesy Chicago Historical Society.)

5. Randolph Street West from the Wabash Elevated Station, 1896

Theaters dotted Randolph Street, just as they do today. Two of the most important are shown in this photo: the Roof Theater in the Masonic Temple (later the Capitol Building) at the northeast corner of Randolph and Clark, and beyond, in the block between Dearborn and State, is the tall cupolaed Schiller Building (later the Garrick Building) designed by Adler and Sullivan, erected in 1892 and demolished in 1961 to make way for a parking lot. (Courtesy Chicago Historical Society.)

3

4

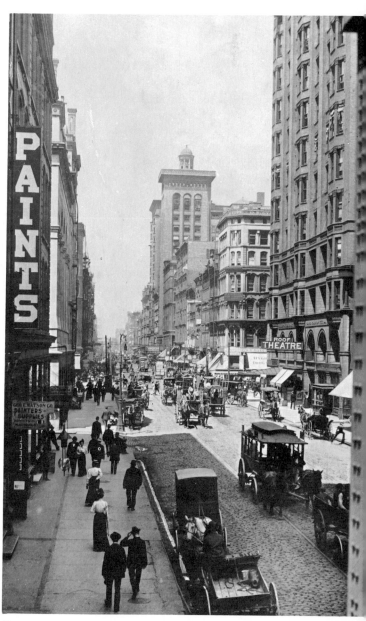

5

220

1. **Arcades and Theaters on South
State Street between Van Buren
and Congress, about 1912**
While a sign proclaims that the
"Entertainment" of the "First Class
Museum" is for "Ladies, Gentlemen and
Children," the character of the street
population indicates that clientele was
somewhat more limited. The upper stories
of these recreation palaces housed many
of the single men who made up the street
types in the photo.
(Courtesy Chicago Historical Society.)

2. **368 to 374 (Now 614 to 626) South
State Street, Midway between
Harrison and Balbo Drive, 1905**
(Courtesy Chicago Historical Society.)

of trade, from watches and boot laces, to the most exquisite art treasures and priceless gems. Anything, indeed can be purchased there, even to real estate and country houses." Comparing these department stores with the best in France and England, they declared Chicago's to be "larger and, if possible, more complete in scale, more daring and perhaps more fantastic in their display."

The Loop, however, had something for every taste. Along Michigan Avenue, just east of the Loop proper, elegant shops catered to the "carriage trade" with the latest fashions from Paris and New York. The wholesale produce market ranged along South Water Street, north of the Loop. Just south of Van Buren on State Street, the penny arcades, cheap saloons, burlesque "palaces," and tawdry vaudeville beckoned to the tourist and the unwary. A little farther away the vice district operated around the clock without much official interference, indeed often with police collusion. For those seeking higher things, there were theaters on Randolph Street, the Art Institute, the Public Library, and Orchestra Hall along Michigan Avenue, and numerous book stores and art galleries scattered about downtown.

Public life also centered on the Loop. The massive new City Hall and County building, built 1906–9, occupied a full city block facing Clark Street between Randolph and Washington, and a few blocks farther south the huge, domed new Federal Post Office and Court House

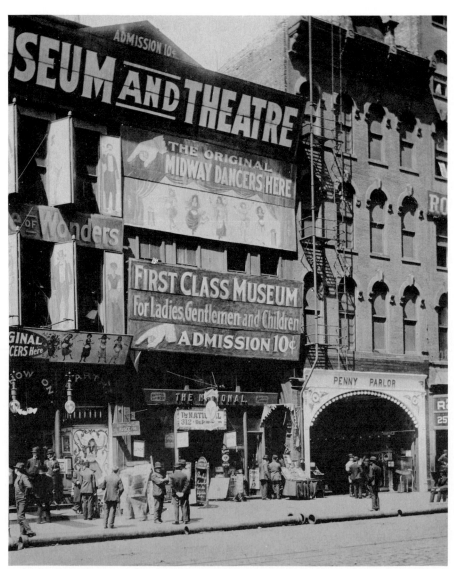

1

3. 412 to 418 (Now 714 to 728) South State Street, Midway between Balbo Drive and Eighth Street, 1905
(Courtesy Chicago Historical Society.)

4. 420 to 426 South State Street (Now 732 South Including Part of Eighth Street), 1905
(Courtesy Chicago Historical Society.)

5. Clark Street, between Madison and Washington, Looking Northeast, 1911
Hotel Planters had been finished only a few months when this photograph was taken. The nine-story building was the work of J. E. O. Pridmore, and in it is found a example of an architectural design contemporary with some of the Chicago School's more famous work.
(Courtesy Chicago Historical Society.)

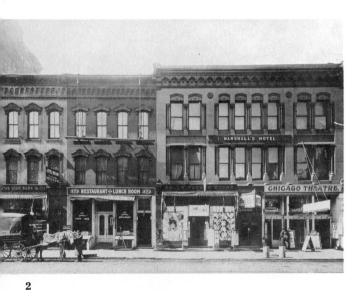

2

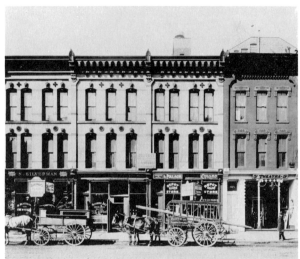

3

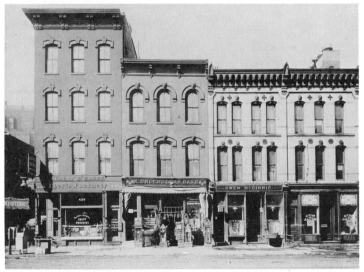

4

5

1. South Water Street Wholesale Produce Market, between 1900 and 1910

"The great central depot for Chicago's fruits, vegetables, fish, and poultry," was this "intensely congested and busy thoroughfare one block north of Lake Street and near the main trunk of the river." Because of the congestion, the access to the market was difficult; and spoilage and business losses from the problems were accepted grudgingly as part of the risks of the trade.

(Courtesy Chicago Historical Society.)

2. Present City Hall and County Building

Designed by Holabird and Roche, the City Hall and County Building was constructed in the block bounded by Randolph, Clark, Washington, and LaSalle Streets between 1906–11.

(Courtesy Chicago Historical Society.)

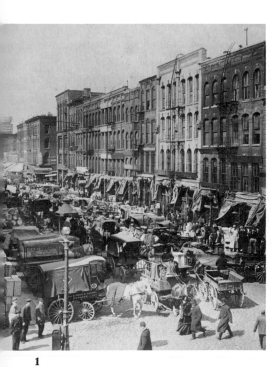

1

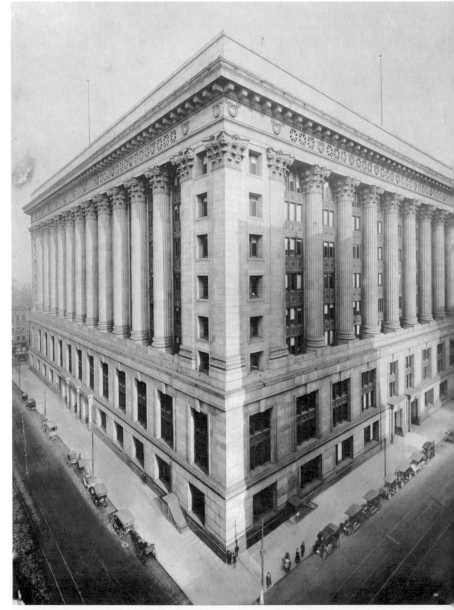

2

3. Libby Prison, Wabash Avenue and Fifteenth Street, 1891

A notorious prison for Union soldiers in Richmond, Virginia, during the Civil War, it was brought, stone by stone, to Chicago and reconstructed in the 1880's. Its walls were subsequently used as part of the Coliseum.
(Courtesy Lawndale-Crawford Historical Society, Toman Branch Library.)

4. The Coliseum, Probably 1908

The Coliseum was the scene of many national political conventions as well as grand events of all kinds. The Republicans met here in 1908, 1912, and 1916. The picture is probably of the 1908 convention, when William Howard Taft received the presidential nomination. Although succeeded as the city's major indoor arena by the Chicago Stadium, International Amphitheatre, and McCormick Place, the building is still used for public and sporting events.

5. Federal Building (Formerly the Chicago Post Office), 1912

Covering the block between West Jackson and West Adams, South Clark and South Dearborn, the Federal Building was completed in 1905 and demolished during 1965–66. Henry Ives Cobb designed the eight-story building with its heavy monumental character and dome. The immense tonnage was carried on fifty-foot wooden piles.
(Courtesy Chicago Historical Society.)

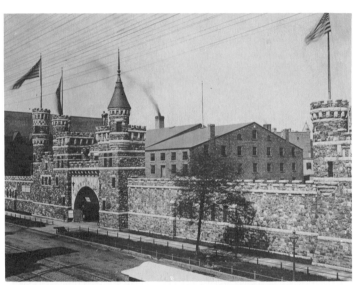

3

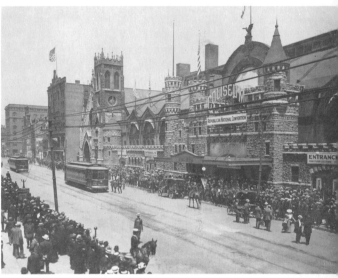

4

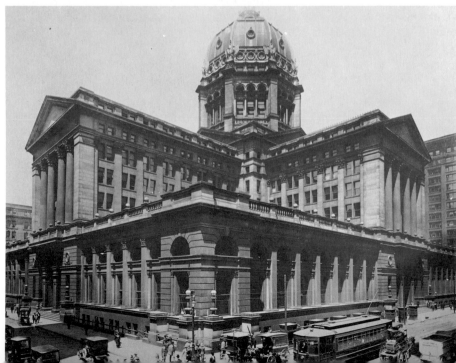

5

224

sat in quiet dignity among the frenzied
financial and commercial activities of the
metropolis. The Coliseum on South
Wabash provided a convenient site for
all kinds of large civic affairs. Through-
out the country it was famous because
both political parties had chosen it many
times for national conventions. But Chi-
cagoans knew it best at this time as the
site of the notorious annual First Ward
balls staged by the amiable and corrupt
"bosses" of the central city—"Hinky
Dink" Kenna and John "The Bath"
Coughlin—to raise money for the Demo-
cratic organization. On these joyous oc-
casions, the city's political swells mixed
with hoi polloi at the levee, and thou-
sands would frolic far into the night. In
1908 one reporter counted two bands,
two hundred waiters, one hundred po-
licemen, 35,000 quarts of beer and 10,000
quarts of champagne. All this was easily
consumed before the hosts "sent for
reinforcements." "It's a lallapalooza,"
said Hinky Dink with measured under-
statement. "All the business houses are
here, all the big people. Chicago ain't
no sissy town." Not many other places
could have handled the crowds so easily,
and perhaps no other townspeople could
handle the refreshments so comfortably.
 Just inside the Loop to the west,
LaSalle Street contained the city's major
financial institutions. At the head of the
canyon rose the Board of Trade, em-
blematic of Chicago's domination of the
nation's grain exchange. Banks and finan-
cial institutions lined both sides of the

Leiter's Chicago

1. Levi Zeigler Leiter (1834–1904)

Levi Leiter arrived in Chicago in 1854. He worked in the wholesale and retail trades until 1865 when, with Marshall Field, he bought a controlling interest in Potter Palmer's business. Leiter sold out to Field in 1881 and retired to his private library, many service organizations, and his real estate holdings. A heavy investor in the Illinois Trust and Savings Bank, he became one of its directors in the mid-1880's. Levi Leiter was, to quote a contemporary, a man whose "great aim has been to be a model citizen, and not to accumulate great wealth." Still, by the end of his life he had gathered a sizable collection of the city's better real estate investments. Leiter had his real estate holdings compiled into an album, with a photograph of each building and a facing map which showed its location. Like Potter Palmer's Album of the late 1860's, Levi Leiter's real estate album graphically illustrates a major Chicago success story and provides insight into one of the city's real estate fortunes. (Courtesy Chicago Historical Society.)

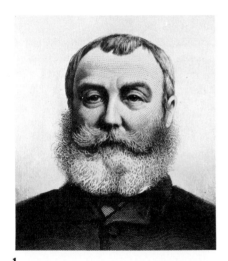

1

2. Siegel Cooper Company Store Building

Located on State Street between Van Buren and Congress, this building stood "as an example of good taste, munificence, and wisdom on the part of its builder, L. Z. Leiter. Its fifteen acres of floor area was contained on eight floors and a basement and was serviced by twelve passenger and six freight elevators." Two thousand employees worked in it in the day when it was claimed as "the largest retail establishment in the world." It cost $1.5 million to build, an amount which was $1 million less than the value of the ground on which it stood in 1905. After several changes in ownership, the building now houses a Sears, Roebuck and Company store.
(Gravure, Levi Z. Leiter Real Estate Album. Courtesy Chicago Historical Society.)

3. Grand Pacific Hotel

Fronting on Clark, Jackson, LaSalle and Quincy streets, this structure was built to six stories in 1872 and covered nearly an acre and a half of land. By the time this photo was taken, the building's original cost, $1.3 million, had shrunk to an assessed evaluation of just over $220,000, while the value of the land at the central downtown location rose to $1.44 million.
(Gravure, Levi Z. Leiter Real Estate Album. Courtesy Chicago Historical Society.)

2

3

Leiter's Chicago

1. Reliance Hotel, Northeast Corner of State and Hubbard Place

The Salvation Army rented this building, which they used as their western headquarters and a workingman's hotel. The land on which this building stood was worth nearly nine times more than the building's assessed value of $21,000.
(Gravure, Levi Z. Leiter Real Estate Album. Courtesy Chicago Historical Society.)

2. 173-75 (Now Railroad Tracks) Adams Street

This Leiter building contained the outstanding Henrici's restaurant on the first floor, a wholesale jewelry and novelty firm on the second, and tailoring and dry goods establishments on the third through fifth.
(Gravure, Levi Z. Leiter Real Estate Album. Courtesy Chicago Historical Society.)

street, their austere classical facades bulging with the driving energy that had made them the commanding force in the financial affairs of the Middle West. In this expensive setting, Burnham and Root's Rookery Building was a special gem.

Few other large cities had so concentrated their central functions. "Within an area of less than a square mile," wrote City Club secretary George E. Hooker in 1910, "there are found the railway terminals and business offices, the big retail stores, the wholesale and jobbing business, the financial center, the main offices of the chief firms of the city, a considerable portion of the medical and dental professions, the legal profession, the city and county government, the post office, the courts, the leading social and political clubs, the hotels, theatres, Art Institute, principal libraries, the labor headquarters, and a great number of lesser factors of city life." He noted by contrast that in New York these features were "scattered from the Bowery to 59th Street, a distance of five or six miles," and in London from "Oldgate Pump to Victoria Station, a distance of four or five miles."

The Loop was the physical symbol of Chicago's commercial power, but the city's strength was based as much on its manufacturing as on its trade. In the period after the Fair, its industrial base,

1

3. 411-13 (Now 721-723) South State Street

Leiter's holdings extended to the edge of the Loop into the workingmen's and transients' quarters. Here a lunch room and cigar store cater to local residents; the upper floors are apartments. (Gravure, Levi Z. Leiter Real Estate Album. Courtesy Chicago Historical Society.)

2

3

Leiter's Chicago

1. The Leiter Flats, Facing Jackson Park Terrace (65th Street) between Jackson Park Avenue (Stony Island Avenue) and Jefferson Street (Harper Avenue)

Leiter's real estate interests also included at least one elegant "flat" building on the South Side. The assessed value of these buildings was $103,000; they were built on land valued at $17,500.
(Gravure, Levi Z. Leiter Real Estate Album. Courtesy Chicago Historical Society.)

1

2. Universal Fuel Company, Thirty-Ninth Street and Iron Street

At first glance this small brick building with its second floor dwelling hardly seems a choice piece of real estate for inclusion in the holdings of a Chicago real estate magnate. But this land was located in the industrial and wholesale complex on the South Branch of the River, north of the Stock Yards. In the background is one of the many grain elevators which settled along the South Branch to take advantage of the railroad and river connections. In the Leiter Album, the reason for the holding of the land became clear; listed as "Dock Property on Iron Street," the value of the buildings occupying the location was only $15,000, but the assessed valuation of the land was $130,000.
(Gravure, Levi Z. Leiter Real Estate Album. Courtesy Chicago Historical Society.)

2

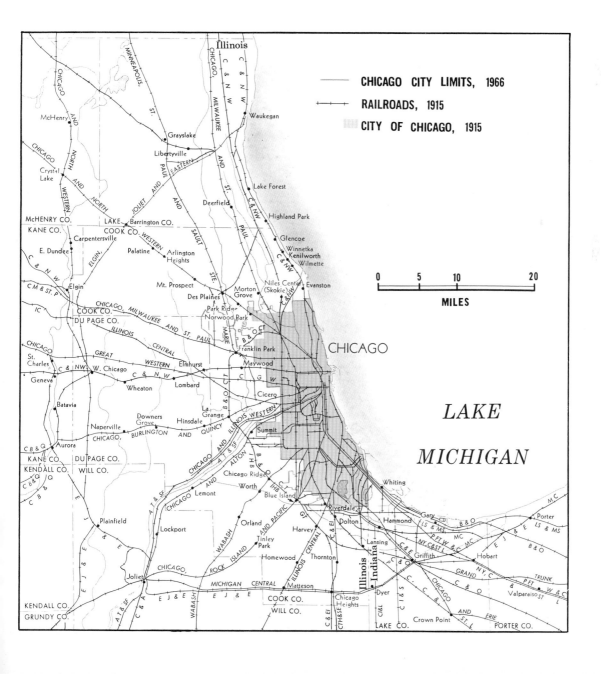

CHICAGO CITY LIMITS, 1966
RAILROADS, 1915
CITY OF CHICAGO, 1915

Illinois

McHenry
Grayslake
Libertyville
Crystal
Lake
Deerfield
Waukegan
Lake Forest
Highland Park
Glencoe
Winnetka
Kenilworth
Wilmette

McHENRY CO.
KANE CO.
LAKE
COOK CO.
Carpentersville
E. Dundee
Palatine
Arlington
Heights
Elgin
Mt. Prospect
Des Plaines
Morton
Grove
Niles Center
(Skokie)
Evanston
Barrington

CM & ST. P
IC
COOK CO.
DU PAGE CO.
Illinois
Park Ridge
Norwood Park
CT
Franklin Park
Elmhurst
Maywood

CHICAGO

St.
Charles
Geneva
W. Chicago
Wheaton
Lombard
Cicero
La
Grange
Downers
Grove
Hinsdale
Summit

0 5 10 20
MILES

LAKE

MICHIGAN

Batavia
Naperville
Aurora
KANE CO.
KENDALL CO.
DU PAGE CO.
WILL CO.
Chicago Ridge
Worth
Blue Island
Whiting

Plainfield
Lockport
Orland
Lemont
Tinley
Park
Harvey
Homewood
Thornton
Riverdale
Dolton
Hammond
Gary
Porter
Lansing
Griffith
Hobart

Joliet
Matteson
Dyer
KENDALL CO.
GRUNDY CO.
COOK CO.
WILL CO.
Chicago
Heights
Crown Point
Valparaiso
PORTER CO.
LAKE CO.
Illinois
Indiana

230

1. Union Stock Yards, about 1905
 Looking westward on Exchange Avenue this view catches a portion of the stock yards operation in one of its peak periods. The Exchange Building at the left, the related railroad activity, and the packing industries provided employment for thousands of Chicagoans, many of them unskilled immigrants.
(Courtesy Chicago Historical Society.)

2. Montgomery Ward and Company Principal Warehouses and Home Offices
 The Chicago Avenue bridge splits the Montgomery Ward complex, which is situated on the eastern bank of the Chicago River's North Branch. This photo was taken in 1964, when most of the half-century old Ward buildings had been modernized.
(Courtesy Montgomery Ward and Company.)

already among the largest and most diversified in the country, developed its present characteristics. Many of the familiar giants appeared, some by mergers, others by sheer growth. The Illinois Steel Company, later Carnegie-Illinois, became part of the United States Steel Corporation in 1901; most of the suppliers of agricultural machinery in the metropolitan area joined the newly-formed International Harvester a year later. Montgomery Ward and Sears, Roebuck, though both were founded earlier, established their national supremacy in the first decade of this century.

Moreover, Chicago's traditional leadership in such areas as meatpacking and food processing continued. The men's clothing industry, which had accounted for eight per cent of the country's output in 1879, produced eighteen per cent by 1914. At the turn of the century, printing and publishing establishments employed over 20,000 people, and Chicago was second only to New York in both areas. Smaller manufacturing firms flourished in these and other industries, most congregating in multiple-storied buildings on the fringes of the central business district where they could take advantage of Chicago's excellent transportation facilities and be close to a large metropolitan labor market.

In this same period, however, Chicago lost two infant industries in which it pioneered and which seemed destined for the Windy City. Motion pictures

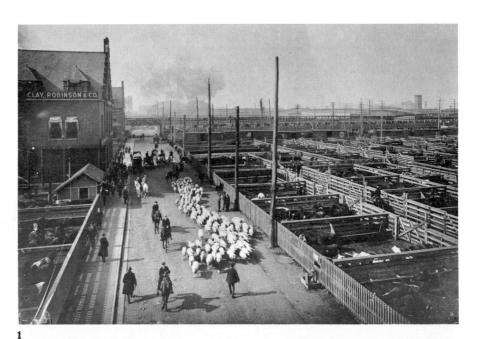

1

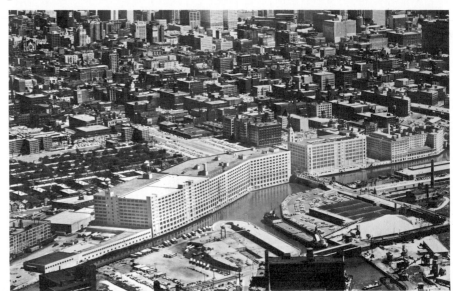

2

3. Sears, Roebuck & Company

In 1910 the editors of the *Daily News Almanac and Yearbook* wrote that "out on the west side of Chicago, only fifteen to twenty minutes' ride from the center of the downtown business district, is located the new plant of Sears, Roebuck & Co., a commercial institution second to none of its kind in the world, greater, in fact, than any three similar houses in the country, and occupying forty acres of ground in the center of a populous residential district." The company was established in 1886, and it began development of its present Homan Avenue site in 1904. On that location they erected a building complex "so large that they were compelled to ask the City Council of Chicago to close certain streets so that they might build over them." In the 1960's Sears was the main employer within the North Lawndale and Garfield Park communities. This view, taken in 1964 looking southeast toward Douglas Park, shows the plant virtually surrounded by the three-story apartment buildings which were erected mainly in the first three decades of the century.
(Courtesy Sears, Roebuck & Company.)

5. Building Facades on East Side of Wells Street (then Fifth Avenue) just North of Madison Street, about 1911

Thousands of seamstresses, tailors, clerks, and other workers spent their working days in cubbyhole offices and workshops in such buildings. In contrast to this scene is the massive LaSalle Hotel directly behind. Completed in 1909 under the architectural direction of Holabird and Roche, its twenty-two stories offered the most modern accommodations to travelers.
(Courtesy Chicago Historical Society.)

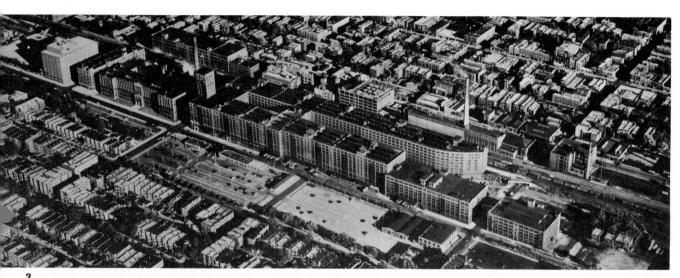

3

5

4. McCormick Reaper Plant of the International Harvester Company, 1906

Mirrored in the murky, still waters of the Chicago River's South Branch, the McCormick Reaper works was one of the many heavy manufacturing plants located in the inner-city industrial complex. It became part of the International Harvester Company when it was merged with McCormick in 1902. All the buildings in the photograph were demolished in the 1950's when International Harvester discontinued all its Chicago operations except for the Tractor Works.
(Courtesy Chicago Historical Society.)

232

1. Essanay Studio, 1345 W. Argyle

Movie making was an outdoor art in the early days, since "shooting with the sun" was the best way to provide lighting. Essanay Studios originated in Chicago in the early 1900's; by 1910, however, they already had established a studio on the West Coast. Still, many early motion pictures were made here. Several stars including Francis X. Bushman, Beverly Bayne, Wallace Beery, and Ben Turpin made pictures in the Chicago studio. (Courtesy Chicago Historical Society.)

2. Automobile Service Station at 1217 (Now 1131) Devon Avenue, Just Off Broadway, 1906–7

While automobile manufacturing did not become one of Chicago's most important industries, it did provide new business opportunities for ambitious entrepreneurs. Replacing the blacksmith and the livery stable, "filling-stations" and auto repair shops grew up along busy streets. (Courtesy Lake View–Ravenswood Historical Association, Hild Branch Library.)

enjoyed a brief importance in the first two decades of the twentieth century. The Essanay Studio on Argyle Street, for example, did some important early work, but the climate and setting of California soon lured most of the industry to Hollywood. The automobile, too, held early promise. On Thanksgiving Day, 1895, the *Times-Herald* expressed the city's interest in the new conveyances by sponsoring a race to Evanston from Jackson Park. Thousands of people braved a fall blizzard to watch the curious machines, and in the following years several small firms began producing cars. A decade later, the scepter of leadership had passed to Detroit.

While automobile manufacturing did not ultimately concentrate in Chicago, the automobile itself did have a significant impact on the growing metropolis. Along suburban highways, ribbons of commercial establishments grew up; the areas between the older suburban commuter railroad lines began to fill in; parking, rush hour traffic, and the electric traffic signal became familiar problems of the motorist.

In the immediate sense, the arrival of the automobile was first felt on Michigan Boulevard. Early in the century the street was paved to accommodate the upper-class residents; it also quickly attracted the "auto trade." From 12th Street to 26th Street, new sales offices and small factories replaced the old, fashionable residences. By 1910 most horse traffic disappeared, and Michigan

1

2

3. West Side of State Street, Just South of Randolph, 1913

Automobiles rapidly became an important means of moving around the city—and a major problem as well.
(Courtesy Chicago Historical Society.)

4. Automobile and Cycle Shop in Oak Park, 1903

The growth of auto stations came rapidly to outlying sections and suburbs. Suburbanites' motives for car ownership were many: often their public transportation systems left much to be desired; they could afford the new conveyances; and a new automobile afforded liberation from the limitations of the mass-transit rail lines.
(Courtesy Oak Park Public Library.)

5. Agencies on "Automobile Row," 1840–42 Michigan Avenue, 1916

"Probably never before has a popular mechanical invention had such a potent influence in diverting a prominent street from its original purpose and, incidentally, influencing the development of a pertinent style of architecture as has the automobile in transmuting Michigan Boulevard, in the city of Chicago, from a residence to a business street." So began an article in the *Architectural Record* in 1910. The movement gained momentum after 1906 when auto agencies offered huge sums for residential sites between 12th and 26th streets. Gradually their new multi-story buildings with their large street level showrooms replaced the older grand residences and churches.
(Courtesy Chicago Historical Society.)

3

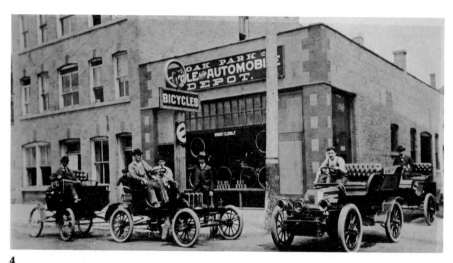

4

6. Express Truck on the West Side, 1913

During the first two decades of the twentieth century the motor truck gradually took the intra-city short haul traffic from the drayman. Here a Brinkmann's Express truck pulls from 4136 West Madison street. The truck was manufactured by Diamond T., a company that was located in Chicago until recently.
(Courtesy West Side Historical Society, Legler Branch Library.)

Boulevard became "the longest and best automobile course in any city of this country." Customers tried out the new cars there, and the street became so associated with the trade that it was known as "automobile row." Symbolically, just as major architects had earlier designed railroad stations and public buildings, many now turned their talent to designing showrooms and factories.

Even without movies and automobiles Chicago's manufacturing expansion very quickly ate up many of the most desirable industrial sites. Residential neighborhoods limited the possibilities of further outward movement from the central city, and downtown areas were already congested. One response was to locate near the edge of the built-up area where land was vacant or where industrial enterprise had already congregated, such as the Calumet region. Another was to go even farther and find room in the belt of satellite cities that ringed Chicago. Still another response was to rent space in one of the newly organized industrial districts, the precursor of the modern industrial park.

In fact, Chicagoans introduced the organized industrial district idea to the United States. Under this scheme, the district acted like the residential developer, assembling land, laying out streets, and installing utilities. It often also provided architectural engineering and financial services to the industrial clients; occasionally the district even furnished dining facilities and executive clubs. But most of all it brought together compatible business enterprises and created an attractive environment that most single companies could not readily provide themselves.

One of the first of these was the Central Manufacturing District which developed a square-mile tract of land north of the Union Stock Yards on both sides of the South Fork of the South Branch of the Chicago River. Organized in 1890, it could promise its clients the same excellent freight facilities enjoyed by the stockyards. The section filled up rapidly with light manufacturing and distribution establishments; by 1915 the District was ready for its second enterprise, the Pershing Road Tract immediately to the west. It, too, flourished and was ready for government use in World War I. Subsequently, the Central Manufacturing District developed many other tracts. This kind of development also proved feasible outside municipal limits, as the Clearing Industrial District on the Southwest Side demonstrated in the same period.

The new industrial districts, however, could not meet all the continuing demands for manufacturing sites. To the south and southeast, the Calumet region beckoned. Well equipped with the prerequisites for heavy industry, it quickly became one of the most important industrial centers in the world. The Calumet Harbor and River provided all-water access to ore, limestone, and coal across the lakes; the eastern trunk line railroads passed through the area around the south end of Lake Michigan; and there was abundant water for the insatiable thirst of the modern factory. And, just as importantly, most of the land lay undeveloped for miles around. Soon iron, steel, and chemical plants lined the river between Lake Michigan and Lake Calumet.

Across the state line in Lake County, Indiana, another industrial complex sprang up, enjoying many of the same advantages that had made the Calumet region such a magnet. The federal government constructed an artificial lakefront harbor and a canal to accommodate the new steel, chemical, and refining plants. Eventually, Indiana Harbor and Canal would handle over twenty million tons of cargo a year and would become the leading petroleum shipping port on the Great Lakes. Indeed, to find room for expansion, companies soon filled newly made land out into the lake. Although this area was outside the jurisdiction of Chicago, indeed, outside of Illinois, it was nonetheless a part of the metropolitan complex.

Even this new manufacturing space did not satisfy Chicago's industrial appetite. Farther east along the lake shore were sand dunes, in an area occupied by only a few hundred families and a few recreational clubs. By mid-century, some of these wide stretches of fine, wind-driven sand, covered with cottonwoods, oaks, and pines, would become a pre-

1. Ashland Avenue Yard of Chicago Junction Railway, Looking West, 1915

"The Central Manufacturing District is served by the Chicago Junction Railway, which is the inner belt line of Chicago *connecting directly with every Trunk Line railroad entering Chicago*," a CMD publication boasted in 1915. "Over the tracks of the Chicago Junction Railway, must pass every pound of freight moving in or out of the Stockyards, Packingtown, or the Central Manufacturing District." To meet these demands, the Junction Railway maintained over sixty switch engines, and sometimes as many as 200 engines of connecting lines came into the Yards in a single day. It was a "freight specialist," and permitted "no passenger traffic on its rails to interfere with the movement of freight."
(From *The Central Manufacturing District*, 1915.)

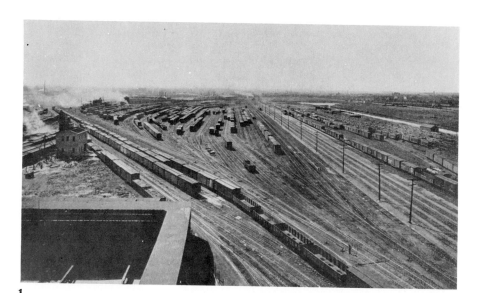

1

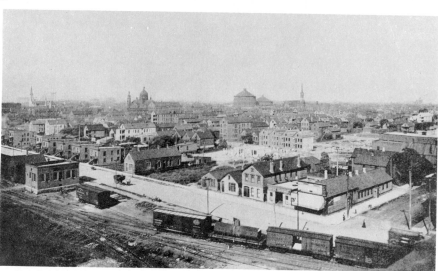

2

2. View from Albert Pick Building, Corner of Thirty-Fifth and Center Avenue, Looking Northeast, 1915

A large number of workers was needed to handle the diversified industrial operations within the District; the area soon became a mecca for the unemployed. As a result tenements and frame dwellings were built nearby. To potential residents, District manufacturers boasted in a publication in 1912 that they could offer a steady and constant labor supply. "It is easily accessible on a five-cent fare from thickly populated sections, where live the laboring classes. . . . With so many applicants for positions, wages are kept reasonably low. . . . The men employed in the packing houses all have large families, and prefer that their children shall find employment within walking distance of their homes, rather than to go to other sections of the city, even at higher wages. . . . It is estimated that 40,000 people find employment within the limits of the Yards and the Central Manufacturing District. The priests and settlement workers in the vicinity of the District are always glad to co-operate with tenants in securing help of all kinds."
(From *The Central Manufacturing District*, 1915.)

1. View of Iron Street before Improvement, 1910

The Central Manufacturing District, organized in 1890 by the Chicago Junction Railway and Union Stock Yards companies, was the first such district in the United States. A. B. Stickney, president of the Chicago Great Western Railroad, consolidated the original acreage of the Clearing District a little later. Development in the Central District began in 1905, and since then its policy has been that of a private industrial banker, financing industrial buildings both inside and outside its developments and creating an inventory of general purpose buildings which young or expanding industries may lease or buy. CMD now includes more than 900 acres in seven developments within Chicago, two suburban developments, a 352–acre development at Itasca, Illinois, a 675-acre tract at St. Charles, Illinois, and one district of 250 acres in Sacramento, California.
(From *The Central Manufacturing District,* 1915.)

2. View of Iron Street after Improvement, 1915

By 1915 over 200 establishments occupied the district's multiple-story buildings, sometimes called "incubator" buildings, which were built as standard types by the corporation. These were then rented to small and medium-sized industries, thus helping new businesses by relieving them of substantial capital investment in buildings. Standardization also permitted the District to re-let a building when a client, due to expansion, relocation, or termination, left the premises. Such buildings are, in fact, industrial apartment buildings.
(From *The Central Manufacturing District,* 1915.)

1

2

3. Calumet River, Early 1870's

Though the precise location of this photograph cannot be determined, it was taken soon after the beginnings of Calumet River industrial development in the early 1870's. The river had low-lying, swampy shores, with numerous bends and curves. Much improvement was required before it became a dependable shipping channel. Even in 1920, Robert Shackleton, who examined the whole Chicago Region, found that the area around Calumet Lake was "an oddly dreary district where, in spite of the dreariness, there are suggestions of parts of Holland, with amphibious houses and amphibious-seeming folk, and great levels of alternate land and lake and canal and stream, with the water brimming to the verge, and with boat landings and little boats; and yet, after all, with but little of prettiness."
(Courtesy Chicago Historical Society.)

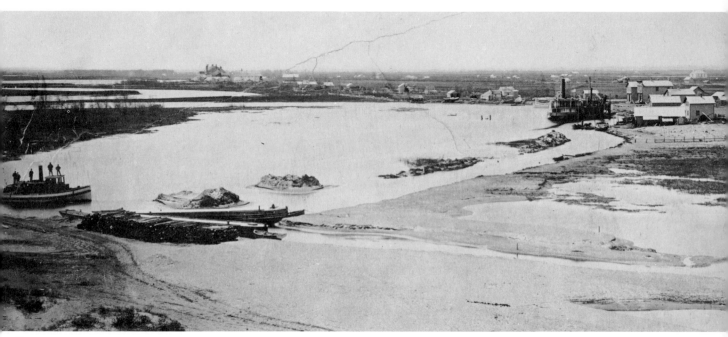

3

238

1. View Southwest from Calumet Harbor, 1874

The Calumet district of South Chicago and nearby northwestern Indiana has now developed into the metropolitan region's principal concentration of heavy industry. The reasons for such development in the area are easy to trace—the need for extensive land, access to extensive railroad facilities, deep navigable water for shipping, cooling and process water and a place for the disposal of wastes. All these factors led iron and steel, chemical and petroleum refining to settle into the area, which had few attractions either for nineteenth century farming or for city building. This picture is from the front page of a real estate brochure showing extensive industrial and residential development; smoke, the plague of mid-twentieth-century urban America, was viewed by these promoters as the symbol of rising power, and it was magnified rather than muted in such drawings.

(Courtesy Chicago Historical Society.)

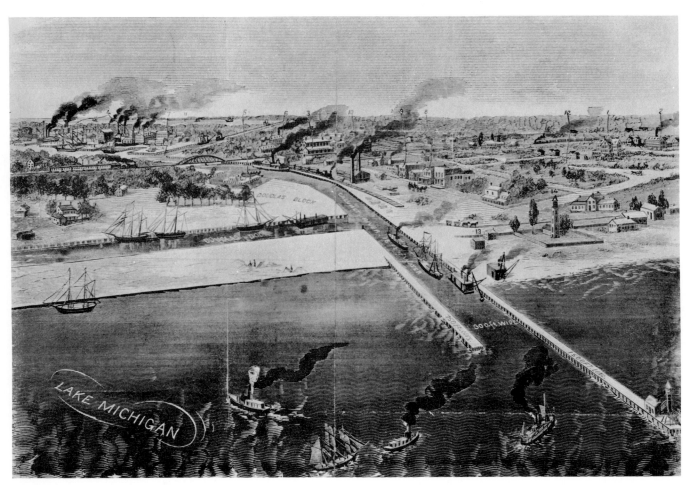

1

2. South Chicago, 1874

From its inception, South Chicago was promoted as an industrial development. Among the improvements in the harbor facilities, slips were dredged to facilitate easy access between railroad and lake. Here, one of the earliest maps of the development illustrates the location of industries, the importance of transportation, and the usual rectangular commercial pattern. By 1915, the Calumet area was one of the most important centers of heavy industry in the world.
(From Everett Chamberlain, *Chicago and Its Suburbs*, 1874.)

3. South Chicago Business District at the Turn of the Century

South Chicago had no monumental architecture to distinguish its drab business facades. Its retail facilities were geared for the working man, and the people who traded there were mainly workers from the local mills and their families. However, South Chicago had a transportation connection with the central city from the mid-1880's, when, in addition to the South Chicago branch of the Illinois Central railroad from downtown Chicago, a horse car line connection came from Hyde Park. In 1891 the South Chicago City Railway Company received the right to electrify its lines. The view is north on Commercial Avenue north of 92d street.
(Lillian M. Campbell Memorial Collection, Courtesy West Side Historical Society, Legler Branch Library.)

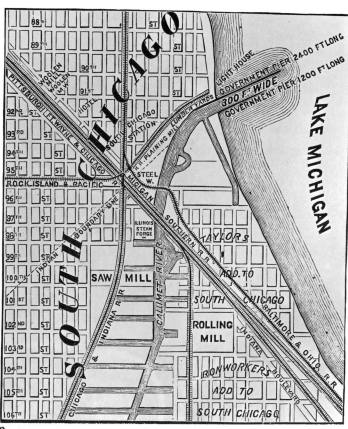

2

3

4. Excursion Boat on Calumet River

Besides fishing, sailing, and various "yacht clubs" the Calumet waterways also had its own excursion boat. In this photograph stalwart funseekers risk tipping the boat to crowd along one rail for this undated photograph.
(Courtesy South Shore Historical Society, South Shore Branch Library.)

4

240

1. South Chicago, View Eastward, in the Early 1920's

This early aerial view captures the character of the South Chicago District. A pall of smoke rises from the heavy manufacturing plants and hangs over the whole area. The breakwater protecting Calumet Harbor is in the upper section of the picture. The river itself is bordered on the north by the South Works of what is now the United States Steel Corporation. Just opposite is the former Iroquois Iron Works, later the Youngstown Sheet and Tube Company. Immediately south of this plant is the land fill which later became Calumet Park. In the foreground is the commercial core of South Chicago.
(Courtesy Chicago Historical Society.)

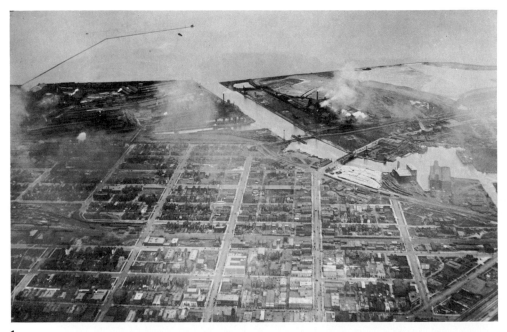

1

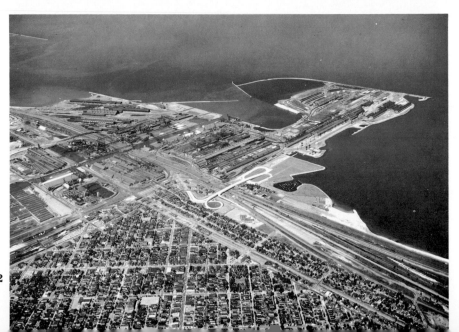

2. Aerial View over the Indiana Harbor Area of East Chicago, Indiana, Looking North, about 1964

At the left of the photo is the Indiana Harbor Ship Canal; beyond is the Youngstown Sheet and Tube Company's East Chicago Works, built partially on landfill in the lake. Adjacent is Jeorse Park, with its boat harbor and grade-separation structure over the railroads; this was recently built by the City of East Chicago and Inland Steel.
(Photograph, Chicago Aerial Survey. Courtesy Inland Steel Company.)

2

Gary

1. Plat of Gary

"Gary stands where most people, except Chicagoans themselves, think that Chicago stands: at the southern end of Lake Michigan," Robert Shackleton wrote. "The location was selected in order to gain real geographic advantages, with its really central situation, its harbor possibilities, its possibilities of railway connections, and ease with which raw material could be gathered and with which manufactured products could be shipped. Gary is so completely down at the foot—or head—of the lake—Lake Michigan stands on its head—that it is actually over the line in Indiana, suburb of Chicago though it is. It is only twenty-six miles from the heart of the great city. . . ."
(Courtesy Chicago Historical Society.)

INDEX
1. CITY HALL
2. GARY HOTEL
3. LAKE HOTEL
4. ROOSEVELT HOTEL
5. MEMORIAL AUDITORIUM
6. HORACE MANN
7. EMERSON
8. FROEBEL
9. LEW WALLACE
10. ROOSEVELT
11. WILLIAM A. WIRT
12. TOLLESTON
13. MARQUETTE PARK & PAVILION
14. GLEASON PARK
15. PULASKI
16. RILEY

PREPARED BY
DEPARTMENT OF ENGINEERING
WILLIAM P. COTTINGHAM CITY ENGINEER
CITY OF GARY INDIANA
AUGUST 1942

Gary

1. The Beginnings of Gary: Leveling the Sands Dunes for Open Hearth Plant, View Eastward, 1906

W. H. Wright, an early Gary realtor, caught the essence of the city's early development when he asserted that "Gary sprang from a zero of sand dunes and scrub oaks." The site of the town was to the east of the plant and was purchased after the original site aquisition was made. Prices for the town of Gary were relatively expensive —"as much as $1,500 per acre." (Courtesy United States Steel Corporation.)

cious natural preserve, but in 1900 they appeared bleak and forsaken. An early surveyor found that "the face of the country" looked like "some powerful convulsion had torn the earth asunder and thrown it up into sand peaks, leaving the cavities to be filled up with the lake and marshes." Yet to United States Steel, scouting about for a site for a new, modern plant, the site seemed more important than its unkempt condition.

Indeed, the very remoteness of the place required that the Corporation create not just a factory complex but a new city as well. The Pullman strike of 1894 had soured many businessmen on the desirability of "model towns." Far from producing a contented and productive labor force, Pullman's experiment had bred bitterness and resentment. The "most perfect city in the world" had become just another industrial town with its ordinary problems magnified by frustrated hopes. But U.S. Steel had no option; major facilities would require a large working population and all the installations and public services needed to sustain it. However, reluctantly, the company went into the city-making business, naming their urban creation Gary after the Chairman of the Board of the corporation, Elbert H. Gary.

A. F. Knotts, attorney for U.S. Steel, formerly employed by Pullman, was determined to avoid the earlier mistakes. Most of all he wanted to keep away from company housing, which he thought had brought such woe to Pullman. Hence Gary was more a gigantic tract development than a model town. The choice sites along the lake went into industrial plants and a harbor; a few blocks were

2. Gary Works, United States Steel Corporation, 1908

"The building of a vast cluster of industries and healthful lodging for workers and their families in the area of drifting sand and poor drainage presented difficulties to engineers, architects and realtors," a geographer wrote of this area. "Undrained swamps, puddles, and the creeping Grand Calumet and Little Calumet had to be overcome." George H. Lawrence's photos, taken from a captive balloon, certainly offer evidence of these contemporary pioneer conditions. At the far right, workers' barracks have already been erected along the shore of the Grand Calumet River. The massive steel works and the looping railroad lines are the only other signs of man's presence in this sandy, desolate region, at the southern end of Lake Michigan.
(Courtesy Library of Congress Collection.)

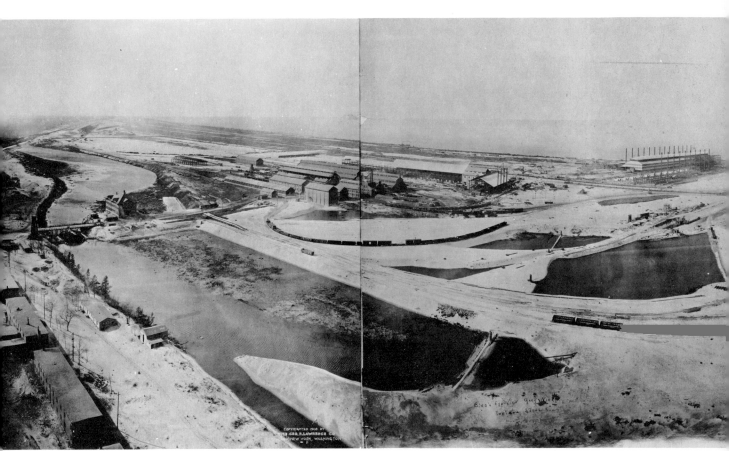

2

Gary

1. Frame Residences in Early Gary

Housing for the workers was put up so quickly that the jerry-built character of the multiple-unit dwellings could not be disguised. Landscaping presented another problem; the sand would not hold enough water to support lawns, and seeding could not take place until top soil had been brought in and water mains installed. Later, a city regulation allowed free water for lawn sprinkling.
(Courtesy Gary Public Library.)

2. Early Frame Dwellings in Gary

At first the United States Steel Corporation refused to build housing, but through the influence of A. F. Knotts, legal staff advisor, the Corporation decided to carry on construction under a subsidiary organization, the Gary Land Company, which eventually planned, laid out, and built much of early Gary.
(Courtesy Gary Public Library.)

reserved for public buildings, and others were set aside for institutional use; the rest was laid out in the conventional grid pattern. Yet the plans were large. The utilities provided for a population of 200,000, and the names of the projected main business streets, Fifth Avenue and Broadway, reflected the pretensions, if not the scope, of the project.

Gary was incorporated on July 17, 1906. By December it had 10,000 inhabitants. Two months later, the first steel poured from the new furnaces. In its way, Gary was the country's first "instant city," although it never matched the grand expectations of its founders. For a long time, however, it was essentially a "company town," an appendage to the immense steel complex at the tip of the lake. More recently, its increasing density, its connections with Chicago, and the American economy's enormous demand for steel have made Gary the largest city in the metropolitan complex outside of Chicago itself.

U. S. Steel had originally planned to build in Waukegan rather than in Northern Indiana. Indeed, that region seemed to have everything a heavy industry needed. A harbor serving the Waukegan-North Chicago complex provided access to the lakes, and the Chicago Outer Belt Line had its northeastern terminus there, furnishing contacts with Chicago's extensive railroad network. Moreover, the area's growing population promised to meet at least the initial labor demand. But the corporation decided Waukegan

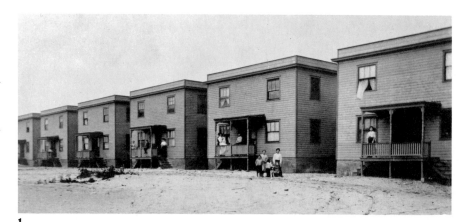
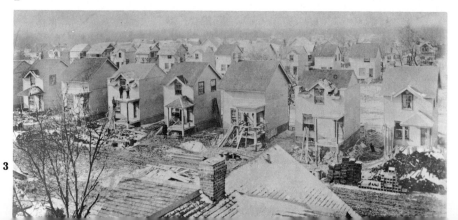
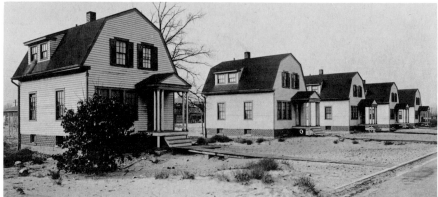

3. Construction of Frame Residences in Early Gary

Modern tract developers, with their look-alike houses on lots of identical shape have nothing on Gary's early developers. Here row upon row of frame dwellings are put up to take care of the pioneer migration to the industrial city.
(Courtesy Gary Public Library.)

4. Broadway, Main Street of Gary, about 1910

Gary had an extensively developed street railway system, related directly to the transportation of workers to and from the steel mills. Although there were still some empty spaces along its commercial frontage, many retail and service establishments had settled in Gary's downtown, especially along Broadway, the city's principal north-south artery. The satellite city's connection with Chicago is evidenced in the wall poster advertising Riverview, "the largest amusement exposition in the world" on Chicago's Northwest Side,
(Courtesy Gary Public Library.)

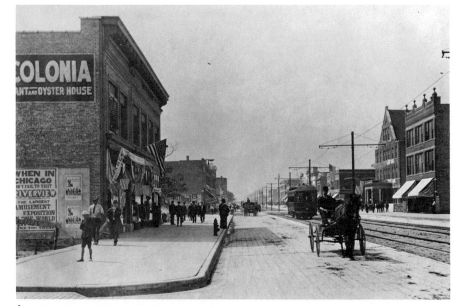

4

5. Modern Three-Story Buildings on Fifth Avenue, 1951

Gary has an extraordinary number of apartment buildings for a city of its size. A great many of these six- and nine-flats were built during the 1920's giving the city a high population density in its central area.
(Photograph, Catharine Brooks. Courtesy Chicago Historical Society.)

5

Gary

The view is north-northeast from Jefferson and 9th streets. In the background along Lake Michigan is the steel works. Like Chicago, Gary's grid street pattern is virtually uninterrupted. When this photograph was taken, the city had a population of nearly 134,000. A decade later it was over 178,000.
(Courtesy Department of City Planning, Gary.)

1. Residential Area and Plant, West of the Central Business District, Looking Northeast, about 1909

Four years after this photo was made, a traveler, Edward Hungerford, "making his way through Chicago environs" by train, noted the startling effect of Gary. Immediately after passing through the "dull flat monotonies of sand and brush and pine," there was Gary "with its newness and its bigness proclaimed upon its very face so that even he who flits through at fifty miles an hour may read both."
(Courtesy Gary Public Library.)

1

2

Waukegan

Waukegan Panorama, 1908

While the first settlement of Waukegan was in the 1830's, (its first railroad came in 1855, and it was incorporated in 1859), the city north of Chicago did not really boom until the South Western Railroad (later the Elgin, Joliet and Eastern Railway) was allowed to enter the city in 1889. Operating as a freight carrier into the area, the railroad stimulated a land boom by 1891. It was in that same year that the Washburn-Moen Manufacturing Company, the city's first manufacturing plant, came to Waukegan. Growth was intensified in 1911 with the establishment nearby of the Great Lakes Naval Training Station.

(Photograph, George Lawrence. Courtesy Chicago Historical Society.)

3

was already too congested and chose to pioneer in the sand dunes of Indiana. Yet the factors which had drawn U. S. Steel to the spot in the first place were already proving compelling to others, and Waukegan itself was becoming a significant manufacturing center. Three railroads and lake shipping closely tied the satellite city to metropolitan Chicago.

To the west, the same urban forces pulled the small towns of the Fox River Valley into Chicago's orbit. Places like Elgin and Aurora were almost as old as the big city itself, but their modern development has been closely related to the metropolitan area. Elgin, for example, began as a dairy center, and as early as 1866 Borden had established a condensed milk plant there. But its substantial growth was also associated with the Elgin National Watch Company, founded in 1864, and the coming of the railroad nine years later. At the beginning of the century, an interurban line (later called the Chicago, Aurora and Elgin) drew the outlying city into the expanding vortex of the metropolis.

Aurora was, from the beginning, more closely connected with railroads than was Elgin. The Aurora Branch Railroad very early, in 1850, made connections with Chicago; and in 1864 the Chicago, Burlington, and Quincy linked it directly to the city. The population jumped from 1,200 to over 7,000 in the same period, in large part due to the decision of the Burlington to locate its extensive shops in the young town. By the 1870's Aurora

1. Interurban Electric Lines Serving Chicago and Neighboring Territory, 1912

When this map was made, seven interurban electric lines either entered Chicago or connected with surface and elevated lines at the edge of the city. An *Electric Railway Journal* publication in 1912 stated the interurban achievement succinctly when it noted that "all of these furnish rapid transit to the outlying districts and as a result have served to increase the number of suburban homes along their lines." At the edge of the Chicago area, Chicago lines connected with the tracks entering three other states—Indiana, Michigan, and Wisconsin. However, a proposed connection between Chicago and the Peoria–St. Louis line was never made. Some of the interurbans were financially unhealthy from the beginning, operating in areas of marginal population density or where steam railroad service was already good. Most of them, however, survived the initial effect of the automobile and the depression, but only one still operates today, the Chicago, South Shore and South Bend.
(From the *Electric Railway Journal,* October 5, 1912.)

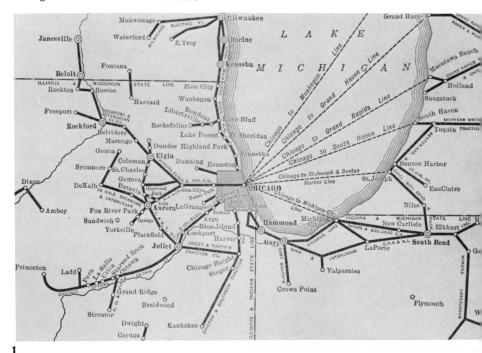

1

2. Boarding a Train of the Chicago, Aurora and Elgin Electric Interurban Railroad at Elgin, 1908

Built by a Cleveland syndicate shortly after 1900, this line was the second high-speed route into the Loop. By 1902 the C. A. & E. had established service to Aurora and Batavia, and in 1903 a branch was constructed from Wheaton to Elgin. Eventually the system contained sixty-one miles of line. Operations generally included trains every half hour on the main lines, with additional trains during rush hour. The line maintained operation into Chicago until construction was begun on the Eisenhower Expressway.
(Courtesy Chicago Historical Society.)

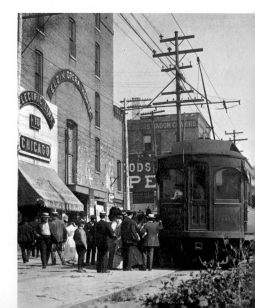

3. Chicago Street, in the Central Business District of Elgin, 1908

Elgin had a population of nearly 25,000 at the time this photograph was taken. Besides being a shopping center for rural dwellers of the area, the city also was a manufacturing focus.
(Courtesy Chicago Historical Society.)

4. Air View Northward, over Elgin and the Fox River, about 1960

In 1888 an Elgin historian wrote: "The city of Elgin owes her present prosperity to the great manufacturing interests which have sprung up in her midst." Many of these, including milk condensing, ice houses, and butter making were dependent on the lake metropolis to the east. But the biggest business and "the one institution which has done more than all other things for the advancement and growth of Elgin," the historian continued, "has been the great factory for the manufacture of watches." By the mid-1880's the Elgin Watch Company employed close to 2,000 persons, and in the mid-1960's it remained the preponderent manufacturing establishment in Elgin. When this photograph was taken, Elgin had a population of nearly 50,000.
(Photograph, Terry E. Schmidt. Courtesy Chicago Historical Society.)

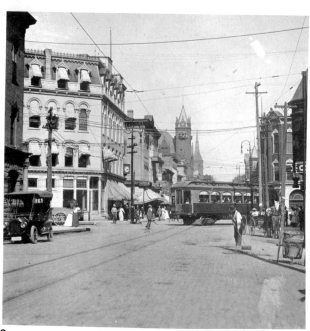

3

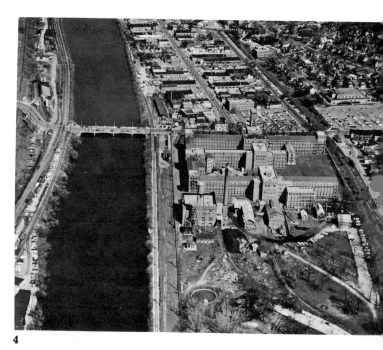

4

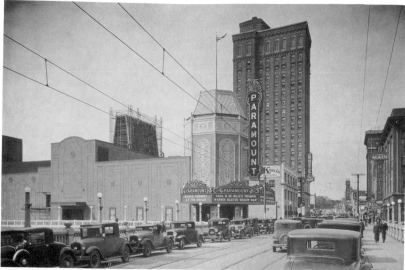

5

5. Business Street in Aurora, 1932–33

Like most of the satellite cities ringing their larger neighbor, Aurora experienced a period of substantial growth in the 1920's. This expansion, reaching a population of over 46,000 in 1930, was based largely on industrial development of already existing plants. The depression halted the growth, but the pattern resumed during and after the war. By 1960 nearly 64,000 people lived in the city, twenty-six per cent of them in housing units built since 1940. So significant was Aurora's own manufacturing and employment base that only four per cent of Aurora workers commuted to Chicago for jobs.
(Courtesy Chicago Historical Society.)

1. View of Western Electric Plant in Cicero, about 1910

In 1903 Western Electric located its Hawthorne Works on the boundary between Chicago and Cicero at 22d Street. Western Electric Company is a division of the American Telephone and Telegraph Company, and is composed of three "works" and their satellites, one of which is the Hawthorne Works. In the early 1950's the plant accounted for over twenty per cent of all employees in the Cicero district and twenty-two per cent of the total employment in the nation's telephone and telegraph companies.

(Courtesy Chicago Historical Society.)

1

2

3

had become a thriving industrial and commercial center; when two more railroads, the Chicago and North Western and the Elgin, Joliet and Eastern railway entered, its future importance was secure. In 1960 the census numbered its inhabitants at over 63,000, a reflection of its rich mixture of industrial enterprises and its vital connections with Chicago's expanding metropolitan life.

Just west of Chicago lies Cicero, one of the most important industrial concentrations in the metropolitan area. Incorporated in 1867, it once included Oak Park and Berwyn and early seemed destined for conventional suburban development. But in 1901 the adjacent towns were detached, and two years later Western Electric, the world's largest manufacturer of telephone equipment, opened its plant there. The extension of elevated lines to Cicero in 1907, coupled with its excellent freight and passenger railroads connections, quickly transformed a small town into a booming industrial suburb. The population jumped from 16,000 in 1900 to 45,000 in 1920: by 1965 it approached 70,000.

The same centrifugal forces that led to an outward movement of industries also strongly influenced residential patterns. As congestion spread away from the central area, wealthier Chicagoans tended to move to the pleasant, uncluttered edges of the city; some went still farther out and built in the burgeoning suburbs. Families with better than average re-

2, 3. Model Suburban Developments, 1913

As the great building surge occurred in the first decades of the twentieth century, many of the city's leading citizens were chagrined by the unplanned and chaotic character of the development. The City Club, as part of its Housing Exhibition in March, 1913, held a competition for the best model suburb. Entrants included architects and engineers from many different states and one foreign country, and Frank Lloyd Wright submitted a noncompetitive design. A pencil manuscript notation identifies these two designs as those of Walter Burley Griffin, an architect and landscape designer who had trained with Sullivan and who, in 1911, designed Canberra, Australia. The model suburbs are done in the best "garden-homes" thinking of the time, with a core containing the utility buildings and administrative center, surrounded by curved garden-like streets where homes, schools, and churches were located. Griffin's design had a greater area of open space—parks and playgrounds—than any other design that is known to have been submitted. (Courtesy Chicago Historical Society.)

4. Annexations and Built-up Areas, 1915

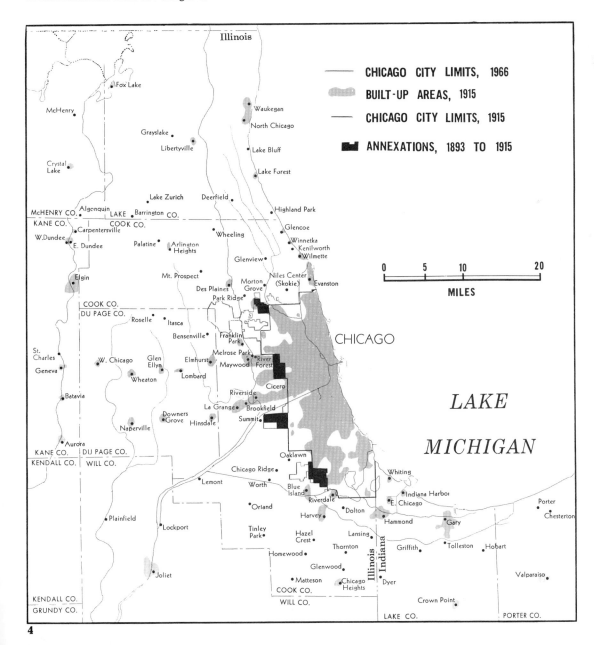

CHICAGO CITY LIMITS, 1966
BUILT-UP AREAS, 1915
CHICAGO CITY LIMITS, 1915
ANNEXATIONS, 1893 TO 1915

1. Gold Coast, North Lake Shore Drive, before 1893
"On the shore the mansions of the millionaires form an uninterrupted line of sumptuous dwellings," a traveler recounted in 1905. "They are of different sizes and styles: some imitate the Italian villa, some the glorified cottage of Anglo-Saxon origin. Others, again, affect the style of the French *château*, or of the crenellated, turreted Tudor castle. All these are attempts to create something impressive, and if not always a success from an aesthetic point of view—for even if built in the most perfect style, both *château* and castle are out of place on a modern boulevard, and cannot be admired—these mansions have at least the advantage of insuring privacy—a rare commodity in the States."
(Courtesy Chicago Historical Society.)

sources filled up large tracts of undeveloped lands which had been annexed in 1889; while those with modest but regular incomes occupied old houses or newer apartments in once-fashionable areas. Many residential districts near downtown continued to be overcrowded, with too many people for every room, too many families for every house, too many buildings for every block.

The human concentration near the center was more immediately visible to observers than was the growth in the city's outer zones. The traveler could hardly miss it as the trains passed through the congested neighborhoods near the depots; the visitor could not get far from the Loop without encountering block upon block of two- and three-story houses and three- and four-story flat buildings, which compressed a great deal of humanity into very small spaces. Newspapers and reformers continually sought to touch the public conscience by exposing the social consequences of high density housing in the heart of the metropolis.

Yet, in one sense, this perspective was deceiving, because it obscured the important fact that Chicago was predominantly a city of middle-class homes and that the great growth in the metropolis took place in the outer zones. In the six years between 1910 and 1916, for instance, the population living within four miles of the corner of State and Madison remained stationary at about 1,000,000, while the number in the area from four

to seven miles jumped from 460,000 to 1,076,000; and in the belt from seven to ten miles from the center the increase was from 180,000 to 332,000.

Among the most spectacular residential changes of the period was the shift of Chicago's social elite to the "Gold Coast" on the Near North Side. Presaged by Potter Palmer's move to Lake Shore Drive in the 1880's, the exodus from "the Avenues" became a stampede after 1893. Mansions on the South Side sold for a fraction of their original cost. A house at Prairie Avenue and Eighteenth Street that cost over $200,000 sold for $25,000; another, one of the finest in the city that cost $150,000 in 1870, went for $36,000 in 1909. On the West Side, Ashland Boulevard met the same fate. As the new generation built lavishly along the lakefront or erected sumptuous town houses along Astor and North State, the old baronial structures fell to the new landlords, who divided up the spacious buildings into small apartments and converted coach houses into multi-family dwellings. Those who stayed watched sadly as the most fashionable neighborhood in Chicago slipped into slumdom.

This residential change seemed even more abrupt because, to the west of the fine old South Side neighborhoods, many of the newcomers were Negroes. Although still only about two per cent of the population in 1910, their numbers increased rapidly. Soon they spilled out of the old ghetto just south of Sixteenth Street and moved south along both sides

of State Street almost to Fifty-fifth Street. The center of black Chicago was the corner of Thirty-first and State, where business and professional men had their offices. Another large Negro neighborhood grew up on the West Side, bounded by Lake Street, Ashland, Austin, and Warren avenues. It did not yet have all the characteristics of the "black belt" farther south, since other nationalities still lived in the area.

Everywhere the Negro moved, the grim specter of segregation was sure to follow. "The color line as it appears in Chicago housing problem is too important to be overlooked," Sophonisba Breckinridge and Edith Abbot wrote reluctantly in 1912. Though the majority of Chicagoans believed in fair play, they observed, the attitude towards the Negro was formed by a minority. "And today they not only refuse to sit in the same part of the theatre with him and to let him live on the same street with them or even in the same neighborhood." More ominously, they added "even where the city administration does not recognize a black 'ghetto' . . . , the real-estate agents who register and commercialize what they suppose to be universal race prejudice are able to enforce one in practice."

Negro housing bore the marks of this discrimination. Poor blacks, of course, lived very much like poor whites. The houses were small and mainly frame. Originally designed for single families, they were now occupied by several. Few

2. Gold Coast, North Lake Shore Drive, Probably 1913

"Along Lake Shore Drive you will find the homes of the great merchants, the makers of Chicago," George Warrington Steevens wrote in 1896. "Many of these are built in a style which is peculiarly Chicago's own, though the best examples of it are to be seen in the business centre of the city. It uses great blocks of rough-hewn granite, red or grey. Their massive weight is relieved by wide round arches for doors and windows, by porches and porticoes, loggias and galleries, over the whole face of the building from top to bottom. The effect is almost prehistoric in its massive simplicity, something like the cyclopean ruins of Mycenae or Tiryns. . . . On the other side of the Drive is the blue expanse of lake; in between, broad roads and ribbons of fresh grass."
(Courtesy Chicago Historical Society.)

3. George S. Isham Mansion

Dr. George Isham built this mansion in 1899 at a cost of $50,000. James Gamble Rogers of Paris designed the L-shaped house, which is now owned by editor-publisher Hugh Hefner.
(Courtesy HMH Publishing Company.)

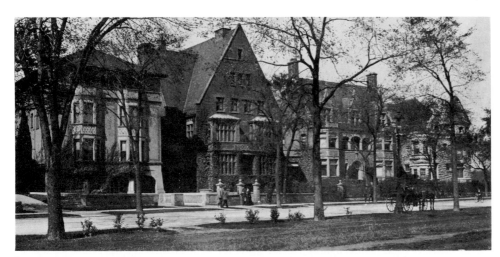

1

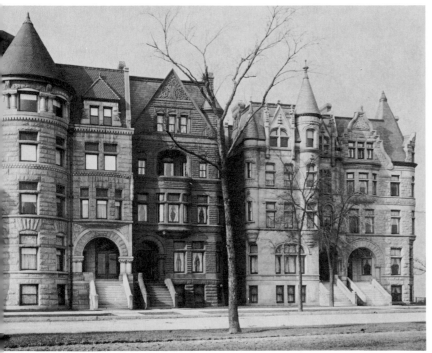

2

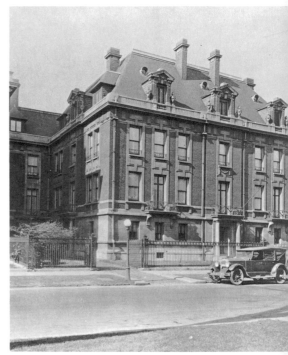

3

254

1. Negro Tenement Housing, 96-102 Thirty-Fifth Street (Now 528-38 E. 35th Street)

If the photograph's evidence of the late nineteenth and early twentieth century could be believed, the Negroes were the city's most invisible inhabitants. Except for reports of reformers interested in portraying the horrors of slum life, the pattern of life in the Negro districts and working class areas is sparsely documented.

In this rare photograph is shown a Negro tenement in the middle of what was Chicago's "Black Belt." Owned by a landlord who lived elsewhere, it was so deteriorated that it was removed in 1918. Still, its ready access to a street car meant that it had a better than average location for workers going to the nearby stockyards or other industrial locations in the city. (Courtesy University of Chicago Library, Department of Special Collections.)

Negroes owned their own homes. Because these people could not readily move, there was little incentive for landlords to maintain the properties. A survey of the area in 1913 found only a quarter of the buildings in good repair; one third still had outside toilet facilities. Yet rents for Negro housing were never less than for comparable white housing and commonly ran twenty-five per cent more.

Moreover, even if the colored Chicagoan was well-to-do he could not escape the ghetto. He might move, as some did, into better housing east of State Street and closer to the lake. Yet housing became available there only after the whites had moved out, and even then rents were exorbitant. In addition, at the edge of the ghetto, vice districts appeared, often with official sanction. "For every man who is black, rich or poor," wrote the Misses Breckenridge and Abbott in 1913, "there is a problem of extortitate rents and of the danger of segregated vice." The inability of the Negro, no matter how respected and successful, to enter the wider urban world around him, led observers to conclude that "the problem of the Negro will be found to be quite different from that of the immigrant groups."

The difference could most easily be seen in the housing experience of the two groups. Although most newcomers from abroad found their first residence near the center of the city, usually amid conditions of squalor and deprivation,

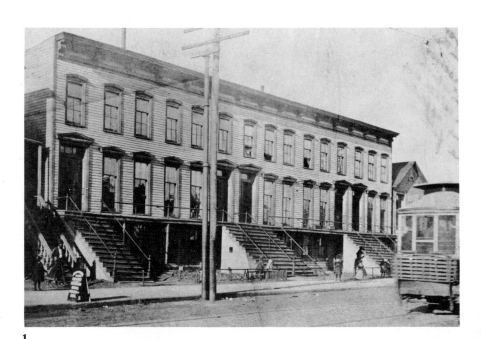

1

2

2. Black Children Playing in Slum Alley

The city's Negroes lived in some of the city's worst blighted areas. Here, two small children play amid the rubbish and wreckage of a dark alley. Dilapidated buildings bump up against the lot lines and garbage boxes set in the public way overflow on the alley surface. This particular alley had a distinctive feature, a fire watchtower built before the day of electronic call boxes and the telephone. (Courtesy Chicago Historical Society.)

3. W. T. Gaines Plastering and Contractor, Probably about 1915

Gaines is first listed in the city directories as a plasterer soon after the turn of the century. In 1914 he added the contractor designation to his listing. His address of 5140 Wentworth Avenue served as both residence and office. It was located just within the railroad-track boundary usually used to delimit one edge of the black belt area. (Courtesy Harry T. Gaines.)

4. People's Grocery Store

The People's Grocery Store does not appear in a city directory for any year, but it was provided for use in this book by Harry T. Gaines who remembers its location on Chicago's South Side around the turn of the century. (Courtesy Harry T. Gaines.)

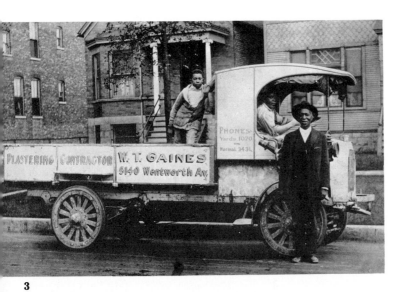

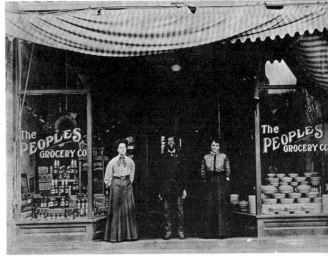

3

4

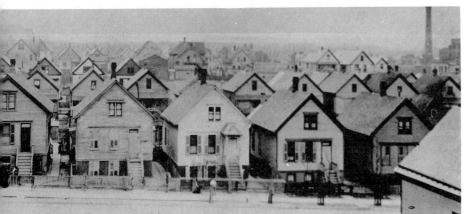

5

5. Working-Class Housing

These monotonous rows of nearly identical houses were considered a step upward for a slum dweller attempting to escape bad conditions and high rents. Homes like these usually represented the first move, as builders used mass-production methods and single designs to create the cheapest possible house and still make a profit. The unusual positioning of the front door, up a long flight of stairs, was no accident. For the builder, it avoided the necessity of digging a basement excavation; for the owner, it represented an additional floor, which when equipped with its own outside entrance (often under the stairway) could be rented to a second family. (Courtesy Chicago Historical Society.)

1. Residence at 5205 South Ashland Avenue, 1917

Many of the houses on this block had their first floors given over to small businesses which needed low rents and heavy traffic to survive. While most of these frame structures were built in the 1880's and 1890's only two per cent of them, as late as 1943, were deteriorated to the point where major repairs were required. Yet the area always had low rents (in 1943 it was a little under $18 for each unit) and dense population, including successive groups of immigrants, who were employed in the stockyards to the northeast.

(Courtesy Chicago Historical Society.)

it was possible for those who found jobs and earned a competence to find better dwellings. Large portions of the second generation were able to obtain better accommodations in less crowded and more pleasant neighborhoods away from the more congested areas. Still later, many of their descendants were in the suburbs enjoying housing that could scarcely have been envisioned by their grandfathers. The Negro was not given the same options even if he managed to accumulate wealth and education; his world remained the ghetto with its small comforts and little hope.

But even the immigrant world of Chicago at the turn of the century looked unpromising. Most of the newcomers jammed into the belt of slums that lay just beyond the central business district. These areas had always been crowded, but the immense influx radically increased the congestion. In many places the old, small frame house remained, though in increasingly dilapidated condition, but it was now "converted" for many more than one family. In some cases it was simply moved to the back of the lot, and a larger and newer building took its place on the street.

This period also saw the ominous appearance of the "tenement," or the "double decker." Three or four stories high, sturdily built of brick, covering nearly the entire lot, these were the characteristic response to the demand for low-cost housing. On the outside it looked much more substantial than the old frame buildings and flats; it even occasionally had a touch of elegance on the facade. Yet to those who knew, these new structures concealed a new level of congestion and degradation. In one West Side "double decker" in 1901, a survey found 127 people in a single building. In one "set of three small rooms," two of which had no windows, investigators found six adults and four children. In another three-room apartment, occupied by at least a dozen people, there were no windows at all. To the inhabitant life was drab and dangerous, if tolerable. He lived, as the survey noted, "in rooms where the sun never enters. The air he breathes must reach him through dark passages and foul courts. He must be content with two yards square of earth's space for himself, for each one of his children, for each one of his thousand close neighbors, and for each one of their children."

Yet, in some ways, the "rear tenement" was even worse than the "double decker." Usually it was simply an old dwelling moved to the back of the lot to make room for a larger structure facing the street. Sometimes it was built for the purpose, tucked in behind a larger front tenement. In either case, it was poorly constructed and always overcrowded. "The houses are usually in bad repair and permitted to become damp and unwholesome," wrote Robert Hunter at the turn of the century. "The front houses cut off the source of light, and the rooms were dark. . . . The demoralization and degradation to which people living in the filthy surroundings of these alley houses eventually descend is obvious." Hunter concluded that "rear tenements make the worse possible dwellings for human beings."

But whether in old buildings, new "double deckers" or in "rear tenements," the level of congestion in Chicago was new and disturbing. Although not as bad as portions of New York at the same time, it was, according to one calculation in 1894, three times worse in the Polish district on the West Side than the most crowded portion of Tokyo or Calcutta. The extent of the crowding was hard to convey, but Dr. Frank Felter estimated in 1900 that if all of Chicago were as densely populated as its average slums (270 persons per acre) the city would have 32,000,000 people; if it were as densely populated as its worst slums (900 persons per acre) the whole of the Western Hemisphere could have been housed in Chicago. And, ominously, the situation was getting worse rather than better. "The evil does not stand still or abate; it is steadily growing," a survey warned in 1901, as it noted that already almost 300,000 Chicagoans were affected by the problem.

2. Remnant of an Older Era: Bull's Head Tavern at Harrison and Wood Streets, after the Turn of the Century

This building was erected in 1848 at Madison and Ogden streets. Originally it was a tavern that served the nearby "Bull's Head" cattle yards around Madison and Ashland. In 1874 the old tavern was moved to this location. The "balloon frame" buildings had a surprising longevity, as Chicago's first important architect, John M. Van Osdel explained: "It is conceded that a frame with every part spiked together offers greater resistance to lateral force than any other method of construction. As an evidence of its power to resist such force it may be stated that the Bull's Head Hotel . . . was a three-story 'balloon frame' of large dimensions. Standing upon the open prairie, with hardly a building within a mile of it, this structure was exposed to the fierce, unbroken prairie winds, yet remained unshaken for many years, until it was taken down."
(Courtesy Chicago Historical Society.)

3. Goudy School, Southwest Corner of Foster and Winthrop Avenues, 1909

Overcrowding is not a new aspect of the Chicago educational system, nor is the use of portable classrooms to contain the seemingly endless numbers of pupils. In this *Daily News* photograph taken in 1909, there are four temporary classrooms on the back of the Goudy School lot. These four portables seated 211; at the time, however, they were occupied by 204 students and only four teachers.
(Courtesy Chicago Historical Society.)

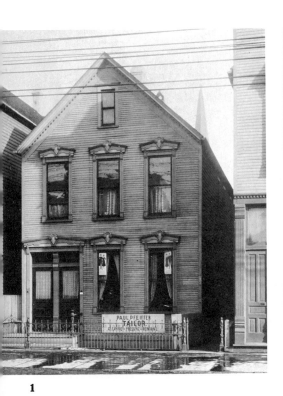

1

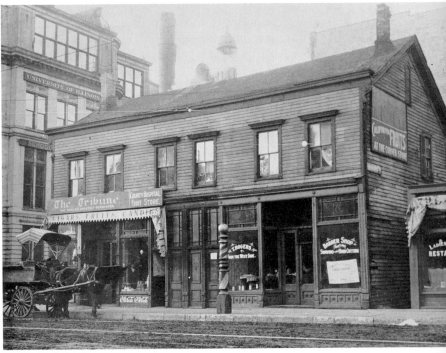

2

3

1. Area near Twelfth and Jefferson, 1906

"The houses of the ward, for the most part wooden, were originally built for the one family and are now occupied by several," Jane Addams wrote. "They are after the type of the inconvenient frame cottages found in the poorer suburbs twenty years ago. Many of them were built where they now stand; others were brought thither on rollers, because their previous sites had been taken for factories. The fewer brick tenements buildings which are three or four stories high are comparatively new, and there are a few large tenements. The little wooden houses have a temporary aspect, and for this reason, perhaps, the tenement-house legislation in Chicago is totally inadequate. Rear tenements flourish; many houses have no water supply save the faucet in the back yard, there are no fire escapes, and garbage and ashes are placed in wooden boxes which are fastened to the street pavements."
(Courtesy Chicago Historical Society.)

The worst areas were on the West Side, where congestion had been an enduring problem but where the spread of commercial and industrial areas into formerly residential neighborhoods had magnified the consequences. Of course, most of the residents were immigrants, especially those recently arrived from southern and eastern Europe. The district had an obvious cosmopolitan flavor, and visitors were astonished by the multitude of tongues heard in shops and in the streets. Actually the mixture obscured some heavy concentrations of these groups.

Street signs, stores, and restaurants all bore the mark of the newcomers. On some blocks, English was rarely spoken, and foreign language newspapers circulated, while those in English had few readers. The churches, synagogues, and schools also tied the Chicago neighborhoods to the Old World by familiar services and instruction in the native tongue. The people's clothing itself provided a simple guide to the ethnic composition of the district. "It is a veritable babel of languages," wrote a European visitor with awe, "It would seem as if all the millions of human beings disembarking year by year upon the shores of the United States were unconsciously drawn to make this place their headquarters."

But no matter what the ethnic predominance in any area at any one time, neighborhoods on the West Side, as elsewhere, were always in great residential flux. Or as a study in 1918 put it: "the

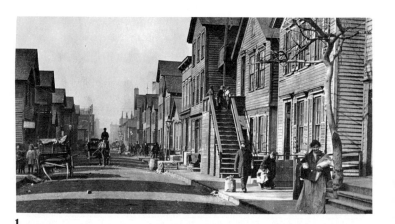

1

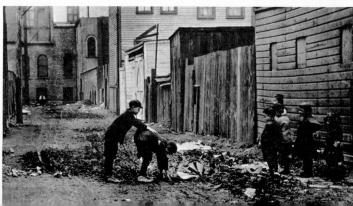

2

3

2. Residences on Jefferson Street between Twelfth and Thirteenth Streets, 1906

In one of her early lectures Jane Addams described a block of housing like that in the photograph. She noted: "The streets are inexpressibly dirty, the number of schools inadequate, sanitary legislation unenforced, the street lighting bad, the paving miserable and altogether lacking in the alleys and smaller streets, and the stables foul beyond description. Hundreds of houses are unconnected with the street sewer. The older and richer inhabitants seem anxious to move away as rapidly as they can afford it. They make room for newly arrived immigrants who are densely ignorant of civic duties."
(Courtesy Chicago Historical Society.)

3. Unidentified Alley on South Side, Undated

Since children in slum neighborhoods had no playgrounds or "totlots" on which to play, they did the best they could with what they had.
(From a stereoptican slide. Courtesy Chicago Commons Association.)

4. Alley View in a Slum Neighborhood

This particular alley was cleaner than many in the older areas of the city, but this shot reveals the high density of these congested areas. Old clapboard houses, like the one in the center of the photograph, were removed from the front of the lot and placed on the alley line. Brick or board tenements then were built at the front. The area in between was utilized as a refuse dump, for children's play areas, and as a place to hang the family wash.
(Courtesy Chicago Historical Society.)

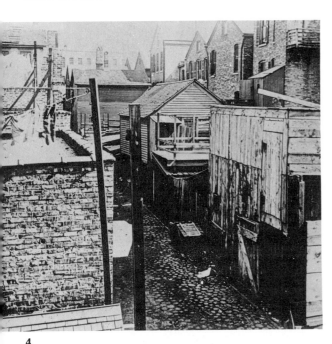

4

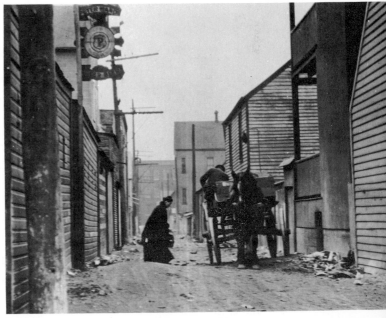

5

5. Alley in a Chicago Blighted Area, 1911

It is impossible to locate this picture exactly, but it conveys the neighborhood environment of Chicago's poor for many decades. Sophonisba Breckinridge and Edith Abbott wrote at the time; "The alley or rear tenement is one of the most characteristic of the bad features of Chicago's housing problem. These rear houses are almost uniformly the old houses which have been 'moved back' to make room for the larger and more imposing building on the front of the lot. The alley houses, therefore, are not only objectionable because the windows look out on the dirty, ill-smelling alley, but because they are old, in poor repair, and, in general, without adequate sanitary provisions." An "alley saloon" is in one of the buildings at the left-center. The woman walking toward the wagon was one of the trained aides of the visiting nurses association, a privately financed welfare group which sought to assist Chicagoans who needed medical help.
(Courtesy Chicago Historical Society.)

6. Pool of Garbage in a Slum-Area Back Yard

"The Stock Yards district and portions of South Chicago show outside insanitary conditions as bad as any in the world," Robert Hunter wrote in 1901. "Indescribable accumulations of filth and rubbish, together with the absence of sewerage, make the surroundings of every dilapidated frame cottage abominably insanitary. These evils do not extend over a large area. They are, in their worst forms, extraordinary and not typical of conditions elsewhere in Chicago."
(Courtesy Chicago Historical Society.)

6

260

2. View Northeast at 518 (Now 1313) South Jefferson, 1906

"Chicago, with its 3,000,000 inhabitants, is one of the largest metropolises from a cosmopolitan point of view," a Frenchman recounted in 1905. "It is a veritable babel of languages. It would seem as if all the millions of human beings disembarking year by year upon the shores of the United States were unconsciously drawn to make this place their headquarters. Chicago is the land of promise to all malcontents and aimless emigrants. More than half of its inhabitants are foreigners, and there are whole quarters where nothing but German is spoken. Others are inhabited entirely by Slavs. Nowhere else has immigration assumed such huge proportions, and nowhere else does the immigration question so seriously affect the local administration and development." The city's ethnic influence is apparent in this street scene. Small shops were the rule, with businesses spilling over the rotting plank sidewalks into the street.
(Courtesy Chicago Historical Society.)

1

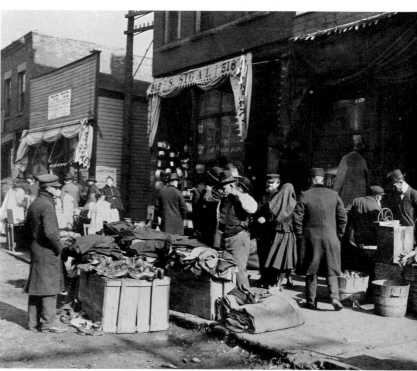

2

1. Two Children on the Porch of a Rear Tenement

"A large part of the overcrowding on the lots is caused by the rear tenement," Robert Hunter wrote in his *Tenement Conditions in Chicago.* "Rear tenements have always been considered the most unhealthful of dwellings. . . . Sickness, epidemics, high death-rates, are universally more common in rear tenements than other dwellings. In fact, almost all insanitary conditions are found in and about rear tenements. The houses are usually in bad repair, and are permitted to become damp and unwholesome. The front houses cut off the source of light, and the rooms are dark. These tenements are, as a rule, on an alley, with windows opening directly over manure and garbage boxes. In some the ground floor is used as a stable. The ill-smelling privies are near, and the filth of rear yards and alleys is all about. The poorest class of people live in these houses, consequently there is often overcrowding in the rooms. The demoralization and degradation to which the people living in the filthy surrounding of these alley houses eventually descend is obvious. With all these evils combined, rear tenements make the worst possible dwellings for human beings."
(Courtesy Chicago Historical Society.)

3. Northeast at Jefferson and Dussold Streets, about 1906

At the left is Pritikin Brothers wholesale tobacco shop where cigarettes were rolled for the stores which that firm maintained throughout the city. Jane Addams and her friends wrote that "the main thoroughfares running parallel with Halsted and the River between Polk and Twelfth" were "semi-business streets, and contain a rather cheap collection of tobacco-stands, saloons, old-iron establishments, and sordid looking fancy-shops, as well as several factories, and occasional small dwelling-houses tucked in like babies under the arms of industry. . . . The back doors of large establishments give glimpses of the inwardness of factory life, and bent figures stitching at the basement windows proclaim that the sweater is abroad in the land. Furnished rooms for rent are numerous; Italian rag and wine shops abound; dressmakers', calciminers', and cobblers' signs in Bohemian, German, and Russian are not infrequent; while the omnipresent midwife is announced in polyglot on every hand."
(Courtesy Chicago Historical Society.)

4. 434 Halsted (Now East Side of 800 Block), about 1905

The cramped nature of West-Side housing is apparent in the photograph. At the left is the entrance to Nathan Brothers Confectionary, a shop which manufactured candy on the premises.
(Courtesy Chicago Historical Society,)

3

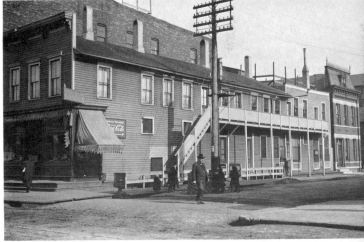

4

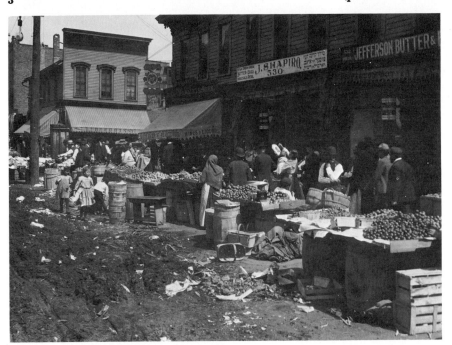

5

5. View Northeast from Jefferson Across Maxwell Street, 1904-6

In a street nearly impassable because of rotting rubbish, a line of fruit venders sell at their street stands on Jefferson. Behind them a produce company, a saloon, and a grocery line the sidewalk. Second floors contained small apartments and furnished rooms for people working in and near the area. A perceptive English journalist described such a scene after he had traveled here in 1896: "Little shops compete frantically for what poor trade there is with tawdry advertisements. Street stretches beyond street of little houses, mostly wooden, begrimed with soot, rotting, falling to pieces. The pathways are of rickety and worm-eaten planks, such as we should not tolerate a day in London as a temporary gangway where a house is being built. . . . The streets are quagmires of black mud, and no attempt is made to repair them. They are miserably lighted, and nobody thinks of illuminating them. . . . All these miles of unkempt slum and wilderness betray a disregard for human life which is more than half barbarous."
(Courtesy Chicago Historical Society.)

1. Hull House, 800 South Halsted, 1910

Jane Addams opened Hull House in 1889 in the center of one of the city's worst areas, utilizing it as a neighborhood social club with a variety of activities for every age. For instructors Addams utilized middle class and upper class men and women, and professional men and educators lent their support to her work. This entire area has now been demolished to make way for the University of Illinois Chicago Circle Campus, leaving only the front section of Hull House standing. (Courtesy Chicago Historical Society.)

2. Chicago Commons Kindergarten, 75 Grand Avenue, undated

Upton Sinclair in his reform novel *The Jungle* caught in a sentence the reason that settlement houses were quick to turn their attention to the children of the slum neighborhoods. Referring to the "Back of the Yards" area he wrote: "The most uncanny thing about this neighborhood was the number of children; you thought there must be a school just out, and it was only after long acquaintance that you were able to realize there was no school, but

population of the district (around Hull House) is unstable, shifting readily at the slightest pressure." The same investigation revealed that only nine percent of the people owned their own homes. Of the remaining "over half had lived in their present quarters less than two years, while a quarter have been there less than six months." Nor did the few owners represent a new investment in the neighborhood, for most of them were "survivors of the earlier period, people who, having invested what little they had in a home, were unwilling or unable to leave when the neighborhood changed." In a few other areas, there was a greater permanency, but throughout the slums transiency, like overcrowding, was a fundamental fact of life.

The only redeeming element of this depressing environment was the fact that many would some day escape it. Indeed, by 1900 large numbers of immigrants had moved into more comfortable quarters away from the slums. The Swedes, Norwegians, Germans, and Irish had deserted the old downtown neighborhoods in large numbers, and behind them moved the second generation Eastern and Southern European immigrants. Out beyond the congestion, in detached houses, in new flats, or in some cases in well-appointed apartment houses, the sons and daughters of previous immigrants brought their particular backgrounds to middle-class areas. To be sure, the ethnic concentrations toward the edge of the city were not as dense as

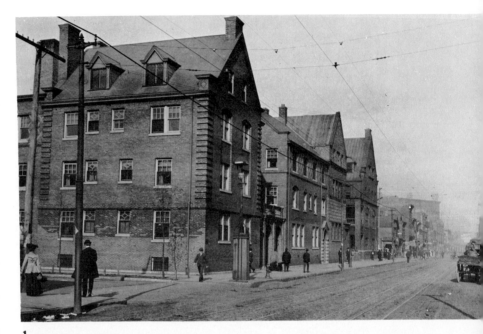

1

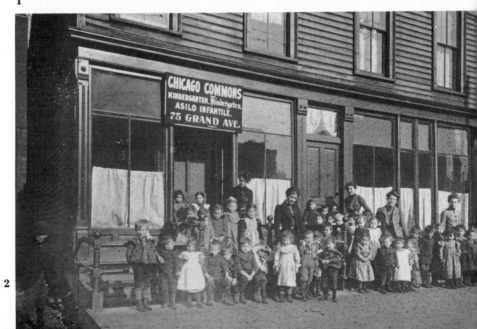

2

that these were the children of the neighborhood—that there were so many children to the block in Packingtown that nowhere on its streets could a horse and buggy move faster than a walk!" Into this situation came the settlement house, bringing school to adult and child alike. The commons kindergarten shown in this photograph was one such attempt to overcome the bad living conditions by educating the young.
(From a glass lantern slide. Courtesy Chicago Commons Association.)

4. Millard Avenue North from Ogden Avenue, about 1905
In 1902 the Douglas Park El was extended to Pulaski Road; this subdivision of substantial brick and stone homes was laid out at almost the same time. Over the next decades, the whole neighborhood filled up rapidly.
(Courtesy Lawndale-Crawford Historical Society, Toman Branch Library.)

5. Northwest Corner Seventy-Eighth and Halsted, about 1910
The blocks east of this corner between 75th and 80th were the first ones filled in this area. This occurred mainly after 1905. Southwest of this corner the area was not developed until late in the next decade. The billboards on both sides of the confectionary establishment advertise the nearby subdivisions of Auburn Heights.
(Courtesy Chicago Historical Society.)

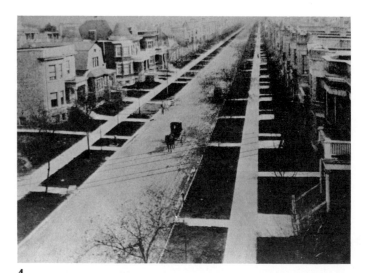

4

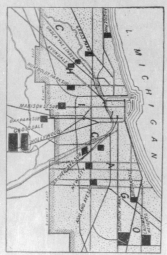

3. S. E. Gross Real Estate Advertisement, 1894
Even during a downward trend in the economy, real estate men assured their prospective clients that there was still a fortune to be made in city property. S. E. Gross advertized that "no other city on earth can show such a record" of improvement in land values. He promised that he had "sure-profit property in any direction from Chicago's center, and on terms that anybody can meet." The subdivision locations are all related to the street railway and elevated systems.
(From *The Economist*. December 31, 1894.)

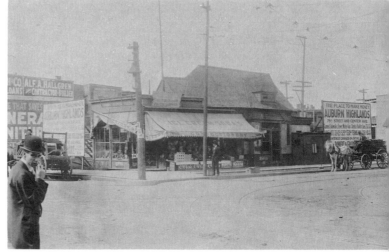

5

before, and time in America had diluted many old customs; but it was still possible to identify areas of strong national flavor by churches, shops, restaurants, and occasional festivals.

A large portion of this population lived in apartments. If the annual income was less than $1,200, the family had little choice, but even those with greater resources preferred flats because of what one visitor called "the restless characteristic of city life." The new buildings hugged the street car and elevated lines, giving the breadwinner quick access to the job downtown or in industrial areas. Mixed in, too, were individual houses. Some were large and spacious, if not pretentious. Others were modest, the result of thrift by "mechanics" or skilled craftsmen. With the help of "building societies" these workers were able to save enough money to buy their own homes. By the turn of the century thousands of laborers had emerged from the most crowded blocks into the newer, more pleasant residential streets.

Life in these districts centered more on the family and neighborhood than on the central city. Nearby shops fulfilled daily needs; and the growth of retailing at major traffic crossings reduced the dependence on downtown. Schools and churches increasingly became the focus of organized social life as other competing forms were excluded. Taverns and saloons, for example, were kept out by use of "local option" and "no licencing" laws. Even second generation immi-

grants were willing to forgo the "corner club" for the propriety of the residential neighborhood.

Thus, every year, second-generation immigrants were released from the overcrowded centrally-located neighborhoods into the middle class world beyond. These areas occupied a wide belt around the densely inhabited residential and commercial core, thinning out toward the municipal limits and fading into nonurbanized areas or suburban settlement. The lots were larger, the buildings more substantial, and the people fewer. These pleasant residential areas were as typical of Chicago as were its skyscrapers or factories, Gold Coast or slums, railroads or grain elevators. In fact, one observer wrote in 1905 that "the peculiar distinction of the city in this field (housing), is . . . that it provides for its great middle class more comforts, more advantages, more opportunities for pleasure and self-improvement, than any other large city in the country."

Beyond the periphery of the built-up areas, the subdividing continued, bringing new land into residential use. The great annexations of 1889 and later had added to the City of Chicago extensive areas of undeveloped property and sparse population which could now easily accommodate the urban middle class in its search for more spacious neighborhoods. In Uptown and Albany Park to the north, Austin and Lawndale to the west, and Chatham and South Shore to

the south, among others, new communities sprang up; and the smaller, older ones expanded quickly.

Morgan Park illustrates development in this period. Platted in 1869, it was designed to attract the emerging middle class. Its location thirteen miles southwest of the Court House placed the new enterprise just beyond the newly extended Chicago municipal limits. Fifteen trains (with a five-cent fare) daily connected it with the city. The Rock Island, a railroad which the promoters described as "very progressive and wide-awake" provided service to downtown in just over a half hour, forty-five times a day. By the late 1880's Morgan Park boasted 2,800 inhabitants and could claim it was no longer an experiment "but a thoroughly established, progressive village," and while "chiefly a residential place" it also had "markets, shops, stores, etc., equal to those of any other place."

More importantly, however, its developers advertised its exclusiveness. "It counts among its residents," they asserted, "some of the best business men of Chicago, and is blessed with having, generally, the right kind of citizens." Not only was it a "temperance village but saloons are *prohibited by law*," which assured residents that "our children grow up surrounded only by good influences, while our families can go upon the street, or walk upon our beautiful greens without fear of insult or dread of meeting intoxicated persons." Yet Mor-

**1. Looking Northwest from
Seventy-Eighth Street across
Ashland Avenue, 1916**

Most of the building in this area before
1920 took place east of Halsted Street.
Electric streetcar lines came into the area
between 1913 and 1918, extended on
Halsted to 119th, and on Racine and
Ashland to 87th street. The Ashland Avenue
extension is in the foreground of the
photograph.
(Lillian M. Campbell Memorial Collection.
Courtesy West Side Historical Society, Legler
Branch Library.)

2. Boating in Garfield Park, 1907

Formerly known as Central Park, Garfield
Park was the western-most link in the
city's chain of parks and boulevards around
the city. Within the 187-acre park was
a double lake, separated only by a narrow
peninsula of land on which there was a
carriage route. The lower lake was designed
to be "pastoral in character," with "its

architecture and construction simple and
rural." The upper lake, at which this
photograph was taken, was more formal and
ostentatious. Garfield Park could be reached
by either the Madison Street or Lake Street
cars, and from the suburbs by the Chicago
& Oak Park Elevated Railroad.
(Courtesy Chicago Historical Society.)

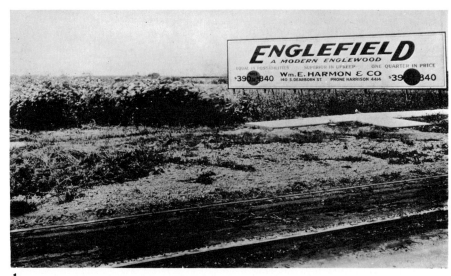

1

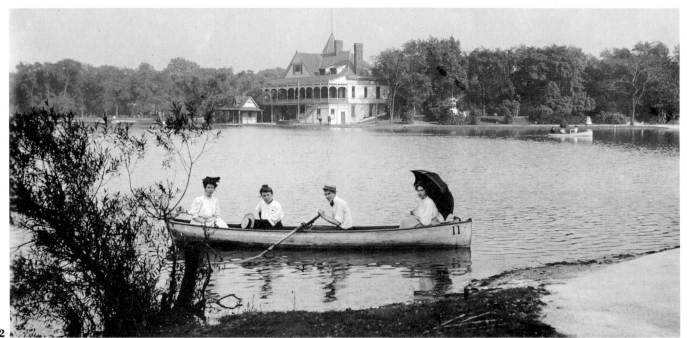

2

1. Humboldt Park Real Estate Advertisement, 1871-74

The Humboldt Park community remained largely unsettled until the West Side park system was laid out in 1869. That same year, Chicago annexed the area as far north as North Avenue and west to Pulaski, thus bringing Humboldt Park into the city. The subdivision advertised in this broadside lies just north of the present Humboldt Park community, and it makes special appeal to the Germans with its bilanguage printing. Real estate values in this area had increased from $250 to $5,000 an acre between 1869 and 1873 in anticipation of such a subdivision.
(Courtesy Chicago Historical Society.)

1

2. First Car on West Division Street, about 1886

The first horse car which turned off Milwaukee Avenue to come up Division Street to Humboldt Park was a real estate promotion car for the S. E. Gross Agency. Behind the car is a hanging sign which advertises lots from $350 and cottages from $1,950, all "on new street car line." Mahler's little restaurant and exchange stood at the corner of Division and California ready to serve the house and lot hunters eager to find new homes.
(Courtesy Chicago Historical Society.)

3. Two-Flat Housing Development, Area of Grand Avenue and Hamlin, 1917

This photograph was made during Humboldt Park's greatest growth. The Humboldt Park branch of the elevated reached Lawndale Avenue by 1895; the Lake Street Branch of the elevated ran only a few blocks to the south; and electric surface lines on Grand and North Avenue completed the transportation net. Two-flats were one of the most popular types of housing built in the area between 1900 and 1920, although there were also new brick bungalows and one- and two-story frame houses.
(Courtesy Chicago Historical Society.)

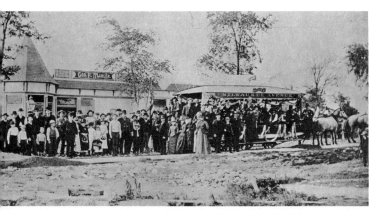

2

3

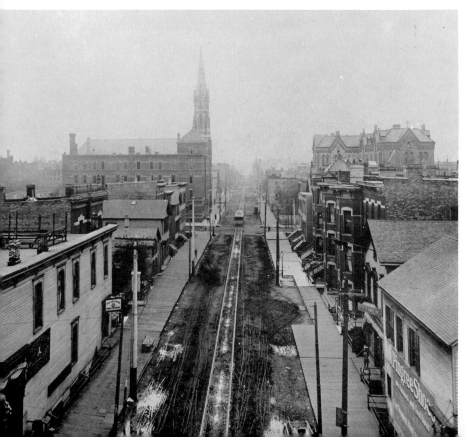

4. Orleans Street, South from Division Street, Near North Side, 1900

Even in 1900 the buildings along Orleans looked old. Some of this appearance came from the exterior alterations made when the grade was raised. Irish and Germans were the predominant ethnic groups in the area when this photograph was taken. Their two most important social institutions —the church and the tavern—are only a short distance apart.
(Courtesy Chicago Historical Society.)

2. Erie Street, Looking East from Rush Street, 1915

Fine homes had existed in this street since before the turn of the century. Already by 1915 commercial structures are moving westward from the lake, replacing palatial single-family homes.
(Courtesy Chicago Historical Society.)

3. Erie Street, Looking East from Rush Street, 1963

At the left, on the northeast corner is the office building of the Metropolitan Sanitary District of Greater Chicago; the Kiwanis International building is on the southeast corner.
(Courtesy Chicago Historical Society.)

4. Dearborn North from Burton Place, 1912

This photograph looks north to Lincoln Park which is only one block away. Development of this pleasant, upper class area was tied into the amenities of the nearby park.
(Courtesy Chicago Historical Society.)

1. Newberry Library, 60 West Walton Street, Northeast Corner of North Clark, about 1905

Located facing Washington Park on Chicago's North Side, the Newberry Library was built in 1892 from a design by Henry Ives Cobb. Today it is one of the nation's major research libraries. The park, now facing a rundown section of buildings across Clark Street, still stands as a green island amid a sea of gradual urban renewal.
(Courtesy Library of Congress Collection.)

1

2

3

5. Northeast Corner, Kenmore and Argyle, 1913-15

This old house was soon to give way to a commercial structure. Even when this photograph was taken it was already being pressed by the multiple-unit apartment buildings. Locationally it was an ideal place, two blocks from the elevated and two blocks from Lincoln Park and the lake.
(Courtesy Chicago Historical Society.)

6. Lincoln-Belmont-Ashland Intersection, 1916

As the twentieth century got well under way, the big downtown department stores began to respond to the growth of the city. As they would follow the population movement into the suburbs outside the city several decades later, so in the 1910's they followed the population into the neighborhood shopping centers. In the center of the photograph the large building under construction is the Wieboldt department store, which opened May 11, 1916. It was one of the first such stores built in an outlying business district.
(Photograph, Kaufmann and Fabry. Courtesy Ravenswood-Lake View Historical Association, Hild Branch Library.)

4

5

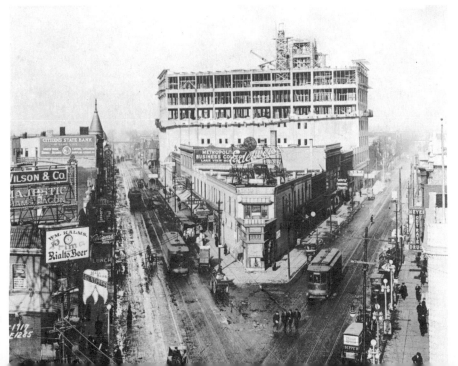

6

7. Northward on Milwaukee Avenue from Berteau Avenue, Portage Park, 1906

The street railway line had been laid down only a short time when this photograph was taken. Milwaukee Avenue was still unpaved, and utilities were being installed. By the end of the decade real estate subdivisions were already so full that the Chicago school board was forced to erect new buildings in the neighborhood.
(Lillian M. Campbell Memorial Collection. Courtesy West Side Historical Society, Legler Branch Library.)

2. Milwaukee Avenue and Chicago Avenue Intersection, Looking Southeast, 1910, Chicago Avenue in the Foreground

Around most intersections of major streets a local or regional shopping district sprang up. Emanating from these intersections were dense ribbons of commercial structures. This photo was taken at the peak of the area's recorded population; in the next decade it declined measurably, though still maintaining a large number of foreign born.
(Courtesy Chicago Historical Society.)

3. Milwaukee and Ashland Avenues, Northwest, 1911

Further out from the downtown was this intersection, within a predominantly Polish area, and only two blocks from St. Stanislaus Kostka church and school. Though the Poles constituted the major ethnic group, there still was a general cosmopolitan air about this area with its restaurants and social clubs representing many nationalities.
(Courtesy Chicago Historical Society.)

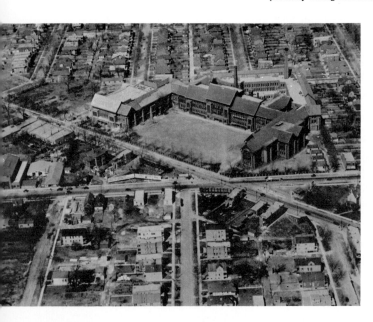

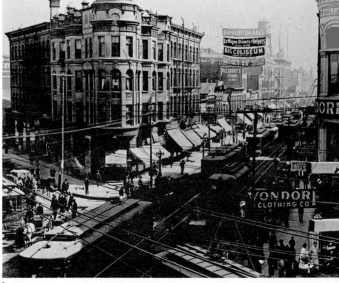

2

1. Air View of Carl Schurz High School, Milwaukee Avenue and Addison Street

When the Milwaukee Avenue and Irving Park Road street car lines were extended into this area in the first decade of the twentieth century, a building boom ensued. In 1905, the Chicago Board of Education appointed Dwight H. Perkins as its chief architect, "and thus pioneered in the adoption of a modern American architecture." In 1909, Perkins' design was incorporated into the Carl Schurz High School; it has been called his "masterpiece." A highly functional design, "the spreading plan and the placing of the building well back from the streets on spacious lawns represent a happy solution to the problem of orientation for light and air and reasonable freedom from the noise of traffic." This picture was taken in the 1930's and captures the surrounding neighborhood setting of the school, with its mixture of three-story apartments, double-deckers and single-family dwellings.
(Courtesy Chicago Historical Society.)

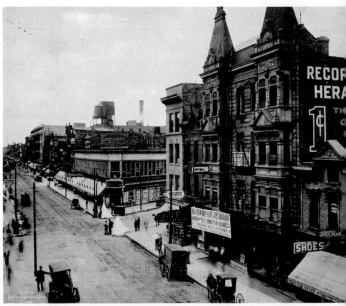

3

5. 3225 North Ridgeway, Probably 1913-15

The unpaved street and the small size of the plantings stand as evidence to the newness of this residential street. Two three-flats, their lower stories partially buried in the ground, are interspaced with the "pea in the pod" wooden double-deckers, typical of mass produced housing. Each of the apartments on this block had its own bath, and in many cases the owners occupied one of the apartments. These houses were located only two blocks from the Milwaukee Avenue streetcar line, and had the additional advantage of being close to industry sited along the Chicago, Milwaukee and St. Paul and the Chicago and North Western railroads which ran diagonally through the neighborhood.
(Courtesy Chicago Historical Society.)

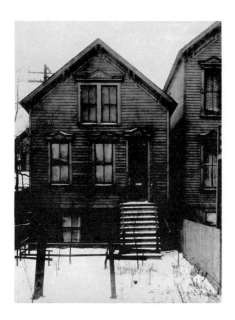

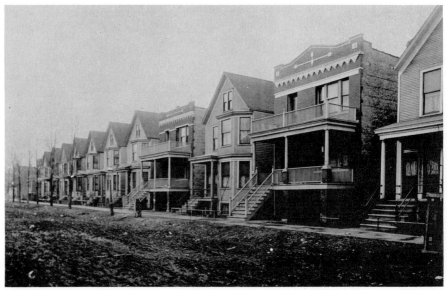

5

4. 1628 North Western, 1916

Occasionally the vacating of a front building on a lot would reveal the amount of activity which occurred in the back. In this photograph, demolition reveals two houses which occupied the back of the lots along North Western Avenue.
(Courtesy Chicago Historical Society.)

6

7

6. Northwest Corner, Devon and Western Avenues, 1914

This area was on the urban fringe of Chicago when this photograph was taken. The transition is symbolized in the stacks of the greenhouses and truck farms in the background and the manhole cover in the foreground. For the less subtle, a real estate sign announces that this project is in the hands of a Loop realtor with a nearby local office.
(Lillian M. Campbell Memorial Collection. Courtesy West Side Historical Society, Legler Branch Library.)

7. West on Devon Avenue from Western Avenue, 1914

Public transportation was relatively remote from this area, but, as the tracks on the unpaved streets indicate, the difference was to be found in the automobile The farm house with its outdoor privy behind and its barn and outbuildings, was soon to give way to the amenities of an urban subdivision.
(Lillian M. Campbell Memorial Collection. Courtesy West Side Historical Society, Legler Branch Library.)

1. **Chicago River, Southeastward from the Present Site of the Michigan Avenue Bridge, about 1900**
Chicago's smoky atmosphere cannot hide the congestion on the city's river at the turn of the century. Tugs and freighters crowd the wharfs, and the stream itself, seeking to load and unload their cargoes at the nation's greatest inland port. On the south bank, at the left, is the Goodrich docks from which the cruise

gan Park was part of the metropolitan area since it was "near enough to Chicago and sufficiently far removed to afford all the blessings of a Suburban Home with all the conveniences and advantages of the city, far from all its objectionable features." The spread of Chicago, however, quickly overtook it; in 1914 Morgan Park was annexed to the city.

Beyond the municipal boundary suburban growth also accelerated. Older places added population rapidly: Evanston jumped from 19,259 in 1900 to 37,234 in 1920; while Oak Park's population increased from 19,444 to 39,858 in the same period. Moreover, newer places sprouted along the railroads that provided commuter service. Typical of these was Maywood, situated along the Des Plaines River just west of Chicago. Serviced by both steam and electric railroads, it enjoyed a brisk development from the time of its first building activity in the 1890's until World War I. To the south, the annexation of the extensive town of Lake brought most of the prospective suburban sites into the city.

The growth of metropolitan Chicago was one of the great national events of the nineteenth century. Newton Dent of *Munsey's Magazine* conveyed the excitement of many observers when he wrote in 1907 that "Chicago stands as probably the fourth city of the world in population. She has doubled her population in fifteen years. But she is the first city of the world in many things—in enterprise, in growth, in energy, and in her indomitable optimism and self-confidence. Nowhere else is there such human voltage." Nearly every state in the Union, he continued, "hurries at the call of Chicago. 'Bring me your lumber,' she demands, 'I want two billion feet of it a year. Bring me every weekday fifty thousand of your farm animals and a million bushels of your grain. Bring me your ore and oil and cloth and paper and tobacco, and be quick, for I am Chicago —the City of Speed.' "

Nor did there seem to be any limit to its power or development. "When their river was crooked, they made it straight," Dent noted with awe. "When it fouled their drinking water by flowing north into Lake Michigan, they dug their famous drainage canal and compelled it to run south into the Mississippi and the Gulf of Mexico. When the lake trespassed on Lincoln Park, they drove it back with a marvelous sea-wall of masonry and marble." "Nothing," he concluded, "that either man or nature can do, apparently, can check the growth of this city that has spread back from the lake like a prairie fire, until its great bulk covers nearly two hundred square miles of Illinois." Residents were also understandably impressed. "Chicago has the bones of a giant," explained Francis Parker, one of the city's leading educators.

Not all were enthusiastic about the results of this urban explosion, however, and criticism of the city was as frequent as praise. In fact, one sensitive Chicagoan thought that attacking Chicago had become a kind of indoor sport. "To condemn her is almost a national trait," he moaned. "People think ill of her as quickly as they accept scandal touching a great personage." Urban experts, for example, scored the disorder, the dirt, and the planlessness, insisting that the city should be built according to rule— the streets of a certain width and arrangement, the population distributed in a definite way, and its institutions of a certain character. Others, like Rudyard Kipling, found Chicago ugly and vulgar. "There was no colour in the street and no beauty—only a maze of wire-ropes overhead and dirty flagging stone underfoot," he wrote, adding that the residents somehow thought it grand to "huddle men together in fifteen layers one atop the other, and to dig holes in the ground for offices." His assessment of Chicago was probably more widely quoted than any other of the time: "Having seen it, I urgently desire never to see it again. It is inhabited by savages."

The rapid growth of population, commerce, and industry complicated the problems of municipal housekeeping. The most serious was the disposal of wastes. Already untreated sewerage threatened the source of water supply in the lake. The first response had been to construct intakes farther away from shore, but this proved inadequate. Frequent epidemics of water-borne diseases

ship *Christopher Columbus* made its daily round-trip excursion to Milwaukee. At the far left, with the banner flying over it, is South Michigan Avenue, its sidewalks still lined by three- to five-story buildings. The Rush street bridge in the center of the photograph was removed in 1920 following completion of the Michigan Avenue Bridge.
(Courtesy Chicago Historical Society.)

2. Lincoln Park Shoreline of Lake Michigan, about 1905

"On holidays, Lincoln Park is a much frequented playground, driveway, and sylvan promenade," wrote a Chicago guide book in 1904. "The park is made beautiful by water, landscape gardening, and vegetation great and small; and further interesting by the presence of the city's zoological collection, by a spacious greenhouse, and monuments." All this, of course,

lay along the lake. As an English traveler wrote: "Driving along the Lake Shore to Lincoln Park in the flush of sunset, you wonder that the dwellers in this street of palaces should trouble their heads about Naples or Venice, when they have before their very windows the innumerable laughter, the ever-shifting opalescence, of their fascinating inland sea."
(Courtesy Library of Congress.)

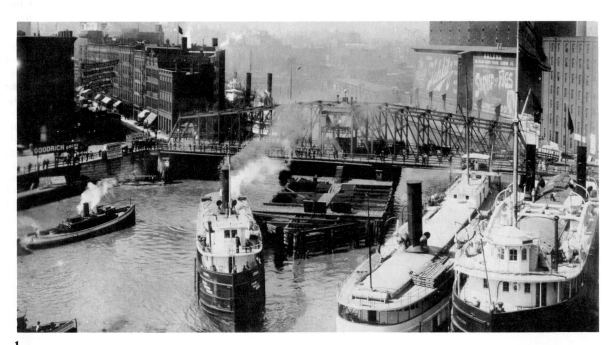

1

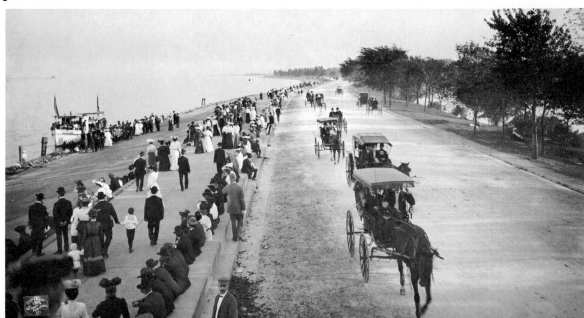

2

1, 2, 3. Construction of the Chicago
Sanitary and Ship Canal, 1894-99
(Courtesy Chicago Historical Society.)

plagued the city; the typhoid death rate alone reached 174 per 100,000 people in 1891.

Chicago's solution was bold—the construction of a canal across the drainage divide between Lake Michigan and the Mississippi Basin, the diversion of lake waters into the canal, thus reversing the flow of the Chicago River. The system depended on the chemical and biological processes of nature to break down the sewage to safe levels for downstream communities. The canal would also meet other needs. By handling storm runoff it reduced flooding, by furnishing navigation facilities for barges it also replaced the obsolete Illinois and Michigan Canal, and by acquiring land along the route it stock-piled sites for future industrial development.

To carry on this work, the Illinois legislature created the Sanitary District of Chicago in 1889, embracing an area of 185 square miles, including all of the city and a number of western suburbs. Now called the Metropolitan Sanitary District of Greater Chicago and covering 860 square miles, it is an autonomous body with elected officials and independent taxing authority. Later known to Chicagoans as the "eighth wonder of the world," the construction of the system was an enormous engineering triumph. Completed in only a decade, it required more land excavation than the building of the Panama Canal. When it opened in January, 1900, the *Inter Ocean* could assert without much exaggeration that it was "the greatest and most important municipal undertaking in modern time."

The urge for greater and better planning was shared by a large number of prominent citizens. In 1906 the Merchants Club (later the Commercial Club) appointed a committee to appraise the physical conditions of the city, to "discover how those conditions may be improved," and "to record such conclusions in the shape of drawings and texts which shall become a guide for the future development of Chicago." This was the genesis of the famous Chicago Plan of 1909. Daniel H. Burnham, who had

1

2

3

played an important role in the development of the "Chicago School" of architecture and was the principal designer of the 1893 Columbian Exposition, was commissioned with Edward H. Bennett to do the job. After several hundred meetings and three years of work, the Plan was submitted to the people of Chicago for consideration and approval. No other document in modern times has had as much influence on the growth of Chicago, or, indeed, on city planning throughout the United States and the world.

Part of the influence of the Burnham Plan stemmed from the breadth of its approach. It was not designed to reconstruct just one part of the city, nor to create a massive and fanciful blueprint for an ideal city. Rather, in the words of its authors, "it should be remembered that the purpose has not been to invent novel problems for solutions, but to take up the pressing needs of today, and to find the best methods of meeting those requirements, carrying each particular problem to its ultimate conclusion as a component part of a great entity—well-ordered, convenient, and unified city." Moreover, the plan recognized that the American city and Chicago preeminently was "a center of industry and traffic," and thus attention was given to "the betterment of commercial facilities; to methods of transportation for persons and for goods; to removing the obstacles which prevent or obstruct circulation; and to the increase of convenience." It

1. Plan of the Complete System of Street Circulation: Railway Stations: Parks, Boulevard Circuits and Radial Arteries: Public Recreation Piers, Yacht Harbor, and Pleasure-Boat Piers: Treatment of Grant Park: The Main Axis and the Civic Center, Presenting the City As a Complete Organism in Which All Its Functions Are Related One to Another in Such a Manner That It Will Become a Unit
"It is certain," the authors of the Plan wrote, "that if the plan is really good it will commend itself to the progressive spirit of the times, and sooner or later it will be carried out." It is obvious to the student of Chicago today that a great deal of the Plan has not commended itself to public attention, but many elements have become commonplace elements of the city. This diagram of the lakefront and the inner circulation system provides an illustration. Among those features shown which have been implemented are the geometric landscaping of Grant Park; the construction of Northerly Island; the building of Adler Planetarium on the site of the structure shown at the northeast corner of the island; the completion of Navy Pier a short distance south of the pier illustrated; the placing of Eisenhower Expressway along the alignment of Congress Street; the straightening of the South Branch of the Chicago River; the building of the monumental Soldier Field on the site of the Plan's "athletic grounds"; and the placing of the Chicago Circle, major focus of the city's expressway system at a location originally designed by the Plan as the civic center plaza.
(From *Plan of Chicago*, 1909.)

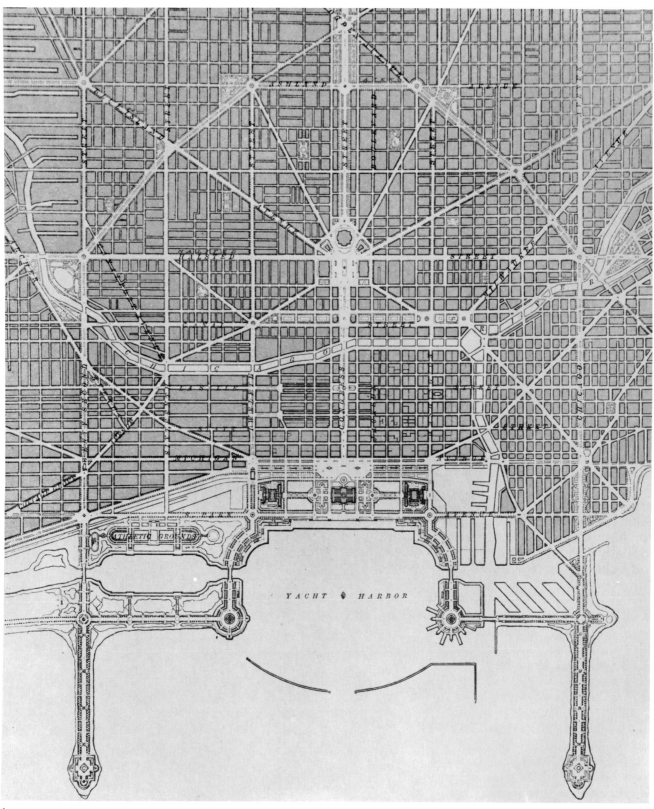

1

Plan of Chicago, 1909

1. Sketch of Proposal, Chicago Plan of 1909
View Looking North on the South Branch of the Chicago River (toward Wolf Point), Showing the Suggested Arrangement of Streets and Ways for Teaming and Reception of Freight by Boat at Different Levels
"Examples of the arrangement exist at Algiers, Budapest, Geneva, and Paris," the plan boasted, and it presented a grand plan to equal them. "Boulevards should extend from the mouth of the river along the North and South branches and on both sides, at least from the mouth of the river to North Avenue on the North Branch and to Halsted Street on the South Branch. These thoroughfares would be an important factor in the relief of traffic congestion downtown; they should be raised above the normal traffic level in order to afford

was this very hard-headed and practical approach that commended the plan to so many and kept it from being just another glossy report or just another idle dream.

Despite this emphasis, other elements were not neglected. Realizing that "good workmanship requires a large degree of comfort on the part of the workers in their home and surroundings," provisions were made for that "rest and recreation without which all work becomes drudgery." Then, too, because "the city has a dignity to maintain," the plan included "impressive groupings of public buildings, and reciprocal relations among such groups." Even more striking, perhaps, was the authors' vision of the future. Assuming that "within the lifetime of persons now living," Chicago would become "a greater city than any existing at the present time," they left generous space for subsequent growth and extended their concern to the whole metropolitan region instead of confining it to the settled areas. In short, the Burnham Plan was at once comprehensive and at the same time flexible; it addressed itself to both the concrete needs of its own time as well as the contingencies of the future.

The Plan was adopted by the city in 1910 and quickly became the guideline for official policy. Over the next half century it shaped the development of the city. Its major provisions such as an east-west boulevard stretching from the Lake into the prairie horizon, the de-

1

greater facility of circulation, and to allow warehouses to be constructed below the roadway. This upper level would thus connect the points on the river at which the street scheme calls for an elevation, as in the case of the north-and-south connecting boulevards, the junctions of the three branches of the river, and Twelfth Street. These boulevards apart from their practical advantages would become the most delightful route to the Lake." Only one of the proposed double-deck

avenues was ever completed, Wacker Drive along the south side of the main branch, but the monumental treatment of the bridge pylons set the architectural style for nearly all of the city's bascule bridges constructed between 1910 and World War II.
(From *Plan of Chicago*, 1909.)

2. Proposed Boulevard to Connect the North and South Sides of the River: View Looking North (on What is Now Michigan Avenue) from Washington Street

The authors of the Chicago Plan stressed the importance of Michigan Avenue: "Michigan Avenue is probably destined to carry the heaviest movement of any street in the world. Any boulevard connection in Michigan Avenue which fails to recognize the basic importance of the avenue will be a waste of time and energy." Their proposal called for a major redrafting of the street's design: "The boulevard is raised to allow free flow of east-and-west teaming traffic under it, and both Michigan Avenue and Beaubein Court are raised to the boulevard level. The raised portion throughout its entire length, from Randolph Street to Indiana Street, extends from building line to building line. It is approached from the cross streets by inclined roadways or ramps." At another point the authors added: "The proposed double roadway is designed to accommodate the immense volume of traffic which will be attracted to the Lake Front. The west roadway cares for shopping traffic and carriages waiting for the crowds attending public functions; the eastern roadway carries traffic through the business section without interference from stationary vehicles A double-deck bridge accommodates the north-and-south traffic-teaming below, and light vehicles above."
(Painting, Jules Guerin. From *Plan of Chicago*, 1909.)

2

Plan of Chicago, 1909

Proposed Twelfth Street Boulevard at its Intersections with Michigan Avenue and Ashland Avenue

"The Twelfth Street location would extend from State Street west to the South Branch of the Chicago River, . . . Here the purpose is to care for passenger service of every sort, except that of roads coming in on the West Side system. These stations should open on the great Twelfth Street Boulevard, which in front of the stations should be two hundred and fifty feet wide, and east and west of the stations should be one hundred and eighty feet in width. This boulevard would begin to rise at Michigan Avenue, and at the final elevation, which is at the level of the main floor of the stations, should pass over the River on a double-deck bascule bridge. This thoroughfare should come to the present street level at Canal Street, where there is to be a round-point from which a new street should extend to the civic center. As a one hundred and fifty foot wide boulevard, Twelfth Street

velopment of a civic center, the acquisition of a greenbelt of forest preserves around the outside of the city, and the creation of lake-front parks and beaches, ultimately moved from vague sketches into living reality. Of course, some suggestions proved too ambitious or even unwise and were postponed or discarded, but others still hold promise for future action. And across the country, interest in this compelling plan for Chicago's future almost equalled the widespread fascination in the city's sudden growth. "Make no little plans," Burnham counselled. "They have no magic to stir men's blood and probably themselves will not be realized. Make big plans; aim high in hope and work, remembering that a noble logical diagram once recorded will never die but long after we are gone will be a living thing, asserting with growing intensity."

should continue westward until it joins the West Park Boulevard now existing on the same line, west of Ashland Avenue. The present rights-of-way of the railroads passing under Twelfth Street can go into business use without loss to the corporations owning them. The freight systems and trackage for all of these roads should be underneath the proposed passenger stations and their yards."
(Painting, Jules Guerin. From *Plan of Chicago*, 1909.)

MORNING IN CHICAGO

A dull murmur, an indefinable commingling of sounds is in the air. Heavy and continuous, it is carried on the wind to my window. Like an accelerating machine the rumble of the wakening city throbs louder: the voices of a million people, the grind of the elevated, the tread of countless feet. Beyond the grimy reach of flat roofs and blackened chimneys the towers of the "loop" rise against the gray of the morning sky like a feudal castle above the clutter of the town. On the south wind the smoke of the factories banks up against white steam-clouds from the office buildings in a thickening pall. To the left the leaden lake stretches off to the pale horizon. South along the shore a slanting gleam through the clouds brightens a low bank of clouds to polished steel; it is gone, and the smoke of the city blots out the distant curve of the lake.

North and south for thirty miles, and back ten miles to the prairie, the flat encrustation of the city presses against the lake. From the low bluffs on the north, where lie the pleasant suburbs, to the cinder-strewn, track-meshed yards of the steel mills, the continuous front of the city stops abruptly at the shore. In from the lake the narrow twisting artery of the river, cluttered with shipping, extends like a slot between wharves and warehouses. I can see the funnels of steamers rising oddly above the roofs, against the sheer sides of the office buildings beyond. The deep whistle of a lake steamer emerges above the growing clamor of the streets. After a wakeful sleep the city is beginning another day.

Across the river-bridges a steady tide of traffic surges into the loop. At Rush Street Bridge a double line of automobiles for two hours unending pours into the heart of the city. From the northern suburbs and the great stone houses of Lake Shore Drive it is carrying the wealth and power of industry; but from the south and west and northwest, in crowded elevated and surging street car, a greater tide is on the flood. Men and women, girls and boys—by the press of their numbered feet the giant treadmill is already beginning to turn.

Under the steel spans of the river-bridges a thick brown current flows back from the lake. Clean at the mouth of the river, it darkens as it passes on; a vast canal which bears in from the wide lake the great steel vessels, rich-laden with coal and grain. Above the wharves the high towers of grain elevators rear their corrugated sides; warehouses, windowless, massive, filled with rich gleaning from a thousand markets.

Back and forth hurry the tugboats, whistles vibrating, funnels dipping back to clear the bridges.

High above Michigan Avenue Diana, poised against the gray sky, has swung pointing to the lake. A cold wind is coming from the water, clean and penetrating. Motors are passing down the wide boulevard in unceasing streams, minor eddies turning into the deep cuts of the cross-streets. Facing the high wall of office buildings the Art Institute, smoke-blackened and weather-stained, rises low and massive from the level park. On either side of it the waste-filled land, faintly green with uncertain sod and newly planted trees, stretches to the distant lake. A cloud of smoke and steam runs out and along a shallow cut parallel with the boulevard. Across the park, almost passing beneath the Institute, the tracks of a railway stretch south from the freight-yards by the river. Against the high buildings the noisy steam locomotives belch blackening smoke.

It is noon, and the rising wind has brushed back the smoke-laden clouds. Against the sky wisps of white steam bend like plumes from lofty roofs. Dearborn Street is choked with traffic. In the bracking air crowds surge, weaving currents along the sidewalks; street-cars, motors, trucks, wagons, congest the street. There is the continuous roar of action; the life-blood of the city pulsates in its great arteries; a static sense of energy is in the air.

Joseph Husband, "Chicago: An Etching," *The New Republic* (November 20, 1915), pp. 70-71.

5 | War and Prosperity, 1917-45

The end of World War I found Chicago poised for a new decade of extraordinary growth. The war effort had diverted the city's energies to supplying the troops and manufacturing military hardware. Residential building slackened and normal commercial and industrial expansion were postponed. With the coming of peace, this pent-up demand suddenly broke loose. A new skyline rose above the Loop; outlying areas in the city filled up quickly; the rapidly increasing use of the automobile produced a whole new set of suburbs; and over 60,000 persons were added to the municipal population each year. Few decades had been so fruitful for the city; none left such a clear mark on contemporary Chicago.

Yet the decade was framed by ominous events. On a hot July day in 1919 race tensions on the South Side spilled over into violence; before the rioting ended six Negroes and one white person were killed, many more were injured, and property damage ran into the millions. A new kind of ghetto had found its way into public consciousness. Ten years later the stock market crash brought an end to the general prosperity which had sustained the extraordinary expansion of the city. New construction halted; after the completion of the Field Building in 1934, no new major structure broke the downtown Chicago skyline until after World War II.

The twenties, nonetheless, witnessed the shaping of much of the modern metropolis. Writing at the peak of activity, Henry Justin Smith ticked off the range of new programs, "the symptoms of the renaissance." They included the "development of the lake front, a great number of things such as street, park, and boulevard improvements; new bridges; straightening of an eccentric embarrassing river branch; expansion of transportation service; a track elevation program; new university buildings, especially for medical service; and a tremendous array of industrial and commercial structures, hotels, theatres, and so on." He estimated that the investment in the city would reach nearly three billion dollars by the end of the decade. "The age of mere millions had passed," Lloyd Lewis observed wryly, "the age of billions had dawned."

The ugly events of the summer of 1919 did not come unannounced. They had been preceded by mounting tension in the neighborhoods surrounding the expanding Negro ghetto on the South Side. A long, narrow band of Negro occupancy stretching south of Twelfth Street had developed, in addition to other smaller concentrations on the North Side and West Side. The early years of the century saw the Negro migration accelerate, and wartime labor opportunities produced a massive movement to the city. Housing for any newcomer was always difficult; for blacks it was especially so. On a single day in 1918 the Urban League processed 664 applications for

284

housing; only fifty-five units could be found. The migrants crowded what little was available to overflowing. Whole families jammed into single rooms; everything that could be converted into living space was occupied.

But the ghetto would not be contained; soon it expanded into other neighborhoods. Block by block, the surrounding areas were occupied by Negroes. Down Grand Boulevard and along South Park (Martin Luther King, Jr. Drive), into aristocratic old Prairie Avenue, and as far south as Sixty-seventh Street, black neighborhoods appeared. In some places whites fled; in others they gave way grudgingly. At the edge of the ghetto, a kind of guerilla warfare broke out—in the twenty-four months before July, 1919, twenty-four bombings occurred, directed at new Negro residents or at real estate agents who dealt in transitional property. Though this reception was harsh, everything was not hopeless. "Twenty years ago less than fifty families of the colored race were homeowners in Chicago," wrote the poet Carl Sandburg in 1919. "Today they number thousands, their purchasing ranging from $200 to $20,000, for tar paper shacks in the still-district to brownstone and greystone establishments."

But on July 27, the South Side erupted after a stone-throwing incident on a beach led to the drowning of a Negro youth. The next five days were the worst the city had known since the Great Fire. Fighting, shooting, stabbing,

1

2. The Central Area, Northwestward from about Ninth Street and the Inner Drive, 1926

From the construction of Grant Park in the foreground to the exposed steel frames of new skyscrapers along Michigan Avenue, the lakefront reflected the physical change of the city in the mid 1920's. Cutting through the park, the Illinois Central Railroad, with its electrification of suburban service nearly complete, has gone below grade. At the lower left, the Standard Oil Building, erected in 1911 as the Karpen Building, had just had seven stories added to its original thirteen. Two blocks to the north, the Stevens Hotel (now the Conrad Hilton) was under construction. The uniformity of downtown building heights was brought about by the zoning ordinance of 1923, which limited building at street line to 265 feet, though setback towers could be added above this height.
(Photograph, Chicago Aerial Survey Company. Courtesy Chicago Historical Society.)

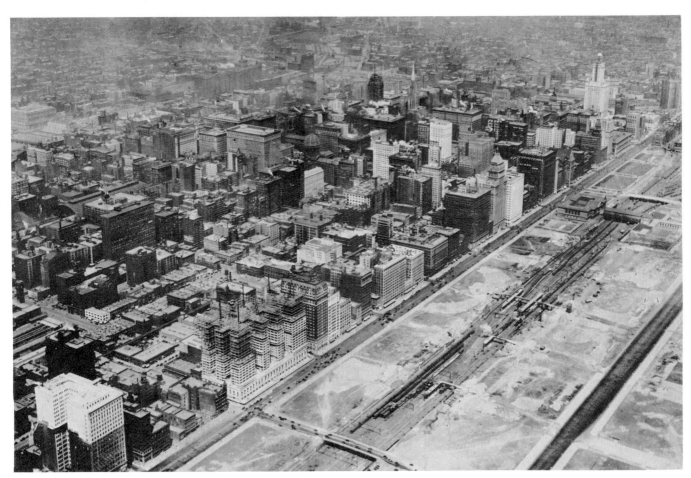

2

**1. Downtown Chicago,
North-Northeasterly, 1936**

The Loop is the "Heart of [the] City," a Chicago publication stated in 1923. "Although it is relatively but a small part of the city, it is a giant in power. Here are gathered the main offices of big businesses which serve the world. Ninety years ago cows were grazing where today are giant skyscrapers and busy streets. In fact, there are 163 skyscrapers in this area known as the 'loop' and more are going up each year. And where years ago but a few settlers lived is today a business section in which are 300,000 workers, to say nothing of 20,000 street cars passing in and out of this area every 24 hours, 150,000 vehicles and pedestrian population of 10,000,000." (Photograph, Chicago Aerial Survey Company. Courtesy Chicago Historical Society.)

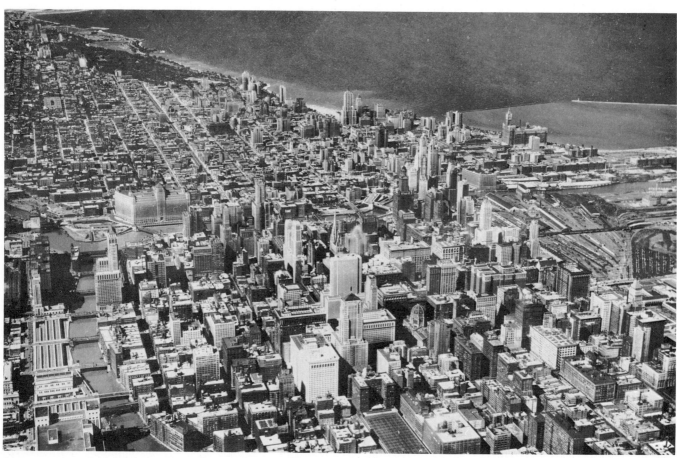

1

2. Southwest View of Central Chicago, 1936

By the mid-1930's, the expansion of business into the North Side gave it an appearance somewhat like that of the Loop in an earlier day. The complex of railroad yards and industry restrained the movement of businesses southward. Fashionable specialty shops, large apartment buildings, and new office facilities found locations north of the Loop more to their liking. (Courtesy Chicago Historical Society.)

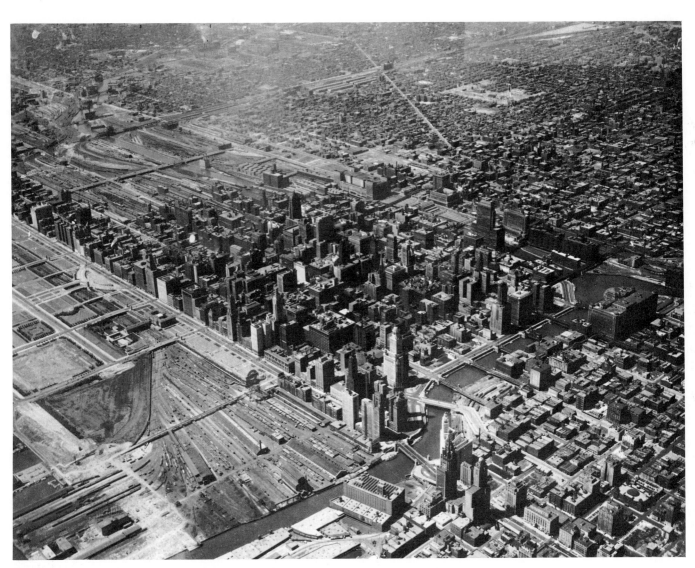

2

288

1. Speed of Building in the 1920's
(Cartoon from the *Chicagoan*, August 13, 1927.)

2. Dearborn Street, Northward from Madison, 1935
(Courtesy George Krambles Collection.)

3. State Street North from Madison, 1923

"State street, with its great department stores each a 'World's Fair' in itself," was one of "the world's most famous bazaar streets" a boosting publication declared in the early 1920's. A study of thirty-nine of the city's department stores in 1926 revealed their total sales as $361,000,000, "18.2 per cent of Chicago's aggregate retail business—first among merchandising concerns." A more sophisticated booster declared pretentiously that they were "museums of present day civilization exceeding in numbers, size, grandeur and volume of business even those of New York, London and Paris."
(Courtesy Chicago Historical Society.)

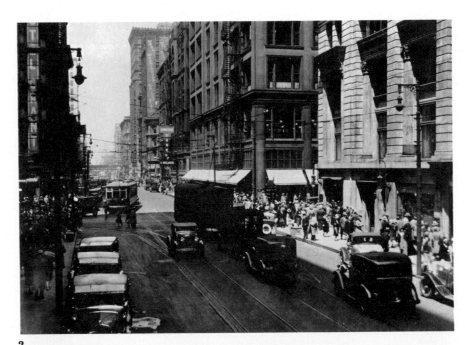

"Come Back in Half an Hour, Joe"

1

2

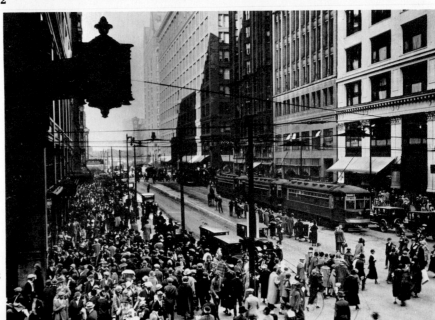

3

4. State Street North from Madison Street, Early 1940's

Few people could afford to use precious gasoline during wartime. Consequently, Loop streets carried few privately owned autos, while public transportation was crowded beyond capacity. The State and Madison corner still had its share of traffic, however, as thousands of people walked about the Loop to shop or to work. Streetcars and buses, some of them double-deckers, shared the responsibility for carrying most people on the surface, while the newly constructed subway, one entrance of which is at the lower right, helped to eliminate congestion. (Courtesy Gordon Coster Collection.)

5. View Northward toward the Loop, from Wabash and Balbo Avenues (Seventh Street), Early 1940's.

The loft buildings in the foreground are typical of those which surrounded the Loop. Most of them were built in the last century, and they continued to house small manufacturing and wholesale establishments. The line of low buildings running diagonally through the center of the photograph is the South State Street skid row. (Courtesy Gordon Coster Collection.)

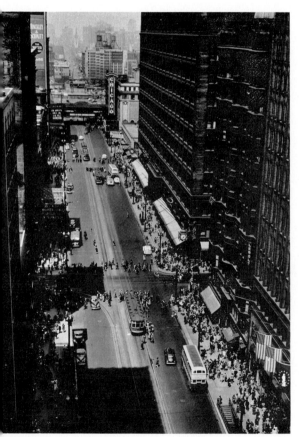

4

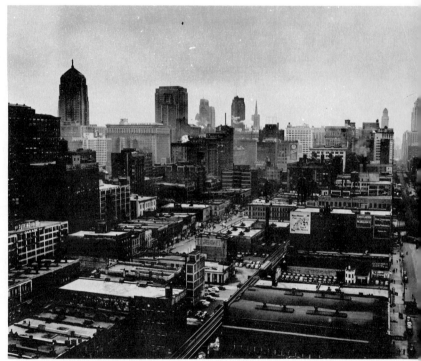

5

2. Whites Chasing a Negro during the Race Riot, 1919
Photographer Jun Fujita followed an unrelenting mob through alleys and backyards, as they chased a Negro. A few minutes later the frightened man was cornered in a back yard and stoned to death.
(Courtesy Chicago Historical Society.)

and pillaging left scores injured and over a half-dozen dead. Mobs pulled blacks from streetcars, bands roamed neighborhoods, homes were sacked and burned. Finally the Governor sent in the troops. Peace was restored, but the scars could not be easily erased, for the grim affair left deep wells of guilt and remorse, hate and bigotry. Worse still, conditions did not change, and the ghetto continued to expand and fester.

The turbulence of 1919 was soon forgotten in the exuberance of the twenties. The city enjoyed an unprecedented prosperity; nearly every index was up. The population of the city jumped from 2,700,000 in 1920 to 3,376,000 ten years later. The dollar value of manufactured products and wholesale trade rose by fifty per cent with a relatively stable price level. The consumption of electricity increased 133 per cent, while the numbers of automobiles in Chicago quadrupled in the decade. The cynics noted, however, that the city's financial debt matched these increases and that crime rates and dollars lost through political corruption more than offset any conceivable gain. Yet it was an impressive record, whether measured by the steel and concrete of new building or the brazenness of Mayor "Big Bill" Thompson's boasting.

Most of the major public projects of the period stemmed from the Chicago Plan of 1909. It had provided the vision, but winning acceptance was never easy.

1

2

3, 4, 5, 6. Negro Ghetto in the 1940's
(Courtesy Gordon Coster Collection.)

3

4

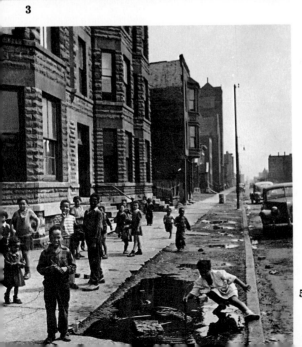

5

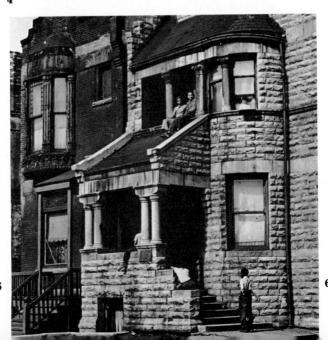

6

1. Lake Shore, North from Thirty-Fifth Street in the 1880's

In the left foreground is the edge of the little park containing the tomb and monument of Stephen Douglas; in the left background are the fashionable residences along Cottage Grove Avenue, and behind them rears the tall smokestack of a brewery demolished a few years ago to make way for an expansion of Michael Reese Hospital. (Courtesy Chicago Historical Society.)

2. Lake Shore Northwestward from Twenty-Third Street, 1892

The Illinois Central's 22d Street Station is in the distance. Shoreward from the railroad, the area is now occupied mainly by the Lakeside Press buildings. The area in the foreground was subsequently filled; it was the main entrance to the Century of Progress Exposition in 1933–34, site of the Railroad Fair of 1948–49, and of McCormick Place. Recalling the condition

Voters responded more positively than did private interests whose property had to be disturbed. The decade after the publication of the plan saw resistance, legal maneuvering, and constant postponement. The discussion about new projects had been necessary and probably inevitable, but as Walter D. Moody put it in 1919: "Reviewing the years of wrangling, bickering, and delay, one is forced to the conclusion that two-thirds of these nine years (1910–19) have been wasted, and two-thirds of the controversy has been stupid."

The development of the lake front was the most striking aspect of the new activity. Between the wars, over a billion dollars went into new landfill on the Lake Michigan shoreline and in constructing commercial and recreational facilities along the water's edge. The Plan called for two piers jutting into the lake, one on each side of the river's entrance. Between 1914 and 1916 the first of these was completed. Called Municipal Pier (later Navy Pier) and designed to handle lake-passenger and package-freight vessels, it reached 3,000 feet into the water and contained not only docking installations but its own streetcar line, which served a dance hall, theater, restaurant, and recreational facilities between the twin towers at the eastern end.

Farther south, Grant Park had been built on land fill east of Michigan Avenue. A stubborn fight by conservationists preserved the new front yard from encroachments. Ultimately, the erection

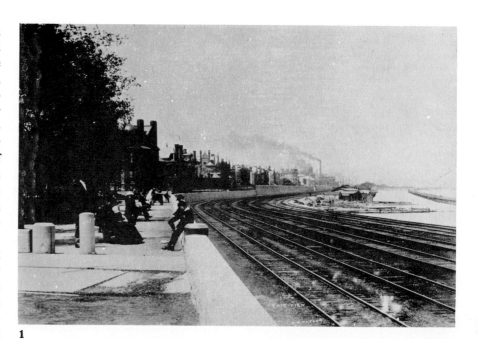

1

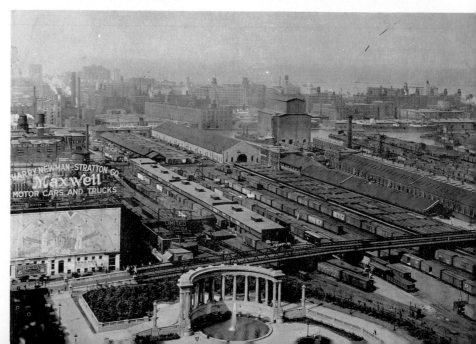

of Chicago's front yard, one author wrote in 1929: "A quarter of a century ago that lake front looked almost hopeless. For the right of way of the Illinois Central Railroad extended along the beach and widened into a brutally uncompromising freight yard by the river. You couldn't get around the tracks or around the noisy locomotives that belched out smoke by day and by night." (From *Chicago*, 1892. Courtesy Chicago Historical Society.)

3. North on the Lakefront from Twenty-Seventh Street

This picture shows the locomotive yard and coaling facility at 27th Street. (Courtesy Chicago Historical Society.)

4. View Northeastward across the Illinois Central Yards on the Downtown Lakefront, 1917

The Randolph Street viaduct cuts like a belt across the expanse of track and cars in the Illinois Central yards, one of more than 100 freight yards which were part of the city's railroad network by 1920. At the lower left, adjacent to Michigan Avenue, is the Peristyle (1917-53) at the northern edge of Grant Park. At the left center is the stone freight shed built in 1854. (Courtesy Illinois Central Railroad.)

2

3

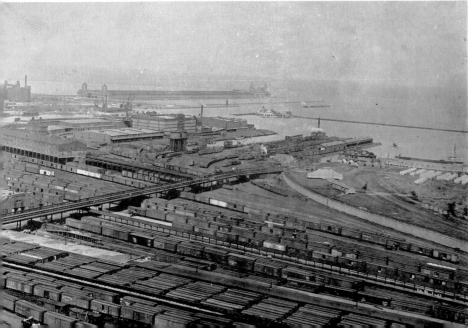

4

of the Field Museum of Natural History (1919), Shedd Aquarium (1929), and Adler Planetarium (1930) rounded out what Carl Condit has called "the largest, oldest, and architecturally most impressive 'cultural center' in the United States." The complex begins on the north with the Public Library (1897) and rings Grant Park along Michigan Avenue, including the Art Institute (1893), Orchestra Hall (1904), Fine Arts Building (1886), and the Auditorium (1889), winding up with the three new institutions at the south end of the Park. Nearby, Soldier Field rose as an all-purpose outdoor stadium.

The Lake Front Ordinance of 1919 prepared the way for the larger lakeshore improvement. It embodied the arrangements, made by the city and the South Park Commission with the Illinois Central Railroad, which cleared the way for the public development of the shoreline south of the city's center. The railroad agreed to construct a new terminal building at Twelfth Street and to electrify its operations into Chicago over a period of years. The Park Commission expected to string a necklace of islands along the water's edge according to the Chicago Plan. Actually the new station was never built; and except for Northerly Island, which later became a peninsula, the island concept was not implemented. Yet, from Grant Park to Sixty-seventh Street, eight miles of parks and beaches replaced the scruffy, ill-kept shoreline. Between Grant and Jackson parks, the

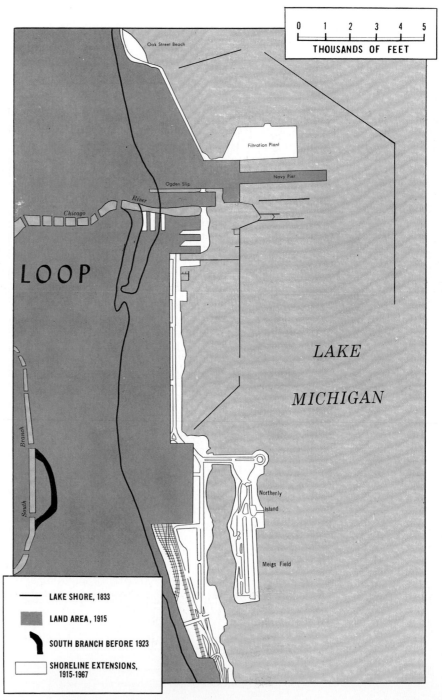

LAKE SHORE, 1833

LAND AREA, 1915

SOUTH BRANCH BEFORE 1923

SHORELINE EXTENSIONS, 1915-1967

2. A. Montgomery Ward (1843–1913)

Montgomery Ward bought property for a building on Michigan Avenue in 1887. Four times between 1890 and 1911, the catalogue magnate sued the city to stop it "from filling the park with public buildings." Law professor Allison Dunham writes, "Ward claimed that because he was the owner of two and one-half lots fronting on Michigan Avenue between Washington Street and Madison Street, he owned in the public area east of Michigan Avenue a right of private property, a right that this area be kept open and unobstructed in order to provide light, air, and view to the property owners on the west side of Michigan." The legality of the claim hung on a notation on an 1836 subdivision map which designated this area as "public ground, forever to remain vacant of building."
(From an undated engraving. Courtesy Chicago Historical Society.)

3. East End of the Municipal Pier, 1916

The east end of the pier contained outstanding recreational facilities, including a dance hall–theater and restaurant. In the summer, small excursion boats operated from the Pier to Lincoln and Jackson parks.
(Courtesy Chicago Historical Society.)

4. Between the Sheds on Navy Pier, 1921

The recreational facilities at the east end of the pier could be reached by public transportation.
(Courtesy Chicago Historical Society.)

2

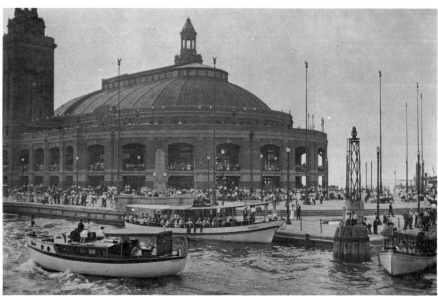

3

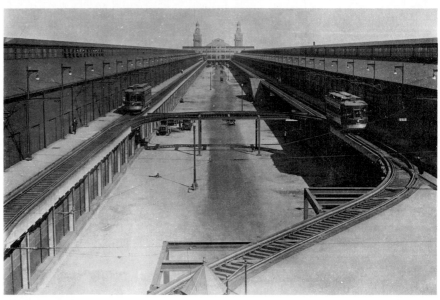

4

1. Northwest across Grant Park toward Michigan Avenue, 1929

The landscaping of Grant Park was not fully completed when this photograph was taken, but its formal symmetry was already apparent. Lying "under the very shadows of Michigan avenue's skyscrapers," the park's 200 acres were a grand respite from the towering buildings. In the foreground is Buckingham Fountain, installed in 1927 and which one observer called "perhaps one of Chicago's greatest prides and in some ways its most distinctive artistic achievement."
(Courtesy Chicago Historical Society.)

2. Buckingham Fountain in Grant Park, View Southwesterly

Like many of Chicago's other monuments, Buckingham Fountain was built with private funds: Miss Kate Buckingham presented it to the city in memory of her brother, Clarence, who had been a director of the Art Institute.
(Courtesy Chicago Historical Society.)

3. Michigan Avenue, North across the Portico of the Art Institute, 1934
(Courtesy Chicago Historical Society.)

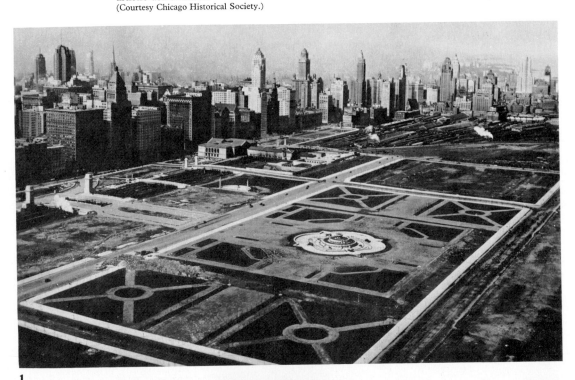

1

2

3

4. Field Museum of Natural History, Shedd Aquarium, and Adler Planetarium, 1947

"There is not another area of its size in all the world that provides as much free education and entertainment as Grant Park," a Chicago citizen wrote in 1932. The foundation of this reputation was the Field Museum built in part with an eight million dollar gift from the will of Marshall Field. "Modelled after a Greek temple" it occupied eleven acres devoted to anthropology, geology, botany and zoology. One observer who toured its maze of exhibits soon after they opened called it the "people's college" of the sciences. Shedd Aquarium, "Chicago's Marine Wonder House," opened in 1930 through a donation of three million dollars from John G. Shedd, president of Marshall Field and Company. Occupying the northern end of Northerly Island is the Adler Planetarium and Astronomical Museum opened in May, 1930. Designed by Ernest A. Grunsfeld, Jr., its twelve-sided design won the 1930 Gold Medal from Chicago's Chapter of the American Institute of Architects. The first planetarium to be built in America, it was erected with a donation from Max Adler, Chicago philanthropist.
(Photograph, Howard A. Wolf. Courtesy Chicago Historical Society.)

1. Army-Navy Game, Soldier Field, 1926

A Chicago guide book observed in 1932: "The great $6,000,000 Stadium—Soldier Field—its classic columns built of reinforced concrete, much of it pre-cast in the form of cut stone, has been built, as was the Parthenon, or the Coliseum of Rome, to endure through the ages. Perpetuating the memory of Chicago's sons who made the supreme sacrifice in the World War, it symbolizes in its classic architecture, in its beauty and its strength, the youth and courage and the will to win—the spirit of the city's young manhood of 1917."
(Courtesy Chicago and Eastern Illinois Railroad.)

2. The Illinois Central Begins Electric Operation on the Lakefront, July 21, 1926

When the Chicago Plan was published in 1909 there was already a serious concern over air pollution. In 1915 the Association of Commerce and Industry published a massive "smoke abatement" study, and one suggestion was to electrify railroad lines

newly created lake-front area was, appropriately, named Burnham Park.

Lake-front improvement to the north was no less difficult. Ten miles of shore-line lay ready for development, but many obstacles had first to be cleared away. Ultimately, Oak Street Beach and park land formed a delightful apron before the imposing line of high-rise apartments overlooking the lake. Lincoln Park was expanded by more land fill and reached Hollywood Avenue after World War II, constituting a complex of beaches, marinas, and recreational areas with few equals.

The rescue of the lake front was a remarkable accomplishment. Most lake and river cities had already devoted their waterfronts mainly to commercial and industrial uses and they lacked either the resources or the will to recover major portions of them for other purposes. But Chicago soon discovered that no success is ever secure or final. Private interests were reluctant to give up valuable lake-front sites in areas not yet developed, and thus they slowed down needed improvement. In addition, conflicting public interests, especially demands for more road space, put previous achievements in constant jeopardy. Yet the Chicago Plan, and the generation which first implemented it, succeeded in making the conservation of the lake front a fixed principle in city affairs.

The Chicago Plan also called for new boulevards to relieve the city's increas-

1

2

entering the city. As part of the Lake Front Ordinance of 1919, the Illinois Central agreed to change its suburban service to electricity. A year after its completion, the *Chicagoan* commented editorially, "since the Illinois Central (I.C.) has been electrified it boasts the most rapid transportation in Chicago. The Chicago and Northwestern, Wabash, and other steam roads, however, have the inducement of free cinders for passengers."
(Courtesy Illinois Central Railroad.)

3. Oak Street Beach, 1921
As the decade of the twenties opened, several gaps remained in the facade facing Oak Street Beach, revealing the lower buildings behind the high-rise luxury apartments. The large building on the right is the thirteen-story Drake Hotel designed by Marshall and Fox and built in 1920 at the southeast corner of North Michigan Avenue and East Lake Shore Drive.
(Courtesy Chicago Historical Society.)

4. Oak Street Beach, 1932
By 1932 the facade of the Oak Street Beach had filled completely east of the widened Michigan Avenue. The tall pyramid-roofed building is the Drake Tower. At the right is the Palmolive Building (now the Playboy Building), topped by the Lindbergh Beacon. The popularity of the beach in the early thirties was attested by one report which noted, "Oak Street beach on a Monday morning after a hot day will yield as much as fifteen tons of trash, and perhaps 1,200 milk bottles."
(Photograph, Fred G. Korth. Courtesy Chicago Historical Society.)

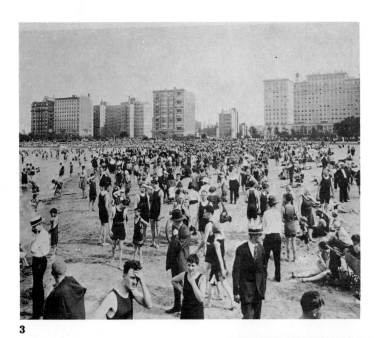

3

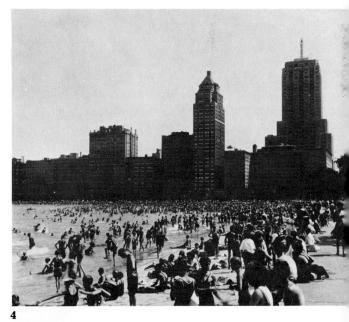

4

5. A Drive in Lincoln Park, 1921
Since automobiles were first regarded as pleasure vehicles, it seemed logical to convert Lincoln Park's carriage drives into automobile roads. Yet, by 1921 cars had already caused an impressive problem.
(Courtesy Chicago Historical Society.)

1. Clarendon Beach and Bath House, 1916
(Courtesy Chicago Historical Society.)

2. Northern End of Lincoln Park, from Irving Park Boulevard (Now Irving Park Road), 1936

Adjacent to the Edgewater and Uptown communities, a hook-shaped, man-made peninsula enclosed Montrose Harbor and beach. On this new land fill, running beside Waveland Golf Course, Lake Shore Drive was extended from Montrose to Foster avenues. The engineers who built this section of the drive were among the pioneers in their use of the grade separation cloverleafs.
(Courtesy Chicago Historical Society.)

ingly intolerable traffic jams. Among the worst bottlenecks was North Michigan Avenue. The portion in front of Grant Park had already been widened, but at Randolph Street what was known as "the Splendid Mile" suddenly narrowed to sixty-six feet. Walter Moody described it in 1919 as a strip which "presented the appearance of a poor, tenth rate city" where "many vacant buildings showed the grime of years upon their windows, the door-lintels were hung with cobwebs, and a general air of decadence prevailed." At the river, traffic moved across the Rush Street Bridge, which carried seventy-seven per cent of all the automobile and twenty-six per cent of all the commercial vehicles coming into the Loop from the North Side —a heavier burden than was borne by the famous and larger London Bridge in England.

As early as 1914 the people had voted a bond issue to begin widening the street and to building a new bridge. Opponents of the project declared it a boon only to "rich automobile owners" and "the swells," and took the issue to court. Before litigation had been finished, over 8,700 property settlements were made and years of construction were lost. But, in May, 1920, an immense public celebration greeted the widened street and the new double-leaf bascule span. The bridge, in Lloyd Lewis' words, "rose into the air like an alligator's jaws when ships whistled" and carried commercial vehicles in the lower level while accom-

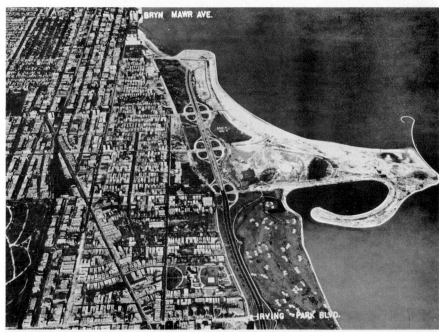

1

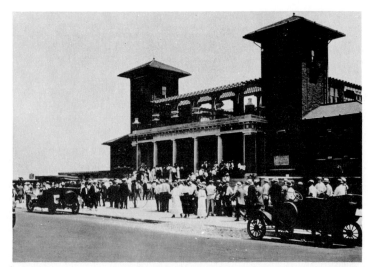

2

3. Junction of River Street (Wacker Drive) and Rush Street Bridge, Eastward, 1914 or Early 1915

Rush Street Bridge was one of the worst traffic bottlenecks in the city, with two different streets feeding into it. At the right is the Hoyt Building erected in 1872 on the site of Fort Dearborn. It stood until 1921 when it was torn down to make way for the London Guarantee Building (now the Stone Container Building). The wharves in the foreground were used by the Goodrich Line steamboats from Civil War times until the thirties. These vessels connected Chicago with ports on both the east and west shores of Lake Michigan. Across the bridge, on the extreme left is the steamer *Eastland* (not a Goodrich liner), which capsized at Clark Street in 1915 with loss of over 800 lives.
(Courtesy Chicago Historical Society.)

4. South on Michigan Avenue from the Chicago River, Probably 1918

A narrow and congested Michigan Avenue in the foreground contrasts with the already widened Michigan Avenue in the distance. The three blocks of buildings on the east side of Michigan Avenue were soon demolished and a widened thoroughfare was completed from Grant Park to the river.
(Courtesy Chicago Historical Society.)

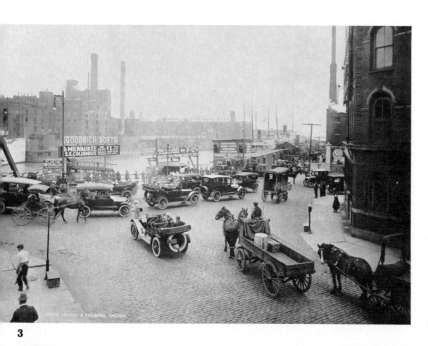

3

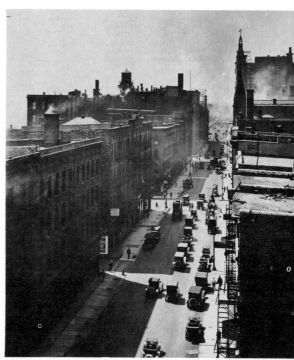

4

5

5. Michigan Avenue (then called Pine Street), North from Ohio, 1918

This photograph was taken just before the widening of Michigan Avenue from the River northward to the Lake at Oak Street.
(Photograph, Charles Barker. Courtesy Chicago Historical Society.)

modating heavy automobile traffic on the surface. Later much of the world would adopt this type of bridge pioneered in Chicago.

The North Michigan Avenue project opened a new era in the history of the Near North Side. The avenue north of the river began to challenge the "splendid mile" with the "magnificent mile." Fashionable shops, hotels, prestige offices, and the communications industry soon settled there. The bridge itself became a focus of new skyscrapers as the Wrigley, Tribune, London Guarantee, and 333 North Michigan buildings rose at the four corners of the structure. To the north, the development was anchored by the quiet dignity of the Drake Hotel, at Oak Street. Streeterville, long vacant or underdeveloped, felt the stimulus and filled in rapidly with apartment, office, institutional building. Samuel Merwin no doubt boasted too much in the *Saturday Evening Post* when he said Michigan Avenue made Fifth Avenue seem "hardly more than a side street," but its size and elegance did leave most visitors short of words.

The south bank of the river also received attention during this decade. The South Water Street Market, the city's major food distribution center, had become hopelessly inadequate. Designed for an age when produce arrived mainly on lake vessels and lacking modern facilities, it could no longer meet the needs

1. North Michigan Avenue Bridge, Northward, 1934

The opening of the Michigan Avenue Bridge in 1920 was a significant event in the history of Chicago's central area. A booster publication of the mid-1920's summarized the change that the bridge had made: "The building up of the portion of the north side, near the river represents the first notable departure on the part of leading business establishments from the traditions which have bound them to the loop, causing that district to become seriously congested." Over the next decade the old warehouses and loft buildings were replaced by the London Guarantee Building (1923, now the Stone Container Building) and 333 North Michigan Building (1928) on the south side of the river; on the north side, at the west side of the avenue is the Wrigley Building (1921–24), and across the street the Medinah Athletic Club (1929, now the Sheraton–Chicago Hotel) and the Tribune Tower. The Plaza in the foreground is the site of old Fort Dearborn.

(Photograph, Fred G. Korth. Courtesy Chicago Historical Society.)

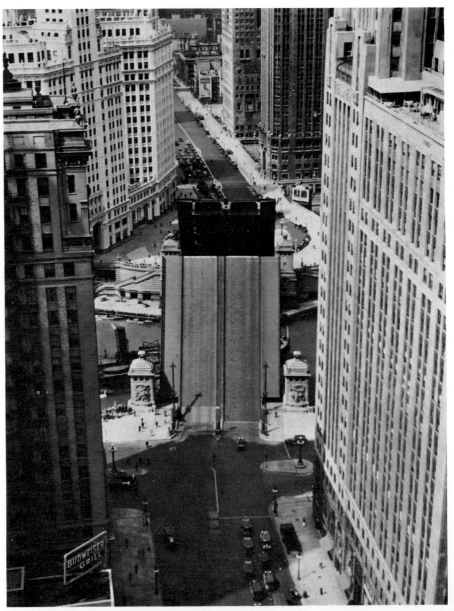

2. North on Michigan Avenue from the River, 1933

Rising above the old water tower are the taller skyscrapers built during the preceeding decade. From the Palmolive Building (now the Playboy Building) and the Allerton Hotel to the Medinah Athletic Club (now the Sheraton–Chicago Hotel) and the Wrigley Building, North Michigan Avenue had a new face.
(Courtesy Chicago Historical Society.)

Tribune Building Contest Entries

In 1922 the Tribune announced a contest for the design of its new building, and they invited architects from throughout the world to submit entries. One-hundred-eighty-nine responses were received and after much consideration the award jury agreed unanimously on first and second places.
(From *Tribune Tower Competition*, 1923.)

3. Winning Design for Tribune Building, Submitted by Howells & Hood
(From *Tribune Tower Competition*, 1923. Courtesy Chicago Tribune Company.)

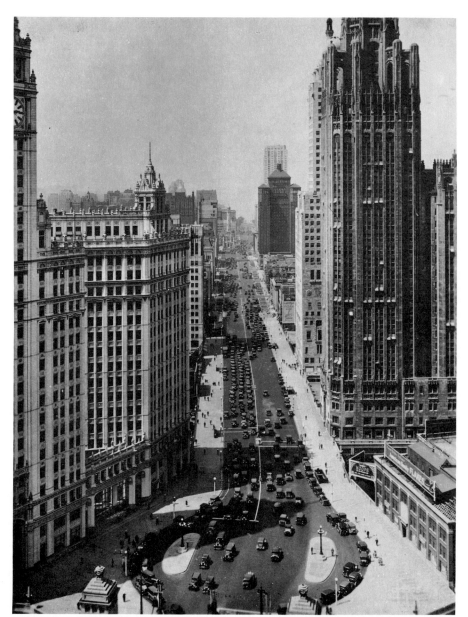

2

3

4. Jacques Building, 554 North Michigan Avenue, 1920's
Swank shops were put up along Michigan Avenue during its rejuvenation; these replaced the lofts, warehouses, and older retail stores of the previous decade. One writer commented in 1927: "scattered up and down Michigan Avenue are many exclusive shops furnished in the latest Louis XV, Spanish and Italian styles. Unlike most museums these have no admission fee; but a cover charge is added to the price of each purchase."
(Courtesy Chicago Historical Society.)

1. Second Prize Winner, Tribune Building Competition
Designers were Eliel Saarinen, Helsingfors, Finland; Dwight G. Wallace and Bertell Grenman, Chicago, Illinois.
(From *Tribune Tower Competition*, 1923. Courtesy Chicago Tribune Company.)

2. Design for Tribune Building Submitted by Walter Gropius and Adolph Meyer, Associate Architects, Weimar, Germany
(From *Tribune Tower Competition*, 1923. Courtesy Chicago Tribune Company.)

3. An Honorable Mention Design by Alfred Fellheimer and Steward Wagner, Associate Architects, New York City
(From *Tribune Tower Competition*, 1923. Courtesy Chicago Tribune Company.)

5. O'Brien Galleries, 673 North Michigan Avenue, about 1930
(Courtesy Chicago Historical Society.)

6. Captain Streeter's Shack, View West-Northwest toward the Water Tower, 1906

While sailing a small schooner he had built in 1886, George Wellington Streeter, a circus and show promoter, ran aground on a sandbar just east of the elegant mansions on North Michigan Avenue. The intrepid navigator took up residence aboard his little ship, and when the lake currents and the garbage wagons had filled in the area around his sandbar, "the Barnum of the Michigan Woods" laid claim to 168 acres. He based his right on an 1821 shoreline survey which indicated that his land was not part of the original Federal grant of land for settlement into states. Streeter soon established a "District," yielding allegiance to none but the Federal government; he built a shack to replace his rotting ship, and from an office at the Tremont House began selling lots to gullible investors. Meanwhile, the owners of the mansions to the west of him, including Potter Palmer, considered him "a rude, blasphemous, drunken thief," a squatter who had to be ousted from the land they owned by riparian rights. Court litigation, raids, forays, "events both spectacular and ludicrous" ensued, but Streeter maintained his hold until World War I, when Mayor "Big Bill" Thompson finally evicted him for selling liquor on Sundays. Streeter continued to press his claim until his death in 1921.
(Courtesy Chicago Historical Society.)

4

5

6

1. Streeterville, View Southeastward, about 1926

Conceived in its broadest sense, Streeter's claim included all the land bordered by Michigan Avenue on the west, the lake on the north and east, and the American Furniture Mart, the massive building on Lake Shore Drive, on the south. More narrowly, Streeter's shack and the land immediately around it included the Furniture Mart and the land north of it, now the site of Northwestern University's Chicago campus. Beyond the Mart is the long row of loft buildings of the North Pier Terminal Company, on the north end of Ogden Slip. Municipal Pier extends into the water at the extreme left. In the foreground is Oak Street, still the highest rental prestige block in the city, anchored to Michigan Avenue by the Drake Hotel.

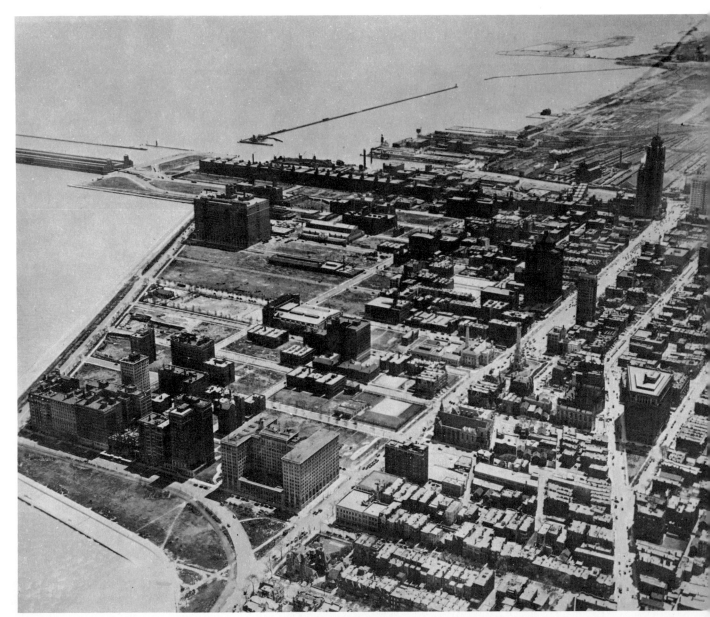

Diagonally northwest from it is the McCormick mansion, site of the present 1000 Lake Shore Plaza building. The diagonal street in the lower right is Rush Street, which had begun its development as one of the city's major concentrations of restaurants and night clubs.
(Photograph, Kaufmann and Fabry. Courtesy Chicago Historical Society.)

2

2. Lake Shore Drive, South from Oak Street, 1915

"The Drive changed so rapidly between 1910 and 1920 that it was a surprise to many a returned traveler of that time," wrote Henry Justin Smith in 1931. "Not only did it acquire the co-ops, in which many a family found a less onerous and less heavily taxed domicile than the old homestead; but the street traffic grew heavy; the honk of horns became deafening, the odor of motor exhausts more pervasive. New wealth invaded the Drive; new families mingled with the old. By 1924, or before that, people had come to see its development as resembling that of New York's upper Park Avenue, and they predicted that before long it would be a region of still more luxurious apartment structures, north of Lincoln Park." Rent for apartments along the drive by the mid-20's averaged from $6,000 to $15,000 annually. At the right is the 999 North Lake Shore Drive Building, erected in 1912 with a ten-story design by Marshall and Fox.
(Courtesy Chicago Historical Society.)

3. North Lake Shore Drive, South from East Lake Shore Drive, 1963

The rapid change which Henry Justin Smith observed in the twenties was even more apparent in the 1950's and 1960's as it was for the period when the Drive began its boom. New high-rise hotels, motor motels, and apartment buildings rose ever higher, dwarfing their older neighbors.
(Courtesy Chicago Historical Society.)

3

1, 2, 3, 4. Building the Popular Mechanics Building, April through August, 1922

Located at the northeast corner of North St. Clair and East Ontario Streets, the seven-story Popular Mechanics Building was designed by Marshall & Fox and was erected in an old established residential section in the North Side boom of the 1920's. The building's exposed framework was particularly revealing; had a glass sheath replaced the sedate brick of its exterior, it might easily have fit into the newer construction of the last two decades. (Photograph, Chicago Architectural Photographing Company. Courtesy Chicago Historical Society.)

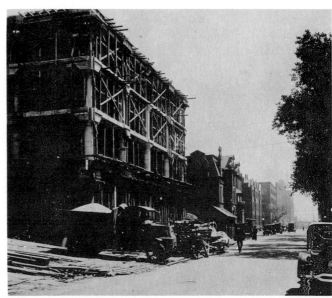

1

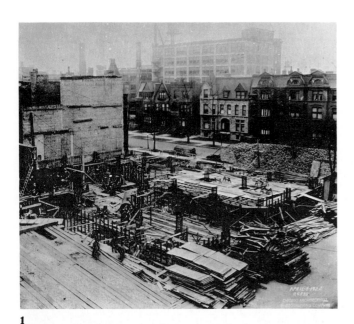

2

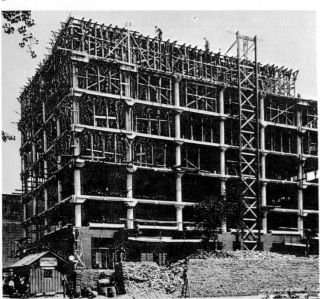

3

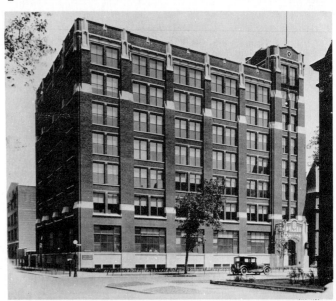

4

5. Old South Water Street, about 1910

"South Water Street today is an economic waste; a burdensome charge on all the people; a drawback to Chicago's progress; obstructive to its prosperity, and a conflagration danger to the whole Loop district," a publication urging implementation of the Chicago Plan declared. "South Water Street is a physical misfit. If left as it is, it must forever remain dwarfed, destroying its own usefulness." "Imagine a condition such as South Water Street is today, two blocks from the Grand Opera House in Paris—two blocks from Trafalgar Square in London—or next to the Waldorf-Astoria in New York. Yet South Water Street is only two blocks from the Chicago City Hall, and only a three-minute walk from the world's busiest retail shopping district."

(Wesley Bowman Studios and Robert Elmore. Courtesy Chicago Historical Society.)

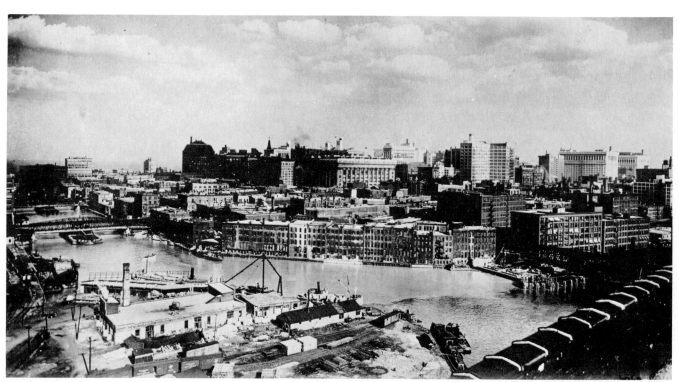

5

Wacker Improvement

1. Proposed Riverfront Improvement along South Water Street, Drawn about 1920

The architectural firm of Bennett and Parsons retouched the previous photograph to illustrate the way the new South Water Street river front would look after it had been remodeled, in line with the conditions of the Chicago Plan. A new Franklin-Orleans Bridge was called for, the river front was improved, and massive new public buildings were magically erected. Wacker Drive, named for the first chairman of the Chicago Plan Commission, was completed in the spirit of this rendering. (Wesley Bowman Studios and Robert Elmore. Courtesy Chicago Historical Society.)

of a bursting metropolis. Moreover, the increasing use of motor trucks made even its central location obsolete. Yet South Water, for all its shortcomings, had its charm. "It was a cheery, chaotic, bartering street, often utterly jammed with wagons or traders," Lloyd Lewis and Henry Justin Smith remembered. "It blocked off bridgeheads. It slowed carlines. Pedestrians squeezed between wagon-wheels, stepped over planks laid from barrels." It was "a silly old street for a great city. Yet every one half loved it; and the traders loved it devotedly."

Sentiment for the old collided with the enthusiasm and needs of the new. The *Plan of Chicago* called for monumental boulevards along both sides of the river, a dream which could not be realized as long as the market remained. As the city moved to implement the Burnham and Bennett scheme, the old occupants struggled for their historic location. "They want to stay where Nature put them, here on the old waterfront," one opponent of change contended; others raised the familiar lament: "We were here first; we belong here and have no place to go." Ultimately, 8,000 property owners received some compensation for the dislocation entailed. Within a few years, however, the value added to the land along Wacker Drive, estimated modestly at sixty-five million dollars, justified the change for most people.

The market was relocated about two miles to the southwest; and Wacker Drive, a double-decked ornamental street, was constructed along the river's edge. Newly located market facilities brought together rail and road traffic, and a series of three-story buildings provided modern installations. The completion of the new drive set off a con-

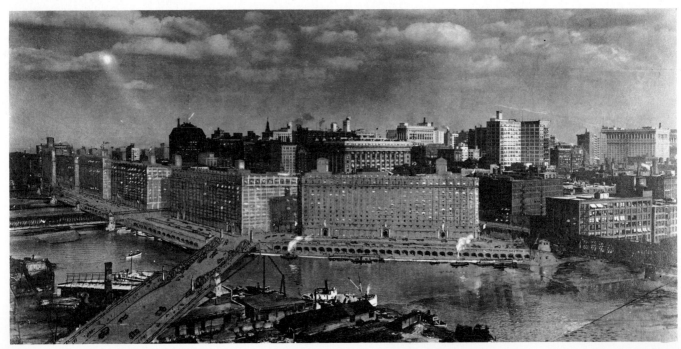

1

2. New South Water Street, 1925

Removal of the produce market to its present location two miles from the center of the city eliminated sixteen per cent of the 150,000 daily vehicle trips into the loop. But only a few decades later the aging market was again slated for replacement. Obsolete design, congestion, and inadequate street access, as well as changes in methods of food distribution, made a more modern food center necessary, and by 1968 several alternative sites were under study.
(Photograph, Kaufmann and Fabry. Courtesy Chicago and Eastern Illinois Railroad.)

3. Wacker Drive between Michigan and Wabash Avenues, 1929

The original portion of Wacker Drive was completed by 1926, a physical testimony to men who pushed for it. "Its very location has destined it to be a modern, high-class business thoroughfare, the second finest in Chicago, and the logical northern boundary of the loop district," one publication stated in the early 1920's. "It is a two-level street," a Chicago school textbook added in 1930. "The upper one is 110 feet wide and is for general traffic. The lower is 135 feet wide and is used by heavy commercial traffic. This level connects the warehouses and the industrial and terminal district on the west side with the boat and rail terminals and the industrial district east of Michigan Avenue. It emerges into the normal level of Market Street between Randolph and Lake streets." By 1929 modern buildings had already broken the skyline along the drive, most notably the 75 East Wacker Drive building (formerly Mather Tower).
(Courtesy Chicago Historical Society.)

2

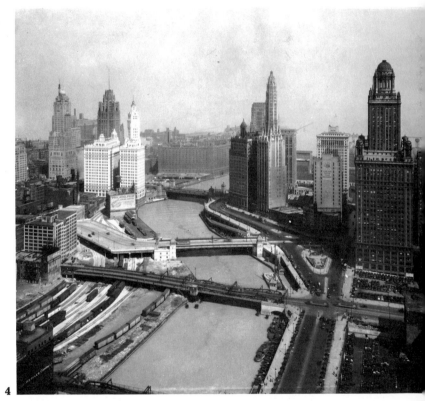

4

3

4. View Eastward toward Wacker Drive and Michigan Avenue, 1931

Samuel Merwin, writing in 1929, expressed a common opinion when he wrote of Wacker Drive: "This drive is, flatly, a new concept. For nearly a mile along the southerly bank of the many-times manhandled little river it curves its unbelievably lovely way, widening here and there into broader areas of pavement, edged with massive stone parapets. The South Water Street of my youth, where one picked his muddy way between crowding market wagons, has vanished. All the old brick buildings where the market men and the commission men once held forth have gone. . . . They hadn't let anything stand in the way of Charles H. Wacker's dream." Amid all the improvements, the problem of the river remained: with the expansion of the Near North Side, traffic movements across the three bridges—at State, Wabash, and Michigan—increased proportionately. A traffic study completed in June of 1926 recorded 35,351 bridge openings during the previous twelve-month period. Each of these openings meant an average delay of a little over three minutes.
(Photograph, Kaufmann and Fabry. Courtesy Chicago Historical Society.)

Wacker Improvement

1. Charles H. Wacker (1856–1929)

The youngest director of the Exposition of 1893, "first a brewer, then a building-association man, wealthy but not too much so, loyal to German musical affairs, mixer in different sets, supporter of various things like the Symphony Orchestra and the United Charities," Democrat Wacker was appointed by Republican Mayor Fred A. Busse as chairman of the Chicago Plan Commission. With this job fell to him the responsibility for winning practical acceptance of the Plan. With the help of other civic leaders, Wacker saturated the city with pleas for adoption of the Plan. Newspaper articles, a booklet mailed to voters, a textbook for school children, stereoptican lectures to civic groups, and a two reel movie playing at Chicago theaters were among Wacker's methods. Out of them grew massive public support for the plan, a fact reflected in the citizens' voting for large expenditures and higher taxes as they were required.
(Courtesy Chicago Historical Society.)

1

struction boom in high-rise office buildings bordering the river. The Civic Opera Building soon rose to dominate the western business district. Standing as high as the Washington Monument, this armchair shaped structure contained a 3,700-seat opera house as well as forty floors of office space. It was quickly dubbed "Insull's throne" in recognition of the role played by the utility tycoon, Samuel Insull, who conceived and financed the enterprise. Across the river, Chicago claimed the largest building ever erected by man in the Merchandise Mart, with its four million square feet of floor space, constructed on air-rights over the Chicago and North Western Railway.

The *Plan of Chicago* also called for the development of the Near West Side through three projects—a modern railroad terminal, a new post office, and the straightening of an awkward bend in the South Branch of the river. The Union Station was completed first. Though constructed by a group of railroads, it represented the creative cooperation among public and private interests. The city was anxious to unlock the congestion surrounding the maze of grade crossings near the business district, and the companies wanted improved facilities. A series of streets and viaducts constructed concurrently with the passenger station eased the traffic flow.

The Union Station complex was one of the crowning achievements of the twenties. It was the "largest, finest and

2. Civic Opera Building (Now the Kemper Insurance Building), 1930

The Civic Opera fronted at 20 North Wacker Drive, between Washington and Madison streets. Its forty-five story design was done by Graham, Anderson, Probst and White, following ideas used by Adler and Sullivan in the Auditorium in order to attain acoustical perfection. It was completed in 1929.
(Courtesy George Krambles Collection.)

3. Merchandise Mart, Looking Northward, 1936

The twenty-four story Merchandise Mart occupies the entire block bounded by North Wells, West Kinzie, North Orleans, and the Chicago River. Erected in 1929, it occupies the former site of the North Western station and is built on air-rights over the railroad; before that, a Wolf Point tavern occupied a small part of the land space in 1830. When completed, the Mart was the world's largest building, nearly twice the size of its nearest competitor. The design was by Graham, Anderson, Probst and White. (Courtesy Chicago Historical Society.)

4. The Widened North LaSalle Street, 1936

The widening of North LaSalle Street was associated with the Wacker Drive Project in the Chicago Plan of 1909. By 1929 the widening was completed, as was the construction of a double-leaf bascule bridge to carry the street across the river, thus providing another access to and from the Loop. As the widening was begun, hundreds of building facades were removed along North LaSalle. The depression and then the war prevented reconstruction of the torn-out facades. Consequently it is still possible to see the ugly, exposed inner walls of buildings along the new traffic artery.
(Retouched newspaper photograph. Courtesy Chicago Historical Society.)

3

4

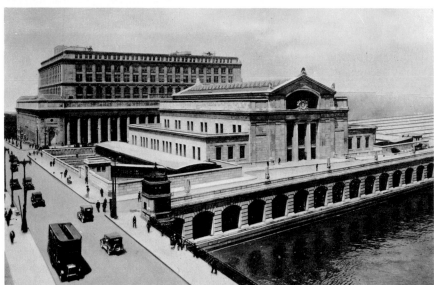

5

5. Union Station, Mid-1920's

Completed in 1924, Union Station was designed by Graham, Burnham & Company and was sited on the spot selected for a union terminal in the Chicago Plan—the block bounded by Jackson Boulevard, Adams Street, Canal Street, and Clinton Street.
(Retouched photograph. Courtesy The Penn-Central Railroad.)

Wacker Improvement

1. Chicago Post Office, 1932 or 1933
The postal facility was originally constructed to take advantage of a close location to Union Station. It also became the focus of a group of functionally related buildings—the Federal Custom House and the Post Office Garage southwest of the central business district.
(Courtesy Chicago Historical Society.)

2. Chicago Daily News Building (Now Riverside Plaza Building), 1960's
The former Chicago Daily News Building was the first commercial structure erected on air rights over the Union Station tracks. It faces the river between Madison and Washington streets. Constructed in 1929, its twenty-six story design by Holabird & Roche included a system by which smoke from the steam locomotives in the station was carried up through the building and emitted through a roof stack.
(Courtesy Turner, Bailey, & Zoll, Inc.)

most modern railway station in the world," the *Chicagoan* crowed. It cost sixty-five million dollars, and its train sheds and tracks covered six square blocks. "Three hundred trains arrive and depart daily. Sixty-six thousand passengers pass through the huge structure every day in the year," the magazine continued. "Two thousand tons of mail are handled in it every twenty four hours." Moreover, this was done without "noise, hurry, or excitement" in doing the job, for the new edifice breathed "a somber dignity" that reminded the author of a bank or "the quiet charm . . . of the lobby of a high class hotel." Even the cuspidors and no spitting signs, the hallmarks of other stations, were missing because "spitters are impressed by the sheer elegance of their environment."

The other West Side projects took a little longer. The Post Office was not completed until 1932, but it was also built to the new Chicago scale. The largest mail transfer facility in the world,

it covered the Union Station tracks for two blocks. Not only did this location speed postal handling, but its roof was later used for helicopter service, a recognition of the growing importance of air transportation. More foresighted still, an opening was left in the building to provide room for a highway; in 1956 the Eisenhower Expressway was opened through this route, which originally appeared on the *Plan of Chicago* as a carriage road.

The most engaging idea for the area was a plan for straightening a clumsy bend in the South Branch of the river between Twelfth and Eighteenth Streets which impeded navigation and complicated land traffic. Although the new channel was cut in time to welcome the first barge through the new Lakes-to-Gulf Waterway in 1933, the larger development was not a success. The city did not build a new set of east-west streets; nor did the railroads east of the river relocate old tracks or facilities.

Many of the arterial streets, especially along the section lines, could no longer carry the increased streetcar and automobile traffic and at the same time provide parking for abutting business establishments. In the post-war decade, the voters consistently supported bond issues which furnished funds for street widening throughout the city. The result greatly increased traffic capacity, which served Chicago until the age of expressways.

The Plan's boulevard for the southern end of the business district also required drastic surgery. Here the widening of Twelfth Street (now Roosevelt Road) required demolition of rows of old buildings for the new thoroughfare. In fact, it had begun in 1916 and was completed in short order, including a bridge across the new channel, but not before the customary resistance and the inevitable resort to the courts by aggrieved property owners delayed wrecking and construction crews.

3. Air View Northward from about Eighteenth Street, about 1926

This photo was taken with the river straightening nearly completed. Because of the meander in the river, only three streets connect the Loop with the South Side: Michigan Avenue, Wabash Avenue, and State Street. Clark Street (right center of the picture), was congested by heavy truck traffic and was ineffective as a major traffic artery. While the straightening did open up another traffic artery, railroad track patterns remained little changed. Once the old channel was filled, the area on the east side of the straightened stream became a pocket of "dead land" with no development until very recently.
(Photograph, Kaufmann and Fabry. Courtesy Chicago Historical Society.)

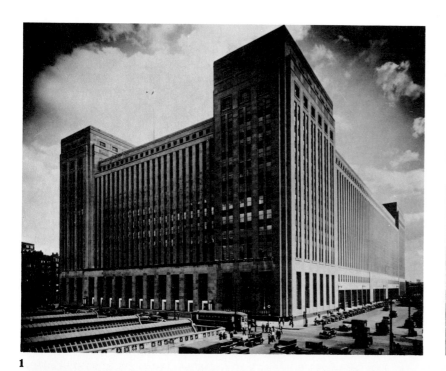

1

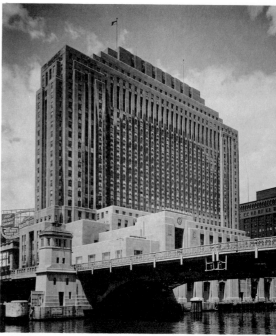

2

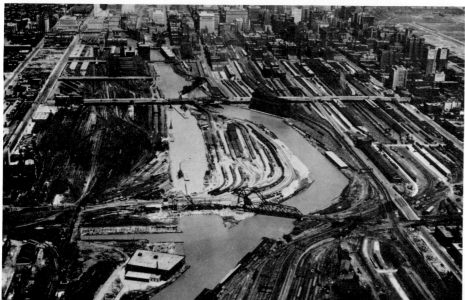

3

316

1. View South-Southwest over Twelfth Street (Roosevelt Road) between Damen and Hoyne, 1934

In the distance is the twin-spired St. Paul's Church, at the southwest corner of 22d Street (Cermak Road) and Hoyne Avenue. Beyond is the International Harvester plant, located on the north side of the east end of the Chicago Sanitary and Ship Canal. This area, near some of the city's heavy industries, has housed low income and working class families since its inception.
(Courtesy Chicago Historical Society.)

2. East across the Elevated Railway Tracks, on the North Side

Harvey Zorbaugh had aptly characterized this section as "The Gold Coast and the Slum." In the distance along the lake front are high-rise apartment buildings, many built in the boom twenties. Between their high-value land and the railroad huddled single frames, flats, and three- and four-story apartments, most built years before.
(Courtesy Gordon Coster Collection.)

The improvement of Chicago's central area reflected the demands of an extraordinary growth in the metropolitan population. In the city alone it increased by twenty-five per cent during the twenties. In the six counties of the metropolitan area, the rate was thirty-three per cent, bringing the total to 4,675,000 in 1930. Suburban Chicago exceeded even this rate, the increase running over fifty-eight per cent. These new residents constituted the very substantial base for the building boom and general prosperity of the city for the years before the crash of 1929.

Not every part of Chicago shared this growth, however. The older residential areas within four miles of State and Madison actually lost 150,000 persons. These neighborhoods witnessed virtually no new building; increasingly they showed up as "blighted areas" in city maps. The houses averaged well over forty years old; the residents were lowest on the economic and social scale, and delinquency, vice, and crime thrived.

Yet some places near the center of the city prospered. Along the improved lake front, especially at Jackson and Lincoln parks and along the Near North Side's Gold Coast new luxury apartments became fashionable. The new "Home Suite Home," as Ruth and Lewis Bergman called them, was the cooperative, ranging from six to twenty stories, in the high-rises along the lake. There had been a few before the war, but in the twenties they became popular with

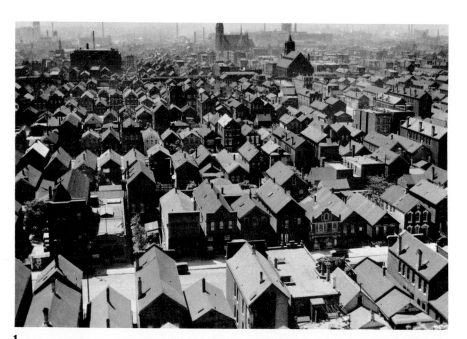
1

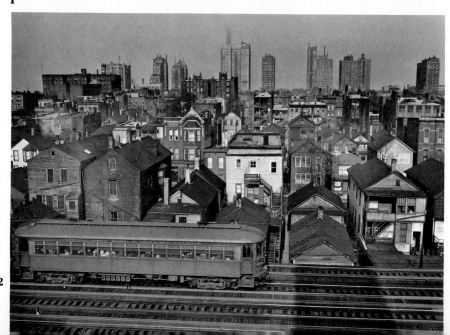
2

3. 2340–44 Wabash, June 26, 1916

The deterioration of older housing was not something new to the City of Chicago. Already in 1916, the area just a few blocks west of the lake was deteriorated to the point where it was no longer saleable. Close to street car lines, near Michigan and Prairie avenues, this block grew up as part of the South Side's early development. It was soon to be torn down and replaced by an industrial structure, an early example of "urban renewal" without public financing.
(Courtesy Chicago Historical Society.)

4. Fry Street East from Elston, October, 1930

Located a few blocks north of the Goose Island industries and the North Western railroad, this Northwest Side area was fully filled by 1900. It had, in fact, been losing population since 1910.
(Photograph, George T. Hillman. Courtesy Chicago Historical Society.)

5. 6733 Prairie, January 26, 1922

This two-family frame house was located only a block south of the New York Central–Pennsylvania Railroad yards.

Several two-family buildings were intermixed with the small single family dwellings along this block.
(Courtesy Chicago Historical Society.)

6. 5003 Shields Street, 1915–20

These brick two-family homes were located across the street east of the Pennsylvania Railroad yards in the narrow corridor between the Pennsylvania and the Rock Island and New York Central (Penn-Central) railroads.
(Courtesy Chicago Historical Society.)

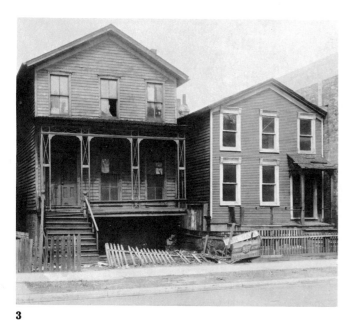

3

4

5

6

3. Storage Lot Adjacent to Albert Dickinson Feed and Seed Company, 2750 West Thirty-Fifth Street, 1935

Abutting the old Illinois and Michigan Canal property and its neighboring railroads, this row of junk cars and airplanes rested on a vacant lot in 1935. Like their heirs of later years, the first generation of the twentieth century cast off their outdated implements of mobility; buggies, horseless carriages, and even an early airplane made up this interesting collection of innovations from an earlier era. The old airplane probably belonged to Charles Dickinson, whose interest in airplanes dated back to the experimental stage and who became president of the Aero Club of Illinois in 1914.
(Courtesy Chicago Historical Society.)

1. 4743 North Paulina, 1921

This elegant old house with its many shade trees had been erected during the previous century. As the city moved out to encompass it and its neighbors, many were converted into flats or replaced by apartments. By 1939 all but a few of the houses on this block were occupied by more than one family.
(Courtesy Chicago Historical Society.)

2. Houseboats on the North Branch of the Chicago River, 1927

The "prosperous twenties" did not reach all Chicagoans, as this makeshift housing clearly indicates. Among the forgotten were squatters in houseboats on the North Branch of the Chicago River. This newspaper photograph was part of a city campaign to force the houseboaters to find a new location.
(Courtesy Chicago Historical Society.)

1

2

3

Coster's Chicago

Gordon Coster is among Chicago's leading photographers. Since 1930, he has uniquely caught the changing face of the city's neighborhoods and downtown skylines. Here is some authentic Coster. Two photographs (nos. 1 and 2) study the contrast between two North Side neighborhoods only a few blocks apart. The others portray life in the famous "back of the yards" area (nos. 3 and 4, this page; no. 1, p. 320) and in a South Side slum (nos. 2,3,4, and 5, pp. 320-21). On other pages (383-84) he documents the dramatic change of the ghetto under the impact of urban renewal.
(Courtesy Gordon Coster Collection.)

1

2

3

4

Coster's Chicago

Neighborhood Shots
(Courtesy Gordon Coster Collection.)

1

3

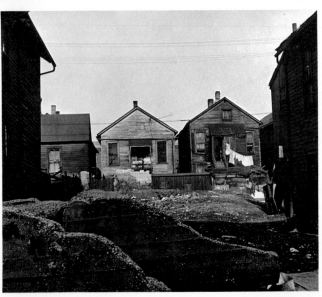

2

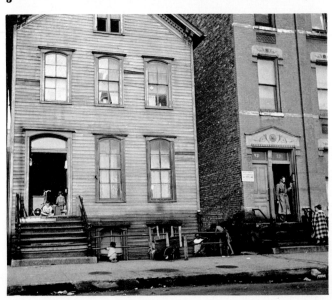

4

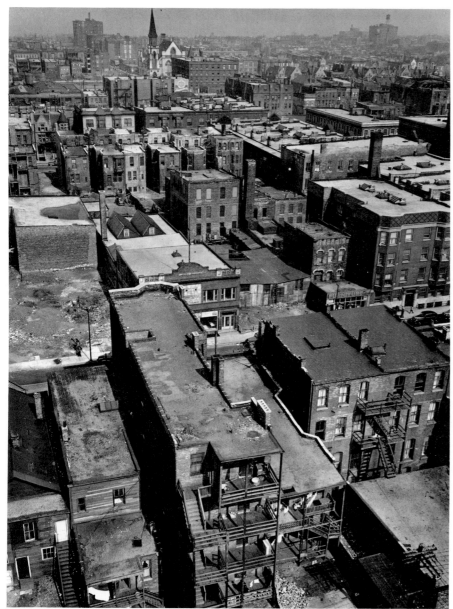

1. Advertisement for 1540 North Lake Shore Drive, 1928

This ad from Baird and Warner's "A Portfolio of Fine Apartments," published in 1929, conveys the appeal of the "apartment boom" of the decade. Confined largely to the well-to-do, it held out the promise of the elegance and space of the old single-family mansion in the new apartment environment.

"Until you enter the lofty panelled lobby of '1500,' " one notice asserted, "you can form no idea of the charm with which the 'grand manner' of older days has been recreated in a modern, efficient cooperative apartment structure.

"The dignified porte-cochere accommodates six or eight limousines at one time—ample for any theatre party you may give. The living and dining rooms are wide and spacious in their hospitality. Owners' bed chambers and guest chambers are delightfully roomy, the clothes closets, even, are rooms in themselves."
(Courtesy Chicago Historical Society.)

the wealthy who had once lived on "The Avenues" or on Lake Shore Drive. An advertisement for 999 Lake Shore Drive summed up the appeal. "A permanent home in one of the finest steel frame, fire proof buildings on the Gold Coast at a cost of about one-half of the present rental value is assured the far-sighted individual who co-operates in purchasing this wonderful ten-story building on the 100% co-operative plan The location is the most desirable site in Chicago, being at the outer bend of Lake Shore Drive and commanding a beautiful view of the lake and shoreline, which will be a constant pleasure to you and will provoke the admiration of all your friends."

The co-ops came in a variety of sizes, "anything from a combination living room–bedroom to a unit, including a two story living room, library, kitchen, dining-room and an assortment of bedrooms and dressing rooms," the *Chicagoan* observed in 1927. And some were designed for sumptuous living. At 1500 Lake Shore Drive, William Wrigley had a twenty-two room duplex and George Wood occupied the roof complex which included thirty rooms and a spacious garden. But the "first consideration" was "a site in a neighborhood of established desirability . . . with access to good transportation, schools, churches and shops." Also important, the same author asserted, was that "desirable neighbors are guaranteed under the terms of the co-operative contract which provides that no one may buy or rent in the building

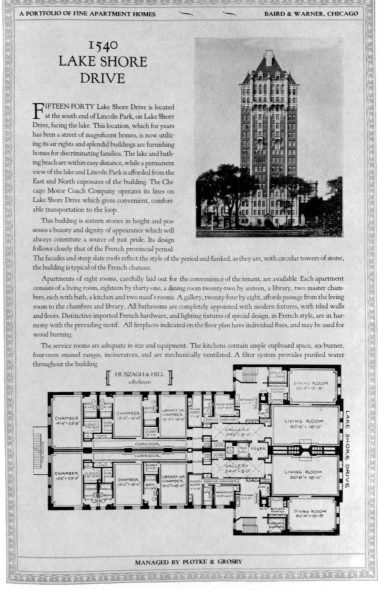

2. North Lake Shore Drive, Northward across Bellevue Place, 1928

"Despite the continued popularity of suburban life, a large class of city dwellers entertain residential ambitions," an editorial in the *Chicagoan* stated in 1929. "They hope to live within walking distance of their downtown offices." The "apartment boom" of the twenties was clear evidence of the same preference which would lead to the "high-rise mania" of the 1960's.
(Courtesy Chicago Historical Society.)

3. Southmoor Apartments, Northwest Corner of Sixty-Seventh Street and Stony Island Avenue, Woodlawn

Located across from Jackson Park, the Southmoor was opened in 1924. On its ground floor facing both 67th Street and Stony Island Avenue were several small shops, which catered not only to hotel residents but to other patrons as well.
(Courtesy Chicago Historical Society.)

4. Hyde Park Hotel, South Side of Fifty-First between Harper and Lake Park Avenue, 1928–30

Designed by Theodore Starrett, a structural engineer, the Hyde Park Hotel was erected during 1887–88; the detached addition was added in 1891. The block-long hotel made use of an inner court to provide light in the inner rooms. Its 300 rooms were arranged into two- and five-room apartments. The Hyde Park stood until 1963, as a reminder of the better, older architecture.
(Courtesy Chicago Historical Society.)

2

3

4

1. 744 Rush Street, 1928
This single residence with its bay windows was built in 1878, on the Near North Side. The expanding needs of the business district came ever closer, and finally in 1928 it was demolished to make way for a commercial structure.
(Courtesy Chicago Historical Society.)

2. 33 South Aberdeen Street, about 1936
Reflections of an earlier apartment house era are seen in this photograph on Chicago's Near West Side (1100 W.).
(Courtesy Chicago Historical Society.)

3. Apartment Houses Built in the 1920's, Ridgeland Avenue, North from Seventy-Ninth, 1934
Located at the southernmost edge of the South Shore neighborhood, less than ten per cent of the buildings along these two blocks had existed before 1920. However, by the time this photograph was taken, every lot had been built upon.
(Lillian M. Campbell Memorial Collection. Courtesy West Side Historical Society, Legler Branch Library.)

without the approval of owners." In addition, many had dining rooms and swimming pools and other facilities which encouraged an enlarged social life among the tenants.

Apartment dwelling, of course, was not confined to the high-priced co-operatives. All across the city the trend ran in the same direction. Three-quarters of the building permits in a three-year period during the twenties were for apartments rather than for single family houses. In fact, the Chicago Zoning Commission reported that more than twice as many Chicagoans lived in apartments as in conventional homes. "A city without apartments," the Bergmans wrote, "is as unimaginable as one without paved streets."

The apartment boom also included smaller units and people with more modest incomes. Some of these were like the old three-story, six-family flats which characterized earlier Chicago housing; others were more elaborate, built around a court or corridor and containing forty-two apartments. But most fell in an intermediate category, with twelve, eighteen, twenty-four, or thirty-six units. These structures had no elevators, doormen, or similar amenities, their popularity resting on lower rents and modern comfort. In the twenties they sprang up in the areas encircling the old settled areas of the city and in vacant prairie lands between outlying railroad communities.

Beyond the apartment belts, cheaper

1

2

4. Wilson Avenue East to Sheridan Road, 1927

Virtually all of the buildings in this photograph were built before 1920. The Uptown community, as this area has been designated, had gained from the northern extension of the elevated line to Wilson Avenue by 1900. Over the next two decades, it became one of the most important outlying commercial centers in the city, a significance which it maintained until the 1960's. While a few hotels and high-rise apartments dominated the skyline, especially around the Wilson Avenue-Sheridan Road intersection in the center of the photograph, the predominant type of structure is the three-story apartment building with its multiple variations. The whole area showed only a mild population increase between 1920 and 1950; after that it began to decrease. Wilson Avenue is the east-west street bisecting the picture from top to bottom; the diagonal artery is Broadway. (Courtesy Chicago Historical Society.)

5. Wilson Avenue West to the Elevated Tracks, 1928–30

"A city within a city," was the way a writer in the *Chicagoan* described Wilson Avenue in July, 1927. "The heart, liver and lungs of uptown Chicago. . . . Hotels, skyscraping apartments of the kitchenette variety, big movie palaces, banks, department stores, specialty shops, big dance halls, a bathing beach, streets filled with motor cars, sidewalks crowded with eager eyed youth. . . . Drugless drugstores on every corner, cafeterias half a block long, a lonely looking church, noisy radio shops. . . . A wide open gambling house well patronized. . . . Tea rooms with funny names. . . . A Greek restaurant. . . . Chop Suey restaurants in profusion. . . . A dance hall with an illuminated mirror floor, 'just like Paris'. . . . Delicatessen stores by the score. . . . Boys and girls who live in hall bedrooms and spend most of their money for clothes. . . . Married couples who live in kitchenette apartments with hideaway bed and sink. . . . The Uptown Railroad station. . . . Old men sitting on benches and talking like small town men at the corner grocery. . . . Orange juice stands with fantastic fronts. . . . A shoe shining parlor with a Victrola where the boys sing jazz songs as they work. Wilson Avenue lives like every day may be the last." (Courtesy Chicago Historical Society.)

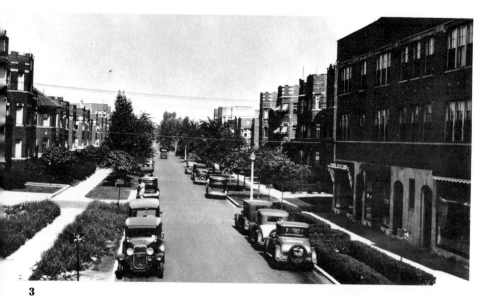

3

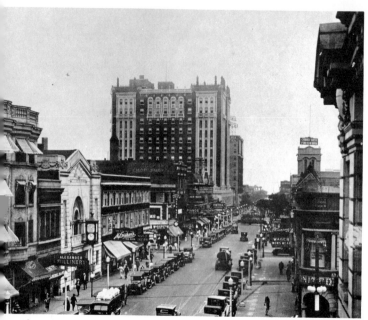

4

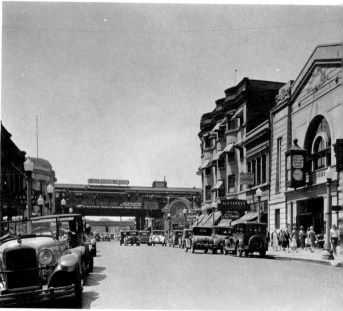

5

1. 8818 South Wabash Avenue, 1940
This photograph shows one block of the "Garden Homes," a 175-unit development done as a combination business and philanthropic venture by Benjamin J. Rosenthal. Started in 1919, Rosenthal's idea was to build homes for the working class at a price they could afford. Working through the Chicago Dwellings Association, which he was responsible for founding, Rosenthal hired Architect Charles Frost to design the 133 detached bungalows and twenty-one duplexes which made up the project. Seven different exterior designs were developed to prevent "sameness of appearance," but they really were much the same: all were five rooms, and all had the same interior arrangements. The houses were placed on lots large by Chicago standards: all were thirty feet wide, thirty-five were 200 feet deep and 140 were 162.5 feet deep. The depth was made to encourage gardening, and to allow landscaping, included in the design.

lands fell to single-family bungalows. Though construction was not on the scale of the flat buildings, over one-hundred-thousand detached homes went up in a decade. And at the outer edges of the city, subdivision took place, bringing into development many of the remaining vacant areas within the city limits. Transit facilities reached out into the new neighborhoods, tying them to the established life of the city.

Urban expansion in the twenties did not stop at the municipal boundaries. Indeed, the suburbs felt it even more dramatically, for they grew more rapidly than even the outlying areas of the city. Not only did old, established places prosper, but new ones rose out of vacant prairies. Some of this development stemmed from traditional factors: Chicago was filling up, more people had acquired the wealth that suburban living required, and some of the railroads, such as the Illinois Central, which electrified its suburban service in 1926, improved their commuter operations to downtown. Without any additional stimulus the outer metropolitan communities would have shared the growth of the decade.

The automobile, however, upset mere conventional expectation. It created a whole new suburban world. It now became possible to build homes miles away from suburban railway stations and still be able to work downtown. Previously the population had to cluster around rail transport. The new conveyance broke

1

2

2. Northwest Side Development
This post card photograph shows two houses erected on the Northwest Side in the early 1920's. Single-family bungalows, the houses were put up in a mass production fashion, using only two or three basic designs.
(Courtesy Chicago Historical Society.)

Materials were purchased below cost and eventually the price for the detached homes was $5,700. Unfortunately, the project did not make money and turnover was high; and since it was so far outside the settled area, it did not attract enough people to keep the homes filled. It was not until after World War II that the area around "Garden Homes" was built up.
(Courtesy the Estate of Benjamin J. Rosenthal.)

3, 4. House on 4900 block of Kinzie Avenue, between Cicero and Lamon, in Eastern Austin

Amid the movement and change so characteristic of Chicago, it is unusual to find as stable a situation as that illustrated in these two pictures. This house was built in 1875, just three blocks from the Fortieth Avenue shops and yards of the Chicago and North Western Railway. By 1936, when the second photograph was taken, much of the area around the old house was built up, but members of the same family which had occupied the house in 1888 (when the first photograph was taken) occupied it in 1936.
(Courtesy West Side Historical Society, Legler Branch Library.)

3

4

5

5. Subdivision at Seventy-Ninth and Western Avenue, View Northeast, October, 1926

In many ways this photograph of a portion of southwestern Chicago capsulates the story of Chicago's growth at its outer edges in the 1920's. In that boom decade, developers bought open land, laid out streets and basic utilities, and began building. Farm land and farmsteads gave way to sidewalks and three- and four-story apartment structures. Unfortunately for the developers of this section, they over-reacted to the movement into this area. It was not until after World War II that this "dead land" filled up.
(Photograph Kaufmann and Fabry. Courtesy Chicago Historical Society.)

1. Intensity of Residential Land Use in Chicago
(From *Chicago Land Use Survey*, 1942.)

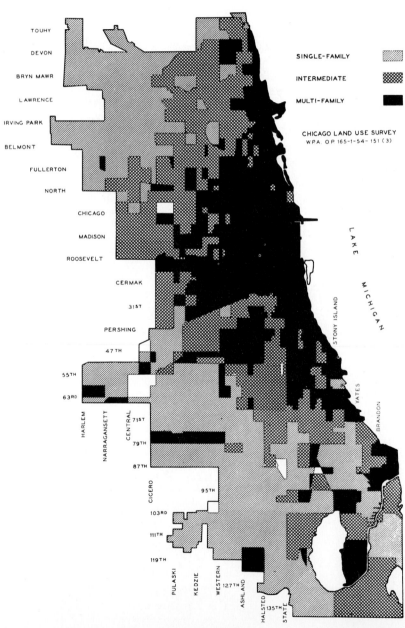

SINGLE-FAMILY

INTERMEDIATE

MULTI-FAMILY

CHICAGO LAND USE SURVEY
W.P.A. O P 165-1-54- 151 (3)

2. Vacant Land in the City of Chicago, 1940

(From *Master Plan of Residential Land Use of Chicago*, 1942.)

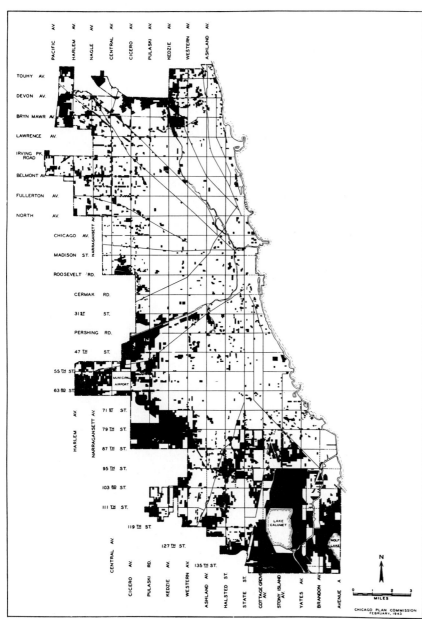

1. Garage and Taxi Station, 3208–12 Sheffield, March, 1916
(Courtesy Chicago Historical Society.)

2. Demonstration of a New Traffic Signal, August 25, 1922
By 1926, 316 intersections were under the control of signal lights, and plans were under way to phase traffic into waves of movement for long stretches by proper timing of lights.
(Courtesy Chicago Historical Society.)

3. Southeast Corner of Dearborn and Washington Streets, September 10, 1924
This *Herald Examiner* photograph shows a driver being detained after he had sped through an intersection, skidded on wet pavement, and hit the rear of another car. Action was then pending before the city council to reduce the speed limits at intersections.
(Courtesy Chicago Historical Society.)

that historic dependency. Its greater flexibility meant that people could live wherever the roads would go. Thus, immense areas of land were opened to settlement; and the space between the railroads radiating out from the city began to fill in. The full implications of the revolution wrought by the automobile would not be apparent until after World War II, but suburban growth in the twenties provided more than a hint.

Suburban changes could be seen everywhere. On the West Side, the small communities suddenly burgeoned. Cicero, which numbered 16,000 inhabitants at the beginning of the century, had 66,000 by 1930. In the process, it lost much of its old suburban flavor as industries, such as the mammoth Hawthorne plant of Western Electric Company, located and expanded there. Just beyond, Berwyn witnessed a similar growth, "a lusty young city which builds whole new blocks overnight," the *Chicagoan* noted in 1928. It had only 14,000 residents in 1920; ten years later the census counted over 47,000. A large portion of the newcomers were first- and second-generation Poles and Bohemians seeking more room than they had in the city.

Farther to the west, the swank older suburb of Riverside was transformed by the new pressures. For years it was somewhat remote from Chicago, a village of winding roads and lovely parks inhabited by a small number of well-to-do

1

2

4. West on Madison Street, between Wells and Franklin, Probably Late 1927

"Parked cars cut the street widths in two, slow up all traffic, strangle business and delay everyone, while only a few car owners are benefited," Superintendent of Police Morgan A. Collins declared in 1926. The problem was one of numbers: in 1910, Chicago had only 12,000 automobiles and only 71,000 vehicles of all kinds; in 1926, the city contained 341,000 automobiles and 18,000 motor vehicles of other kinds. A parking ban was put into effect on downtown streets in January, 1928. The ban led one humorist to consider patenting a new invention, "a set of grappling hooks attached to a heavy chain. Take these hooks and fasten them securely to the fenders of your car," he instructed. "The chain . . . is connected to a patented pulley which you attach to any convenient L structure. One-man power is sufficient to hoist your car and you can leave the car suspended thus as long as you please. Another advantage is that no cop can reach the tin he loves to touch to put a ticket on it."
(Courtesy Chicago Historical Society.)

5. Filling Station Open at Night, July 9, 1927

By the mid-twenties, over 1,500 garages, agencies, grease stations, battery stations, service stations, parts and accessories establishments, and distributers operated in Chicago. An observer attested to the automobile's popularity in another way in 1926 when he wrote wryly: "In eight months, in Chicago, three thousand automobiles were stolen. Such a fact gives one an idea of the magnitude of the commercial activities of that city."
(Courtesy Chicago Historical Society.)

3

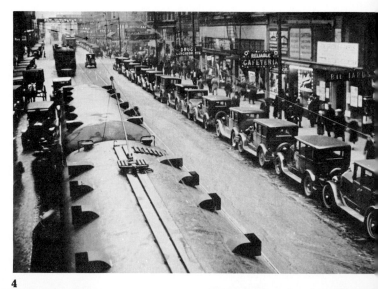

4

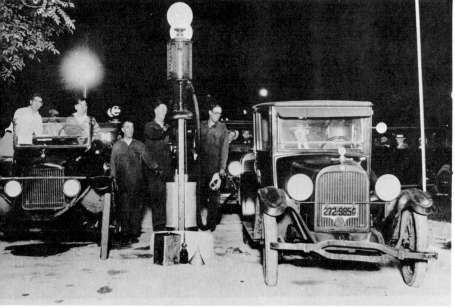

5

6. Suburban Service Station at Ogden Avenue and LaGrange Road, 1935

As the automobile grew more popular, with ownership increasing even during the depression years of the thirties, the service station became a broader operation. No longer were various functions separated, and the filling station instead became a one-step service facility for the family car.
(Courtesy Standard Oil Company [Indiana].)

332

The 1926 traffic study recommended that private businessmen begin building off-street parking facilities in the Loop. This elevator parking lot was one response to the need for more parking space. However, it proved too slow in operation, especially during rush hours.
(Courtesy Chicago Historical Society.)

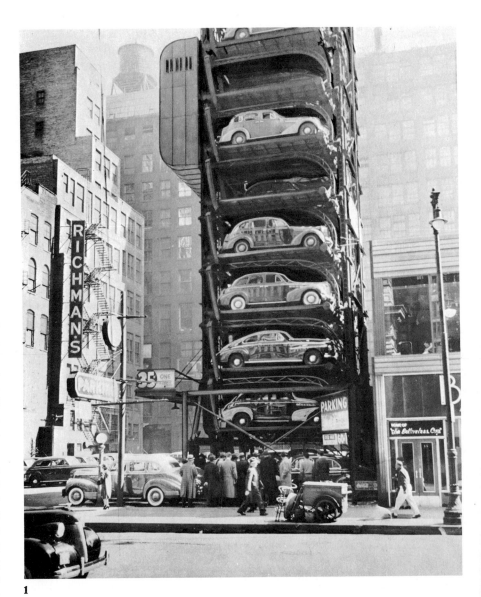

residents of old stock. A native observed the changes brought by the twenties: "From Cicero, Berwyn and the great West Side came the Bohemians and the Poles and other non-Anglo-Saxon Americans. They are good thrifty citizens, mostly wealthy enough to build good homes and keep up a front in Riverside, but not after all, according to the Old Timers, filled with 'the Riverside Tradition.' " Moreover, "modern apartment buildings crowd in and shadow the great twelve-room frame houses of the eighties." Over the bitter protest that "those who live in Riverside know where everyone lives, anyhow, and the others we don't care about," the streets were marked and residences numbered for the first time. The old Riverside Hotel, once described as "a sumptuous palace, on the lovely, gondola-laden Des Plaines," wasted away. Metropolitan expansion had reached an old suburban outpost. In spite of these pressures, the old core of Riverside, platted by Olmsted in 1869, retained much of its charm and character.

A few places were still able to remain beyond the outward thrust of urban development. Hinsdale, for example, beyond Riverside and situated astride the Cook–DuPage County line, was able to keep the old detachment. It had not a single apartment house, and its zoning and planning were designed to keep the village, in the words of an official, "sensible and dignified." It attracted not only the wealthy and successful but young

1

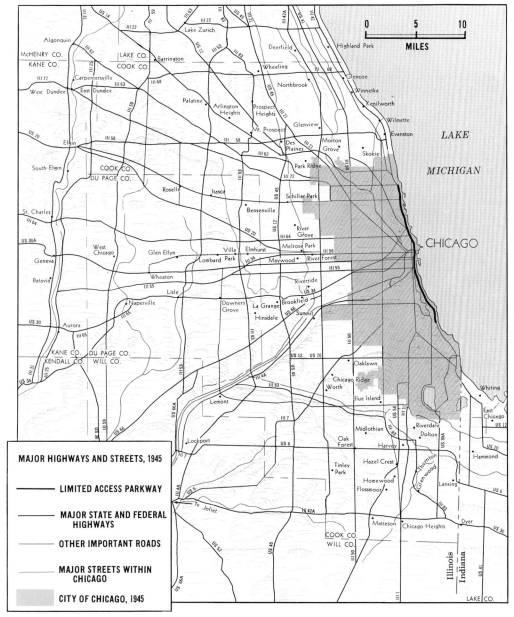

MAJOR HIGHWAYS AND STREETS, 1945

——— LIMITED ACCESS PARKWAY

——— MAJOR STATE AND FEDERAL
HIGHWAYS

——— OTHER IMPORTANT ROADS

——— MAJOR STREETS WITHIN
CHICAGO

CITY OF CHICAGO, 1945

1. Automobiles at Diamond Lake, Mundelein, 1930

The automobile brought a new freedom to the metropolitan resident. On weekends and holidays, urban families could drive to the many lakes and forest preserves in the vicinity of Chicago. "Automobiling" became the new craze, and new types of recreation facilities grew up to take advantage of the increased mobility. (Courtesy Chicago Historical Society.)

2. Automobiles in Cook County Forest Preserve, East of Wheeling, 1923

The Chicago Plan Commission, together with the Chicago Regional Planning Association, worked to build up "a green border of forest preserves about Cook County" and laid out "new highways through and about them." Summarizing their development in 1929 one observer wrote: "The present extent of the forests is about 35,000 acres, and it is growing. The forests are designed neither for show nor for tree cultivation as such, but for

couples with the proper background, "fine girls who attended Wellesley, Smith and Vassar" who "married the right sort of man," one matron explained to a contributor to the *Chicagoan*. To be sure, it was expensive, but she observed "they can buy small homes and bring up their families away from Chicago's undesirable influences." It looked serene in the interwar years, but the doubling of its 4,000 population of 1920 over the next twenty years indicated that even seventeen miles from the Loop was no permanent protection against metropolitan encroachment.

On the North Shore, the established communities first felt the outward surge. Evanston, already a patriarch among the suburbs, nearly doubled its numbers in a decade, from 32,000 to 63,000. It was still known for its tree-lined streets with the vast houses of bank presidents and chairmen of corporation boards—and its most distinguished resident, Charles G. Dawes, Vice-president of the United States. With growth, however, came change. Apartment houses began to "rear their ugly flat heads among the noble trees and victorian spires," wrote David Streeter in 1928, and "in time young clerks with pretty wives and babies began to move out from town." Evanston remained "quiet and conservative" and was still primarily a "city of homes" as its slogan proclaimed; but, as Streeter noted "the bank books and blue bloods" began to heed the "siren songs" of Winnetka and Lake Forest.

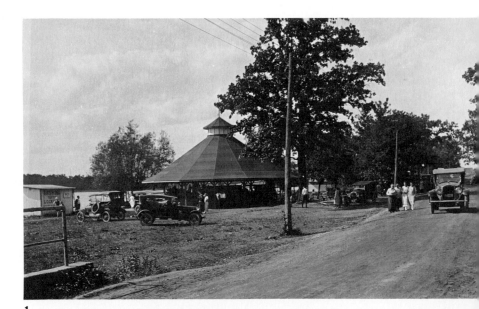

1

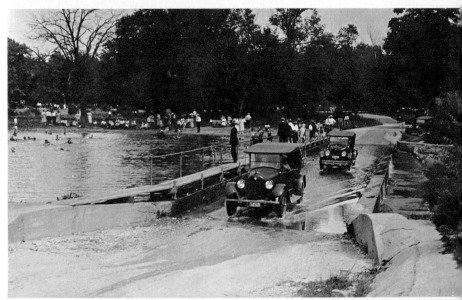

2

the use of the people, for park and picnic grounds, if you will. On Sundays and holidays hundreds of thousands of people swarm there. Just as the beach of Lake Michigan is being kept open for bathers over all that twenty-six miles of shore front within the city limits, so the strip of forests about the rim of the county is being kept for picnickers." The scene in the photograph is at the low-water dam across the Des Plaines River.
(Courtesy Chicago Historical Society.)

3. Wilmette Business District, Probably 1932

Wilmette shared the transportation and location advantages of other North Shore suburbs. With little industrial employment, the village became one of the North Shore's "dormitory suburbs," an area which consistently sent fifty per cent of its workers to Chicago for employment.
(Courtesy Chicago Historical Society.)

4. Interurban Electric Railways of the Chicago area, 1925

Chicago area interurbans were relatively prosperous in the 1920's. But drastic changes were occurring which brought the abandonment of weaker lines even before the depression. Costs of operation were rising, and the automobile increasingly competed as a passenger carrier.

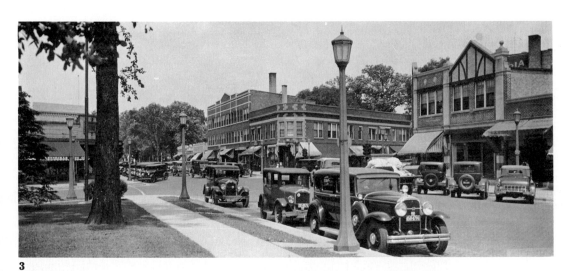

3

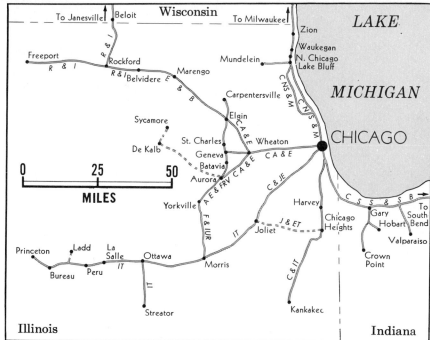

1. Chicago, North Shore and Milwaukee Electric Train at Elm Street Station in Winnetka, Probably 1936

"Among the various transportation agencies serving this community," the Winnetka *Talk* noted on March 8, 1930, "the one whose own development has been most closely linked with that of Winnetka is the Chicago, North Shore and Milwaukee railroad." The "Road of Service," as the North Shore was called, came through the village in 1902 as part of the link between Waukegan and Evanston, and Elm Street Station was "finished in [an] Old English style of architecture to harmonize with surrounding business structures." In 1930, eighty limiteds and fifty-three locals ran between Chicago and the village. However, automobile competition brought hard times to the North Shore line and in 1955 its Shore Line route was abandoned. Meanwhile, the population of Winnetka increased from 584 in 1880 to 13,368 in 1960.

The search for new suburban homes led many to go farther north. Wilmette, just beyond Evanston, was especially handy. It was connected with the city both by steam railroad trains and an extension of the El. An aggressive annexation policy in the interwar years nearly doubled its territory. The twenties was a prosperous period, bringing its population over the 15,000 mark and establishing its retail centers around the train stations. Wilmette, from the first, was a residential suburb, with virtually no apartment dwellings or industry. In this period, it gained distinction in the educational and religious world when the National College of Education, the oldest private elementary teachers' college in the United States, moved there, and work was begun on the famous Baha'i Temple.

The other lake-shore suburbs also shared the growth of the twenties. The building boom hit Kenilworth, Winnetka, Glencoe, and Highland Park; and the choice lakefront suburbs, especially, filled up with prosperous Chicagoans. Highland Park's business center soon ranked behind Evanston and Waukegan as the largest along the North Shore. And in the minds of many, this string of fine residential communities equaled Lake Forest in status and prestige.

Not all Lake Foresters agreed. Arthur Meeker, an old booster, declared in 1928 that it was an article of faith among his neighbors that Evanston was "almost entirely inhabited by white-haired music

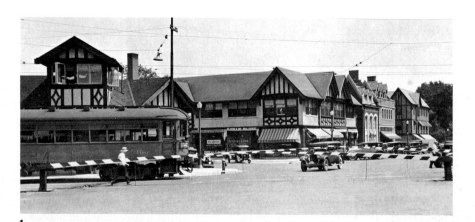

1

2. Highland Park Business District, about 1930

Located in the southeast corner of Lake County, twenty-six miles from the Loop, Highland Park's history dates back to 1845 when the village of St. Johns was founded nearby. The new settlement experienced only modest growth, however, until the establishment of the Chicago and North Western Railway to Waukegan in 1855. Highland Park incorporated in 1869, and by 1880 the village had over 1,100 residents. City fathers annexed nearby Ravinia in 1889; and at about the same time Fort Sheridan, an army post, was built on the site of old St. Johns. By 1925 Highland Park had the third largest business center in the North Shore, following only Evanston and Waukegan. The population reached 12,000 by 1930.

3. Crescent Street in Glen Ellyn, 1927

In the mid-1920's amid a tremendous growth spurt which tripled the village's population by the end of the decade, the Glen Ellyn planning commission and the zoning board recommended the redevelopment of the community's business district along a "desirable Old English type of architecture." Their purpose was "to do away with the old 'flat tops' and secure a uniformly lovely district architecturally." At the right are some of the old "flat tops"; the newly erected Glen Theater and a remodeled Miller Brothers showroom illustrate the extent of the transformation. (Courtesy Chicago Historical Society.)

4. Chicago, Aurora and Elgin Electric Railway Station, Glen Ellyn, 1927

The C. A. & E. electric planned to build a new station in Glen Ellyn in the mid-twenties. The Plan Commission "urged the company to discard its commonplace for one more in keeping with the contemplated development of the village of Glen Ellyn." The station, completed in 1926, was "the most beautiful one on the line," according to the writers of the village's history. (Courtesy Chicago Historical Society.)

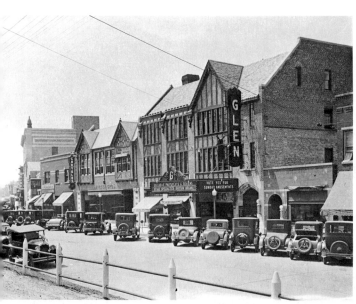

3

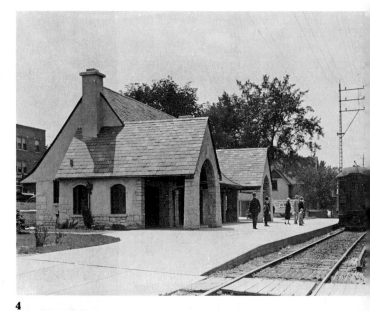

4

5

5. Residential Street in Glen Ellyn, 1927

By the end of the twenties, the "Old Town" had a population of over 7,500; but its decade of greatest growth was still to come: between 1950 and 1960 the city added over 6,000 residents, to end the decade with a population of nearly 16,000. (Courtesy Chicago Historical Society.)

1. Maywood Business District, 1928

Maywood lies to the west of Oak Park, eleven miles from the Loop. It was formed in 1869 by the Maywood Land Company, which purchased 500 acres on the west bank of the Des Plaines River and built a hotel. A spurt of growth occurred after the fire of 1871, but the size of the community stabilized until 1885 when Norton Brothers moved their can company to Maywood. By the 1930's, as a division of American Can Company, the firm employed several thousand workers. The Aurora, Elgin, and Chicago electric railroad came to the city in 1904, providing a second connection with Chicago, along with the Chicago and North Western. Maywood doubled its population in the 1920's, reaching nearly 26,000 by 1930. To cope with this rapid increase, Maywoodites passed a zoning ordinance in 1922, "envisioning an ultimate

mistresses in *pince-nez* who have made successful second marriages," that "none of the good trains stop at Highland Park" and that "everyone in Winnetka is too civic for words and goes to welfare meetings in something called the 'Guild Hall' Friday night." He could still remember when Lake Forest was a "comparatively unsuburban suburb," when few of the roads were paved, when "everybody kept horses and rode them," and when there was "only one country club."

But the twenties changed all that. A new group of young marrieds living in "made over village houses" and a set of the more wealthy living in "white-wash-and-timber Norman Villas boldly set on a bit of quaint Illinois prairie" had been added. A new commercial center replaced the old main street, the dirt roads disappeared, automobiles became fashionable, and three new country clubs were opened. Worse still, Meeker thought that so few of the new generation knew how to ride that fox hunts had become more dangerous for the huntsman than the animal. His nostalgia was perhaps a little severe, but it did serve to indicate that Lake Forest, too, was being reshaped by the suburban exodus of the twenties.

Not all suburban development was successful, however. Many areas shared the optimism but not the achievements of the time. New sections were opened up, streets, sidewalks, and utilities laid in, and lots placed on the market. Buyers snatched them up, and in many places

1

2. Chicago, Aurora and Elgin Station in Wheaton, 1928

Wheaton's first settlement occurred in 1837; it became a town in 1848. Wheaton grew slowly and steadily: in 1870 the federal census recorded 998 people in the little community, and it experienced its first real estate boom between 1920 and 1930 when it grew from 4,000 to 7,000 people. An additional 4,000 were added between 1940 and 1950, but it was in the last full decade that Wheaton experienced its greatest development. Between 1950 and 1960 population climbed from 11,638 to 24,312. Still, the city maintained much of its character of fifty years before. It was still in the eyes of most residents "the City of Country Homes" and because of its large shade trees, "the Sylvan city." (Courtesy Chicago Historical Society.)

population of 70,000 with land set aside for industry, business, and apartments, but attempting to preserve the single-family home character of the village." By the end of the decade its residences included, however, many small flats and apartment buildings. Maywood was unusual among the suburbs in one other way: by 1930 it had slightly more than three per cent Negroes among its population.
(Courtesy Chicago Historical Society.)

3. Main Street, North from Oakton Street, Business Heart of the Village of Niles Center, 1907–8

Original settlement was made in the Niles Center area in the 1850's, but population growth was slow. In 1910 only 568 persons were counted in the federal census, just thirty-nine more than in the previous decade.
(Courtesy Mrs. Armin J. Mayer.)

4. Chicago and North Western Railroad Station in Wheaton, 1930

"In . . . the matter of transportation— Wheaton far excels all other suburban towns located the same distance from Chicago, or from any other city in the entire world for that matter," a real estate publication bragged in 1911. "Yes, Wheaton has by far the best transportation of any suburban town in the world located thirteen miles or more from city terminal. . . . Wheaton has 150 passenger trains daily and 170 on Sundays and holidays."
(Courtesy Chicago Historical Society.)

3

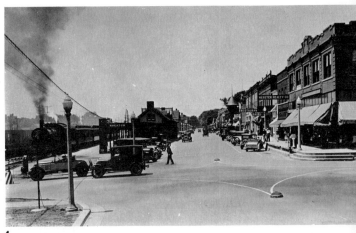

4

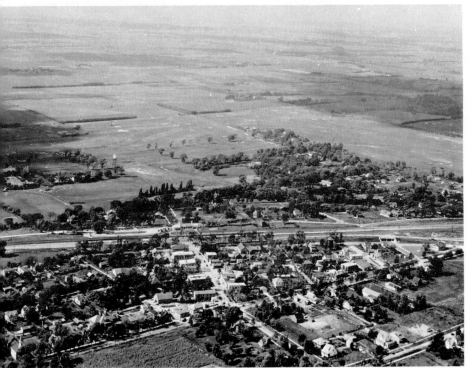

5

5. Air View of Homewood, Illinois, 1924

Homewood was platted in 1852 by James Hart, who started a general store in that year. Called Hartford, the village grew only slowly. Its name was changed to Homewood when the Illinois Central initiated suburban service in 1865. In these early years, "Homewood was almost exclusively a German settlement, and everywhere are seen evidences of thrift and prosperity, so characteristic of the German people." The village was incorporated in 1895; five years later the census recorded only 352 people within corporate limits. The community's growth was greatly stimulated when the Illinois Central initiated high-speed electric service through the suburb in 1926. A real estate publication in 1914 noted that Homewood "is a forty-five minute drive from the business district of Chicago, making it attractive to one who wishes to flee from the crowded city and flat life. . . . The village has a large amount of cement walks, and with its greatest abundance of beautiful flowers 'Homewood has been called the Los Angeles of Illinois.' "
(Photograph, Kaufmann and Fabry. Courtesy Chicago Historical Society.)

1. Klehm Brothers General Store on Lincoln, Corner of Oakton Street and Lincoln Avenue, 1907–8

Most of the early settlers in Niles Center were German immigrants, who grew vegetables and other greenhouse items for the Chicago market. A group of Luxembourgers followed the Germans to the little community even before it was incorporated as a village in 1888.
(Courtesy Mrs. Armin J. Mayer.)

2. Interior of the Klehm Store in Niles Center, Probably 1910–15

An old-time resident of Niles Center recalls that the Klehm store was the way station for laborers on their way home from the brick yards in Evanston and the greenhouses in nearby Morton Grove.
(Courtesy Mrs. Armin J. Mayer.)

construction commenced. But the depression soon set in and frustrated the hopes and plans of developer and land owner alike. Prospective residents could no longer afford to build; indeed, many could not even maintain tax payments on the land. All around the edge of the metropolis these ghost villages appeared at the end of the decade. Grass grew back over the pavement, lamp posts and fire hydrants stood forlornly along empty streets, and an occasional house or apartment remained as a grim reminder of the happy expectations of earlier years.

This premature suburban development was perhaps best illustrated by Skokie's experience in the twenties. Incorporated as Niles Center in 1888, it was situated between the major transportation routes out of the city and contained only 763 inhabitants in 1920. Seven years later the Skokie Valley line of the Chicago North Shore and Milwaukee electric interurban railway opened service to the village, bringing the area into the Chicago transit system. Coinciding with the boom in suburban real estate, this enterprise set off immense speculative activity. Subdividers cut up the vacant area into lots of 25 or 30 foot widths, installed water, gas, and electric facilities and paved sidewalks and streets. The response was gratifying. Soon houses and small apartments were built, and the population jumped to over 5,000. But the depression of 1929 brought construction to a halt, and more than

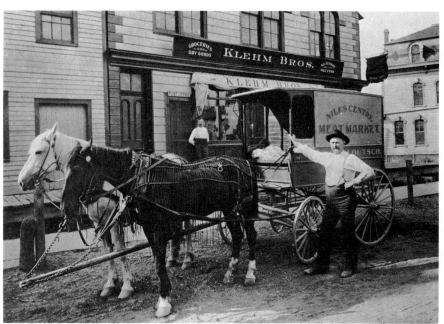

1

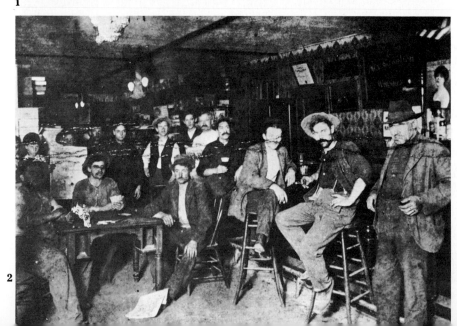

2

3. Lincoln Avenue, North from Oakton Street, Business Heart of the Village of Skokie, 1959

After World War II, Skokie city fathers took steps to revitalize their community. As one brief history summarizes: "In 1946, many lot titles were cleared, and a new zoning plan was completed. Much of the property zoned as commercial was reclassified as residential, and lots were revised (from eighty-foot frontages) to provide for single-family homes with 40- to 55-foot frontages. Light industrial zones lined the railroad tracks, and heavy industry was zoned for the southeastern corner of the village, near Chicago." Skokie's timing was perfect: new industries and old ones from the central city moved into the planned industrial locations. "The automobile and the single family home" became the major factors in the community's growth. Skokie's population quadrupled between 1950 and 1960, reaching 59,364 people by the latter date.
(Photograph, Glenn E. Dahlby. Courtesy Chicago Historical Society.)

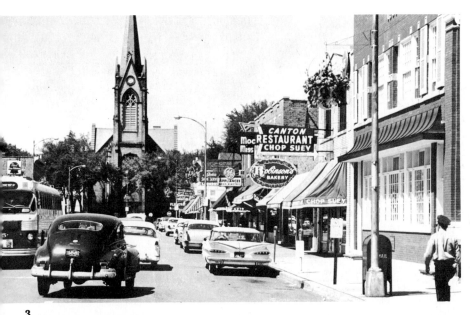

3

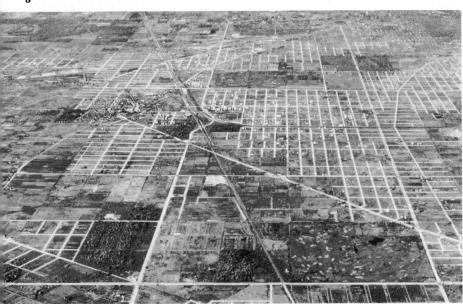

4

4. Air View Northward, across Devon Avenue at Cicero toward Sauganash, Lincolnwood, and Skokie, 1936

In 1926 the Chicago elevated line to Evanston was extended to Dempster Street in Niles Center; the year following, the Skokie Valley route of the North Shore line was completed. The new transportation facilities stimulated a land boom in Niles Center and Tessville, renamed Skokie, and Lincolnwood. Speculators moved in to subdivide the farm land, lay out utilities, and build streets. Population in Skokie went up sevenfold between 1920 and 1930, going from 763 to 5,007. But the depression killed the boom. Lots were abandoned, utilities lay unused. "As late as 1948, it was estimated that there were 30,000 vacant lots in Skokie, many of which were being farmed." Until the years after World War II, the almost ghost-town-like Skokie remained a textbook example of "dead land."
(Photograph, Chicago Aerial Survey Company. Courtesy Chicago Historical Society.)

342

Cicero's population nearly quadrupled in the twenties, reaching over 66,000 in 1930. With excellent transportation connections with Chicago and with several railroad connections, Cicero's growth rested on a strong industrial base. One notable example was that by 1922, Western Electric Company had transferred its entire operation to Cicero. Foreign stock made up seventy-nine per cent of the population in 1930, with Czechoslovakians constituting almost half, followed by Poles, Germans, Lithuanians, and Italians. The 1930 census recorded only five Negroes. (Photograph, Kaufmann and Fabry. Courtesy Chicago Historical Society.)

30,000 lots remained vacant for almost twenty years. Throughout the thirties, Skokie stood as a reminder of the excessive optimism of the age. The hopes of the twenties, however, would be redeemed manyfold by another suburban surge at a later time that would urbanize much of the "dead land" that had been prematurely subdivided.

Industrial suburbs also grew with the general metropolitan expansion of the decade. Harvey, for example, saw its population rise from 9,000 to 16,000 between 1920 and 1930. The town had already attracted industry because of its good rail connections, and electrification of the Illinois Central's suburban service promoted intensive residential growth in a ten-mile strip along the tracks.

The vast dispersal of population to the outer parts of the metropolis produced a similar dispersal of many commercial facilities. Small clusters of stores had always sprung up in residential areas outside the business district, but now these were increasingly reinforced with new activity. A convenient index of their development was the tripling of the average land value of important business corners in the outlying sections. The Loop, of course, retained its retail predominance, but total sales began to level off in the face of growing localized competition.

Within the City of Chicago, commercial construction followed the grid section-line and half-section streets, spaced

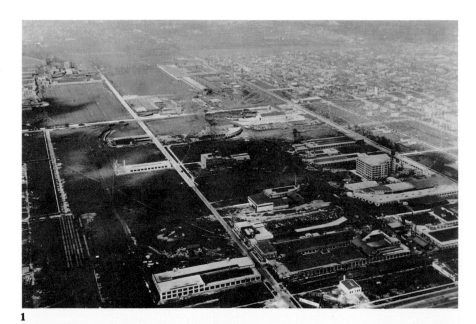

1

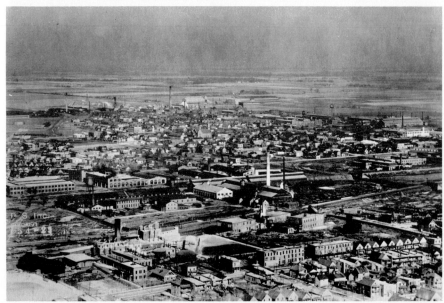

2

2. Chicago Heights, 1923

By 1920 Chicago Heights was a firmly established industrial city of almost 20,000 people. A deliberate policy of gradual growth was adopted by the city in the 1920's, and Chicago Heights' population was only 22,300 by 1930. Six railroads, connected by the Chicago Heights Terminal Transfer belt line, made most locations in the community accessible as industrial sites. However, the depression struck hard. The upward trend continued after the war. A 1958 census of manufacturers listed eighty-two manufacturing establishments in the city; together they employed over 7,000 persons.
(Courtesy Chicago Historical Society.)

3. Growth Areas of Chicago, to 1945

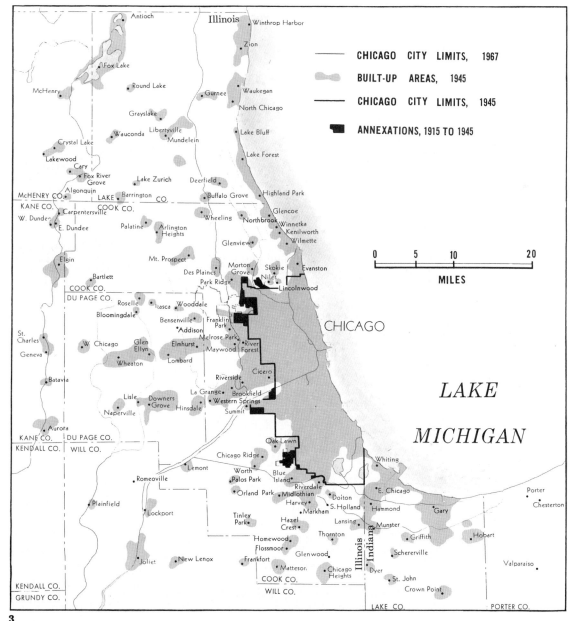

CHICAGO CITY LIMITS, 1967

BUILT-UP AREAS, 1945

CHICAGO CITY LIMITS, 1945

ANNEXATIONS, 1915 TO 1945

0 5 10 20
MILES

344

1. Uptown Center, Broadway, View from Leland Avenue Northward toward Lawrence Avenue, 1926

"Within the past ten years or so," a school textbook stated in 1930, "the retail section in the 'Loop' has put out its tentacles north, south, and west in outliers of the great district. They make shopping easier, especially for the mother of the family. Twenty-six principal shopping centers or neighborhood retail sections have developed which are so to speak

centers of little towns within the city. Certain of these department stores and offices have branches in these neighborhood centers. In some of the centers large independent stores form the nucleus. An editor of a Chicago paper calls these centers 'little Chicagos'. . . . Grouped around these centers are residential sections, (with) many houses, but many, many more apartments, growing more numerous each year as the city becomes more compact." (Courtesy Chicago Historical Society.)

one mile, and one-half mile apart. Most commercial establishments were modest, occupying small lots twenty or thirty feet wide and 125 feet deep; commonly the second floor was devoted to residential use. Literally hundreds of miles of this frontage was built. In the densely populated area, shops and stores lined both sides of the street; in other places the development was intermittent. Where subdividers had over-reached the market, whole blocks of buildings remained vacant.

This ribbon commercial development would later have many critics. Commonly occupied by marginal or submarginal business, the buildings quickly became run-down. Noisy streetcars (and later motor buses), heavy pedestrian traffic, unsightly overhead wires, and ill-kept, track-filled pavements combined to discourage residential construction. Many businesses, such as plumbing, hardware, and sheet metal shops, scarcely lent themselves to attractive upkeep; and in those that did—such as restaurants, taverns, and barber and tailoring shops—the cost seemed high for working on small volume. Nevertheless, ribbon development spread; moreover, it was given generous official encouragement in the Zoning Ordinance of 1923. In this legislation large areas along main streets were reserved for commercial use; indeed, one writer estimated enough footage had been zoned as commercial to meet the needs of a city of eighty million people.

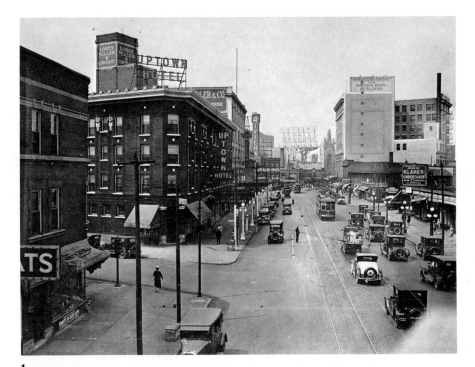

1

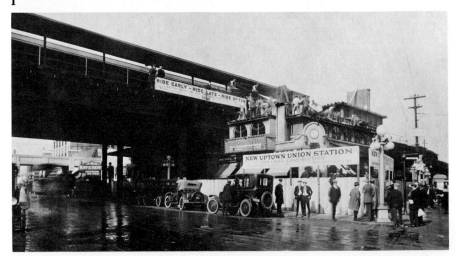

2

2. Construction of the Wilson Avenue Elevated Station at Broadway, Probably 1925

Workers are just beginning to rip away the roof of a building designed by Frank Lloyd Wright in the first decade of the century. The small office and store building gave way for a new union elevated station utilized by both the Chicago Rapid Transit Company, which united all the elevated lines for the first time in 1924, and by the Chicago North Shore and Milwaukee electric railroad. Yet even as the new station was being erected, the elevated lines faced a decline in riders. The photograph shows the reason: automobiles and taxicabs were beginning to fill Chicago's streets.
(Courtesy George Krambles Collection.)

3. West on North Avenue, from Half Block East of Crawford, 1934

This community-sized shopping center focused on the streetcar intersection of Crawford and North avenues. The Pioneer Bank Building, with its professional tenants on its upper floors, provided the only real relief from the predominantly two-story height of the business buildings.
(Lillian M. Campbell Memorial Collection. Courtesy West Side Historical Society, Legler Branch Library.)

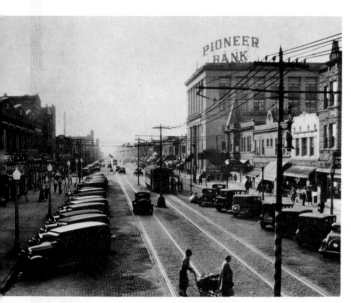

3

4

5

4. A "Community" Size Commercial Intersection Development, West Madison Street, Eastward across Western Avenue, 1934

In an older portion of the city in a relatively low income area, this community shopping center developed at the intersection of two streetcar lines.
(Lillian M. Campbell Memorial Collection. Courtesy West Side Historical Society, Legler Branch Library.)

5. North Side of Bryn Mawr Avenue between Sawyer and Spaulding, 1935–36

A block of small stores, all built at the same time, lined this street. They were located just a short block from the Kedzie–Bryn Mawr intersection.
(Courtesy Chicago Historical Society).

346

1. **Intersection in the Heart of an Outlying Business Center, Northwest Corner of Lawrence and Kedzie Avenues, about 1935**
Streetcar lines intersected at the Lawrence-Kedzie center, the principal business area for Albany Park, a community which had residents primarily of Russian and Polish-Jewish ancestry.
(Courtesy Chicago Historical Society.)

2. North on Crawford Avenue (Pulaski Road) from Madison Street, 1934
A Central Cigar chain store and a Walgreen drug store, both chains which expanded rapidly in the twenties, occupy the corners in this photograph.
(Lillian M. Campbell Memorial Collection. Courtesy West Side Historical Society, Legler Branch Library.)

At the intersections of major arterial streets land values rose to sharp peaks. Here, at "transfer" corners, streetcar riders did impulse buying; and drug stores, banks, specialty shops, and variety stores—increasingly operated as chains—found enough sales to justify the necessarily high rentals. Taller buildings at the corner, with sizes tapering off down the approaching streets, formed a profile which reflected the land values and commercial activity involved.

Even more striking was the appearance of major outlying regional shopping centers. Less localized, their market area stretched for miles, contained hundreds of thousand of people, and their sales volumes ran into the millions. They contained movie palaces with capacities of two to five thousand, several banks, and one or more large department stores. Six of those developed in the arc of heavily populated sections several miles from downtown. To the north was Uptown (at Lawrence and Broadway), northwest at Lincoln-Ashland-Belmont, west at Madison and Pulaski (Crawford), southwest and the largest, at Englewood (63d and Halsted), south at Woodlawn (63d and Cottage Grove), and far south at Roseland (Michigan Avenue and 111th Street). Beyond the municipal limits the same type of development occurred in downtown Evanston, Oak Park, Hammond, and Gary.

Nothing, perhaps, illustrates the significance of the new commercial centers so well as the story of Chicago's depart-

1

2

3. Paradise Theater, East Side of Crawford (231 N. Pulaski Road) near Madison, 1929-30

"Chicago was once the jumpingest movie city in the world and had more plush elegant theaters than anywhere else," author Ben M. Hall writes in his *The Best Remaining Seats*. Balaban and Katz were among the most famous owners. Combining movies with musical productions and promotional contests and features, the public packed their movie houses to see stars like Mary Pickford and Richard Barthelmess. The Paradise is now torn down; its seats are part of the International Amphitheatre. (Courtesy Chicago Historical Society.)

4. The Marbro, near Madison and Crawford, about 1929

Chicago writer Norman Mark in a 1967 *Daily News* story recalled the grand days of "the Popcorn Palaces." Those were the days he recalled when "Momma . . . went to a true neighborhood palace, where all her cares were wafted away by one of the world's early air conditioners. Nowhere else in America could you find such splendor in your own neighborhood. New York concentrated its theaters along Broadway, but Chicago sprinkled its golden pleasure domes north, south and west through the neighborhoods (by the mid-'20's Balaban & Katz alone could seat more people than all the Broadway theaters put together)."
(Courtesy Chicago Historical Society.)

3

4

6

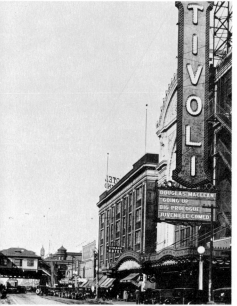

5

5. North on Cottage Grove, across Sixty-Third Street, 1924

Located in the western part of the Woodlawn Community, this was one of the major business centers of the South Side. The Tivoli Theater, with over 4,000 seats, was one of the largest of the early movie palaces.
(Courtesy George Krambles Collection.)

6. East Side of Halsted Street at the Corner of Sixty-Third, about 1927

The frame construction of these buildings reveals the age of the 63d-Halsted Shopping Center. In 1920, over 86,000 people lived in the Englewood community area, of which this intersection was the main core.
(Courtesy Chicago Historical Society.)

348

1. Michigan Avenue North from One-Hundred-Eleventh Street, 1934

Over 28,000 people clustered in Roseland, as the community centering at this corner is known. As in the days when Roseland was a farming community, Dutch and Swedish still predominated in 1920, although Lithuanians, Polish, Italians, and a few Negroes were beginning to enter the neighborhood. Between 1920 and 1930, Roseland's population increased over fifty per cent, with brick bungalows, two-story single frame houses, and small apartment buildings erected to house the newcomers. (Courtesy Lillian M. Campbell Memorial Collection, West Side Historical Society, Legler Branch Library.)

ment stores. Marshall Field and Company, seeing the potential in the upper income areas, established stores in Evanston and Oak Park in the twenties. Others reversed the process, originating in the outlying areas and moving to the Loop later. Sears, Roebuck and Company and Montgomery Ward had several outlets in regional shopping centers before locating downtown. Likewise, Goldblatt's and Wieboldt's began operations in the new areas of the city and suburbs, only later entering the central business district. After World War II, the flight to the suburbs dominated the strategy of most prominent retail establishments; but it is interesting to notice that the conditions which induced this outward movement appeared much earlier.

The same centrifugal movement which characterized residential and commercial change in the twenties governed industrial growth. The trend was most clearly demonstrated in the location of new organized industrial districts. Just before the war, the Pershing Road tract of the Central Manufacturing District was established on the Southwest Side; the Clearing Industrial District was even farther from downtown. Each new enterprise was not only nearer the municipal boundary, but was also developed at lower density on more extensive tracts. New construction abandoned the old multiple-story loft building in favor of the one-story plant arranged for straight-line production and unlimited floor load-

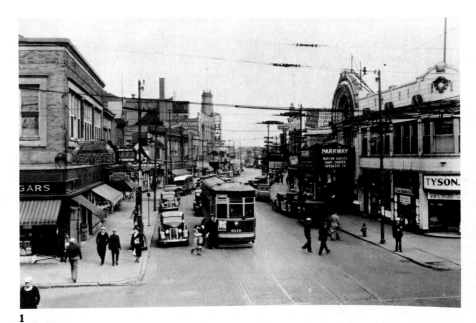
1

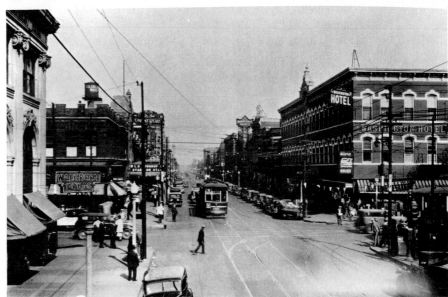
2

2. Commercial Avenue, North from Ninety-Second Street, 1934

South Chicago's retail center is somewhat older than some business centers equidistant from the Loop, reflecting the area's early development as an industrial locus. South of this center were located railroads and wharves, and southeast were the steel mills. When this photograph was taken, this area was undergoing a population decline, as people sought out more pleasant surroundings farther away from the manufacturing, shipping, and congestion.
(Courtesy Lillian M. Campbell Memorial Collection, West Side Historical Society, Legler Branch Library.)

3. Cuneo Press, Northeast from about Twenty-Third Street, 1920's

The first job printing office was started in Chicago in 1833 as part of a newspaper. In 1838 Robert Fergus opened a job printing establishment which relied entirely on individual and firm printing contracts. Out of these early beginnings grew one of Chicago's largest industries; in 1924 over 30,000 employees worked in Chicago's printing establishments, which had a total value of $270,000,000 by the end of the decade. The Cuneo Press buildings are in the center of the photograph.
(Courtesy Cuneo Press.)

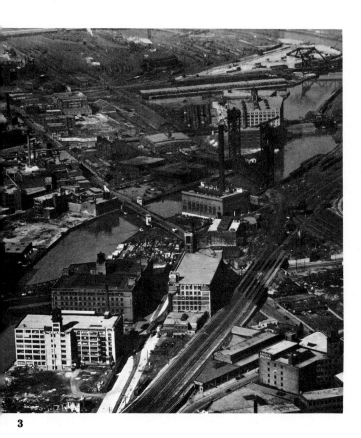

3

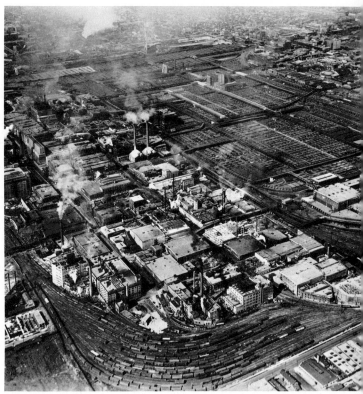

4

4. "Packingtown," West of Union Stock Yards, Late 1920's

The "big four" packers enjoyed relative prosperity in the late 1920's. The depression years brought a decline in meat consumption, and it was not until the mid-1930's that the packing industry was again on firm ground. In the meantime, technological changes, beginning as early as the 1890's, were making the need for so concentrated a location unnecessary and led eventually to the decline of Chicago's packing hegemony.
(Photograph, Kaufmann and Fabry. Courtesy Chicago Historical Society)

1. View Northward over the North Branch of the Chicago River from Southwest of the Intersection of Chicago Avenue and Halsted Street, 1936
The North Branch of the Chicago River had been among the early industrial sites. Through the years various kinds of industry had settled there; in 1924 Goose Island and its river neighbors included representatives from the metal processing, chemical, electrical, meat packing, and food processing and household industries. Crossing the island is Ogden Avenue, constructed in the 1920's and the core of Chicago's largest Polish settlement.
(Photograph, Chicago Aerial Survey. Courtesy Chicago Historical Society.)

ings, and with adequate provision for off-street loading and unloading of trucks and parking of automobiles.

Electrical machinery and electronics equipment manufacturing comprised one of the categories of greatest industrial development during the interwar period. Chicago was already a center for the manufacture of telephone equipment. With the proliferation of new appliances and the growing popularity of the radio, the city became even more important in this field. Zenith, Motorola, Admiral, and Hallicrafters were among the new giants; and, even before the war, television receivers started to come off the assembly line in modest numbers. By 1945 one quarter of the national employment in the production of radio and television sets was found in metropolitan Chicago.

The most rapid growth of heavy industry also took place at the periphery. Indeed, factories had been initially established there because of low land costs and good transportation. The prosperity of the twenties reinforced this pattern. The Calumet region continued to attract new industry as well as to provide ample facilities for the expansion of established plants. The six miles along the river between Lake Michigan and Lake Calumet became the axis of one of the world's great industrial complexes. Huge blast furnaces and rolling mills, acres of stockpiled ore, coal, and stone, towering grain elevators, the exposed tubing of chemical and paint works, large gantry cranes hovering over wharves and ships, and

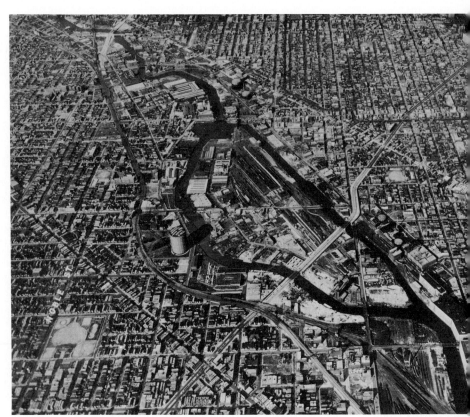

1

2. Montgomery Ward and Company, 1940

Located opposite the south end of Goose Island, seen against Chicago's North Side, the Montgomery Ward complex, which lines the river in the center foreground, offered an impressive sight in the years before World War II. Recovering from the worst years of the depression, Montgomery Ward grossed over 515 million dollars in 1940. At the end of that year the company had 650 retail stores in operation throughout the country.
(Courtesy Montgomery Ward and Chicago Historical Society.)

3. View Northward from over Ninety-Second Street and the Calumet River, 1936

On the periphery of Chicago from the 1870's onward had grown the industrial complex of South Chicago shown in the foreground; behind it is the neighboring community of South Shore. Dominating the photograph is the 575-acre South Works of the United States Steel Corporation, extending from the Calumet River to 79th Street.
(Photograph, Chicago Aerial Survey. Courtesy Chicago Historical Society.)

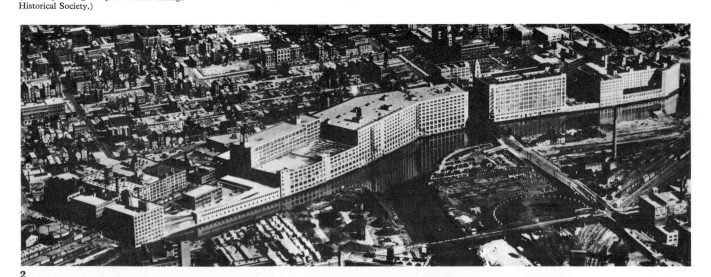

2

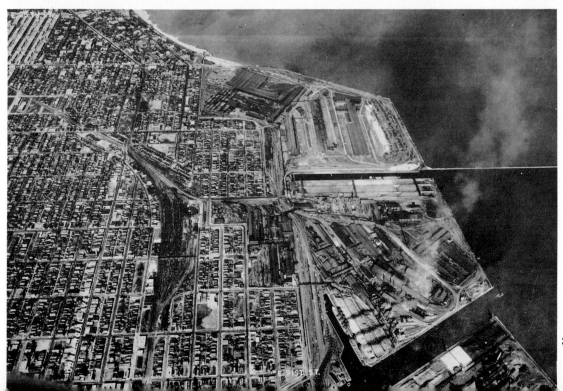

3

1. View Northward of Indiana Harbor (East Chicago and Whiting, Indiana), 1936

At the entrance to the Indiana Harbor Canal on artificial peninsulas are the plants of Youngstown Sheet and Tube Company (left) and the Inland Steel Company. The Y-shaped canal gave access past the steel properties for the heavy industries further inland. At the left is the refinery of the Sinclair Oil Company and north of it is the massive Standard Oil Company (Indiana) refinery.
(Photograph, Chicago Aerial Survey. Courtesy Chicago Historical Society.)

mile upon mile of drab, almost sullen buildings, crowded in around the water. Fire and smoke charged into the sky as a constant reminder to the world of Chicago's brute industrial strength.

Most people were appalled by the dirt, pollution, and ugliness of the scene, but to some there was an elemental beauty to the rough shapes and raw power embodied in this steaming jungle of steel and brick and concrete. Carl Sandburg celebrated the city of the "broad shoulders," and William Bolitho, the English novelist, found it one of the most awesome and fascinating sights in the modern world.

Even the enormous productive capacity of the Calumet region could not meet the expanding and complex industrial demands of the decade. Southeast of the city limits, oil refining and soap and chemical manufacturing developed. Beyond that, Indiana Harbor grew into one of the largest bulk-cargo ports on the Lake to funnel ore, stone, and coal into the yawning furnaces of Inland Steel Company, Youngstown Sheet and Tube Company, and other industries. And still beyond, Gary prospered with the growth of United States Steel Corporation. Along the other edges of Chicago new manufacturing activity developed in a dozen suburbs and satellite communities. Evanston, Skokie, Cicero, Berwyn, Harvey, Chicago Heights, Waukegan, Aurora, and Joliet all attracted substantial industrial investment before World War II.

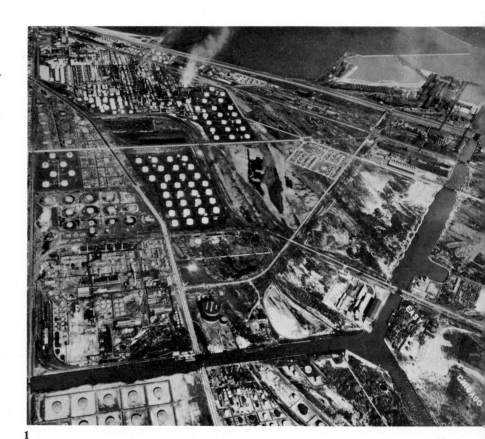

1

2. Burlington's *Pioneer Zephyr*, 1934

The *Zephyr* was the first diesel-powered, stainless steel passenger train. It is shown here while on exhibition at the Century of Progress Exposition "Pageant of Travel" exhibit on Chicago's lake front in 1934, following its record-breaking run from Denver.

(Courtesy Chicago, Burlington & Quincy Railroad.)

3. Electromotive Plant in LaGrange

A division of General Motors, the LaGrange plant is the world's largest producer of locomotives.

(Courtesy Electromotive Division of General Motors Corporation).

2

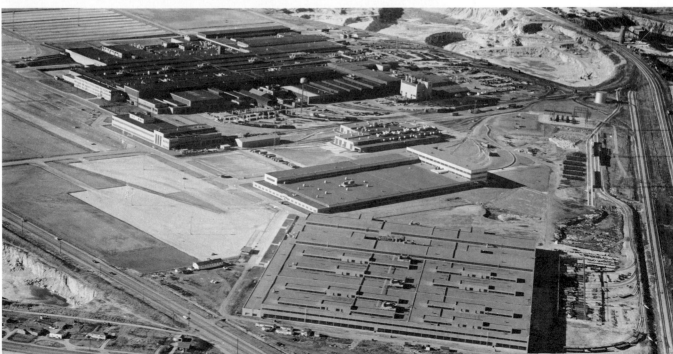

3

1. The Clearing Industrial Yards, View Eastward, Mid-1920's

The original tract of the Clearing Industrial District was not fully developed until after World War II. Its occupants in the 1920's found two-story buildings with adequate floor space and good connections with public transportation and the railroad yards. Fields were more common than houses in this area when the original tract of the Clearing Industrial District was sited here in the 1920's. The depression delayed the District's full development until the 1940's, and it was not until the post-World War II housing boom that residents filled the lots surrounding the district.
(Courtesy Chicago Historical Society).

The decade of expansion brought new demands on the nation's transportation system, and a readjustment of Chicago's key role. The most significant change came in the development of competition for the railroads. Automobiles, buses, and airlines cut into their passenger revenue, while inland waterways, trucks, and air cargo service reduced their share of freight traffic. The new modes of transportation required installations which altered parts of the metropolitan landscapes. Truck terminals, additional port facilities, and airports meant that more land had to be found for transport use. The railroads, to meet the competition, developed vast, land-using, freight classification yards.

The most important railroad response to its new rivals was the introduction of diesel-electric power. Originally introduced in 1925 for local switching service, the new locomotives were only slowly adopted. The popular acceptance of the sleek *Pioneer Zephyr* in the mid-thirties, however, signaled a dramatic change in inter-city travel. Ironically, the new streamliner's measured-mile speed was almost identical with the *Empire State Express's* 1893 record of 112 miles per hour, but its other attributes—the reduction of noise and air pollution, smoother ride, and air-conditioning—ultimately drove the iron horse from the rails. Chicago benefitted briefly by the innovation not only because of the boost in passenger traffic, but also because it became the largest producer of the new

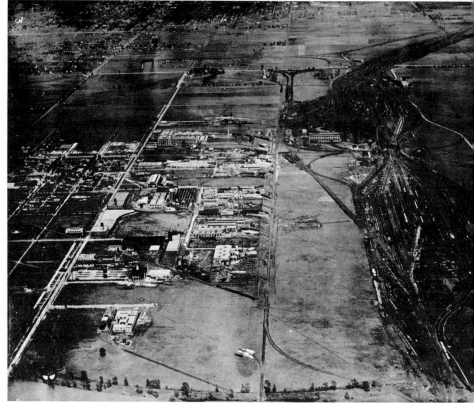

1

2

2. The S.S. *Makefjell* in Ogden Slip, Downtown Chicago, Following its Inaugural Voyage into the Great Lakes in 1933

The *Makefjell* was the first ocean-going vessel in direct scheduled cargo liner service between Chicago and an overseas port. Limited by the Canadian canals to a length of 258 feet, a beam of 43.5 feet and draft of fourteen feet, these vessels were the largest in direct Chicago-overseas trade until completion of the St. Lawrence Seaway enlargement in 1959. (Courtesy Great Lakes Overseas, Inc.)

3. International Aviation Meet in Grant Park, 1911

It was optimistically estimated that between three and four million people witnessed the international aviation meet held in Chicago August 13–20, 1911. Leading Chicagoans, many of them members of the Aero Club of Illinois, put up $80,000 in prizes to attract the world's best aviators to what was hailed as "the greatest aviation event the world has ever seen." The meet represented one of the early attempts by city residents to make Chicago the primary center of heavier-than-air flight. An observer recalled years later: "Paid $2 a minute while in the air, pilots spent as little time as possible on terra firma, and the sky above the park was continually dotted with the birdmen." (Courtesy Chicago Historical Society.)

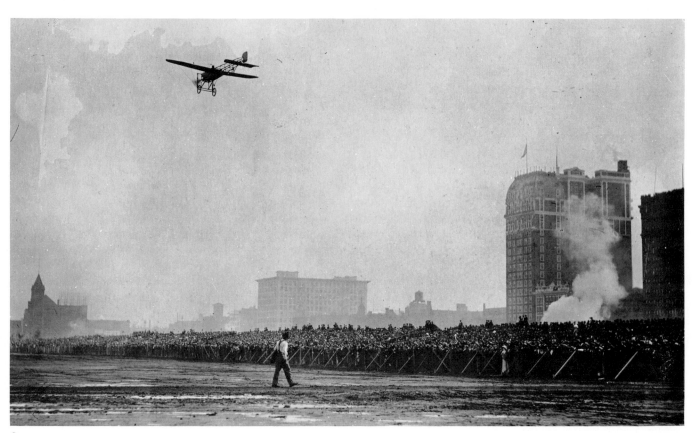

3

356

1. Curtiss Biplane Flying Passengers over an Airfield at Kedzie Avenue and Peterson Road on the Northwest Side, 1919

A Curtiss "Jenny," a type common during World War I, was often used by "barnstormers," a rugged group of early flyers who made their living giving air shows and rides to passengers from prairies and corner lots.
(Photograph, J. Sherwin Murphy. Courtesy Chicago Historical Society.)

2. United Air Lines Plane along Chicago's Near North Side Shoreline, 1928–29

Between 1928 and 1930 United acquired Boeing 80 twelve-passenger and Boeing 80-A sixteen-passenger trimotors to increase its passenger hauling capacity. These planes were designed primarily for flying over the high western terrain; they came into Chicago on a regular basis in 1930, flying to Salt Lake City and San Francisco.
(Courtesy United Air Lines.)

locomotives and modern cars in the world.

Located at the outskirts of the city, the freight classification yards performed the sorting out, transfer, and dispatching of freight cars. The system required elaborate equipment and plenty of space. The Proviso yard of the Chicago and North Western, for example, comprised 230 miles of trackage with a capacity of 26,000 cars, and the main yard alone had fifty-eight switches and thirty mechanical retarders operated from three towers. The location of the classification centers contained so many advantages that organized industrial districts grew up nearby, contributing to the decentralization of manufacturing activity.

Water transportation, too, had to adjust to the new competitive conditions. The old package freight and passenger service declined in the twenties, and virtually disappeared in the thirties. But this slack was picked up in part by the increase in Great Lakes–overseas direct cargo services by ocean-going vessels. Earlier connections with Europe had been confined to small ships because small Canadian canals could not handle anything with a draft of more than 14 feet. In 1931, however, the tiny Norwegian steamer *Anna* tied up at Montgomery Ward's with a cargo of cod liver oil and barbed wire. This trip pointed the way to regularly scheduled service, and soon Norwegian vessels of the Fjell Line and Dutch ships of the Oranje Line were frequent visitors.

Overseas shipping was complemented by the opening of large-scale barge connections with the Mississippi. The completion of the Illinois Waterway in 1933, with its seven locks between Lockport and the Mississippi made regularly scheduled service possible between Chicago and New Orleans. Powerful diesel-electric towboats pushing long lines of steel barges soon became familiar sights on the inland system. Over a third of the city's water-borne commerce—over twenty million tons a year—is moved in barges along the rivers and canals. Situated at the junction of the lake and rivers, Chicago prospered both as a terminus and transfer center.

A spectacular new element in the city's transportation structure was the rapid development of air traffic. Chicagoans had an early interest in aviation; in 1911 they had held a meet in Grant Park. By the late twenties air travel had ceased to be a novelty, and scheduled service

tied together both coasts via Chicago, while the federal government regularized inter-city mail routes. Flying was still primitive and precarious, an adventure for the passenger and a challenge to the pilot. On the Chicago to St. Louis run, a sandy haired youth with destiny in his eye, Charles Lindbergh, was preparing for greatness.

The air age had arrived, and Chicago needed an airport appropriate to the new demands. Fortunately, a square mile on the Southwest Side, already owned by the city, was available. Only Nathan Hale School, a few truck farms, and some railroad tracks occupied the area. Moreover, a portion of the land was used for "sandlot" aviation. In the late twenties and thirties, the city transformed this unpromising spot into the busiest airport in the world. The Municipal Airport, later called Midway, was handling 80,000 planes and 1,300,000 passengers annually by 1945.

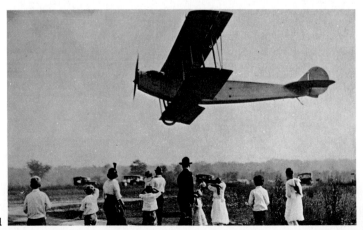
1

3. View Northward of Chicago Municipal Airport (Now Midway), 1936

Bounded by 55th and 63d, Cicero and Central Avenues, the square mile on which the airport grew up was a school-section mile as designated under the Northwest Territories Ordinance of 1787. In 1926 Nathan Hale Elementary School, visible at the left, was erected in the southwest corner of the mile. The following year a municipal airport was placed within the mile, occupying the southeast corner. It replaced a decrepit private "air park," which had been there since 1923. A cinder runway was laid out, and hanger facilities were built and improved. The airport was dedicated in 1927, and the city's air mail service began to use the field, moving from the Maywood Airport. A decade later, runway developments were completed for the full half section minus the school site. The airport then faced the problem of expanding beyond the Belt Railway tracks which crossed the whole mile just north of the new field. After lengthy negotiation with the Belt Line in 1941, the runways were joined and the airport was expanded to its present size. Nine runways were in full operation by 1949.

(Photograph, Chicago Aerial Survey. Courtesy Chicago Historical Society.)

2

3

1. Jobless Men Reading Papers and Sitting in Old Peristyle in Grant Park, 1931–32

Scenes like this were common in the depression years. A reporter who came to the city in the winter of 1930–31 wrote about the contrasts he saw: "You can ride across the lovely Michigan Avenue bridge at midnight, with the 2,000,000,000 candle-power Lindbergh beacon flaming above you and the lights all about making a dream city of incomparable beauty, while twenty feet below you, on the lower level of the same bridge, are 2,000 homeless, decrepit, shivering and starving men, wrapping themselves in old newspapers to keep from freezing, and lying down in the manure dust to sleep."
(Photograph, Fred G. Korth. Courtesy Chicago Historical Society.)

2. Unemployed Men in Front of Oak Park Bank, June, 1933

The suburbs also felt the pinch of unemployment. In this photograph a group of those without jobs sit on the curb before the Oak Park Bank. In May, 1932, a writer in the *Nation* explained what

The year began with bumptious optimism. The lead article of the first 1929-issue of *The Chicagoan*, "Speaking of the Market," frothily described the universal fascination with buying and selling stocks. Everyone was getting into it. "The ticker mania has spread to all classes of society," the author observed, calling it a "national obsession." "No one need be surprised if the washerwoman halts her rinsing operations long enough to sprint to the telephone and place an order to 'sell fifty Anaconda on the Market.'" There were a few who expressed doubt. "There are portentous references to 'stringency in money' and 'discounting the future,'" the article further noted. "But these questions trouble the common speculator not at all. His confidence in the ticker tape as a catalyst is profound and abiding."

But the whole edifice came tumbling down before the year was out. What had been thought to be permanent prosperity suddenly collapsed. To be sure, there had been some danger signals. The real estate market had lost its buoyancy in 1927. The volume of transfers, new buildings, and lots subdivided declined, apartment rents leveled off, and the demand for vacant lots abated. Yet these warnings were overlooked in the frantic speculation in the stock market. It was not until October, 1929, that their significance became clear.

The immediate jolt was severe. But worse still, recovery was nowhere in sight. Every year after 1929 seemed a

1

2

so much unemployment meant to the strained welfare agencies of the inner city: "Chicago is in desperate need. It cannot pay its debts; it cannot feed its hungry. Here there are 700,000 men and women without work, more than 100,000 families on the dole. These people are being fed for the time being, but not with Chicago's money. State funds are being used, funds borrowed on the strength of the state government's credit, and even this money will be exhausted before long."
(Courtesy Chicago Historical Society.)

3. Squatters in Hoboville, Harrison and Canal Streets, 1932

Throughout the city, on vacant lots, near railroad yards—on unused land of all kinds—"Hobovilles" and "Hoovervilles" sprung up. With houses built of flattened tin cans, cardboard, scrap lumber and tar paper, these villages of the unemployed were often run with surprising cleanliness and organization. This one had not only its own flagpole but an attempt at landscaping as well.
(Courtesy Chicago Historical Society.)

4. Unemployed Meeting in February, 1932

Between two and three thousand unemployed persons gathered at this meeting held at Monroe and Sangamon Streets in 1932. Carrying signs reading "Flophouse Starvation Army" and "Don't Starve, Fight," such mass meetings and demonstrations were the overt signs of the discontents bubbling in the 1930's.
(Courtesy Chicago Historical Society.)

3

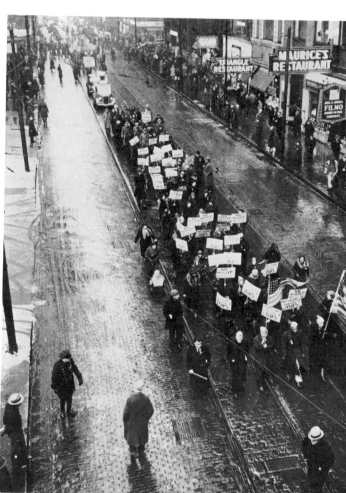

5

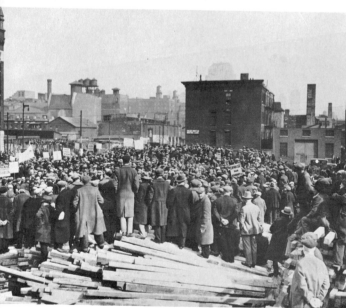

4

5. WPA Parade, January, 1939, Madison Street East from Wells

The depression clung to the whole decade of the thirties. Unemployment was still a problem in 1939, and WPA marchers exercised their right to demonstrate with demands for jobs for themselves and milk for their children.
(Courtesy Chicago Historical Society.)

360

A Century of Progress

1. Northward on the Lakefront, across the Century of Progress, 1933–34

The sparkling white and bright colored Century of Progress Exposition stood out in bold relief to the smoky lakefront buildings. Amid the depression the Exposition seemed a promise of a brighter future. *The Literary Digest* caught the mood: "Rainbow City—thus Chicago's new World's Fair is dubbed by *The Literary Digest*—flaunts to the sky the boldest hues of the spectrum, in audacious and sometimes cock-eyed forms. . . . Bathed in extraordinary effects of light, they signal Chicago's invincible optimism to Arcturus, the Rainbow City's guiding star—for it was a forty-year-old beam from Arcturus, a beam born at a time of the White City, that Science employed to open 'A Century of Progress.'" (Photograph, Kaufmann and Fabry. Courtesy Chicago Historical Society.)

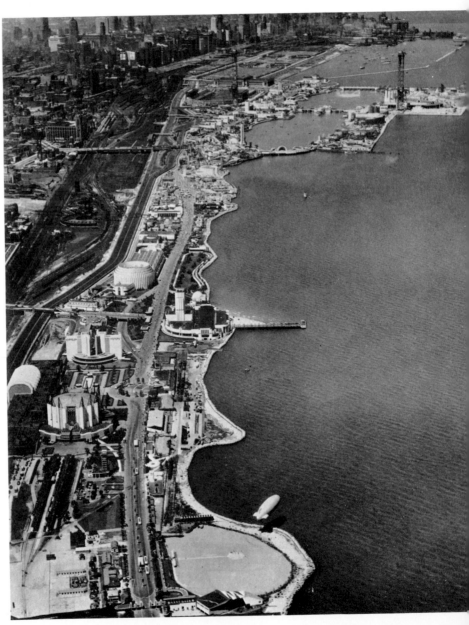

step down. By 1933 employment in the city's industry had been cut in half; payrolls were down almost seventy-five per cent. Foreclosures jumped from 3,148 in 1929 to 15,201 four years later; over 163 banks, most located in the outlying areas, closed their doors. Land values which had reached the five-billion-dollar level in 1928 dropped to two billion dollars at the beginning of 1933. Every index reflected the same grim story.

Yet no statistics could convey the human impact of the Great Depression. How do you measure the hunger, anxiety and despair bred by months and years without regular work or family income? How do you measure the missed opportunity, shattered careers, and unfulfilled hopes? Chicago in the thirties was a place which few people of the twenties could recognize, and a city hard to imagine even now. In the first half of 1931 alone, the Bailiff's Office evicted nearly 1,400 families. The Urban League reported on August 25, that "every available dry spot of ground and every bench on the west side of Washington Park between 51st and 61st Streets is covered by sleepers." On October 3, the *Chicago Times* described 1,500 men huddled along the lower level of Michigan Avenue between Wacker Drive and Lolde Street waiting for food. "Some were young, others old, their clothes were shabby but not tattered Everywhere the men carried huge rolls of old newspapers or lay covered by the sprawling black and white sheets." One young man laid off

1

2. Exposition Grounds

Milton Mayer, concluding a series of articles on the Exposition, probably captured the main impression of the fair. In June, 1933 he wrote: "It does not matter that one exhibit is swell and another one terrible. What matters is that you can't keep away from the place. . . . It is so confoundedly different from everything we have seen and heard and cursed and wept over the past few years. It is so bright and so simple. It is so new. You go in cynical and sour and you come out convinced that you'll pull through and so will everyone else. You sit on your front porch or you sail on the lake or you drive down the boulevard at night and watch the lights go on and transform the place into a paint factory on fire, and you say to yourself, 'By the dog of Egypt, if someone had given me twenty-five million smackers and a strip of land and told me to do what I wanted, this is what I'd have done. It's just what I'd have done. A green building here. A purple building there. A yellow building there. Filled full of people and light. I couldn't have done it better myself. And you couldn't have. The people who conceived this Fair and built it struck just the right note at a time when the rest of us did not know where to turn next. If you ask me . . . I think that A Century of Progress (drat that name!) is a galloping success.' " (Courtesy Chicago Historical Society.)

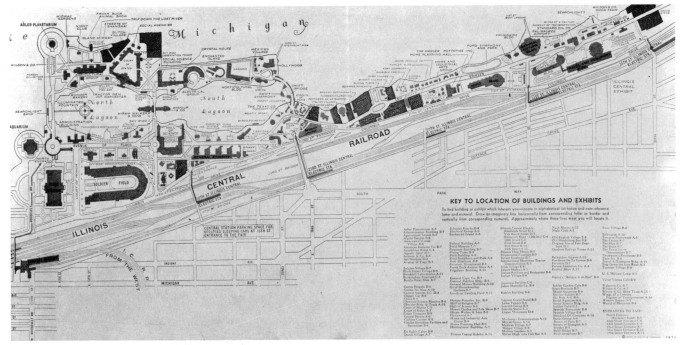

2

3

3. Northern Entrance to the Century of Progress Exposition, 1933

To the north, Michigan Avenue's crisp facade stands as a background for this temporary pedestrian ramp and street railway terminal. These were built on a trestle through the Central Station of the Illinois Central and across the I.C. tracks. The ramp across Outer Drive still provides access to the Field Museum of Natural History, though it has been partially reconstructed.
(Courtesy George Krambles Collection.)

A Century of Progress

2. Travel and Transport Building, 1933
To cut expenses, the buildings of the Exposition utilized new building materials, including prestressed concrete, asbestos board, and sheet metal. The Travel and Transport Building was a special illustration. Its walls were of sheet metal, bolted and clipped together. Its roof was suspended, hanging from a series of twelve cables, much in the way that suspension bridges were erected. "Planes and surfaces

by a railroad expressed the frustration and depair of the times. "I've looked everywhere for work. I go to the public library and wash my shirt there, cribbing a bar of soap whenever I can. I've only one sock left—the other is gone out. If I don't get something soon I'll simply have to check out—that's all." And radio comics Amos and Andy summed up the hopelessness of the years by the grim story of the man who went to a hotel and asked for a room. "For sleeping or jumping?" the clerk replied to his inquiry.

Yet there was some relief from the drabness and grimness. On the lakefront, amid man-made islands and lagoons, Chicago opened its second World's Fair in 1933. Against the backdrop of the grey and beaten city, it was a flashy assembly of bright colors, angular buildings, and "modernistic" forms. The Columbian Exposition of forty years before had reached back to the classical past for its architectural theme; the "Century of Progress," designed by Joseph Urban, groped toward tomorrow. "The fair stands a symbol of the architecture of the future," the chairman of the architectural commission asserted, "—the icons of the past cast aside, the ingenuity of the designers of the present thrown on their own resource to meet the problems of the day—strengthened only by the background of scientific engineering and inventive genius."

Not all architects agreed, and the

1

2

characterize this architecture instead of classical lines or a parade of plaster, ornamentation and decoration," D. H. Burnham, Jr., wrote in 1932. "Instead of expensive exteriors, we are depending on the dramatic effects of lights and bright colors to furnish a background both new and inspiring. As a result, we are building for less than fourteen cents a cubic foot of space."
(Courtesy Chicago Historical Society.)

3. Century of Progress Exposition, Southeasterly across Grant Park, 1933–34

Contrasting the new exposition to the one held in 1893, a *Literary Digest* observer was awestruck: "Once more Chicago startles the world with a great, big show, as she did forty years ago. And what a difference!

Then it was the 'White City,' which took the breath away with the stupendous 'frozen music' of its classic architecture, while this year the modernistic towers of 'A Century of Progress' outmarvel the Arabian Nights with their varicolored splendor."
(Courtesy Chicago Historical Society.)

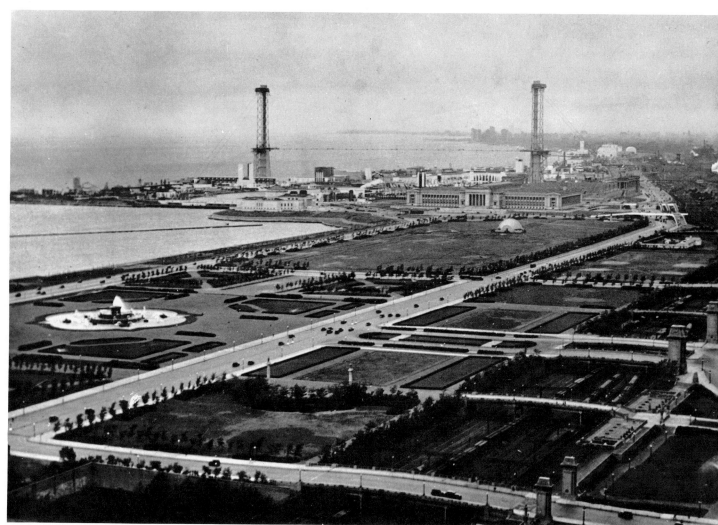

1. Marshall Field Garden Apartments on Sedgwick Street, 1928
"The purpose of the Marshall Field Garden Apartments . . . was to provide moderate-priced living quarters to a selected tenancy close to the downtown section," the *Architectural Record* recalled in 1934. "This involved building in an area where surroundings were not of the standards desired within the apartments," so a private community was created within the larger community providing its own social organization and services. By mid-1967 this development, renamed Old Town Gardens, had badly deteriorated, and its future was uncertain. (Courtesy Chicago Historical Society.)

"Century of Progress" set off a lively debate among experts. Frank Lloyd Wright, rejected as a member of commission, dismissed it as "stale." "There is nothing in the fair except wholesale imitation, hit or miss, of the genuine forms that occurred in out-of-the-way places many years ago." Ralph Adams Cram found it an assemblage of "incorrigible ugliness—a casual association of the gasometer, the freight-yard and the grain elevator." And, in words reminiscent of Louis Sullivan's judgment of the Columbian Exposition, he concluded that it was "a return to the vegetable aberrations of the fifty years of esthetic dark ages in the United States." Between conflicting appraisals, the editor of *American Architecture* pronounced the style to be "transitional" and a vivid reminder "of the part science now plays in architecture and building."

Others, however, saw the fair from other perspectives. The Chicago *Tribune's* Reuben D. Cahn thought the exposition was just the "dramatic event . . . needed to promote the return to happier thinking and more normal living" to a depression-weary people. "Chicago is leading the country back to prosperity," he asserted, calling the city "the business spark-plug of a nation." Milton Mayer, an early skeptic, examined the exposition and declared, "I am a changed man. I have thrown away my hammer, which I love dearly, and I have got me trumpet I am a World's Fair booster." Indeed he shared the *Tribune's* broader optimism. "I have been to the lake front and I have seen men taking the bull of the depression by the horns."

Most importantly, the people responded to the Century of Progress. After a slow start, daily attendance averaged over 100,000. When the gates finally closed in October, 1934, over thirty-nine million people had seen the fair. Just as surprising, the enterprise had been an unqualified financial success. It repaid all its debts, gave the bondholders their six per cent, and wound up with a cash surplus.

In the long run the impact of the Century of Progress was psychological rather than economic. For after the buildings came down, the grimness of the depression lingered. Unemployment remained high, business recovery was slow, and people began to adjust to a more modest future. Increasingly, the city government turned to Washington for help. The New Deal responded sympathetically, perhaps a little more to Chicago than elsewhere because Anton J. Cermak, the popular new mayor, had been killed by an assassin's bullet directed at President-elect Franklin D. Roosevelt. Most of the new federal programs for municipalities involved relief and jobs for the distressed and left no physical mark on the city. But others, concerned with housing and planning, had an important long range influence.

The most significant assistance in housing flowed from the new Federal Housing Administration. It provided funds to lending institutions which guaranteed home mortgages and stimulated a dull building market. This policy favored single-family dwellings and encouraged construction on the outer edges of the city or in the suburbs while discouraging apartment investment. Most importantly, it did nothing for rehabilitation in the older areas of the city where the pressure was most acute and the structures were most in need of immediate attention. The FHA, then, tended to accentuate the flight from old neighborhoods and to magnify the problems for those remaining.

Public housing programs, however, tried to come to grips with the needs of the inner city. There had been some assistance for low-income families in previous years. The federal government built some housing in the Calumet region in Indiana for migrant workers in the first World War. In the twenties, two of Chicago's wealthiest men experimented in large projects with private funds. In 1928 the Julius Rosenwald Fund contributed the Michigan Boulevard Garden Apartments of 421 units complete with playgrounds and day nurseries. It served the rapidly growing Negro South Side, while the Marshall Field interests developed a similar enterprise on the Near North Side.

The depression brought a more ambitious effort. Under the new legislation over 5,000 units of public housing were constructed in various parts of the city

2. Looking North from about 850 North Cleveland Avenue, 1940

Many of the buildings in this photograph were soon to be demolished to make way for public housing. At the time the photograph was taken, well over fifty per cent of the dwelling units were branded as "needing major repairs or unfit for use," and nearly seventy-five per cent of them had no bath or toilet.
(Courtesy Chicago Housing Authority.)

3. "Marked for Razing," September, 1934

"Such congestions of old lumber, rickety porches and patchwork garages are doomed in the West Side area where the federal housing projects will be undertaken," a *Herald-Examiner* caption ran. "This picture was taken in the 900 block on (South) Lytle St. and is typical of the neighborhood, which has declined from its opulence of twenty-five years ago."
(Courtesy Chicago Historical Society.)

4. In a Chicago Slum Area, 1934

This *Herald-Examiner* photograph appeared in the fall of 1934 to illustrate one of the blocks which was to be removed to make way for the Near West Side public housing projects. The newspaper caption noted hopefully, "streets, alleys and buildings such as these will be replaced by parks, lawns, and modern airy apartments renting at low cost," as part of a federal Public Works Administration program.
(Courtesy Chicago Historical Society.)

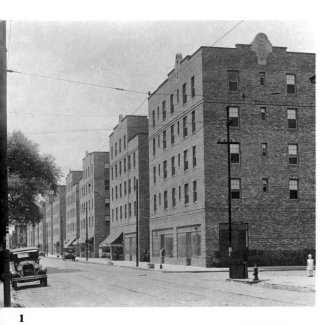

1

2

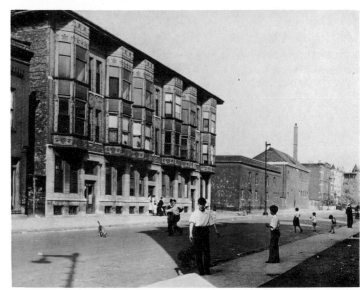

4

1. Edgemont Avenue (Now Grenshaw), West from Loomis, September, 1934
These "dilapidated, weatherbeaten buildings" were replaced by the Jane Addams Homes, one of the earliest low-rent public housing projects.
(Courtesy Chicago Historical Society.)

2. Jane Addams Housing Project, Completed Spring, 1938
In its original plan, the Jane Addams Homes consisted of a mixture of three-story apartment buildings and two-story row houses, totalling 304 units ranging from two to five rooms. Edith Abbott, completing her study of Chicago's tenements just as the Addams project was well under way wrote of it: "The buildings themselves will cover only about 25 per cent of the six-acre tract of land just south of Vernon Park that formerly belonged to the Jewish People's Institute. The rest of the area will be left

before the end of World War II. The apartments did not go above four stories, and some row houses were also built. All had extensive open spaces for play areas, off-street parking and extensive landscaping. They remain today among the most attractive low-income rental dwellings in Chicago. Yet this achievement scarcely dented the housing crisis. In 1939 the Land Use Survey found 76,000 units, nearly eight per cent of the city's total supply, in need of major repairs or unfit for use. And many more were slipping into dangerous condition through over-crowding and neglect.

The city's mounting problems revealed the urgency for more careful planning. The old *Plan of Chicago* had been implemented to a large extent, and it was no longer adequate for the future. It had emphasized boulevards and civic buildings rather than the living and working environment. But now federal funds became available for more modern planning. The Land Use Survey, which went into the field in 1939, represented the first step. Concentrating on residential conditions, it produced two statistics-packed general volumes and 150 others containing maps, figures, and neighborhood detail which laid the factual basis for subsequent activity.

In 1939 the Plan Commission was reorganized for a larger role in city government. Its first job was to produce a "master plan" to succeed the old Burnham Plan, now three decades old. The war curtailed its work, but it did publish

1

2

open; a part of it will be planted in trees, shrubbery, and grass; and parts will be reserved for playgrounds and gardens. The buildings will be of the most modern construction, fireproof and sanitary. They will have ample light and air. All rooms will be outside rooms. . . . In addition to this development on the vacant land of the old Institute grounds, the government purchased some fifteen acres of adjoining property to insure proper surroundings for the new project. Here the old buildings are being demolished and the land will be used for additional housing, similar to that of the Jane Addams Houses, except that there will be more open space for park and recreation purposes. The federal government has allotted $6,950,000 for this project, which will accommodate a total of 981 families, or, assuming an average of four to a family, nearly 4,000 persons." (Courtesy Chicago Housing Authority.)

3. Ida B. Wells Housing Project
The Ida Wells project consisted of two-story row houses and three-story apartment buildings. Opened January 18, 1941, to house 1,662 low income Negro families, it covered nearly forty-seven acres between South Parkway (Martin Luther King, Jr. Drive), Cottage Grove, 37th Street and 39th Street. Over 18,000 preliminary applications were received for dwelling space in Ida B. Wells; 4,000 were screened out as having too high an income, and from the remainder, the original tenants were selected. Attractive landscaping, enhanced over the years by the natural process of growth, and a low percentage of land coverage added to the merit of the project.
(Courtesy Library of Congress Collection.)

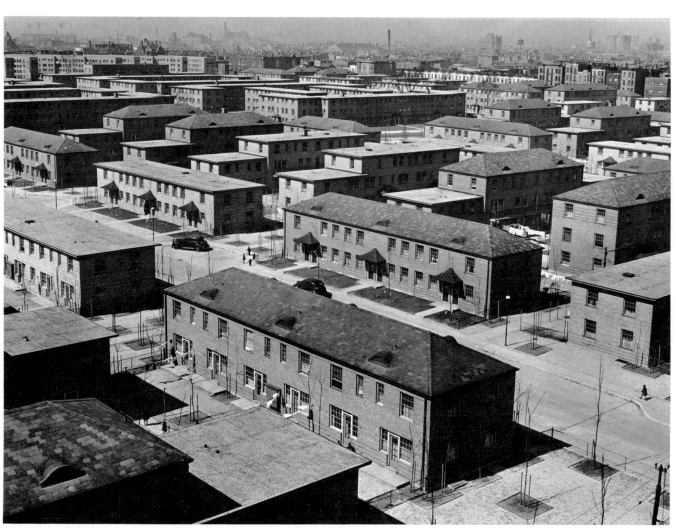

368

1. View near Cabrini Homes

Lecturing to a group of middle class college students, reformer Louis Kurtz noted: "You have noticed many vacant lots in the neighborhood. Well the houses that formerly stood on them either burned down, collapsed or were wrecked. Since 1905 there were no new buildings built in this neighborhood, and so the lots, as a rule, became dumping places and general catch-alls for everything from dead cats to junk of all kinds."
(Courtesy Gordon Coster Collection.)

2. Frances Cabrini Homes

Bounded by the alley north of Chicago Avenue, Oak Street, the alley west of Larrabee Street, and Hudson Avenue, the Frances Cabrini Homes were erected in 1941. The 586 units replaced 700 apartments which were torn down. According to Mayor Edward Kelley, of those 700, "210 had inadequate light and air because the buildings were built close to each other; 433 families had no bath-tubs at all. . . . Forty-three toilets were shared by two families each; There were 29 yard toilets and ten under-sidewalk toilets. 480 of them had no hot water." The Cabrini site was

the *Master Plan of Residential Land Use in Chicago*, which classified the city's neighborhoods and made recommendations for future public policy toward them.

Transportation planning accompanied the work on residential development. The automobile had drastically altered the character of internal circulation and made the need for new facilities obvious. A series of reports between 1937 and 1939 outlined a system of subways and superhighways radiating away from downtown which could handle the increasing demand. The expressways had to be postponed until after the war, but a new State Street subway was opened in 1943; the Milwaukee–Lake Street–Dearborn Street section could not be completed until 1951.

1

If the war interrupted the new efforts of the Chicago Plan Commission, it also brought an abrupt halt to the depression. The nation's entire life had to be organized into a massive productive unit to sustain the troops abroad. In this mobilization Chicago played a big role. As the center of transportation, it became one of the most strategic spots on the globe, and its industrial capacity made it one of the primary producers of war material. New plants sprang up to meet the demands of the crisis. Northwest of the city at Orchard Place, the Douglas Aircraft Corporation made frames for the famous C-54 transport; southwest, Pratt and Whitney aircraft

2

chosen to remove an area of serious blight which was threatening the surrounding neighborhoods, especially the Gold Coast to the east. The project cost $3.7 million including demolition.
(Courtesy Gordon Coster Collection.)

3. Tent Compound for Soldiers at Fort Sheridan, 1941
Within the confines of Fort Sheridan on Chicago's North Shore, soldiers created a city of tents to house wartime inductees while they underwent training.
(Courtesy Chicago Historical Society.)

4. Scene at Stagg Field, September 6, 1943
As war became more scientific the services of universities became more important. This photograph shows the review which took place before the graduation and commissioning of a group of Army Air Force meteorology cadets.
(Courtesy University of Chicago Libraries, Department of Special Collections.)

3

4

engines rolled off the assembly lines of the world's largest single story plant. The Quartermaster Corps took over large parts of the Central Manufacturing District facilities and it became one of the major sources of logistical support for the military forces.

Other Chicago resources were also enlisted. The Stevens Hotel was turned into a military training facility; the Chicago Beach Hotel became a hospital. The Auditorium was handed over to the USO, and its magnificent theater was turned into a recreation hall and its mammoth stage into bowling alleys. Universities, like Chicago and Northwestern, were partially converted to manpower training. Curtis Air Field rapidly expanded as the Glenview Naval Air Station; and the city's Municipal Pier became a naval training base. Two large sidewheel lake passenger ships, the *Greater Buffalo* and the *Seeandbee* were stripped of their superstructure and remodeled as aircraft carriers for training purposes.

Chicagoans took great pride in their support of the war effort. Yet few knew that the most important contribution was taking place in a most unlikely spot. Underneath the west grandstand of Stagg Field at the University of Chicago, a group of scientists had been working since December, 1941, to unlock the secret of the atom. Enveloped in great mystery and secrecy, the work of these men, drawn from all over the world—including refugees from totalitarian countries—was in some ways the most crucial struggle of the war. For it was thought that Germany was close to success in creating a bomb that would dwarf all others and put the world at the mercy of the Nazis. The only safety rested with winning the scientific race, with beating the enemy to the decisive weapon.

The big breakthrough came on Friday, December 2, 1942. It was a cold, blustery day with predictions of below-zero weather by nightfall. The city went about its routine wartime business. The papers headlined the news from the front: "U. S. Drives to Sea in Tunisia" and "Mussolini Puts Spur to Italy." The other big stories concerned the impact of gas rationing: parking lot use fell off sharply in the Loop, public transportation strained with the increasing load, and investigators uncovered widespread gas hoarding. The Christmas book section of the *Daily News* reviewed John Steinbeck's *Bombs Away, the Story of a Bomber Team*, and over at the United Artists Theater Hedy Lamarr played in "White Cargo," where she put "her feminine charms wholly to the services of evil." The Chicago Cardinals prepared to play the Bears, and DePaul University and the University of Chicago opened their basketball seasons that night.

Late in the morning Enrico Fermi, the great Italian physicist who directed the construction of the experimental atomic reactor, was ready to take the fateful step. A dozen other scientists stood on the balcony that overlooked the awkward pile of graphite and uranium blocks where the chain reaction would occur. More ominously, on a nearby platform was the "suicide squad" ready to destroy the pile and quench the chain reaction if all went wrong. Fermi gave the order to release the safety rods. "We all knew this was the real test," Arthur Compton wrote later. "The geiger counters registering the neutrons from the reactor began to click faster and faster, until their sound became a rattle. Now the galvanometer pointer, indicating a current in the ionization chambers, began to move, at first slowly, then faster and still faster. The reaction grew until there might be danger from the rays coming from the pile. 'Throw in the safety rods," came Fermi's order. Immediately the pointer moved back toward zero. The rattle of the counters fell to a slow series of clicks. For the first time atomic power had been controlled and stopped." After a moment's pause, someone handed Fermi a bottle of chianti and a cheer went up. Outside on Ellis Avenue students and faculty and passersby moved briskly through the unpleasant, chilling winter air unaware that a few hundred feet away the "Modern Age" had begun.

1. West Stand of Stagg Field, 1942

No place seemed less appropriate for an important scientific project. Not only was it located in an athletic stadium, but the University of Chicago had not been victorious there for years.

(Photograph, *Chicago Tribune Magazine*. Courtesy Chicago Historical Society.)

2. The First Nuclear Reactor, 1942

The reactor was later dismantled and reassembled at the Palos Park unit of the Argonne National Laboratory.

(Sketch, Melvin A. Miller. Courtesy Argonne National Laboratory.)

3. "Nuclear Energy"

Henry Moore has tried to capture the ambiguous legacy of the event in this piece of sculpture located on the exact spot where the modern age began.

(Courtesy University of Chicago Library.)

1

3

2

CHICAGO AT NOON

The most impressive first sight of the New World is when you sail into New York harbor—if it is on a clear day. But the most impressive first sight of the Midwest is when you fly into Chicago at night from the East, descending over the blackness of the prairie to the great, ruddy blast furnaces and steel mills, catching the first winkings of the Lindbergh beacon from the Palmolive Building away on the starboard bow, and watching the brilliant rectangles formed by a thousand square miles of straight streets and buildings. Huge, sprawling city of swamp and prairie; one community of many communities, *communitas communitatum;* it is both a Pittsburgh and a Detroit; a financial and commercial center; a warehouse, department store, mail-order house, granary, slaughter-house, and inland seaport; a repository of great wealth and great poverty; a center of learning; metropolis of that million square miles which is the heart of America. It is something of a national metropolis, too, because of its position. It is the national headquarters of the medical, surgical, and hospital associations; of Rotary and other service clubs; of America's library associations; of the mail-order business; of the musical and juke-box industry, which plays so large a part in American life; of the *Encyclopaedia Britannica;* and of the cinematograph equipment trades. It is a part of all American life. . . .

In Chicago all the extremes and extremisms of the region reach a grand climax. Within a minute or two's walk of the splendid stores and hotels and offices in the Loop you pass the flophouses of West Madison, Canal and North Clark streets; the hiring office for casual railroad laborers ("Good Eats Provided" painted white on the windows); the terrible slums and Negro district near the stockyards; the waste lands near the railyards; the hangouts of the bums and especially of the old, wrinkled, slow-moving, pathetic bums. I think "bums" and "bumming around" are still used more frequently in the Midwest than anywhere else because of the size of the region, the importance of its vast railroad network, the building of that network and its maintenance. It is natural, in the region of the greatest mobility in America, that the Germans' *bummeln* should have thus passed into the general slang. . . .

One feature in which Chicago is very like big British cities is in the size of its suburbs. That is scarcely surprising, since the city has grown by absorbing small outlying villages and converting them to suburbs. These are now the home of the middle class, the clerical workers and the professional men. Being the Midwest capital and metropolis, Chicago has a very big middle class—or perhaps, as "classes"

are not supposed to exist in America, I had better say, as Americans do, "a great concentration in the middle income brackets." But these Chicago suburbs of the well-to-do and the "middle income brackets," unlike the suburbs of European cities, are very beautiful; they have also far more variety than those of the British cities. They have more of a community sense and community life of their own, centered round their community houses, libraries, forums, clubs, societies, or high schools. Places like Oak Park with 70,000 souls—"biggest village in the world"—Winnetka, Riverside, and Hinsdale set a high standard for suburban community life, and though they are not satisfied, they have already outdistanced most suburbs in overcoming the problems of life in a big city. They have community sense and community achievement to their credit, where the suburbs of cities in the Old World have only apathy and bleak failure. Indeed, the suburbs of most of the big cities in the Midwest are way ahead of others, both in and out of America, in this respect; and that is scarcely surprising, because the sense of community is, and always was, so strong in this new region. But, in making these communities, the community sense has been taken away from the city's center. The problems of Chicago, as of the other big cities and towns in the Midwest and everywhere else, are left at or near the center: the "inner ring" of solid and densely settled residential areas where the manual workers live; the areas of slums, dilapidation, or overcrowding; and these are linked with the level of incomes and the grading of jobs. That leaves the problems with the city fathers while the satisfied suburbanites go free. You cannot take the "El" or the Illinois Central out of the Loop and look out of the windows without wondering when and how Chicago is going to clear its slums, its deathtraps, and its breeding grounds of crime and social problems.

David Graham Hutton, *Midwest at Noon* (Chicago, 1946), pp. 140–48.

6 | Revival and Crisis, 1945–69

The coming of peace in 1945 brought with it special problems for Chicago. Not only did the end of the conflict bring back memories of the prewar depression with its unemployment and want, but it also conjured up the scenes of readjustment and disorder that had followed World War I. The city braced itself to meet the crises. Public works, long on the drawing boards, were brought out in the hope that new construction would absorb some of the jobless as well as meet many of the city's deferred civic needs. While some officials talked bravely about forty million jobs for postwar America, most people planned for the return of scarcity and hard times.

Actually, the postwar years brought prosperity, not depression. For over two decades the nation's economy expanded. Unemployment, except for brief periods, was modest; and personal incomes rose continually. To be sure, not all shared equally in the new affluence, but the conditions in which decisions, both public and private, had to be made were quite different than the grim predictions based on the past. Ironically, however, the character of postwar growth magnified the city's problems. Most of the new metropolitan development took place outside of the old municipal limits; the suburban expansion drew away many of Chicago's substantial taxpayers; even the commercial and industrial base of the city dwindled as more and more firms located new establishments in the surrounding areas.

But if the city's financial resources were smaller, its responsibilities were larger. As older middle-class residents left for the suburbs, low-income newcomers took their place. These people not only had fewer resources, they also had greater problems. Hence the city had to do more than before—in the way of housing, education, and welfare—with less money. Moreover, Chicago remained the center of the expanding metropolis and was expected to provide the additional services for an ever-burgeoning population that lived outside its boundaries but which contributed little to its public revenue.

Chicago, of course, was only facing the same set of problems that afflicted every major metropolis. Central cities, fringed by suburbs, could no longer expand; indeed, the census of 1960 revealed that most of the larger places actually lost population in a period of enormous metropolitan growth. They all had, in addition, an aging urban plant that needed renewal, if not replacement. To compound their problems, cities were restricted in raising revenue. State legislatures, dominated by rural and suburban interests, denied to local officials the power to collect additional monies. Relatively little help was forthcoming from the federal government until the mid-sixties. It was these facts that generated a pervasive pessimism about urban prospects. As elsewhere, many people in Chicago were gloomy about the future of the city. Scholars and critics pre-

dicted its decline and decay. A. J. Liebling, who spent a year in Chicago (1949–50) and wrote his unflattering portrait, *The Second City*, found "pride and singing had been muted" and that "Chicago wore a grin that might have indicated punch drunkenness." The only question for him was what had killed Chicago.

The pessimists did not seem entirely wrong during the first postwar decade. While the suburbs flourished, the city languished; while new shopping centers sprouted up all around the municipal boundaries, not a single major building went up downtown. Housing starts rose only modestly in Chicago, but construction could scarcely keep up with the constant demand for new homes in the surrounding communities. The census told a large part of the story. By 1950 the metropolitan population reached nearly 5,600,000; yet Chicago's 3,621,000 represented only a 6.6 per cent gain over 1940. By 1960 the figures of 6,794,461 and 3,550,404 indicated a further relative city decline and an absolute drop over the previous count.

Yet this picture was somewhat deceiving. In the first place, the disproportionate suburban growth followed an historic pattern. Chicago and other American cities had always grown fastest at their outer edges. Previously, however, the new areas on the periphery were annexed to the city and became part of the larger municipality. Indeed, before the massive annexations of 1889

more people lived in the surrounding areas than in Chicago itself. But annexation was no longer possible in most places. The surrounding suburbs resisted joining the city, and the newer developments took place even beyond the old suburban boundaries, where people were even less interested in becoming a part of Chicago. Thus the metropolitan area grew at the expense, so to speak, of the city.

Dismal predictions about Chicago's future also overlooked the civic revival that was under way already. Initially evident in public redevelopment projects, it was soon visible in many parts of the city. Not only did the city tackle the historic problem of cleaning out the slums, but private investment returned to the city in unprecedented amounts. Two massive modern filtration plants assured clean and abundant water for a whole generation to come. Port improvements and the opening of the St. Lawrence Seaway gave added impulse to Chicago's water commerce. O'Hare International Airport pushed the city once again towards leadership in the air age. A new expressway system, transit improvements, and changes in railroad commuter services relieved the growing paralysis of the circulatory system within the metropolitan area. New residential construction and high-rise apartment buildings partially stemmed the outward flow of middle- and upper-income urbanites, and a new skyline rose spectacularly over the city's center.

To be sure, the critics still talked about the "death of the city," but the facts everywhere belied the theory.

The central figure in the Chicago revival was Mayor Richard J. Daley, first elected in 1955 and then re-elected three successive times. His position as head of the majority party and chief executive of the city provided him with both the political power and administrative strength to focus and direct the divergent forces demanding public action. Enjoying cordial relations with business and labor, and managing to establish effective contacts with most neighborhoods, he emerged by the 1960's as one of the nation's most formidable mayors. On taking office Daley immediately began to assemble a "cabinet" of young municipal experts who brought training and energy into City Hall and who devised programs that attracted wide attention. At a time when many raised the question, "Are American cities really governable?" Chicago developed the most energetic administration in its history.

Even this effort, however, did not "solve" the perplexing problems of an urban society, although it did lead to measurable progress on many. Dilapidated housing, for example, dropped from twenty-eight per cent of all dwellings in 1950 to less than ten per cent in 1967. Medical services were improved and more widely available. The police department was overhauled, new alley and street lighting was installed, and the

1. 558 West DeKoven Street, 1952

Long before this photograph was taken, a historical plaque was placed on the front of this building to designate it as the site on which the great fire of 1871 had begun. But by 1952 the buildings on this block, located near the southern edge of the Loop district, were dilapidated. Soon after the photograph, the area was cleared for industrial redevelopment.
(Photograph, Mildred Mead. Courtesy Chicago Historical Society.)

2. Southwest Corner of Clinton and Liberty Streets, Adjoining the Soo Line Railroad Tracks, 1949

A handwritten caption on the back of this photograph indicated the condition of this house: "10 people—5 families. No toilet, no outhouse, no electricity."
(Photograph, Byron C. Sharpe. Courtesy Metropolitan Housing and Planning Council.)

1

2

3. 1400 Hastings (Located between Thirteenth and Fourteenth, between Throop and Loomis), 1950

Within walking distance of the South Water Market, this Near West Side photograph shows an old bus used as a house by one family. A high proportion of the homes in this area was already dilapidated in 1940 (forty-six per cent of the block in the photograph). In 1943 the Chicago Housing Authority opened the 834-unit Robert H. Brooks Homes just north of here. The city–state financed 126-unit Loomis Courts replaced the area in the photograph, in 1953. Five thousand seven hundred people occupied the megablock replacement in 1960.
(Photograph, Mildred Mead. Courtesy Chicago Historical Society.)

3

1. 3600 Block on Federal Street, 1951

Referring to the South Side slums, Louis Kurtz wrote in 1945 that "I have seen pitiful, pathetic, deplorable, rotten and damnable shacks, hovels, leantos and hell-holes in my travels, but when you see these Negro families huddled together like cattle in dilapidated wood sheds, garages, make-shift huts made of old lumber, old tin signs, cardboard and whatever could be picked up and fastened together as a shelter, one cannot help but realize that, rotten and deplorable as all slum areas are, the '*Black Belt*' of Chicago beats them all when it comes to *Misery at its worst!*"
(Photograph, Mildred Mead. Courtesy Chicago Historical Society.)

2. Unidentified Slum Dwellings in Chicago, about 1950

"Walking eastward from his Loop hotel," a Chicago publication stated in 1947, "the visitor to Chicago may find inspiration at the Art Institute, peace in the changing cascades of the Buckingham Fountain, or

fire department was modernized. National awards for cleanliness and safety indicated that routine housekeeping chores were being well managed. Yet public education and race relations remained troublesome and potentially dangerous questions. Indeed, the crises in these two fields were consistent reminders of the distance Chicago still had to travel before the pessimists would be proved to be finally mistaken.

The physical problems of postwar Chicago were only too obvious. Just south of the Loop was the Near South Side, once the city's most fashionable neighborhood, now its worst slum. Where the Armours, Fields, and Palmers had lived in style were now row upon row of dilapidated buildings, overcrowded and pest ridden. The most recent arrivals to Chicago settled there first; for some, especially Negroes, there was no escape. The cancer stretched for miles. Years later critics of urban redevelopment would complain of the massive slum clearance and the destruction of "old neighborhoods." But to those who lived in these areas or to those who knew them well, the bulldozer was the only remedy left. Most of the buildings were erected in the nineteenth century; many lacked modern plumbing and electricity. Virtually none had been adequately maintained for more than a quarter century. As early as 1943 the Plan Commission's *Master Plan of Residential Land Use* called for total demolition in twenty-

1

2

relaxation on a park bench overlooking beautiful Lake Michigan. South, west, or north of the Loop there is a different picture. Chicago's visitors seldom see the poverty, disorder, dirt and human misery of what was once the city's finest residential area—now degenerated to a slum. Chicago knows—but does not boast—that on its South Side, between 12th Street and 47th Street, lies the largest contiguous slum area in any American city."
(Photograph, Leonard J. Welter. Courtesy Metropolitan Housing and Planning Council.)

3. Honore Street, between Thirty-Fifth and Thirty-Sixth, 1949

This view was taken across the back yards of a block that for a time was dubbed "Outhouse Alley." Just behind the old row houses, which lined the street, a row of privies attested to the lack of interior sanitation facilities. These houses were built before McKinley Park, just two blocks west, was opened in 1901. They housed working class families, who were employed in industrial plants along the nearby South Branch of the river and the banks of the Chicago Sanitary and Ship Canal.
(Photograph, Mildred Mead. Courtesy Metropolitan Housing and Planning Council.)

3

4

5

4. Northwest Corner of Vincennes Avenue and Thirty-Seventh Street, 1953

The area shown in this photograph had been undergoing redevelopment since the early 1940's. In 1930 eighty-nine per cent of the neighborhood residents were black, a figure which increased during the next decade. Lake Meadows lay just to the north, but it was not until 1955 that this area was replaced by the 641-unit Ida B. Wells Public Housing Project Extension.
(Photograph, J. Sherwin Murphy. Courtesy Chicago Historical Society.)

5. 6217 South Wabash, Washington Park

By 1915 the Washington Park community was completely built up. During the next half-decade, Negroes in the areas to the north began moving into this area. The influx was rapid, and by 1930 it was ninety-two per cent Negro. To meet this heavy demand for housing, landlords converted old single-family dwellings into multi-family units. The block containing the house in this photograph, located at the southwest edge of the community, fared little better. In 1961 a federally sponsored development for the elderly, Washington Park Homes, was completed on this site.
(Courtesy Chicago Housing Authority.)

1. 2621 South Cottage Grove Avenue, 1950

The three-story brick building on the right contained one of the worst examples of overcrowding in the city. On the middle section of the third floor an investigation revealed that twenty-four people were living in one four-room apartment. These two buildings were torn down to make way for the Prairie Shores project, which now houses middle and upper middle income families.

(Photograph, Mildred Mead. Courtesy Metropolitan Housing and Planning Council.)

2. 215–19 East Thirty-First Street, 1950

The tall building in the center was a notorious tenement in a neighborhood of endless troubles. The story of the block's decline was told in the census tract data. In 1940, 218 dwelling units occupied thirty-seven different buildings. A decade later 253 dwelling units occupied virtually the same buildings. Meanwhile, rents rose from about nineteen dollars per unit to

three square miles of blighted and near-blighted residential areas. The solution could, no doubt, have been better, but any city which left these slums standing could be rightfully indicted for callous injustice as well as for shortsightedness.

Part of the attack on this enormous wretchedness came from private sources, for the spread of deterioration not only scarred the lives of those who lived there, but it also jeopardized important institutions. On the Near South Side, the Michael Reese Hospital, at the time the largest private hospital in Chicago, and the Illinois Institute of Technology were almost engulfed in blight. Both occupied old buildings; both had ambitious expansion programs on the drawing boards. For each, a critical decision was at hand: whether to remain in the area and help transform it, or to move to some other place where land was cheaper and the neighborhood more desirable. Both courageously decided to stay and to throw their weight into the effort to create a new environment.

Once committed to remaining, both institutions girded for the battle. Michael Reese became the first hospital in the nation to hire its own professional planning staff with Reginald R. Isaacs as director. I.I.T. responded similarly, and appointed the celebrated architect Mies van der Rohe as chairman of its Department of Architecture with the responsibility of designing its new campus. Other institutions and business establishments in the area also joined the

1

forty dollars per unit. In both decades Negroes made up over ninety-seven per cent of the residents. By 1960 the worst of the buildings had been removed. Still, out of the 141 dwelling units remaining, only fourteen were sound, ninety-six were deteriorated, and thirty-one were dilapidated. Rent per unit had meanwhile risen to an average seventy-three dollars per month. (Photograph, Mildred Mead. Courtesy Metropolitan Housing and Planning Council.)

3. Northeast Corner, Thirty-Third and Rhodes, 1950

All but one building on this block were built before 1900, and by 1950 their history was typical of the South Side black ghetto. Increasing conversions had brought the number of dwelling units to 145 on a block where the buildings were probably meant to hold under 100 families. Meanwhile, business establishments took over some of the ground floors near 31st Street. In 1950 over sixty per cent of the units on this block had no bath, no running water, or were

dilapidated; it was cleared to make way for the Lake Meadows project. (Photograph, Tedward A. Dumetz, Jr. Courtesy Chicago Historical Society.)

4. 3400 Block on Cottage Grove Avenue, View Southward, 1954

The characteristic wooden rear porches associated with the older three-story building style became a fire and health hazard as they aged. This building was on the site of the Lake Meadows project. (Photograph, Mildred Mead. Courtesy Metropolitan Housing and Planning Council.)

2 3

4

1. Air View of the Michael Reese–Lake Meadows–Prairie Shores Area before Redevelopment Northeast from Thirty-Seventh and South Parkway (Martin Luther King, Jr. Drive), about 1947

Illinois Institute of Technology was the first organization to announce plans to stay in their old neighborhood and to rebuild and expand a campus for what was "the fastest-growing engineering school in the country." "The example was infectious," according to Dorothy Rubel, Director of the Metropolitan Housing and Planning Council. "Soon Michael Reese Hospital, a neighbor one mile to the east, abandoned its search for a slum-proof location, and joined Illinois Tech in the fight to redeem its tatterdemalion surroundings."
(Photograph for Planning Department, Michael Reese Hospital. Courtesy Municipal Reference Service.)

effort, forming the South Side Planning Board and working with city officials.

After the broad plan had been drawn up, the New York Life Insurance Company was induced to invest in a large pioneering project in middle income, racially integrated housing. The Lake Meadows enterprise ultimately covered over 100 acres, including ten high-rise buildings with a total of 2,033 residential units. The public contribution consisted of assembling and clearing the site, providing a "write-down" of the land cost to a level which was competitive with outlying areas in inducing development, relocating former occupants, vacating and adjusting streets, rerouting utilities and modifying the zoning. In addition, the school board and the park district

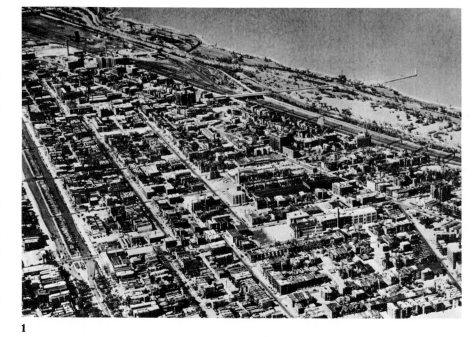

1

2. Air View, Northward across Thirty-Fifth Street of the Michael Reese–Lake Meadows–Prairie Shores Redevelopment, Late 1950's

Running along the left of the photograph is South Parkway (Martin Luther King, Jr. Drive). East of it are five twelve-story buildings, and behind them is a luxury apartment building and four twenty-one story buildings, all part of the Lake Meadows project. Beyond them, on King Drive, three of the five apartment buildings which make up Prairie Shores had been completed. Immediately east is the enlarged plant of the Michael Reese Hospital. Many of the buildings in the immediate forground were subsequently removed to make way for additional renewal projects, and Doolittle School, located in the right foreground, was expanded.
(Photograph, Mart Studios Incorporated. Courtesy Municipal Reference Service.)

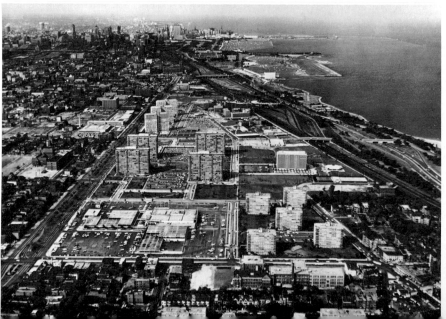

2

3, 4. View Eastwards toward Michael Reese Hospital and Prairie Shores Apartment Houses, 1944 and 1963

Taken from the same viewpoint, nearly two decades apart, these two photographs offer the startling contrast which urban renewal made on the South Side. Worn-out three-story buildings, which crowded each lot, gave way to high-rise buildings, which maintained relatively high densities as well as creating large amounts of open space but which housed a much higher income group than that of the former residents on the site.
(Courtesy Gordon Coster Collection.)

5. Prairie Shores Apartment Buildings Northwesterly across Thirty-First Street from Michael Reese Hospital, 1960

This project contains five nearly identical buildings.
(Photograph, Edward F. Kloubec. Courtesy Chicago Historical Society.)

6. Old and New in a South Side Redevelopment Area, View Westward from the 3100 Block on Wabash, 1950's
(Photograph, Mildred Mead. Courtesy Metropolitan Housing and Planning Council.)

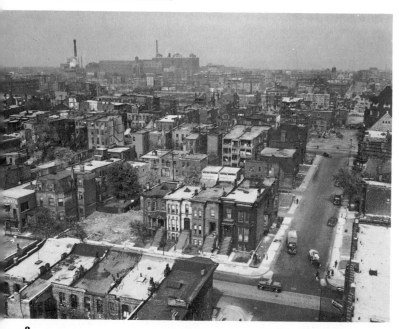

3

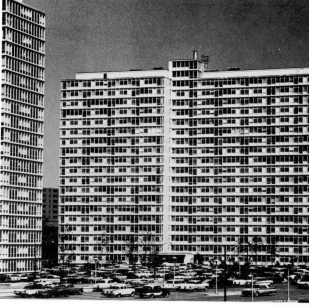

4

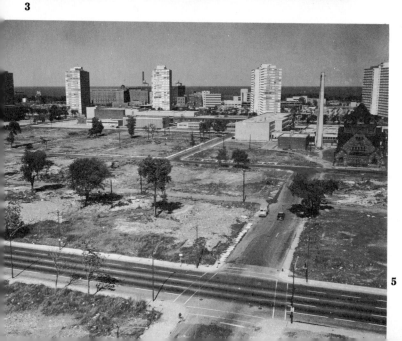

5

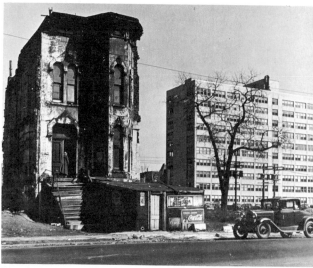

6

1, 2. View across the Illinois Institute of Technology Campus, Corner of Thirty-First and Wabash, 1944 and 1963
Old houses surrounded the I.I.T. campus in 1944 when the first photograph was taken, and some of the city's worst slums were in immediate proximity to the campus.
(Courtesy Gordon Coster Collection.)

3. George Washington Carver Homes, 1951
Located at 35th Street and Michigan Avenue, Carver Homes is a private, middle-income housing project.
(Photograph, Mildred Mead. Courtesy Chicago Historical Society.)

installed educational and recreational facilities near the project. The first buildings were finished in 1953, and the enterprise was completed within a decade; the total construction cost ultimately exceeded $35,000,000.

As a large experiment in urban renewal, Lake Meadows has been under constant scrutiny and some criticism. Nearly everyone agrees that as a demonstration of integrated living by middle class whites and Negroes, it has been successful; it has also suggested the creative possibilities of public and private cooperation in slum clearance and neighborhood rebuilding. The increased tax revenue coming from the renewed area indicates that in the long run the public's money will more than be repaid. The complaints center on the dislocation of the former residents, virtually none of whom can afford to live in the new apartments. Yet of the 3,416 families formerly living on the site, ninety-two per cent eventually moved into standard housing, a significant improvement over their previous conditions.

One of the first results of the Lake Meadows success was the Prairie Shores project immediately to the north. Once again public money provided the first incentive, with $6,200,000 spent in acquisition and site preparation. Ultimately private investment exceeded twenty-seven million dollars for over 1,200 dwelling units in five large apartment buildings, a local shopping center, and new playground facilities. East of Prairie

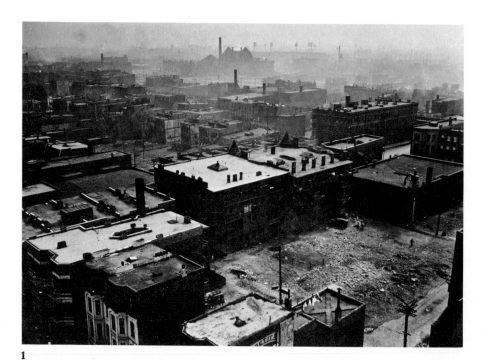

1

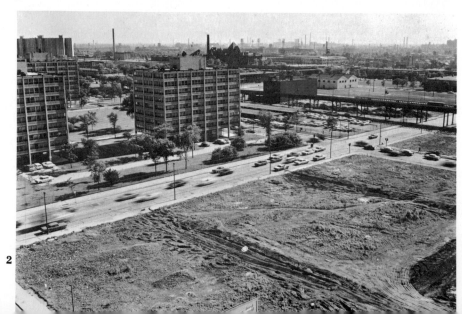

2

4. Raymond Hilliard Homes at State Street and Cermak Road, 1966

Built by the Chicago Housing Authority, this low-rent public housing project was designed by Bertrand Goldberg. It consists of two circular and two semi-circular towers. Many of the apartments were intended for occupancy by the elderly.

(Photograph, Albert M. Hayashi. Courtesy Chicago Historical Society.)

5. North Side of West Twenty-Fourth Street, Looking West from 260 West Twenty-Fourth Street, 1966

(Photograph, Sigmund J. Osty. Courtesy Chicago Historical Society.)

6. Northwest Corner of West Thirtieth Street and South Parnell Avenue, 1966

Only two per cent of the dwelling units in this neighborhood of Bridgeport were built since 1920; many of them date from the turn of the century and before. Nearly one-third of the units are occupied by owners. The awkward exterior stairways do not necessarily indicate conversions; many Chicago houses were built this way to accommodate worker families who used one floor and rented the other. The neighborhood continues to be "cosmopolitan" in its population character, with Poles, Lithuanians, Italians and Germans being the predominant groups. While the ethnic breakdown has changed little in thirty years, the population has declined from over 60,000 in 1920 to 41,500 in 1960.

(Photograph, Sigmund J. Osty. Courtesy Chicago Historical Society.)

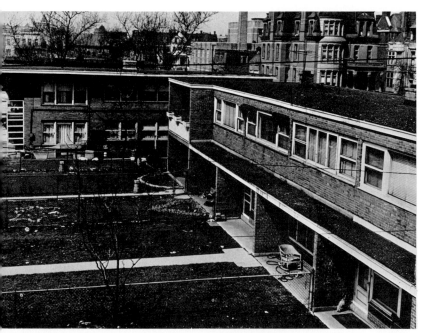

3

4

5

6

1. North Side of Archer Avenue, 200 Feet West of Stark, 1963

These two buildings, originally of wood frame construction, have been refronted to improve their appearance.
(Photograph, Ann Maksymiec. Courtesy Chicago Historical Society.)

2. Auto Parts Yard, at Thirtieth and Kedzie Streets, 1959

Scenes like this view were not uncommon in the older sections of the city. Small manufacturing and service businesses were mixed in amid the housing.
(Photograph, John McCarthy. Courtesy Chicago Historical Society.)

3. 3330 and 3334 South Seeley Street, 1960

These houses have been at this location since before the raising of the street grade. Their yards reflect the old level, the street the new.
(Photograph, John McCarthy. Courtesy Chicago Historical Society.)

Shores, Michael Reese's expansion eliminated many substandard structures while producing an attractive "campus" of new hospital buildings. I.I.T. transformed its neighborhood into a showplace for the architectural talents of Mies Van der Rohe. Just off the Stevenson Expressway on Martin Luther King, Jr. Drive (formerly South Parkway), Mercy Hospital expanded and rebuilt its plant. South Commons, a large, privately developed high rise and town house project, moved in to fill up a full block on South Michigan Avenue. Involving an expenditure of twenty million dollars, and completed in 1968, it is the latest in a series of developments which are remoulding what was one of Chicago's worst slum areas two decades ago. The city entered the picture more directly in the construction of Dunbar School, Dunbar Park, Ickes Homes, Dearborn Homes, Stateway Gardens, Prairie Court, and in its contribution to the Stevenson Expressway extension.

Although the South Side received the first redevelopment programs, other areas also needed attention desperately. Immediately west of the Near North Side's Gold Coast, with its luxury apartments and expensive private homes, lay a wide belt of decaying commercial and residential structures. As early as 1929 Harvey Zorbaugh had described this shabby slice of the city with all its problems as a "belt of bleak, barren, soot-begrimed, physically deteriorated" buildings. This blighted area he divided

1

2

3

4. Jeffery Avenue, South of Seventy-Sixth Street, 1947

So great was the demand for housing at the end of the war that nearly anything was purchased gratefully. These uniform structures were typical of much of the early postwar private housing construction. (Photograph, Otho B. Turbyfill. Courtesy Chicago Historical Society.)

5. South from 11333 on St. Lawrence Avenue, 1966

Located immediately across from Pullman's monumental old Florence Hotel and constituting part of his old model town, these workers' row houses have stood the ravages of time very well. Increasingly, they have been rehabilitated by individual owners, who have found them structurally sound but in need of major repairs including plumbing and wiring. Over half of the dwelling units on this block were occupied by their owners in 1960. (Photograph, Glenn E. Dahlby. Courtesy Chicago Historical Society.)

4

5

6

6. 8752–14 South Luella Avenue

Housing developers and builders sometimes attempted to vary the shapes of their new buildings. But since all the units were constructed at the same time, landscaping and individual touches had not had time to work the process of differentiation found in older neighborhoods. These houses were built about 1960. (Photograph, Ralph E. Tower. Courtesy Chicago Historical Society.)

7. 9920 Longwood Drive, 1950

Frank Lloyd Wright completed this house in 1908 for Robert W. Evans. Located in Morgan Park on one of the community's curving drives, it stands as a representative of some of the best housing in the city. All of the thirty-seven houses in this block are occupied by their owners. Population density is low. Large lots and an average 7.7 rooms per house account for these figures. (Photograph, Otho B. Turbyfill. Courtesy Chicago Historical Society.)

7

East Side Neighborhood

Located near the Calumet River in southeastern Chicago, the first settlement in this area was made by workers as a result of nineteenth century industrialization. Even by 1930, however, there were still many vacant lots, and most of the houses which had been built were small, single-family dwellings. A new population surge occurred during the World War II decade and has continued into the sixties, with each recent decade also showing an increase in the proportion of home ownership.

1. 9198–9100 Colfax Avenue
(Photograph, Ralph E. Tower. Courtesy Chicago Historical Society.)

2. 10625 Avenue B, 1953
(Photograph, C. J. Horecky. Courtesy Chicago Historical Society.)

into two parts: an area of cheap lodging-houses along Clark and Wells streets, and blocks of tenements west of Wells Street. "The tenement area," he wrote, "is the worst of foreign tongues and cultures; the area of cheap lodging houses is a jungle of human wreckage." The depression and war had only furthered neglect; and, more ominously, the blight had oozed over toward the lake, jeopardizing some of the city's most exclusive residences.

The city's response, the North LaSalle redevelopment, focused on Carl Sandburg Village, a large privately financed complex of middle and upper income high rise apartment buildings and townhouses. Built on land acquired by the city with federal aid, it provided a stimulus for the whole area, especially for the extraordinary development of "Old Town" along North Wells Street where restaurants, art and antique shops, book stores, specialty shops, and jazz and entertainment spots give the area a unique flavor. Other projects, such as the transformation of Ogden Avenue into a mall where it approaches Lincoln Park, promise to give new vitality to one of the city's oldest areas.

The most celebrated, if not largest, urban renewal programs in the United States, however, took place on the South Side in Hyde Park-Kenwood, the home of the University of Chicago. These two communities, extending from Forty-seventh Street on the north to the Midway on the south and bounded by Wash-

1

3. 10524 Avenue G, 1953
(Photograph, C. J. Horecky. Courtesy Chicago Historical Society.)

4. 10657 Avenue H, View North on One-hundred-Seventh Street, 1953
(Photograph, C. J. Horecky. Courtesy Chicago Historical Society.)

5. 10320 Avenue J, West Side, Looking West, 1953
(Photograph, C. J. Horecky. Courtesy Chicago Historical Society.)

6. 10400 Avenue M, West along One-Hundred-Fifth Street toward Marblehead Lime Plant, 1952
(Photograph, C. J. Horecky. Courtesy Chicago Historical Society.)

7. 10755 Avenue O, 1953
(Photograph, C. J. Horecky. Courtesy Chicago Historical Society.)

2

3

4

5

6

7

1. West Grand Avenue and Green Street, 1949

Successive waves of ethnic and racial groups have passed through this neighborhood—Germans, Swedes, Italians, Polish and Russian Jews, Puerto Ricans, Negroes, and southern whites. After the mid 1890's, the attraction for every group was the same: relatively low-cost housing, good public transportation, and jobs at nearby plants along the Chicago River or in the Loop. As the neighborhood grew older, it attracted fewer residents.
(Photograph, Mildred Mead. Courtesy Metropolitan Housing and Planning Council.)

2. View Eastward, at 955 West Grand Avenue, 1949

Framed against the Gold Coast skyscrapers, the gaping windows of this old apartment building testified to the contrasts of living standards found in Chicago.
(Photograph, Mildred Mead. Courtesy Chicago Historical Society.)

3. Southeast from 955 West Grand, 1949

Redirecting her camera towards the Loop, Mildred Mead caught the physical

ington Park and Lake Michigan, had always been prestige locations. Beginning as suburbs along the Illinois Central, they had early attracted the well-to-do. In 1889 they were annexed to the city. In subsequent years the area was developed with town houses and apartments to accommodate the growing population. The location of the university there in 1890 and the Columbian Exposition three years later added a cosmopolitan dimension to the area.

In the twentieth century it developed its own character—a unique blend of some of the city's elite, faculty members from the university, the special resort of authors and artists—and it became the center of a vibrant, if somewhat anarchic, community life. Along the lakefront, high-rise apartments commanded breathtaking views of Lake Michigan and Jackson Park. This special urban island furnished more than its share to the business, political, intellectual, and cultural leadership of Chicago.

During the depression and in the postwar years, the normal processes of urban change began to transform Hyde Park and Kenwood. Slums, once banked up at Forty-seventh Street in the north and Sixty-third Street in the south, spread into the community. Poor whites and Negroes, finding housing expensive or unavailable elsewhere, began to settle in aging buildings. Single family dwellings were broken up into small units, and large apartments were "converted" into multi-family tenements. Old residents

1

2

proximity of the deteriorated houses of the slums, the manufacturing both in and near the neighborhood, and the skyscraper towers of the Loop.
(Photograph, Mildred Mead. Courtesy Metropolitan Housing and Planning Council.)

4. 52–65 West Ohio Street, 1954

In 1950 this block contained dwelling space for 168 families, who paid an average fifty dollars per month rental. Over two-thirds of the apartments were substandard, and over one-third were overcrowded.
(Photograph, Mildred Mead. Courtesy Metropolitan Housing and Planning Council.)

5. Alley between Clark and Dearborn, North toward Huron, 1953

With little new construction, this block, between 1940 and 1960 showed a rapid rise in the number of rental housing units. In 1940 only ninety-three units were listed; in 1960, 196 units contained 247 people. Rents also jumped from twenty-nine dollars to fifty-seven dollars.
(Photograph, Mildred Mead. Courtesy Metropolitan Housing and Planning Council.)

6. Back Yards of the 700 block on North Green, 1949

In 1950 only ten families occupied this block living in nine dilapidated and one substandard dwelling. Nine families had no running water and no bathroom. The proximity of industry and residence is characteristic of many of the older areas of the city developed before adoption of Chicago's first zoning ordinance in 1923.
(Photograph, Mildred Mead. Courtesy Metropolitan Housing and Planning Council.)

3

4

5

6

392

1. 1143 North Hudson, 1953

Only about twelve per cent of the dwelling units on this block were built between 1900 and 1910, the remainder having been erected sometime in the nineteenth century. The area was demolished soon after this photograph was taken to make way for the 1,900-unit Cabrini Extension project of the Chicago Housing Authority, which was completed in 1958. (Photograph, Mildred Mead. Courtesy Chicago Historical Society.)

2. 1322 North Cleaver, 100 Feet North of Potomac, 1956

This photograph of one block graphically illustrates that old housing does not deteriorate at the same rate throughout the city. All of these structures were built before 1919, and almost half before 1900. Located immediately across from St. Stanislaus Kostka Church, this block has achieved about as much stability as might be expected in a rapidly changing neighborhood. Between 1940 and 1960, the

began to leave; commercial facilities sprang up to accommodate newcomers; population densities rose significantly. As conditions deteriorated, the character of the university was put in jeopardy.

Most observers despaired of being able to arrest the decline. Hyde Park–Kenwood seemed destined to go through the cycle of decay that sociologists had described as part of the "natural history" of a neighborhood. Though new governmental tools were now available, the disintegrative process was so far advanced that the task seemed forbidding and the cost staggering. But by the early 1950's the consequences of inaction seemed more ominous than the cost of drastic action.

Neighborhood groups had already started to organize. The Hyde Park–Kenwood Conference was established in 1949; three years later the South East Chicago Commission, with strong university connections, began its operations. Initial activities were modest in scope and defensive in nature, concentrating on public safety and community services. It was soon apparent, however, that only a broad, unprecedented effort, encompassing almost two square miles and involving clearance, massive rebuilding, and widescale rehabilitation programs, could stay the spreading blight. Moreover, it could only be done if City Hall, the federal government, and local institutions were willing to pour in money and resources on a previously unheard of scale.

1

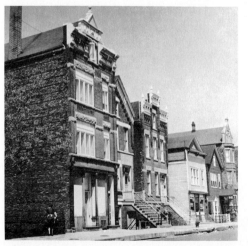

2

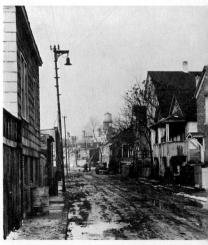

3

number of dwelling units remained constant at 243. Monthly rents rose in the two decades from just over thirteen dollars per unit to thirty-nine dollars. At the same time the number of owners living on the premises increased from nineteen to thirty-three, and the number of those units listed as substandard decreased from 201 to sixty-six.
(Photograph, Betty Hulett. Courtesy Chicago Historical Society.)

3. Honore Street, North towards Ellen (1282 N.), undated

These Honore Street dwellings face the back of the lots and garages of their neighbors on Marion Street to the west. Census figures show this block has been deteriorating steadily since 1940. Of the 127 units reported in 1960, thirty were deteriorated and twelve were dilapidated. One hundred and eight of the units were built before 1900.
(Courtesy Metropolitan Housing and Planning Council.)

4. View Eastward from Ogden Avenue Viaduct, North of Division, 1954

Amid the rubble of demolished houses and vacant lots, some owners attempted to maintain their old buildings. Asbestos and tar-shingle siding often proved the least expensive way to cover a house whose wood was so old it would not retain paint. Still, the neighborhood was an old one—streets were narrow, plumbing and wiring outdated, land use haphazard.
(Photograph, Lillian Ettinger. Courtesy Chicago Historical Society.)

5. View Northeastward of the Water Tower, 1955

Three decades after the growth surge of the 1920's, the "castellated gothic" of the water tower was almost lost amid its taller and larger neighbors. No longer did anyone challenge the Water Tower's right to existence; it had become one of the city's most important visual symbols, a reminder of Chicago's lusty adolescence.
(Photograph, J. Sherwin Murphy. Courtesy Chicago Historical Society.)

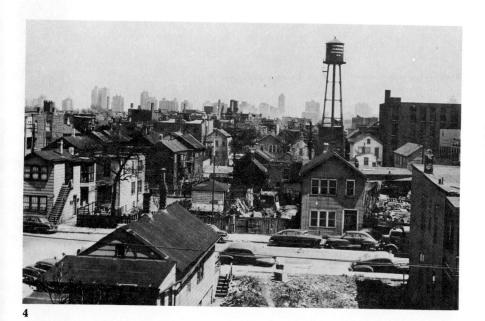

4

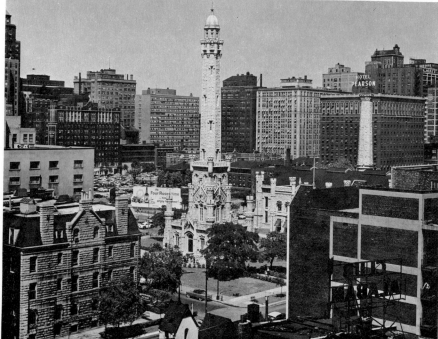

5

1. Carl Sandburg Village, View Northeast, with LaSalle and Division Streets in the Immediate Foreground

Framed against Lincoln Park and its Gold Coast neighbors, the Sandburg high-rises and town houses provide a rich newness compared with their older Near North Side neighbors.
(Courtesy Portland Cement Association.)

2. View Northward from 1408 Sandburg Terrace in Sandburg Village, 1964

Nestling at the bases of the high rise apartments of Sandburg Village are clusters of town houses.
(Photograph, Stella Jenks. Courtesy Chicago Historical Society.)

3. 200 block, South Side of West Eugenie Street, Just East of North Park Avenue, 1965

Set in a quiet neighborhood with tree-lined streets and framed against the high rise buildings of Carl Sandburg Village, this old North Side neighborhood shows the effects of extensive private rehabilitation.
(Photograph, Betty Hulett. Courtesy Chicago Historical Society.)

By 1955 basic planning was completed, and the Chicago Land Clearance Commission began the assembly of sites and demolition of dilapidated and substandard buildings. Code enforcement on sound structures was stepped up; every tool to bring compliance by owners was utilized—and a few new ones devised. Town houses by Harry Weese replaced commercial buildings along many streets. Ieh Ming Pei, Loewenberg and Loewenberg, and Harry Weese combined talents to erect twin apartments in the middle of Fifty-fifth Street giving a visual focus to the planning of one portion of Hyde Park and winning critical acclaim everywhere (except, perhaps, in Hyde Park where the project was irreverently dubbed "monoxide island"). A new shopping center provided a home for a much expanded Co-op store, long a community institution, and for other commercial establishments.

Within five years the worst appeared to be over. Most of the clearance had been completed, although the northern anchor on Forty-seventh Street still remained to be carried out (it was finally approved in 1968). Over twenty-four million dollars of public funds had been spent; millions in institutional and private funds had been invested. Not only had Hyde Park–Kenwood broken the historical cycle of inevitable neighborhood decline, but once again it had regained its position as a prestige residential section. The University of Chicago was not only preserved, but it entered a

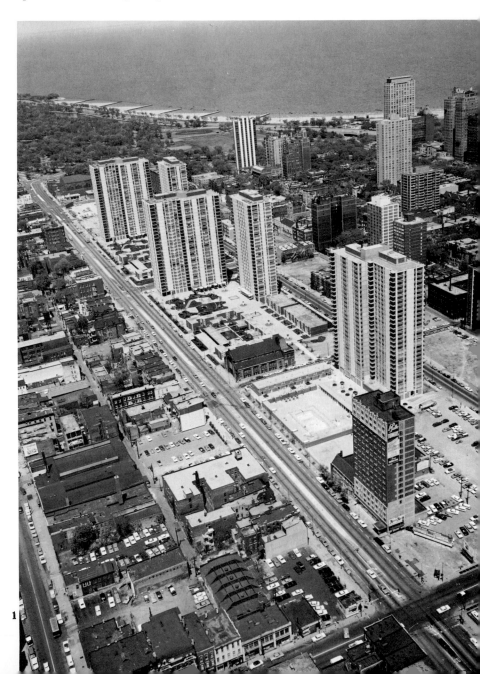

1

4. Northeast Corner of North Sedgwick and West Wisconsin, 1966

With its neighbors, this block has witnessed a succession of ethnic groups. The 1930 census provided a cross section of the story: a majority was German, but there was a large sprinkling of Italians, Irish, Poles, Austrians, English, and Romanians. Located just a few blocks from Lincoln Park and close to Old Town, this block has undergone extensive rehabilitation in recent years.
(Photograph, Sigmund J. Osty. Courtesy Chicago Historical Society.)

5. 1821 Lincoln Avenue in Old Town

Even over a long period of time, land clearance and complete rebuilding can treat only a portion of the city—and then at the cost of disrupting existing population. Increasingly, city officials and civic groups advocated rehabilitation and conservation. Old Town was one area where this policy was put in motion some time before adoption of an official renewal program for the area. Selective renewal removed the completely dilapidated structures, but most of the effort was put into fixing up the old but sound structures. By the mid-1960's the block was part of a highly desirable area of large single-family homes and apartment buildings.
(Courtesy Metropolitan Housing and Planning Council.)

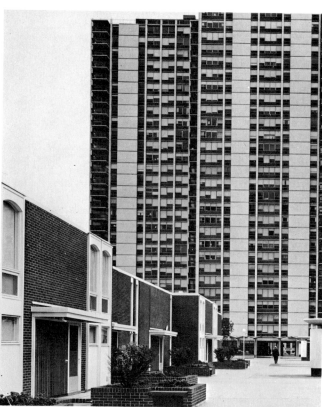

2

4

3

5

1. Siebens Brewery, 1470 North Larrabee Street, 1966

Siebens began brewing in this North Side neighborhood when the area was settled mainly by first- and second-generation Germans. The company's primary retail outlet has continued to be this old-fashioned beer hall with its picturesque interior court, but, through the years, the neighborhood has undergone a major transformation. Still Siebens continued to be a favorite luncheon spot for North Side business men until it closed in 1967.
(Photograph, Sigmund J. Osty. Courtesy Chicago Historical Society.)

2. Cyrus McCormick Residence on Rush Street, Near North Side, 1950

"Prestige Location For Sale, Lease or Development." The sign in front of the old McCormick mansion embodies the natural history of an urban neighborhood. The fifties brought new pressures to replace the houses of Chicago's early millionaires. Their plumbing and wiring inadequate by more modern standards, their walls creaking and settling, and land values rising all around them, the opulent old houses could no longer hold out against the blandishments of high-rise developers.
(Photograph, Dr. Frank E. Rice. Courtesy Chicago Historical Society.)

3. Frances Cabrini Homes, South from Edward Jenner Public School, 1951

Even with the moderating influence of age, the "project" character of the Frances Cabrini Homes is apparent. Yet at the time they were completed in 1942, their barracks shells were a forward-looking experiment in rehousing.
(Photograph, Mildred Mead. Courtesy Chicago Historical Society.)

1

2

4. Northwest Corner of North Felton Street and West Elm Street, 1966

Located across the street from the block-square Seward Park, this census tract was 86.7 per cent Negro in 1960. Since 1950, 95.6 per cent of the population had moved to the block from a different house. The median income was $3,270 and median rental was sixty-four dollars. In the background is the 1,921 unit extension of the Cabrini Homes, completed in 1958.
(Photograph, Sigmund J. Osty. Courtesy Chicago Historical Society.)

5. Northwest Corner, Seneca and Chestnut Streets, 1965

Three building types appear in this photograph taken on the North Side, just a block east of Michigan Avenue and two blocks from the Lake. The Seneca Hotel overshadows its smaller apartment house neighbor. Behind it is a modern skyscraper, which by the mid-1960's overshadowed the Seneca and its neighbors.
(Photograph, Glenn E. Dahlby. Courtesy Chicago Historical Society.)

6. View Northwest at the Corner of Pearson and North Lake Shore Drive, 1966

This photograph shows three of the four metal and glass towers which Mies van der Rohe designed at 860–900 North Lake Shore Drive between 1949 and 1958.
(Photograph, Sigmund J. Osty. Courtesy Chicago Historical Society.)

3

4

5

6

1. View Northwest, North Lake Shore Drive between Walton and Oak Streets, 1966
When this photograph was taken these three buildings were fifty years old, yet they remained among the most expensive rental properties in the city. At the left, is the ten-story 936 Building, built in 1913; in the center is the ten-story 942 Building, completed in 1915; both were designed by William Ernest Walker. The third building, at the corner of North Lake Shore Drive and Oak Street is the 999 Building, completed in 1912. Its ten-story design was done by architects Marshall & Fox. (Photograph, Sigmund J. Osty. Courtesy Chicago Historical Society.)

period of new growth and expansion. It was now clear that one thing that spreads faster in a city than blight is improvement. Real estate values soared, private investors stumbled over one another to get in, and tax revenues to the city rose to make up for the earlier use of taxpayer's money. Observers from all over the country—indeed all over the world—trekked to the area to see how urban renewal could be made to work.

The job was not done, however, without human cost and legitimate criticism. The planning called for a reduction of the new postwar densities and a return to the neighborhood's old middle- and upper-middle–class texture. The thinning out was done largely at the expense of lower income newcomers—both Negro and white. While relocation programs did much to cushion the shock and most residents went to adequate housing elsewhere, the impact on many was harsh. In addition, old commercial enterprises, mainly specialty shops and small craftsmen, were displaced, though space for some was later erected in the community-owned Harper Court. And institutional expansion has continued to eat up scarce residential space.

Yet, by most standards, the Hyde Park–Kenwood renewal program has been a success. The old racial exclusiveness was gone, and the neighborhood goal of "an integrated community of high standards" was largely achieved. There were, of course, many fewer low

1

2

2. View Southwest of North Lake Shore Drive at East Division Street, 1966

Five decades of apartment architecture are represented in this photograph. From the left, the buildings are—1120 North, an eighteen-story design by Robert S. DeGolyer and Walter T. Stockton, completed in 1925; 1130 North erected in 1910, a nine-story building by Howard Van Doren Shaw; 1150 North, a twenty-four-story building by Hausner and Macsai, completed during 1956–58; and 1200 North, formerly the Stewart Apartments, a twelve-story building by Benjamin H. Marshall finished in 1912.
(Photograph, Sigmund J. Osty. Courtesy Chicago Historical Society.)

3. East Side of 1300 Block on North Ritchie Court, from Corner of Goethe and Ritchie Streets
(Photograph, Glenn E. Dahlby. Courtesy Chicago Historical Society.)

4. West Side of North Bissell, View South from 100 feet South of Webster Street, 1966

Midway between the North Branch industrial area and Lincoln Park, this neighborhood catered to working men and their families when it was first built. Two, four, and six flats line this street, their façades, brickwork, and windows all telling of an earlier era.
(Photograph, Sigmund J. Osty. Courtesy Chicago Historical Society.)

3

4

5

5. Northernmost Extension of Lincoln Park, Looking West, 1955

For many years the northern end of Lincoln Park was Foster Avenue, marked by the underpass at the left of the photograph. City officials, however, decided that the park had to be extended, not only for aesthetic reasons but to absorb a new double-laned parkway system to the far North Side. After prolonged litigation with beach owners, the city used the time-honored Chicago method of solving its congestion problem—a land-fill extension was built into the lake, landlocking the now misnamed Edgewater Beach Hotel in the center of the photograph. In the following decade, newly erected high-rise apartment buildings formed an almost continuous façade fronting on the park extension.
(Courtesy Chicago Historical Society.)

1. Northwest Corner of West Lemoyne Avenue and North Paulina Street, 1966

Old wooden and brick two flats characterize this block on the Northwest Side. While there was some construction of two and three flats in this neighborhood after 1920, these buildings were erected much earlier.

(Photograph, Sigmund J. Osty. Courtesy Chicago Historical Society.)

2. 1240–46 North Paulina Street, 1966

Brick two and three flats like these were built in this area (West Town) during the 1920's. Many times they replaced old wooden frame one-family structures, which were moved to the back of the lots. Polish residents continue to be the dominant group in the neighborhood, although almost every nationality is represented. Mexicans, Puerto Ricans, and southern whites are the most recent arrivals. Urban renewal and construction of the Eisenhower Expressway have contributed to the decline

1

2

3

in population over the last decade, although the trend has been under way since 1910.
(Photograph, Sigmund J. Osty. Courtesy Chicago Historical Society.)

3. North Clarendon Avenue, 1966
These three-story bay-windowed structures still constituted good housing in the mid-1960's, but the block as a whole had more deterioration in it than the exteriors indicated.
(Photograph, Sigmund J. Osty. Courtesy Chicago Historical Society.)

4. 2346 West Chase, 1955
New and old examples of multiple-unit housing are found in this area of West Ridge (West Rogers Park). In the background is one of the old Chicago triple deckers, with part of its porches enclosed to make an additional room.
(Photograph, M. J. Schmidt. Courtesy Chicago Historical Society.)

5. Shoreland Apartment Building, 6331 North Sheridan Road, 1965
Land values have risen greatly along the north shore. Older apartment buildings, some of them built as recently as the 1920's have been removed to make way for high rises which overlook the lake. From Chicago's Loop to Wilmette, driving along Sheridan Road, the traveler in the mid-1960's is seldom out of sight of a high rise.
(Photograph, Sigmund J. Osty. Courtesy Chicago Historical Society.)

4

5

1. Rear of 1321–31 East Fifty-Fifth Street and 5508 South Kenwood, Early 1950's

What at first glance appears to be the back yard of a two-story apartment building, in reality turns out to be the first floor roof of a three-story corner unit. This building and many others in the block have been replaced in the past two decades. (Photograph, Mildred Mead. Courtesy Chicago Historical Society.)

2. 5115 Cornell Avenue, 1952

Banker, Board of Trade member, and philanthropist B. P. Hutchinson built this house in 1880. He gave it to his son Charles and the latter's new bride as a wedding present. By the mid-twentieth century, the old house stood, paintless and worn, symbolic of an earlier and more prestigious age and the problems of our time. (Photograph, J. Sherwin Murphy. Courtesy Chicago Historical Society.)

income residents than ten years earlier, but probably more than forty years ago. Moreover, a sprinkling of small public housing projects provided some class mixture as well as an opportunity to experiment with a new approach to housing the poor. Most of all, it demonstrated that something could be done to meet the whole range of problems which afflict the modern city, if there is enough intelligence, organization, determination, money, and will.

Not every neighborhood, however, has the resources of a Hyde Park–Kenwood. Essential to its success was a university with a large physical investment and a faculty and staff living nearby, an area of basically sound buildings, and a community delighting in public affairs and political action. Other areas of the city have been more vulnerable. When change threatened, the first response was often to flee rather than to fight. Local institutions were not so strong, nor the people so secure. Hence Hyde Park–Kenwood provides a special, rather than general, lesson to other places.

Despite the significant achievements in the renewal of many neighborhoods, Chicago still faces a dangerous problem in the continued growth of its Negro ghetto. The war years and the two decades that followed witnessed an acceleration of the massive migration of black people from the farms of the South to Chicago. At its height between 1916 and 1920, an estimated 50,000 new-

1

2

3. Rehabilitated Unit at 5729 South Blackstone Avenue, 1957

Part of the success of the Hyde Park–Kenwood renewal program stems from the vigorous private efforts of individual owners. Here one part of a duplex indicates the difference that one improvement made. (Photograph, Mildred Mead. Courtesy Metropolitan Housing and Planning Council.)

4. Looking Southwest from the Illinois Central Station Platform at Fifty-Sixth Street, 1951

The row of old apartment houses with their small street-level stores was constructed to take care of Columbian Exposition patrons during 1892–93. Their baywindowed apartments provided housing for university students and new neighborhood residents at the end of World War II. In 1960 they were replaced by town houses. (Photograph, Mildred Mead. Courtesy Metropolitan Housing and Planning Council.)

5. West on Fifty-Fifth Street from the Illinois Central Overpass, 1951

Fifty-fifth Street had an essentially commercial character when Webb and Knapp were contracted to handle this portion of the Hyde Park renewal project. The plans called for a new almost wholly residential character. With the exception of the first building at the left, all the structures in this photograph have been replaced. (Photograph, Mildred Mead. Courtesy Chicago Historical Society.)

3

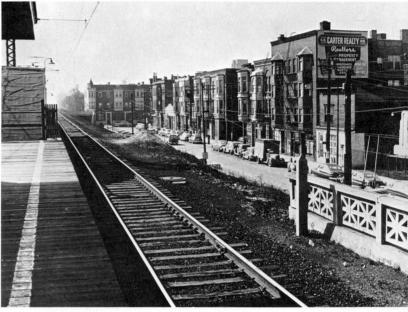

4

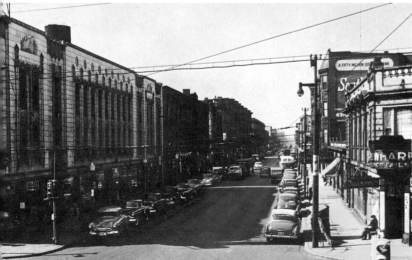

5

2. East Side of Kenwood Avenue, Looking North from East Park Place toward Fifty-Fifth Street, 1961

The Webb and Knapp plan was to create a town house development, either "arranged to form inward looking, small scale squares, or alternately extend as fingers into adjacent areas." The walls of these houses which faced on busy streets expressed a desire for privacy through their slight visual contact with the street.
(Photograph, Marian M. Celander. Courtesy Chicago Historical Society.)

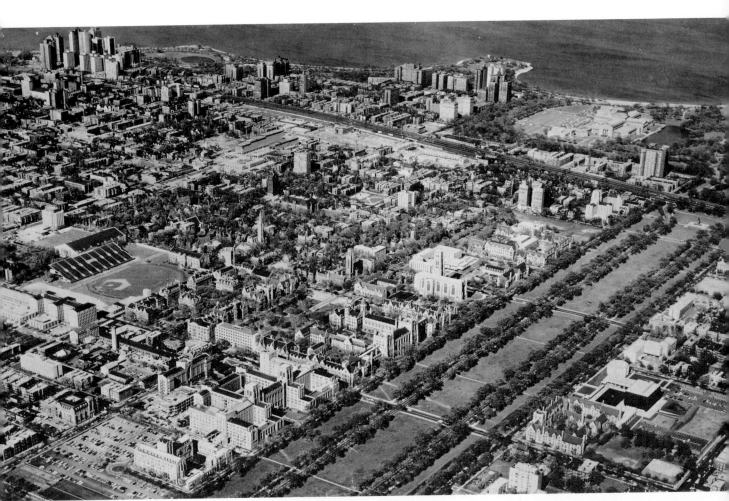

1

1. View Northeast of the University of Chicago and Hyde Park, 1960

The early phase of the Hyde Park project were already under way when this photograph was taken. In the right foreground is the beginning of the University's South Campus development in northern Woodlawn, with Eero Saarinen's Law School complex already completed. In the middle distance, demolition has taken place and construction has begun around Fifty-fifth Street and Lake Park Avenue. There the double blockhouse University Apartments and the Hyde Park Shopping Center, both by Webb and Knapp, are taking shape.
(Photograph, Chicago Aerial Industries. Courtesy University of Chicago, Department of Public Relations.)

3. Pioneer Co-op, 5427–37 South Dorchester Avenue

One of the first stages of Hyde Park renewal was the building of this cooperative. Designed by George Fred Keck and William Keck, it won more than local awards. (Photograph, Hedrich-Blessing. Courtesy *Hyde Park Herald.*)

4. 5424 South Blackstone Avenue

Hyde Park's renewal program brought not only new building but the refurbishing of old ones. This remodelled home was built at the time of the Columbian Exposition. (Courtesy *Hyde Park Herald.*)

5. Townhouses and University Apartments, Fifty-Fifth Street and Dorchester Avenue

The Hyde Park program called for a mixture of townhouses and high rises along 55th Street. This photograph shows both, as well as their proximity. (Photograph, Nancy Hays. Courtesy *Hyde Park Herald.*)

2

3

4

5

1. View Southeasterly of the West Side Medical Complex, 1965

The West Side Medical Complex was facilitated by the Chicago Medical Center Commission which used its authority to acquire land and to raze blighted housing. The photograph shows the present extent of the concentration, which includes Cook County Hospital (center of picture), the University of Illinois Medical group (lower center), Presbyterian–St. Luke's Hospital (extreme left), and Convalescent Park.
(Courtesy Chicago Association of Commerce and Industry.)

2. View Northward, Dearborn Homes at Twenty-Seventh and State Streets, August 1, 1954

Dearborn Homes was the first high-rise public housing project completed after World War II. Opened in 1950, it contained 800 dwelling units in twelve seven-story and four nine-story buildings. Only sixteen per cent of the project's sixteen acres was covered by buildings; trees and grass occupied the rest. In the upper background is the Loop.
(Photograph, Mildred Mead. Courtesy Chicago Historical Society.)

comers settled in the city. Housing for everyone was scarce; for Negroes it was particularly difficult. The tradition of exclusion was deeply embedded; discrimination by real estate agents and white home-owners was customary and rigid. In addition, most of the migrants were poor and did not have the resources to command good housing even if more had been available.

The result was extraordinary overcrowding in the old areas of Negro occupancy and the spread of the ghetto into other parts of the city. One line of movement was south along the historic southern axis; another reached westward toward the city line. Every week during the 1950s, three-and-a-half blocks changed from white to Negro. Most of the change took place in neighborhoods which had already begun to decline and where whites, enjoying the postwar prosperity, were leaving for the more pleasant spots farther away from downtown or in the burgeoning suburbs. The newcomers jammed into these areas where conversion of single family dwellings into multi-family units and the cutting up of large apartments into much smaller ones became common.

Staggering congestion resulted. Blocks virtually burst at the seams; the deterioration of already substandard buildings accelerated. In its train came the long list of social ills that afflict blighted areas—poor health, inferior education, unskilled jobs or none at all, fragile family life, delinquency, and much more.

1

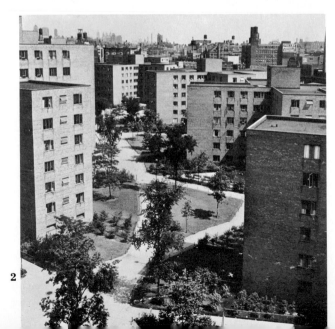

2

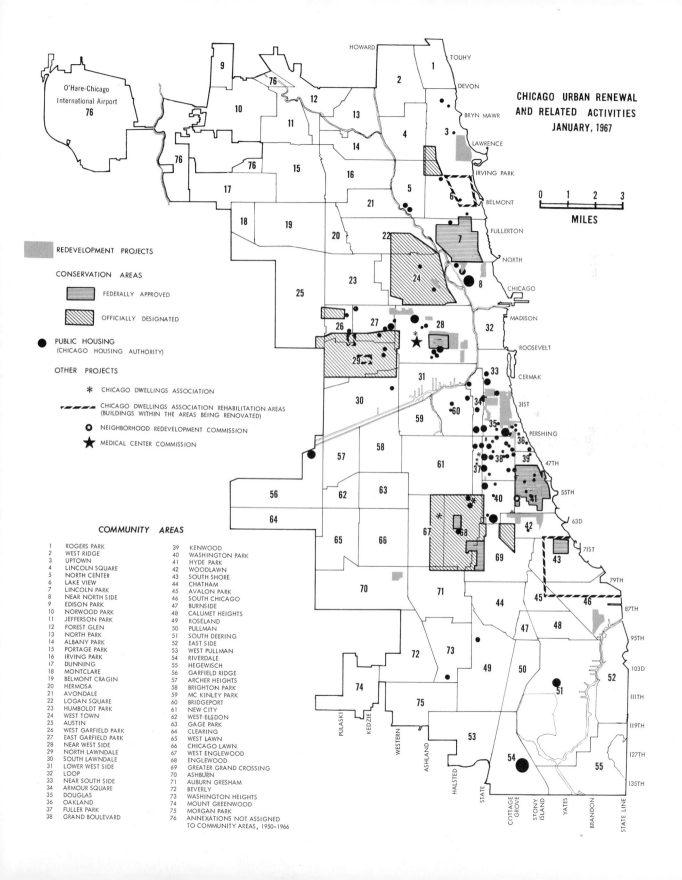

CHICAGO URBAN RENEWAL
AND RELATED ACTIVITIES
JANUARY, 1967

O'Hare-Chicago
International Airport
76

MILES
0 1 2 3

REDEVELOPMENT PROJECTS

CONSERVATION AREAS

FEDERALLY APPROVED

OFFICIALLY DESIGNATED

PUBLIC HOUSING
(CHICAGO HOUSING AUTHORITY)

OTHER PROJECTS

* CHICAGO DWELLINGS ASSOCIATION

CHICAGO DWELLINGS ASSOCIATION REHABILITATION AREAS
(BUILDINGS WITHIN THE AREAS BEING RENOVATED)

⊛ NEIGHBORHOOD REDEVELOPMENT COMMISSION

★ MEDICAL CENTER COMMISSION

COMMUNITY AREAS

1	ROGERS PARK	39	KENWOOD
2	WEST RIDGE	40	WASHINGTON PARK
3	UPTOWN	41	HYDE PARK
4	LINCOLN SQUARE	42	WOODLAWN
5	NORTH CENTER	43	SOUTH SHORE
6	LAKE VIEW	44	CHATHAM
7	LINCOLN PARK	45	AVALON PARK
8	NEAR NORTH SIDE	46	SOUTH CHICAGO
9	EDISON PARK	47	BURNSIDE
10	NORWOOD PARK	48	CALUMET HEIGHTS
11	JEFFERSON PARK	49	ROSELAND
12	FOREST GLEN	50	PULLMAN
13	NORTH PARK	51	SOUTH DEERING
14	ALBANY PARK	52	EAST SIDE
15	PORTAGE PARK	53	WEST PULLMAN
16	IRVING PARK	54	RIVERDALE
17	DUNNING	55	HEGEWISCH
18	MONTCLARE	56	GARFIELD RIDGE
19	BELMONT CRAGIN	57	ARCHER HEIGHTS
20	HERMOSA	58	BRIGHTON PARK
21	AVONDALE	59	MC KINLEY PARK
22	LOGAN SQUARE	60	BRIDGEPORT
23	HUMBOLDT PARK	61	NEW CITY
24	WEST TOWN	62	WEST ELSDON
25	AUSTIN	63	GAGE PARK
26	WEST GARFIELD PARK	64	CLEARING
27	EAST GARFIELD PARK	65	WEST LAWN
28	NEAR WEST SIDE	66	CHICAGO LAWN
29	NORTH LAWNDALE	67	WEST ENGLEWOOD
30	SOUTH LAWNDALE	68	ENGLEWOOD
31	LOWER WEST SIDE	69	GREATER GRAND CROSSING
32	LOOP	70	ASHBURN
33	NEAR SOUTH SIDE	71	AUBURN GRESHAM
34	ARMOUR SQUARE	72	BEVERLY
35	DOUGLAS	73	WASHINGTON HEIGHTS
36	OAKLAND	74	MOUNT GREENWOOD
37	FULLER PARK	75	MORGAN PARK
38	GRAND BOULEVARD	76	ANNEXATIONS NOT ASSIGNED TO COMMUNITY AREAS, 1950-1966

1. 3949 Lake Park Avenue, Victor Olander Homes in the Background

These two large houses were among the city's best at the turn of the century, but by the early 1950's many of their neighbors had deteriorated to the point where removal seemed the only solution. In their place was raised the Chicago Housing Authority's Victor Olander Homes, originally a single fifteen-story building completed in 1953. (Photograph, J. Sherwin Murphy. Courtesy Chicago Historical Society.)

2. Washington Park Homes

Completed in 1962 on the city's South Side, this project contains 1,445 units in sixty two-story buildings and seven sixteen-story buildings. Nearly 800 of these units contain three bedrooms and over 400 contained four, an important provision for the many large families who reside in public housing. (Photograph, Mart Studios, Incorporated. Courtesy Chicago Housing Authority.)

3. Locational Patterns of Ethnic Groups, 1960

The old became discouraged; the young despaired; hopelessness pervaded the ghetto. Finding a footing in the city had never been easy for any group; discrimination based on color added another high hurdle; for some it made advancement impossible.

Despite all the obstacles, increasing numbers of Negroes contrived to hold family and careers together, and began the long trek out of the worst areas. By 1968 over a third of Chicago's non-white population was listed by the social statisticians as "middle class." This achievement often involved dependence on more than one breadwinner in the family, but it made possible a more satisfying, hopeful life. Some moved into good neighborhoods recently abandoned by the whites at the edge of the ghettoes. Other successful Negroes found housing on a non-discriminatory basis in Lake Meadows, Prairie Shores, Sandburg Village, or Hyde Park–Kenwood.

Yet the numbers who escaped the ghetto were still small. The Negro's confinement continued, increasing the bitterness of those who were successful and sought a housing market free of discrimination, and reenforcing the despair of those who seemed hopelessly caught in the teeming tenements of the South and West Sides. A few Negro families moved into white suburbs without incident; others clustered in the isolated ghettoes within other suburban communities. Fair housing ordinances in the city and in a number of the smaller

1

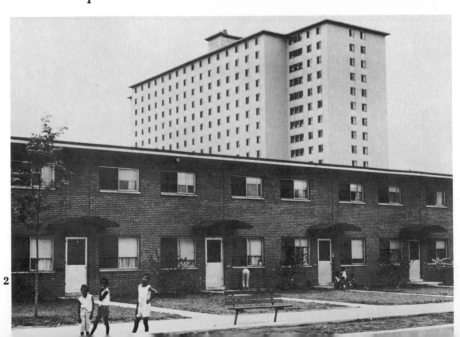

2

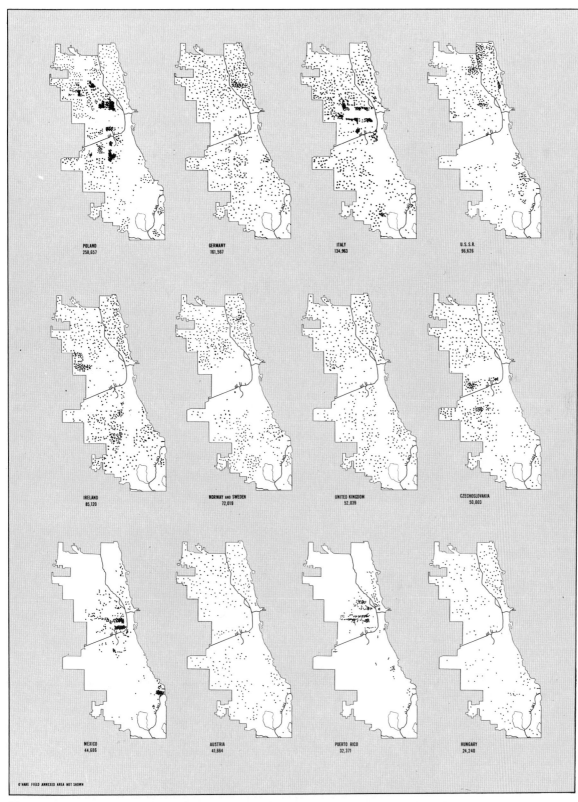

POLAND
258,657

GERMANY
161,567

ITALY
134,963

U.S.S.R.
96,626

IRELAND
85,120

NORWAY and SWEDEN
72,019

UNITED KINGDOM
52,039

CZECHOSLOVAKIA
50,003

MEXICO
44,686

AUSTRIA
41,664

PUERTO RICO
32,371

HUNGARY
24,240

O'HARE FIELD ANNEXED AREA NOT SHOWN

1. Slum Clearance on Dearborn Street, View North to Thirty-Ninth Street, 1959

The "best" of the old neighborhood structures not torn down for urban renewal contrast with the seventeen-story buildings of Stateway Gardens completed in 1958. All but two of the Stateway Gardens structures reached the seventeen-story height. Together the eight buildings house 1,635 families, utilizing only eight per cent of the nearly thirty-four acres of land included in the project site.
(Photograph, Clarence W. Hines. Courtesy Chicago Historical Society.)

2. The Old Makes Way for the New

This photograph was taken looking east into the Stateway Gardens project. The wrecking is taking place on ground which eventually became part of the Dan Ryan expressway right-of-way.
(Photograph, Clarence W. Hines. Courtesy Chicago Historical Society.)

3. Negroes in Chicago, 1920–65

surrounding communities indicated a growing official determination to end this demeaning practice. But sporadic outbreaks of violence on the West Side and civil rights marches into outlying neighborhoods in 1966 and large-scale rioting in 1968 were grim reminders of the distance Chicago had still to travel before it became an open metropolis.

Outside the city, in the mushrooming suburbs, the changes and problems were scarcely less important than those inside municipal limits. The postwar decades witnessed an extraordinary acceleration of the suburban trend that had been increasingly visible in the twentieth century. The demand for housing, dammed up by the depression for lack of money and during the war for lack of material, now broke loose. Older families, enjoying a new prosperity, moved into the areas around the city, and new families increasingly made their first homes there. All around Chicago for over twenty years the land fell before the bulldozer and developer. Soon the suburban tide moved out over Cook County boundaries and into Lake, DuPage, Kane, and Will counties. Around Gary it reached into Porter County.

The magnitude of this population movement would be hard to exaggerate. The 1970 census will disclose that for the first time over half the people residing in metropolitan areas live outside the central cities. When metropolitan Chicago will reach that point is not

1

2

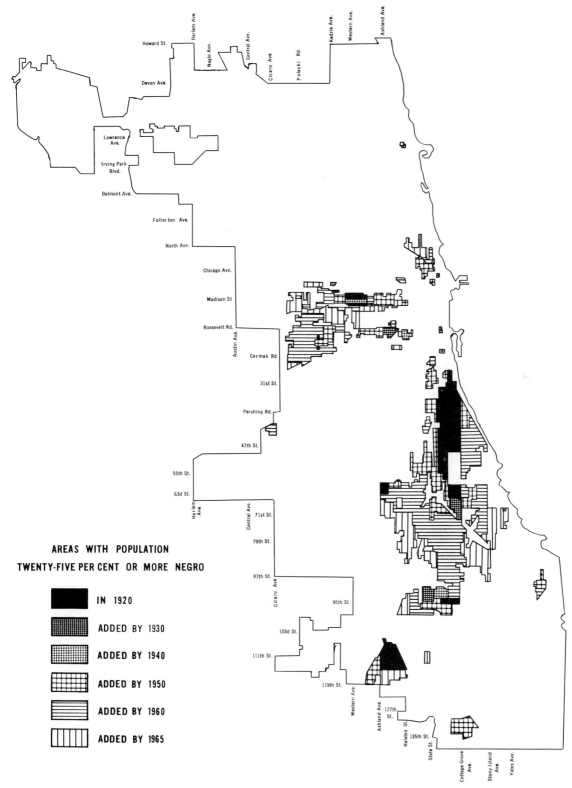

Howard St.
Harlem Ave.
Nagle Ave.
Central Ave.
Cicero Ave
Pulaski Rd.
Kedzie Ave.
Western Ave.
Ashland Ave.

Devon Ave.

Lawrence Ave.

Irving Park Blvd.

Belmont Ave.

Fullerton Ave.

North Ave.

Chicago Ave.

Madison St

Roosevelt Rd.

Austin Ave.

Cermak Rd.

31st St.

Pershing Rd.

47th St.

55th St.

63d St.

Harlem Ave.

Central Ave.

71st St.

79th St.

87th St.

Cicero Ave.

95th St.

103d St.

111th St.

119th St.

Western Ave.

Ashland Ave.

127th St.

Halsted St.

135th St.

State St.

Cottage Grove Ave.

Stony Island Ave.

Yates Ave.

AREAS WITH POPULATION
TWENTY-FIVE PER CENT OR MORE NEGRO

IN 1920

ADDED BY 1930

ADDED BY 1940

ADDED BY 1950

ADDED BY 1960

ADDED BY 1965

3

2. 4545–53 South Wabash, 1952

Between 1940 and 1960 this block remained ninety-nine per cent Negro. In these two decades the number of dwelling units on the block rose from 121 to 163, and rents went up on the average from just under thirty-six dollars per month to eighty-six dollars per month. The percentage of deteriorating units remained almost constant at about one-half of those reported. (Photograph, Mildred Mead. Courtesy Metropolitan Housing and Planning Council.)

3. Altgeld Gardens, View Eastward

World War II stimulated industrial activity in the Calumet region, and an influx of workers in the area created a demand for relatively inexpensive housing. During 1943–44, the Chicago Housing Authority built Altgeld Gardens, between 130th and 133d Streets, between Langley Avenue and Greenwood Avenue. One thousand four hundred ninety-two units in 162 two-story row houses were rented at relatively low rates. The design of the

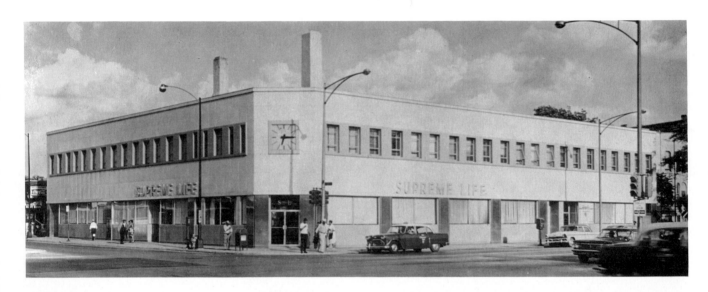

1. Supreme Life Insurance Company Head Office

Located at 3501 Martin Luther King, Jr. Drive, the Supreme Life Insurance Company is the result of a series of mergers of various Negro insurance companies. The direct hereditary ancestor of Supreme Life was Liberty Life Insurance Company, begun in Chicago in 1919. Frank L. Gillespie, its founder, maintained that the Negro community could and should have its own insurance companies, since white firms generally did not hire Negroes or solicit black business.
(Courtesy Supreme Life Insurance Company.)

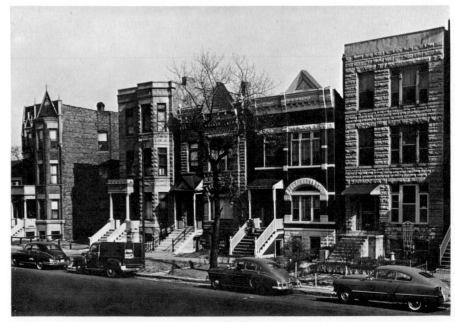

2

150-acre project is noteworthy because of its self-contained features: schools, shopping centers, and a street pattern which routed through traffic around the development made it a distinctive unit. Between 1945 and 1950 Altgeld Gardens became almost entirely black. In 1950 Chicago Housing Authority completed the Philip Murray extension to Altgeld Gardens, adding 500 units to the older development at its west edge.
(Photograph, Mart Studios, Incorporated. Courtesy Chicago Housing Authority.)

4. Chatham Park, 1951

A Human Relations Council study released in 1962 showed that over one-third of the city's Negroes had middle class incomes (over $6,000) in 1960, while only 8.9 per cent had middle class incomes (over $5,000) in 1950. Current estimates put the percentage of black middle class incomes at well over forty per cent. The rise in income is directly related to the increase in home ownership among non-whites. Between 1950 and 1960 the proportion increased from eleven to sixteen per cent. The census tract in which Chatham is located reflects this change. Almost all of the tract's 6,000 residents were Negro in 1960. Of these, 1,102 owners had houses which had a median value of $22,000, while 854 renters paid an average $110 per month.
(Photograph, Mildred Mead. Courtesy Metropolitan Housing and Planning Council.)

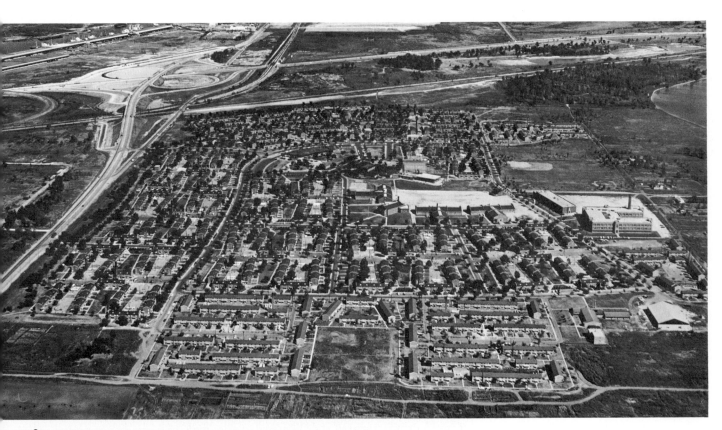

3

4

414

3. Chinatown, North on Wentworth Avenue at Cermak Road, 1952

Though small in number within the city, the Chinese constitute one of the most distinctive ethnic groups in Chicago.
(Photograph, J. Sherwin Murphy. Courtesy Chicago Historical Society.)

4. Chinese Community Center, 250 West Twenty-Second Place, 1966

The Chinese began moving into this Near South Side neighborhood about 1912, from their original area of settlement on South Clark Street. Settling within a few blocks in each direction from 22d (Cermak Road) and Wentworth, they established a small community, of which this building is the center.
(Photograph, Sigmund J. Osty. Courtesy Chicago Historical Society.)

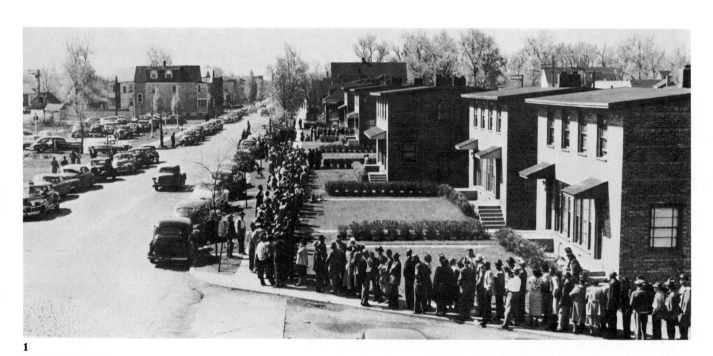

1

1. West Chesterfield Homes

At the end of World War II, many Negro families wanted new housing. This private housing development, West Chesterfield, offered one opportunity.
(Photograph, Tony Rhoden. Courtesy *Chicago Defender*.)

2. A Yard at Albany and One-Hundred-Thirty-Eighth Streets, Robbins, Illinois, 1957

Located southwest of Chicago and adjacent to Blue Island, Robbins was incorporated as a village in 1917. It grew up as the creation of Negro realtor Eugene S. Robbins who planned it from its inception as a community for blacks only. By mid-century the older part of Robbins was badly deteriorated, though new subdivisions were opened in both the fifties and the sixties.
(Photograph, Mildred Mead. Courtesy Metropolitan Housing and Planning Council.)

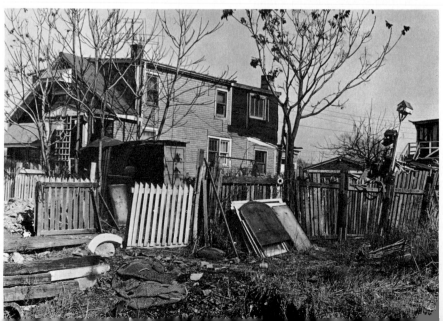

2

5. A Street in Chicago's Chinatown, 208 to 200 West Cermak Road, 1966

Growth of the Chinese community has been slow but steady, reaching over 1,500 by 1960. All of the housing in the neighborhood was built before 1920, except for two low cost housing projects erected nearby in the 1950's.
(Photograph, Sigmund J. Osty. Courtesy Chicago Historical Society.)

6. Office and Plant of *Polish Daily Zgoda* (Polish Language Newspaper and Alliance Printers and Publishers), Northwest Corner of Milwaukee Avenue and Division Streets, 1961

Ethnic enclaves are still evident throughout the city. Scattered here and there along the main section-line streets or at important intersections groups of Germans, Swedes, Dutch, Poles, Slavs, or Irish can still be found. Yet while papers like the Polish *Zgoda*, the *Naujienos* (Lithuanian Daily News), Lithuanian *Daily Draugas* and daily *Vilnis*, the *Jewish Daily Forward*, the *Italian News*, and the German *Abendpost* are circulated in these ethnic areas, many of them go to other neighborhoods, suburbs, and other cities.
(Photograph, Tom H. Long. Courtesy Chicago Historical Society.)

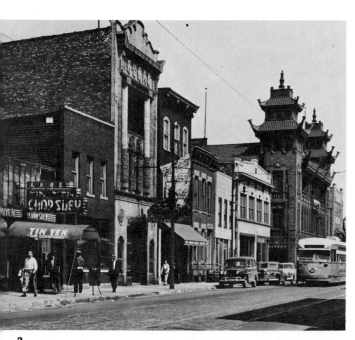

3

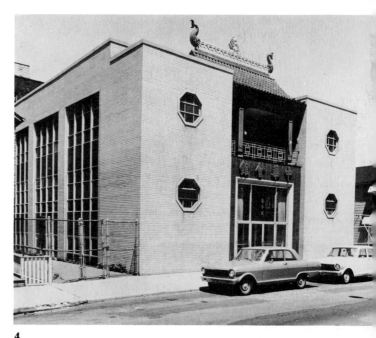

4

5

6

1. 1126–30–34 Milwaukee Avenue, 1966

As it traverses Chicago's North Side, Milwaukee Avenue serves some of the most heterogeneous areas in the city. Amid its service shops, employment agencies, and converted buildings are restaurants representing many nationality groups. (Photograph, Sigmund J. Osty. Courtesy Chicago Historical Society.)

2. Crows Island School, Winnetka, about 1964

The desire for better schools is one of the most frequently given reasons for moving to the suburbs. In the outlying areas school systems more often have lower student-teacher ratios, diversified programs, and generally better physical plants. This school, designed by Eliel and Eero Saarinen and Perkins, Wheeler and Will, has attracted world-wide attention for its many departures from traditional design. (Photograph, Hedrich-Blessing. Courtesy Perkins and Will Partnership, Chicago.)

clear, but it cannot be far away. The older suburbs nearer the city shared this general growth to some degree, but many had little land left for new development. Evanston, for example, grew from 65,389 to 79,283 between 1940 and 1960; Oak Park actually lost population, declining from 66,015 to 61,093 during the same period. But the experience of Hinsdale and Homewood was more characteristic; the former jumped from 7,336 to 12,859 while the latter increased from 4,078 to 13,371.

Most impressive, however, was the extraordinary development of relatively new suburbs. Skokie, to cite but one instance, leaped from 7,172 to 59,364 between 1940 and 1960; by the mid-1960's it had wrested the title of the "world's largest village" from Oak Park. Nor did the figures for the 1960 census tell the full story. The growth continues unabated. Oak Lawn, virtually unnoticed in earlier surveys of suburbs, was discovered to have over 50,000 people when a tragic tornado brought it to national attention in 1967. DuPage County, essentially a suburban area, added 113,515 people to its 154,599 between 1950 and 1960 alone. By 1969 the estimates placed its population at 438,000.

The effective agent in this suburban explosion was, of course, the automobile. Providing access to areas which could not be reached by mass transportation, it opened up almost endless stretches for residential development. By the mid-fifties almost everyone owned one; in

1

2

Commuting Fields in Chicago Urban Area

Figures on the commuting contours show the percentages of workers commuting to Chicago.

(Commuting lines computed by Brian J. L. Berry, *Metropolitan Area Re-evaluation Study*. Center for Urban Studies, University of Chicago, 1967.)

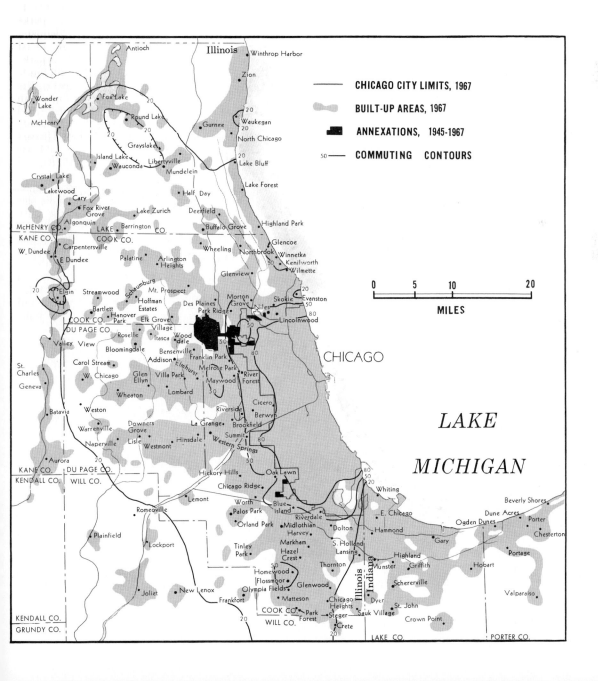

418

Park Forest
(Courtesy Department of City Planning, Park Forest, Illinois.)

fact, outside the city there were more cars than families as early as the mid-fifties. With the building of modern expressways, it was possible to live sixty miles away from the Loop and still commute to work. As a result, a subtle shift took place inside the metropolis. The historic supremacy of the central city gave way to a new balance between the suburb and the city, with the future power moving increasingly toward the outer communities.

This massive development, however, revealed a growing diversity among suburbs. Previously, they shared certain common characteristics. Their residents tended to be middle class in income, relatively high in education, and white, if not homogeneous, in ethnic composition. Moreover, the bulk of their population lived in single-family dwellings on generous lots, and the breadwinners usually commuted to the city. There had always been exceptions to this pattern, but the description was generally apt.

In recent years, however, the differences among suburbs have become increasingly clear. Perhaps the broadest distinction is by age. The older ones, usually abutting on the city or clustered around the suburban stations of the railroads, tend to fit the older pattern more closely, though the postwar period has brought significant changes in them, too. Evanston and Oak Park, for instance, increasingly permit apartment building, and, where space allows, industrial establishments. Their physical plants are

getting old, and many of these suburbs find themselves knocking at the doors of urban renewal officials for help in rehabilitation and replacement. Moreover, their population becomes more cosmopolitan, and some even have begun to accept Negro residents outside the old enclaves. In short, the inner ring of suburbs looks more and more like an extension of the city rather than discrete, identifiable communities.

The newer suburbs, newer in development if not in legal age, tend to be less well-to-do, houses less expensive, lots more modest in size, and population younger and more consciously white. Their problems are in creating new facilities and institutions rather than in refurbishing older ones. Nearly everything is new. When the developer leaves, the landscaping has to be put in, schools built, civic centers created, and shopping facilities opened. In addition, governments appropriate to the new growth have to be instituted, new zoning laws adopted, and planning for the future begun.

Indeed, the very speed of suburban growth complicates the search for solutions to the new problems. The case of Niles, northwest of Chicago, perhaps poses the paradox most clearly. Though not a young community, its expansion has come intensively in the past decade. In 1967 its population passed the 31,000 mark; but fifty-three per cent of that figure had arrived after 1960. Of the 2,902 new dwelling units constructed

in the same period over half were apartments. Meanwhile, green space, previously abundant, became scarce; parks and recreational areas were inadequate. Its main street, in the words of an official report, became "an ugly jumble of parking signs and miscellaneous buildings; highways tend to be barren strips; streets lack trees." The once famous Tam O'Shanter golf course was transformed into an industrial park. In 1967 a study commissioned by the Niles Park District asserted that the community had accumulated in ten years the problems of a hundred-year-old city.

Nor are Niles' difficulties unusual. Suburbs throughout the metropolis face similar crises. Everywhere taxes have risen ominously until most are higher than Chicago's. Yet problems keep piling up. Water and air pollution threaten even the more remote communities; growing populations require increased water supplies and enlarged sewer facilities. Precious land for recreation and parks has disappeared before the bulldozer. Traffic jams, once unique within the city, become increasingly serious. The need for new schools is almost universal. Social problems once associated only with large cities, move into the surrounding areas. Crime rates, for example, have gone up twice as fast in the suburbs as in Chicago in the past few years. Village governments, unaccustomed to the new situation, are often unable to devise new remedies; some have been wracked by scandals. In short,

1. A Park Forest "Superblock," 1951

These two-story apartment buildings were originally intended for rental, but many have since been converted into cooperatives. The fronts of these units face interior-block parks; their backs abut upon streets and parking areas.
(Photograph, Mildred Mead. Courtesy Chicago Historical Society.)

2. Portion of Park Forest, 1952
(Photograph, Owen Kent. Courtesy Chicago Historical Society.)

metropolitan problems are no respecters of political boundaries or historic conditions; wherever men live together in large numbers, problems are sure to follow.

Park Forest was the most important and the most renowned of Chicago's early postwar suburbs. A comprehensive project from the very beginning, it embodied many of the most modern planning concepts. Like the British "new towns," it was located on the outer edge of the metropolitan area, 30 miles from the Loop. Furthermore it abutted on a forest preserve on one side, giving it partial protection against conventional developers. Designed for 30,000 people, it consists of a series of neighborhood units tied together by common community facilities and services. Curved roads, a mixture of garden apartments and detached houses, and generous open spaces provided a pleasant setting for the enterprise. Nearby, the Illinois Central furnishes access to downtown Chicago.

Park Forest was a private undertaking, organized by the American Community Builders. The driving force was Philip A. Klutznick, a former housing official and later a United States delegate to the United Nations. The A.C.B. assembled about 3,000 acres of vacant land, farms, woods, and swamps and brought in a group of bright young experts. The first occupants of the rental units arrived in August, 1948. By 1950 the census counted 8,138 inhabitants; by 1960 the

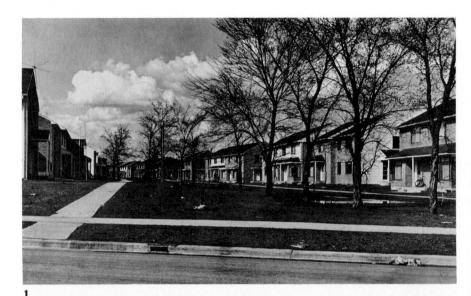

1

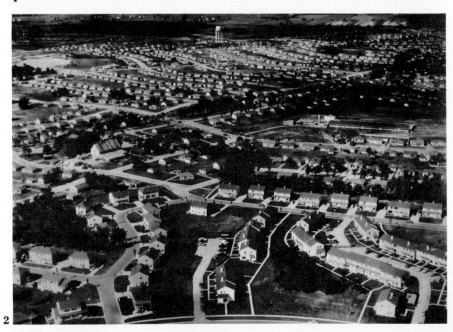

2

3. Plat of Elk Grove Village

More conventional in approach is the plan of Elk Grove Village. Developed by Centex Construction Company, it combines an industrial park and housing development with an excellent natural setting. (Courtesy Centex Development Company.)

4. Residential Portion of Elk Grove Village, Northerly View, 1963

Like Park Forest, Elk Grove Village incorporated a neighborhood unit design, with limited access streets, cul-de-sacs, and major arterial streets. In this photograph the neighboring forest preserve is at the upper left, and one unit of the Centex Industrial Park is at the upper right. (Photograph, Airpix. Courtesy Centex Development Company.)

3

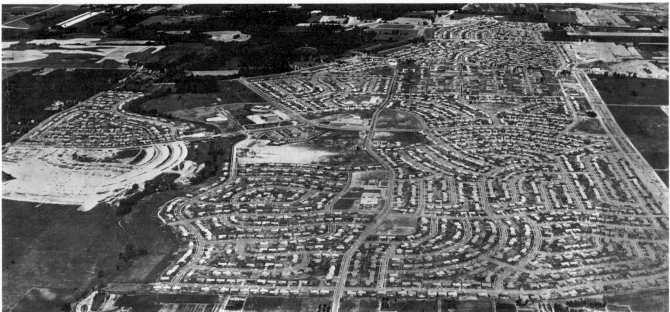

4

population moved over the 30,000 figure.

Most of the residents were young couples, who had begun their families, held promising white collar jobs, and had developed a taste for comfortable living. The first wave was heavy with professional and academic people, young executives of large corporations, army officers, and research experts. The median educational level was the highest for any community in the state. Social life quickly organized around town projects, schools and churches, and community improvement. The developers tried to convey the full texture of this living in words reminiscent of earlier suburban advertisements:

You *Belong* in Park Forest
The moment you come to our town
 you know:
You're welcome
You're part of a big group
You can live in a friendly small town
 instead of a lonely big city.

and again;

Come out to Park Forest where small-
town friendships grow—and you still
live so close to a big city.

Almost immediately Park Forest attracted national attention as a "model" suburb, a peek into the future of metropolitan life. William S. Whyte, Jr.'s best selling *The Organization Man* (the most celebrated analysis of the community) saw the Park Forester as a prototype of the new postwar society. Like others, he emphasized the frenetic togetherness of the young people, the almost compulsory participation *mystique*, and the vigorous social consciousness of town affairs. "It all got pretty hectic at times," he quotes a former resident as saying, "but one thing's sure—we were *living*." He notes, too, the high transiency. "Always, they will be moving on," he wrote. In the initial years over thirty per cent of the rental units were occupied by a new family annually; one out of every five homes changed owners each year.

Yet Whyte was in truth describing a process that was not new but very old. Chicago has grown through suburbanization. From the beginning, people have sought more land, larger houses, and less congestion outside of the municipal limits. They have subdivided farm lands, woods, and swamps, to create new communities which would combine the advantages of the open country with proximity to the city. These areas have always been characterized by high residential turnover, by shifting population, and by changing ethnic composition. Park Forest was one of the most carefully planned, and in many ways among the most successful. But within twenty years the nearby land was built up; the metropolis moved still further out; Park Foresters had begun to grapple with the ordinary range of suburban questions. If not all the hopes had been realized, neither had many of fears of analysts come to pass.

A more conventional enterprise was Elk Grove Village, another postwar suburb. Located northwest of Chicago, it was built upon automobile as well as railroad commuting. It also depends heavily on inducing industry into the new development. Park Forest had set aside areas for industrial use, but it was only modestly successful in attracting new enterprises. Elk Grove's proximity to O'Hare airport and to other manufacturing districts proved alluring from the start, providing the Village with much needed revenue for community services.

The variety of land uses has resulted in a mixture of white and blue collar residents. Average incomes are lower than in Park Forest, as is the average level of formal education. But essentially Elk Grove is typical of the new middle-class suburb. Detached houses stand on modest lots, curved streets replace the monotony of the urban grid, and trees and shrubs mute the newness of the development. Although the village is only a decade old, its population has already risen well above 10,000; and churches, schools, and a prosperous shopping center bespeak strong neighborhood attachments and a vigorous social life.

The new surge of population outward meant that shopping downtown became increasingly difficult. To serve this growing market, shopping centers sprang up throughout the suburbs. Some were small, containing only a few shops; but

1. Garden Apartments in Elk Grove Village

The Surrey Oaks Apartments are built to the maximum height permitted in Elk Grove Village.
(Photograph, Airpix. Courtesy Centex Development Company.)

2. Houses on a Cul-de-sac in Elk Grove Village, 1962
(Courtesy Centex Development Company.)

1

2

424

1. Location of Centex Industrial Park in Relation to Elk Grove Village and Chicago
(Reproduction by permission of publisher from Harold M. Mayer, "Centex Industrial Park: An Organized Industrial District" in Richard S. Thoman and Donald J. Patton, eds., *Focus on Geographic Activity*. New York: McGraw Hill Book Company, 1964.)

many were large, covering a quarter square mile of land in stores, plazas, and parking space. Like their unplanned counterparts inside the city at an earlier time, the largest became important regional centers, drawing on a market of several hundred thousand people and developing sales that approached the hundred million dollar mark.

Chicago's metropolitan shopping centers were not unique, but some were among the country's largest. Old Orchard and Oakbrook, for example, ranked fourth and fifth in the nation in sales volume. To the north are Edens Plaza and Golf Mill in addition to Old Orchard. Hillside joined Oakbrook in serving the west, while Evergreen and Ford City catered to the southwest. Residents of the southern suburbs used Park Forest and Olympia Plaza. Woodmar in Hammond, River Oaks in Calumet City, and The Village in Gary handled the growing trade of the Indiana sector of the metropolitan area. All depended largely on automobile access, and hence emerged as one- and two-story islands in a sea of parking.

As the metropolis rapidly spread out, industries joined the residential procession into the suburbs. This centrifugal movement had been apparent before the war, but after 1945 it reached dramatic proportions. Not only did new enterprises choose outlying locations, but even some established Chicago operations moved into suburban settings as their

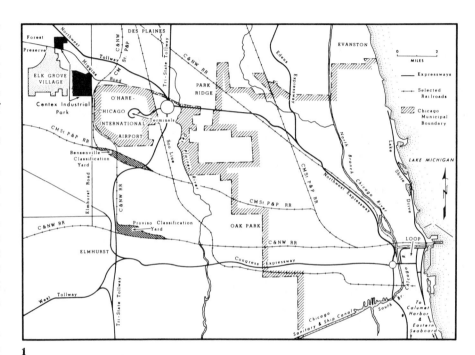

1

2. Oak Brook Shopping Center

Located in Chicago's near western suburb, this regional shopping center was opened in 1961. By 1963 with gross sales of sixty-seven million dollars, Oak Brook ranked second in total sales among the organized shopping centers of metropolitan Chicago and fifth in the United States. It is conveniently located near the intersection of the Eisenhower expressway and the Tri-State Tollway, and serves an extensive middle, upper-middle income group which resides in the area.
(Courtesy Draper & Kramer.)

3. Scottsdale Shopping Center in Southwestern Chicago

Before World War II the residential area in the background was open prairie; soon after it began to fill in, and Scottsdale, a typical community-sized shopping center conceived on a more modest basis than Oak Brook, was built in the fifties to serve the surrounding residents.
(Courtesy Chicago Association of Commerce and Industry.)

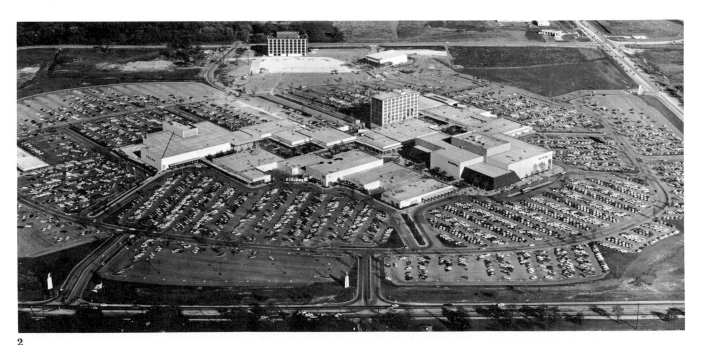

2

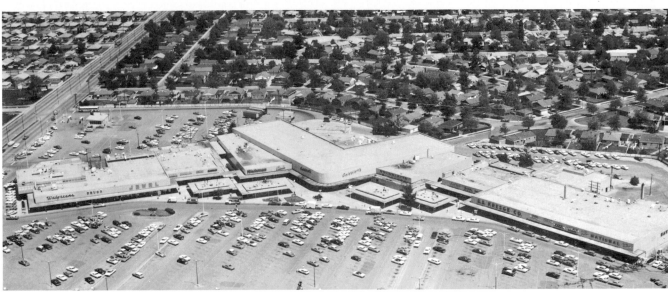

3

426

1. General Mills Plant, West Side of the Calumet River

Excellent rail and water connections have made the Calumet area a good location for the milling industry.
(Courtesy Chicago Board of Trade.)

2. Packingtown, 1950's

The shift of meat packing out of Chicago was already under way when this photograph was taken. In 1954 Cudahy moved its four plants from the city, and the Armour plant in the center of the photograph was closed in 1959.
(Courtesy Armour and Company.)

old facilities became obsolete or as they required new land for expansion. As a result the City of Chicago's share of manufacturing employment in the metropolitan area dropped from seventy-one per cent in 1947 to fifty-four per cent in 1961. By 1965 over half the industrial jobs were to be found outside the city limits of Chicago.

The reasons for this decentralization were clear. Sites on the periphery afforded freedom from the congestion of central locations, with their limited land for expansion and their scarcity of off-street space for parking and truck loading. In addition, single-story plants, which gained increasing favor before the war, became commonplace. Requiring more room than the traditional installations, they needed locations where they could tap the new expressways, where there would be opportunities for landscaping, and where nearby residential communities would be more attractive to workers and executives.

The rising importance of the motor truck and automobile also accelerated this outward industrial movement. Previously, most factories depended on rail transportation and had to have direct access to sidings; they depended, too, on mass transit to bring their workers to the gates. Now the truck and automobile liberated many of the manufacturers from these restrictions. With the exception of bulk goods in large quantities, most goods can be carried to and from the plants on highways;

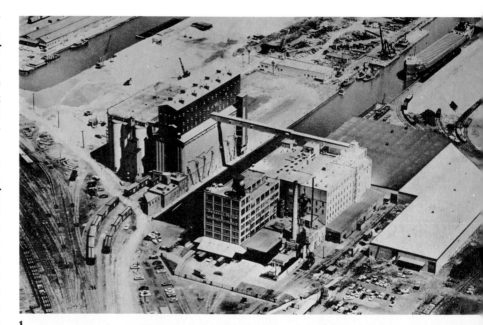

1

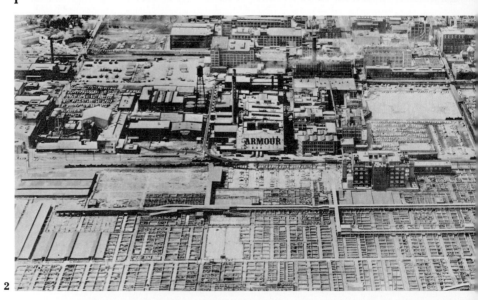

2

3. E. J. Brach and Sons, 4656 West Kinzie, 1964
Located in Austin on Chicago's far West Side, Brach's is one of the city's largest confectionary manufacturers.
(Courtesy E. J. Brach and Sons.)

4. Zenith Plant No. 6
One of the many plants comprising Chicago's vast television and radio manufacturing complex, this plant was built in Austin, on the city's West Side, in 1964.
(Courtesy Zenith Sales Corporation.)

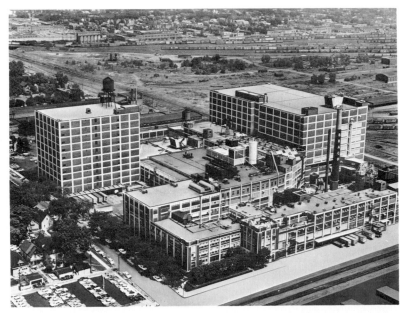

3

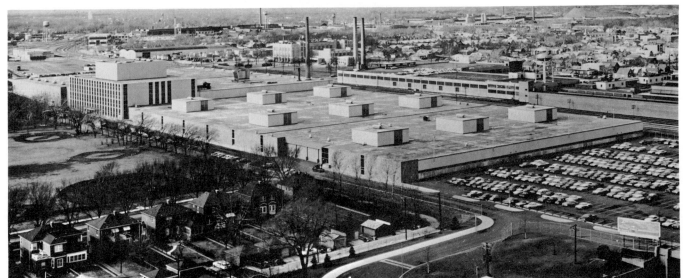

4

428

1. Fisk Street Plant of Commonwealth Edison Company, View Southwest over Halsted and Twentieth Streets, about 1960

Chicagoans switched rapidly to electricity for many purposes after the turn of the century; gas for home lighting and steam power for manufacturing gave way to the cleaner and more easily accessible power source. The Fisk Street Plant, which had been built in the 1890's, was expanded and modernized to take care of the greater requirements; but other plants had to be built to keep up with a demand which called for thirteen billion kilowatt hours annually by 1964.
(Photograph, Harry Williams. Courtesy Commonwealth Edison Company.)

employees can commute by car rather than by train. The expansion of the expressway network opens up additional sites every year.

One consequence of this manufacturing decentralization has been to sharpen the locational distinction between "heavy" and "light" industry in the metropolitan region. The new developments have hardened the pattern which found iron and steel, petroleum and chemicals concentrated in the Calumet area, south Cook County, and Northwestern Indiana—and other industrial activity located to the north and west. The former still depend on water and rail transport and can not move far from their historic sites, while "light" industries can take full advantage of the new conditions.

Among the casualties resulting from the decentralization of industry was Chicago's primacy in meat packing. For nearly a century the city had been, in Carl Sandburg's phrase, "hog butcher of the world." Decline set in after the war and accelerated during the fifties. Technological changes, altered market conditions, and the motor truck reduced the advantages of scale that the Stock Yards offered; increasingly the big firms located in smaller towns and in newer plants. By the mid-sixties almost all the great plants had been removed. Chicago was no longer the nation's most important meatpacking center. In Chicago, as a result, 30,000 workers had to find new jobs.

Other industries also suffered. Apparel manufacturers, for example, once congregated in lofts along Franklin and Market streets west of the Loop, were displaced first by the development of Wacker Drive in the twenties and then finally by the construction of the Wacker-Eisenhower interchange in the fifties. Much of the graphic arts industry was also displaced by expressway construction and had to find facilities elsewhere. Indeed, in the past ten years the city's loss of manufacturing enterprises reached almost 200, giving birth to a new program by the Mayor's Committee on Economic and Cultural Development to promote new areas for industrial development and to attract investment.

The Committee has had some successes; but the decentralization of industry continues. The organization of new industrial districts provides a convenient index of this movement. Of the 172 such districts created between World War II and 1968, only twenty-three were within the city limits. The Central Manufacturing District continued to be the most active, but the railroads and Chicago's Department of Urban Renewal also participated. The Santa Fe, for instance, secured control of the International Harvester location north of the Sanitary and Ship Canal at Western Avenue; the city promoted certain areas cleared for urban renewal. At Ford City at Seventy-third Street and Cicero Avenue the old wartime airplane engine plant, the largest single story plant in the world, was finally converted into a combined industrial district and shopping center, the latter the largest of its kind within the City of Chicago.

Outside Chicago, industrial district organization was even more extensive. Suburban communities, finding it difficult to provide essential services on a residential real estate tax base, eagerly sought certain types of industry. To be sure, they avoided installations which would bring in noise, air pollution, excessive traffic, or unsightly buildings, but the newer, lighter, and cleaner factories with their "campus landscaping" widened the tax base, created jobs, and provided revenue without excessively compromising the suburban quality of the area. The Sara Lee bakeries in Deerfield illustrates this trend. Opened in 1964 with a floor space of one-half million square feet and the capacity to produce one hundred million dollars worth of frozen foods a year, its automated process, antiseptic facilities, and modern design conceals its industrial character.

This extraordinary performance of suburban industrialization was not without its costs and problems, however. Most of the expansion of "heavy" industry took place along the shore of Lake Michigan, endangering some of the few remaining park and recreation sites in the metropolitan area. Although the issue appeared everywhere, it was most dramatic in the Indiana Dunes area east of Gary. Here the Midwest Steel and Bethlehem Steel corporations built on

2. Dresden Atomic Power Station

As the need for electricity grew, Commonwealth Edison turned to a new power source. In the far southwestern suburbs, the company built this atomic power station, which it linked into its growing power grid serving the metropolitan area. The capacity of this station was more than quadrupled in the late 1960's.
(Photograph, Ed Senecal. Courtesy Commonwealth Edison Company.)

3. View Northeasterly of Ford City Development, Seventy-Sixth and Cicero Avenue, 1965

Development of this shopping center was just nearing completion when this photograph was taken. Originally the two large single-story buildings were one, forming the Dodge-Chicago aircraft engine plant built by the Defense Plant Corporation early in World War II. Subsequently the building was utilized by the abortive Tucker Motor manufacturing operation, then by the Ford Motor Company which built aircraft engines there during the Korean conflict. Ford City's present developer has split the two buildings, utilizing the larger one to the north as an industrial district and the southern one-third as a shopping center, the largest in the City of Chicago.
(Courtesy Chicago Association of Commerce and Industry.)

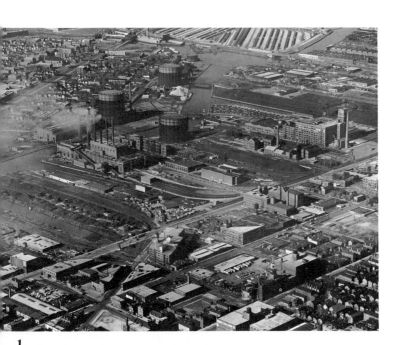

1

2

3

dunes land along the lake front, eating away at beaches and conservation areas. The Save-the-Dunes Council rallied the forces which hoped to protect this unique natural wonder from further encroachment by promoting a National Lake-shore Preserve. After a prolonged and often bitter battle, Senator Paul H. Douglas finally succeeded in 1966 in getting a federal commitment to develop portions of the area for recreation and conservation purposes.

Two industries perhaps demonstrate this centrifugal movement even more clearly—steel, one of the historic bases of Chicago's economic strength, and atomic energy, a development of the last generation. The former needed space to grow; the latter required it to be born. World War II had greatly expanded metropolitan Chicago's steel producing capacity; and postwar prosperity sustained the high demand. Yet there were danger signals everywhere. Competition from newer plants both here and abroad threatened Chicago's share of the market; technological changes rendered some of its older equipment and processes costly if not obsolete; and cramped quarters made expansion and new construction difficult. If metropolitan Chicago was to maintain its position, its steel companies would have to modernize swiftly.

This they did. New processes were introduced; open hearth furnaces gave way to a new type of basic oxygen furnace; continuous casting replaced sev-

eral steps in the steel-making process; the Seaway opened up new ore sources, especially from eastern Canada; and the expansion of the automobile, construction, and machine industries in the Midwest provided a constantly expanding market for Chicago's producers. Inland Steel Company developed along a two mile artificial peninsula into the lake. Youngstown Sheet and Tube closed its old Iroquois plant in South Chicago and expanded its Indiana Harbor plant, also partly on lake fill. United States Steel did the same in Gary and was also planning to expand on new fill in South Chicago. Others also joined the rush to modernization. By 1954 the Chicago metropolitan area, turning out a quarter of the nation's total output, had already forged ahead of Pittsburgh as the foremost producer of iron and steel in the world.

While Chicago established its national domination in iron and steel, it struggled to hold its own in the area of the newest technology in which it had pioneered—atomic energy. Though the Modern Age had been ushered in at Stagg Field during the war, leadership in the field moved to the East and West coasts, where massive "atom smashers" in New York and California attracted scientists and technicians from all over the country. The Argonne National Laboratory, established in 1946 and located twenty miles southwest of the Loop, increasingly paid the price of pioneering in a rapidly changing technology. While im-

portant work was still done there, the focus of activity gravitated to the newer and larger facilities elsewhere.

In 1966 the decision of the federal government to locate the world's largest accelerator at Weston in DuPage county promised to redress the balance. The site was chosen after a spectacular national sweepstakes in which there were over thirty entrants from nearly every part of the country. In the final analysis, it was metropolitan Chicago's excellent transportation, O'Hare International Airport, abundant and cheap water and electricity, and the proximity to first-class universities that tipped the scales to Illinois. A more than three hundred million dollar enterprise, Weston will be the center of the most significant research and development in the atomic field in the next two decades. The Atomic Energy Commission expects to employ over 2,000 scientists and technicians; the annual payroll will run to sixty million dollars. A "scientific city" is expected to spring up where there was nothing before but a scattered population on rich farm land.

The growth of activity in atomic research has been matched by growth in the practical application of atomic energy. The initial electric power station at Dresden, on the outskirts of the metropolitan area, was in operation in the early sixties, and in 1967 the Commonwealth Edison Company announced plans for a four-fold expansion. Other atomic power installations have been

1. Kitchens of Sara Lee at Deerfield, a Northern Suburb

(Courtesy Daniel J. Edelman & Associates, Inc.)

2. View Westward, Burns Harbor Plant of the Bethlehem Steel Corporation, 1966

The U-shaped buildings in the foreground house the sheet and tin mills; in the background are located a plate mill and hot strip mill. In the far background is the beginning of the construction of Burns Waterway Harbor, to serve this plant and that of Midwest Steel Corporation farther west.

(Courtesy Bethlehem Steel Corporation.)

3. Air View of Argonne National Laboratory

Operated by the University of Chicago under contract with the Atomic Energy Commission, Argonne National Laboratory is located in a former forest preserve southwest of Chicago.

(Courtesy Argonne National Laboratory.)

1

3

2

planned for Northern Illinois and Indiana. By the early seventies about forty per cent of metropolitan Chicago's electric power will probably be produced by atomic reactors.

Chicago's industrial strength rested, in part, on its continuing role as the mid-continent's transportation center. Though the postwar years witnessed continuous technological changes, the city maintained its old leadership. The St. Lawrence Seaway enhanced its importance as a lake port and made it a critical link in the shipping lanes through the continent and around the world. The construction of O'Hare International Airport gave Chicago the world's busiest air-terminal; and a new set of expressways made Chicago a major focus of a new national highway system. Even the city's historic railroad dominance was sustained, although automobiles, truck, and airplane competition radically altered the railroad's role in the country's transportation network.

The most obvious symptom of the railroads' problems was the precipitous decline of passenger traffic. Unable to compete with the speed of jet airplanes for long journeys or the convenience and flexibility of the automobile for short trips, the railroads almost disappeared as a major factor in inter-city personal travel. A few statistics convey the magnitude of the change. On the national level, the Interstate Commerce Commission reported that traffic dropped from 95.7 billion passenger-miles at the wartime peak of 1944 to 15.2 billion in 1967; by the late sixties the rails accounted for under two per cent of the country's personal inter-city travel. Many of the famous-name trains disappeared altogether, and most of those remaining had lost the elegance and excitement which made cross-country travel memorable for more than a century. A new generation grew up getting its only appreciation of the heyday of railroading through history books and old movies. The drop in passenger traffic did not, however, lead to the long-dreamed-of terminal consolidation. Though all the city's inter-city travel could be handled in the Union Station, six downtown terminals remained active—and underused.

The freight picture was much less gloomy. While railroads lost some of their relative importance to trucks, pipelines, and barges, their volume increased substantially. By 1966 it had exceeded the swollen wartime level of 747 billion ton-miles. Part of this success was due to innovations which permitted railroads to compete in time, flexibility, and price with other carriers. The most visible change was the introduction of "piggyback" service, which places a truck trailer on a flat car, thus combining the terminal flexibility of the motor truck with the economies of long distance railroad transportation. Actually as early as the twenties the Chicago North Shore and Milwaukee electric carried trailers to Milwaukee, but it was not until 1954 that the new system received legal authorization, and metropolitan Chicago became the national focus of piggyback traffic.

The introduction of new electronic techniques into classification yards also revolutionized the handling of cars and introduced new efficiency. Though most yards adopted many of the innovations, Santa Fe's Corwith Yard provides one of Chicago's most complete illustrations. Unusually compact, occupying only 190 acres, it can store 6,000 cars and has a working capacity of 3,000. The main classification yard consists of thirty-two tracks where trains are assembled as the cars are pushed over a gravity hump. They descend a gentle grade, being controlled by electropneumatic retarders set along the rails. These retarders and the switches, in turn, are controlled by a computer system, in which the operator need only push a button to set up a route for cars to enter the appropriate track; the switches are then automatically set and the retarders slow up the descending car just enough to enable it to couple easily on the end of a train. The computer can "store up" five movements in advance and the system can handle four cars a minute. New techniques were working the same magic in the Chicago and North Western's Proviso Yards, in the Illinois Central's Markham Yards, and the Milwaukee Yards in Bensenville, among others.

While the city sustained its railroad hegemony, it also secured further its position as the world's leading inland

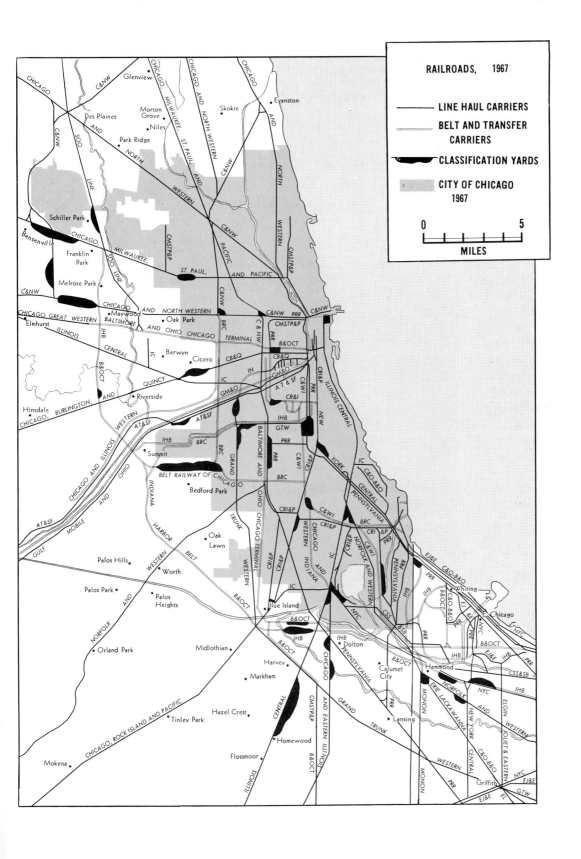

RAILROADS, 1967

——— LINE HAUL CARRIERS

═══ BELT AND TRANSFER
 CARRIERS

▬ CLASSIFICATION YARDS

▓ CITY OF CHICAGO
 1967

0 5
├──┼──┼──┼──┼──┤
 MILES

1. Modern Trains and an Ancient Terminal, about 1960
With the Loop skyscrapers as a backdrop, two of the Santa Fe's passenger trains prepare to depart the city's eighty-year-old Dearborn Station.
(Photograph, Frank E. Meitz. Courtesy Santa Fe Railroad.)

2. Classification Hump in the Proviso Yards of the Chicago and North Western Railway.
A locomotive pushes incoming freight cars up the hump in the foreground. At the top of the hump the cars are manually uncoupled into "cuts" of one or more which then descend the grade. They are directed into the proper yard tracks by switches controlled from the three towers, their speed being regulated by retarders in the tracks.
(Courtesy Chicago and North Western Railway.)

port. The "Port of Chicago" is no single, concentrated enterprise. Instead it is strung out along the lake from Waukegan in the north to Burns Waterway Harbor in the Indiana dunes area. It includes, as well, two inland connections to the Lakes-to-Gulf Waterway, major installations along the six-mile, deep-draft Calumet River and a major terminal on Lake Calumet. This scattered complex, however, normally handles about seventy million tons of water-borne commerce a year.

Internal traffic on the Great Lakes, both domestic and to and from Canada, comprises the most important component of the volume. Across the waters come the iron ore, limestone, chemicals, and newsprint to feed Chicago's industry. From Chicago's docks move grain, petroleum products, coal, sulfur, scrap, and other commodities to the ports around the Lakes and down the St. Lawrence. The bulky "lakers," up to 730 feet long and with 28,000 ton capacities, are the backbone of the trade; and even larger vessels are under construction.

The second component of the commerce of the Port of Chicago is the inland waterway traffic, handled in barges and amounting to twenty or twenty-five million tons annually. Consisting largely of inbound bulk commodities, this trade moves to the city through the Calumet Sag and the South Branch Chicago River–Chicago Sanitary and Ship routes from the 12,000 miles of the rivers and

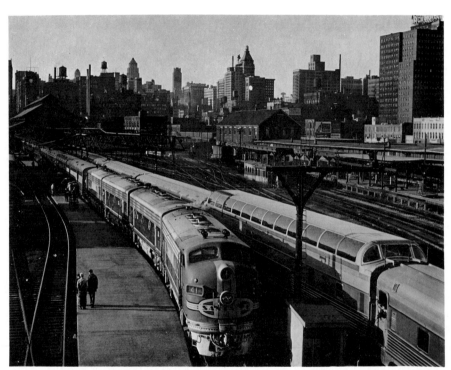

1

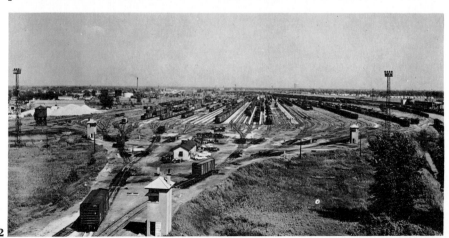

2

3. View of Santa Fe's Corwith Yards, North from Forty-Seventh Street, Early 1960's

"The Chicago area is served by 20 trunk line railroads which operate close to one-half of the nation's total railway mileage," the *Chicago* magazine boasted in 1965. "They reach directly to all or parts of 26 states with nearly half of the nation's 200 cities of population of 65,000 or more. Here—

in these states—are 37 per cent of the nation's wholesale establishments, 38 per cent of its retail stores, 39 per cent of its manufacturing concerns, and 40 per cent of its farm output in terms of product dollar value." All of these facts continue to make Chicago the nation's rail center.
(Photograph, Frank E. Meitz. Courtesy Santa Fe Railway.)

4. View Southwest across Santa Fe's Corwith Yards, about 1962

In the background is the Corwith classification yard and a newly installed "piggyback" loading facility in the foreground. At the middle left is the special automobile facility which takes cars from triple-deck "rack" cars for over-the-road delivery to dealers.
(Photograph, Orville Brent. Courtesy Santa Fe Railway.)

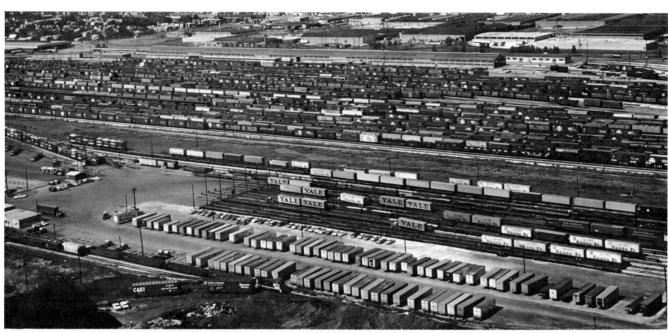

3

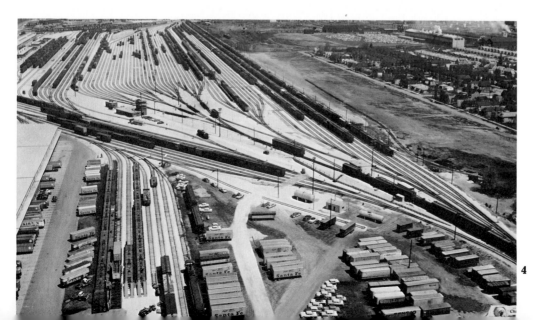

4

**1. Harbors and Inland Waterways
of Metropolitan Chicago, 1967**

**2. Arrival at Navy Pier of the First
Overseas Vessel through the Newly
Enlarged St. Lawrence Seaway,
April 30, 1959**

The *Prins Johan Willem Friso* of the
Dutch Oranje Line was the first arrival at
Chicago after the Seaway expansion was
completed.
(Photograph, Andrew F. Dober. Courtesy Chicago
Historical Society.)

canals which make up the Mississippi
River system and the Gulf-Intracoastal
Waterway. During most of the year,
powerful diesel towboats, like slow and
deliberate beetles, can be seen pushing
long lines of barges through the inland
complex.

The most celebrated part of the traffic
of the Port of Chicago is the direct over-
seas trade. Though carried on in a mod-
est way before World War II, its po-
tential was greatly magnified by the con-
struction of the enlarged St. Lawrence
Seaway which opened the inland waters
of North America to medium-size ocean-
going ships. In June, 1959, the long
heralded event was officially recognized
when the royal yacht *Britannia*, carrying
Queen Elizabeth II and Prince Philip,
led a procession of fifty vessels from
Montreal to Chicago. Actually, two
months before, the *Johan Willem Friso*
of the Oranje Line had tied up at Chi-
cago, representing the vanguard of a
new dimension of commerce.

Chicago's share of the new trade de-
pended, however, on a wide range of
improvements in the port. Even before
the opening of the Seaway, work was
begun on rebuilding the Navy Pier. On
November 2, 1955, the first spade was
turned on the enlargement of the Cal-
umet-Sag Channel, and the development
of Lake Calumet was already under way.
Indeed, as a result of a wide range of
projects including deepening the channel
to Lake Michigan, Lake Calumet has
become the largest comprehensive termi-

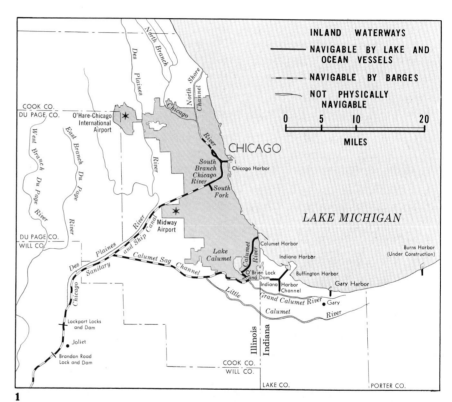

1

2

3. View Northwestward, Chicago Regional Port District Terminal at the South End of Lake Calumet
(Courtesy Chicago Association of Commerce and Industry.)

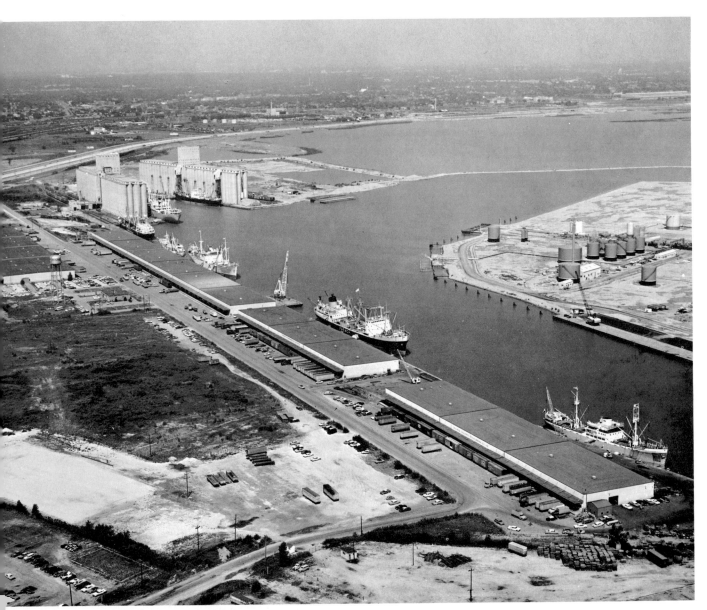

1. Calumet River Southward from the Chicago Skyway Bridge, 1958
On the east bank beyond the 100th Street bridge is the Chicago yard of American Shipbuilding Company. In the foreground, on the west bank, is the unloading wharf of Commonwealth Edison's 100th Street Station, which receives bargeloads of coal from central Illinois via the Calument Sag system.
(Photograph, Hugh Celander. Courtesy Chicago Historical Society.)

2. Calumet River Southward from One Hundredth Street Bridge, 1958
On the east bank, a former LST is being converted at the plant of the American Shipbuilding Company. The steamer *Ben E. Tate* is in midstream. A self-unloading lake coal carrier, it is being towed from the Rail-to-Water Terminal with a load of coal from southern Illinois and western Kentucky bound for other lake ports.
(Photograph, Larry E. Hemenway. Courtesy Chicago Historical Society.)

nal complex on the Great Lakes, serving ocean and lake shipping as well as inland barges. Symbolically, this formerly shallow little lake of only 2,200 acres is the only meeting place of the two great inland waterways of the continent—the Great Lakes–St. Lawrence system to the north and east, and the Mississippi River complex to the south and west.

Chicago dominated the new modes of travel as well as the old. It became a major transfer point on the inter-city bus network of North America. In fact, as a symbol of that importance, it is the headquarters of the Greyhound Corporation which accounts for about half the scheduled inter-city passenger miles by bus in the United States. In trucking the story is the same, with Chicago becoming the most important center of intercity movement in the country. It is served by more truck lines and is the headquarters of more trucking companies than is any other place in the nation. This importance in the trucking world reflected Chicago's key position in the development of a national expressway system. The extraordinary popularity of the automobile in the postwar period quickly made the old road system obsolete. In 1945 the city registered 428,000 cars; by 1953 the number reached 765,000. The metropolitan figures were equally impressive; in 1963 there was one car for every three people. Clearly, only a massive construction program could accommodate a "population explosion" of this magnitude.

1

2

3. An Oceangoing Ship Loading at One of the Two 6.5 Million Bushel Grain Elevators in Lake Calumet
(Photograph, Calumet Studios. Courtesy Chicago Regional Port District.)

4. Oceangoing Ships at Navy Pier, 1961
The vessel in the foreground, the M.V. *Takeshima Maru*, a Japanese cargo liner of the Iino Lines, is taking aboard soybean oil from tank cars. Several Japanese lines serve Chicago on regular schedules, bringing such diverse imports as steel wire, automobiles, electronic goods, and toys.
(Photograph, Norman A. Tegtmeyer. Courtesy Chicago Historical Society.)

5. An Inbound Tow in the Chicago Sanitary and Ship Canal at Harlem Avenue, Summit
A towboat pushes a six-barge tow loaded with coal past a tank farm on the Sanitary and Ship canal. The coal, cut from seams in central Illinois, is bound for the Commonwealth Edison Company, the principal consumer in Chicago. Coal and oil are the two principal commodities on Chicago's inland waterways.
(Photograph, Larry E. Hemenway. Courtesy Chicago Historical Society.)

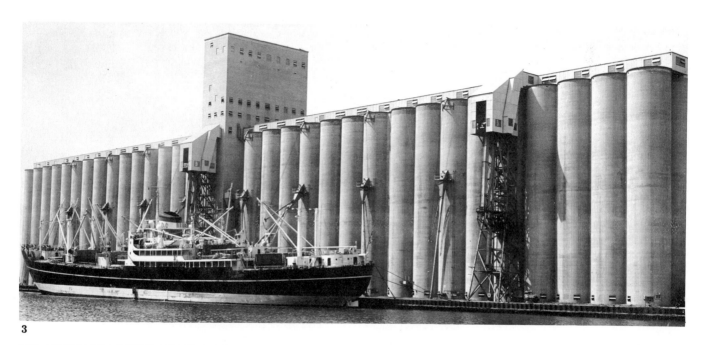

3

4

5

440

1. Intercity Motor Truck Terminals, Eastward from Blue Island and Ashland Avenues, about 1960

With 1,568 lines operating 177,288 trucks, Chicago is home base for more common carrier motor trucks than is any other city in America. The reason for this heavy concentration is that Chicago with its numerous industries and excellent railroad and water connections is a primary point of origin for intercity truck traffic.

(Photograph, Mart Studios. Courtesy Harry F. Chaddick Associates, Inc.)

Fortunately, Chicago had already paved the way, so to speak, for this development. The lakefront expansion had created the Outer Drive, later renamed Lake Shore Drive. European pioneering, especially the *autobahnen* in Germany and *autostrade* in Italy pointed the way, however, toward the broader and more appropriate response. When the Pennsylvania Turnpike opened in 1940, it was evident that the age of the expressway had begun. The war, of course, postponed building, but in the past two decades Chicago devised and has nearly completed its modern complex.

The broad design was to give automobile access to (and through) the city from every part of the metropolis. The Edens and Kennedy were built north and northwest; the Eisenhower penetrated the west, the Stevenson and Dan Ryan serviced the south and southwest, while the Calumet and the Kingery plunged through the southeast toward Indiana. Meanwhile, the Tri-state Tollway skirted the metropolitan area and tied Chicago into the massive inter-state structure. By 1969 only a north-south connection along the western edge of the city remained to be located and constructed.

The federal government paid ninety per cent of the construction and land acquisition costs of many of the expressways, and their design standards left little room for local innovation. Yet Chicago's expressways had some distinctive features. The most doubtful was

1

2. View East-Northeast, University of Illinois Circle Campus, 1966

The search for a site for the Chicago branch of the University of Illinois began in 1954. Ninety different locations were eventually considered, but all proved unavailable or impractical except one, an urban renewal area at the Circle interchange of the city's expressway system. This site combined two advantages: "It was eminently accessible, and heartwarmingly inexpensive: the city and federal governments would pay all but $4 million of its $27 million cost."
(Courtesy Portland Cement Association.)

3. University Hall and Lincoln Hall, Chicago Circle Campus, 1966

Walter Netsch of the architectural firm of Skidmore, Owings & Merrill was in charge of the design for the Circle Campus. An *Architectural Forum* article explained: "The concept was to group the campus buildings by their function, rather than by discipline. Offices are with offices, lecture halls with lecture halls, classrooms with classrooms, and all academic departments of the university come together in their use of these common facilities." University Hall, at the left is the 33 story office and administration building of the Campus.
(Courtesy Public Information Office, University of Illinois at Chicago Circle.)

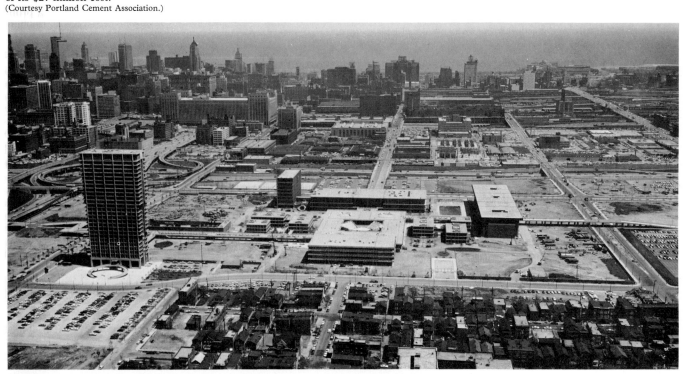

2

3

the Dan Ryan's claim of being the world's widest roadway. The Kennedy's two reversible lanes permit a flexibility for reducing rush-hour congestion, and the double-track rapid transit lines down the median strip of the Eisenhower demonstrate how expressways can also strengthen mass transportation. Perhaps most unusual of all, however, is the Chicago Skyway that connects the Dan Ryan Expressway with the Indiana Toll Road. Early in the development of the expressway system it looked as though a vital link to the south would be missing, and heavy traffic would be dumped into the city with no facilities to handle it. Local officials decided to build a toll road to meet the emergency, only to find that the city lacked the authority. But soon it was discovered that it did have the power to build toll bridges. Moreover there was no limitation on the length of the approaches. As a result, Chicago has a unique seven mile expressway bridge soaring 120 feet over the Calumet River. But generally the new system looked like everyone else's—massive strips of concrete slicing through industrial, commercial, and residential areas, punctuated regularly by access roads, and tied together by concrete bows at the interchanges.

Perhaps the best symbol of the new dominance of the automobile in the metropolis is the fact that the spot that the Burnham Plan had marked for the civic heart of Chicago is now the site of the most elaborate expressway interchange in the city. Just west of the Loop where Burnham had located a domed civic center, the Kennedy, Dan Ryan, and Eisenhower come together in a baffling maze of ramps, overpasses, underpasses, entrances, and exits. Just beyond this complex, however, and more in keeping with the spirit of the Plan of 1909, is the newly established University of Illinois Chicago Circle campus, probably the only campus in the world named for a traffic interchange. A frankly "urban campus," it is a series of varied buildings united by concrete walkways. By 1970 over 20,000 students will be commuting to this new institution.

The expressway system has not only considerably eased automobile and truck movement throughout the metropolitan region, but it has also accelerated the centrifugal forces historically at work in the city. Newly developed areas are no longer dependent upon mass transportation; thus it is possible to build with much lower density at the outer edges. In the suburban areas the expressways strike out over formerly unoccupied country midway between the railroads. Here land acquisition is cheaper, parcels larger, and relocation problems fewer. Around the interchanges, however, commercial clusters have grown up, presenting a focus not entirely unlike the development around the stations of the old railroad suburbs.

If the automobile presented an opportunity to reduce residential densities throughout the metropolitan area, it also compounded severely the parking problem. The urban landscape everywhere bore witness to an almost insatiable demand. Downtown, the parking garage became a common, and seldom edifying, sight. In Grant Park, every day the cars, like alewives washed up on the shore, filled the massive lots near the lake. New facilities underneath Michigan Boulevard and Grant Park cared for 4,500 more. Zoning laws increasingly required off-street space in new construction; but nowhere had property owners or architects found a pleasant mask for this essential function. In the shopping centers and in the suburbs the accommodation was even more unblushing. Acres of asphalt and concrete ate up five and six times as much land as the commercial installations that they served.

Planners and city officials have long hoped for some relief through the revival of mass transportation. Indeed, in the 1960's there seemed to be more unanimity in this proposition than almost any other "solution" to urban ills. Yet the progress was of the most touching modesty. Mass carriers each year handle a smaller percentage of the passenger traffic, and many companies define success by mere survival. A few statistics convey Chicago's plight. For the past four decades between 800,000 and 900,000 persons daily enter and leave the central business district. In 1926, 300,000 entered and left by streetcar. By the sixties only a third, about 120,000, rode CTA buses for the trip. Meanwhile,

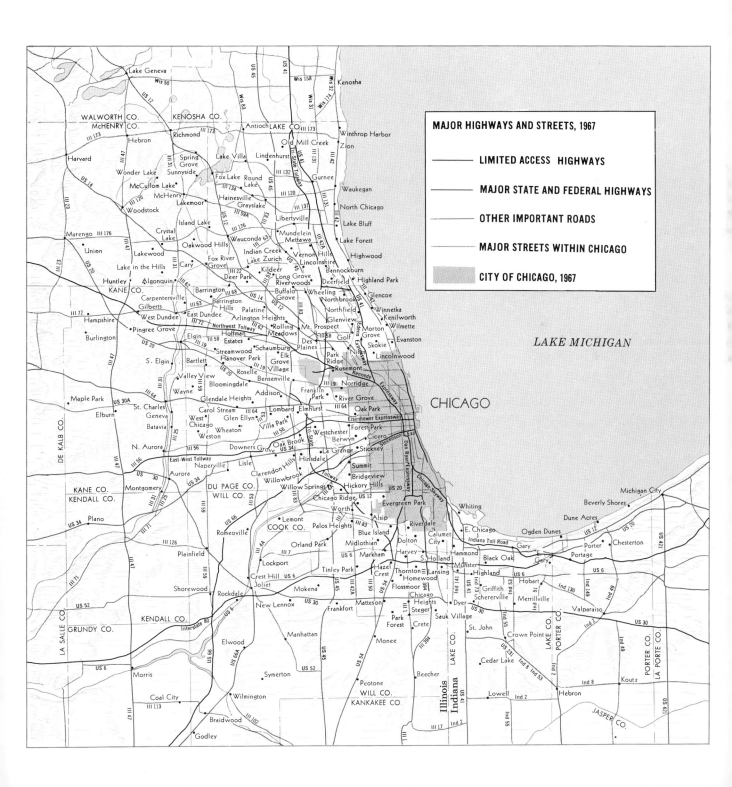

444

1. View Eastward of the Chicago Circle Traffic Interchange of Three Major Expressways West of Loop, 1961

Chicago's Loop continues to have a high concentration of businesses and services. For traffic engineers, the design problem was how to bring increasing auto traffic into the Loop, in the most efficient manner. The result was this "spaghetti bowl," as it is fondly called by many drivers, which provided a maximum number of access points to downtown parking lots while still connecting with all expressways so that through traffic may continue past the Loop without entering.
(Courtesy Portland Cement Association.)

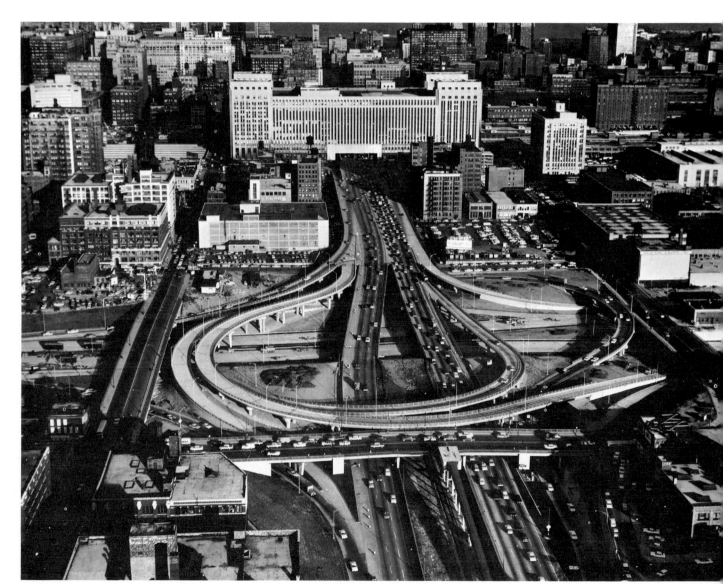

1

2, 3. Before and after Views of the Dan Ryan Expressway on the South Side, 1943 and 1963

In the top photograph, along both sides of the Rock Island and New York Central railroads are slums of the South Side, including the notorious Federal Street with its back against the railroad embankment. Chicago's expressway development between 1948 and 1966 was the single greatest cause for family relocation in the city, though redevelopment and public housing developments ran close seconds. These two photographs illustrate why. The Dan Ryan Expressway eliminated a block-wide swath through some of the city's worst housing. Access ramps and parallel streets added further to the cleared numbers. To the east of the expressway is the Stateway Gardens project.
(Courtesy Gordon Coster Collection.)

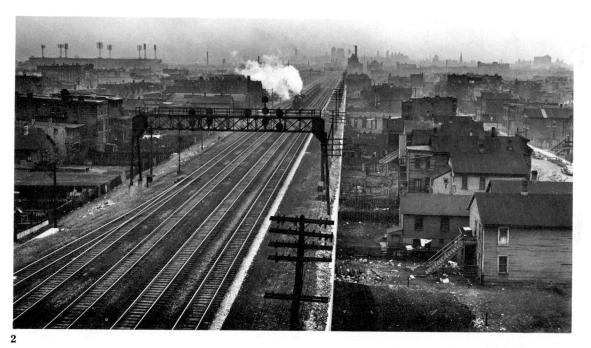

2

3

1. Dan Ryan (South) Expressway, Northward from Thirty-Second Street, 1965

At this point the Ryan has fourteen through lanes, a medial strip designed for a double track rapid transit line authorized in 1967, and six lanes of frontage or local access streets. The intersection with the Stevenson (southwest) Expressway is in the middle distance and was completed in 1967.

(Courtesy Portland Cement Association.)

2. Eisenhower Expressway in Forest Park, View South-Southwest, 1961

Forest Park is a pleasant near-western suburb. Here the expressway is one lane narrower in each direction than it is in Chicago. It is also at this point that the rapid transit rail line ends, although suburban railroad trains carry passengers farther west.

(Courtesy Portland Cement Association.)

the 165,000 who came by automobile climbed to 250,000. Rail lines—elevated, subway, and suburban rail passenger services—on the other hand, remain remarkably constant, holding at between 200,000 and 250,000 a day.

The carriers have not been idle even in the face of this deteriorating situation. The previously private facilities were consolidated in the Chicago Transit Authority. The Milwaukee Avenue–Lake Street–Dearborn Street Subway was opened in 1951 and a new double-tracked line in the median of the Eisenhower Expressway replaced the old West Side Elevated. Construction began in 1967 on similar installations in the Dan Ryan and Kennedy Expressways. Obsolete equipment gave way to modern cars; stations were refurbished; new express services were instituted along some runs. But even this energy and ingenuity could not arrest the decline of mass transportation.

Maintaining suburban rail service was one of the postwar achievements in Chicago transportation. Elsewhere, services were severely curbed or discontinued altogether. All around the country, established lines went under or were kept alive only by subsidies. Yet Chicago carriers, by putting on new, air conditioned double-decker cars, by converting to diesel powered engines, and by improving management, were able to at least break even on their suburban operations. Indeed, the Chicago and North Western, whose three routes parallel new express-

1

2

3. Eisenhower Expressway, Cloverleaf Interchange at Mannheim Road in the Western Suburbs, View East, about 1959

This photograph shows the expressway interchange as it joins three state highways at Mannheim Road. At the right of this interchange is the Hillside Shopping Center which has grown up since the coming of the expressway. It serves the Hillside, Westchester, and Bellwood suburbs.
(Courtesy Cook County Highway Department.)

4. Parking Garage, State and Wacker Drive, View West from Twentieth Floor of Executive House, 1959

The city of Chicago created a municipal parking authority in the early 1950's. This agency assembled sites for open lots on the fringes of the business district; they also built garages in the Loop, financing them through revenue bonds. Some of these garages were leased, some run by the city itself.
(Photograph, Don Honick. Courtesy Chicago Historical Society.)

5. Kostner Avenue Station of the Chicago Transit Authority's Eisenhower Expressway Line

Placed two-thirds of a mile apart, medial stations of the rapid transit line are reached from street level by ramps.
(Courtesy Chicago Transit Authority.)

3

4

5

1. View Northeast from the Lake Street Bridge across the South Branch of the Chicago River, 1965

Four levels of transportation cross the river at this point: the elevated railroad, surface street traffic on the bridge, vessel traffic in the river, and the Milwaukee-Lake-Dearborn subway under the river. A now-abandoned freight tunnel formerly constituted a fifth level crossing this point. (Courtesy Chicago Transit Authority.)

2. Chicago and North Western Suburban Train, about 1962

This photograph is a good illustration of the competing forms of transportation which converge upon Chicago's Loop district. In the background, is the John F. Kennedy (northwest) Expressway, its lanes lined with outgoing evening rush-hour traffic. In the foreground is a Chicago and North Western "double deck" commuter train. The C. and N.W. has

ways, received national attention by increasing its volume and turning a neat annual profit.

Chicago's hegemony on land and sea was matched by its increasing importance as the mid-continent's air center. Indeed, in number of flights and number of passengers on scheduled air lines it is second in the world; it is first in air cargo, and has the busiest commercial airport on the globe. This primacy, of course, was built on the growth of Midway during the thirties and the immediate postwar epoch. By the mid-fifties, though hopelessly inadequate for the mounting demand, it was handling nearly ten million passengers a year.

But Midway's future was limited. The volume was already too high to handle regular flights without vexing delays; the new and larger jet airliners needed longer runways; and the built-up area around the airport did not permit any substantial expansion. Fortunately, just two miles beyond the northwest corner of the city, at Orchard Place, the Douglas Aircraft company had built runways to test its four-engined transport plane that made up the backbone of most commercial air fleets after World War II. This territory was now transferred to the city for a new airport, later called Chicago-O'Hare International Airport (although the letters ORD still remain on tickets and baggage as an abbreviation for Orchard and a reminder to travelers of the early modest origins of the new facilities).

1

2

made a major effort to win and hold
commuters to their line. Most important
from the standpoint of passenger service
was the purchase of a fleet of 210
double-deck cars like these in the
photograph.
(Courtesy Chicago and North Western Railway.)

**3. Midway Airport, Main Terminal
Area, 1956**
(Courtesy United Air Lines.)

**4. View Eastward of a Portion of the
Terminal Complex at O'Hare
International Airport, 1965**
(Courtesy United Air Lines.)

3

4

450

The new airport, ten square miles and ten times the size of Midway, seemed to meet Chicago's space needs for a long time to come. Here were facilities for international travel, 10,000 parking places, and ideal highway connections to the entire metropolitan area. Indeed, in a sense O'Hare was too good, for soon all the major airlines abandoned Midway and resettled in the new and modern installations. The old airport languished, used only for private phanes, charters, and unscheduled flights. The motels, restaurants, and inns around it fell on hard times and the commercial vitality of the area declined.

Meanwhile, O'Hare and the entire northwest area of the metropolis flourished. In 1967 over twenty-seven million passengers arrived and departed through the new terminal. United Air Lines, the world's largest, moved its headquarters from Midway to Elk Grove Village. New, luxurious motels sprang up around the airport, not only catering to ordinary travelers, but also to service the new breed of commuting business and professional men. Every day scores of meetings, conferences, and conventions are held in plush surroundings comparable to those of the leading downtown hotels, the convenient location permitting quick and easy access and saving the long trip to the Loop.

Very soon, however, O'Hare itself became overcrowded. Air traffic mounted more rapidly than even the most generous projections, and the old problem

that afflicted Midway now vexed its successor. The construction of new runways and facilities provided some relief, and the development of jet aircraft with shorter runway requirements made the reactivation of Midway possible. Yet both the experts and the public were increasingly convinced that Chicago needed a third major airport. Speculation centered mostly on the southwest or on an artificial island in the lake.

The large commercial aircrafts were not the only problem. The rising number of small private planes and the growth of commuter airlines posed another question. Most of this traffic was carried by Meigs Field built on Northerly Island in Burnham Park and one of the busiest single-runway commercial airports in the world. Its convenience, only a few minutes from the Loop, is unmatched. Yet its location on the lakefront had always drawn criticism, and the construction of new high-rise buildings along the shoreline now present an additional hazard to the flyers. Moreover, by the seventies it was likely to be as crowded as Midway or O'Hare.

Residential growth, industrial expansion, and a virtual revolution in transportation were evidence enough that the city was not stagnant. But the most visible sign of change in postwar Chicago was the erection of an exuberant new skyline. After the Prudential rose forty-two stories on air rights over the Illinois Central tracks, the whole pent-up vital-

ity of a city which had not had a major building since 1934 broke loose. Within a decade over a billion dollars was invested in new construction. The most imposing buildings rose over the downtown and along the lake front, but the impulse spread throughout the entire metropolitan area.

Though much, no doubt too much, of the new building was derivative at best, and garish and tasteless at worst, there was still plenty of evidence of the continual vitality of the Chicago tradition or "style" of architecture. Carl Condit, the Chicago School's leading student, has divided that tradition into two parts. One springs from Holabird and Roche and is marked by an "organic architecture," one "which begins with a functional plan carefully developed in the scientific spirit," "exploits to the full the structural means provided by iron and steel framing, and emerges with a form that is determined essentially by the structure." The other stream in the Chicago tradition stems from Louis Sullivan and "starts with functionalism but reaches beyond structural expression to a statement of personal feelings generated by the new social and technical currents of the 19th century."

Condit finds both facets of this tradition renewed in postwar building. The organic principle is embodied in Mies van der Rohe's Promontory Apartments in Hyde Park and the two towers along North Lake Shore Drive, but its ultimate statement he finds in the Civic

1. Meigs Airport on Chicago's Lakefront, 1965

Located on the city's lakefront, Meigs Field offers the ultimate in convenience for small plane air trips to and from Chicago. Helicopter, air commuter, and charter services operate from the field, just minutes away from the Loop and, before it burned down, McCormick Place, the city's largest convention center. (Courtesy Chicago Association of Commerce and Industry.)

2. United Air Lines Headquarters, Elk Grove Village, 1962

This building, in the middle center of the photograph, was designed by Myron Goldsmith of Skidmore, Owings & Merrill's Chicago office. What Goldsmith created was described by Allan Temko in the *Architectural Forum* in 1962: "On a raw industrial tundra . . . the new United Air Lines headquarters building stands white and calm and powerful, its great grid effortlessly spanning 66-foot bays with tremendous horizontal emphasis. This impersonal monument of prestressed concrete belongs to its own epoch with the same rational confidence as the jets flying overhead. It could have been created at no other time, and perhaps in no other place: its plain, virile strength springs from the vigor of Chicago today." In the foreground is United's Educational and Training Center. (Courtesy United Air Lines.)

1

2

1. The Prudential Building, Completed 1955

"Until the Prudential Building was finished in 1955, Chicago had built a total of less than one million square feet of net rentable office space since 1947," the *Architectural Forum* reported in a special issue on Chicago in 1962, "In the same period, New York built 10.7 million square feet." Between 1933 and 1952 Chicago construction was concentrated mainly in North Shore luxury apartments or in industrial buildings. But "The Prudential broke the ice," realtor Leo J. Sheridan noted. "It is doubtful that all of the subsequent buildings would have been built if Prudential had not established these things."
(Photograph, E. C. Bunting. Courtesy Chicago Historical Society.)

Center completed in 1965, which was designed by three leading firms—C. F. Murphy Associates; Skidmore, Owings & Merrill; and Loebl, Schlossman, Bennett and Dart. "This immense tower," he writes, "has revolutionized traditional building scale through a powerfully articulated revelation of the steel frame. The extreme length of the bays, the great size of the individual members, and the unpainted metal surfaces convey a unique sense of enormous strength combined with dignity and richness of texture."

He finds the Sullivan tradition expressed to some degree in the United States Gypsum Building by Perkins and Will, although he adds that it is some ways "in a class by itself." The Brunswick Building by Skidmore, Owings & Merrill, however, is more easily placed. "The concrete-frame bearing walls," Condit asserts, "are presented to us unadorned structural revelation, thus placing the tower squarely in the mainstream of the Chicago tradition. The similarity of this building to the Monadnock is not an accident: both are constructed with load-bearing exterior walls, and both require the inward curve at the top of the base to maintain a uniform vertical plane in the inner surface of the wall structure."

But no categorization can fully contain the variety and richness of the new work. Reyner Banham, the British critic, caught much of the diversity when he constructed a walking tour through the

1

2. Chicago Civic Center
(Photograph, Bill Engdahl, Hedrich-Blessing. Courtesy C. F. Murphy Associates.)

3. U.S. Gypsum Building, Corner of Wacker Drive and Monroe
(Photograph, Hedrich-Blessing. Courtesy The Perkins & Will Partnership, Chicago.)

4. The Brunswick Building, Washington and Dearborn, Looking North
(Courtesy Author Rubloff and Company.)

2

3

4

Loop for the *Chicago* magazine. At the corner of Wabash and Jackson our visiting cicerone called attention to the Continental Center designed by C. F. Murphy. Pronouncing it an "immensely handsome building," he noted that the requirements of air conditioning had led the architects to finish off the top with two stories of grillwork instead of the projecting cornice, one of the insignia of the old Chicago style. Farther west, on Wacker and Monroe, across from the new U.S. Gypsum Building, is the Hartford Plaza, an "elegant setting forth of the facts of structural life in reinforced concrete." It makes its "elegant effect from an inelegant material," Banham observes, "by setting the wall back behind the frame, so that the repeated openings can make their effect unencumbered."

At Clark and Monroe, he was struck by the Harris Trust Building whose "missing middle," where two recessed floors carried all its machinery, made it "unique in its generation" of construction. On Dearborn, he found the reticence and simplicity of Mies van der Rohe's Federal Court Building almost perfect. A block north is the Inland Steel Building which Banham considered "one of the few modern buildings in the Loop that can even claim to be in the same league as Mies" because the architects, Skidmore, Owings & Merrill, "decided to unpick the basic skyscraper proposition and see what it's made of. The carrying structure has been put out-

1

2. Continental Center, Jackson and Wabash
(Photograph, Hube Henry, Hedrich-Blessing. Courtesy C. F. Murphy Associates.)

3. Federal Office Building, First Building in the Federal Center Complex
(Photograph, Sigmund J. Osty. Courtesy Chicago Historical Society.)

2

3

456

1. **The Inland Steel Building,
30 West Monroe**
(Courtesy Inland Steel Company.)

side the walls, seven big stainless-clad columns on each side, and the elevators have been put outside the main slab in a separate tower."

Farther north, just across the river is Bertrand Goldberg's Marina City, a complex of apartments, offices, restaurants, garages, a television studio, a marina, and a bank. Its twin towers, reaching sixty stories, became a symbol of the new architectural audacity of Chicago even before it was completed in 1964. Banham thinks that they are "far from perfected in detail" yet "so heroic in conception, so right for their site where Dearborn crosses the river, that they have the authority of a sketch for a possible third phase in the history of the Chicago School."

The British visitor's walking tour ended at the edge of the Loop, which contains most of the important buildings of the early masters as well as the bulk of the recent work. But the postwar construction boom extends well beyond the old limits and is every day changing the skyscape of nearby sections. New hotels, office buildings, and high-rise apartments have transformed North Michigan Avenue without compromising its role and reputation as the city's most fashionable shopping street. Indeed, the hundred-story John Hancock Center has become, for a while at least, Chicago's tallest edifice, a symbol of the rising importance of the Near North Side. West of the Loop, The Gateway Center, a large office concentration

1

2. View of the North Side from the Chicago River at Wabash Avenue, 1954

When this photograph was taken, the area in the immediate foreground had received little attention for many years, but massive changes were soon to follow. The site of the future Marina City is just beyond the extreme lower left, and the automobile parking lot in the center foreground is the site of the Sun Times–Daily News Building, demolition for which is apparent on the industrial building at the east end of the site.
(Photograph, Mildred Mead. Courtesy Metropolitan Housing and Planning Council.)

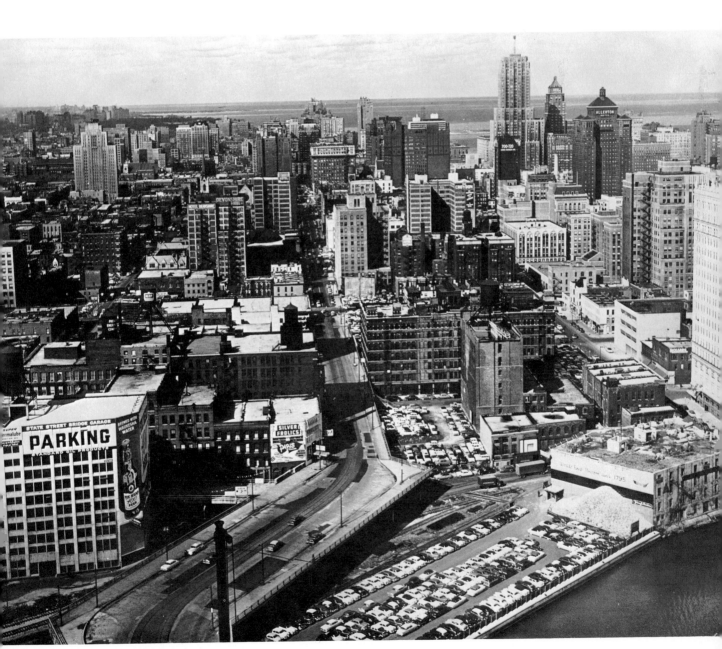

1. View Eastward along Main Stem of the Chicago River from over Wolf Point, 1965

Since the 1920's, many establishments have settled on prestigious, yet still central, locations within the city's major trade area. In the process, the River and the adjacent Wacker Drive have become a corridor which provides a panorama of the city's best architecture. One writer in 1965 went so far as to declare that the Drive was a fair representative of the character of the whole city. "Wacker Drive is like the city itself—bold, spectacular, and unfinished. It is the youngest of all downtown thoroughfares, a strong-willed maverick that would rather run with the river than with its grid-harnessed brothers: a wall-to-water corridor, broad and fair, that angles through the city's heart; a double-deck wonder between the Near West and the Near North that speeds drivers along in four directions beyond the nerve tips of the Loop."
(Courtesy Chicago Association of Commerce and Industry.)

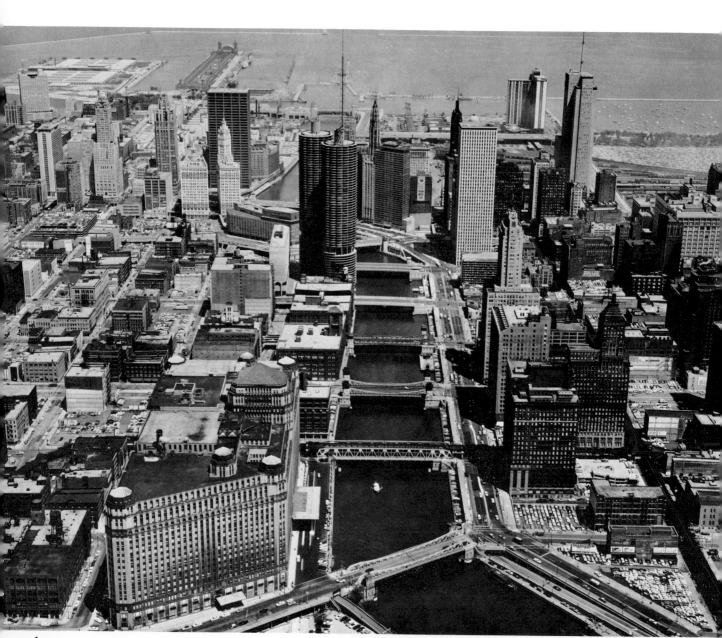

2. Apartment House Balconies in the West Tower of Marina City, 300 North State Street, August 16, 1966
(Photograph, Betty Hulett. Courtesy Chicago Historical Society.)

3. First Building in the Gateway Center Project, River between Madison and Monroe, 1965

This is the first of three office buildings, each containing three-quarters of a million square feet of floor space, constituting the Gateway Center project. Located just west of the South Branch of the Chicago River immediately west of the Loop, this building was designed by Skidmore, Owings & Merrill. It was completed in 1965 on air rights over the north approach tracks to the Chicago Union Station.
(Photograph, Hube Henry, Hedrich-Blessing Company. Courtesy Skidmore, Owings & Merrill.)

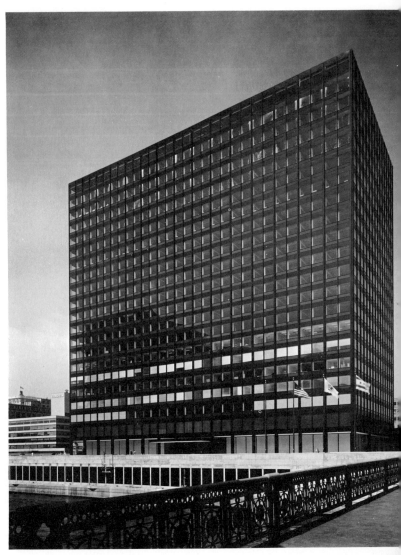

2

3

1. Equitable Building, Looking North across the River

"A new kind of urban space has been created and Chicago's North Michigan Avenue has a new point of visual interest with the completion of the 35-story Equitable Building and its large-spreading plaza," the *Architectural Record* declared in October, 1965. Designed by Skidmore, Owings & Merrill for The Equitable Life Assurance Society of the United States, the "tower and plaza are skillfully designed to forward . . . the interest and charm" of the Avenue. "The new plaza is a defined yet open space, bounded on the east by the new tower, on the north by the Tribune tower, and on the west by the Wrigley building. It opens in spreading fashion to the south and the river; serves as a transitional element for the juncture of avenue space and river space."
(Photograph, Hedrich-Blessing. Courtesy Skidmore, Owings & Merrill.)

erected on air rights over the Union Station tracks, signals a revival of that area, while to the south a mixture of public and private buildings is bringing new life to a large depressed area.

Some of the construction contained a new element, which may have far-reaching implications for urban living. Many architects used pillars, malls, and small plazas to open up space around or underneath their buildings, thereby breaking up the continuous line of store fronts and entrances characteristic of nearly all American streets. This technique not only creates a sense of light and spaciousness but establishes a new context for human contacts amidst the thickening mass of concrete, masonry, glass, and steel. Previously the street was the scene of casual meetings, of chance groupings, and the pathway to various parts of town. But the automobile has pretty much appropriated the street, and instead of being something that brings people together, the streets effectively separate pedestrians and discourage informal contacts. The new plazas, however, are turning life toward the center of the block. People can get away from the traffic, reduce the pace a bit, or even loiter on a good day around a fountain or beneath a tree. Critics of the modern city have constantly lamented the decline of street life, but they have not yet appreciated the new open spots downtown as a pleasant and modern substitute. Ordinary people, however, are discovering them more each day.

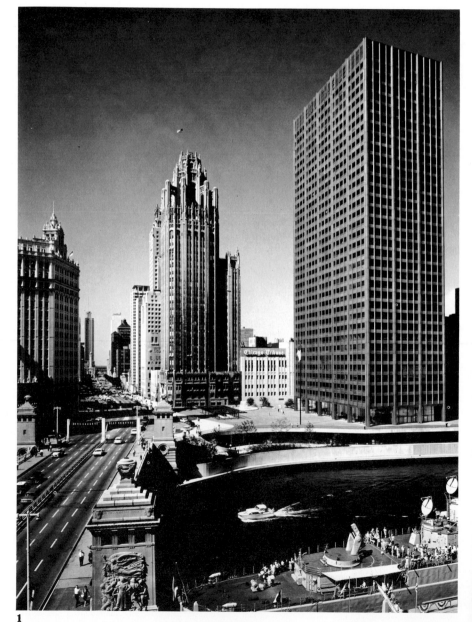

1

2. View Southwesterly from over Chicago Harbor off Chicago Avenue, 1964

Navy Pier and the newly completed Central District filtration plant stand as neighbors, although they have a half century of difference in their age. In the middle distance is the panorama of Michigan Avenue and the city's Loop and Near North Side.
(Courtesy Chicago Association of Commerce and Industry.)

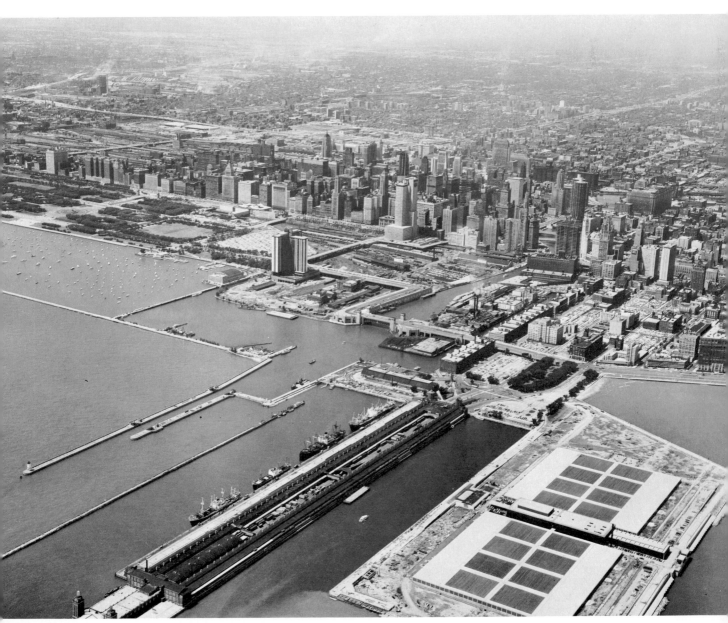

1. View South of a Portion of Burnham Park from over Eighteenth Street, 1965
McCormick Place, which burned down in 1967, was Chicago's largest exhibition hall. It was surrounded by a sea of parking lots and interrupted the continuity of the lakefront park development. In the foreground is a part of Burnham Harbor, one of the yacht basins operated by the Chicago Park District. On the left is a small part of Meigs Field, and beyond McCormick Place the buildings of the Lake Meadows and Prairie Shores projects can be seen.
(Courtesy Chicago Association of Commerce and Industry.)

The impact of this construction boom was less happy along the lakefront than elsewhere. Although officials consistently reiterated the policy that the water's edge should be developed for recreational and park use, a series of major installations severely compromised that goal in the minds of some people. Two water filtration plants, one between Seventy-fifth and Seventy-ninth streets and a larger one on an artificial peninsula just north of Navy Pier, met a pressing need for the entire metropolitan area but only did so at a cost to the lake shore. Meigs Field, with less general benefit, marred another section. And guided missile sites and anti-aircraft installations despoiled a number of shore line parks. Furthermore, all along the lake the widening of roads and drives imperiled precious land.

The decision over each of these projects brought heavy criticism of public officials. But the most celebrated controversy swirled around the construction of the massive exhibition hall at Twenty-third Street, McCormick Place. Conservationists objected because its location seemed to violate historic lakefront policy; others felt it duplicated facilities already available in the city; still others complained that it was too removed from downtown hotels and restaurants. Nevertheless, the building, designed by Alfred Shaw and containing 300,000 square feet of exhibition space, opened in 1960. Its financial success somewhat muted the opposition to McCormick

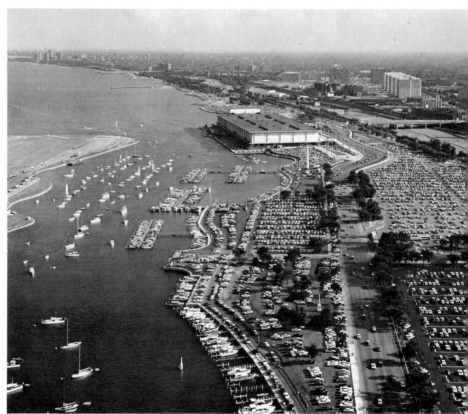

1

2. Marshall Field and Company Department Store on State Street between Randolph and Washington, View Southeast from Randolph, about 1960

Standing amid the new steel and glass skyscrapers of the 1960's are the older buildings which add variety and contrast to the city's downtown. The north end of this building was erected in 1902, the south end in 1907. Marshall Field shares with R. H. Macy in New York and J. L. Hudson in Detroit the status of being one of the three largest department stores in the world.
(Courtesy Marshall Field and Company.)

3. Field Building, Mid-1960's

The Field Building, completed in 1934, was the last skyscraper built in the Loop for over two decades. While its bulk was still impressive in the 1960's, its height was often surpassed as the Chicago downtown boom continued.
(Photograph, Bill Engdahl, Hedrich-Blessing.)

4. Palmer House at State and Monroe Streets, 1965

This hotel is the fourth Palmer House to be erected on this site. Designed by Holabird & Roche, it was completed during 1925–27 to a height of twenty-five stories with 2,000 rooms. Acquired by the Hilton chain, the hotel has recently undergone extensive modernization.
(Courtesy Palmer House, Chicago.)

2

3

4

1. View West, Old Post Office and Federal Building, 1962

Overlooking the construction site of the new Federal Office building, the old Federal Building sits staid and regal, its massive bulk soon to be knocked down to make way for a new government building.
(Courtesy Chicago Historical Society.)

2. View Southeast from the Landscaped Plaza of the Chicago Sun Times–Daily News Building, North Bank of the Chicago River, 1965

Two downtown building booms transformed the south facade of the main stem of the Chicago River. From left to right are the Stone Container Corporation Building at Michigan Avenue and Wacker Drive, Lincoln Tower, the Executive House Hotel, the Pure Oil Building, the

Place, but the question was revived when the managers announced expansion plans in 1966; and the whole issue resurfaced when in January, 1967, a fire gutted the entire installation. By 1969 construction was well along on an even larger structure on the same site.

The new skyline astonished people who had come to think of Chicago in static terms. Like every previous generation they lamented the passing of old landmarks and found much of the new shabby and pretentious. But those who know something about history realized that American cities have always been changing and dynamic; and Chicago, especially, had been the most brash and audacious of all. As Carl Sandburg once said:

Put the city up; tear the city down
put it up again; let us find a city.

Yet Chicago would never be "found." For it was not only a place, but a process. Every generation put its hand on it and around it, leaving a mark if not a memorial. Still Chicago existed at least as much for tomorrow as for today. And what the camera recorded at any moment was not only a piece of one time, but a prelude to another. For, as Sandburg observed, it is "wisdom to think new workingmen, new laughing men may come and put up a new city," and that "tomorrow will have its own say-so."

1

2

United of America Building, and one of the several municipal garages. All of these front on the double-decked Wacker Drive. (Courtesy Chicago Association of Commerce and Industry.)

3. View West across Michigan Avenue and the Chicago River, 1963

"Visitors to Chicago, and even Chicagoans themselves, are looking with astonishment these days at what's happening in that toddlin' town," a *Life* writer declared in December, 1962. "The city is giving itself the most dramatic change of profile since the fire. . . . From the 20th Century silo shape of 60-story Marina City . . . to the startling geometry of parking garages, the new buildings eclipse even such classic landmarks as the clock-topped Wrigley Building. Though the modern shapes and pell-mell expansion worry some conservative old Chicagoans, they delight the boosters who have always maintained that with enough push their city could surpass all others." Immediately behind the Wrigley building is the Chicago Sun Times–Daily News Building, with a lake vessel unloading newsprint into its lower floors. Across the River, on Wacker Drive is the United of America Building, designed by Shaw, Metz Associates. The parking lot in the immediate foreground would soon become the site of the Equitable Building. (Photograph, Walter Krutz. Courtesy Chicago Historical Society.)

A VALENTINE FOR CHICAGO

. . . No city that I know is so dependent for pleasure and usefulness on a body of water as Chicago is on the great lake which it amorously receives into itself. The lake is an immense resort, a supplier of water, a receiver of cargoes, a purifier of waste, and a harbor for the searchers of solitude, fishermen, sailors, artists, lovers. Chicago outlines the lake with question-mark-shaped beaches pointed at the tip with clumps of handsome museums and apartment houses whose gorgeous reflections seem the domestic translation of the outlying factory fires whose profits are their source.

Behind this spectacular facade, the western plain erupts into what for me is little-known brush—small factories laced by antique tenements, or new apartments rising high out of treeless pavements, pretty homes grazing in small lawns, or files of efficiency units which know the lake largely by reputation. Yet the lake counts for the west, if indirectly, for it mothered the marsh in which Chicago rose. Unlike rock-bottomed New York, Chicago's bottom is soft, and the result is that she's green. *Urbs in horto* is the city motto. For years she was known as "the garden city," and her park system is studied the world over. Even a slum, simmering in ash, sports its pair of cottonwood trees and plank of grass.

To accommodate the green, Chicago built its streets wide—unlike, say, Harlem, where incarcerated eyes glare ten yards across the street to other locked eyes. Here, eyes are at least veiled by leaves. (It was Nero who knew the deadliness of propinquity, and decreed that Roman streets must be twice as wide as their houses' height.)

The Chicago green may be as important as the famous $2.50 minimum wage which has drawn a great migration from Kentucky hills and Mississippi levees to the steel mills, although now and then, a volley of automation sends them right back, or into domestic service in the new suburbs bubbling up continuously west and south.

Chicago has always had strong Southern ties, even after the building of the Erie Canal changed it from a city dependent on New Orleans river trade to a northern link between the East and West. It has employed Southern workers, supplied Southern factories with machines, money, and engineers, and, in my view, it has some of the ease of Southern cities today. This is due in part to the large numbers of poor Negroes who discover the city's natural delights—the lake fishing, the ball parks (Wrigley Field is advertised as a good place to have a picnic), the free concerts in Grant Park, the free sailing lessons at the Sixty-third Street harbor, the Y expeditions to the woods and dunes. The poor Negro practices and invites an ease of life which he has rescued

Chicago's Loop District, View North-Northwest, 1961
(Courtesy Chicago Association of Commerce and Industry.)

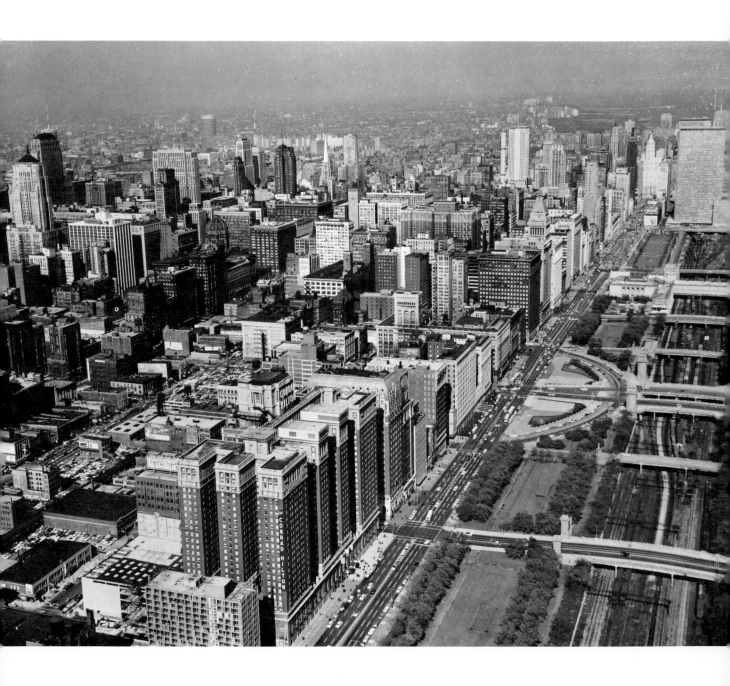

from the leprous exclusions of this country. Such exclusion, and the new fellowship of the Negro with the equally displaced hillbillies, is supposedly behind the revival of blues singing in the tiny Southside Negro bars. It is only one chapter in Chicago's long Negro history which began with the anonymous Indian's joke that Pointe du Sable, the "first white man" to come to Chicago, was a Negro.

Even its vices. Flavor and openness, roses and peaches in the street. Not quite. If cities have typical experiences, they may have typical vices. Perhaps Chicago's vice is a blinding concentration on the immediate and the future, accompanied by merciless abuse of its past. It's been said that the city's only genuflexion to history is the turn that Michigan Avenue, Chicago's elegant showplace of the new, makes at the grotesque old Water Tower, the sole survivor of the Great Fire in the near Northside.

Recently, Sullivan's beautiful, sagging Garrick Theatre was ripped down, despite an agitation which should have raised a Lazarus, let alone the $200,000 needed to buy and restore it. What Wright called "the declaration of independence for American architecture"—his Robie House of 1909—almost went the same way, until a New York developer bought it as headquarters for the Hyde Park Redevelopment Project. The Indiana Dunes, Chicago's "playground," is being whittled away by the vicious rapacity of Indiana steel companies, despite the assiduous work of Hyde Park's former alderman, Senator Paul Douglas.

"Sweep away," says Chicago, confident in the fabulous metabolism which exploded it from the onion marshes into the prototypical city of industrialism in fifty years. But there are metropolitan sores which cannot be swept away. On the Southside, the Negro schools are sinking into a dark age of blank violence. The city's transportation founders as the Illinois legislature—rural, Republican, and Chicago-hating—refuses it a proper share of tax revenues. Meanwhile, the parasitic, contemptuous suburbs siphon the city's wealth and invest theirs in their own backyards. In the city itself, culture is thin and gaudy—statistics and clubs replacing the reading of books or the pride in and patronage of local artists: young Easley Blackwood's symphonies will probably be performed in San Antonio before the brilliant Chicago Symphony (under Reiner, the best but most conservative in America) condescends to them

I crossed LaSalle Street, went through an alley to the parking lot, surrendered a dollar, headed through downtown traffic to the Outer Drive, and shot home along the glistening lake. I drove past the great museums, the Illinois Central tracks and the statue of their originator, Stephen Douglas, the huge Donnelley Press, the high-

Lake Shore Drive North of Ohio Street, 1965

Standing adjacent to the massive American Furniture Mart and the Chicago Campus of Northwestern University, two new downtown motels testify to the number of tourists, travelers, and conventioneers who pass through the city each year. (Courtesy Robert Clarke Associates and Holiday Inns of America.)

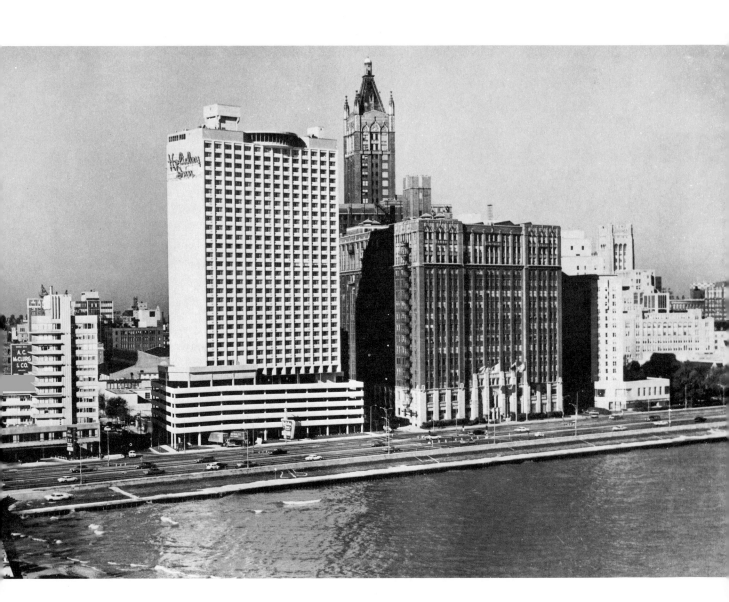

rises of the Prairie Shores apartments, the rickety, three-story brownstones, the queening hotels of the South Side. All seemed to be concretions of the abstract control at City Hall; and though forever resistant to the intentions of that control, they seemed protected rather than assaulted by it.

That afternoon, I took the children to the Point, a grassy Southside promontory, jutting into the lake not far from the University. The Point is coiffeured now with three huge aluminum lollipops—missile guides—under which lounge Hyde Parkers of every age, shape, color, and language. They come each summer day to swim, sun, read, talk, play casino, fry hamburgers on hibachis, and dispute the warnings of occasional policemen vainly attempting to enforce the No Swimming signs, painted in yellow on the four-tiered stone terrace rising from the lake. Petitions to the Fifth Ward's Alderman Despres—the Council's only independent and second non-Democrat—about the badgering policemen, or the motorboats which swing their water skiers toward the illegal swimmers, pass from hand to hand. The Hyde Parkers sign with the righteous ease of habitual public complainers and go back to the water or to wrinkled perusing of the *Nicomachean Ethics.*

Five miles away, the summer's sixth gangland killing victim is being removed from a Cadillac on the Wacker Drive; twenty blocks south the police are keeping a "wade-in" demonstration against the stolid white burghers of Rainbow Beach from being more than a demonstration, but here at the Point, the day's work done, an evening of hi-fi and a book, or a trip to the trotters at Sportsman's Park ahead of him, the besummered Chicagoan takes in like good wine the grace and possibility his city provides.

Richard G. Stern, "A Valentine for Chicago," *Harper's Magazine,* vol. 224 (February, 1962), pp. 63–69.

Lake Shore Drive from Michigan Avenue to the Lake, 1969

The new North Side skyline runs from Lake Point Tower on the east to the John Hancock Center on the west. Between these landmarks stretches the history of Chicago architecture for the past seventy-five years. At the end of Oak Street are luxury apartments constructed at the turn of the century; behind them are their postwar counterparts by Mies Van der Rohe. On Michigan Avenue is the Drake Hotel which dominated the area until overshadowed by the Playboy Building; now both are dwarfed by "Big John." The Hancock Center is only a few feet short of the Empire State Building in New York. The fact that it settled for second place in the world's skyscraper sweepstakes instead of topping New York perhaps indicates a mellowing of the brash youthful drive that had historically insisted that Chicago had to be biggest in everything.
(Courtesy John Hancock Mutual Life Insurance Company.)

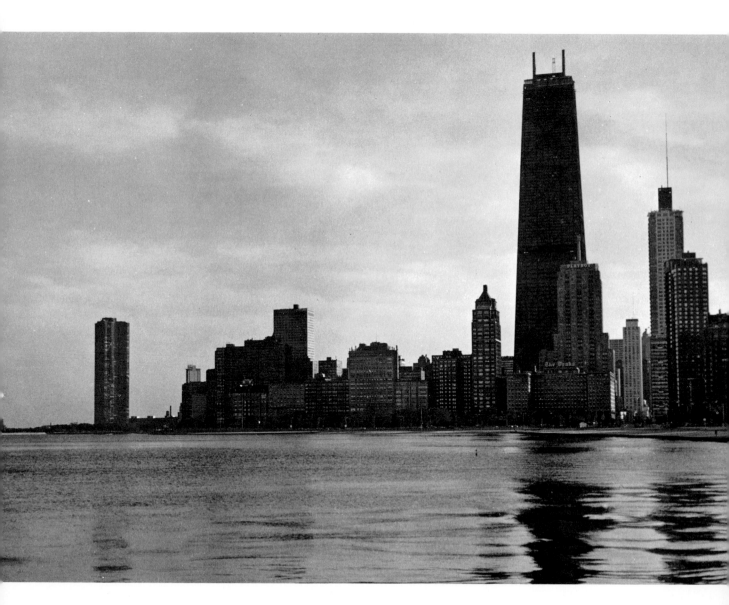

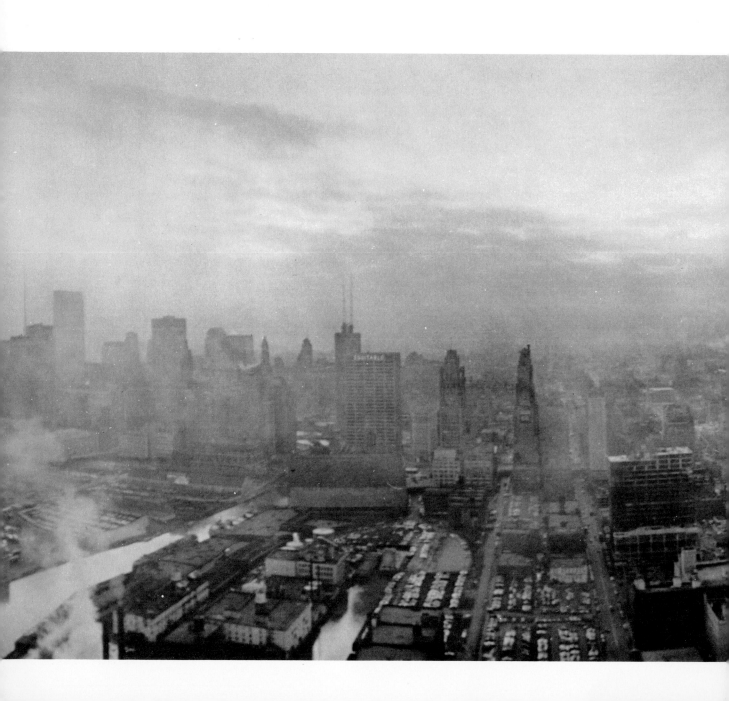

(Courtesy *Chicago's American.*)

Selected Bibliography

BOOKS

Abbott, Edith. *The Tenements of Chicago, 1908–1935*. Chicago: University of Chicago Press, 1936.

Abrahamson, Julia. *A Neighborhood Finds Itself*. New York: Harper & Brothers,1959.

Addams, Jane. *Twenty Years at Hull House*. New York: Macmillan, 1910.

Ahmed, G. Munir. *Manufacturing Structure and Pattern of Waukegan–North Chicago*. Research Paper no. 46. Chicago: University of Chicago Department of Geography, February, 1957.

American Institute of Electrical Engineers. *The Chicago Electrical Handbook: Being A Guide for Visitors from Abroad Attending the International Electrical Congress, St. Louis, Mo., September, 1904* Chicago: The American Institute of Electrical Engineers, 1904.

Ampère, Jean Jacques Antoine. *Promenade en Amérique: Etats-Unis—Cuba—Mexique.* . . . rev. ed. Paris: M. Lévy Frères, 1860.

Andreas, Alfred T. *History of Chicago*. 3 vols. Chicago: A. T. Andreas, 1884–86.

Angle, Paul M., ed. *The Great Chicago Fire, Described in Seven Letters by Men and Women Who Experienced its Horrors, and Now Published in Commemoration of the Seventy-Fifth Anniversary of the Catastrophe*. Chicago: The Chicago Historical Society, 1946.

Angle, Paul M., and Getz, James R., eds. *Journal to the "Far-Off West."* Chicago: The Caxton Club, 1957.

Appleton, John B. *The Iron and Steel Industry of the Calumet District*. University of Illinois Studies in the Social Sciences, vol. 13, no. 2. Urbana: University of Illinois, 1925.

Archer, William. *America Today: Observations and Reflections*. London: W. Heinemann, 1900.

Arpee, Edward. *Lake Forest Illinois: History and Reminiscences, 1861–1961*. Lake Forest, Ill.: Rotary Club of Lake Forest, 1963.

Barker, Frances (Long). *From the Green Mountains to the Prairies*. Great Barrington, Mass.: Berkshire Courier Press, 1955.

Barnes, Margaret Ayer, and Fairbank, Janet Ayer. *Julia Newberry's Diary*. New York: W. W. Norton & Co., 1933.

[Barton, Elmer E.] *A Business Tour of Chicago, Depicting Fifty Years' Progress*. Chicago: E. E. Barton, 1887.

Bassman, Herbert J., ed. *Riverside Then and Now: A History of Riverside, Illinois . . . Compiled by Dr. S. S. Fuller* [and others] Riverside, Ill.: Riverside News, October, 1936.

Basterot, Florimond Jacques, Comte de. *De Quebec à Lima: Journal d'un voyage dans les deux Ameriques en 1858 et en 1859*. Paris: L. Hachette et Cie, 1860.

[Beadle, Charles.] *A Trip to the United States in 1887*. London, 1887.

Beauvoir, Simone de. *America, Day by Day*. New York: Grove Press, 1953.

Berger, Max. *The British Traveller in America, 1836–1860*. New York: Columbia University Press, 1943.

Berry, C. B. *The Other Side, How It Struck Us*. London: Griffith and Farran, 1880.

Biographical Sketches of the Leading Men of Chicago, Written by the Best Talent in the Northwest. Chicago: Wilson of St. Clair, 1868.

Birkenhead, Frederick Edwin Smith. *My American Visit*. London: Hutchinson & Co., 1918.

Birmingham, George A. [Hannay, James Owen]. *From Dublin to Chicago: Some Notes on a Tour in America*. New York: George H. Doran Company, 1914.

Bishop, Glenn A. (in collaboration with Paul T. Gilbert). *Chicago's Accomplishments and Leaders*. Chicago: Bishop Publishing Company, 1932.

Blanc, Marie Therese. *The Condition of Woman in the United States: A Traveller's Notes*. Boston: Roberts Brothers, 1895.

Blanchard, Rufus. *Discovery and Conquests of the North-West, with the History of Chicago*. Wheaton, Ill.: R. Blanchard & Company, 1880.

Boddam-Whetham, John Whetham. *Western Wanderings: A Record of Travel in the Evening Land*. London: R. Bentley and Son, 1874.

Brainerd, Charles N. *My Diary; or, Three Weeks on the Wing: A Peep at the Great West*. New York: Egbert, Bourne & Co., 1868.

Bratt, John. *Trails of Yesterday*. Lincoln: The University Publishing Company, 1921.

Breese, Gerald William. *The Daytime Population of the Central Business District of Chicago*. Chicago: University of Chicago Press, 1949.

Bross, William. *History of Chicago*. Chicago: Jansen, McClurg & Co., 1876.

Bryan, Patrick Walter. "The Cultural Landscape of Chicago." In *Man's Adaption of Nature: Studies of the Cultural Landscape*, edited by P. W. Bryan. London: University of London Press, 1933.

Bryant, William Cullen. *Letters of a Traveller; or, Notes of Things Seen in Europe and America*. 3d ed. New York: G. P. Putnam, 1851.

Buckingham, James Silk. *The Eastern and Western States of America*. 3 vols. London: Fisher, Son & Co., 1842.

Burnham, Daniel H., and Bennett, Edward H. *Plan of Chicago*. Chicago: The Commercial Club, 1909.

Burnham, Daniel H., Jr., and Kingery, Robert. *Planning the Region of Chicago*. Chicago: Chicago Regional Planning Association, 1956.

Buss, Henry. *Wanderings in the West, during the Year 1870*. London, 1871.

Butler, Charles. *Travel from Detroit to Chicago in 1833*. Railway Library, vol. 3, Chicago, 1912.

Butt, Ernest. *Chicago Then and Now*. Chicago: Aurora, Finch & McCullouch, 1933.

Campbell, Edna Fay; Smith, Fanny R.; and Jones, Clarence F. *Our City—Chicago*. New York: Charles Scribner's Sons, 1930.

Cawley, Elizabeth Hoon. *American Diaries* [of Richard Cobden]. Princeton: Princeton University Press, 1952.

Chamberlain, Everett. *Chicago and its Suburbs*. Chicago: T. A. Hungerford & Co., 1874.

Chapin, Louella. *Round About Chicago*. Chicago: Unity Publishing Company, 1907.

Chatfield-Taylor, Hobart C. *Chicago*. Boston and New York: Houghton Mifflin Company, 1917.

The Chicago and Interurban Trolley Guide. Chicago: The Chicago and Interurban Trolley Guide, 1907.

Chicago and Northwestern Railway Company. *Yesterday and To-Day: A History*. Chicago: Rand, McNally & Company, 1905.

Chicago Area Transportation Study. *Final Report*. 3 vols. Chicago, 1959, 1960, and 1962.

Chicago Association of Commerce, eds. *Chicago, The Great Central Market*. Chicago: R. L. Polk & Co., 1923.

Chicago Association of Commerce Committee of Investigation on Smoke Abatement and Electrification of Railway Terminals. *Smoke Abatement and Electrification of Railway Terminals in Chicago*. Chicago: Rand, McNally & Co., 1915.

Chicago Association of Commerce and Industry. *Survey* [of the Progress and Development of the City of Chicago]. Chicago, 1925.

Chicago Board of Trade. *Annual Report of the Trade and Commerce of Chicago*. 1858–90.

Chicago City Council Committee on Local Transportation. *A Comprehensive Local Transportation Plan for the City of Chicago*. Chicago, 1937.

Chicago City Council Committee on Railway Terminals and Citizens Committee on River Straightening. *The Straightening of the Chicago River*. Chicago, 1926.

Chicago City Directory and Business Advertiser. 1846–67 and 1855–56.

Chicago Commission on Race Relations. *The Negro in Chicago: A Study of Race Relations and a Race Riot*. Chicago: The University of Chicago Press, 1922.

Chicago Evening Post. *The Book of Chicago, 1911*. Chicago, 1911.

Chicago Herald. *Illustrated History of Chicago* Chicago, 1887.

Chicago History. Chicago: Chicago Historical Society, 1945—.

Chicago, Illustrated and Descriptive: A Description of the City As It Appears in 1882, Comprising Its Railway Interests, Hotels, Public Buildings, Theaters Chicago: N. F. Hodson & Company, 1882.

Chicago in 1860: A Glance at Its Business Houses, Its Trade, Manufactures, and Commerce. Chicago: W. Thorn & Co., 1860.

Chicago Land Clearance Commission. *Michael Reese–Prairie Shores Redevelopment Project, Final Project Report*. Chicago, 1962.

Chicago Land Use Survey. *Vol. I: Residential Chicago. Vol. II: Land Use in Chicago*. Chicago: Chicago Plan Commission, 1942 and 1943, respectively.

Chicago Plan Commission. *Forty-Four Cities in the City of Chicago*. Chicago, 1942.

Chicago Plan Commission. *Master Plan of Residential Land Use of Chicago*. Chicago, 1943.

Chicago Plan Commission. *The Outer Drive*. Chicago, 1929.

Chicago Record Herald. *Chicago as it Appeared in 1858*. Chicago, 1894.

Chicago's First Half Century: The City As It Was Fifty Years Ago and As It Is To-day Chicago: Inter Ocean Publishing Co., 1883.

Chisholm's All Round Route and Panoramic Guide of the St. Lawrence: The Hudson River; Trenton Falls; Niagara . . . the White Mountains; Portland; Boston; New York. Montreal: Chisholm & Co., 1881.

City of Chicago Department of Development and Planning. *The Comprehensive Plan of Chicago*. Chicago, December, 1966.

Clark, John Alonzo. *Gleanings by the Way*. New York: R. Carter, 1842.

Cleaver, Charles. *Early Chicago Reminiscences*. Fergus Historical Series no. 19. Chicago: Fergus Printing Company, 1882.

Club-Fellow & Washington Mirror Consolidated; The National Journal of Society. *To The City of Chicago*. souv. ed. New York: The Club-Fellow Publishing Co., 1912.

Colbert, Elias. *Chicago: Historical and Statistical Sketch of the Garden City* Chicago: P. T. Sherlock, 1868.

Colbert, Elias, and Chamberlain, Everett. *Chicago and the Great Conflagration*. Cincinnati and New York: C. F. Vent; Chicago: J. S. Goodman & Co., 1871.

Colean, Miles L. *Renewing Our Cities*. New York: The Twentieth Century Fund, 1953.

[Collier, Price.] *America and the Americans from a French Point of View*. 8th ed. New York: Charles Scribner's Sons, 1897.

Commercial and Architectural Chicago. Chicago: G. W. Orear, 1887.

Condit, Carl W. *The Rise of the Skyscraper*. Chicago: University of Chicago Press, 1952.

————. *American Building Art: The Nineteenth Century*. New York: Oxford University Press, 1960.

————. *American Building Art: The Twentieth Century*. New York: Oxford University Press, 1961.

————. *The Chicago School of Architecture: A History of Commercial and Public Building in the Chicago Area, 1875–1925*. Chicago: University of Chicago Press, 1964.

Cook, Frederick F. *Bygone Days in Chicago: Recollections of the "Garden City" of the Sixties*. Chicago: A. C. McClurg & Co., 1910.

Cottenham, Mark Everard Pepys. *Mine Host, America*. London: Collins, 1937.

Coyne, F. E. *In Reminiscence: Highlights of Men and Events in the Life of Chicago*. Chicago, 1941.

Cramer, Robert E. *Manufacturing Structure of the Cicero District, Metropolitan Chicago*. Research Paper no. 27. Chicago: University of Chicago Department of Geography, 1952.

Cromie, Robert. *The Great Chicago Fire*. New York: McGraw-Hill, 1958.

Cunynghame, Sir Arthur Augustus Thurlow. *A Glimpse at the Great Western Republic*. London: R. Bentley, 1851.

Currey, Josiah Seymour. *Chicago: Its History and its Builders: A Century of Marvelous Growth*. Chicago: S. J. Clarke Publishing Company, 1912.

Currier, Frederick A. *A Trip to the Great Lakes*. Fitchburg, Mass.: Sentimental Printing Company, 1904.

Cutler, Irving. *The Chicago-Milwaukee Corridor: A Geographic Study of Intermetropolitan Coalescence*. Northwestern University Studies in Geography no. 9. Evanston: Northwestern University Department of Geography, 1965.

Dana, Charles W. *The Garden of the World; or, The Great West* Boston: Wentworth and Company, 1856.

Davenport, Montague. *Under the Gridiron* London: Tinsley Brothers, 1876.

Davis, James Leslie. *The Elevated System and the Growth of Northern Chicago*. Northwestern University Studies in Geography no. 10. Evanston: Northwestern University Department of Geography, 1965.

Dedmon, Emmett. *Fabulous Chicago*. New York: Random House, 1953.

DeMeirleir, Marcel J. *Manufactural Occupance in the West Central Area of Chicago*. Research Paper no. 11. Chicago: University of Chicago Department of Geography, 1950.

Dewar, Thomas R. *A Ramble Round the Globe*. London: Chatto and Windus, 1894.

Draine, Edwin H. *Import Traffic of Chicago and Its Hinterland*. Research Paper no. 81. Chicago: University of Chicago Department of Geography, 1963.

Drury, John. *Old Chicago Houses*. Chicago: University of Chicago Press, 1941.

Duncan, Otis Dudley, and Duncan, Beverly. *The Negro Population of Chicago: A Study of Residential Succession*. Chicago: University of Chicago Press, 1957.

Edgar, William Crowell. *Judson Moss Bemis, Pioneer*. Minneapolis: The Bellman Company, 1926.

Edwards Annual Directory . . . of the City of Chicago 1866–73.

Elliot, James L. *Red Stacks Over the Horizon: The Story of the Goodrich Steamboat Line*. Grand Rapids: William B. Eerdmans Co., 1967.

Ellett, Mrs. Elizabeth Fries Lummis. *Summer Rambles in the West*. New York: J. C. Riker, 1853.

Estournelles de Constant, Paul Henri Benjamin, Baron d'. *Les Etats-Unis d'Amérique*. Paris: A. Colin, 1913.

Federal Writers Project. *The Calumet Region Historical Guide*. Gary, Indiana: Garman Printing Co., 1939.

————. *Illinois, A Descriptive and Historical Guide*. 2d ed. Chicago: A. A. McClurg & Co., 1947.

Fergus, Robert, compiler. *Fergus' Directory of the City of Chicago, 1839*. Chicago: Fergus Printing Company, 1876.

Ferguson, Fergus. *From Glasgow to Missouri and Back*. Glasgow: T. D. Morison [etc.], 1878.

Ferguson, William. *America by River and Rail; or, Notes by the Way on the New World and Its People*. London: J. Nisbet and Co., 1856.

Fiske, Horace Spencer. *Chicago in Picture and Poetry*. Chicago: R. F. Seymour for the Industrial Art League, 1903.

————. *Poems on Chicago and Illinois*. Boston, Mass.: The Stratford Company, 1927.

Foster, Lillian. *Way-side Glimpses, North and South*. New York: Rudd & Carleton, 1860.

Fraser, John Foster. *America at Work*. London: Cassell and Company, 1907.

Frazier, E. Franklin. *The Negro Family in Chicago*. Chicago: University of Chicago Press, 1932.

Frignet, Ernest, and Carrey, Edmund. *Etats-Unis d'Amérique: les Etats du Northwest et Chicago*. Paris: Jouaust, 1871.

From the Lakes to the Gulf. Chicago: Illinois Central Railroad, 1884.

Fryxell, F. M. *The Physiography of the Region of Chicago*. Chicago: University of Chicago Press, 1927.

Fuller, Sarah Margaret. *Summer on the Lakes, in 1843*. Boston: C. L. Little and J. Brown; New York: C. S. Francis and Company, 1844.

Gale, Edwin O. *Reminiscences of Early Chicago and Vicinity*. Chicago: F. H. Revell Company, 1902.

Ganinwari, Onkwe [Frank Randolph Chandler]. *Che-Cau-Gou*. Chicago: The Faithorn Company, 1924.

Gerard, A. G. *Itineraire de Quebec à Chicago*. Montreal: C. O. Beauchemin & Valois, 1868.

German Press Club of Chicago. *Prominent Citizens and Industries of Chicago*. n.p.: Under the Auspices of the German Press Club of Chicago, 1901.

[Gilbert, Frank.] *Centennial History of the City of Chicago; Its Men and Institutions*. Chicago: Inter Ocean Publishing Co., 1905.

Gilbert, Paul Thomas, and Bryson, Charles Lee. *Chicago and Its Makers*. Chicago: F. Mendelsohn, 1929.

Gillette, John Morris. *Culture Agencies of a Typical Manufacturing Group: South Chicago*. Chicago: University of Chicago Press, 1901.

Glazier, Willard. *Ocean to Ocean on Horseback* Philadelphia: Hubbard Publishing Company, 1896.

————. *Peculiarities of American Cities*. Philadelphia: Hubbard Brothers, 1886.

Goode, J. Paul. *The Geographic Background of Chicago*. Chicago: University of Chicago Press, 1926.

Goodrich, Charles Augustus. *The Land We Live In; or, Travels, Sketches, and Adventures in North and South America* Cincinnati: H. M. Rulison; Philadelphia: D. Rulison, 1857.

Goodsmith, Elliott S. *The Story of a Forty-Niner*. Chicago, 1930.

Goodspeed, Edgar Johnson. *History of the Great Fires in Chicago and the West* New York: H. S. Goodspeed & Co.; Chicago: J. W. Goodspeed, 1871.

Gosnell, Harold F. *Negro Politicians: The Rise of Negro Politics in Chicago*. Chicago: University of Chicago Press, 1935.

Gottschalk, Louis Moreau. *Notes of a Pianist*. Philadelphia: J. B. Lippincott, 1881.

Granding, Mme Léon. *Impressions d'une Parisienne à Chicago*. Paris: E. Flammarion, 1894.

Greenwood, Thomas. *A Tour in the States and Canada; Out and Home in Six Weeks*. London: L. U. Gill, 1883.

A Guide to the City of Chicago. Chicago: The Chicago Association of Commerce, 1909.

Half Hours in the Wide West London: W. Isbister, 1880.

Hall, Newman. *From Liverpool to St. Louis*. London: George Routledge & Sons, 1870.

Halpin's . . . Chicago City Directory. 1858–1865/6.

Hamilton, Henry Raymond. *The Epic of Chicago*. Chicago and New York: Willett, Clarke & Company, 1932.

Hancock, William. *An Emigrant's Five Years in the Free States of America*. London: T. Cautley Newby, 1860.

Hansen, Harry. *The Chicago*. Rivers of America Series. New York: Rinehart & Co., 1942.

Hardmon, William. *A Trip to America*. London: T. V. Wood, 1884.

Hardy, Mary (McDowell) Duffus. *Through Cities and Prairie Lands: Sketches of an American Tour*. New York: R. Worthington, 1881.

Harper, Robert A. *Recreational Occupance of the Moraine Lake Region of Northeastern Illinois and Southeastern Wisconsin*. Research Paper no. 14. Chicago: University of Chicago Department of Geography, 1950.

Harper, William Hudson, ed. *Chicago: A History and Forecast*. Chicago: The Chicago Association of Commerce, 1921.

Hauser, Philip M., and Kitagawa, Evelyn M. *Local Community Fact Book for Chicago, 1950*. Chicago: Chicago Community Inventory, University of Chicago, 1953.

Hayes, Dorsha. *Chicago, Crossroads of American Enterprise*. New York: J. Messner, 1944.

Head, Franklin Harvey. *Untrodden Fields in History and Literature, and Other Essays*. Edited by George Brooks Shepard. Cleveland: The Rowfant Club, 1923.

Healy, George Peter Alexander. *Reminiscences of a Portrait Painter*. Chicago: A. C. McClurg and Company, 1894.

Helvig, Magne. *Chicago's External Truck Movements*. Research Paper no. 90. Chicago: University of Chicago Department of Geography, 1964.

Hoffman, Charles Fenno. *A Winter in the West: Letters Descriptive of Chicago and Vicinity in 1833–34*. Chicago: Fergus Printing Company, 1882.

Holand, Hjalmar R. *My First Eighty Years*. New York: Twayne Publishers, 1957.

Hoyt, Homer. *One Hundred Years of Land Values in Chicago, 1830–1933*. Chicago: The University of Chicago Press, 1933.

————. *The Structure and Growth of Residential Neighborhoods in American Cities*. Washington: Federal Housing Administration, 1939.

Huddleston, Sisley. *What's Right with America*. Philadelphia and London: J. B. Lippincott Company, 1930.

Hulot, Baron Etienne Gabriel Joseph. *De l'Atlantique au Pacifique à travers le Canada et les etats-Unis*. Paris: E. Plon, Nourrit & Cie, 1888.

Huret, Jules. *En Amérique; de San Francisco au Canada*. Paris: E. Fasquelle, 1905.

Hurlbut, Henry Higgins. *Chicago Antiquities*. Chicago: Eastman & Bartlett, 1875.

Hyde Park Now and Then. Chicago, 1929.

Illinois, Commission on Human Relations. *Nonwhite Population Changes in Chicago's Suburbs*. rev. ed. Chicago, 1962.

Illinois State Geological Survey. *Geologic Map of Illinois*. Urbana, 1967.

Johnson, James D., compiler. *A Century of Chicago Streetcars, 1858–1958*. Wheaton, Ill.: The Traction Orange Company, 1964.

Jones, John H., and Britten, Fred A., eds. *A Half Century of Chicago Building: A Practical Reference Guide*. Chicago, 1910.

Kenyon, James B. *The Industrialization of the Skokie Area*. Research Paper no. 33. Chicago: University of Chicago Department of Geography, 1954.

Kingsford, William. *Impressions of the West and South during a Six Weeks' Holiday*. Toronto: A. H. Armour & Co., 1888.

Kirkland, Joseph. *The Story of Chicago*. 3 vols. Chicago: Dibble Publishing Company, 1892–94.

Kitagawa, Evelyn M., and Teauber, Karl E., eds. *Local Community Fact Book; Chicago Metropolitan Area, 1960*. Chicago: Chicago Community Inventory, University of Chicago, 1963.

Klein, Felix. *In the Land of the Strenuous Life*. Chicago: A. C. McClurg & Co., 1905.

————. *L'Amérique de demain*. Paris: Plon-Nourrit et Cie, 1910.

Klove, Robert C. *The Park Ridge–Barrington Area: A Study of Residential Land Patterns and Problems in Suburban Chicago*. Chicago: University of Chicago Department of Geography, 1942.

Kogan, Herman, and Wendt, Lloyd. *Lords of the Levee: The Story of Bathhouse John and Hinky Dink*. Indianapolis: The Bobbs-Merrill Company, 1943.

————. *Chicago: A Pictorial History*. New York: Dutton, 1958.

Kune, Julian. *Reminiscences of an Octogenarian Hungarian Exile*. Chicago: Julian Kune, 1911.

The Lakeside Annual Directory of the City of Chicago. 1874/5–1917.

Latrobe, Charles Joseph. *The Rambler in North America, 1832–1833*. New York: Harper & Brothers, 1835.

Laugel, Auguste. *Les Etats-Unis pendant la guerre (1861–65)*. Paris: Germer Baillière, Libraire-Editeur, 1866.

Leech, Arthur Blennerhassett. *Irish Riflemen in Amercia*. London: E. Stanford; New York: Van Nostrand, 1875.

Lewis, Charles E. *Two Lectures on a Short Visit to America*. London, 1876.

Lewis, Lloyd, and Smith, Henry Justin. *Chicago, the History of Its Reputation*. New York: Harcourt, Brace and Company, 1929.

————. *Oscar Wilde Discovers America* [1882]. New York: Harcourt, Brace and Company, 1936.

Lippincott, Mrs. Sara Jane. *New Life in New Lands: Notes on Travel*. New York: J. B. Ford and Company, 1873.

Logan, James. *Notes of a Journey through Canada, the United States of America, and the West Indies* Edinburgh: Fraser & Co., 1838.

Loudon, John Baird. *A Tour through Canada and the United States of America Containing Much Valuable Information to Intending Immigrants and Others*. Coventry: Curtis and Beamish, 1879.

McClintock, Miller. *Report and Recommendations of the Metropolitan Street Traffic Survey*. Chicago: Chicago Association of Commerce, 1926.

McClure, James Baird, ed. *Stories and Sketches of Chicago: An Interesting, Entertaining, and Instructive Sketch History of the Wonderful City "By the Sea."* Chicago: Rhodes & McClure, 1880.

McIntosh, Arthur T. *Chicago*. Chicago: Press of G. G. Renneker, Co., 1921.

McLellan, Hugh, ed. *Journal of Thomas Nye Written during a Journey between Montreal and Chicago in 1837*. Champlain: Moorsfield Press, 1932.

Macrae, David. *The Americans at Home: Pen-and-Ink Sketches of American Men, Manners and Institutions*. 2 vols. Edinburgh: Edmonston and Douglas, 1870.

Maga Excursion Papers. New York: G. P. Putnam & Son, 1867.

Malézieux, Em. *Souvenirs d'une mission aux Etats-Unis d'Amérique*. Paris: Dunod, 1874.

Mansfield, John Brandt. *History of the Great Lakes*. 2 vols. Chicago: J. H. Beers and Company, 1899.

Marshall, Walter Gore. *Through America; or, Nine Months in the United States*. London: S. Low, Morston, Searle & Rivington, 1882.

Martineau, Harriet. *Society in America*. 3 vols. London: Saunders and Otley, 1837.

Mason, Edward Gay, ed. and annot. *Early Chicago and Illinois*. Chicago: Fergus Printing Company, 1890.

Masters, Edgar Lee. *The Tale of Chicago*. New York: G. P. Putnam's Sons, 1933.

Mayer, Harold M. *Chicago: City of Decisions*. Papers on Chicago no. 1. Chicago: The Geographic Society of Chicago, 1955.

————. *The Port of Chicago and the St. Lawrence Seaway*. Chicago: University of Chicago Press, 1957.

_____. *The Railway Pattern of Metropolitan Chicago*. Chicago: University of Chicago Department of Geography, 1943.

Mayer, Meyer, Austrian, and Platt, Chicago. *Corporate and Legal History of United Air Lines and Its Predecessors and Subsidiaries, 1925–1945*. Chicago: Twentieth Century Press, 1953.

Medley, Julius George. *An Autumn Tour in the United States and Canada*. London: H. S. King & Co., 1873.

Meyerson, Martin, and Banfield, Edward C. *Politics, Planning, and the Public Interest*. Glencoe, Ill.: The Free Press, 1955.

The Ministerial Legacy, by a Lady. Rochester: E. Darrow & Brother, 1858.

Mitchell, C. C. & Co. *The New Chicago*. Chicago, 1920.

Monchow, Helen Corbin. *Seventy Years of Real Estate Subdividing in the Region of Chicago*. Northwestern University Studies in the Social Sciences no. 3. Evanston and Chicago: Northwestern University, 1939.

Moody, Walter D. *Wacker's Manual of the Plan of Chicago: Municipal Economy* Chicago: H. C. Sherman & Co., 1911.

Moore, Nathanial Fish. *Diary: A Trip from New York to the Falls of St. Anthony in 1845*. Edited by Stanley Pargellis and Ruth Lapham Butler. Chicago: Published for the Newberry Library by the University of Chicago Press, 1946.

Morleigh [pseud.]. *Life in the West* London: Saunders & Otley, 1842.

Moscheles, Felix S. *Fragments of an Autobiography*. New York and London: Harper & Brothers, 1899.

Moses, John, and Kirkland, Joseph. *History of Chicago*. 2 vols. Chicago and New York: Munsell & Company, 1895.

Muirhead, James F. *America, the Land of Contrasts; A Briton's View of his American Kin*. 3d ed. London and New York: J. Lane, 1907.

Naylor, Robert A. *Across the Atlantic*. Westminster: The Roxburge Press, 1893.

Newmarch, William Thomas. *Letters Written Home in the Years 1864–5 Describing Residence in Canada, and Journeys to New York, Washington and the Pennsylvania Oil Region, and a Visit to the Army of the Potomac* . . . collected and rev. London, 1880.

Noguchi, Yoné. *The Story of Yoné Noguchi, Told by Himself*. Philadelphia: G. W. Jacobs & Co., 1915.

Norris, J. W. *Norris' Business Directory and Statistics of the City of Chicago, for 1846*. Chicago: Eastman & Davidson, 1846.

Northeastern Illinois Planning Commission. *The Comprehensive Plan for the Development of the Northeastern Illinois Counties Area*. Chicago, 1968.

Olcott's Blue Book of Land Values in Chicago and Environs. Chicago, 1909—.

[Orear, George Washington.] *Commercial and Architectural Chicago*. Chicago: G. W. Orear, 1887.

Ossoli, S. M. *At Home and Abroad.* Boston, 1874.

Palmer, Vivien M. *Social Backgrounds of Chicago's Local Communities.* Chicago: Local Community Research Committee, The University of Chicago, 1930.

[Park Ridge, Illinois, Community Church, Park Ridge Community Church Circle.] *The History of Park Ridge, 1841–1926.* Chicago, 1926.

Parker, Amos Andrew. *Trip to the West and Texas.* Concord, N. H.: White & Fisher, 1835.

The Parks and Property Interests of the City of Chicago. Chicago: Western News Company, 1869.

Peto, Sir Samuel Morton. *Resources and Prospects of America, Ascertained during a Visit to the States in the Autumn of 1865.* New York: A. Strahan & Co.; Philadelphia: J. B. Lippincott & Co., 1866.

Peyton, John Lewis. *Over the Alleghanies and across the Prairies.* London: Simkin, Marshall and Co., 1869.

Pierce, Bessie Louise. *As Others See Chicago: Impressions of Visitors, 1673–1933.* Chicago: University of Chicago Press, 1933.

————. *A History of Chicago.* 3 vols. New York: A. A. Knopf, 1937–57.

Pierce, Warren H. "Chicago, Unfinished Anomaly." In *Our Fair City,* edited by Robert S. Allen. New York: The Vanguard Press, 1947.

Pierrepont, Edward W. *Fifth Avenue to Alaska.* New York: G. P. Putnam's Sons, 1884.

Plumbe, George Edward. *Chicago; the Great Industrial and Commercial Center of the Mississippi Valley* Chicago: The Civic-Industrial Committee of the Chicago Association of Commerce, 1912.

Price, Morgan Philips. *America after Sixty Years; The Travel Diaries of Two Generations of Englishmen.* London: G. Allen & Unwin, 1936.

Putnam, James William. *The Illinois and Michigan Canal: A Study in Economic History.* Chicago: University of Chicago Press, 1918.

Putney, Mark H. *Real Estate Values and Historical Notes of Chicago.* Chicago, 1900.

Quaife, Milo M. *Checagou: From Indian Wigwam to Modern City, 1673–1835.* Chicago: University of Chicago Press, 1933.

————. *Chicago and the Old Northwest, 1673–1835: A Study of the Evolution of the Northwestern Frontier, together with a History of Fort Dearborn.* Chicago: University of Chicago Press, 1913.

————. *Chicago's Highways Old and New: From Indian Trails to Motor Road.* Chicago: D. F. Keller & Company, 1923.

————. *Lake Michigan.* The American Lakes Series. Indianapolis: The Bobbs Merrill Co., 1944.

Ralph, Julian E. *Our Great West: A Study of the Present Conditions and Future Possibilities of the New Commonwealths and Capitals of the United States.* New York: Harper & Brothers, 1893.

Randall, Frank A. *History of the Development of Building Construction in Chicago.* Urbana: University of Illinois Press, 1949.

Reeling, Viola Crouch. *Evanston: Its Land and its People.* Evanston, Ill.: Fort Dearborn Chapter, Daughters of the American Revolution, 1928.

Reminiscences of Chicago During the Civil War. Chicago: The Lakeside Press, 1914.

Reminiscences of Chicago During the Forties and Fifties. Chicago: The Lakeside Press, 1913.

Reminiscences of Early Chicago. Chicago: R. R. Donnelley & Sons Co., 1912.

Rey, William. *L'Amérique protestante: Notes and observations d'un voyeaur* 2 vols. Paris: Joël Cherbuliez, Editeur, 1857.

[Richardson, Mrs. Abby (Sage).] *Garnered Sheaves from the Writings of Albert D. Richardson.* Toledo: W. E. Bliss, 1871.

Riley, Elmer. *The Development of Chicago and Vicinity As a Manufacturing Center prior to 1880.* Chicago: McElroy Publishing Co., 1911.

Robertson, William. *Our American Tour, Being a Run of Ten Thousand Miles from the Atlantic to the Golden Gate in the Autumn of 1869.* Edinburgh, 1869.

Rossi, Peter H., and Dentler, Robert A. *The Politics of Urban Renewal: The Chicago Findings.* New York: The Free Press of Glencoe, 1961.

[Roundy, William Noble.] *The Visit of Apollo* Chicago: Hack & Anderson, 1907.

Rousiers, Paul de. *La vie américaine* Paris: Firmin-Didot et Cie, 1892.

Salisbury, R. D., and Alden, W. C. *The Geography of Chicago and its Environs.* Chicago: University of Chicago Press, 1920.

Sauvin, Georges. *Autour de Chicago: Notes sur les Etats-Unis.* Paris: E. Plon, Nourrit et Cie, 1893.

Schiavo, Giovanni Erminegildo. *The Italians in Chicago: A Study in Americanization.* Chicago: Italian American Publishing Co., 1928.

Schoolcraft, Henry Rowe. *Narrative Journal of Travels through the Northwestern Regions of the United States . . . to the Sources of the Mississippi River . . . in the Year 1820.* Albany: E. & E. Hosford, 1821.

————. *Travels in the Central Portions of the Mississippi Valley: Comprising Observations on Its Mineral Geography, Internal Resources, and Aboriginal Population.* New York: Collins and Hannay, 1825.

Schroeder, Douglas. *The Issue of the Lakefront: An Historical Critical Survey.* Chicago Heritage Committee, n.d., *ca.* 1963.

Sears, Robert. *A Pictorial Description of the United States; Embracing the History, Geographical Position, Agricultural and Mineral Resources . . . of Each State and Territory in the Union.* new ed., rev. and enl. New York: R. Sears, 1860.

Seeger, Eugen. *Chicago, the Wonder City.* Chicago, 1893.

Shackleton, Robert. *The Book of Chicago.* Philadelphia: The Penn Publishing Company, 1920.

Shirreff, Patrick. *A Tour through North America; together with a Comprehensive View*

of the Canadas and United States: As Adapted for Agricultural Emigration. Edinburgh [etc.]: Oliver & Boyd, 1835.

Siegel, Arthur, ed. *Chicago's Famous Buildings.* Chicago: University of Chicago Press, 1965.

Sienkiewicz, Henryk. *Portrait of America; Letters.* Edited and translated by Charles Morley. New York: Columbia University Press, 1959.

Simonin, Louis Laurent. *Le monde américain: Souvenirs de mes voyages aux Etats-Unis.* Paris: Hachette et Cie, 1877.

Sinclair, Upton. *The Jungle.* New York: Doubleday Page, 1906.

Smith, Henry Justin. *Chicago's Great Century, 1833–1933.* Chicago: Consolidated Publishers, 1933.

Solomon, Ezra, and Bilbija, Zarko G. *Metropolitan Chicago: An Economic Analysis.* Glencoe, Ill.: The Free Press, 1959.

Solzman, David M. *Waterway Industrial Sites, A Chicago Case Study.* Research Paper no. 107. Chicago: University of Chicago Department of Geography, 1966.

South, Colon. *Out West; or, From London to Salt Lake City and Back.* London: Wyman & Sons, 1884.

Spender, Harold. *A Briton in America.* London: W. Heinemann, 1921.

Spice, Robert Paulton. *The Wanderings of the Hermit of Westminster between New York & San Francisco in the Autumn of 1881.* London: Metchim & Son, 1882.

Spray, John Campbell, ed. *The Book of Woodlawn.* Chicago: John C. Spray, 1920.
———. *Chicago's Great South Shore.* Chicago: South Shore Publishing Company, 1930.

Statistical and Historical Review of Chicago Chicago: City Directory Publishing House, 1869.

Steevens, George Warrington. *The Land of the Dollar.* New York: Dodd, Mead and Company, 1897.

Stirling, James. *Letters from the Slave States.* London: J. W. Parker and Son, 1857.

Stoddard, Francis Hovey, ed. *Life and Letters of Charles Butler, Financier and Philanthropist.* New York: Charles Scribner's Sons, 1903.

Storr, Richard J. *Harper's University: The Beginnings.* Chicago: University of Chicago Press, 1966.

The Story of an Old Town—Glen Ellyn. Complied by Ada Douglas Harmon and edited by Audrie Alspaugh Chase. Glen Ellyn, Ill.: Anan Harmon Chapter, D.A.R. 1928.

Street, Julian. *Abroad at Home.* New York: The Century Co., 1920.

Taaffe, Edward J. *The Air Passenger Hinterland of Chicago.* Research Paper no. 24. Chicago: University of Chicago Department of Geography, 1952.

Taylor, Frank J. *High Horizons: Daredevil Flying Postman to Modern Magic Carpets, The United Air Lines Story.* New York: McGraw, 1951.

Thompson, George. *Impressions of America.* Arbrath, Scotland: T. Bunele & Co., 1916.

Thompson, William Hale. *Chicago: Eight Years of Progress: January, 1923* Chicago, 1923.

Thorn, W., & Co. *Chicago in 1860: A Glance at Its Business Houses* Chicago: W. Thorn & Co., 1860.

Tissandier, Albert. *Six mois aux Etats-Unis* Paris: G. Masson, 1886.

The Tricks and Traps of Chicago. pt 1. New York: Dinsmore & Company, 1859.

Turland, Ephraim. *Notes of a Visit to America: Eleven Lectures.* Manchester: Johnson & Rawson, 1877.

Turner, J. H. *A Three Month's Tour in the United States and Canada.* Brighouse: R. H. Ashworth, 1911.

Tweedie, Ethel Brilliana. *America As I Saw It; or, America Revisited.* New York: Macmillan, 1913.

The United States and Canada As Seen by Two Brothers in 1858 and 1861. London: E. Stanford, 1862.

University of Chicago Center for Urban Studies. *Mid-Chicago Economic Development Study.* 3 vols. Chicago: Mayor's Committee for Economic and Cultural Development, 1966.

Unrivaled Chicago; Containing an Historical Narrative of the Great City's Development, and Descriptions of Points of Interest Chicago and New York: Rand, McNally & Company, 1896.

Vandenbosch, Amry. *The Dutch Communities of Chicago.* Chicago: Knickerbocker Society of Chicago, 1927.

Van Tramp, John C. *Plain and Rocky Mountain Adventure; or, Life in the West* Columbus, Ohio: Gilmore & Segner, 1866.

Vay, Petér Gróf. *The Inner Life of the United States by Monsignor Count Vay de Vaya and Luskod.* London: J. Murray, 1908.

[Vynne, Harold Richard.] *Chicago by Day and Night: The Pleasure Seeker's Guide to the Paris of America* Chicago: Thomson and Zimmerman, 1892.

Wallace, Elizabeth. *The Unending Journey.* Minneapolis: University of Minnesota Press, 1952.

Ward, Martindale C. *A Trip to Chicago: What I Saw, What I Heard, What I Thought.* Glasgow: A. Malcolm & Co., 1895.

Waterman, Arba N. *Historical Review of Chicago and Cook County and Selected Biography.* 3 vols. Chicago and New York: The Lewis Publishing Company, 1908.

Watson, John. *Souvenir of a Tour in the United States of America and Canada, in the Autumn of 1872.* Glasgow, 1872.

Webb, Beatrice. *American Diary, 1898.* Edited by David A. Shannon. Madison: University of Wisconsin Press, 1963.

Weiss, Harry Bischoff, and Ziegler, Grace M. *Thomas Say, Early American Naturalist.* Springfield, Ill. and Baltimore, Md.: C. C. Thomas, 1931.

Weld, Charles Richard. *A Vacation Tour in the United States and Canada*. London: Longman, Brown, Green, and Longmans, 1855.

Whibley, Charles. *American Sketches*. Edinburgh and London: W. Blackwood & Sons, 1908.

Wilkie, Franc Bangs. *"Walks about Chicago," 1871–1881; and Army and Miscellaneous Sketches*. Chicago: Belford, Clarke & Co.; St. Louis: Belford & Clarke Publishing Co., 1882.

Wirth, Louis. *The Ghetto*. Chicago: University of Chicago Press, 1928.

Wirth, Louis, and Bernert, Eleanor H., eds. *Local Community Fact Book of Chicago*. Chicago: University of Chicago Press, 1949.

Wirth, Louis, and Furez, Margaret, eds. *Local Community Fact Book, 1938*. Chicago: Chicago Recreation Commission, 1938.

Wright, John Stephen. *Chicago: Past, Present, Future*. 2d ed. Chicago: Horton & Leonard, 1870.

Zincke, F. Barham. *Last Winter in the United States* London: John Murray, 1868.

Zorbaugh, Harvey W. *The Gold Coast and the Slum*. Chicago: University of Chicago Press, 1929.

PERIODICALS

"Airports: The King is Dead." *Newsweek* 60 (July 16, 1962): 66, 68.

"All Roads Lead to Chicago's Rainbow City." *The Literary Digest* 115 (June 3, 1933): 29–33.

Atcheson, Richard. "Marina City: Chicago's Pies in the Sky." *Holiday* 38 (December, 1965): 24, 27–29, 31–32.

Bach, Ira J. "Chicago Expands Its Burnham Plan." *The American City* 76 (September, 1961): 102–3.

Bailey, William L. "Regional Planning Makes Suburban Federations Imperative." *The American City Magazine* 34 (March, 1926): 257–60.

Bennett, Edward H. "The Beginning of the Lake Front Improvement in Chicago." *The American City* 16 (March, 1917): 231–33.

"Big Steel: Chicago's Civic Center Complete." *The Architectural Forum* 125 (October, 1966): 33–37.

Bigelow, Ellen. "Letters Written by a Peoria Woman in 1835: By Boat, Wagon, Horse, and Foot to Peoria in the Days of Pioneers." *Journal of the Illinois State Historical Society* 22 (July, 1929): 335–53.

Bowen, William. "Chicago: They Didn't Have to Burn It down after All." *Fortune* 71 (January, 1965): 142–51, 231–34.

Buswell, Arthur M. "Chicago and the Mississippi Waterway Problem." *The American Review of Reviews* 74 (December, 1926): 610–12.

"Chicago." *The Architectural Forum* 116, special issue (May, 1962): 81–142.

"Chicago." *Holiday* 2, special issue (May, 1947): 18–53.

"Chicago, 1856." *Putnam's Monthly Magazine* 7 (June, 1856): 606–13.

"Chicago Gets Suburb." *Architectural Record* 100 (December, 1946): 14–15.

"Chicago's Multi-Use Giant." *Architectural Record* 141 (January, 1967): 137–44.

"The City: A New Time for Old Town." *Time* 86 (September 10, 1965): 68, 70.

Crane, Jacob L., Jr. "Ultimately, the Regional City." *The American City Magazine* 34 (January, 1926): 95.

Crew, Mildred H., trans. "A Frenchman in America, Two Chapters from Ampére's 'Promenade en Amérique 1851.' " *Journal of the Illinois State Historical Society* 38 (June, 1945): 207–26.

Dedmon, Emmett. "Hustling Metropolis." *Saturday Review of Literature* 34 (December 8, 1951): 17–18.

Dent, Newton. "The Romance of Chicago." *Munsey's Magazine* 37 (April, 1907): 2–20.

Evans, Walker. "Chicago: A Camera Exploration of the Huge, Energetic Urban Sprawl of the Midlands." *Fortune* 35 (February, 1947): 112–21.

Fellman, Jerome D. "Pre-Building Growth Patterns in Chicago." *Annals of the Association of American Geographers* 47 (March, 1957): 59–82.

Fuerst, J. S. "Public Housing Measured—3 Criteria for Success." *The American City* 64 (February, 1949): 97–99.

Fuller, Henry Blake. "Chicago's Book of Days." *The Outlook* 16 (October 5, 1901): 288–99.

George, W. L. "Hail, Columbia! America in the Making." *Harper's Magazine* 142 (January, 1921): 137–53.

"Handy Little Strip." *Business Week*, November 9, 1963, p. 33.

Harper's Weekly, special Chicago issue. New York, London: Harper & Bros., 1902.

Haussner, R. A. "Alexis Clermont: An Old Mail Carrier." *Journal of the Illinois State Historical Society* 22 (July, 1929): 362–64.

Hayes, A. A. "Metropolis of the Prairies." *Harper's New Monthly Magazine* 61 (June, 1880): 711–31.

Head, Franklin H. "The Heart of Chicago." *The New England Magazine* n.s. 6 (July, 1892): 551–67.

Hergesheimer, Joseph. "A Post of Trade." *The Saturday Evening Post* 195 (September 16, 1922): 10–11, 123–28.

"Historical Riverview, Then and Now." *Chicago Tribune Magazine*, July 28, 1963, pp. 22–24.

"History and Statistics of Chicago Street Railway Corporations." *The Economist* (Supplement). Chicago: The Economist Publishing Company, 1896.

Husband, Joseph. "Chicago: An Etching." *The New Republic* 5 (November 20, 1915): 70–71.

"Innovation in Chicago." *Architectural Record* 135 (January, 1964): 133–38.

"Institutional Character at Competitive Cost [Hartford Building]." *Architectural Record* 130 (September, 1961): 121–26.

Jones, Dallas L. "Chicago in 1833: Impressions of Three Britishers." *The Journal of the Illinois State Historical Society* 47 (Summer, 1954): 167–75.

Jordan, Robert Paul. "Illinois: The City and the Plain." *The National Geographic Magazine* 131 (June, 1967): 745–97.

Joyaux, Georges J., trans. "A Frenchman's Visit to Chicago in 1886." *Journal of the Illinois State Historical Society* 47 (Spring, 1954): 45–56.

[Kirkland, Caroline M.] "Illinois in Springtime: With a Look at Chicago." *Atlantic Monthly* 2 (September, 1858): 475–88.

Lee, Guy A. "Historical Significance of the Chicago Grain Elevator System." *Agricultural History* 11 (January, 1937): 16–32.

Leibling, Arthur J. "Profiles: Second City." "I—So Proud to be Jammy-Jammy," January 12, 1952, pp. 29–37; "II—At Her Feet the Slain Deer," January 19, 1952, pp. 33–55; "III—The Massacree," January 26, 1952, pp. 33–48. *The New Yorker*, vol. 27.

"Living on the Top." *Look* 28 (January 14, 1964): 53–58.

Long, John P, "Matthew Arnold Visits Chicago." *University of Toronto Quarterly* 24 (October, 1954): 34–45.

McQuade, Walter. "Architecture." *The Nation* 194 (April 21, 1962): 366–68.

Masters, Edgar Lee. "Chicago: Yesterday, To-Day and To-Morrow," *The Century Magazine* 94 (July, 1928): 283–94.

Mathews, Shailer. "Uncommercial Chicago." *The World To-Day* 9 (September, 1905): 984–90.

Mayer, Harold M. "Patterns and Recent Trends of Chicago's Outlying Business Centers." *The Journal of Land and Public Utility Economics* 18 (February, 1942): 4–16.

————. "Politics and Land Use: The Indiana Shoreline of Lake Michigan." *Annals of the Association of American Geographers* 54, no. 4 (December, 1964): 508–23.

Meyer, Alfred H. "Circulation and Settlement Patterns of the Calumet Region of Northwest Indiana and Northeast Illinois." *Annals of the Association of American Geographers* 44, no. 3 (September, 1956): 312–86.

"Mies Designs Federal Center." *Architectural Record* 137 (March, 1965): 127–34.

Monroe, Lucy B. "Art in Chicago." *The New England Magazine* n.s. 6 (June, 1892): 411–32.

Morgan, William T. W. "The Pullman Experiment in Review." *Journal of the American Institute of Planners* 20, no. 1 (Winter, 1954): 27–30.

Moulton, Robert H. "Chicago's Improvement Plans." *The American Review of Reviews* 57 (March, 1918): 281–89.

"The New Chicago." *Holiday* 41, special issue, March, 1967.

Nicholson, Meredith. "Chicago." *Scribner's Magazine* 63 (February, 1918): 137–62.

O'Keeffe, P. J. "The Chicago Stock Yards." *The New England Magazine* n.s. 6 (May, 1892): 358–71.

Parker, Francis W. "An Appreciation of Chicago." *The World To-Day* 9 (September, 1905): 996–99.

Parton, James. "Chicago." *Atlantic Monthly* 19 (March, 1867): 325–45.

"The Point of View." *Scribner's Magazine* 67 (February, 1920): 247–49.

Richey, Elinor. "What Chicago Could be Proud of." *Harper's Magazine* 223 (December, 1961): 34–39.

Runnion, Ray. "Chicago the Beautiful." *The Nation* 161 (July 21, 1945): 61–62.

Ryerson, Joseph. "What Chicago Looked Like a Century Ago." *Townsfolk Magazine* 39 (March, 1949): 160.

"St. Lawrence Seaway." *The Chicago Daily News*, special section, June 26, 1958.

Schiller, Andrew. "Chicago's Miracle: How a Unique Railroad Man Is Making Money out of Commuters—And Makes Them Like It." *Harper's Magazine* 232 (January, 1966): 65–68, 73–75.

Sheahan, James W. "Chicago." *Scribner's Monthly* 10 (September, 1875): 529–51.

Shedd, John G. "Chicago: The Central Market." *The World To-Day* 9 (September, 1905): 935–41.

Slater, John R. "Chicago: A City of Homes." *The World To-Day* 9 (September, 1905): 965–72.

Showalter, William Joseph. "Chicago Today and Tomorrow." *The National Geographic Magazine* 35 (January, 1919): 1–42.

Sikes, George C. "Chicago—North America's Transportation Center." *The American Review of Reviews* 57 (March, 1918): 273–80.

Skorupa, Thomas. "From Park Departments: A City Park That Is a True Civic Institution." *The American City* 17 (August, 1917): 153–55.

"Small Shops Get Their Own Renewal." *Business Week*, January 29, 1966, pp. 34–35.

Smith, Henry Justin. "Chicago, Her Plans and Her Growing-Pains." *The Century Monthly Magazine*, n.s. 91 (March, 1927): 607–12.

————. "The Ugly City." *The Atlantic Monthly* 124 (July, 1919): 27–33.

Staudenraus, P. J. "The Empire City of the West—A View of Chicago in 1864." *Journal of the Illinois State Historical Society* 56 (Summer, 1963): 340–49.

"A Tale of Towers." *The Architectural Forum* 125 (April, 1966): 28–37.

Thomas, Edwin H. "Areal Association between Population Growth and Selected Factors in the Chicago Urbanized Area." *Economic Geography* 36, no. 2 (April, 1960): 158–70.

"Transportation Conditions in Chicago." *Electric Railway Journal* 40, special convention number (October 5, 1912): 519–98.

"Transportation: 'World's Busiest' Turns to Ghost Airport." *Business Week*, March 3, 1962, pp. 86–87.

"Up, Up, and Up in Busy Chicago." *Life* 52 (February 23, 1962): 28–38.

Van Dorn, Luther. "A View of Chicago in 1848." *Magazine of Western History* 10 (May, 1889): 41–46.

Walker, Natalie. "Chicago Housing Conditions: X Greeks and Italians in the Neigh-

borhood of Hull House." *The American Journal of Sociology* 21 (November, 1915): 285–316.

Walker, Stanley. "Our Far-Flung Correspondents: Return of a Non-Native." *The New Yorker* 22 (April 6, 1946): 90–96.

Weiser, Frederick S. "Early Times around about Glen Ellyn." *Daily Journal* (Wheaton, Illinois), series, June through September, 1949.

"The West As It Is." *Chicago Magazine*, March–August, 1857.

"When Whites Migrate from the South." *U.S. News & World Report* 55 (October 14, 1963): 70–73.

White, Charles Henry. "Chicago." *Harper's Monthly Magazine* 118 (April, 1909): 729–38.

Wrigley, Robert L., Jr. "The Plan of Chicago: Its Fiftieth Anniversary." *Journal of the American Institute of Planners* 26, no. 1 (February, 1960): 31–38.

Young, Hugh E. "New Wacker Drive Supplants 'Run Down' Water-Front Street." *The American City Magazine* 34 (April, 1926): 381–85.

Young, James H. "Land Hunting in 1836." *Journal of the Illinois State Historical Society* 45 (Spring, 1952): 241–47.

UNPUBLISHED MATERIAL

Dodson, Mrs. Harriet N. (Warren). "The Warrens of Warrensville." Typescript. Chicago: Chicago Historical Society, n.d.

Greene, Elizabeth Venilea Trowbridge. "Journey to Illinois in 1835." Typescript. Chicago: Chicago Historical Society, 1924.

Horak, Jacub. "Assimilation of Czechs in Chicago." Ph.D. dissertation, University of Chicago, 1928.

Law, Hazel Jane. "Chicago Architectural Sculpture." Master's thesis, University of Chicago, 1935.

Leonard, H. Stewart. "The History of Architecture in Chicago." Master's thesis, University of Chicago, 1934.

Messer, Moses Haynes. "Diaries, 1853–89." Chicago: Chicago Historical Society.

Morrison, Elizabeth Newman. "The Development of Skyscraper Style." Master's thesis, University of Chicago, 1931.

[Morton, Sterling.] "Horse and Carriage Days." Chicago: Chicago Historical Society, [1949].

Proudfoot, Malcolm J. "The Major Outlying Business Centers of Chicago." Ph.D. dissertation, University of Chicago, 1936.

Puzzo, Virgil Peter. "The Italians in Chicago, 1890–1930." Master's thesis, University of Chicago, 1937.

Shapiro, Dena Evelyn. "Indian Tribes and Trails of the Chicago Region." Master's thesis, University of Chicago, 1929.

Starrett, Helen Ekin. "Cottage Grove Avenue." Typescript. Chicago: Chicago Historical Society, 1920.

Index

Acknowledgments

Authors always accumulate an impressive list of indebtedness to the many people who help shape and develop a manuscript. A book of this kind, with its unconventional material and widely divergent sources, required much more than the ordinary assistance.

The pictures came from both small holdings, public and private, and a few large archives. The Chicago Historical Society, with its incomparably rich collection, represents the single most important repository of Chicago photographs. It includes the work of some of the city's best professional practitioners, from Alexander Hesler of the nineteenth century to Gordon Coster in our own time. Its contributions also range from hundreds of anonymous photographers to such gifted contemporary amateurs as Sigmund Osty. Mary Frances Rhymer, its curator, was almost as indispensable as the collection itself, for she alone has mastered its intricacies and volume. She was always gracious and understanding during the long period of location and selection of pictures. Walter Krutz, also of the Chicago Historical Society, transformed old pictures and glass slides into the shape necessary for reproduction. Anyone who has seen his work knows he is an artist as well as a technician.

We are also indebted to the Public Library and especially to its staffs in the many branches where much of the residential photographs have been preserved. In addition, other local historical societies and individuals were also helpful and courteous. They are, of course, recognized in the courtesies beneath each legend. Yet George Krambles needs special mention for his generosity in letting us use his extensive and unique collection of transportation photos.

In preparing the text, we could draw upon the extraordinary primary and secondary sources available in the area. Chicago is the most studied city in the world. A checklist of master's theses and doctoral dissertations at the University of Chicago alone runs to over 1,000 titles. Though literally scores of people helped at one time or another, none gave so much time or such useful advice as did Archie Motley of the Chicago Historical Society.

Anyone who writes about Chicago owes a particular debt to earlier scholars, and most especially to Bessie Louise Pierce, whose three volumes are a pioneer achievement, and to Homer Hoyt, whose *One Hundred Years of Land Values in Chicago* remains something of a classic. Carl Condit's works on building and architecture in Chicago are, of course, indispensable.

Partial financial support, which made this publication possible, came from the Social Science Research Committee of the University of Chicago and from the Lambda Alpha Foundation.